# The Virgin of Chartres

In memoriam Chanoine Pierre Bizeau,
Archiviste diocésain de Chartres, 1959–2007, d. 2008. Photo, de Feraudy.

# THE VIRGIN OF CHARTRES

*Making History through Liturgy and the Arts*

Margot E. Fassler

Yale

UNIVERSITY

PRESS

*New Haven & London*

Published with assistance from The Yale Institute of Sacred Music
and from the foundation established in memory of Philip Hamilton McMillan
of the Class of 1894, Yale College.

Set in Postscript Electra type by Tseng Information Systems, Inc.
Printed in the United States of America.

Library of Congress Cataloging-in-Publication Data
Fassler, Margot Elsbeth.
The Virgin of Chartres : making history through liturgy and the arts / Margot E. Fassler.
p. cm.
Includes bibliographical references and index.
ISBN 978-0-300-11088-3 (cloth : alk. paper)
1. Chartres (France)—Church history. 2. Mary, Blessed Virgin,
Saint—Shrines—France—Chartres. I. Title.
BR848.C47F37 2010
232.91′709445124—dc22
2009035845

A catalogue record for this book is available from the British Library.

This paper meets the requirements of ANSI/NISO Z39.48-1992 (Permanence of Paper).

It contains 30 percent postconsumer waste (PCW) and is certified by
the Forest Stewardship Council (FSC).

10 9 8 7 6 5 4 3 2 1

# CONTENTS

*Color plates follow page 202*

# PREFACE

History is entirely shaped by the system within which it is developed. Today as yesterday, it is determined by the fact of a localized fabrication at such and such a point within this system. . . . To take seriously the site of historiography is still not tantamount to expounding history. Nothing of what is produced in it is yet said about it. But taking the place seriously is the condition that allows something to be stated that is neither legendary (or edifying) nor atopical (lacking relevance). . . . "Making history" is a practice.

*— Michel de Certeau*

This book explores the broad enterprise of history making undertaken in every town and region in Christian Europe during the central Middle Ages, long before the triumph of the textual genre that moderns, following premedieval classical ancestors, call history. Even though the number of medieval chronicles is vast, and their numbers increase dramatically from the twelfth century forward (the electronic *Encyclopedia of the Medieval Chronicle* has over two thousand entries), most medieval towns were neither blessed nor cursed with a school of local history writers. In the central Middle Ages, the Benedictine Abbey of St. Denis and the archiepiscopal court at Reims had distinguished schools of chroniclers and local historians whose works built on one another for generations. In most geographical centers, however, each diocese, each town, each church, each religious order, even each noble family took a different approach during the tenth through the twelfth centuries, seeking to acquire a past through the "discovery" of new saints and the revisiting of old ones and through the accumulation of regionally specific adaptations of the liturgical framework of time inherited from Carolingian reformers of the eighth and ninth centuries, especially through the addition of new feasts or new materials for these local and regional saints.

In the tenth through the twelfth centuries, the history makers in most places were inventing a past for their constituents through the liturgical arts: texts, chants,

artworks, shrines, and ceremonies. In this process liturgists often tied these materials to political struggles, while foundational histories were created within the "paper trails" of increasingly active ecclesial and secular scriptoria. Music, texts, and artworks took on new meanings as the sons and grandsons of Charlemagne wrestled for control of their territories and needed to be reborn through revised understandings of genealogy and *adventus*, the magnificent ceremonial coming of a rightful ruler to the throne. This sense of a new coming was especially important in northwestern Francia during the central Middle Ages. Here a new line of kings struggled to assert itself against the old Carolingian line, while the new kings' most powerful vassals themselves harbored hopes of *adventus*, with entwined lineages that kept their sons and daughters heartbeats away from the thrones of England and of Francia. History was made then—in the central Middle Ages, as in the Carolingian centuries just before them—through processes that differ considerably from those familiar to moderns and postmoderns. Most people learned about the past in what they heard and saw and reenacted, not in what they read.

The measurement of what made effective and memorable history for medieval Christian cultures is alien to contemporary ways of judging achievement. The histories made within the liturgical framework of time were not about verity, nor were they concerned with depictions of events and people based on eyewitness accounts, dispassionate or not. Success lay, rather, in the ability to create long-lasting, liturgically based, and steadily reenacted visions of the past. These imaginaries proclaimed the importance of particular towns or regions, dioceses or religious orders, and demonstrated an ongoing sense of God's love, however disguised, or of God's displeasure when things went wrong. Most important was the creation of local characters associated with particular chants and ritual actions, figures that could endure for generations and promote local identity and communal strength. Through the many ways that the past could be represented—by the action, chants, and intoned texts of ritual action and through the visual arts—each place had a sense of the past dependent upon what survived. At Chartres, from the twelfth century forward, the visual arts have been primary to historical understanding, not only because so much survives from the past, but also because of superb workmanship and design. The survival of such artworks and of such a building as Chartres Cathedral has inspired centuries of study and explanation, from the people who live in Chartres to pilgrims to scholars from all over the world who study this place and its liturgical artworks. Every so often a group of scholars gathers to speculate about why Chartres matters so much: I have heard it said that Bourges cathedral is just as beautiful, and the abbey church of St. Denis is more important. But when Chartres Cathedral rises in view on the plains of the Beauce, the detractors fall silent, and scholars continue their studies.

The major industry in Chartres is history. Central to the ongoing interweaving of facts, legends, liturgy, and the arts found over centuries at Chartres is a piece of

cloth, the relic of Mary's gown, which was held by the bishop's hands over the city in Carolingian times in the town's foundational myth. This banner was present in people's minds, hidden though it was in a jewel-encrusted box that lay upon or near the main altar of the cathedral throughout much of the Middle Ages. The position of the relic recalls that it, like all medieval relics, found its most profound definition within the liturgy. The power of materiality to shape history—even though the actual relic was far removed in shape and size from the chemise-like picture often displayed in the later Middle Ages—cannot be denied. The history and local identity that evolved over the centuries at Chartres was a manifestation of the cloth relic and its unique character, especially as defined over time through liturgical associations and artistic contexts.

The relic introduces the two main characters of the story told here, both of whom were ever coming and going within the cathedral on the breath of liturgical song and on the feet of ceremonial action. Mary, of course, is the heroine, for her cult inspired many generations of history makers, and her relic forced a special interest in lineage, birth, and motherly love. The hero, Bishop Fulbert, became Mary's special servant. These two characters were joined and celebrated by cantors and liturgists and enshrined in the arts to make a uniquely Chartrain sense of the past, one that was transformed by the rising and falling fortunes of the local nobility and the genius of local and regional artists.

Although the making of history is its subject, this book is not only for medievalists. It offers a mode of study that should prove useful to all engaged with this process, in any century and in our time as well: history making never ceases. Mary of Chartres contains mysteries from long ago; she embodies what was familiar and comprehensible and, like the medieval liturgy, expresses ideals of a far-removed time. Emblematic as she is of a basic process of human knowing, she encourages every person encountering her to remember their own entrances into the world of time. Her cult, a collective commemoration of birth and lineage ever shifting over time, points to the fact that individuals cannot remember their own births without help, from mothers, from fathers, from communities. Each person must find his or her own past, even when the desired special or intimate secrets of identity have been destroyed. The Mary of this book is a symbol of knowing and remembering, of stories and legends, of adoration and rediscovery. She ever calls to mind the persons who explained her through acts of adoration and patronage, for they made and remade her in their own image and to address particular needs.

Mary of Chartres cannot be known without unraveling a made history and coming to understand medieval processes for fabricating the past. This process, in its turn, offers understanding for any age. History making in the Latin Middle Ages is directly and powerfully illustrative of how contemporary communities create identity from remade myths of the past and through the modes of action by which the past is known and celebrated. Now, as in the Middle Ages, history makers of

many kinds fashion figures from the past necessary for present survival. But the staying power of these figures will not be, cannot be, the same as it was for Mary of Chartres. The processes are similar, but the sense of time is not. The framework against which historic figures unfolded for Christian communities in the central Middle Ages was that of liturgical time. This made all the difference, not only for how the past was made but also for how it was understood, by individuals and by communities, and not just for years or decades but for centuries.

# Acknowledgments:
## À la recherche du temps perdu

The September sun was veiled with rain clouds, offering light perfect for shooting. I had left a friend's house early, making my way toward the West, or Royal, Portal of Chartres Cathedral, the artistic display that has inspired this book about history making. In the days before, another chapter of *Le Spectacle*, the light show that "paints" the sculpture and walls of local buildings in vibrant color, had taken place, drawing tens of thousands to the streets to rediscover the glories of local architecture and to make history once again in something of the spirit of the Middle Ages (see plate 2).

On this morning the town was tired and empty, and a familiar panhandler in his purple shirt, ready to chant "He's got the whole world in his hands" to yet another day's worth of tourists, was easy to spot. We hailed each other and continued together toward the cathedral. When we arrived, the photographer Henri de Feraudy and a friend, Hélène du Chalard, had the cameras set up; I joined them eagerly, as my escort took up his customary place by the iron fence. The day was typical: we in front of the church worked in the midst of an elaborate gathering for the wedding of an official of the ambulance corps, finding it powerfully suggestive of the way the Royal Portal still defines times and occasions for the people of Chartres (see plate 1). Malcolm Miller, whose tours have entertained so many, had lunch at his usual table; an Australian graduate student happened by, recognized me, and we discussed our work; the afternoon included coffee with a French architect, the translator of John James's books, and a visit to Pierre Bizeau, who was recovering nicely from a recent fall. These details acknowledge the culture flourishing *devant la cathédrale* and my gratitude at having been part of it. So I begin by thanking Chartrains who opened their hearts and homes to an American scholar trying to figure out the early centuries of the local Virgin's cult and its embodiment in the Royal Portal: thank you to Ludovic, to Nicole, to François, Mazarine and Louise, to Marianne and Philippe, to Isabelle, to Jane and Jacques, to Beatrice, to Patricia, to Hélène and her family.

I owe debts of another kind to the staffs of many institutions: the Municipal Library of Chartres (more recently known as the Médiathèque), the Archive of the Department of Eure and Loir, the Diocesan Archive of Chartres and its Library, the Municipal Library of Provins, the Institut de Recherche et d'Histoire des Textes in Paris, Véronique Trémault of the Institut de recherches et d'histoire des textes in Orléans, the Libraries of the Ste. Geneviève and of the Mazarine, and the French National Library, most especially to those who have offered help in the Salle des Manuscrits and in the Arsenal. American libraries too have played a key role in the work, especially the Library of Brandeis University; Sterling Memorial Library, the Herrick Music Library, the Beinecke Rare Book and Manuscript Library, and the Divinity Library, all of Yale University; the Library of the Institute for Advanced Study; Firestone Memorial Library and the Index of Christian Art of Princeton University; the Library of the Princeton Seminary; and the Library of the Catholic University of America. Several foundations and institutions have provided funds for study, travel, and materials, including the Howard Foundation, the Mellon Foundation, the American Philosophical Society, the National Endowment for the Humanities, the Institute of Advanced Study, Brandeis University, and Yale University, and most especially the Yale Institute of Sacred Music. Many aspects of the book have been presented as papers at scholarly conventions and at American and European colleges and universities, and I am grateful for these rich learning opportunities, too numerous to name but crucial nonetheless.

There are more colleagues to thank than I can mention, and so I have singled out a representative group: Harold Attridge, Howard Bloch, Pamela Blum, Susan Boynton, Carolyn Bynum, Walter Cahn, Madeleine Cavaniss, Tova Choate, Marcia Colish, Giles Constable, Christopher Crockett, Rachel Fulton, David Ganz, Walter Goffart, Jeffery Hamburger, Peter Hawkins, Nicholas Howe, Michel Huglo, Martin Jean, Jacqueline Jung, Kathryn Kerby-Fulton, Jaime Lara, Marilyn Lavin, Kenneth Levy, Meredith Lillich, Claire Maître, Charles McClendon, Stephen Murray, Barbara Newman, Bryan Noell, Daniel Poirel, Pamela Potter, Virginia Raguin, Susan Rankin, Edward Roesner, Colleen Farrell, Bryan Spinks, Patricia Stirnemann, Jan van der Meulen, John van Engen, Anders Winroth, Charlie Wright, and Craig Wright. Charul Kothari added his technical expertise in preparing the plates. I am grateful for the advice of members of the staff of the Yale Institute of Sacred Music, especially Sachin Ramabhadran, Jacqueline C. Richard, Albert Agbayani, and above all Martin Jean, Director of the Institute of Sacred Music, whose support was crucial in the final stages of manuscript preparation. It has been a joy to work with the staff of Yale University Press: senior editor Margaret Otzel, Jennifer Banks, my editor, and her assistants, Joseph Calamia and Christina Tucker. Special thanks are due to the copyeditor Lawrence Kenney, who has made the prose cleaner and clearer and been helpful in so many ways. Finally, the work of the composer Robinson McClellan, who prepared the camera-ready copy of the music must be

acknowledged. His painstaking care with the notes, texts, and their alignment was crucial to the final result.

There are people without whom the book simply could not have been written, especially at a time in my life when I was occupied with heavy administrative duties. I am grateful to the two readers, James Bugslag and Rachel Fulton, wisely chosen by Yale University Press: their excellent suggestions caused me to rethink many details of the argument, to add missed bibliography, and to reorganize the opening. Early study of the portal was supported by the photography of Carla Januska and Jens Ulff-Moller; as the book developed, Henri de Feraudy became involved, taking hundreds of photographs and working tirelessly, on his own and with others, to get the shots necessary for particular iconographical arguments. Christopher Crockett read parts of the book at a crucial stage and offered invaluable advice, most of which I took with gratitude. I thank John Leinenweber, who read the entire manuscript with great care many times over, offering suggestions for Latin translations and for other matters, always supporting me when it seemed I would never finish, and shredding every verbosity; he prepared the index as well. Andrew Kraebel served as research assistant at the end of the project, and his unstinting care, boundless energy, generosity of spirit, and peerless skills in matters bibliographical and linguistic were crucial at every turn. My husband, Peter Jeffery, and my sons, Joe Fassler and Frank Jeffery, supported my work in more ways than I can name, from discussing fine points to carrying tripods. My beloved mother, Susan Cooper Fassler-Babcock, listened for hours to my thoughts about Chartres and history making and would have rejoiced like none other had she lived to see the book's completion.

One person falls within all these categories of acknowledgment—from local friend to sine qua non: Rev. Pierre Bizeau, canon of the cathedral of Chartres and former diocesan archivist. A creative and superbly trained professional—the worthy successor to the great Yves Delaporte, whose bibliography he prepared—Bizeau was the one person in the world of Chartrain studies who "knew it all." Scholars who labor *devant la cathédrale* (or to either side of it, or within it, or beneath it in the crypt) have long been informed by his extraordinary expertise and nurtured through the warmth of his generosity and good humor. It is with the deepest respect and gratitude that I dedicate this book to his memory.

*Part One*

---

# MARY BEFORE FULBERT

# CHARTRES IN EARLY HISTORIES AND LEGENDS

Suddenly, Bishop Walter charged out of the city robed as if to celebrate Mass, and bearing the cross and the tunic of the Holy Virgin Mary in his hands, with the clergy and the citizens following behind; attended by "steel-clad squadrons" he struck the backs of the pagans with spears and swords.

—*Dudo of St. Quentin,* History of the Normans

Southeast of the site where the medieval Abbey of St. John in the Valley once stood, the land rises steeply past the medieval walls of Chartres and upward to the cathedral; on the other side of the cathedral a high, sharp cliff falls eastward to the river.[1] Were a fortress located here instead of a church, the viewer would naturally contemplate the military advantage accruing to those occupying the summit of such a hill. In modern-day Chartres the cathedral dominates the landscape from its high vantage point, and one can easily forget that when the counts of Chartres/ Blois built their military enclave in the region, they located it on the plateau south of the cathedral. From there it stood guard to the rear flank of the town.[2] From the mid-tenth century on, those laying siege to the town on the north and east confronted the cathedral's walls and tower or towers, while those attacking from the south and west faced the ramparts of the Thibaudians. By that time two fortresses protected the town, and each offered its own kind of defense.[3] Each institution slowly developed its own qualities of remembrance, and these grew independently in the ninth and tenth centuries, only to converge during the tenure of Bishop Odo in the late tenth century (see chapter 2). Early legends surrounding the nascent Virgin's cult and the earliest history of the bishops of Chartres explain how a sense of the past developed in Chartres, where, as in the vast majority of places, there was no early school of history writers to record events.

The earliest known priestly class of the region was described by Caesar in the *Gallic Wars,* book 6, as learned and responsible for the ritual life of the culture; he reports in chapter 13 that the Druids of Gaul assembled once a year in "a con-

secrated place in the territories of the Carnutes." Stretching the cult of the Virgin
back into early Christian times and finding her pagan archetypes was, however,
the work of Chartrain historians from the fourteenth through the seventeenth cen-
turies (see chapter 12); the central Middle Ages had little interest in such machi-
nations, except for an omnipresent desire to connect early saints with the apostles
and the Franks with the Trojans.[4] Sulpicius Severus, the late fourth-century biog-
rapher of Martin of Tours, followed the saint throughout Gaul, documenting his
sermons and miracles. Saint Martin twice saved children in Chartres, raising one
from the dead and curing muteness in another. Both miracles are of a kind later
associated with the miraculous powers of Saint Mary in this place. But there is no
Virgin in Chartres during Saint Martin's time, or at least not documented in the
extant sources. Chartres is also mentioned in a prominent source from the late
sixth century: Gregory of Tours, whose history provides a general understanding
of northwestern Merovingian Gaul, mentions Chartres briefly several times. Only
once does he offer details, in a passage concerning an aborted attempt of officials
at Châteaudun to create a new diocese next to that of Chartres.[5] The earliest docu-
ment included in Lépinois' and Merlet's edited charters from Chartres Cathedral
concerns a Synod of Paris held in 573 to settle the dispute mentioned by Gregory of
Tours.[6] No Virgin is mentioned there either.

Two sources from the eighth and early ninth centuries witness to the fact that the
cathedral at Chartres was dedicated to Mary. A donation by King Pepin the Short
to the Abbey of St. Denis in September 768 of the forest of Iveline exempts those
parts of it previously given to other churches, which include "ecclesia Sancte-Marie
Carnotensis urbe."[7] A supposed eighth-century burning of Chartres recorded in
the early ninth-century *Annales Mettenses* never became part of local traditions or
historiography. It too mentions the cathedral as being dedicated to the Virgin.[8] The
stories that did develop over time were those about raids by the Vikings into the vast
tract of land called Neustria, which by the ninth century designated those lands
north of the Loire and south of the Seine, a volatile territory with ever-changing
boundaries, the heart of which included the old cathedral towns of Evreux, Paris,
Soissons, Le Mans, Angers, Orleans, Tours, and Chartres.[9]

## CHARTRES IN THE NINTH CENTURY:
## THE EXAMPLE OF BISHOP FROTBALD

Written descriptions of life in mid-ninth-century Neustria are found most notably
in the chronicle called by moderns the *Annals of St-Bertin*.[10] Begun in the 840s and
850s by the Spaniard Prudentius of Troyes, the work was taken over by Hincmar
of Reims, who loathed his predecessor for political reasons but revised his efforts
only moderately as he continued the chronicle. The years leading up to 857 and a
decisive battle are dominated by brief reports of attacks involving, among others,

the medieval towns of Tours, Blois, and Chartres, the region that would contain the central lands of the Thibaudian family by the mid-tenth century.

The partition of territory by the Treaty of Verdun in 843 had left Charlemagne's grandson Charles II ("the Bald") the ruler of West Francia, an area Dunbabin calls "a ragbag of old sub-kingdoms and peoples."[11] Charles the Bald, who has been termed the last great Carolingian emperor, might have made something more permanent out of his patrimony were it not for the Viking invasions that kept him always on the defensive.[12] Because of this relentless pressure he entrusted parts of his lands to various of his *fideles*, men ever ready to increase their own powers and be rewarded for their successes.

King Charles named both soldiers and scholars as bishops. Bishop Burchard of Chartres was apparently a "strong man," that is, a well-trained military leader; his inappropriateness for the office of bishop was woven into the imaginative writings of the Carolingian cleric Audrad the Short, who, until deposed when the office was abolished, was "co-archbishop" of Reims.[13] Audrad, a partisan of Charles the Bald, saw the Viking raids as punishment by God for various mistakes made by the church and its leaders. His book of visions, the *Revelations*, draws on Augustine's *City of God* as well as on texts apparently borrowed from the Advent liturgy of his time. His visions offer a history filled with portents; regarding the bishop of Chartres, he claims to have seen a great light before the Lord spoke to him, saying, "Evil is the day on which Burchard will be a bishop."[14] Giselbert, a bishop of Chartres who ruled not long after Burchard (see below), was of the other type, a notary of Chartres and one of King Charles's most trusted associates. The appointment of these men to the office of bishop of Chartres and the comments about them demonstrate the importance of the see in the mid-ninth century. Chartres, BM 3 was a ninth-century copy of Jerome on the Psalms offered to the cathedral of Chartres in the time of Giselbert and written by the cleric Dodaldus; the photograph of a single folio (59v) and the description are thanks to Canon Delaporte, whose collected works in the Diocesan Archive at Chartres have proved crucial to this and so many other studies.[15] The manuscript is in the Tours script, and Rand (1931) dated it to around 820.[16]

As passages from the *Annals of St-Bertin* from the years 843–57 reveal, Chartres and its bishops were often in the news, and saints as well as subjects, especially those near waterways, needed protection in a region under attack. When the bodies of the saints were moved, new cults arose, as did controversy over ownership. Feasts were created to mark the translation, or relocation, of holy bodies and to make histories for new locations; many of the relationships between locales and sets of holy bones had their beginnings in the late ninth century, or so later hagiographers claim. Stories surrounding the precious body of Saint Martin reveal how many communities could lay claim to it. Orleans was constantly threatened, and in 854 an attack on the city was prevented through the combined military action of the bishops

Figure 1.1. Chartres, BM 3, Jerome on the Psalms, ninth century. Médiathèque de Chartres. Photo, Delaporte.

of Orleans and Chartres. The following passage from the Annals proves that Blois (part of the diocese of Chartres in the Middle Ages) was fortified at the time: "The Danes stayed on the Loire. They sailed up as far as the stronghold of Blois which they burned. Their aim was to reach Orléans and wreak the same havoc there. But Bishop Aigus of Orléans and Bishop Burchard of Chartres got ready ships and warriors to resist them; so the Danes gave up their plan and headed back to the lower waters of the Loire." The invaders were beaten again in 855 by the Aquitanians, who came up to meet them and allowed only three hundred to escape. In 856, Orleans was sacked by Danish pirates.[17]

Pierre Bauduin (2004), following Chédeville (1973), believes that Chartres was a major center in the mid-ninth-century reorganization of territory that took place in the aftermath of the divisions of Verdun and that Bishop Burchard of Chartres was chosen by the king for his military and administrative abilities. In this view, Burchard was one of a group of three (the other two were Raoul, uncle of Charles the Bald, and Henry, abbot of Saint-Lômer-de-Corbion) responsible for defending an enormous block of territory at whose strategic center was Chartres; the city bore responsibility for a line of defense that included safeguarding the valley of the river Eure. This theory would help explain the legendary importance given to several battles that took place in Chartres in the late ninth and early tenth centuries, battles that would be incorporated into early legends of the Virgin's cult.[18]

In entries for 857 the *Annals* tells of an attack on Paris and Chartres and of the

death of Bishop Frotbald, Burchard's successor, as he attempted to flee, an event reinterpreted in later historiography and ritual at Chartres many times over: "The Danes who were coming up the Seine ravaged everything unchecked. They attacked Paris where they burned the church of St-Peter and St-Genevieve and all the other churches except for the cathedral of St-Stephen, the Church of SS-Vincent and Germain and also the church of St-Denis: a great ransom was paid in cash to save these churches from being burned. . . . As the Danes attacked his *civitas*, Frotbald [bishop of Chartres], fled on foot and tried to swim across the river Eure but he was overwhelmed by the waters and drowned."[19]

Frotbald's successor as bishop of Chartres was Giselbert, who probably took up his office in 858, serving until sometime between 879 and 885.[20] Giselbert was a scholar as well as a strongman, a producer of charters, and a member of King Charles's immediate entourage before becoming bishop; his new office created a connection between the court of Charles the Bald and the cathedral of Chartres. It was during his tenure as bishop that the major relic of the cathedral supposedly came to Chartres, from the hands of the king. Bishop Giselbert, who served after the destruction in the era of Frotbald, constructed the cathedral that seems to have endured at Chartres until the mid-tenth century. He may have been given the relic to enhance the liturgy of his new church and the cult of the Virgin, to whom Chartres Cathedral had by then long been dedicated. Giselbert's presence also helps explain the surviving deluxe liturgical books from the second half of the ninth century that were once found in Chartres.[21] Compilation and copying of documents and liturgical books for the use of cathedrals and monasteries in the ninth century was time-consuming and arduous, but prayer was deemed as essential to well-being as the implements of warfare. Charles the Bald's tutor, Walahfrid Strabo, produced what has been called the first liturgical history, and he has been linked to the preparation of liturgical books necessary for the high court liturgy favored by Charles and his retinue.[22] Religious leaders who served the royal courts were men such as the liturgist Amalar of Metz in eastern Gaul and Rabanus Maurus in the west, whose commentaries on scripture frequently became part of the Office liturgy, as in Chartres.[23]

The slaughter at Chartres and the killing of Bishop Frotbald referred to in the *Annals of St-Bertin* (dated 857) were inscribed in the necrology/martyrology Chartres, BM N₄, a source prepared during the time of Fulbert (d. 1028) by the cantor Sigo, a student of Fulbert whose work was crucial to eleventh-century developments in the cult and the history of Chartres, and members of his entourage (see chapter 4). There the event is situated in the ninth century (one year after the date found in the *Annals of St-Bertin*), but the entry is a later, eleventh-century addition to the original work and thus was known in Chartres later, at least as far as is presently known: "ii id. Jun. [June 12] In the year of the incarnation of our Lord 858, the sixth indiction, a great slaughter was carried out in Chartres by pagans coming

from the Seine river, in which Bishop Frotbald, the priest Stephen, the priest and monk Titulf, the priest Tetbert, the priest Rainulf, the cleric Adalgaud, the cleric Modo, the subdeacon Landram, the subdeacon Letram, the subdeacon Almand, the subdeacon Ulgarius, the cleric Adalbert, the cleric Gaubert, and a great many others were killed; entreat the Lord for them!"[24]

This notice, written in the mode of a chronicle entry, records an event that was to receive far greater elaboration in the centuries to follow (see *MSC*, the edited version of Chartres, BM Na4, 102–03). The eleventh-century hand that wrote it also records an entry on the next day (June 13) for a Bishop Jerard, unknown before this time, and connected through the entry to Bishop Frotbald. The successors of Sigo were fashioning a new version of the story; they may have possessed an early chronicle that no longer exists, but even if they did not they created that appearance. Through their addition, Bishop Frotbald's character is transformed. Unlike the figure in the *Annals of St-Bertin*, who drowned in flight, Frotbald wins honor for his bravery, along with other members of the clergy, now named. The turntail has become a hero in the course of local eleventh-century history making through an entry in a liturgical source. From this time on, the event and Frotbald's place in it were recalled in the liturgical necrology of Chartres year after year, establishing his character.

The tale of the mid-ninth-century slaughter at Chartres is also found in another local source, the compilation of the Chartrain historian Paul of St. Peter (fl. 1060–88). His late eleventh-century interpretations dovetail with the revisions to the early eleventh-century martyrology/necrology Chartres, BM Na4 but have added the Virgin Mary to the story. Paul sought to compile a history in the last decades of the eleventh century, a recording of the past that would champion his monastery and create a magnificent past for it. He compiled the first set of extant Chartrain charters and wrote Chartres' first surviving history, intermingling two kinds of evidence, one documentary and the other narrative. His work is not a history, but rather a *historia, cum cartis*, that is, a collection of charters arranged in a particular order, each with a few notes. The balance between the two kinds of materials varies from section to section; the charters in each section either relate to the points he makes or are related to a particular bishop of the cathedral or to an abbot of the Benedictine Abbey of St. Peter.[25] Modern historians use the necrology in Chartres, BM Na4 with its additions and Paul's charters with its short histories in tandem: sources emanating from two different institutions in the same town offer a richer tradition than either could alone and, in some cases, a way of measuring the veracity of dates through checks and balances. When one deals with the works of Paul of St. Peter, some sort of yardstick is helpful.[26]

Paul the Scribe, as he signed himself, was probably the keeper of the library of the Benedictine abbey dedicated to St. Peter in Chartres, often called St. Père in the modern period. Although it cannot be proven that he held the office of cantor,

according to Benedictine custom cantors were also librarians and were in charge of monastic scriptoria.[27] From what is known of him he was heavily invested in the preservation and production of charters. He may have experienced the fire that occurred at St. Peter's in 1077—which apparently ruined much of the contents of the monastic library—as both a personal and a professional tragedy.[28] As keeper of the library and head of the scriptorium, Paul was the guardian of the documents recording rights to land and other hard-won privileges; without documents attesting to its rights, any medieval institution became vulnerable. Crucial to survival was the ability to produce the necessary charters at the appropriate times to gain favorable judgments and prevent losses, and the forging of "missing" documents or revising of earlier ones was simply a means of survival.[29]

Given the loose chronological ordering of Paul's history, that he foreshadows the mid-ninth-century slaughter by introducing the constantly attacking barbarians and their leader, Hasting, is not surprising. Hasting, famed for his murderous deeds in the stories and histories of many regions, is known in some sources as an ur-count of Chartres.[30] In the events of 858 as Paul reports them in the late eleventh century, Hasting and his pirates head home from their distant ravages to Neustria, coming finally to the town of Chartres; the barebones of history have been fleshed out, and the men only mentioned in passing in ninth-century sources have taken on character, mingling the lofty past of classical antiquity with early medieval hagiography:

> Secure now, with their boats and various kinds of plunder left behind, they came with swift approach to this city. Finally, at night, with the city surrounded and the citizens unexpectedly besieged, the barbarians—rushing in through walls often battered by foes and the gates, piling upon themselves—killed indifferently with the sword. Inside the mother church they slaughtered with their gory swords, as if they were sheep, no small crowd, along with their bishop, whose name was Frotbald, the canons of the church, and monks who had fled to the church in a group. With the city depopulated and burned, swift and jubilant, as stirred by their lust, they decided to return with their great riches to their waiting boats. But by the intercession of blessed Mary, the mother of God—whom it mattered nothing to them to offend— instead they descended that very day by their deserved death to the harsh lower world through the mouth of the doorkeeper of hell. For before they were able to reach their boats, the Franks came together with them, and, by God's favor, took their victory from them, leaving their butchered bodies strewn through the fields to be gnawed by the birds and wild beasts.[31]

Paul redeems the killing of Frotbald and transforms the burning of Chartres through recourse to the avenging powers of the Virgin, carried out by the Franks. Martyrs found in the entry from the first necrology of the cathedral, cited above, appear in Paul's history as both clerics and monks, demonstrating Paul's desire to credit the joint leadership of the two groups: both died for the local church. Instead

of protecting Chartres from slaughter and loss, the Virgin inspires revenge upon the
attackers of her church. She would act more decisively in the future.

The new bishop of Chartres, Giselbert, successor to the unfortunate Frotbald,
would have fought by the side of another of Charles's associates. In the decade fol-
lowing the death of Frotbald, Robert the Strong, the first of the Robertian line to
achieve major power, emerges in the *Annals of St-Bertin* as a man faithful to King
Charles the Bald, one of several figures who helped the king defend the crucial
regions of the western kingdom. According to the *Annals of Fulda*, Robert held
territories in the Loire valley, including Anjou, by 852; he was still in control there
when he was rewarded for his defence of Chartres in 865: "Then in mid-September,
Charles (the Bald) moved to the *villa* of Orville to do some hunting. But the guards
still had not taken up their positions on this [i.e., the east] bank of the Seine, so
those Northmen dispatched about 200 of their number to Paris to get wine. Failing
to find what they sought there, they came back to their people who had sent them
without suffering any losses. More than 500 of them planned to advance from there
beyond the Seine to sack Chartres, but they were attacked by the troops guarding
the west bank of the Seine and after losing some men killed and some wounded,
they retreated to their ships."[32]

This aborted attempt to attack Chartres—apparently for its wine—is the last
mention of the city and Viking raids in the *Annals of St-Bertin*. However, in 867,
the year after the death of Robert the Strong, Charles the Bald convened all his
fighting men at Chartres on August 1, planning to depart from there to fight in Brit-
tany against the warlord Salomon. This inspired negotiations with the Bretons, and
Charles threatened a second gathering at Chartres on August 25 if the treaty was
not followed. His reasons for choosing this location are not known, but they imply
connections with powerful relics and the saints and underscore once again the stra-
tegic importance of Chartres.[33]

The battles of Chartres were remembered locally, although it is not clear whether
the sources were written or oral or both. By the twelfth century a series of lessons
written for the feast of Saint Anianus (Aignan), an early Christian bishop in Char-
tres, contained a summary list of the fires of Chartres. The Chartrain liturgical
Office for the first translation of the relics of Saint Anianus probably dates from the
institution of the translation feast in the second quarter of the twelfth century; it
would have been created for the rededication of the church in 1136.[34] The history
embodied in the readings for the Office claims that the city or its cathedral or both
burned at least once each century after the ninth, until what was then the most
recent fire, that of 1134. This understanding of destruction and salvation is closely
related to the feast of Mary's Nativity, and the text of the Office will be referred to
repeatedly in this book as central to understanding the history of the cathedral as it
was conceived in the mid-twelfth century. Its writer claimed to draw upon a variety
of sources, including local informants:

We have learned from the old people among us, and found in the writings of our forebears, that over a period of fewer than two hundred eighty years this city was burnt five times, with its churches and other buildings almost totally destroyed, and raised again in the wasteland. The first of these fires took place in the year 870; the second in 963, in the time of the Huns, who carried out a great massacre of Christians. Among those killed was the venerable bishop Frotbold [*sic*], as well as the greater part of his clergy. The third fire occurred in 1020, the fourth year of the episcopate of Lord Fulbert, on the very night of the Nativity of the Virgin. In this fire the cathedral was not only burnt but was completely destroyed. The glorious Bishop Fulbert then devoted his diligence, his labor, and his money to its reconstruction from the foundations; he made it of an astonishing beauty and grandeur, and left it almost finished. The fourth fire took place in 1030, on the eleventh of September, during the second year of the episcopate of Lord Thierry. The fifth fire took place in the year 1134, on a Wednesday, September fifth. Nearly the entire city was consumed, but by the miraculous mercy of Jesus Christ the church of his genetrix was spared from the rushing flames.[35]

The nineteenth-century editor of the Office, l'abbé Clerval, found that the dates given for the first two fires and other details as well were at odds with the received tradition: "Our author was not immune to errors. When he referred to the five fires that destroyed the city of Chartres he offered the dates 870, 963, 1020, 1030, and 1134: it is to be noted that the first fire took place in 858 and not in 870; and it was not in the year 963 that Frotbald, with his clergy, was killed by 'Huns,' that is, by the Danes."[36]

Clerval's corrections have been accepted by subsequent Chartrain historians, but reevaluation of these dates was ongoing at Chartres throughout the Middle Ages. The ways the legendary events mentioned here are related to the saints' cults are elemental to exploring the ways the past was understood; attempts to explain one historical event through the use of another put dates in constant flux. Yet once the *vita* of Saint Anianus was introduced into the liturgy in the mid-twelfth century, it provided a publicly proclaimed record of the town's most traumatic events and meant that, just as they would not be forgotten throughout the diocese, so too would they need constantly to be explained. The twelfth-century compiler of the *vita* speaks of consulting ancient documents and of talking to people in town who possessed relevant memories. From the tenth century onward, burnings of Chartres were commonly swathed in the Virgin's gown; her ability to protect the town (or not) becomes crucial to the ways in which the past was understood.

Twelfth-century revisions and additions to the history of Paul of St. Peter underscore the history found in the life of Saint Anianus and offer yet another version of the story of Bishop Frotbald, here related to a deep well still to be seen today in the cathedral's crypt (see chapter 12). Passages concerning this place are found only in the later of the two manuscripts used for Guérard's edition of Paul's charters (both of these were destroyed in 1944):

The Franks, massed together from all around, met the barbarians before they were
able to reach their waiting boats. With God presiding, they took their victory from
them, as is evident to the present time, leaving their butchered bodies strewn through
the fields to be gnawed by the birds and wild beasts. Then the people who had been
able to escape the barbarians' sword returned to the smoldering city, and, gather-
ing the bodies of the burned, threw them in a certain well, situated in the church
itself. Hence that well is called by the citizens "the strong place" [*Locus Fortis*] up to
the present time. There their ashes wait to rise with Christ and to reign with him in
heaven, and with his co-operation many miracles take place.[37]

Frotbald, who drowned in the mid-ninth-century *Annals of St-Bertin* as he tried to
escape the city, is now buried along with other martyrs in a well in the crypt of the
cathedral. The addition to the story shows a magnified legend tied to the physical
circumstances of the cathedral building: the well has become a reliquary for Frot-
bald and his brave followers. His journey through the sources was a long one, but
his bones were secure, at least until the fourteenth century, when his revised history
was presented in the *Vieille Chronique*, a local history that will be referred to fre-
quently (see also chapter 12).[38]

## THE EVENTS OF 886

Charles the Bald died in 877. Sometime not long afterward, Abbo, a monk of St.
Germain in Paris, wrote his epic poem on a siege of the city, an event he dated to
885–86.[39] Abbo was then a young man and styled himself an eyewitness to the siege.
He did not speak of himself as a native Parisian but revealed his love for Neustria,
which he personifies at several points. The siege and battle Abbo described resemble
earlier skirmishes in their outline, but in Abbo's telling the events are embellished
with developed characters, interventions of the saints, and actions that unfold in
majestic proportions. The first part of the story puts an early hymn of praise for the
Virgin in dactylic hexameters in the mouth of Gozlin, bishop of Paris, who was
about to fight and die for his city:

> In a loud voice, he besought the Mother of our Lord and
> Savior: "Blessed Mother of our Redeemer—sole hope
> Of this world, bright Star of the Sea, brighter far than all the stars—
> Bend thine ear, in mercy, to my prayers and to my pleas.
> If it is thy pleasure that I again celebrate the Mass,
> Grant that this foe—impious, fierce, cruel and most wicked,
> That has slain the captives—be led, I pray, into death's grim noose."

Abbo then adds his own text, beginning "Pulchra parens salve Domini, regina polo-
rum" (O mother most fair of our Savior, Hail, Queen of Heaven). He charges all to
sing "hymns of peace to her divine glory" (330).[40]

Although Mary is central to the first section of Abbo's Parisian history, in the second section local saints are invoked: the relic of Saint Geneviève, carried in procession to the city gate, thwarts the pagans with its presence; when Geneviève's aura appears to have worn down, the powers of Saint Germain revive the troops, and the history becomes an ode of praise for this particular saint and the abbey possessing his relics.[41] The story moves from the most universal saint, Mary, to a more local saint, Geneviève, patron of Paris, to the most local saint, Germain, patron of Abbo's own abbey and, as Dass says, "the hero of the entire poem" (118n175). The framework of time is liturgical, the victory coming on the Marian feast of the Purification, February 2; the cycle of events forms a long vigil for a feast that commemorates Mary's bringing the child Jesus to the Temple and his reception by the ancient prophets Simeon and Anna (Luke 2:22–39). In this history secular figures have powers because of their connection to the saints, and the figures connected to these holy persons are all Robertians. A major purpose of Abbo's poem is to champion the count (of Paris) Odo, a son of Robert the Strong who would be king of the West Franks from 888 to 898.[42] Odo was the brother of Robert I, who would rule as king in 922–23, and so the granduncle of Hugh Capet, who would give the Robertians their name, Capetian.[43] Odo is able to be great because of the powers of the saints who are one with his cause: "Gladly Odo took the title and authority of king; He was happily supported by all the Frankish people; In his hand was placed the scepter; on his head was placed the crown. France was filled with joyfulness, although he came from Neustria; never would she find another like him, among her children" (2:444–48; trans. Dass, 89).

The story of the battle of Chartres, as Abbo describes it, follows almost immediately upon the year-long siege of Paris.[44] Although it takes place two decades after the one Hincmar reports as occurring in 868, it seems to magnify earlier understandings of strife and redemption. Both situations provide a context for the legend of the first martyrs of Chartres (see above), as it developed over time. This, the final section of Abbo's first book, is witness to a slaughter of pagans at Chartres on February 16, 886, soon after the siege of Paris that was broken on the feast of the Purification. Abbo reveals that the initial loss and victorious revenge made Chartres a symbol of peace and of historical transformation in the late ninth century, and later versions of the legend give prominence to this element of the story as well. The voice of Neustria itself cries out:

> You have read how I was plundered—learn now of my great triumphs.
> The chief desire of the Danes was the capture of my towns,
> Yet, by the Lord's grace, our weakness became their hindrance.
> These merciless strangers brought ceaseless strife to Chartres. But they
> Had to leave behind a thousand corpses of their own men,
> As well as five hundred more, after a battle most bloody.[45]

The siege and battle of 886–87 reported by Abbo took place soon after the *Annals of St-Bertin* ends in 883 and just before the late tenth-century historian Richer of Reims picks up the historical thread in 888. The years between the death of Charles the Bald in 877 and the coming to the throne of King Odo in 888 were chaotic and remain poorly documented, Simon Maclean's being the only modern monograph concerned exclusively with the period. Charles the Bald's lineage had seemed verdant with eligible male successors during his lifetime, but the vine shriveled quickly upon his death. Charles's son Louis the Stammerer was crowned less than two months after his father's death but died in 879; Louis's two young sons, Louis III and Carloman II, were crowned in 879 and divided their patrimony. Carloman lived longer than his brother, but only until 884. The attacks of the Northmen were virulent at this time, and the young King Carloman, before his death at the age of eighteen, knew that a vast tribute of twelve thousand pounds of silver was paid to win a single reprieve. The only remaining child of Louis the Stammerer, Charles,[46] was a toddler at the death of his last remaining brother, and so in 885 the kingdom went to the emperor Charles III, a nephew of Charles the Bald and son of Louis the German. His nickname, "the Fat," falls into place with the common view of his supposed advance toward a besieged Paris, which ended in his refusal to fight. Charles III has seemed no match for the energetic Robertians and their ambitious vassals in the historiography, but Maclean warns that Charles's contemporaries respected him far more than do modern historians and were in many ways desirous of and desperately in need of his leadership.

Abbo's history shows a late-ninth-century view of the siege of Paris and was written not long after Charles the Fat had been deposed (887) and replaced by the Robertian Odo, count of Paris (888) and the first in the family to serve as king.[47] Accounts of the period with actual connections to Chartres, or produced in Chartres, date from much later and take the battle stories in new directions. The earliest is by the late tenth-century Richer of Reims, a historian who knew Chartres well. It is a story of a different battle, one fought during the time Odo was king, and provides the best surviving understanding of a Chartrain view from the late tenth century of events that took place a century before.

Because Richer of Reims retells the stories of the battles described above at a distance of a century, he has a wealth of oral tradition as well as his own political and liturgical understanding to guide him. Richer opens his history with a great battle situated near Claremont during the decade King Odo ruled (888–98);[48] it is not generally known in other sources and matters here because it contains the earliest characterization of a count of Chartres/Blois, one that stands in contrast to those offered by Dudo of St. Quentin and Rudulphus Glaber, which would appear a generation or so later (see below). Although Richer does not date the battle precisely, he offers details of the sort not found in his historiographical predecessors from

Reims. This is not the only time that his firsthand knowledge of Chartres may have come into play.[49]

Ingo, the main character of the scenes described here, is a man who acts dishonorably for honorable reasons. In Richer's history, book 1, section 9, a new battalion of pagans has arrived to do battle, and the Franks are losing ground.[50] King Odo's leading warriors are wounded, and there is no one who can bear his standard. At this point Ingo, who says he is of the lowborn, comes forth and offers to take up the king's banner, saying he does not fear the battle "as he can die but once!" He leads the charge, and the Franks prove victorious.[51] Subsequently King Odo marches the captive leader of the pagans, Catillus, to the church of St. Martial and offers him a choice: baptism or death. Catillus accepts baptism; the event is to take place on Pentecost, and the scene is set, rich with the kinds of liturgical details a cantor-historian would relish. Bishops from the region arrive, and the pagan warrior undergoes a three-day fast. Then, led by the king, he descends at the appropriate time to the sacred font in the basilica where he is to be baptized in the name of the Father, Son, and Holy Spirit and is immersed three times. Suddenly, however, Ingo the standard bearer rushes forth and stabs Catillus through, turning the baptismal waters bloody and horrifying the king and the assembly.

As the king orders Ingo seized, the murderous warrior throws down his sword and flees to the altar of Saint Martial; embracing it, he implores the indulgence of the king and the nobility. The king then orders that Ingo be allowed to speak: "I offer my witness to God, who knows my intentions, that nothing is more dear to me than your safety. It is the love I have for you that pushed me to these dire actions; it was for the life of all here that I was not afraid to approach such great danger. Most surely, what I have done is serious, but even more important is the benefit it will bring to you. . . . I could tell that it was fear alone that caused the tyrannical captive to submit to baptism; once it was over, he was going to revenge many injuries, and the slaughter of his people." Ingo goes on asking the king and nobles to inspect his fresh wounds, won for their sake in battle, as well as the ancient scars covering his body, all gained in defense of the king and his troops. He brings the crowd to tears, and they come to believe that his rash action has saved them from great harm. King Odo rewards Ingo with the stronghold of Blois, for its noble lord was killed in the recent battle. Ingo marries the former lord's widow, produces a son named Gerlo, and dies of his war wounds soon afterward. The king establishes a tutor for the child, who, along with his mother, keeps his paternal inheritance.

Richer's establishment myth of a ruling family in Blois at the time of King Odo offers far more details than the historical sources themselves. The few scholars who have worked on the history of the Thibaudian family before the *Annales* of Flodoard, which begins in 918, have only disparate scraps of evidence and offer a tentative genealogy that includes various figures from the ninth century, with great disagreement among them as to interpretation.[52]

## THE SIEGE OF CHARTRES IN 911

Reports of battles involving Chartres from the early tenth century converge upon 911, a watershed year for the Franks in particular and for Christianity in general. This myth-making process involved a complex of legends surrounding the defeat of the pagan warrior Rollo, a counterpart of the ferocious Hasting, and in some versions created a precise period for his conversion as well, often dated to 912, one year later.[53] Although many early accounts of the siege of Chartres that came to be situated in 911 do not mention the relic of the chemise, versions featuring Rollo and the miraculous repulsion of his company from Chartres are likely to refer to Mary's power as crucial.[54]

An early recounting of the story is found in the life of a bishop of Auxerre, written in the late tenth or first half of the eleventh century. Several key elements are found in this version of what was to become one of the most famous battle stories to circulate through the chronicles and in the miracle collections of northern Europe in the Middle Ages: the bishop's "victorious right hand, together with Richard and Robert, two of the greatest princes, took part in the battle waged in the city of Chartres, where, by the intervention of Mary, the Mother of God, a great slaughter of pagans took place."[55] This story is also related to the establishment of the Robertians as kings of France, a major factor in the growth and development of regional myths in the eleventh century. Other early Robertian legends, in addition to those in the work of Abbo of St. Germain, can be found in the chronicle of Regino of Prüm.[56] From the second half of the tenth century on the story existed in three branches according to Vogel, Norman, Burgundian, and French. The local versions produced in Chartres itself are best understood against the background of this threefold tradition.[57]

Norman versions of the siege of Chartres are the most numerous and important and are, for the most part, dependent upon the expansive account contained in the early eleventh-century history of Dudo of St. Quentin.[58] The story of Rollo is offered in Dudo's Virgilian style, with frequent allusions and references to classical literature, to the Bible, and to hagiographical texts that are characteristic of his mode of organization and choice of language. Dudo described his task as a historian in the terms of a musical conceit—his writing is part of staying in tune with God's call to him and obeys the laws of proportion that govern sound.[59] Depicting himself as one knowledgeable in the art of music, Dudo was spiritually moved through a related art too, the art of rhetoric, whose "sweet nectar" would "intoxicate with harmonic beat." Dudo, like Sigo the cantor of Chartres (see chapter 4), is a musician and historian but of a different sort; music as a liberal art is the model he imitates as he writes, and the ideal of song, inherited from his classical training, shapes his history.

In Dudo's account, the Dane Rollo, pagan scion of the dukes of Normandy, is on a journey toward winning salvation. By contrast, Rollo's sometime companion, the

pirate Hasting, is savage and irredeemable.[60] In several sources Hasting becomes the ancestor of the powerful House of Chartres/Blois, which was much feared in the first half of the eleventh century as an enemy to the Normans. Dudo places the siege of Chartres just before the final chapter of his history, forming a denouement for the entire story. Up until this time the Franks are depicted by Dudo as unwarlike men who "'with frozen blades' had begged Rollo like women for an armistice" (*History*, 42). In 911, in the midst of one of many killing frenzies, Rollo "made a warlike attack on the city of Chartres, and laid siege to it with a great army." The bishop of Chartres, Walter,[61] called upon Richard, duke of Burgundy, and Ebalus, count of Poitou, "that for the love of God they should come to the relief of the city, which had been 'seized by untimely death.'"[62] In this battle the Frankish swords have turned hot, as the two forces "stand up to each other, taking life with alternate blows." In the midst of the melee, the bishop of Chartres appeared:

> When suddenly Bishop Walter charged out of the city robed as if to celebrate Mass, and bearing the cross and the tunic of the Holy Virgin Mary in his hands, with the clergy and the citizens following behind; attended by "steel-clad squadrons" he struck the backs of the pagans with spears and swords. Seeing that he was standing between two armies, that he himself was not winning, and that his men were growing fewer, Rollo "passed through the midst" of those armies, and began to withdraw from them, lest he be "seized by untimely death."[63]

The tables have been turned on the pagan warrior who brought weak-kneed Franks to defeat repeatedly in the past; now he knows fear, and Dudo expresses the change that the divine powers wielded by the bishop of Chartres have worked upon his courage through a lyric in direct address:

> Rollo the powerful, valiant, vigorous, fiercest in warfare,
> Be not ashamed if now for a fugitive you should be taken.
> No Frank puts you to flight, nor does the Burgundian strike you,
> Nor the gathering of all sorts of people, in double formation;
> No, but the bountiful tunic of the Virgin Mother of God, also
> The relics, and reliquaries too, and the venerable crucifix
> Which the reverend prelate carries in meritorious hands.[64]

Rollo must not despair; no military force could have subdued him. He is conquered only by the power of God manifested in the relics of the saints, especially the "bountiful tunic" of the Virgin of Chartres and the magnificent cross—certainly not by the secular powers of the warlike counts of Chartres from Dudo's period, who have no role in any retelling of the event. Although in Dudo's version the battle ends in a stalemate, the stage is set for the baptism of Rollo, reportedly in 912, one year later.[65] The ferocious Northman becomes a Christian Norman, the prototype of the dukes of Normandy, and Mary of Chartres inspires his transformation.

William of Jumièges, who took up the work of Dudo in the 1050s, is even more protective of Rollo's reputation in his retelling of the siege of Chartres: "Finally Rollo laid siege to Chartres. While he was launching siege engines and catapults against the city, Richard, duke of the Burgundians, arrived with his army of Franks and attacked him. Engaging in battle, Rollo and his men offered fierce resistance until Bishop Antelm and an armed force unexpectedly appeared from the town carrying the tunic of Mary, holy mother of God, and set on Rollo attacking him in the rear. At length Rollo, realizing that he and his men were facing death, decided to yield to his enemies for a while rather than continue fighting to his men's destruction; thus—as a wise man, not as a timid coward—he abandoned the fight."[66]

Whereas Norman versions of the story lend honor to churches and leaders from the region and emphasize the power of the relic of the Virgin of Chartres, Burgundian versions make much of the role of the Burgundian Richard the Justiciar and are in general far less detailed.[67] An early description of the battle by the mid-eleventh-century writer Rudulfus Glaber does not even mention the place of the battle by name and seems to refer to the event described by Abbo rather than the siege of Chartres: "The events which we have recounted here occurred repeatedly in the interval between the collapse of the emperors and kings of Italy and Gaul and their restoration. But when these people determined to make another of their accustomed descents upon Gaul, the venerable Richard, Duke of Burgundy, father of King Rudolf, as we have already mentioned, confronted them in a place remote from their bases, and defeated them in battle with such great slaughter that very few of them contrived to escape and make their way back to their own lands."[68]

A report from the chronicle of St. Pierre-le-Vif (s.v. Clarius) in Sens adds more detail to Glaber's bare-bones description. It ties the battle to the reception of lands by the pagans and shows why the year 911 became important in the region through its association with a historic treaty. Here it is Robert, scion of the Capetian line, who saves the day, whereas the Carolingian King Charles foolishly gives away Normandy, demonstrating yet another shift in the meaning of the term "Neustria": "At that time the pagans laid siege to the city of Chartres. Having assembled an army, Duke Richard and Prince Robert hurled themselves against them, killing sixty-eight hundred pagans and taking the rest hostage. After taking counsel with his leading authorities, King Charles handed Neustria over to the Normans, and since that time it has been called Normandy. After this, in the middle of March, a star appeared in the north, shedding great light for fourteen days. The following year there was a great famine throughout all of Gaul."[69]

These accounts from Glaber and from Sens emphasize not only particular leaders but also a massive slaughter of pagans, offering revenge as an antidote to a land "made bare" by the burning and killing of the men from the north. In these historical recountings, too, the battle is a turning point. Glaber says, "Although after this the

Normans ravaged many islands and provinces close to the sea, they never again descended on those parts ruled by the kings of the Franks, except at royal request."[70]

Dudo was the first to associate the treaty that concluded the troubles of 911 with Sainte-Clair. He does not claim the land exchanged to be all Normandy, and he introduces a hilarious episode of obeisance gone awry, providing further definition of the character of King Charles the Simple, whose lineage is soon to come to an end. The story conveys the sense of a crumbling Carolingian past, so significant for the Robertians and their vassals, among whom the Thibaudians of Chartres/Blois/Tours were numbered. The vignette begins with the insistence of the Carolingian King Charles that Rollo kiss his foot as a sign of fealty. The rugged Dane (who often in Dudo's account possesses patrician sensibilities) found the king's request unacceptable: "Rollo was unwilling to kiss the king's foot, and the bishops said: 'He who accepts a gift such as this ought to go as far as kissing the king's foot.' Rollo replied: 'I will never bow my knees at the knees of any man, and no man's foot will I kiss.'" Instead he summoned one of his sturdy warriors to perform the act. Apparently not practiced in the effete ways of the Carolingian court, the Nordic soldier strode forward. He lifted the king's foot off the ground and raised it to his lips, standing up to do so, and as a result toppling the king over backward. And "so there arose a great laugh, and a great outcry among the people."[71] The lineage of King Charles was doomed, as Dudo, from his early eleventh-century vantage point, knew full well, and the late tenth century would be a period of scrambling for new alliances and of creating the myths that would sustain them.

A third account of the siege of Chartres emerges in those few accounts Vogel termed French (389). He points to Flodoard's history of the church of Reims, chapter 14 (MGH SS 13:577), and believes that although the dates are far off (as they often are in Richer too), a battle he depicts relates to the story. His long report shows that what matters is Robert's ability to command forces from a vast region. In no part of his account of this military action is mention made of Chartres or Chartrains or of the Virgin Mary or her relic; the Burgundian Richard the Justiciar is not part of the story either. The stage belongs to Robert, called "dux Celtice Gallie."[72] Richer's decision to make Rollo the enemy of the Capetians fits well with his sympathetic view of Ingo, the slayer of Rollo's father:

> During this time, Robert, duke of the Celtic Gauls, eagerly attacked the pirates, who, under their leader Rollo, son of Catillus, had unexpectedly invaded Neustria. They had already crossed the Loire in their fleet, and were subduing the banks of this river without resistance. Dispersing here and there, they brought great booty back to their fleet. Duke Robert gathered troops from all of Neustria; he also brought many from Aquitania. He even had four cohorts from Belgium, sent by the king. . . . The Duke himself rode round the legions, calling the chief men by name, and exhorting them

to remember above all their courage and their nobility. He asserted that they were fighting for their country, for life, for liberty; they were not to be concerned about death, since death is uncertain for everyone; if they were to flee, nothing would be left them by their enemies. By these and many other words he inflamed the minds of the fighters. . . .

With no less boldness did the enemy make their battle plan. . . . The pirate legions were stretched out in a long line, curved like a crescent moon, to take the enemy; when the enemy burst on them with great fervor, they could surround and take it. Those who remained in the two wings, attacking from the rear, could surround them like a flock of sheep.

The two sides being ready, the two armies, carrying their ensigns, meet. Robert with the Neustrians, and Dalmas with Aquitanians, penetrate the pirate legions, and at once are attacked from the rear by those in the wings. Soon too the Belgians unexpectedly follow, and press the pirates, who are at their rear, bringing about a huge slaughter. The Neustrians also press them with great fierceness. In this melee, with the Aquitanians surrounded by the pirates, by a great effort they compel those who are attacking them to flee. . . . Overcome, the pirates lay down their arms, and plead with loud cries for their lives. Robert, seeking to stop so great a slaughter, insists that they be released. Scarcely is he able to restrain the army from the slaughter, as they are excited by so much success. But when the tumult quieted, those who seemed more important among the pirates were seized by the Duke; the rest are allowed to return to their fleet under the law of hostages.

With victory achieved and the army disbanded, Robert deposited his captives in Paris. Questioning whether they were Christians, he found that none of them had had any contact with this religion. Being sent the reverend priest and monk Martin to instruct them, they were converted to the faith of Christ. Those who had returned to their fleet were found mixed, some Christian, some pagan (*Historiae*, 1:28–31, ed. Hoffmann, 65–68, abridged).

As the comparisons above suggest, some details from the historic battle of Chartres, which apparently took place in 886 or 887, were transposed to live a second life during the time of Rollo in the early tenth century. This reestablishment, combined with other, newer details, is the material from which the central Chartrain myth, with its focus on the year 911, was made. Each city and its local historians would hear—or in a few cases read—the generally circulating facts of history in its own way, connecting at least some of them to place and to local circumstances. In the case of the siege of Chartres, local historians selected from widely circulating tales of pagan brutality and worked them closely into the fabric of regional understanding. None of the three strains described above, however, can be proved to have originated in Chartres, although in many the city becomes associated with the Virgin's cult and her powers to turn the tide. The retelling of Richer of Reims, with its story of a murdering ally of the king in need of redemption, may be the closest

surviving account, and the probable psychology underlying it is discussed below (see chapter 2).

## THE CENTRAL MYTH IN CHARTRES

When did Chartrains begin to write about the siege of 911, which they discussed throughout the eleventh century? When did the relic of the chemise (which has many names in early sources) become central to the cult of the Virgin in Chartres itself?[73] It is clear from entries in the early-eleventh-century necrology in Na4 that the Virgin's chemise was venerated in Chartres in the late tenth and early eleventh centuries (see chapter 2). For the relic to be venerated in this way, surely some sort of miraculous context, one resembling that found in sources from outside the city by the early eleventh century, was present in Chartres as well.

Chartres, BM Na4 contains an entry for the bishop who broke the siege of Chartres, Vualtelmus, a man whose name is spelled in a way similar to the rendering by Dudo (Gantelmus), yet the entry provides no year, no details, no glory-promoting phrases: "ii kal. feb. Obiit Vualtelmus, episcopus Carnotensium" (January 31. Gantelmus, bishop of Chartres, died) (*MSC* 153). Lucien Merlet argues that the chronicle's sources began after the time of Vualtelmus, and so he had no copious entry in the first written necrology. The entry for Bishop Vualtelmus is not an addition to Na4, whose first hand wrote around 1027. Perhaps the story of the first siege of Chartres, or at least the role of this particular bishop in it, had not yet become part of local historical understanding (see *MSC* 104) reflected in the tenth-century materials from which the first liturgical necrology of Chartres was assembled. Two generations later, however, Paul of St. Peter knew the story well, as is shown by his brief discussion of the tombs of famous bishops found at his monastery (see chapter 4). His history does not contain the tale itself, however; the revisions (or additions) to his work claimed by his editor Guérard for the mid-twelfth century provide the first written Chartrain version of the story.

Rouen and Chartres were geographically close; they were steady rivals during the tenth and eleventh centuries, and members of their ruling families had occasionally intermarried.[74] Hence to find that the Chartrain version added to the work of Paul of St. Peter in the twelfth century reveals many features found in the Norman tradition is not surprising. This was first established in writing by Dudo of St. Quentin and prolonged in the historical writing of William of Jumièges and others, though it is impossible to say for sure which way the influences were flowing within the oral circulation of legends.[75] The spelling of the name of the bishop in the Norman sources, Gancelinus, comes close to the way it would be rendered in later Chartrain sources: with the *n* transformed to a *u*, the word becomes the Gaucelinus of the Chartrain *Vieille Chronique* of the late fourteenth century, a name close to that of a mid-twelfth-century bishop of Chartres, Goslen, a name that also had

many spellings (and that was common in the region).[76] A long passage in Gué-rard's manuscript B was placed in brackets by the editor for he believed it to be a significant later addition. It begins with a first-person introduction, asserting that relics function with the intercessory power of Christ, working through his saints: "I considered it worthwhile to insert into this discourse the siege held at the time of Bishop Gancelinus, not only on account of the novelty of the time, but also because of the memorable wonder that the Lord Jesus Christ deigned to carry out by the intervention of his mother, the blessed Virgin Mary."[77]

This apparent addition shows that local history gives the bishop of Chartres com-plete control of the relic's power. He has been told by God ("divino relatu") that the siege will occur; he summons the duke of Burgundy, the count of Poitou, and two of the most powerful counts of the region to come to Chartres on precisely the day he knows the battle will occur; then he sets the stage for the triumph of the Virgin in a way that will make the miracle visible to all: he commands the citizens to take up arms and that the gates of the city be opened; he stands on the ramparts of the portal facing the foes (the "Porta nova," the door of the cloister, not the Royal Por-tal) and unfurls the chemise of the blessed Virgin; and he watches as the citizens of Chartres, on the one hand, and the forces he summoned earlier, on the other, decimate the pagans.

The story mentions nobles from two particular places by name: Burgundy and Poitou. These may have mattered in the Chartrain oral tradition, and their presence here could indeed have proved useful to Bishop Fulbert in the early eleventh cen-tury, if the story circulated in Chartres during his lifetime (one assumes it did, as Fulbert was a contemporary of Dudo, who knew it well). This version of the siege of 911, most probably copied in the twelfth century, offers a history of the cult as championed in Chartres at this time—a time when the artworks discussed in the final chapters of this book were commissioned, designed, and created. Its authors, inspired doubtless by the mid-twelfth-century episcopal dynasty to be discussed later, have reshaped the myth to resonate with their own times, with their build-ing campaign, and with events discussed in chapters 7 and 8. In this description, Mary's relic is the "interior tunic," of an adult woman, a description which puts the garment directly on her flesh and makes it witness to the most important events of incarnation and birth:

> Then next, having left their boats behind, with running swiftness, [the Normans] come to the city [of Chartres], and fortify it all around with a blockade. But yet then, the fore-mentioned bishop, having known of the coming siege by divine revelation, commissions the Count of Poitiers, and the Duke of Burgundy, the two most power-ful counts in France, to come to his aid; and they, on the day established by the bishop, come to bear help to the Christian people, prepared by common vow with a great army. And when the pagans, confident with might and force, would press on fully, and would hasten to seize the city, the bishop, on the day which he knew the

above mentioned counts would come to help him, commands all his subjects to be supplied with arms at dawn and to go as far as the gates of the city. Then lengthening out the interior tunic of the Mother of God over the door which is called the "New Door," he presents it to the gaze of the pagans, and opens the gates of the city, and commands the Christians faithfully to bear arms.[78]

The relic of the Virgin of Chartres, controlled and wielded by the bishop of the city, inspires a new kind of action: the head of the church leads the people and protects them through the power of the relic. The secular rulers so often found in other accounts are afterthoughts. Empowered by the relic's power, the Chartrains take to the streets and fight for their own protection; they win the day because God fights with them through the intervention of the blessed Virgin. The miracle is tied to specific features of the town, to a portal of the cathedral cloister, to its topography, and to the character of popular piety in the mid-twelfth century.[79] The mode of understanding illustrated here predominated in the region around the year 1000 and again in the mid-twelfth century. Peace was the desired norm, and relics promoted peace, but when they were not obeyed they had miraculous powers to defend and destroy those who failed to keep their vows. It seems too that the story has been fashioned to offer historical resonance with an actual threat to the city in 1119 and the legends that grew up to surround it.

Here in the tenth and eleventh centuries the mythic underpinnings established for the Virgin's cult at Chartres can be seen operating throughout a broad geographical region. To outsiders the cult was associated with the power of the bishop of Chartres or with secular leaders from other places, never with the Chartrain nobility, for they commissioned no history in the late tenth or eleventh centuries. These early sources joined a complex group of related tales concerning the siege of Chartres as the story was told and retold throughout Francia and beyond in the centuries to follow, in connection with shifting perceptions of the Robertians and their allies. Through the legend of the siege of Chartres the story of a rout became intertwined with the Virgin's relic, giving it a widespread and significant life as the town became defined as a historic place where distinctive modes of ecclesial power were wielded by its bishops. The legend and its various permutations also served as a counterpart to the evolving character of the lineage of Thibaudians and with their role in the shaping of kingdom and character in medieval Francia. The sense of longing begotten through constant near success first develops in the early eleventh century, shaping cultic ethos in an elemental way.

## NEW LITURGICAL TEXTS FROM THE LATE NINTH CENTURY: THE SEQUENCE "ALLE CELESTE NECNON"

Reconstruction of what was first known about Chartres and the Virgin's cult there, and when and by whom, presents a central historiographical problem: his-

tory writing was a rarified activity in ninth- and tenth-century Europe; by the time a need was felt in the eleventh century to have a written local history, much of the evidence was gone. The few written accounts studied here may represent what was known more generally in the oral tradition and in earlier accounts long lost. Of necessity they come first, mere bits and pieces but nonetheless the stuff of the legends that slowly became history. Alongside the legends, another kind of historical understanding brewed within the liturgy itself, an elemental historical process that conditioned the minds not only of medieval cantors but of all learned medieval Christians. In case after case—eleventh-century Chartres is but one example—cantors and the scribes who were normally under their auspices had charge of two essential kinds of materials: those that belonged to the liturgy, including the obituaries and martyrologies, and the chronicles and other written histories. The early necrology from Chartres referred to above is a well-worn example.[80] It is a book prepared in the early eleventh century and then kept current by the cantors of Chartres Cathedral until the mid-twelfth century. Cantors were the primary keepers of time in the central Middle Age: they calculated Easter and all other feasts and seasons and were responsible for scriptoria in monasteries and cathedrals and so were the producers of liturgical books. As a result they often wrote new saints' lives and chants, but also often produced the most important surviving records of individuals. It was the cantor who recorded death notices in obituaries and necrologies so that people could be commemorated in the liturgy, and, as a result, the writing of chronicles, year-by-year entries of important happenings in a region or institution, often fell to cantors as well.[81]

It is not difficult to demonstrate why medieval cantors and other figures continuously used their liturgies and saints' lives to create local history. They had no choice: there simply were no written records of the past for most places in the ninth and tenth centuries. Modern scholars naturally gravitate toward study of places that had early history writers, but what about those that did not—in the central Middle Ages the vast majority of places? How did understandings of the past evolve where there were no records and no local written histories? Taking Chartres as an example, only stray references are found in early historical writings and next to nothing about what had become by the late tenth century the major cult of the region, that of the Virgin Mary. The liturgy was the only sure way of getting historical material embedded within communal memory. A saint's life such as that of Anianus provides a twelfth-century recounting of the burnings of Chartres in earlier centuries; it is one of two local retellings of the events studied in this chapter, the other being that of Paul, librarian of St. Peter, and additions to his work. Necrologies such as Na4 were liturgical books, and people who were mentioned in them had their lives commemorated every year. Here, too, it was the work of the liturgy to remember what was known of the local past, and the work of the cantor to make sure this happened.

An obituary notice provided in the early eleventh century for the early tenth-century Bishop Haganus calls him "episcopus et comes" and compares him to the revered Saint Lubin, whom later sources place in the sixth century.[82] This information suggests that early bishops came to be thought of as the first counts, a view that had considerable play by the late fourteenth century, when the Chartrain history called the *Vieille Chronique* was compiled. One can see why this might happen in ecclesial histories, not only to promote power through the creation of tradition, but also because there was no early evidence about the ruling family itself. In the *Vieille Chronique* the bishop-count had achieved an important place in local historiography, and Bishop Helias, who supposedly served during the time of Charlemagne, had been added to the ranks of such figures (*CNDC* 1:10). This history added strength to the idea that "counts" of Chartres/Blois existed long before figures who held this title actually existed, and that they were men of the sword as well as of the cloth.

In the course of the central Middle Ages, new chants were steadily added to the liturgical materials inherited from the Carolingians. Among the most important of these additions were sequences, long chants sung before the Gospel of Mass. Throughout this study, the nature of sequences composed for the Virgin's cult will be referenced, offering an understanding of how her character developed within the liturgy itself. It would be possible to approach the liturgy of Chartres, and the Marian cult in particular, through any body of liturgical materials, and in this case study sermons especially will be of major importance, as will select readings and chants from the Office. Each genre offers something special to the study of the liturgical framework of time. Sequences are distillations of scriptural, exegetical, and liturgical materials, placed in an intense and thick liturgical moment, right before the Gospel, the most important single text of any feast, was intoned. As a preface to the central moment of a festive event, sequences offer powerful statements about the past as recollected for the community and often contain the most locally prized and well-worn images, the very stuff of the liturgical arts. In addition, sequences are particular to regions and even to towns and institutions, and so often provide local interpretations of sacred history. In any place where medieval visual arts are to be studied, sequence repertories (if they survive) offer the richest material for understanding ideas underlying imagery; the sequence repertory of Chartres cathedral can be studied from the twelfth century on and contains layers assumed to have been in place even earlier. It is also a repertory in place for centuries, and I have used a microfilm of the now-destroyed gradual from St. John in the Valley, Chartres, BM 529, for the transcriptions. This early fourteenth-century manuscript demonstrates the longevity of the tradition in Chartres and also shows the care with which these early texts and melodies were copied in Chartres.

The earliest Marian sequence found in the group that became part of the repertory at Chartres cathedral was "Alle celeste necnon" (see appendix D, along with

other Marian sequences from Chartres). When the legends of early history were developing in the tenth and early eleventh centuries this was the kind of piece northern European cantors were introducing into their Mass liturgies. "Alle celeste" hails new lineage and expounds ideas concerning change and would have had special resonance for times such as these in the western kingdom of the Franks. "Alle celeste," which probably dates from the second half of the tenth century, was created for the feast of Mary's Nativity and was circulating in both northern and southern Francia by around the year 1000.[83] The text offers a framework for the legends surrounding the Virgin and her cult as it developed in the late tenth and eleventh centuries in the region. Set to the sequence melody "Mater sequentiarum," it addresses the instant transformation wrought by the Virgin Mary, especially in her state of being "about to bear," *paritura*, a theme especially favored at Chartres from the time of Bishop Fulbert on. With God's grace, Mary, the "Davidic shoot having produced," creates a new ruling lineage, one related closely to its predecessor, yet different as well. This power was of special importance in late tenth- and early eleventh-century Chartres and nearby regions, and the long, magnificent sequence poem, with its melody emblematic of maternity, established the liturgical framework for the meaning of cloth relics associated with the Virgin Mary: "From the highest heaven the angel stands near her: 'Maria,' he says, 'hail, kind one, full with grace and blessed above all women, you are about to bear [*paritura*] a king.'"[84]

In Chartres and elsewhere throughout the region the melody "Mater" was also set to a text for Saint Michael the Archangel, "Ad celebres rex celice."[85] Scholars cannot say which was the original text for the melody, although thematic and liturgical associations argue for "Alle celeste." The two pieces offer versions of the same theme for two September feasts, one centered on the Virgin and her power to change and protect as emphasized on the feast of her Nativity, September 8, and the other on Michael, that great warrior, the "Satrape of heaven" as the sequence has it, whose feast day is September 29.

This chapter opened by identifying Chartres cathedral and the count's castle as twin fortresses offering two kinds of protection. The sequence poems, related through a common melody, evoke the same idea and would have done so whenever and wherever they were sung by cantors in the Anglo-Norman world at Mass. Early battle stories such as those recounted here worked in counterpoint with contemporary chants such as the sequence "Alle celeste necnon." Saints' cults in the central Middle Ages were primarily local phenomena that created individual identities for particular places and even for competing churches within the same place.[86] Relics that were created as a result of ancient battles—bones, cloth, bits of hair—and the famous powers associated with them became in turn subjects for later wars of possession between monks, canons, and burghers.[87] Towns developed cults through the dramatic discovery, rediscovery, and translation of holy relics of the saints, and by writing liturgical Offices to create their histories. The loss of relics through fire

or sometimes theft, like the loss of buildings, caused a need for regeneration of the past, especially given that relics had strong interregional appeal through association with local topological and architectural features.

The cult of the Virgin had greater potential for growth and power than that of any other saint, especially if aspects of cult could be regionalized through intense specificity and close ties to well-known people and historical events. The process by which this happened in the eleventh century at Chartres exemplifies a process at work throughout Europe, and here, as elsewhere, liturgy played a central role in the work.[88] As seen in these early legends, the central myth of Chartres depends upon the particular power of Mary to transform time, utterly and instantly, as pictured in sieges and battles as well as in the sequence text described here. When Mary's flesh, exemplified by a cloth relic, is seen and acknowledged, the past is reversed, violently and dramatically, like the action of a swift and sudden battle. In accordance with such myths and liturgies, those who do not recognize her powers will die, as they did in early battles fabled to have been fought in Paris and in Chartres. Those who sang of her powers confessed a kind of victory all too well understood, both from achieving it and not. But Mary worked alongside those who wielded the sword, and Michael is such a saint, the one to whom it would seem the counts of Chartres/Blois dedicated the chapel of their fortress in Chartres.

———— •—•—•— ————

# WAR AND PEACE IN THE MID-TENTH CENTURY

Bringing new joys to heaven through the announcement of a child on earth, within
the enclosure of your womb you bear him who governs the eternal ages, and who
brings peace to all times.

*—From the sequence "Hac clara die"*

In the tenth century the leading families of Anjou, Normandy, and Chartres/
Blois secured the landholdings that would become their traditional domains. The
early histories of the ducal and comital families of northern Europe are sustained
by myths of origin filtered through the agendas of their recorders, and both the
general and the particulars of the times are required to evaluate familial character.[1]
With deceit a commonplace and bloodshed a necessity, the saints worked long and
hard to secure blessing, redemption, and divine favor. Their names were invoked
before wars and after them, inspiring the dispirited, redeeming reputations, offer-
ing reasons for donating gifts to the building projects necessitated by defeat, and
pleading for peace in the face of threatened attacks.[2] A major battle could live on in
many guises, adding characters and situations with each recorded expression of its
history.

In this bellicose age, the so-called Peace of God, said by some to be the first
peace movement in the history of western Europe, flourished in some regions.
Calls for peace and visions of its promises appear in new liturgical texts from the
period. "Hac clara die," quoted above, is a fine example: these works were written
by clerics who promoted peace, if only as a way of gaining greater power for them-
selves. Chroniclers of the period, such as the ambitious Adémar of Chabannes, were
often responsible for new chant texts and saints' lives as well, and they punished or
demonized those who supposedly broke the peace.[3] The Burgundian Rudulfus Gla-
ber wrote in a time when some believed that peace was needed to usher in the final
days; as Cowdrey says (1970, 44), his view of time is "chronologically telescoped,"
allowing him to present the Peace of God from many vantage points all at once,

displaying a war-weary culture: "Throughout the dioceses it was decreed that in fixed places the bishops and magnates of the entire country should convene councils for re-establishing peace and consolidating the holy faith. When people heard this, great, middling, and poor, they came rejoicing and ready, one and all, to obey the commands of the clergy . . . such enthusiasm was generated that the bishops raised their croziers to the heavens, and all cried out with one voice to God, their hands extended: 'Peace! Peace! Peace!'"[4] Such longing was driven by the actions of kings, dukes, counts, and their vassals, who brought destruction to Neustria in the mid-tenth century more devastating than any the Vikings had caused a century before.[5] Added to these terrors for those with Christian perspectives were raids from the Magyars into Francia and of Muslims into Italy and the southern territories.

That the tenth century reads much like the ninth, especially given a later vantage point and lack of evidence, has caused historians to debate whether it was or was not a time of profound change.[6] To the liturgical historian it seems clear that the old ways were in place and did not disappear, but that new trends emerged and existed in counterpoint with what had evolved in the ninth and early tenth centuries. Chartres, because of its strategic location, was able to symbolize the peace breakers in its ruling family and the advocates of peace through the cult of the Virgin.

## ORIGINS OF THE THIBAUDIANS

Although theories concerning the early history of the Thibaudian family are plentiful, the evidence is too tenuous to make a sure case about how they rose to what seems a lofty position in the ranks of the Robertians.[7] It is, however, certain from the writings of Flodoard of Reims (compiled from 919 to 966 and continuing the historiographic tradition found in the *Annals of St-Bertin*) that the first Thibaut was active and well established by the mid-tenth century.[8] Flodoard's world witnessed the dying Carolingian line of kings alternately sustained by or under siege by the Robertians, whose members had already been kings, who were the powers next to the throne, and who sometimes patiently, sometimes not, persisted in their intention to reign once again. The decade of the 940s was marked by steady skirmishing between the Robertians, headed by Hugh the Great, duke of the Franks, and the royal party headed by King Louis IV, son of Charles the Simple, also known as Louis "from across the sea."[9] The *northmanni* (Normans), now settled into their own territories, were led by Rollo's son William Longsword—that is, until his assassination in 942, which left a young son, Duke Richard, not yet ready to rule. The Normans and the various counts and viscounts of the region shifted allegiances frequently between the Robertian and the royal parties in the aftermath of William's death, in the constant realization that becoming king oneself was not completely out of the question in such tumultuous times.[10]

When Thibaut of Tours (called Theobald by Fanning and Bachrach) first appears

in Flodoard's *Annals* in 945, he is on the attack, in league with his brother-in-law, Heribert the Elder (son of Heribert II) of Vermandois, and another of his relatives, Bernard, count of Senlis. During Easter season they stormed the king's castellum of Montigny, captured and burned it, "making it indefensible." The passage introduces three central themes concerning Thibaut, themes often developed by his enemies: he is a Robertian; he fights deceitfully, in this case breaking the peace during Eastertide; and he is occupied with fortifications, here their destruction, but often with their construction as well. The building and maintaining of various kinds of strongholds dominate descriptions of warfare in the period: to build a fortification was a major act of aggression, blocked by the opposing side whenever possible. Strong fortresses were built to withstand siege and attack and to hold hostages. When King Louis IV was captured by the Normans in Rouen in the same year (945)—and then ransomed into the duke Hugh's hands by the relinquishing of his younger son—the king was subsequently given to Thibaut, who detained him for a year and then released him at Hugh's bidding (Thibaut apparently was given control of Laon for his pains). Flodoard mentions a raid in 947 in which Thibaut stole grapes and marauded with "other wrongdoers" (section 29I, p. 46). In 948 Thibaut is described as a builder of the "munitio" of Montaigu and as continuing to hold Laon against the king; in the same year the bishops, gathered in Laon, excommunicated Thibaut, while excoriating his leader the Robertian Duke Hugh, who was forced to make amends (30K, p. 50); Hugh was eventually excommunicated himself. In 950 Thibaut was seen holding the castrum of Coucy-le-Château and refusing to relinquish it when attacked by the king and his men (32E, p. 55). Flodoard's picture is consistent: the duke of the Franks opposed the rightful king, and Count Thibaut continued to be one of the duke's chief yeomen, ever ready to be rewarded for his prowess through the acquisition of land and power.

In the next decade the situation shifted dramatically. Thibaut disappears from the *Annals* while the Magyars plunder the area; King Louis died in 954 and was succeeded by his young son Lothair; and then, unexpectedly, in 954 Hugh the Great, duke of the Franks, died as well, leaving his son and namesake not yet of an age to rule. Lothair being but a stripling and Hugh's son even younger, an uneasy balance of power disintegrated into utter confusion. This boded well for the strongmen of Hugh the Great, who had long earned their titles and lands through services rendered. Werner (1980) lays out the scenario, arguing that the counts of both Anjou and Chartres/Blois strengthened their claims to lofty titles and holdings of land in the vacuum caused by the untimely death of their overlord Hugh the Great. By the time the Robertians were able to rule once again, their two vassals had gained extraordinary power and skill.

The late 950s and early 960s were also a period of strange bedfellows: the Carolingian royalists, needing a defender, allied themselves with the Normans, who by then had a strong leader in Duke Richard I, who had come of age; the power-

hungry Robertian satraps, the counts of Chartres/Blois/Tours and of Anjou, arch-enemies before and after this time, were allies through marriage. Thibaut I's sister was married to Fulk "the Good" (d. 960) of Anjou, and Thibaut's wife, Leutgard, had a younger sister, Adela, who was married to Geoffrey Greymantle (r. 960–87), Fulk's son by his first marriage.[11] It has been pointed out that this couple was married thirteen years before Adela, in her early thirties, produced her first male child.[12] This was the desired heir, Fulk Nerra (r. 987–1040), a doubly related neighbor to the Thibaudians; nonetheless he was their scourge and chief enemy throughout the early eleventh century.[13] The deteriorating relationships between the Thibaudians and the Normans may also have been a result of family situations: Leutgard of Vermandois had been married briefly as a child to the Norman William Longsword, a fact played up to great dramatic power in Dudo of St. Quentin's history of the period.[14]

## THE MIDCENTURY FIRE

The burning of Chartres that took place about 962, a time when the Thibaudians and the Normans were at each other's throats, marks a watershed in the history of the family and their reputation in regional historiography. The story is told in several different ways: in Chartres, among the Normans, and in the writings of Glaber, and all contribute to understanding of the history-making process.

In Chartres itself, little was said, as was common after humiliating defeats. Indeed, the fire of the mid-tenth century, unlike that of 858 described in chapter 1, is shrouded in silent sorrow. The necrology in Chartres, BM Na4 has a memorial of the loss and lists this "death" of the Carolingian cathedral at Chartres in a manner befitting the anniversary of a person: "Nonis augusti, anno dominice incarnationis dccccclxii, urbs Carnotensis et ecclesia Sancte-Marie succensa est"(August 5: In the year of the incarnation of the Lord 962, the city of Chartres and the church of Saint Mary were burned).[15] Paul of St. Peter never mentions it. The life of Saint Anianus from the mid-twelfth century covers it over by locating it at the time when Bishop Frotbald—who had become a hero by the time the life was written—was slain, saying that the second burning of Chartres took place in 963 "at the time of the Huns, who massacred at that time many Christians and killed the venerable bishop Frotbald [Frotbold (*sic*)], as well as the greater part of his clergy"—comforting misalignments of events and dates. The bishops' list in the *Vieille Chronique*, in the entry for Hardoin, says only that "in his time, that is in 963, the city and church of Chartres were totally consumed by fire" (*CNDC* 1:13).[16] The great Chartrain historian of the seventeenth century Souchet fills out the battle with details taken from William of Jumièges and Wace's *Roman de Rou* and dates it to 962. The nineteenth-century Chartrain historian Lépinois reports that evidence concerning the wars of Thibaut the Trickster and Richard of Normandy are diverse and very confused.[17]

Regardless of the uncertain voices from Chartres, a vengeful burning of church and town at about this time belonged to regional history, although the date is not secure and the precise circumstances surrounding it can be pieced together only through the views of strangers and enemies. Léonce Lex, the only historian who has culled a group of documents related to the Thibaudians in the late tenth and eleventh centuries, says that the young Thibaut, son of Thibaut I (the Trickster), was killed in 958, fighting in Hermentruville (today St.-Sever, near Rouen) against Duke Richard I of Normandy.[18] This event suggests a general time period for the warfare that resulted in the burning of the city. It also bespeaks a time when Thibaut had grown exceedingly powerful, especially by the construction of fortresses; he had built one, apparently just before this event, in Chartres. Sassier argues that the traditional picture of Thibaut as usurper is not accurate, that Hugh the Great deliberately promoted him and wanted him to succeed, without realizing the ultimate consequences to his own line of having such a powerful leader controlling a block of lands as large as his own (see Sassier, 1997, esp. 148–49).

Modern historians know more than medieval writers about many things, and Pierre Bauduin offers a summary, relying on the works of scholars from Lot to Werner but colored by medieval propagandists as well. He notes the "brutal" establishment of fortified castles in Blois, Chinon, Chartres, and Châteaudun by Thibaut I at midcentury, here picking up on the negativity of some medieval historians concerning actions that all the counts were engaged in at the time. A description of Thibaut's penchant for building is found in a poem contained in Marchegay's and Mabille's edition of the chronicles of the churches of Anjou; it dates from the eleventh century and reflects the situation at St. Florent of Samur after the Thibaudians had lost it in the second decade of the eleventh century: "So a certain Thibaut, the Frankishborn, had died, / duke and master, after the king, of this noble land. / While alive he built tall towers and a temple, / being a resident of Chartres, but among the Dunense / he did not lessen his guilt, bestowing on them a turreted fortress. / He built many things; this he did not do guiltlessly. / Yet he built a convent; for this is he blessed" (Ut fuit ereptus Theobaldus francigenatus / Terrae dux et herus, post regem, nobilis huius. / Qui vivens turres altas construxit et aedes / Unum Carnotum; sed apud Dunense reatum / Non minuit proprium, turritum dans ibi castrum. / Multa construxit, quae non sine crimine fecit; / Verum conventus construxit, in hoc benedictus).[19]

The young Hugh Capet, whose sister Emma had married Richard, duke of Normandy, became old enough to rule in 960. Surely Emma swayed Hugh's opinions, as Thibaut's wife, Leutgard, did his. When war broke out between the Thibaudians and the Normans, Hugh, upon whose favor Thibaut had counted, was slow to come to his vassal's aid. This lack of support had profound consequences for the entire late tenth century: the Thibaudians and their firm allies, the counts of Vermandois, be-

came supporters of Lothair and the Carolingian line, whereas the Robertian duke of the Franks, Hugh Capet, reached out to the Normans, who became his sworn vassals in 968.[20] In one of the final years he covered (962), Flodoard speaks of the defeated Thibaut's visit to King Lothair: "A certain man named Theobald fought against the Northmen but was defeated and escaped by flight. Therefore he considered his lord (senior) Hugh [Capet] to be hostile, so he went to the king [Lothair]. He was received by Lothair and Queen Gerberga and consoled with gentleness, and then he departed."[21]

The burning of Chartres around 962 and the circumstances surrounding it are recounted by several historians besides Flodoard of Reims, who is only the earliest. Richer of Reims, who would have known the story from Flodoard, may have been a supporter of the Carolingians too, but, if so, was closeted in his views. We will see below that he uses this story indirectly in his depiction of Thibaut I's son Count Odo I.

Eleventh-century historians encountered when studying the ninth century provide background for tenth-century events as well, including Dudo of St. Quentin, who wrote to lionize Richard I of Normandy (d. 996) and to serve the political aspirations of his son Richard II (d. 1026). Dudo provides the most detailed surviving information for the period and uses the burning of Chartres around 962 to set up the character of Count Thibaut I of Chartres as a man who would be worthy of the nickname first bestowed by Glaber slightly later: "the Trickster" (as it is commonly translated into English, from the French "le Tricheur").[22] In Dudo's work Thibaut becomes a foil for the good and godly Normans, descendants of the pagan-turned-Christian Rollo: "However, while he [Richard I] was rejoicing at the fitting partnership with so noble a wife, and at the beneficial Breton alliance, and was repressing through salutary counsel the sudden tumults of wicked rebels throughout almost the whole of Francia and Burgundy by the power of his rightful dominion, a satrap by the name of Thebaut, who was rich in possessions and very well supplied with knights, was inflamed by malevolent rage, and by jealousy and hatred, and began to connive against him by means of numerous slanders, and to raise a quarrel against him, and needlessly to invade his land" (Dudo, *History*, 139).

Dudo seems fascinated not only by the treacherous Thibaut, but also by his wife, Countess Leutgard, daughter of the powerful Heribert II of Vermandois, and by her supposed earlier marriage to the fabled Norman leader William Longsword, son of Rollo.[23] Dudo depicts Heribert's prenuptial negotiations with his daughter—assumed by most scholars to have been Leutgard—and the much older William Longsword (d. 942) of Rouen, a marriage destined for failure and the promotion of strife:[24] "And when Heribert saw that William of Rouen was growing strong and formidable, and fairly shone forth in Christ by virtue of his mind, body, and grandiose works, he gave his daughter to him by the council of Duke Hugh the Great.

Conveyed in a most seemly fashion, with wonderful Fescennine displays, and with accoutrements of novel and inexpressible honor and dignity, and attended on the way on all sides by a crowd of matchless knights, he conducted her in splendor to the castle of the city of Rouen."[25] This is an *adventus* ceremony befitting a great queen but ironic at every step of the procession.

The event Dudo described, soon to be followed by the death of the bridegroom, sets up supposed bad blood between Leutgard and her stepson, Duke Richard I of Normandy. Her Norman in-laws disowned her before her second marriage to the Count of Chartres/Blois, who is depicted in Glaber as the murderer of her first husband, William Longsword. Accordingly, Leutgard became the wife of a second husband whose actions—to the extent that they were inspired by his wife's vengeful hatred of the Normans—would miscarry. Dudo's account of the fire of 962 interprets the event as punishment for Count Thibaut, whose miscalculations in the heat of strife with the Normans and hapless attempt to flee from his errors lost the day many times over.[26] The town and its church were forced to suffer not only for his military mistakes, but also for the evil of their leader's ways: "And finally, Count Thibaut was bereft of his faithful followers, who had been put to flight, knocked down and slain, and he sought safety in a very rapid flight with a few men; and once he had spurred his horses to the gallop, he missed the turning to Évreux, which his own men were holding. For on that day, through the merits of the blessed marquess Richard, he experienced the misfortune of a fourfold defeat. That is, he beheld his faithful followers laid low in battle; he himself was routed and wounded; one of his sons was seized by death, and fell; the city of Chartres and its fort were burned by fire and collapsed to the ground."[27]

Dudo's history of the fire and the strife surrounding it is Norman, an early eleventh-century use of tenth-century events from oral tradition, and reveals as much about the author's time as it does about the generations before.[28] Dudo's account contains two histories: one of the events in 962 and the other of events that occurred just before and during the time he wrote, events that will be discussed in subsequent chapters. Dudo knows of an early animosity and recasts it to excoriate the House of Chartres/Blois as well as its leaders during his own time, Odo I and his son Odo II.[29] The legends of the battle in 962 are surrounded by a series of vignettes of Thibaut I, liar, deceiver, and murderer.[30]

As noted earlier, the Chartrain historian Paul of St. Peter does not mention the burning of Chartres in 962, and this in spite of his possible knowledge of Dudo's work. He does, however, paint a vivid picture of Chartres at this time, especially through the charters he copied or forged that relate to the countess Leutgard. She is the first in the family to demonstrate a powerful connection to Chartres, and even though it would seem that her husband had not long been established there, she chose to make it her city and to be buried at St. Peter's, a fact of great importance to the historian Paul.

## THE BISHOP AND THE COUNTESS

Two figures dominate in Paul's version of the mid-tenth century: Bishop Ragenfredus, who supposedly lived in the years just before the fire of 962, and Countess Leutgard, who in Paul's hands becomes the central character of the saga. Accordingly, Leutgard and Ragenfredus are allies in their support of the Abbey of St. Peter.[31] Their actions also provide a contrast with the work of Bishop Odo of Chartres, discussed below, who is the first Chartrain bishop known to have elevated the Virgin's cult and promoted the legend of her cloth relic at the cathedral.

Paul's writings and the documents he produced suggest that two institutions in Chartres were in competition for controlling the past and the future of Chartres in the late eleventh century when he wrote. These were the Benedictine Abbey of St. Peter and the cathedral dedicated to the Virgin. Both looked to tenth-century figures to make their cases. Paul's tour of the tombs of early Chartrain bishops reveals much of what he knew of historic figures from his late eleventh-century vantage point, and he puts his own spin on the artifacts he describes.[32] In fact, Paul's descriptions offer a fine example of the history-making process at work at the interstices of liturgical veneration, the arts, and historical and cultic myths. At its opening, a sorry history of destruction and neglect before the middle of the tenth century is told; the way to renewal is led by Bishop Haganus, a man who was also highly revered in Chartres, BM Na4 as both bishop and count.[33] Paul writes,

> Yet, with the crimes of the citizens disposed of, the city was again laid waste by pagans from across the seas, and this place itself [St. Peter's] was utterly destroyed, and until the time of Haganus, the glorious bishop, remained so. This man, resplendent in his noble lineage and overflowing with stores of human kindness, radiant with virtue, ached for a place formerly venerated by people, now in such a state of neglect, and abandoned. Inflamed with the zeal of divine virtue, he summoned stonecutters and masons, spending lavishly, commanding that this place be entirely restored, and enacting the restoration with a pontifical blessing. He also established there a group of clergy, who restored the nightly praises owed to God which had ceased; contributing those things needed for their use, he gave as a perpetual gift an enclosure of vineyards and the contiguous land which his forerunners [earlier bishops] had stolen away for themselves with a sacrilegious vow, as well as estates, in an amount that he believed to be sufficient for the number of clergy. . . . When by a happy death he had been taken by angels out of the sea of this world to the fellowship of the saints he was succeeded in the episcopate by the venerable Ragenfredus, who loved the place with such a love that he was easily able to understand what to do next. For by his sagacious intelligence and quick suggestion, Alveus, distinguished by lineage and works, and abbot of this same place, appeared with certain canons wishing to proceed so as to go in by that narrow way that leads to God, exhorting a group of monks from the monastery of Fleury to establish the triennial rule of Benedict.[34]

Here the mid-tenth-century bishops of Chartres, Haganus and Ragenfredus, are depicted as religious reformers who restored St. Peter's even as they returned lands usurped by earlier bishops.[35] In addition, they introduced monks from Fleury known to be careful in observing the liturgical and other regulations of the Rule of Saint Benedict. Paul is proud of the heritage these men, in his account, reestablished for the abbey, and he wrote his history to lay permanent claim to territories as well as to prestige.

In such a statement, meant to refer to rebuilding efforts from the mid-tenth century, one hears a cry for renewal in the face of massive destruction of the sort that apparently happened both one hundred years before Paul compiled his historical writings (see *CSP* 1:49–51) and at the time of his writing. Although Paul does not describe the ignominious mid-tenth-century battle and the resulting devastation, he does mention the donors to what must have been a significant campaign of restoration. He then provides a series of charters, showing that not only the bishops of Chartres, but also the noble Thibaudians, were firm supporters of the rebuilding and of securing the properties and rights of the Abbey of St. Peter. As background, he produces a charter signed by Countess Leutgard in the company of Hugh the Great and his son Hugh Capet, dated to 954. This probable reconstruction by Paul of St. Peter, possibly dependent upon earlier documents and surely on tradition, serves to proclaim Bishop Ragenfredus's restoration of twelve prebends in the cathedral chapter to the monks of St. Peter's, an action that was much contested in later centuries (*CSP* 1:49–54). Bishop Odo is cited as having added his name to the document later on to verify it.

The next charter purporting to bear Leutgard's signature is dated February 5, 978, and in this document the countess presents lands to the Abbey of St. Peter. The text provides an example of the beliefs of donors regarding the importance of their gifts, here perhaps in language designed by the monk Paul: it also suggests the ways in which Paul may have appealed in his own time to donors he hoped to inspire:

Wonderfully laudable and ever laudably wonderful is the dispensation provided by our Creator, from the beginning of the primordial world. To those redeemed at the price of his blood, and to those cleansed by the washing of holy baptism from original sin—foreseeing and foreknowing, after all these things, that not during a single day can a person live immune from sin of any kind or be able to evade the stain of human corruption—he conferred many remedies for the welfare of the soul. By these not only are the sicknesses of the vices treated, but the joys of blessed immortality are acquired as well. Among these remedies, generosity in almsgiving is especially valued, to which not only the authority of many fathers attests, but it is also praised by the blessed voice of the Lord himself when he says: "Forgive and you will be forgiven" [Luke 6:37] and "whatever you do to one of these little ones [paraphrase of Matt 10:42] you show to me." Concerning these things also a certain wise man says that "the ransom of a man's soul is his riches" [Prov 13:8] and "Give alms, and all things

are clean unto you" [Luke 11:41]. Many things similar to these are found, especially for encouraging almsgiving; going through these one by one would take too long.[36]

Further on in this long document, which assigns lands from Leutgard's dowry to the monks of St. Peter, mention is made of Leutgard's deceased father, Count Heribert, of her husband, Thibaut, and of her two living sons, Count Odo I and Hugh, archbishop of Bourges. Odo, bishop of Chartres, and her daughter Emma, countess of the Aquitaine, are in the list of witnesses, along with Leutgard and her sons. A codicil to the document offered by Archbishop Hugh and Count Odo I makes specific requests for *memoria* for their mother in the Divine Office as sung in St. Peter's abbey church.[37] In these documents Paul of St. Peter mixes local stories and his memory of recently burned documents to establish Leutgard as a heroine for the Chartrains. The memory of Leutgard was long-lived in Chartres, and she seems always to have represented the connection of the Thibaudians and Chartres and their special love of the town. Souchet in the seventeenth century knows much of her; he reports that "the common folk call her 'Madame de Rigeard' on account of her marvelous deeds, which are fables rather than the truth." "To this day," he says, "a solemn service is said at St. Peter's on November 14 for the repose of her soul, with the ringing of all the bells from evening until daybreak" (*Histoire*, 2:167). Whatever the truth of her life's circumstances, the Chartrains believed in her legacy and made Leutgard their own. The charters, the necrology, and the liturgy served to make her place in the past and to create a special place for Thibaudian women in Chartres.

## THE VIRGIN IN THE WAKE OF DEFEAT

The bishop in the year of the so-called fire of 962, Hardoin, and the bishop during the subsequent five years, Vulfad, do not have significant numbers of documents attributed to their reigns.[38] If the cathedral of Notre Dame was actually burned around this time, as seems likely, Odo is the only bishop involved about whom we have substantial information. Odo, mentioned in the forged charter of King Lothair cited above in chapter 1 (note 26), is said to have held the see of Chartres for almost forty years, from 967 to 1003.[39] In order to secure the funds he needed to rebuild the cathedral and replace lost furnishings and objects of art, Odo seems to have encouraged devotion to the Virgin's cult among several local donors, providing thereby the first evidence of the cult's celebration in Chartres itself. Chartres, BM N a4 provides information about Bishop Odo and the group of people who seemingly joined forces with him to reconstruct the burned church and promote the cult of the Virgin in this place, particularly through the relic of the interior tunic.[40] These records concerning Bishop Odo and his circle were created in the workshop of the cantor Sigo, with the blessing of Bishop Fulbert. Thus evidence compiled about Bishop Odo and his role in promoting the Virgin's cult is in har-

mony with the ideals of Fulbert, Sigo, and their entourage; the extent to which they
elaborated upon or fabricated entries outright in the necrology and martyrology
cannot be told, although Paul's charters can sometimes provide a check. The histo-
riographical strain developed at this time promotes a pacific vision through the cult
of the Virgin Mary. This served as yet another way of protecting and promoting the
Thibaudian family, whose reputation for bellicosity and deceit spread far and wide,
however unjustly—at least in comparison with the counts of Anjou and the dukes
of Normandy, who were no less vicious in their actions and consistent in their de-
ceptions. We find here, as well, the sense of peace symbolized by Mary's presence
at Chartres, in keeping with the tenets of the peace movement, often championed
by the clerical or monastic historians of the times.

Whereas it is clear that the cathedral of Chartres had been dedicated to the
Virgin for centuries before the time of Bishop Odo and that the miracle of her
intervention at the battle of 911 was known in the region by the late tenth century,
only in this period do we have local evidence pointing to the cult of the cloth. The
entries in Chartres, BM Na4 concerning Odo and his circle, taken at face value,
suggest that the years just before Dudo wrote his history were witness to a campaign
in Chartres to elevate the relic and to give it stature. The Norman Dudo, who spent
much of his life in nearby Rouen, would have known the stories that circulated as
part of the elevation of the cult; thus he can testify to this early sense of the Virgin
of Chartres, seen, of course, through an alien lens.

Raoul, dean of Chartres during much of the lifetime of Bishop Odo, had been a
cantor, and so would have been a well-respected musician; as an older man he suc-
ceeded Odo as bishop for a brief tenure of his own.[41] Cantors from the period must
have been involved in matters regarding the liturgical cult of the Virgin, and surely
Raoul would have worked closely with Bishop Odo in the compilation of sources
and liturgical ceremony required for the cult's elevation, whatever these may have
been.

The necrologies introduce early members of the Thibaudian family as well:
Countess Leutgard, who supported the monks of St. Peter's and was buried in their
church, may have been part of a small group of religious women in Chartres who
offered important donations to local churches in the third quarter of the tenth cen-
tury. In a charter that has all the problems encountered with Paul's works, Godeleia
and her friend Clementia are seen as "illumined within by the flame of the Holy
Spirit" and taught by the biblical passage to "give and it will be given to you" as
they offer the rights to lands in exchange for the promise that their names will be
remembered in prayers and solemn masses (CSP 1:62). Another charter of bequests
links Godeleia by blood as well as friendship to the Countess Leutgard: "I, Leut-
gard, in the name of God, most devout and faithful servant of God. It should be
noted to all faithful of the orthodox and catholic church that I myself and a certain
other woman devoted to God, by the name of Godeleia, joined to me by physical

descent as well as in soul. . . ."[42] Charters from the cathedral of Notre Dame provide further information; small in amount, this information may be more reliable, depending on the extent to which Paul revised the documents he copied. Leutgard has only one line in the necrology of Notre Dame; Godeleia's obituary says more: "Godeleia died, a holy woman, who led a religious life, and who gave many ornamental objects to this church."[43] Others who signed charters in the company of these women gave to the church as well. Avesgaud, who signed two charters promoted by Leutgard, gave to the canons of Notre Dame property that Leutgard had previously given to him in remembrance of her (*MSC* 126 and 172, August 14).

The name Teudo, in various spellings, is frequently encountered in Chartrain charters dated to the second half of the tenth century and is used by later figures also, some lay and others clerics. The Teudo who signed all the charters also witnessed by Leutgard is styled a wealthy layman; he is the same who crafted (or had crafted) the first known reliquary for the sacred chemise and contributed in major ways to the construction of Bishop Odo's church, as a notice in the necrology testifies: "Dec. 15. Teudo died, who designed the golden reliquary in which is located the tunic of blessed Mary, and made the front of this church, and roofed this same church, and gave to the brethren the earnings of Clauso-villari."[44] The first charter in which he is listed is that of Godeleia and Clementia in 977, and the last is dated 988, a work in the familiar style cultivated by Paul of St. Peter (*CSP* 1:84–86). Teudo witnessed charters in the same company of people: the bishop, the leading nobility of the town, and other dignitaries, sometimes including Count Odo, his mother, Leutgard, and, in "Lothair's" charter (a forgery discussed in chapter 1), Odo's wife, Berta.[45]

A witness to a charter in 986, Canon Hilduin, is probably the same figure who was assigned the task of watching over the new reliquary of the garment or tunic (both terms were found in eleventh-century documents), along with other precious objects recently given to the rebuilt cathedral, including, it may be assumed, Godeleia's plentiful gifts. Hilduin, one of the first "head sacristans" whose name is known to us, has an obituary that offers a description of this important position at the cathedral of Chartres and that demonstrates that much of the goods and property of the cathedral canons was held in common, requiring a supervisor and distributor of income and materials. This office would become increasingly important in regard to cults of the saints in general and to the cult of the Virgin of Chartres in particular. "March 24. Hilduin died, a canon of nourishing Mary, the keeper of the reliquary of the holy garment and of all the ornaments of the church, a faithful overseer of the household and a generous distributor."[46]

These early eleventh-century records were crucial to the way in which subsequent generations were to think about liturgical arts and their care. From a very early period the so-called front of the church and the reliquary of the sacred garment were connected through their attribution to the same artist. There was also

Figure 2.1. Surviving remnant of the Holy Cloth of Notre Dame of Chartres. Archives diocésaines de Chartres. Photo, Delaporte.

an officer who, as head sacristan, watched over the relic "of the holy garment" and all the church's artworks. Chartres was significant for its ornaments, the precious artwork, furnishings, and metalwork given to magnify cult and ritual, even in this early period. Already by the third quarter of the tenth century the precious art and treasury associated with the relic of the Virgin required its own caretaker.

Although their deaths are recorded in the necrology of St. Peter's, neither Count Thibaut I (d. January 16 or 17, 975), nor his son Count Odo I (d. March 12, 996), has obituaries in Chartres, BM Na4. All the major gifts presented by the family to the church seem to have been inspired by women, with Bishop Odo's encourage-ment.[47] Bishop Odo's own family was not immune to the inspiration he offered to the female sex, for his mother's obituary in the cathedral necrology includes mention of her gift to the cathedral of "golden eagles fashioned with wondrous workmanship by Saint Eligius for the reliquary of the Mother of God."[48] Bishop Odo in turn donated land in his mother's name, as he did in his brother's name as well.[49] The attribution to the famed sixth-century artisan Eligius of golden winged creatures on top of the reliquary added luster and authority to the object. Saint

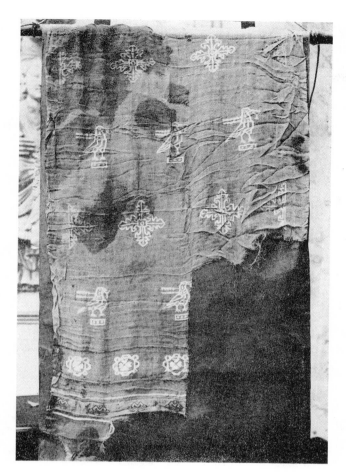

Figure 2.2. The cloth that surrounded the Tunic of Notre Dame. Archives diocésaines de Chartres. Photo, Delaporte.

Eligius (Eloi) was thought to be a seventh-century craftsman, especially venerated in Flanders, and renown as bishop of Noyon.[50] His *Vita* was copied in Brussels in the ninth century and in Tours and Paris in the tenth century. Clearly his fame had reached Chartres by the time of Bishop Odo. Eloi's feast day was customarily December 1.[51]

Of the group sustaining the rebuilding of the cathedral of Chartres after the fire of 962 and establishing the cult of the Virgin, the most important figure may have been Bishop Odo himself. There is no record of Count Odo I having contributed to the cult of the Virgin, although his wife, Countess Berta, gave substantially.[52] Count Odo cared primarily about Marmoutier in Tours, a fact recognized by history makers in Chartres. But Bishop Odo looms large in the Chartrain *Vieille Chronicle* as the administrator who reorganized the cathedral chapter, regularizing the monies from prebends so that each of the seventy-two canons was paid a comparable amount (see *CNDC* 1:14). The number seventy-two, deliberately selected to reflect the number of the first disciples of Christ, was an exceptionally large number of persons to be subsidized at equal rates by a single cathedral chapter, and at this

stage in the cathedral's development it is highly doubtful that such a large number of canons was actually in residence. Also, according to the *Vieille Chronicle*, Bishop Odo promoted the magnificent choir and liturgy of Notre Dame of Chartres. The number seventy-two, with its symbolic significance, was a source of pride for the Chartrains for centuries, however, and is frequently mentioned in later histories and other documents; the splendor of the singing and of special liturgical ceremonies at Chartres was also praised throughout the later Middle Ages, especially in Chartrain sources.[53]

The necrology, which may have reflected the actual state of affairs, also suggests that Odo worked by raising the cult of the Virgin and by emphasizing the power of the sacred cloth. The first known reliquary was constructed during his tenure and ornamented by his mother. The first story to place the relic in the context of the siege of Chartres circulates from the time he was bishop.[54] Bishop Odo was apparently the first to associate himself powerfully with this cult, and the history made in Chartres itself promotes carefully crafted connections among relic, reliquary, and bishop from his time on. The presence of the counts of Chartres/Blois at this time of rebuilding, with a countess as a major presence, is to be noted; and it should be recalled that the family was renowned in the eleventh century for its buildings, especially of magnificent, tall towers.

The legend of the reliquary of the Virgin's garment, with its golden ornaments, played a major role in the Chartrain sense of the object's appearance and its meaning, stirring up the imaginative legends about the miraculous power of "La Sainte Chasse," the golden, jewel-bedecked box that reflected the holy worth of its contents. At Chartres, the main character from Bishop Odo forward would be the Virgin, especially the Virgin of the cloth relic. The main supporters of her cult were the canons and bishops of the cathedral, whose work was steadily buoyed by the populace, both its merchants and its religious, and sometimes by the Thibaudians as well. Bishop Odo would be lionized by the canons of Chartres Cathedral in the fourteenth century and given a prominent part in the history of the town and its cathedral, but his fame was contained within the fortresslike walls of the city of Chartres; the fate of his successor Fulbert would be otherwise.

## POLITICAL TURMOIL IN CHARTRES IN
## THE LATE TENTH CENTURY

Christians in the central Middle Ages, long tutored by the liturgy of Advent (see chapter 3), awaited kings whose lineage suited them for the office and who came to reign at appropriate times. In accord with the model established at Advent, Christian kings were rightful kings because they were appropriately heralded and presented to the people whom they would serve. It has long been said both that Hugh Capet was pronounced king on June 1, 987, the Vigil of the Ascension, in Noyen,

and that he was subsequently anointed and crowned in Reims on Sunday, June 3, the feast of Pentecost.[55] He rose and the Spirit descended upon him: a king who had actually been created through election rather than through lineage, and by the machinations of Bishop Adalbero of Reims (969–89), was surrounded by ancient liturgical symbolism through the work of cantors and historians.[56]

Hugh Capet reigned in the midst of civil war, the Carolingians still claiming the throne in the person of Duke Charles of Lorraine. Hugh felt he could not wait for his son to become king upon his death, but, according to Richer of Reims (*Historiae* 4.13), had Robert crowned king on Christmas day, 987.[57] On this feast, or on its vigil, the lineage of Christ from Matthew 1:1–18 would have been proclaimed in the liturgy; the dramatic "Laudes regiae" rang out at the same feast. The entire liturgy and complex of chants joined liturgical texts to praise the royal line of the recently reestablished Capetians, and not for one king but two.[58]

Throughout the tumultuous years between his coronation and his death in October 996, Hugh Capet was harried by the conspiratorial deeds of his vassals, chief among them Count Odo I of Chartres/Blois, son of Thibaut I and Countess Leutgard.[59] Odo's plan — launched around 993 in concert with Adalbero of Laon — to replace the co-kings Hugh and Robert with Duke Charles, and then to make himself second in command, was uncovered early in the game; soon afterward, in March of 996, Count Odo grew sick and suddenly died. At the time of his death Odo's schemes were in disarray, and he had been branded a traitor by Hugh and Robert — as, of course, he was.[60] These disastrous events of betrayal and death unfolded in the Thibaudian realm at the same time that Bishop Odo's program to strengthen the cult of the Virgin was under way in Chartres, and repertories of tropes, as in Reims at the Royal Abbey of St. Remigius, were being copied to make the liturgical *adventus* of kings, abbots, and bishops ever more splendid.[61] Richer of Reims's description of Count Odo's deathbed includes the cries of Countess Berta and her entourage. Her husband's death left the countess, daughter of Conrad the Peaceful, king of Burgundy, and Mathilde of France, with ferocious enemies on either side of the lands amassed by Thibaut I and his warrior son Odo I. In a scene depicted by Richer, the dying count attempted to negotiate the final stages of a truce between himself and the father-son team of kings, a diplomat attempting to redeem himself in royal eyes and to preserve his comté:

> While he was deliberating most diligently concerning those of his subjects left with the king under conditions of the truce, Odo was troubled by a surplus of humors resulting from a change in the weather, and laid low by a sickness the doctors called quinsy. This was settled in his throat; produced by rheumy fluids, it led to a very painful swelling, sometimes in his jaws and his cheeks, and at other times in his chest and lungs. These parts are swollen and inflamed on the first day, and carry off the patient on the third day. Odo, fallen into this condition, was stricken with invasive pains all

round his throat, and the seething of his windpipe cut off all speech. . . . His soldiers wept, his servants cried aloud, and the women made constant piteous cries, for they were losing their lord unexpectedly, and his sons would have no hope of ruling, since the kings still raged against their father, and Fulk, a man of insolent spirit, was disturbing the peace in many ways. But Odo, near death, sent fleet envoys to the kings; they offered persuasive entreaties for himself, and pledged the most just reparation for the wrongs he had done them. The old king [Hugh Capet] wished to accept the redress offered by Odo's envoys, but was prevented by his wrathful son [Robert]. Therefore he completely rejected the petition of the envoys, and forced them to retire, having obtained nothing. They drew out their journey back, and before they arrived the fourth day of his quinsy came, when Odo, having become a monk, died. Such was the end of his life. He was taken to Saint Martin, and in the place called Marmoutier was buried with much ceremony by his family.[62]

Richer had firsthand knowledge of both parties in this unresolved dispute and, as was typical of the way medieval chroniclers wrote their works, steadily revised his *Historiae* to answer to the unstable political situations of the times.[63] His depiction of Odo's death reveals his sympathy for and intimate knowledge of the Thibaudians as well as his interest in medicine.

As noted in chapter 1, Richer, who apparently knows local legends, offers the first depiction of a historic ancestor of the line of Chartres/Blois. This was Ingo, the standard bearer of the early Robertian King Odo, a supposed early count of Blois who is otherwise unattested. When Richer visited Chartres in 991, ostensibly to gain access to medical texts available in the school there, he gave us our only view of life in tenth-century Chartres written by someone who was actually present and favorably disposed toward the Thibaudians.[64] Jason Glenn emphasizes the importance of this journey to Chartres in Richer's history even more: "Although we do not know precisely when Richer began to compose this history [which survives only in a single autograph copy], we may speculate about where he did so. Odo's prominence in the aftermath of the civil war between Hugh and Charles suggests that he may have written a good part of the history in Chartres."[65] Glenn places Richer's actions in the context of his affection for and loyalty to the old Carolingian line and Duke Charles, who was also supported by Count Odo; he suggests, although without direct proof, that Richer may have remained in Chartres for several years with time on his hands and with motivation to compose his own version of the events of the time and their historical antecedents. If so, his detailed knowledge of Odo's death would be at first hand; if he was not in Chartres himself, he seems to have been in direct contact with someone who was.

In his review of early necrological documents from Reims, Glenn discusses Reims, BM 15, an eleventh-century necrology from Reims, to which names were added in the early twelfth century from other documents. Glenn hypothesizes that the entry for Richer (May 19), who is listed as "cantor and canon of this church,

and afterwards a monk of St.-Remigius," is probably for the historian.[66] If Richer indeed was the cantor of Reims Cathedral at some point in his career, it would accord well with the way he constructed history, that is, by paying great attention to the details of ceremony. Geoffrey Koziol (1992) says that "Richer loved nothing so much as a good political ceremony" (save, we might add, for a gruesome death scene), and "where Flodoard ignored ceremonies, Richer lavished attention on them" (116–17).

Glenn's hypothesis, if true, would have far-reaching historical implications for history, liturgy, and music during the time of the first Capetians. We can speculate in the same vein that Richer, as a close ally of Adalbero of Reims and of Gerbert, would have lost his office as cantor for political reasons. When Arnulf was named bishop of Reims the game was up, and he could have departed for the monastery at that point. His visit to Chartres, as Glenn suggests, was likely prompted by the complete breakdown of civic order that took place in Reims during the period leading up to Count Odo's death. Glenn is right that the narrative of the journey to Chartres is exceedingly strange, not what would be expected of a monk making a simple trip to study some medical treatises. It seems rather that Richer was in full flight, attempting to travel through lands favorable to the count of Chartres/Blois as he stumbled in the dark of night through violent and crashing storms with his companions and their miserable, ill-fated horse. Pondering his motivations gives intense pleasure, but we have no proof for causality beyond what is in Richer's text itself.

The antagonist in the scene as Richer recorded it is King Robert II, who, with youthful impetuosity, denied Odo the truce he sought, the chance for a deathbed reconciliation with the king, and royal protection for his vulnerable wife and young children.[67] Thus Robert, who became the sole king on his father's death in October 996, only months after Count Odo's unexpected demise in March, was about to assert himself. However, the young king immediately made up for his apparent cruelty to the House of Chartres/Blois by taking on himself to provide sanctuary for Odo's widow and offspring. Richer's notes on events of the times were never, as far as we know, turned into prose, but they recount the actions following the death of Count Odo I and demonstrate his ongoing connection to the Thibaudians:

> Berta, wishing to marry Robert, consults Gerbert [of Aurillac], who seeks to dissuade her.
>
> Gerbert goes to Rome to defend his cause [as Bishop of Reims], gives his reasons to the pope, and, as none have accused him, another synod is indicated.
>
> King Hugh, his entire body covered with boils, died in a place called Ville-des-Juifs.[68]
>
> King Robert, succeeding his father, married Berta on the advice of his counselors, applying the principle that it is better to meet a lesser evil in order to avoid a greater one.

King Robert, having married Berta, marches against Fulk, who had been Odo's enemy, and takes Tours back from him by force, and all else that he had seized.

King Robert lays siege to Hildebert in Aquitania in support of his nephew William.[69]

Gerbert goes to Rome a second time. While he prolongs his visit, Arnulf is installed by King Robert [as bishop of Reims].

Gerbert, learning of the perfidy of King Robert, flees to King Otto, who, having recognized the extent of his gifts, gives him the see of Ravenna.

Pope Gregory meanwhile allows Arnulf to carry out the episcopal functions [in Reims] until such time as the case is decided by law (*Historiae* 4:108–09; 307–09).

Richer thus offers a synopsis of the crucial facts as they appeared at the time, an overview that modern historians have little choice but to accept, as other evidence is scarce. Immediately after her husband's death, Countess Berta of Chartres/Blois sought the advice of Gerbert of Aurillac, then attempting to establish his contested position as archbishop of Reims. Gerbert, realizing that Berta and Robert were second cousins, related through Henry the Fowler, advised against their marriage.[70] Consanguinity was a possible charge, yet second cousins often married, and in many courts of judgment their marriage would have been allowed. But Robert and Berta were marrying at a time when the church was looking to strengthen its ability to decide on the possible illegality of marriages, and contemporary liturgical texts, with their concentration on appropriate lineage, underscore the point. Michel Rouche (2000) argues that a shift began around the year 1000 from a time when women often arranged and controlled marriage to a time when the church and men managed it exclusively. Countess Emma of Blois, the estranged wife of William IV of Aquitaine, for example, was a broker in the marriage of her son William to Adalmode, who as a daughter of Countess Adelaide-Blanche was a first cousin to Fulk Nerra (Bachrach, 1993, 66–68).

The marriage of Berta to Robert exemplifies the old way, at least in part: Berta played a role in arranging and negotiating the marriage and held firmly to her position, even after the marriage had been annulled and Robert had remarried. However, Robert and his counselors too were strongly involved. The problems the couple faced from the church at that time of increasing ecclesiastical control testify to the difficulty high-ranking nobility had in securing suitable and politically advantageous marriages that were not also consanguineous, a problem that would only grow worse.[71]

Study of the lives of King Robert, Queen Bertha, and Robert's second queen, Constance, of writings about them, and of the kinds of liturgical song created in the late tenth and early eleventh centuries is an exercise in understanding how politics made liturgy and liturgy framed politics. No issue was more important than right

descent in both arenas, and the Virgin Mary was a symbol that could play both ways. She could seem to pronounce upon rightful descent from ancient lineage, but she could also demand something different: Jesus' own lineage was both predictable, in that he was from the house of David and born at a particular time, and strange in its progression, as later discussion of Matthew 1:1–16 will demonstrate.[72] The ways that the Advent liturgy and the texts and music it inspired were related to the political situation of the times, how they were read and expanded upon, depended on who was doing the exegesis and why, and how the past was constructed to justify a particular present. In the early eleventh century, when some of the surviving trope manuscripts such as Bamberg 30 were copied, proclaiming which set of kings or rulers would be hailed was crucial. The hailing itself had to be adaptable to a variety of circumstances during this age of widespread controversy and indecision, especially in royal monasteries and cathedrals with strong connections to the king.

Both King Robert and his would-be bride seem to have urgently desired their union, and not only because of their mutual attraction. The marriage would protect Berta and her children against the Angevins, who, unless Berta remarried swiftly and astutely, would swallow as much of the territories of Chartres/Blois as the king, their only major defender, would allow. Berta's sons, whose fates are lamented in Richer's description of Odo I's death, were very young when their father died. Robert, heirless king of the West Franks, would have been tutored throughout his life in the ways that Angevins, Thibaudians, and Normans had threatened the Capetians' small, landlocked realm. Marrying Bertha would shift the balance of power in Robert's favor by doubling the wedge of royal land between Anjou and Normandy, since Thibaudian lands were immediately adjacent to his own. For a king seeking legitimacy and heirs of a particular bloodline, this marriage had much to offer. Berta was a direct descendent of Charlemagne through her mother, Mathilde.[73] Marriage to her would join the scions of Charlemagne to the Robertian ranks: through such a lineage their son would be the king of kings, the agony of the recent civil war might be soothed, and the Capetian line would be more powerfully established.

Robert's marriage to Berta of Chartres/Blois, however, seems to have been more than one of convenience, for rumors swirled around the liaison from the start.[74] We have no firm evidence, but the few facts are unusual and suggestive: namely, the swiftness of their marriage and the unyielding stance of the parties involved. Robert's hagiographic biographer, Helgaud of Fleury, reports that at this early period of his life the king was like David and Berta his Bathsheba.[75] If Odo I played the part of Uriah the Hittite, it was not because he was sent to die in battle but because he died without hope, unforgiven by his king. Helgaud calls it adultery and describes it as keeping in bed a woman from whom Robert was doubly separated by law, meaning both their cousinhood and that he was a godfather to one of Berta's children. A con-

temporary satirical poem attributed to Adalbero of Laon mentioned the liaison and remained in circulation after Robert had taken another wife and produced male heirs.[76]

Hugh Capet had opposed the marriage of Berta and Robert, and in fact the couple married only after the old king had died. Familial ties were close: Robert's mother, Queen Adelaide, was the daughter of William III, duke of Aquitaine.[77] William IV of Aquitaine, then, would have been her brother; he was married to Emma of Blois, Odo I's sister. Thus, Berta of Chartres/Blois was an aunt by marriage to King Robert. William V of Aquitaine was Odo II's first cousin through his aunt Emma, and the two were frequently together in Chartres and Blois.[78] William V, however, was also a first cousin to King Robert II through Robert's uncle William IV, and Robert, as noted, was Odo's, or Odo's brother's, godfather. These relationships not only suggest the bond between men who had known each other all their lives, but also help to explain the close relationship Bishop Fulbert had with each of them, especially with William V, who begged him to spend more time in Poitiers, the Aquitanian capital, and to come to Limoges for the dedication of the cathedral.[79]

Hugh Capet's opposition to Robert's marriage with Berta of Chartres/Blois was well founded: in difficult times, when the Capetian claim to the throne was only recently reestablished, this would be Robert's second problematic marriage. His first marriage, to Rozella-Suzanne, widow of Arnolf II of Flanders (r. 965–88), had been arranged to end skirmishes over the castle of Montreuil and its surrounding territories in the Ponthieu.[80] Robert had detested "that ancient Italian" (Rozella-Suzanne was the daughter of King Berengar II of Italy) and had repudiated her on grounds of age within a year's time.[81] Yet he refused to return her dowry, and Richer's history describes the pitiful Suzanne, still contesting her land, installed in one of her few remaining castles.[82] Surely Robert had learned some sort of lesson and did not intend the marriage to Berta to repeat his first, although it may have appeared so to his father: Berta was indeed older than Robert (by six or eight years), and he doubtless wished to triumph politically through acquiring control of her territories and checking Angevin expansion, at least until such time as her sons could govern Thibaudian lands as his vassals. But the maneuvers the couple went through to remain together, even years after Robert had been forced by church authorities to abandon Berta, can be explained only by love.[83] Robert seems to have loved Berta of Blois for around twenty years and to have regarded Odo II as something of a son, forgiving his many transgressions and enjoying his company at court—during those periods that the two were not engaged in combat, either with the Angevins or with each other. And Berta herself remained firm in her loyalty to him as well, at least as far as can be told.

The fate of Robert's consanguineous marriage was sealed by the circumstances surrounding the appointment of Gerbert of Aurillac as archbishop of Reims. The story is well known, but its ironic twists warrant summarizing. King Hugh Capet,

Robert's father, seems to have miscalculated in choosing Arnouf as successor to Adalbero of Reims rather than Gerbert, who was the king's secretary and trusted adviser as well as his son's teacher and sometime mentor. Arnulf, a canon of Laon, was a natural son of King Lothaire, but he swore loyalty to the Capetian cause upon being awarded his office. However when captured by his uncle Duke Charles of Lorraine in the storming of Reims, apparently in the autumn of 989, Bishop Arnulf changed his mind and went over to Charles's camp. Duke Charles and Bishop Arnulf, who intended to use Reims as a Carolingian stronghold, were ultimately overthrown by Bishop Adalbero of Laon, who pretended to be an ally but, once enjoying the pleasant company of Charles and Arnulf, took them under arrest and handed them over to King Hugh. Charles was imprisoned for the rest of his life, and Arnulf was deposed by the clergy of the realm at the synod at Verzy, near Reims.[84] Adalbero of Laon, who had once been charged by the Carolingian Louis V for adultery with Queen Emma, the widow of Lothair, had his own score to settle.[85]

Gerbert, who had counted on election as archbishop of Reims from the beginning, was subsequently elected in Arnulf's place and began to serve.[86] But complaints against the deposition of Arnulf and his replacement by Gerbert were then lodged with Pope Gregory V, who, to the surprise of many parties — especially Gerbert, who did not doubt that his own superior abilities would achieve papal recognition — was less than pleased at his accession. The pope called a Council at Pavia early in 997 to resolve the difficulty and excommunicated the fifteen bishops who had supported the deposition of Arnulf and the election of Gerbert (see Jaffé, *Regesta*, 1:492). By then Hugh Capet was dead and Robert married, and Robert seems to have tried to win papal support for his marriage to Berta by pledging to support Arnulf if the pope would not press charges of consanguinity. Robert's strategy seemed to Gerbert the cruelest treachery. His letter to Robert's mother, the widowed Queen Adelaide, reveals his mood and the sense of the times when he had just learned that the pope had deposed the bishops who elected him and reinstated Arnulf as archbishop of Reims: "The too wicked and almost incredible report has affected me with such grief that I have almost lost the light of my eyes in weeping, but when you order me to come to you to offer consolation — an excellent idea, indeed — you command the impossible."[87] In early April of 997 Gerbert fled to the German emperor, Otto III, suggesting in a letter that he had brought about his own downfall by refusing to defend Robert and Berta's marriage (*Letters*, 281). Perhaps the keenest and best-formed intellect of the late tenth century and surely its most influential teacher, Gerbert was never to return west of the Rhine.

Robert's plan to win papal support for his marriage by supporting Arnulf against Gerbert recoiled on him doubly. Pope Gregory V called a general council in Rome; in January 999, it declared against the marriage of Robert and Berta: the king was to leave Berta; if he did not, they were both to be anathematized, a worse punishment than excommunication, as it condemned in perpetuity. The documents were

signed by Gregory V and then by Gerbert, who had become archbishop of Ravenna, by three Italian bishops, three Burgundian bishops, a German abbot, and eighteen suburbican bishops.[88] Not one Frankish authority was represented, and none of the bishops who had celebrated Robert's marriage were to be reinstated without first going to Rome. Soon after this—as if to prove the adage that truth is stranger than fiction—Gregory V died, and Gerbert became Pope Sylvester II, elected on April 2, 999, and consecrated on April 9. As the months unfolded it seemed that although Gerbert would not sanction the marriage he might not take further legal action against Robert either. His predecessor had already declared the ultimate sanction, and Gerbert was a confidant of Berta and may have been reluctant to censure her further.

Robert's counselors were slow to admit defeat, as were Robert and Berta themselves. Their complex of power was powerless before the church. Yet could Robert not have continued to stay with Berta in spite of it all? Some historians (see Pfister, 1885b, 60) think he would have done so except for one fact: in the four years they were together Bertha had produced no heirs for the Capetian line—the male child with the head and shoulders of a goose that she was later said to have borne is a myth concocted by reformers to censure consanguinity.[89] As time moved on, people surely wondered if the king and queen were going to draw their subjects with them to the certain condemnation of excommunication, even as the newly established Capetian line wore thin and threatened to break.

By September 1001, Reine Berthe, as she was known generally even after the repudiation, was living once again with her sons in Blois and in Chartres, and Robert II was seeking a new wife in order to produce heirs for his line.[90] He found one, probably in 1004 (the precise date is a matter of dispute), in Constance, daughter of William, count of Arles, and his wife, Adelaide of Anjou.[91] Queen Constance was thus a first cousin to the Chartrains' serpentine foe, the Angevin leader Fulk Nerra. With this marriage power shifted once again: Berta, the repudiated queen, was merely a widowed countess, and the new queen of France was near relative to her most feared enemy.[92] The sea changes witnessed in the decade 995–1005 would rock the boat of Capetian power for centuries, forcing it to list toward either Chartres/Blois or Anjou, often depending upon how the winds from Normandy caught the sails.

During this same period it became clear that the ambitions of the Thibaudian mother had passed on to her young son, Count Odo II of Chartres/Blois, whose most impressionable years were spent in the shadow of the throne. As the events of their tumultuous lives reveal, he never ceased longing to be a king, just as his mother always styled herself a queen. Berta continued a long affair with her former husband, Robert the Pious, but was never able to achieve her apparent goal of regaining her place by his side. The cult of the Virgin of Chartres developed in lands that had a resident queen and a king at the turn of the year 1000 and lost them both;

they lost their bishop designate as well. King Robert and Queen Berta must have sought to put a Thibaudian at the head of the cathedral of Chartres. Fulbert, in a letter written to the abbot of Fleury in 1003, reveals in an aside that Count Thibaut had been named as the next in line for the office of bishop but died in 1004 en route to Chartres/Blois from Rome.[93] No Thibaudian would serve as bishop of Chartres until the second half of the twelfth century, and no queen would reign in Chartres but Mary.[94]

## HAC CLARA DIE

The sequence "Hac clara die" (transcribed and translated in appendix D) is the kind of new work added to the chant repertory in the tenth century to solemnize the Virgin's cult. Hiley's study of the Anglo-Norman sequence repertory (1980–81) groups the piece among those found throughout Francia by the year 1000. Accordingly, this late ninth- or tenth-century sequence, written west of the Rhine in the years after the division of the Carolingian empire, would have been in place at Chartres during the time it was burned around 962 and sung during the rebuilding of the town and its cathedral. "Hac clara die" was broadly regional; it proclaimed the history it contained and defined Mary in accordance with west Frankish liturgical, musical, and linguistic developments. The style of the poetry and music and the nature of the relationship between them are different from what was found in the Notkerian sequences written east of the Rhine in the ninth and tenth centuries.[95] The sequence "Gaude Maria Virgo" by Notker, for example, opens with a single line, and the melodically paired versicles that follow may or may not rhyme. In several cases they break, and an unmatched phrase emerges, as in the fifth unit in Richard Crocker's reconstruction of this piece.[96] In his analysis Crocker emphasizes here, as elsewhere in his study, the elegant rhetorical flourishes that characterize the heightened prose of Notkerian sequences, and the tightly knit, repeating melodic phrases that unify the music evolving to partner with them.[97]

"Hac clara die" belongs to another world. Unlike the Notkerian sequence mentioned above, its lines are regularly shaped, and each is punctuated by a-assonance, with but few exceptions. Kruckenberg points out that Notkerian sequences lacked this ending, the "regularized versicle lengths," and the regular stress patterns of the then-developing traditions of western Frankish Latin poetry.[98] Roger Wright's work on the way Latin was taught and received in the Carolingian period (1991) has sparked a lively debate on the topic, with engaging new discussions by authorities in the field. A piece such as "Hac clara die" demonstrates the potential for bringing music into the study of late Latin and medieval learning.[99] This is poetry proclaimed, taught, and learned through singing. As such, it is filled with tricks of the classroom, and what seems crabbed to those who have learned at Virgil's feet is an exercise in liturgical Latin that was intensely studied and practiced. That a modern

singer or reader finds playfulness in these religious songs is sometimes a result of how they were made, rather than of their intention. Texts such as these were set in many ways and sometimes linked by use of the same tune. Such strategies raised the stakes in the linguistic games that youths played with their masters in the tenth century as they learned Latin and composed new works for the liturgy as the fruit of their knowledge.

"Hac clara die," like each of the Marian sequences in the Chartrain repertory, is set to one of the popular melodies that circulated throughout the region. Anselm Hughes, whose collection of these melodies—which he termed *sequelae*—is basic to the study of tenth- and eleventh-century sequences, believed that "Hac clara die" was the original text for the *sequela*, or sequence melody, to which it was set, and this too would give the piece and its Marian meaning special emphasis. In addition, because sequences were traditionally viewed as songs sung in imitation of angels, in many secular and monastic churches the alleluias they followed in the liturgy, and the pieces themselves, belonged especially to child choristers.[100] The sequence provided an opportunity for the demonstration of poetic and musical skills; it drew the adults of the choir to a variety of performance practices, from the singing of verses *alternatim*, to the use of wordless melismas, to the use of the organ and polyphonic improvisation. The words, frequently colored with an unusual vocabulary, could transport listeners to another zone of understanding, one to which they were led by a child. The differences between East-Frankish and West-Frankish sequence repertories remind us that what young clerics sang was both prayer and educational formation.

As pieces such as "Hac clara die" established regional musical and linguistic understanding, its hagiographic content helped define the Mariology of the times. This sequence shows Mary as an unblemished queen, pregnant yet still biologically intact. The crowd hails her with honeyed concord, proclaiming her full of grace throughout all time. This song, first designed for the feast of the Annunciation on March 25 but frequently sung for the Purification and other Marian feasts as well, claims a transformation brought about by an eternal God entering human flesh and ends with a proclamation of peaceful times brought by this newborn. It offers an image divorced from the bellicose culture into which it was received, a world marked by the need for a leader who could bring peace and by a queen who would not die from the body-wrenching experience of giving birth.[101] It is not a particularized piece but was sung throughout the area today known as France, both north and south. The Mary it offered was foundational, but she needed to be further explained, which would be the work of composers and liturgists in the eleventh century. Every city wished her to be its own queen, even as the families of the territories then forming were attempting to gain royal power for themselves.

*Part Two*

# MARY'S TIME

### From Advent to the Nativity of the
### Virgin at Chartres

—————— ✦ ——————

# *ADVENTUS* AND ADVENT

## History and Lineage in the Latin Rite

I look from afar, and behold, I see the power of God coming, and a cloud covering
all the land. Go you out to meet him, and say: Tell us if you are he who will reign
over the people Israel.

—*Great Responsory, first Sunday of Advent*

The interdependence of cult and historical understanding referred to in part I
unfolded within a shifting liturgical framework of time. The earlier layer of liturgi-
cal materials was primary to historical understanding for centuries and consisted of
themes, texts, and chants inherited from Carolingian reformers who shaped the Ad-
vent season in the central Middle Ages (discussed here as an example of their work).
Mariology at Chartres was further refined through a second group of chants, litur-
gical texts, and exegesis drawn from the feast of her Nativity, an occasion given spe-
cial emphasis at Chartres during the tenure of Bishop Fulbert.[1] Fulbert understood
the connections between the Advent season, for which he wrote a series of sermons,
and the Marian feast that he and his disciples used to establish a festive framework
for the cloth relic of the Virgin at Chartres. I demonstrate here the complex process
of liturgical evolution that took place from the ninth to the eleventh centuries, as
towns throughout northern Europe acquired new relics and enriched regional and
local cults of the saints through the reuse of preexisting materials and the addition
of new texts and music as well as the development of bold new exegetical strategies
to draw the new and the old together into a sensible whole.[2] The political develop-
ments discussed in chapters 1 and 2 were grounded by both enlarged older cults
and completely new strategies, the two going hand in hand to provide histories and
*historiae*, the latter being the common term for the texts and music making up the
liturgical Offices of the saints.

The themes of the Advent season applied through sermon literature and chants
to the Virgin's cult went through yet another stage of development in the second
half of the eleventh century. At Chartres writings from various periods were col-

lected into a liturgical book designed to appear as if it had been written (or at least inspired) by Fulbert himself. The evolution of cult within liturgical materials is often a long, complex process and allowed for the most sophisticated and enduring kind of history making, especially when a historic figure could be associated with it, not only locally but even more broadly. The liturgy accepted new texts and music reluctantly in Chartres, but once changes in understanding were embraced by and through it, they tended to remain in place. Every town in medieval Europe had a unique liturgical profile, one that begot a particular way of knowing the past and a special past to remember. The liturgy of Chartres Cathedral was highly conservative, at least after an eleventh-century period of ferment and development. Its nature reflects an apparent desire to sustain Fulbert's character as a builder of the cathedral and as an instrumental figure in its liturgy and saints' cults, notably that of the Virgin Mary.

History in the liturgy developed layer by layer in the central Middle Ages, and the materials studied in this chapter constitute the first and fundamental layer. Subsequently—we will see—the liturgical Advent established in the Carolingian period was transformed and reshaped within and through the liturgy of the Nativity of the Virgin—which was especially prominent at Chartres Cathedral—and other feasts for the Virgin as well. These richly textured materials were subsequently embodied within the visual arts at Chartres Cathedral in the first three quarters of the twelfth century. Variations on this program appear in numerous other monuments throughout northern Europe in the twelfth century and long after. Because the visual program was deeply rooted in Advent texts that every church celebrated, it would make sense for any Christian community. Yet, in the art as well as in the liturgy of Chartres in the mid-twelfth century, the Virgin is prominent, and her heritage comes to define the perceived history of several groups of people, most importantly that of Jews and Christians, and of their royal, priestly, and prophetic lineage. Advent in the Roman rite embodies the fundamental medieval Christian *adventus* procession, taking the participant on a journey from the dawn of time to an evolving apocalyptic present.

## *ADVENTUS*: MODES OF RECEPTION IN THE MEDIEVAL LITURGY

From antiquity on, the reception of a ruler into his or her kingdom was understood as an event transforming time; it represented acknowledgment of a particular order and offered answers rather than questions. When the situation was more specific, and a new leader was coming to accept the reins of power, people acknowledged by acclamation that this was the heir to the kingdom, heralded by appropriate signs of his position, from the cosmic to the humble.[3] Prominent among the models for royal entrance and reception are the several depictions of adventus ceremonies found in the Hebrew Bible. In their Latin translation these presented West-

ern medieval Christians with an elemental sense of kingship, removed though it was from its original setting and intentions. Psalm 23 (Hebrew 24), more than any other text in the Christian liturgy, helped to define "entrance," and in the Middle Ages its words were featured in several ceremonies at the main door or gate of a city or church:

> Who shall ascend into the mountain of the Lord: or who shall stand in his holy place? The innocent in hands, and clean of heart, who hath not taken his soul in vain, nor sworn deceitfully to his neighbor. He shall receive a blessing from the Lord, and mercy from God his Saviour. This is the generation of them that seek him, of them that seek the face of the God of Jacob. Lift up your gates, O ye princes, and be ye lifted up, O eternal gates: and the King of Glory shall enter in. Who is this King of Glory? the Lord who is strong and mighty: the Lord mighty in battle.[4]

The entrance depicted in Jeremiah 7:2–15 offers a long list of desiderata for those who would enter the temple and asks for the public display of the House of Juda: "Stand in the gate of the house of the Lord, and proclaim there this word, and say: Hear ye the word of the Lord, all ye men of Juda, that enter in at these gates to adore the Lord" (Jer 7:2). The idea that members of the House of Juda should stand in the temple gates and proclaim is central to the portal sculpture of the west façade of Chartres cathedral.

The Gospels offer many parallels to these and other ancient adventus ceremonies, thereby proclaiming their Jewish heritage and announcing messianic fulfillment. Jesus is hailed as an entering ruler at the beginning of his life as well as at the end, and these entrance greetings came to play a major role in the liturgy of the Latin West. The three major processions of the medieval church year took place on the feast of the Purification, on Palm Sunday, and on Ascension Day.[5] Each of these was an adventus ceremony, hailing the king and marching with him to a place where a statement would be offered about the nature of his power. The three canticles sung daily in the Western Office are all adventus hailings and are all from the Gospel according to Luke.[6] The Song of Zachariah, the "Benedictus," which belongs to the Office of Lauds, recognizes John the Baptist as the prophet who will prepare the way of the Lord. In the "Magnificat," Mary's song of joy and acknowledgment, a new song is created, distinguishing her greeting from that for John the Baptist, who is for Christians the last great prophet of the Jews, just as Mary is the first great Christian prophet. The song of Simeon, "Nunc dimittis," closed the daily Offices of prayer in the Western Christian rite and brought Jesus into the temple, where he was received by the prophet Simeon and recognized as the Messiah. These three acts of greeting and receiving were deeply ingrained in the imaginations of medieval Christians as they were reenacted every day, coloring particular hours through their proclamation.

In the late antique and medieval worlds, well-known patterns of public acknowl-

edgment indicated who was king in times of indecision and confusion and attempted to remove doubt regarding appropriate succession and valid rule. Pivotal to the adventus ceremony is the idea that each participant must make a choice: either be a subject and publicly declare fealty or be dismissed. The ceremony not only introduced the rightful ruler; it also distinguished his followers. The nature of adventus in the medieval West is essential to understanding how supporters were controlled and alliances solidified and how nonaligned segments of society were marginalized. Adventus proclaimed triumph: the vanquished were displayed and humiliated; winners marched together in celebration as they were received and acknowledged.[7]

The adventus model was reworked and played upon in a multiplicity of ways in the later Middle Ages, both in ceremonial enactment and in written histories.[8] When the king, count, or other leader came to a church or monastery, he and his entourage had to be ceremonially received; to refuse this reception was to deny allegiance. The adventus procession, for a count, for a bishop, for a king, or for the Messiah, asked a question of the assembly: Whose side are you on? In many cases, the ruler too had to acknowledge his support of the community, often by a token act of honoring people or by giving and receiving gifts. By the end of the ceremony the answer had been revealed and affirmed, and the goats—if there were any—separated from the sheep. Relationships had been defined and reaffirmed. The foot-kissing incident, part of the reception of Charles the Simple (see chapter 2), takes on special meaning when placed, as it would have been in the perceptions of all medievals, in the context of adventus. To turn the ceremony completely inside out allowed the historian, in this case Dudo of St. Quentin, to predict dire consequences for the figure improperly hailed.

Although the claim for the imperial character of some early depictions of the Christian Messiah has been challenged, there seems to be no doubt concerning the regal display of medieval kingship and its liturgical roots in the Advent season of the Roman rite.[9] Study of Carolingian court rituals, especially those of obeisance that include rites of welcome and entrance, suggests the influence that Byzantine court ceremonial had in the West in the ninth century; the many explorations of how French kings were installed at Reims in the later Middle Ages take these ideas into realms of the Capetian and Valois dynasties.[10] The pageantry, plays, and ceremonial associated with royal entry in the fifteenth and sixteenth centuries demonstrate that many *topoi* established in late antiquity and the Middle Ages were still operating in later periods, adapted with a complexity nothing short of astounding.[11] We know from the work of Duby on medieval marriage and lineage (1966 and 1983) how carefully these subjects were studied by leaders, both ecclesial and secular, for their lives and the futures of their children often depended upon their interpretations.

Although the subject of formal entrance in antiquity and in the Middle Ages

is much studied, several crucial elements have been missing from the discussion. Most fundamentally, there is no detailed and systematic analysis of adventus themes in the medieval Latin liturgy itself. Missing, too, then, has been discussion of the framework of history the liturgy created through the season of Advent, with its particular depiction of time-altering events, and exploration of the complex ways in which the framework created by the Advent liturgy shaped perception of events and character central to the history-making process. Advent texts and themes need to be examined within their most universal manifestation, the four-week season of Advent that preceded the "entrance" of the Messiah into the world of time at Christmas. These studies are requisite not only for what they have to say about Christians' understanding of their own place in history, but also for the ideas found in the Advent liturgy concerning the Israelites and, by transferal, of Jewish communities in the Latin Middle Ages.[12] Advent itself was key to shaping the Jewish–Christian polemic in the Middle Ages, and its centrality has never been recognized or explored as such in any detail. Adventus—as political and liturgical ceremony, as a liturgical season, and as a way of thinking about history—is fundamental to understanding the visual arts in the central Middle Ages as well, above all when one is ultimately interested in the ways time was depicted in the sculptural programs of central portals. A Romanesque portal, like Adventus itself, is a triumphal gateway to a new understanding of the past and to one's place in it.[13] Enter; decide.

## THE ADVENT SEASON AND THE WORKINGS OF TIME

Near the end of his liturgical commentary *Speculum ecclesiae*, Honorius Augustodunensis offers a long explanation of the passage of time, framing his thought within the liturgical season of Advent, the four-week season of penance and expectation that unfolds before Christmas.[14] In his work, units of liturgical time are interpreted as being directly representative both of the passage of time in human life and of historical events themselves.[15] Indeed Advent, as Honorius understood it, recreates several units of time, from the single night and its subsequent dawn to the swathes of centuries composing historical epochs.[16] These various temporal units themselves are interrelated in his argument because each of them replicates the liturgical structure of Advent, and so all can be seen as reflections in a singular mirror of recorded events. I have chosen his work to introduce this discussion of Advent, royal lineage, and the Virgin Mary not only because it is the most thorough explanation of the season among the medieval liturgical commentators, but also because it demonstrates the peculiar depth of an endlessly refracted time sense, one that was commonplace to the medievals who both made and wrote history in the central Middle Ages.[17]

The massive historical shift that medieval Christians believed took place at the Incarnation and birth of Christ was first commemorated in the church year at Ad-

vent and thereby linked to the seasons and the days as a point between darkness and the rising of the sun. In our age the dawn retains little of its symbolic power; modern people remain wakeful and at work regardless of the sun's setting and are awakened by mechanical devices rather than by the coming of the light and the cock's crow. For medieval Christians, steeped in the tradition described by Honorius, each night recreated Advent: the coming of the Messiah was viewed as paralleling the coming of the light; the dawn was perceived as a reenactment of a historic, time-transforming event, one experienced acutely by those living in monastic and clerical communities.[18] Honorius emphasized that night was calculated to have twelve hours and that these were divided into four vigils, or periods of waiting. For him these divisions of the night replicated other temporal benchmarks: the year has twelve months, and these are divided into four seasons; the seasons of a person's life are four as well: childhood, adolescence, adulthood, and old age; so too the ages of temporal history are divided into four eras: first from Adam to Noah, second from Noah to Moses, third from Moses to Christ, and the last from the advent of Christ to the end of the world.[19]

The visual contrast between darkness and light seen in each transition from night to day shaped the texts of the season and their interpretation; their relationship to time and its passing as commemorated in the liturgy and commentaries was evident to all who knew the tradition. Advent constituted a long night, followed by the breaking dawn of Christmas. Honorius set up quaternities for individual days the better to play upon the structure of the Advent season as it was commemorated in his own time: in his era the Sundays of Advent were four, and each had a vigil.[20] A long allegorical explication of these four Advent vigils emphasized the darkness of the sky and the contrasting signal of the daystar which hailed the coming of the Messiah. Honorius draws together the fullness of the coming, the prophecies and structures of the liturgy, and the motions of the heavenly bodies to make a past that lives in the present and points to the end of time, all as commemorated in Advent: "And since the just were awaiting the advent of Christ in these four vigils, so four Sundays are made for celebrating the advent of the Lord. And since the four elements of the world are to be purified by his second coming, therefore the fourfold church is accustomed to celebrating his advent by four services" (PL 172:1080D–81A).

Honorius takes up the four Sundays of Advent in turn, relating each to an age of history; he emphasizes the prophets and the virtues these men exemplified, as they lit up the dark sky of temporal existence. The procession of these four Sundays, like the ages of history and the stages of human life, are the preface to the wedding feast of the messianic king who comes at the close to claim his bride, the Church. All are to assemble and to watch and wait: the Gospel warns Christians that they know not the precise way or time the Messiah will come. Advent retells the centuries-long waiting period for the first coming and anticipates Christ's second coming, both of

them synchronized with the sun, the moon, and the stars. The act of remembering is connected to the sense of expectation, and present knowledge depends upon constant review of past events and their significance within a liturgical context. Events are both predictable and pregnant with time to come. The future depends, as Augustine explained in his *Confessions*, upon a past constantly remade in the present, and this was poignantly so in Honorius's interpretation of Advent.[21]

Honorius closes his discussion of the Sundays of Advent with that final age demarcated by the coming of the Messiah, and the star imagery that guides the entire passage prevails here: "In the fourth vigil the star of the sea, the Virgin Mary, a brilliant flame, glowed red, as by her humility and chastity she indicated the way to the eternal sun. On this occasion, too, John the Baptist was resplendent as a wandering star, he who first taught repentance to sinners" (*PL* 172:1082A).

Discerning signs and predicting change are the chief lessons of the Advent season, just as they become the underlying themes of medieval portal sculpture in the twelfth century. Like the portals modeled upon its themes, Advent is about entrance and transformation. The voices teaching these lessons belong to several larger-than-life figures who perform their parts during this vast liturgical reenactment each year: men and women from the Old Testament, Gospel characters, and saints. Chief among them were the messianic prophet Isaiah and his Christian counterparts John the Baptist and the Virgin Mary, both of whom were celebrated as the last of an old order and the beginning of a new. They were doubly capable: they explicated the signs they offered and the signs they embodied. Because the liturgy represented the time spans of daily life—the hours, days, months, and years as well as the stages of life—the history it framed and reenacted was always rooted in the individual experience of time. Through experiencing it as a whole, every participant, depending upon training, sensitivity, talent, and inclination, could live a life peopled by the historic figures encountered in liturgical and festive display. In turn, of course, these historic figures and their actions were models for the creation of local histories, be they obituaries, charters, chronicles or more ambitious historical works, saints' lives, or the recorded deeds of important figures. The liturgical framework was understood to underlie lives from the distant past, from the immediate past, and in the present. All these lives were believed to unfold according to a commonly held sense of progression and motivation, the season providing an opportunity to study these various dimensions of time as a lived and experienced history capable of reenactment through concentration upon key figures and their interdependent voices. Adventus in the Latin rite was for the hailing of Jesus; at Chartres, themes were developed in liturgy and art to create a ceremonial advent for Mary as well.

Advent served as an important model for time because it was hard to depict in a single scene. It was not an event but a process of knowing unfolding in time and so was directly about history and the workings of history. The drama of Advent cen-

ters upon a figure who has not yet appeared but who is constantly made present through foreshadowing and archetypes. According to the medieval Christian view of time and history, potential redemption was present at the beginning of creation. Because the initial act of creation was already ordered by the messianic agent of creation, all history was pregnant with this agent's first and second comings.[22] The more successful Christian historians were in the central Middle Ages, the better they could demonstrate the ability to read events in the way the liturgy taught every worshiper to contemplate prophetic predictions of the messianic king. The ideal, as will be demonstrated repeatedly in this book, was to create history that paralleled the familiar unfolding of liturgical time, stretching and manipulating events and people in a multitude of ways and using a variety of genres and materials, depending upon audience, place, and time. The Advent liturgy, the creation of Roman-Frankish liturgists in the eighth and ninth centuries, taught a unique model of historical understanding: signs and portents predicted past events, future events, and the present time. And it focused attention upon a specific band of years, those during which Christ walked the earth, expanded at Chartres and other places to include the life of the Virgin as well.

The Office for the first Sunday of Advent—the dramatic opening of the entire church year—offers a superb example of the materials the liturgy provided for contemplation of the past as well as an array of commentary showing how medieval worshipers were trained to understand the passage of time through liturgically arrayed texts and chants. Both history writing and history making in the Christian tradition of the central Middle Ages depended directly upon this training, as did the understanding medieval Christian exegetes had of the relationship between an old and a new order in the playing out of salvation history. It would also suggest a strategy for the liturgical arts in mid-twelfth-century Chartres, as will be seen in chapters 9–12.

The first responsories and readings from the Advent Office discussed below demonstrate why the Office was the most important textbook of the central Middle Ages. It was through the daily singing of the Office that all learned men and women perceived scripture, as well as the most important commentaries upon it, and the related lives of the saints. These materials as arranged in the Office formed within worshipers a sense of how to understand time past and a view of the role individuals had within history. Select chants stand within a vast assortment of intoned readings as particular pronouncements, as places in which historic characters are given voice or new voices are established through unique combinations of materials taken from scripture. Because chants were selected and packaged to emphasize and summarize the meaning of larger sections of the liturgy, they were highly valuable sources for the visual arts and material depictions of history. The chants are the underscored passages in the textbook of the Latin liturgy.

A skeletal outline of the Advent matins service demonstrates the ways in which

Table 3.1. First Sunday in Advent at Chartres Cathedral: Readings and Incipits of Responsories

First Nocturn
Three Psalms with antiphons
Reading 1: Isaiah 1:1–3
Responsory 1: "Aspiciens a longe" Verses: "Quique terrigenae," "Qui regis Israel intende qui,"
   "Ecce dominator dominus"
Reading 2: Isaiah 1:3–6a
Responsory 2: "Aspiciebam in uisu noctis" Verse: "Potestas eius"
Reading 3: Isaiah 1:6b–9
Responsory 3: "Missus est Gabriel" Verse: "Ave Maria"
Second Nocturn
Three Psalms with antiphons
Reading 4: From Maximus of Turin
Responsory 4: "Ave Maria, gracia plena" Verse: "Quomodo fiet istud"
Reading 5: From Maximus of Turin
Responsory 5: "Saluatorem expectamus" Verse: "Sobrie et juste et pie"
Reading 6: From Maximus of Turin
Responsory 6: "Audite uerbum domini gentes" Verse: "Annuntiate et auditam facite"
Third Nocturn
Three Psalms with antiphons
Reading 7: From Matthew 24 (Christ's Entrance into Jerusalem) and commentary by Bede
Responsory 7: "Ecce uirgo concipiet" Verse: "Super solium David"
Reading 8: Commentary on Matthew 24
Responsory 8: "Obsecro domine mitte quem" Verse: "A solis ortu"
Reading 9: Commentary on Matthew 24
Responsory 9: "Laetentur caeli et exsultet" Verse: "Ecce dominator dominus"

(These responsories were typical for Sunday I of Advent. Choice and ordering of the verses vary, and all can be located in the CANTUS database. See Ottosen [1986], 77.)

each of three sets of readings—from Isaiah, from Maximus of Turin, and from Matthew, with commentary by Bede—is responded to by long chants of repose and reflection. The readings themselves reflect a typical arrangement of Office readings for a feast: proclamation from the Old Testament, interpretation by a Christian father of the church (in this case a fifth-century writer whose sermons were highly favored in the compilations of Paul the Deacon in the late eighth century),[23] and finally a reading from the Gospel according to Matthew, chapter 21, with further commentary from Bede.[24]

The purpose of Advent is to allow worshipers to witness the slow, deliberate prophecies of messianic lineage, to hear God's promise that a Messiah will come, and to become capable of recognizing the Messiah at his appearance. For the monk, nun, or cleric steeped in this liturgical tradition, this recognition came every year in the pre-Christmas cycle of feasts; every individual who sang the Office and heard Mass was taught to read the signs, both of the coming of the Messiah and of his return, and to contemplate the parallels between the first coming and the second and

the meaning each had as a milestone in the progression of events past and events to come. The charge to do so was taken from scripture itself in Jesus' commandment to "look up" found in Luke 21:25–28, a key text in the Advent liturgy of the medieval Roman rite.[25] The liturgical context defined the sense of "coming" and "coming again" as parallel events, for this is a text about the end of time: "And there shall be signs in the sun, and in the moon, and in the stars; and upon the earth distress of nations, by reason of the confusion of the roaring of the sea and of the waves; men withering away for fear, and expectation of what shall come upon the whole world. For the powers of heaven shall be moved; and then they shall see the Son of man coming in a cloud, with great power and majesty. But when these things begin to come to pass, look up, and lift up your heads, because your redemption is at hand."[26]

## LESSONS ON LINEAGE

The ways in which medieval Christians were able to use the liturgy as a history book are many. Music and texts interacted not only with each other but also with well-known commentaries on the texts read and sung. The opening of the Advent season—and the two medieval commentaries upon the chants and texts constituting this opening tabulated above—provide a richly textured example of the sense of the past and of knowing the past that was common to learned Christians, all of whom knew these liturgical traditions and their modes of interpretation. The history of Advent itself is complex, and the chant texts found in two early ninth-century sources reveal significant differences; the writings of Amalar of Metz in the middle of the ninth century demonstrate that he knows competing versions of Advent Offices.[27] Yet by the early tenth century, at least in many areas of western Europe, the liturgy had been standardized, with some variation in choice and ordering of Office chants; this tradition operated in medieval Chartres, with local variants, tropes, sequences, and newly composed Office liturgies customizing a more generally received tradition.

The plan of matins of the first Sunday of Advent shown above suggests several ways in which texts and chants interacted in the Office, as can be seen from study of the first three readings and their responsories, followed by commentary from two medieval writers. These materials demonstrate the many biblical and other resonances found in these chant texts and also their special relevance to understanding the Virgin's cult as it evolved in Chartres and as it was embodied within the arts at Chartres in the mid-twelfth century.

The first responsory, laid out below in the way it was performed, shows how the respond and fragments of it alternate with the verses and the Gloria Patri, as would have been the case with many responsories sung on solemn feast days at Chartres.[28] This common performance practice caused the arrangement of phrases in

the chant texts to form a sonic kaleidoscope of historical meanings. The example reveals the aptness of responsory texts as sung meditations and commentaries on the intoned readings, in this case the opening of the book of Isaiah. Indeed, the scripturally composite chant texts formed a parallel scriptural "canon," operating interactively in the liturgy with readings taken either from the Bible itself or from the writings of the Church Fathers and lives of the saints.[29] Here the intention is to invoke the slow coming of the Messiah over the long centuries of waiting and to point to the moment of his entrance into the world of time. As the organization of the church calendar evolved during the Carolingian period, the first Sunday of Advent was often reckoned as the opening of the church year, a change from earlier times when Christmas had been the opening of the year. Small wonder that such a complex and strategically positioned chant inspired liturgical commentators from the ninth century on.

Although the reading from Isaiah could be divided in several ways, readings had in general become shorter by the time the Chartrain antiphoner now in the Vatican library (lat. 4756) was produced in the second quarter of the thirteenth century (see appendix B). This is not a pure cathedral book, but it does represent the use of Chartres Cathedral as celebrated in a house of Augustinians. The choice and ordering of the Advent responsories found there are consistent with those found in the Chartrain ordinals and with the now-destroyed thirteenth-century breviary from the cathedral Chartres, BM 588 (one of the many sources that Delaporte inventoried early in the last century).[30]

The opening of Isaiah read in the Advent Office creates the sense of a people who have abandoned God and who, of their own choice, will not be aligned with the Messiah. The medieval Christian interpretation of the text was conditioned by Jerome's commentary on Isaiah, which formed the standard interpretation of the book throughout the Latin Middle Ages.[31] The liturgical sense of this section of the Office arises from knowing the text as interpreted through both Jerome and the chanted responsory that follows. Whenever a well-known and much studied passage of the Bible was used as a liturgical reading, the accompanying commentary upon it was recalled in the minds of those who worshiped, and Jerome, the translator of the Bible in use throughout the Latin West by the twelfth century, had produced the favored commentaries upon many of the books he translated in the early fifth century.

Early in Jerome's commentary is a short discourse upon *visio*, expounding what having a vision means and showing a parallel between the prophets of the Old Testament and those of the New; this was a text crucial to understanding the medieval sense of time "seen," a theme of major importance to the later chapters of this book. On the text "Visio Esaiae, filii Amos, quam vidit super Judam et Hierusalem" (The vision of Isaias the son of Amos, which he saw concerning Juda and Jerusalem) (Isaiah 1:1a), Jerome wrote,

Earlier prophets were called "see-ers." They were able to say, "Our eyes are ever towards the Lord" [Ps 24:15/25:15; the Vulgate reads "my eyes"], and "To thee have I lifted up my eyes, who dwellest in heaven" [Ps 122:1/123:1]. For this reason the Saviour commanded the apostles, "Lift up your eyes, and see the countries; for they are white already to harvest" [John 4:35]. The bride in the Song of Songs also possessed these eyes of the heart, she to whom the Bridegroom says, "Thou hast wounded my heart, my sister, my spouse . . . with one of thy eyes" [Cant 4:9]; and in the Gospel, we read, "The light of thy body is thy eye" [Matt 6:22]. In the Old Testament too it is said that the people could see the voice of God.[32]

In the well-known text the prophet Isaiah "sees" the voice of God, the Word as it progresses in time, and this text justifies the many scenes in which Isaiah looks upon, or tries to look upon, the Word to come.[33]

After expounding the eyes of the prophet, Jerome discusses ears and hearing: "Hear," says Isaiah, "O ye heavens, and give ear, O earth, for the Lord has spoken." Jerome discusses the two kinds of hearing: that of angels in heaven, who have mystical understanding, and those who hear on earth, who must rely upon "simple history."[34] These modes of hearing were explored by medieval composers in the sequence repertory.[35]

In his commentary on the next two lines of the text, Jerome moves on to themes related to standard interpretations of Advent and Christmas throughout the Middle Ages. The exalted children who despise God are the firstborn, the Hebrews, who are displaced from their inheritance. They are represented by a series of Old Testament figures: Cain, who was replaced in God's favor by Abel; Ishmael, whose brother Isaac received the inheritance; Esau, supplanted by Jacob; and Ruben, who lost out to Juda, the progenitor of the messianic line of kings that Christians believed led to Christ. Jerome elaborates upon the idea that an ox knows its owner, and an ass the crib of its lord, with reference to the Christmas imagery of ox and ass in the stable of Bethlehem, animals that recognized the Messiah.

In the hands of the fifth-century Jerome, who was both establishing the texts of Christian scripture through his translations and writing the basic commentary upon them, Isaiah is used not only to proclaim the coming of Jesus as Messiah, but also to demonstrate that the Hebrews of the Old Testament have lost their position as God's firstborn. This theme dominates throughout the Advent season as Isaiah, read chapter by chapter throughout the four weeks, is interpreted as proclaiming Jesus the messianic fulfillment of the Judaean House of David. In this way the prophet Isaiah (as translated by Jerome and read during Advent) was closely tied to Christian themes of rejection and acceptance. Isaiah was Christianized, not only within the biblical text as Jerome had translated it, but subsequently through exegesis and the liturgical setting of the Advent Office as it developed in the Roman rite. The exegetical debates between Jews and Christians, which played out in so many ways

in the Middle Ages and are intensely studied today by scholars in every field, were foundational to the Advent liturgy; understandings of Advent underlie the polemic in the Latin West.[36] Medieval Christians worked not only to appropriate the texts of the Hebrew Bible as fundamental to their own liturgical understandings, but often to reshape them so that Christians become the Chosen People, with a unique and privileged relationship to the God of Israel. In Jerome's explication, the operation of the senses, particularly that of sight, is fundamental, and these interpretations would govern the depiction of time and the coming of Christ in medieval art.

The first responsory, sung at Chartres immediately following Isaiah 1:1–3, announces the seeing of the Messiah by a composite of prophetic figures from the Old and New Testaments. The reading is about those who deny; the chant is about those who saw throughout the ages—even if only dimly through the glass—and who accepted and believed. The singer thus proclaims a prophecy that measures up to Jerome's ideal of the God "see-er." With Ezechiel, the singing prophet looks from a long way off, yet whereas Ezechiel saw God "ascending"—going up and coming like a storm, covering all the earth—here the "power of God" comes, "a cloud covering all the earth."[37] The people are charged to go out and meet him, becoming the virgins of Matthew 25, only five of whom are prepared. The singer then becomes John the Baptist, for his voice demands that those who go out to meet the Bridegroom question whether he is the one who will rule. The verb *venturus* of Matthew and Luke is transformed in the chant text to *regnaturus*, and the people to the tribes of Israel. The singing "voice" here is of two periods of time, pre- and post-Messiah, and combines many perspectives and modes of knowledge: the singing *persona prophetarum* knows, asks, recognizes, and seeks, all at once. Yet the second refrain of this response, frequently repeated, is the text of John the Baptist, "Tell us if you are he"; thus through this mode of performance the precursor's questioning voice is the strongest strain. The nearer one gets to the appearance of Christ clothed in flesh, the brighter the light for seeing and for knowing.

FIRST READING AND ANALYSIS OF "ASPICIENS A LONGE"
(LOOKING FROM AFAR), FOLLOWING VATICAN, LAT. 4756

Reading 1: Is 1:1–3 [intoned to simple formulae, as were all liturgical readings]:

The vision of Isaiah the son of Amos, which he saw concerning Juda and Jerusalem in the days of Ozias, Joathan, Achaz, and Ezechias, kings of Juda. Hear, O ye heavens, and give ear, O earth, for the Lord hath spoken. I have brought up children, and exalted them: but they have despised me. The ox knoweth his owner, and the ass his master's crib: but Israel hath not known me, and my people hath not understood.

Great Responsory 1, sung text [only this first responsory is written out with all the refrains and the Gloria and the final repeat; the practice is assumed for all the others studied here as well]:

R. I look from afar, and behold, I see the power of God coming, and a cloud covering all the land. Go you out to meet him, and say: Tell us if you are he who will reign over the people Israel. V. 1: All you earthborn and you children of men, rich and poor together. R. fragment: Go you out to meet him. V. 2: Listen, you who reign over Israel, who lead Joseph like a flock. V. 3: Behold, the sovereign Lord will come with might. R. fragment: Tell us if you are he who will reign over the people Israel. Glory to the Father and to the Son and to the Holy Spirit, as it was in the beginning, is now, and ever shall be, world without end. Amen. R. I look from afar, and behold, I see the power of God coming, and a cloud covering all the land. Go you out to meet him, and say: Tell us if you are he who will reign over the people Israel.

Latin text of responsory 1 with both scriptural sources and resonances:

R. Aspiciens a longe, ecce video Dei potentiam venientem, et nebulam totam terram tegentem:

Ez 38:9 Ascendens autem quasi tempestas venies et quasi nubes ut operias terram

Jer 23:23 putasne Deus e vicino ego sum dicit Dominus et non Deus a longe
Ite obviam ei et dicite:

Mt 25:6 Media autem nocte clamor factus est ecce sponsus venit exite obviam ei
Nuntia nobis, si tu es ipse,

Mt 11:3 ait illi tu es qui venturus es an alium expectamus
Luke 7:19B tu es qui venturus es an alium expectamus
Qui regnaturus es in populo Israel.

I Sm 9:17b Ecce vir quem dixeram tibi iste dominabitur populo meo
V. 1: Quique terrigenae et filii hominum, simul in unum dives et pauper.

Ps 48:3 Quique terrigenae et filii hominum, in unum dives et pauper
V. 2: Qui regis Israel intende, qui deducis velut ovem Joseph.

Ps 79:2 Qui regis Israel intende qui deducis tamquam oves Joseph
V. 3: Ecce dominator dominus cum virtute veniet.

(The phrase "dominator dominus" occurs rarely in the Vulgate Bible and primarily in the book of Isaiah. The following two examples resonate with the chant text.)

Is 10:16 Propter hoc mittet Dominator Deus exercituum in pinguibus eius tenuitatem et subtus gloriam eius succensa ardebit quasi combustio ignis

Is 10:33 Ecce Dominator Dominus exercituum confringet lagunculam in terrore et excelsi statura succidentur et sublimes humiliabuntur

Amalar of Metz offers a ninth-century guide to the meaning of this first responsory. In his view the singer is in the persona of John the Baptist, and this is indicative of later commentaries upon this striking liturgical chant. His reliance upon Gregory the Great also points to the way in which this responsory was interpreted throughout the post-Carolingian period and even at the time of its strategic location at the opening of the liturgical year:

I have not proposed to speak about each responsory, but rather about each Sunday Night Office. The first two responsories, that is "Adspiciens a longe" and "Adspiciebam in visu noctis," establish at the beginning of the book the person of the Christ, who is God and human being, and universal king. The holy Church is at present striving to proclaim his *adventus* far and wide. In the first responsory the cantor introduces the sayings and deeds of John the Precursor. In John's person the Church can say, "I look from afar," that is, from as far as heaven is from earth. John says of himself, "He that is of the earth, of the earth he speaks"; but of Christ, "He that cometh from heaven, is above all" [John 3:31]. What he can observe by gazing with such concentration, he adds, "behold, I see the power of God coming." Concerning this power blessed Gregory speaks for the Precursor in his homily: "Pondering both his humility and the power of his divinity, he said, 'He that is of the earth, of the earth he speaks,'" and so forth. And then there follows: "and a cloud covering all the land"; that is, I see a fog of ignorance covering the earthly hearts of those Jews who do not recognize God present in the human Christ. This responsory recalls the divine nature in Christ. John says, "Make straight the way of the Lord" [John 1:23]. And Saint Gregory explains it in this way: "We make the Lord's way to our hearts straight when we listen humbly to the word of truth." Thus far Gregory.

When the word of truth goes into the heart, Christ goes into the mind of a human being; when this word is heard humbly, the human heart goes to meet Christ. This meaning is recalled when the responsory says, "Go you out to meet him." And there follows: "and say, 'Tell us if you are he who will reign over the people Israel.'" Indeed, the Precursor sent his disciples to Christ to ask him: "Art thou he that art to come; or look we for another?" [Luke 7:19].[38]

Amalar's commentary on the responsory "Aspiciens a longe" has several points in common with that by Odorannus of Sens, a contemporary of Fulbert of Chartres, and who lived in the archdiocese that included Chartres. Odorannus was the sort of figure whose works are of interest to this book about historiography and the liturgy: a monk of St.-Pierre-le-Vif, he was a music theorist and doubtless held the office of cantor at some point in his career; he also wrote a monastic chronicle; he composed *historiae*, that is, saints' lives; and he was an artist as well.[39] Odorannus designed his gloss or commentary upon the opening Advent responsory as a discourse upon the nature of events in time (see his *Opera*, 227–28).

He writes that the opening, "Aspiciens," refers to those who have meditated long on the advent of Christ; the words "Ecce video Dei potentiam venientem" mean "with the eye of real truth I contemplate the realization of what the psalmist says, 'Stir up thy power, and come to save us,' [Ps 79:3], and what Isaiah says, 'Behold, the name of the Lord cometh from afar' [Is 30:27]." The cloud covering all the land is the glory of the Savior, just as in Ecclesiasticus 24:6, "I made that in the heavens there should rise light that never faileth, and as a cloud I covered all the earth." All the faithful are to go out with the psalmist of Psalm 94:2 (95:2) before them

and to speak, addressing the Lord with canticles and psalms. The musical greeting announces that this is he "who will reign over Israel," and those who govern Israel are those who have the vision of the Messiah. Then Odorannus offers a statement concerned with mixed levels of time: "All this must be carefully understood, for in the psalms and the prophets future time is taken for the past, and the past for the future, and also the present for the past or the future, and the past and the future for the present" (*Opera*, 228). Odoranus has moved the discourse of Amalar to a congregational proclamation of the recognition of truths as envisioned through various senses of time. The biblical characters have not been minimized, but they have been linked to contemporary needs; the ideal of "going out to meet," the basic action of the adventus, belongs to the present time as powerfully as it does to the past.

The second reading for the Office of the first Sunday in Advent at Chartres is Isaiah 1:4–6a. Along with the responsory that follows, this pair of intoned reading and elaborate response engages the themes described above, but in a different way from that of reading 1 and the first responsory, "Aspiciens a longe." Here the reading emphasizes abandonment of God by his own people, while the responsory recognizes the Messiah as the Son of God. Together the pair pronounces that the rejection of God by one group is a foil for the many others who will accept that the Messiah to come will be king of all and that his reign will be everlasting. In the reading one group loses its right to rule; the responsory gives that right to the Christian Messiah and to the multitudes he claims as his followers.

SECOND READING AND ANALYSIS OF "ASPICIEBAM IN VISU NOCTIS"

Reading 2: Is 1:4–6a:

> Woe to the sinful nation, a people laden with iniquity, a wicked seed, ungracious children: they have forsaken the Lord, they have blasphemed the Holy One of Israel, they are gone away backwards. For what shall I strike you any more, you that increase transgression? The whole head is sick, and the whole heart is sad. From the sole of the foot unto the top of the head, there is no soundness therein.

Responsory 2:

> R. I saw in the visions of the night, and behold, the Son of man came on the clouds of heaven, and a kingdom and glory were given him: and every people, nation, and language shall serve him. V. His dominion is an everlasting dominion which shall not be taken away, and his kingdom shall not be destroyed.

Latin text of responsory 2, both respond and verse, with their scriptural source:

> R. Aspiciebam in visu noctis et ecce in nubibus celi filius hominis veniebat; et datum est ei regnum et honor et omnis populus tribus et lingue servient ei. V. Potestas eius

potestas aeterna, quae non auferetur; et regnum eius, quod non corrumpetur. Et datum.

Dan 7:13–14 Aspiciebam ergo in visione noctis et ecce cum nubibus celi quasi filius hominis veniebat et usque ad antiquum dierum pervenit; et in conspectu eius obtulerunt eum et dedit ei potestatem et honorem et regnum et omnes populi tribus ac linguae ipsi servient potestas eius potestas aeterna quae non auferetur et regnum eius quod non corrumpetur

Resonance with Gen 49:10 Non auferetur sceptrum de Juda et dux de femoribus eius donec veniat qui mittendus est et ipse erit expectatio gentium. (See below for discussion of this text, basic to Fulbert's sermons *Contra Judaeos*.)

Amalar said that the second responsory is in reply to the first, which asked through the voice of the Baptist if Christ was the one who was to come: "In the second responsory the human nativity is made manifest by the words: 'And behold, the Son of man came on the clouds of heaven.' Here it is answering the previous responsory, which asked if Christ would be the one to rule over the people Israel. This responsory says, 'and a kingdom and glory were given him,' and not only that he might reign among the people Israel, but so that the Judaic tribe, and the people Israel, and all tongues might serve him" (*Liber de ordine antiphonarii* 8.7, p. 39).

As Jerome interprets the passage from Isaiah, there were two kinds of Israelites, those who threw in their lot with Christ as Messiah and those who did not. The inheritance belonged to those who did. Pointing ahead to Isaiah 32:20 and continuing his discussion of the ox and ass of Isaiah 1:2, Jerome creates a dynamic force among three historic groups of people: Jews who acknowledged Christ as the Messiah; Jews who did not make this acknowledgment; and Gentiles, who would be ingrafted onto the older stock of those Israelites accepting the Messiah. This threefold division is basic to the structure of Advent as it was celebrated in the liturgy of the Latin Middle Ages:

In the book of Deuteronomy it is written: "Thou shalt not plough with an ox and ass together" [Deut 22:10], and in this same book of Isaiah, that the one who sows on all waters, where an ox and an ass tread, is blessed [see Is 32:20]. . . . Blessed is the one who sows in the declarations of the scriptures of both old and new testaments, and treads on the waters of the letter that kills in order to reap the fruit of the Spirit that gives life.

In the mystical sense the ox refers to Israel, which bore the yoke of the law and is a clean animal. The ass, oppressed by the weight of sins, we take to be the Gentiles, to whom the Lord said, "Come to me, all you that labour, and are burdened, and I will refresh you" [Matt 11: 28]. While the Pharisees and Scribes, who possessed the key and knowledge of the law, and were properly called "Israel"—that is, a mind seeing God—did not believe, a part of the Jewish people did believe, so that in one day three thousand at once would believe, and on another day five thousand [Acts 2:41; 4:4].[40]

The third reading of Advent, when studied alongside the third responsory, moves singers and listeners on to the moment of the Incarnation. The first two units are concerned first with questioning and gazing and then with accepting the Messiah's taking on human flesh. In the third the mystery is presented in three ways: the reading from Isaiah describes the desolation of Sodom and Gomorrah, where there is no righteous person, and all must be destroyed; the "daughter of Sion" is a female figure, desolate and abandoned, standing for the people who rejected God; the kernel of hope will survive—it is the believing remnant, of which the "seed" belongs to the house of David, the seed that was the subject of Isaiah's prophecy, both beginning, as here, and end.[41]

### THIRD READING AND ANALYSIS OF "MISSUS EST GABRIEL"

Reading 3: Is 1:6b–9:

> Wounds and bruises and swelling sores: they are not bound up, nor dressed, nor fomented with oil. Your land is desolate, your cities are burnt with fire: your country strangers devour before your face, and it shall be desolate as when wasted by enemies. And the daughter of Sion shall be left as a covert in a vineyard, and as a lodge in a garden of cucumbers, and as a city that is laid waste. Except the Lord of hosts had left us seed, we had been as Sodom, and we should have been like to Gomorrah.

Responsory 3:

> R. The Angel Gabriel was sent to Mary, a virgin espoused to Joseph, to bring her the word: and when the Virgin saw the light she was afraid. Fear not, Mary, for you have found grace with God. Behold, you will conceive and bear a son, and he will be called the Son of the most High. V. Hail Mary, full of grace, the Lord is with you.

Latin text of Responsory 3, with scriptural sources:

> R. Missus est Gabriel angelus ad Mariam virginem desponsatam Joseph nuncians ei verbum et expavescens virgo de lumine: ne timeas maria invenisti gratiam apud dominum ecce concipies et paries et vocabitur altissimi filius. V. Ave Maria gratia plena dominus tecum. Ecce.
>
> Luke 1:26–32 In mense autem sexto missus est angelus Gabrihel a Deo in civitatem Galilaeae cui nomen Nazareth ad virginem desponsatam viro cui nomen erat Joseph de domo David et nomen virginis Maria et ingressus angelus ad eam dixit ave gratia plena Dominus tecum benedicta tu in mulieribus quae cum vidisset turbata est in sermone eius et cogitabat qualis esset ista salutatio et ait angelus ei ne timeas Maris invenisti enim gratiam apud Deum ecce concipies in utero et paries filium et vocabis nomen eius Iesum hic erit magnus et Filius Altissimi vocabitur et dabit illi Dominus Deus sedem David patris eius
>
> *Pseudo-Matthew* 9.1 Altera autem die Maria dum staret iuxta fontem ut urceolum impleret, apparuit ei angelus et dixit ei: Beata es, Maria, quoniam in mente

tua deo habitaculum praeparasti. Ecce ueniet lux de caelo ut in te habitet et per te universo mundo resplendeat. Item tertio die dum operaretur purpuram digitis suis, ingressus est ad eam iuuenis cuius pulchritudo non potuit enarrari. Hunc uidens Maria expauit et contremuit. Cui ille ait: Noli timere, Maria, inuenisti gratiam ante deum. . . .

The responsory offers a picture of the Annunciation scene at which the Incarnation takes place, and not only in the words of Luke, but also through a reference to the *Protevangelium of James,* the second-century story of Mary's life that makes her of the house of David. The version quoted in the chant text is that of the Carolingian *Pseudo-Matthew,* which was created around the year 800 and became important for the feast of Mary's Nativity, especially as it evolved in the eleventh century at Chartres.[42] Thus Mary of the Annunciation, as the example shows, is the figure continuing the line predicted by the prophets, most strongly by Isaiah. She is the Davidic vine from which the Messiah would come, encountered at the opening of Advent.

Continued explication of the readings and responsories of the first Sunday in Advent would demonstrate the multilayered complexity of the feast, brought about in part by the superimposition of various liturgical traditions one upon the other and by placing the Gospel of the day, Matthew 21:1–9 (the story of the triumphal entrance into Jerusalem), in a context of liturgical materials, some of which may originally have been designed for other liturgical locations.

The second group of readings in this Office at Chartres is from the fifth-century Maximus of Turin: it comments on Luke 17, offers signs of warning, charges those who wait and watch to look to their own lives, and orders them to meet the Bridegroom. The second group of responsories (see table 3.1) begins with the words of the angel Gabriel to the Virgin Mary and her reply to him, continuing the annunciation theme in the first group of three (an emphasis that will be made again in Ember week of Advent). The second responsory of this group, the fifth in the set of nine, provides a dramatically engaging counterpart to the three readings attributed to Maximus of Turin. The chant text answers the question of John the Baptist prominent in the earlier responsories: Are you the one we have awaited? Its affirmative answer is adapted from the apostle Paul (Phil 3:20b–21a).

The nine responsories for the first Sunday in Advent, taken as a whole, have been arranged to provide a dialogue between characters from the first and second testaments (usually referred to as "old" and "new" here, as in the Middle Ages). The conversation is carried on among several figures (with others, such as Daniel, adding their voices): Isaiah, who, as Jerome translated him and the liturgy contextualized him, proclaimed the defeat of those not accepting God's Son as the Messiah; John the Baptist, who as the last of the prophets had questions to ask, and who could see, but from afar; and the Virgin Mary and the apostle Paul. Mary and Paul answer

John's questions; they could see directly, and they proclaimed their answers in the liturgy, although in very different voices. The responsories begin with general wonderment: Who is this king? and continue with an affirmation of identity, of himself and of his followers. The nature of the Virgin Mary's flesh becomes the key to understanding that this is the rightful king. Her position on the threshold of time matters so much not only because the end of the old order is a sign of the new, but because her prophetic hailing signals fulfilment of several historic strains, each of which would be carefully explored through the cult of the Virgin of Chartres.

The final three readings of the first Sunday in Advent are from the Gospel of the day, Matthew 21:1–9, and Bede's commentary upon it. The reading contains the story of the triumphant entrance into Jerusalem, which brings forth the Christian king in the most elaborate of all adventus ceremonies, one reenacted in cathedral and monastic towns throughout Europe during the Middle Ages. Here, at Advent, this ceremony received definition, and voices of expectation were touched with the foreshadowing of Lent and Passiontide.

The mingling of several layers of tradition at Advent creates a liturgical sense that is deep and difficult. The long procession, pregnant with many themes even at its opening—and containing strong emphasis upon the Virgin Mary and John the Baptist—winds through the book of Isaiah. As it goes, Isaiah is presented against a variety of Gospel readings and interpretations. The nature of the procession is profoundly triumphalist in its structure and intent, and this aspect of existence was central to the way the past was perceived by most Christians in the central Middle Ages. As the time of the new order drew nigh, the sense of uprooting and transformation was ever more sharply drawn, leading to a climax in the final days of the season. The polemical defenses of the Virgin and her honor woven into Christian exegesis from the fourth century on find a place here too, as does her partnership with her kinsman John the Baptist.

The chants and readings of the Office were the basic texts used to explain history to religious communities; they revealed truths about the Messiah, the saints, and about local traditions. These chants for Advent offer a cosmic level of time and its transformation. The readings from scripture and commentary upon them evoked a response in chants made up of various texts drawn together to form a complex voice, returning song in acknowledgment of textual meanings. Chant texts offer a particular kind of historical understanding because they were proclaimed by soloists and by choir members who answer universal and difficult questions. Who are you? Where are you? What do you know? Advent chants proclaim knowledge about the most elemental mysteries of the universe as believed in medieval Christian communities, always from the mouths of familiar biblical characters. In chants such as these time stops for awhile and gives the singers and their audiences a chance to take up the past, hold it, and think about its meanings.

## THE FIRST MARY OF THE ROMAN RITE:
## THE VIRGIN IN EMBER WEEK

Study of adventus and of the Christian Advent season as a long ritual of coming leads to the Virgin Mary as both historical witness and agent. The attention given to Mary in the first week of Advent grew much more intense near the end of the season, during Ember week, that special time of penance and solemnity falling just after the third Sunday of Advent.[43] Mary was first venerated liturgically in Rome not through specific feasts dedicated to her—these were imported from the East in the seventh century—but she found her place at Ember week, near the close of Advent.

The practice of offering special homage to Mary the Theotokos just before the season that includes Christmas and Epiphany is an ancient one and can be found in other rites besides the Roman. In Spain the Virgin was venerated on December 18, a week before Christmas; the Bobbio missal, a Gallican hybrid, has a Marian feast for the Vigil of Christmas, this in addition to the Gallican Theotokos feast celebrated on January 18; in Constantinople, Mary was celebrated just before Christmas from the early fifth century. The Marian emphasis prominent on Wednesday and Friday of Ember week continued on Saturday as well, but here the Gospel featured John the Baptist. As they did earlier in the season, Mary and John work in concert with their Old Testament counterparts to announce the coming of the king.[44]

As the thirteenth-century Chartrain notated breviary Vatican, BAV lat. 4756 demonstrates, Ember Wednesday concentrated upon the Annunciation of the angel Gabriel to Mary. The three readings at matins consisted of the Gospel of the day—here, as in seventh-century Rome, Luke 1:26–38—and, in Chartres, commentary from Bede on this text. While the readings describe Mary's encounter with the angel and comment upon it, the responsories announce Old Testament prophecies about the messianic birth. The words are from the prophets, especially Isaiah, and from the psalms and serve as commentary upon the words of Gabriel.[45]

The emphasis upon lineage culminates at the end of the week. Three sung texts, all from Ember Saturday, have been selected for study. They point to Mary and her Davidic heritage as predicted by the prophets: one is a responsory referring to a central text for the season, Isaiah 11:1–2; another responsory refers to the throne of David; the last is an antiphon for the Benedictus of Lauds. The Gospel for Saturday in Ember Week, Luke 3:1–6, looks back to Isaiah 40, but through the mouth of John the Baptist, and established the liturgical tone of the entire day:

Lesson 1: Luke 3:1–6:

Now in the fifteenth year of the reign of Tiberius Caesar, Pontius Pilate being governor of Judea, and Herod being tetrarch of Galilee, and Philip his brother tetrarch

of Iturea, and the country of Traconitis, and Lysanias tetrarch of Abilina; under the high priests Annas and Caiphas; the word of the Lord was made unto John, the son of Zachary, in the desert. And he came into all the country about the Jordan, preaching the baptism of penance for the remission of sins; as it was written in the book of the sayings of Isaias the prophet: "A voice of one crying in the wilderness: Prepare ye the way of the Lord, make straight his paths. Every valley shall be filled; and every mountain and hill shall be brought low; and the crooked shall be made straight; and the rough ways plain; and all flesh shall see the salvation of God."

The matins readings are from Gregory the Great's twentieth homily on the Gospel, "Redemptoris praecursor." The passages read at Chartres and elsewhere emphasize that the reign of one kingdom and priesthood was nearing its end, and another was taking its place.[46] The readings of Gregory that make this point were punctuated by three responsories based on Romans 15:12 and Isaiah 52:15; Isaiah 11:1–2 and 5; and Isaiah 9:6–7.

The combination of the reading from scripture, the commentary by Gregory the Great, and the chant texts advances the idea that the root of Jesse, the Christian Messiah, is the new king and priest, a person who will supplant the old order of both kings and priests. This new king will sit upon the throne of David, an action that demonstrates his lineage and fulfills prophecy. The hearkening back to the opening of Advent, with the responsory that incorporates allusions to the *Protevangelium of James* and the Davidic lineage of the Virgin Mary, could be contemplated in a special way by any person who sang this liturgy and who could make connections over time through the power of memory. This liturgy, first shaped in the Carolingian era, presented materials adapted later in the eleventh and twelfth centuries through the interpretations of liturgical scholars like Fulbert of Chartres and reshaped by the men who designed the west façade of Chartres Cathedral in the twelfth century.

Of special importance to the visual arts in twelfth-century Chartres was the antiphon sung for the Benedictus of Lauds on Ember Saturday, "Omnis vallis implebitur."[47] Its text is from the Gospel of the day, Luke 3, the text commented upon above by responsories referring to the root of Jesse and Mary's Davidic stock. In this chanted text the words of Isaiah 40:4, as spoken by John the Baptist in Luke 3:5 (with the verb changed from *exaltabitur* to *implebitur*), were sung along with the canticle of Zachary, the father of John the Baptist, whose tongue was loosened when he named his son according to the Lord's command. The words of the prophet are heard, then, as accompaniment to the prophecy of John's father. The Benedictus is the text chanted at the close of every Lauds, with an antiphon related to the feast and season. Ember Saturday was a solemn festival in the eleventh century, and the antiphon would not have been truncated in any way. This presentation would join with the apocryphal gospel related to the Virgin to make Mary of the house of David, a theme central to the development of her cult at the cathedral of Chartres.

Mary at Advent appeared every year to acknowledge her lineage, to grow large with the passing of time, and to give birth in the spring. Her character at the beginning of the church year was reworked at Chartres to give her a special place at harvest time as well, a time when allusions to her unique fecundity could be linked to the fairs and festivals that came to be associated with her feast. (See appendix D for the Latin text and music of "Omnis uallis.")

ANTIPHON FOR THE BENEDICTUS, SATURDAY IN EMBER WEEK, ENGLISH TEXTS

Antiphon: Every valley shall be filled, and every mountain and hill shall be brought low, and all flesh shall see the salvation of God.

Blessed be the Lord God of Israel; because he hath visited and wrought the redemption of his people:
 And hath raised up an horn of salvation to us, in the house of David his servant:
 As he spoke by the mouth of his holy prophets, who are from the beginning:
 Salvation from our enemies, and from the hand of all that hate us:
 To perform mercy to our fathers, and to remember his holy testament,
 The oath, which he spoke to Abraham our father, that he would grant to us,
 That being delivered from the hand of our enemies, we may serve him without fear,
 In holiness and justice before him, all our days.
 And thou, child, shalt be called the prophet of the Highest: for thou shalt go before the face of the Lord to prepare his ways:
 To give knowledge of salvation to his people, unto the remission of their sins:
 Through the bowels of the mercy of our God, in which the Orient from on high hath visited us:
 To enlighten them that sit in darkness, and in the shadow of death: to direct our feet into the way of peace (Luke 1:68–79).

After the Gloria Patri the antiphon was repeated. In this antiphon text, the act of seeing is emphasized ("and all flesh shall see"), and the Virgin Mary becomes the vehicle of revelation through lending her Davidic flesh back to its creator. This theme became of major importance to liturgy, exegesis, history making, and the arts at Chartres in the central Middle Ages.

"Sonent regi nato," an eleventh-century sequence sung at Chartres on Christmas, is a work that offers welcome to a newly born Messiah through a new song, a "nova cantica" (the work is translated in appendix D). The chant resonates with the texts of the Advent liturgy cited above and demonstrates how newly written sequences summed up meanings of the older texts of the Office liturgy for singing at Mass. In this statement about the nature of time, the word "born from the heart of the father before time" comes to the world of time in the body of the mother. Hearkening back to adventus, prophets appear in the sequence "who spoke knowing

that the one about to be born was the Son of God." "Sonent regi nato," a northern French sequence, consistently represented in Chartrain sources, is focused on the role of the Virgin in the transformation of time and her relationship to eternity. It underscores ideas found in Fulbert's sermon for the Virgin's Nativity as well as in the Book of the Cult, Chartres BM 162 (see below). Advent was the foundation for the Virgin's cult at Chartres, but new works from the eleventh century would complete the building.

# 4

---

## TRAUMA AND THE REMEDIES OF HISTORY

The approved custom among Christians is to observe the birthdays of our forebears with careful attention, and then especially to read aloud in church their virtues, ascribed to them in books, for the praise of God, by whose gift they exist, and for the good of lesser folk.

—*From Fulbert of Chartres's sermon* Approbate consuetudinis
*for the feast of the Virgin Mary's Nativity*

In 1020, on the eve of the feast of the Nativity of the Virgin Mary, fire once again engulfed the cathedral town of Chartres; this blaze, like all the others, had a unique character and history-making power. The fiery triduum extended from September 7, the vigil of Mary's Nativity, through the feast day itself on September 8 and into the next day. The cathedral and much of the town burned to the ground, and people had to reconcile massive loss with the feast of their major saint and its festive display and economic opportunity. The twelfth-century vita of Saint Anianus recalled the disaster as follows: "The third fire occurred in 1020, the fourth year [*sic*] of the episcopate of Fulbert, on the vigil of the Nativity of the Virgin. This time, the cathedral was not only damaged by the flames, but was completely ruined. Fulbert then devoted his genius, his activity, and his wealth to its reconstruction from the foundations; he made it of an astonishing beauty and grandeur and left it almost finished."[1]

Fire and the military shaming of 962 must have been recalled at this time, over half a century later, when people who remembered the earlier fire may still have been alive. Medieval cathedral towns needed to come to terms with the fires that so often destroyed them, seeming to offer direct encounters with God's wrath. This fire would be different, for Chartres burned on the day that would become most holy in the minds of the townspeople, their bishop, and their clergy, the feast of Mary's Nativity, September 8. There is no firm evidence that this day had been singled out at Chartres as the cathedral's patronal feast before this time, although it

may well have been. Building up the feast's profile was undoubtedly part of Bishop
Fulbert's and his successors' grand scheme to promote the Virgin's cult in a way
specific to Chartres and its major relic.[2] Events after 1020 suggest that the renewed
interest in the Virgin's cult at Chartres was born of fire and that Bishop Fulbert was
its midwife. Fulbert and his generation had lived through the removal of a queen
and through numerous military defeats of Chartres/Blois. Chartres needed a more
dependable sovereign, and this sovereign needed a history. The great cloth relics of
Constantinople, to which the Chartrains' own relic was historically related, were
garments that protected, especially against fire and military attacks.[3] Rebuilding at a
time of devastation such as this called upon the genius of theologians, artists, archi-
tects, and liturgists to create an antidote for loss and to further define the meanings
of the Virgin's relic at Chartres.

The elevation of the feast of Mary's Nativity required a remaking of the past on
several fronts. If Mary was to have a birth, then she had to have parents and a set
of historical events to indicate the nature of her royal lineage. Mary's nativity is
not described in the Bible, but it required scriptural texts for its foundation, texts
to supplement those already in place as part of the feast's regular celebration. For
this work liturgists turned to Advent and Christmas materials already established in
the Chartrain liturgy by the early eleventh century. Christian communities through-
out eleventh-century Europe were industriously shaping their histories through new
hagiographical ventures, but always, as at Chartres, these were rooted in the chant
and liturgy of the Carolingian past. To these were added new tropes and sequences
related to local legends and contemporary political situations as well as new Offices
for rediscovered or refurbished saints. In the case of Chartres, the Mary of Advent and
Christmas was drawn out of winter and into the fall of the year, the full bloom of the
sanctoral season. The character of her Nativity feast emphasized her flesh, flesh that
was symbolized by the relic of her gown, the touchstone of divinity and humanity.
The materiality of relics was defined by particular liturgical texts and chants assigned
to feasts of the appropriate saints. In turn, the material understanding of the relics in
liturgical context inspired artists, some of whom, like Helgaud of Fleury and Odoran-
nus of Sens were cantors in charge of artistic programs and the design of reliquaries.

In the eleventh century Mary of Chartres acquired a magnificent shrine for her
relic, a transformed narrative for her life story, and a set of sermons and songs, some
of which would become known all over Europe. The creation and establishment of
these basic materials of the cult took place over three generations, beginning within
the lifetime of Fulbert himself and continuing through the creation of the Book
of the Cult, Chartres, BM 162; this further established Fulbert's character as litur-
gist (see chapter 5). Fulbert's time, which witnessed the magnification of Mary's
Nativity and doubtless encouraged the coming of festive tropes, was also the period
in which the feast of the Dedication of the church may have been moved from May
to October, placing it in close proximity to what was becoming a powerful patronal

feast.[4] Fulbert had lost everything, but when the smoke cleared he must have seen a new opportunity in the ruins of his church.

## A NEW LIFE FOR THE VIRGIN AND FULBERT'S SERMON *APPROBATE CONSUETUDINIS*

From what documents reveal of his considerable influence, Bishop Fulbert became known throughout his region for more than his letters and the architectural innovations of the new cathedral he must have had a hand in designing. Just as important, he was celebrated for the liturgical sermons in well-crafted prose and the chants of exquisite beauty for the feast of Mary's Nativity that are attributed to him.[5] His work on the feast solidified its role at Chartres at a time when the Assumption was the dominant Marian feast in most churches, including many in the diocese of Chartres.[6] His contributions sprang from his knowledge of Advent and transferred established ideas found there to the feast of Mary's Nativity. This created a powerful new liturgical framework of understanding, one directly related to the relic of the cloth that represented the flesh of the Virgin and the procreative act itself.

Fulbert's Advent sermons added deeper understanding of Mary's lineage. In these works Fulbert initiated the idea of three generative lines—of prophecy, of priesthood, and of kingship—all three of which were to be broken off during the great watershed of time heralded by the Incarnation. The ideas Fulbert selected for his discussion of kingship in the Advent sermons are found as well in his writings on Mary's Nativity.[7] He sought ways of expanding the sliver of time in which she lived, so that what was known of her would prepare his listeners for deeper understanding of the nature and appearance of the Messiah. Fulbert composed at least two sermons for the feast of Mary's Nativity, one of which, *Approbate consuetudinis*, became the standard reading for matins of the feast throughout much of Europe.[8] In this sermon, Fulbert made Mary's flesh the nexus for both the kingly and the priestly strains of the Messiah's lineage and observed the prophetic acts of those who predicted them and recognized them. This work was the very fountainhead of the cult of the Virgin of Chartres and its eventual manifestation in the visual arts.

Before composing *Approbate consuetudinis* Fulbert consulted the so-called *Libellus de Nativitate Sanctae Mariae*, once thought to have been composed in the mid-ninth century but now dated to around the year 1000.[9] This treatise comes several centuries after its source, *Pseudo-Matthew*, which its editor dates to the eighth century. Fulbert is the first figure known to have referred to this important retelling of the apocryphal *Protevangelium of James*.[10] In fact, that he or someone close to him wrote the *Libellus*, as study of the earliest manuscript tradition suggests, is not unlikely; it is clear from what Fulbert says in his sermon about apocryphal texts and his dependence upon them that the work was highly revered and first used as a source at Chartres Cathedral in his lifetime. A new prologue and a letter attributed

to Saint Jerome circulated with the *Libellus*; this letter was written as if in response
to one from the bishops of Aquileia. Pseudo-Jerome claims that the *Protevangelium*
is filled with falsehoods and that it was written by the heretic Seleucus, who also
wrote apocryphal passions of the apostles. Yet this Jerome of about 1000 CE was
willing to translate the life of Mary from the Hebrew, knowing that some of it was
false and that it appeared to incorporate work by the evangelist Matthew. He com-
ments that although many events reported in the work are doubtful, they cannot be
rejected completely: for people to think that God can bring forth miracles of the
sort described in the treatise does no harm.[11] Long-standing legends in keeping with
orthodox theology and historical understanding of God's actions can be accepted
in liturgical texts. This liberal attitude toward apocryphal texts was practical for a
period of intense cultic activity. Fulbert's era was not a time for a narrow reading, al-
though in the case of the life of the Virgin it was a time for pruning the earlier text.

The *Libellus*'s modern editor, Rita Beyers, describes the ways in which it is to be
distinguished from its source, *Pseudo-Matthew*: the editor was bold and took great
liberties with the tradition of *Pseudo-Matthew*; he excised material concerning the
infancy of Christ and concentrated on the birth and early life of the Virgin; he chose
episodes carefully, leaving out the most controversial and anecdotal; he reinforced
the scriptural roots of the work whenever possible and used language to strengthen
the biblical character of the contents; last, he wrote in a more learned style than the
author of *Pseudo-Matthew*. Bishop Fulbert's liturgical ideals are closely related to
the synopsis Beyer presents of the *Libellus*. Fulbert was a contemporary of the per-
son who wrote this new life of the Virgin and came from the same region; indeed
he may have written it himself; one of the capable students from his school, Bernard
of Angers or the cantor Sigo, are other possible authors. The interplay among the
treatise, the letter by Pseudo-Jerome that forms its preface, and the sermons attrib-
uted to Fulbert suggests powerful affinities. The treatise and Fulbert's sermons are
representative not only of shifting liturgical tastes but also of a Mariological dimen-
sion of the peace movement then current in Chartres (see *Libellus*, 20–21). Beyers's
list of around 140 manuscripts demonstrates that the work was popular throughout
Europe for centuries, particularly in northern France (see *Libellus*, 346–57).

*Approbate consuetudinis*, a work consistently attributed to Fulbert by his con-
temporaries, and by historians of the Middle Ages as well, contains nothing in its
earliest textual sources to challenge Fulbert's authorship. A close reading demon-
strates that Fulbert's goals in creating it were, indeed, very near to those of the com-
piler of the *Libellus*, and the sermon actually provides a defense of the *Libellus* and
its contents. Fulbert sought to dispel early problems over the legends in the Mary
stories for the purpose of making them part of the liturgy of her Nativity, the feast
he worked to magnify. Taken together—and they did commonly circulate together
in the eleventh century—the *Libellus* and Fulbert's sermon worked to transform

the Virgin's life story as related in *Pseudo-Matthew* into the understanding of her history and the cult of her nativity as celebrated at Chartres. Fulbert was certainly no stranger to the idea that apocryphal legends concerning Mary deserved a place on the feast of her Nativity. The table of contents of a now-lost homiliary from St. Peter's of Chartres, prepared in the late tenth century, reveals that the sermon *Inquirendum est, fratres karissimi, et explanandum*, a work containing excerpts from the *Protevangelium of James*, was read on this date.[12] Fulbert's job was to replace this older set of readings with a new text for the patronal feast, and the sermon became his liturgical calling card from England to eastern Europe in the decades after his death.[13]

Fulbert's sermons for Mary's Nativity recast Mary's life to be in harmony with the thousands of other saints' lives being written at the time. Through hagiographical writings of this type the Mother of God became a medieval saint, replete with her own set of miracles that would expand in number dramatically in the late eleventh and twelfth centuries. The converging facets of her character, both as Theotokos and as a local cultic figure with an apocryphal life and numerous miracles, explain the unique power she exerted in the central Middle Ages. The expansive treatment of the Virgin and of other figures of the first century of the Christian era affected the way in which the Bible was known and understood and offered a rich, imaginative gloss upon its characters, making the moment of Incarnation and Nativity as layered with meanings as the many narratives associated with the Passion. The characterizations were often, as was true of the Virgin, at the expense of their earlier Jewish counterparts yet kept figures from the Hebrew Bible, albeit in newly woven garments, central to medieval Christian interpretations.

*Approbate consuetudinis* is a carefully constructed work, falling into clearly demarcated sections (see appendix E). The sermon not only offers a history of the Virgin, but also explains to the reader how to make history through the adaptation of preexisting liturgical materials that offer validation when the incidents described are not treated in the canonical scriptures.

The opening section of the sermon was widely adapted for liturgical use in the Middle Ages; the section is crucial to the development of the *styrps Jesse* motive made prominent in a Chartrain chant by that name (see chapter 5). The sermon's introduction, which has been much cited in the scholarly literature, has two goals: to herald the importance of the feast of Mary's Nativity and to justify the use within the liturgy of apocryphal Marian infancy legends, particularly of the *Libellus* itself. Fulbert claims that celebrating the feast with a solemnity matching that of older Marian celebrations is appropriate because she is the greatest of the saints and also because *devotio fidelium*, popular piety, demands that the feast have priority. A famous likeness found in the manuscript Chartres, BM N4 shows Fulbert greeting the people of Chartres.[14] In the sermon he claims to listen to them as well,

and he advances the piety of the folk as a proper consideration in the designing of liturgies:

> The approved custom among Christians is to observe the birthdays of our forebears with careful attention, and especially to read aloud in church their virtues, ascribed to them in books, for the praise of God, by whose gift they exist, and for the good of lesser folk. Among all the saints, the memory of the most blessed Virgin is more often and more joyously celebrated, since she is believed to have found more favor with God. Hence the devotion of the faithful, not being content with her other, older feasts, added this day's solemn feast of her nativity. And so it seems that on this day in particular the book that has been found concerning her birth and life ought to be read in church, even though the Fathers decided that it should not be counted among the apocrypha. But since it seemed appropriate to great and wise men, let us—since we read certain other apocryphal texts that are not hostile to the faith— respectfully follow ecclesiastical usage.[15]

Thus the opening of the sermon introduces the legends of Mary's nativity and with an immediate and unapologetic stroke legitimizes their use as Office readings. Fulbert does not, as his Carolingian counterparts did, pretend to be Jerome, like the author of the letter accompanying the *Libellus*; he does not express serious doubts or caustic criticisms of the legends. The stories of Mary's birth are appropriate to her feast, and there is precedent for their liturgical use; the feast must be celebrated with appropriate attention rendered. For those liturgists who wished to associate the legends and the feast, this sermon from a well-known and much-respected church- man would have been most welcome; the additions of miracles would have offered justification for the use of such exempla in sermons. The sermon began to circulate in the eleventh century while early manuscripts of the *Libellus* were finding their ways into various centers; the two efforts were coordinated, as was the case in the Chartrain liturgy that developed in the second half of the eleventh century.

The next section of the sermon fuses three important themes. Signs and prophe- cies in scripture (canonical and apocryphal) foretold Mary's role in the history of salvation, and her birth and its circumstances had to fulfill them. "The lineage of the human race"[16] had a particular cast of sin, the lust of the Fall, which blocked the coming of salvation; this sinful progression of events could be contravened only by a certain type of human being, one who was humble in mind and unmarked by the sin of concupiscence: Mary, "a child prophetically ordained by her lineage, shone forth, marked by the privilege of her virtues." It is Mary's chastity and utter goodness that block the stream of the human heritage and staunch the wound of sin; called in the fullness of time to become the throne of Wisdom and to consum- mate David's lineage, she provides "most pure flesh" for the Messiah. Mary's flesh is suitable for three reasons: it is pure; its coming as the throne of the Messiah is foreknown by the prophets; and its lineage is appropriate to fulfill their predictions.

Her position in the history of humankind explains the favor she won in the central and later Middle Ages, from the learned as well as unlettered. The Virgin of Fulbert's *Approbate consuetudinis* is the Virgin of the Advent season, transposed to the time of her own *adventus* and birth. The liturgical symbolism used here relates the history and myths surrounding the Virgin's flesh to those of Christ, thus promoting her body's importance and complementing the chemise. To associate the cult with incarnation and birth linked the cloth to those events. Her flesh must establish the lineage appropriate to Christ, and the cloth of her gown is woven as a reminder of this prophetic past. The sermon helps explain both Mary and the relic of Chartres, binding her nature to the cloth itself; the *Libellus* provides a historical context for both sermon and relic.

In the next section of the sermon Fulbert continues to expand upon the theme of lineage. The compiler of the *Libellus de Nativitate Sanctae Mariae* turned miracles into scripture; in *Approbate* Fulbert works in a different way. He begins with events found in the Bible and recasts them, emphasizing their miraculous aspects to build up the themes found in events of Mary's life. The two biblical scenes he chooses are the flowering rod of Aaron and the messianic prophecies of Isaiah. A comparison of the three modes of treatment found in *Pseudo-Matthew, Libellus,* and *Approbate* distinguishes Fulbert's exegesis from its earlier models.[17]

In *Approbate* the story of Aaron's rod appears as the miracle of Joseph's rod; in the Carolingian *Pseudo-Matthew* it appears as a version of the tale from the *Protevangelium of James.* Mary, who has lived in the Temple since her infancy, must leave with the onset of puberty and the impurity caused by her menstrual cycle. The priest Abiathar announces that a husband is required for Mary, a man who will respect her vows of virginity.[18] Lots are cast to determine from which tribe of Israel the man will come, and the cut falls to the tribe of Juda. A rod is collected from each man who is as yet unmarried, including an old man, Joseph, and God commands that these be placed in the Holy of Holies. He promises that the following morning a dove will fly from the rod of that man who is to marry the Virgin, but the next morning, after each man has taken up his rod, nothing happens. The high priest enters into prayer, and an angel relates that the very smallest and most miserable of rods, that of Joseph, has been forgotten; it must be put with the others. And that is done. When Joseph collects his rod, a dove, shining and beautiful, flies from it straight through the Temple and then heavenward.[19]

In the story of Aaron's rod, related in Numbers 17, Moses is commanded by an angry God to take twelve staffs, one from each chief of an ancestral house, including Aaron, who will represent Levi. In the Bible each rod is inscribed with the name of the leader. The rods are to be placed in the tent of the covenant, and the rod that blossoms will be the rod of the person who is to make expiation. The next day Moses enters the tent of the covenant, and the rod of Aaron has sprouted, blossomed, and brought forth almonds. The Lord told Moses, "Carry back the rod of Aaron into the

tabernacle of the testimony, that it may be kept there as a token of the rebellious children of Israel." And the Lord told Aaron (Numbers 18:1) that any guilt connected with the sanctuary of the Lord would be borne by him and his tribe.

Although the story as told in the early eleventh-century *Libellus* parallels closely that of *Pseudo-Matthew* from centuries earlier, God's words to the high priest in the later work are expressed in radically different language and introduce other themes. The *Libellus* refers to Isaiah 7 and 11—to the virgin who will give birth and to the flowering rod that will rise from the root of Jesse, with the spirit resting upon him, a spirit described in terms of its attributes, as in Isaiah. Whereas in *Pseudo-Matthew* the dove alone is the symbol of the blessed rod, in the *Libellus* the rod sprouts flowers as well as emitting the dove, thus making the parallel with Numbers 17 more powerful.

In his sermon *Approbate* Fulbert takes up the blending of Numbers 17 and Isaiah 7 and 11 found in the *Libellus* in a way that will prove important in subsequent developments in art and dramatic literature. Fulbert states that the story in Numbers 17 must await its explanation in the prophecies of Isaiah, and he addresses Isaiah as found in the famous sermon for Advent/Christmas by a fifth-century Carthaginian preacher and contemporary of Augustine, Quodvultdeus, who, in a sermon that is the textual basis for the prophets' plays of the Middle Ages, charged each of the prophets to speak.[20] Quodvultdeus emphasizes the idea of line and lineage, creating a domino game of events in time: one tile falls, then the next, until the last leans upon the Virgin's foreordained and miraculous flesh, the coming of which has long been prophesied. In Fulbert's sermon the coming of the Messiah is linked with the coming of the human throne that will bear the Wisdom of God. Mary is the rod, Christ the flower and the fruit. She, "the rod without a root, without support of nature or artifice," was able to bear fruit and flower; her son was represented by "a flower by reason of its beauty, fruit by reason of its usefulness." He is "beautiful above the sons of men" (Psalm 44:3/45:2) and "the life-sustaining food not only of humans but even of angels."

The author of the *Libellus* and Bishop Fulbert were not the first to fuse the imagery of the root of Jesse and the rod of Aaron, making the Virgin Mary central to the fusion in the process: this had happened in occasional exegetical works predating them. Jerome in his commentary on Isaiah stated that the rod of Aaron prefigured Mary and the flower, Christ (see *Commentariorum*, 147–49). An example dating from the early fifth century occurs in the commentary on the Song of Songs by Apponius, a Syrian who wrote in Rome;[21] another fifth-century exegete to make the connection was Quodvultdeus, who wrote his *Liber promissorum* when exiled in Naples.[22] A sermon attributed to Caesarius of Arles, based on a section of Origen's commentary on Numbers, links the root of Jesse to the rod of Aaron but does not mention the Virgin Mary.[23] A sermon which Fulbert may have known, *Legimus sanctum Moysen*, circulated widely in early homiliaries. It is rich in the exegeti-

cal themes he prized and was actually compiled from fifth-century North African sources for the Roman liturgy of Advent.[24]

Immediately after this section recalling miracles in the Bible, Fulbert begins in quiet tones to describe the early life of the Virgin Mary as found in the *Libellus*; with the words "just as we read" he acknowledges that he quotes from the apocryphal tradition he defended earlier. He relates Mary's lineage to scripture, for Mary was born of a mother from Bethlehem and a father from Nazareth, the towns designated by the prophets as those where the Messiah would be born and would live.[25] He also mentions both Abraham and David, thus making reference to Matthew 1:1, which opens as the "book of the generation of Jesus Christ, the son of David, the son of Abraham."[26] It was stated in the *Libellus* that Mary was of the house of David, but nowhere is there reference to Aaron and the Levites. In *Pseudo-Matthew* Mary's maternal grandfather is a high priest and so a Levite, but the *Libellus* does not mention this. Mary is raised in the Temple and is consecrated to God. Fulbert emphasizes the priestly strain found in the earlier tradition.[27]

According to Fulbert, Mary knots two strands of lineage: she "drew out her origin" from the root of David and the rod of Aaron, from the royal stock of David and the priestly lineage of the house of Levi, "at the same time," for she was "about to bear the highest King and the highest Priest." Fulbert calls Mary *paritura* (about to bear), and this word, which also appears in the sequence "Alle celeste necnon" (see chapter 1), has a long history in the celebration of Mary's Nativity. Fulbert's sermon unites her flesh and the action of impending birth, and this emphasis on the act of birthing alludes indirectly too to the relic of her chemise, an undergarment that was being further defined through liturgical associations and themes. Fulbert's cultic history embodies a particular Mary, the Mary of incarnation, pregnancy, and birth. This is the figure who becomes the Virgin of Chartres in the generations immediately after Fulbert, and whose relic, first explained through liturgical association, would then be recontextualized in exegesis and the arts.

This theme is further established in the final section of the sermon, a commentary upon the Carolingian hymn "Ave maris stella," which was sung throughout the day at Chartres on the feast of Mary's Nativity, followed by brief synopses from the miracle literature.[28] Mary is born, a lily among thorns, a spotless virgin with sinful brethren, images suggested by the Song of Songs.[29] The rhetorical figure of her name (connecting *Maria* with *mare*) proclaims her great stature and offers a sign of her guiding powers, as in the hymn.[30] Mary, although of human lineage, shone outwardly with virtue, and this makes her an example for humans and worthy of great honor. In the hymn Gabriel acknowledged her difference, she who was human and yet pure, when he gave her his greeting. He had known long before that she was to come: "eam antequam Dei mater fieret, quia futuram noverat, tanta veneratione salutando praevenit" (because he knew what she would be, before she became God's mother he anticipated this by greeting her with such great respect).

In Fulbert's interpretation of these standing liturgical materials, Mary's coming as a star and a great light was foreknown and predicted, and the feast of her Nativity acquires a messianic sense, paralleling that of Advent and Christmas.

Fulbert's discussion of miracles, based on the biblical stories and on a famous liturgical text, hails the lineage of the Virgin. His particular concentration upon ideas of birth, and the transformation of time through her birth, adds further emphasis not only to the feast of Mary's Nativity and the importance of her flesh, but also, by implication, to the cult of the robe she wore while giving birth, and—as the cult developed—at the time of the Annunciation as well. Biblical and liturgical meanings are directly stated; cultic meanings are implicit in his work. Fulbert's Mary has acquired a lineage that is well defined and explained in terms of a prophetic heritage, making her a proper queen for a new line of rulers. She succeeds where Berta of Chartres/Blois had failed (see chapter 2), and where her husband, Odo I, and her son, Odo II, both of whom tried to be kings or dukes, had lost out as well. Saints and their cults supplied political power, and from the cult's very beginning the Virgin of Chartres excelled on the battlefield. Fulbert was a contemporary of Countess Bertha and Odo II and did his work of cult building against the backdrop of Thibaudian triumphs and losses (see chapter 3).

Fulbert ends the sermon with miracles that take place in a church building. He begins with a brief reference to Basil of Caesarea, in a legend found in the manuscript Chartres, BM 27 from the eleventh century, now destroyed. But his major emphasis is upon Theophilus;[31] he tells the story of a congregation and a people in need of Mary's help in a way that calls to mind his own troubles and losses as bishop of Chartres. Through this sermon Fulbert entered the history of his own cathedral in the liturgy of its patron saint. Fulbert's Mary is a queen whose lineage is clear, a queen who, unlike Berta, will not be denied the throne for reasons of consanguinity and who will provide protection when secular powers fail. Mary was Joseph's cousin, but then her husband was not the parent of her child. Proper lineage, as manifested in the Virgin as Fulbert conceives of her, makes her invulnerable, possessing royal power that cannot be challenged by her foes. The reference joins the sermon to a prayer of his as well, making a devotional web of meaning reflective of the bishop's character and the history of his dramatic life.

This long prayer attributed to Bishop Fulbert, in circulation in the twelfth century, shows him as a servant of the cult of the Virgin Mary, drawing on earlier legends as well as on the character met both in his letters and in his sermons for the Virgin Mary.[32] In the prayer, edited in facsimile with notes by Delaporte (*Une prière*), Fulbert emerges as a figure who alludes to fire and finds the Virgin seated on the throne in its midst offering protection.[33] He refers to the legends of Theophilus and Basil of Caesarea and also to Gregory of Tours, whose tale of the miraculous intervention of the Virgin to protect a Jewish child whose father, most ironically in this Christian legend, has thrown him into fire because of his desire to go to church.[34] Fulbert says

in his prayer, "May you be gentle and merciful, as you were to the little Jewish boy, so that just as you freed him from the furnace of glowing fire, so may you free me from the seasurge of carnal desires with your intercessions and holy prayers."

Gregory of Tours's description of the miracle of the boy to which Fulbert refers was one of the best known medieval Marian legends. The following excerpt from the end of the story demonstrates the protective power of Mary's clothing and trades upon the stereotypes of Rachel lamenting for her children, of the three boys in the fiery furnace from the book of Daniel, and of Mary, the mother who, seated on her throne with a child in her lap, has a special power to protect. It is this visual understanding of the Virgin that would be featured at Chartres in the twelfth century, and this passage connects it directly to Fulbert and to the main altar of the cathedral:

> When his mother heard that the father had evidently decided to incinerate their son, she hurried to save him. But when she saw the fire leaping from the open mouth of the furnace and flames raging here and there, she threw her barrette to the ground. Her hair was disheveled; she wailed that she was in misery and filled the city with her cries. When the Christians learned what had been done, they all rushed to such an evil sight; after the flames had been beaten back from the mouth of the furnace, they found the boy reclining as if on very soft feathers. When they pulled him out, they were all astonished that he was unhurt. The place was filled with shouts, and so everyone blessed God. Then they shouted that they should throw the instigator of this crime into these flames. Once he was thrown in, the fire burned him so completely that somehow scarcely a tiny piece of his bones was left. When the Christians asked the young boy what sort of shield he had had in the flames, he said: "The woman who was sitting on the throne in that church where I received the bread from the table and who was cradling a young boy in her lap covered me with her cloak, so that the fire did not devour me."[35]

## PROPHECY AND POLEMIC AT CHARTRES: FULBERT'S SERMONS *AGAINST THE JEWS*

The long Advent procession that unfolded in the four weeks before Christmas offers the fundamental context for medieval Christian arguments concerning the messianic coming, the Incarnation, and the Nativity of Jesus Christ. Here scriptural texts were arranged and commented upon so that the new king entered the world of transformed time through a well-marked virginal gateway. At the close of the season, the arrangement of texts appears to reject sharply those who will not accept the Christian Messiah, and so, in what has always been understandably difficult for Jewish exegetes, scripture is turned against the people who created it. The beauties and complexities of Christian liturgical exegesis and the visual arts were often dependent upon denial of the parent faith tradition.

The opening readings for matins of the fourth Sunday of Advent are from Isaiah 13. In the third of these the prophet predicts doom, wailing, and destruction through the Lord's wrath. This reading is then followed by a responsory chosen from Jacob's prophecy to his sons in Genesis 49, singling out two of the verses spoken to Juda, progenitor of the line of David, the house from which the Virgin was believed to have come. As translated in the Vulgate, the text says that the scepter of the king will not be taken from Juda until the Messiah comes. In the verse the Messiah is bridegroom-like — the text is also from Isaiah 13 — resonating with the lover of the Song of Songs. The implicit message here is that the appearance of the Messiah will coincide with the destruction of Jewish kingship, and that God will seek a new beloved.

The procession of events involves two primary groups, those of the house of Juda who will become Christians and those who will not; the ideas regarding their respective acceptance and nonacceptance of the Messiah are refined as the season unfolds. On this fourth and last Sunday of Advent, some are left on the doorstep of the fullness of time, cherished as the true and glorious ancestors of the kingdom, and yet abandoned and chastised for unbelief; others, past and present, are members of the kingdom, taken heavenward by the Messiah at the Harrowing of Hell. The responsory was widespread and well established in the liturgy of the last Sunday in Advent throughout northern Europe; its position near the end of the period of waiting points to the transformation of time and the breaking of tradition about to be represented by the feast of Christmas.[36] It is in the context of these chants that the heavily symbolic meaning of the scepter was created for medieval Christians, transcending the Jewish-Christian polemic and turning the exegesis to any ruler whose actions were out of tune with Church doctrine.

In the early Christian period and throughout the Middle Ages, Genesis 49:10 was interpreted as a proof text for the identity of the Christian Messiah. It was frequently highlighted in polemical treatises and debates pitting Jewish and Christian exegetes against each other. The destruction of the line of Jewish kings at the time of Christ was believed to demonstrate that the one "that is to be sent" is indeed the Messiah. This, in conjunction with the absence of new Jewish leadership after the time of Christ, was believed to proclaim his identity, Herod being seen as the last king; the destruction of the Temple bore witness that the Jewish priesthood too had come to an end.[37]

The position of Genesis 49:10 in the Chartrain liturgy is especially telling, for it was sung just before the reading of passages from a treatiselike sermon by Quodvultdeus, *Contra Judeaos, Paganos, et Arianos.* The sermon is a fifth-century tract that used quotations from Old Testament prophets to refute Jewish positions denying the messiahship of Christ.[38] The readings from this work that followed the responsorial setting of Genesis 49:10 are well known and have been much studied, although infrequently with the responsories that punctuated them.[39]

This text, read in the context of Genesis 49:10, which is sung just before it, and of responsories that refer to John the Baptist that draw together the ideas of priestly and kingly succession, displays a centuries-old polemic between Jewish and Christian exegetes in Carthage at the close of the Advent season. In addition, the reading from Quodvultdeus's sermon began at section 11, following a long passage concerning King Herod—this was the case in all regions where it was used as a reading.[40] Although most polemical attacks were not made through actual confrontation, but through closely developed theological arguments within homiletic and other exegetical traditions, occasionally the debate arose in the context of actual experience.[41] Research on such core subjects as the Trinity and the Incarnation reveals that in general both sides knew the other's positions, however imperfectly, and that religious training for the learned on either side included practicing strategies of refutation, including the study of key passages from scripture and exegesis upon them. Thus the debates, although surely varying over the centuries, revisit a static group of proof texts and of attitudes toward their significance regarding Christian messianism.[42] The particular rhetorical stance and organizing strategies of Fulbert of Chartres in regard to these texts are thus vital to a local, Chartrain understanding of them and their liturgical context; furthermore, they point to a whole other range of ideas of exclusion and rejection deemed appropriate to the season of Advent and the coming of Christ, ideas that grow out of the very nature of the ancient *adventus* ceremony itself.

Evidence of the polemic unfortunately survives too often from the Christian side alone; for the first several centuries of the tradition, Jewish arguments circulated primarily in an oral tradition, at least as far as can be told from the sources. Quodvultdeus's Carthage was important in the establishment of the tradition, for it had been home to the so-called Father of Latin theology, the famed rhetorician Tertullian, whose treatises may have been based upon actual exchanges with Carthaginian Jews.[43] The background for Quodvultdeus's treatment of Jews is thus well established in North Africa, home to a range of writers from Tertullian to his contemporary Augustine, who knew eastern writers as well, especially the influential John Chrysostom.[44]

Although its ideas are derivative, Quodvultdeus's sermon shows the lively character and dramatic rhetoric for which North African homilies are known. It presents a mock interview in which the first-person speaker encourages apostles to affirm and heretics, Jews, and pagans to speak openly about the Christian Messiah. Quodvultdeus then turns the tables on nonbelievers, using texts from their own traditions to refute their positions. The sermon is arranged so that the denying Jews, cited in the opening of section 11, are convened as a group and then rebuked through the speeches of their own prophets, only two of whom, Isaiah and Jeremiah, happen to be cited in this Chartrain version of the reading. The master of debate in the texts

found in the thirteenth-century Chartrain liturgy is John the Baptist, whose words and ideas serve to reinforce the statements of Isaiah and Jeremiah. Thus a Christian polemic against the Jews, here in a fifth-century North African formulation, was intoned and performed at the end of each Advent season in Chartres and many other centers in northern Europe, the actual day being a matter of local decision. Quodvultdeus's text made the line of the prophets and kings a procession that testified to the lineage of the Christian Messiah. Liturgical texts, ceremonial action, and messianic proof texts were joined together, offering pronouncements that interpreted key passages of scripture and selected figures from both testaments as witnesses.

The point of view is well summarized in Augustine's *City of God*, 18.45–46, which incorporates Genesis 49:10, the verse of scripture upon which Fulbert's sermons *Contra Judaeos* are based, and a text that would have been known to Fulbert:

> By that time Rome had already subjugated Africa and Greece and was mistress also of a widespread dominion in other parts of the world; and yet it seemed as if she had not the strength to bear her own weight, and she had, as it were, broken herself by her own size. In fact she reached the point of serious domestic broils, and had proceeded to wars with her allies, and soon afterwards to wars between citizens, and had so diminished her strength and worn herself out that a constitutional change to a monarchy was necessary and imminent. This was the situation when Pompey, a leader of the Roman people of the highest renown, entered Judaea with an army and took the city. He opened the doors of the Temple, not with the devotion of a suppliant but by the right of a conqueror, and made his way into the Holy of Holies which only the high priest was allowed to enter; and Pompey's entrance was not in the spirit of reverence but of profanation. After confirming Hyrcanus in the high priesthood, and imposing Antipater on the subjugated nation as protector, the name then given to procurators, he carried off Aristobulus as a prisoner. Henceforward the Jews also were tributaries of the Romans. At a later date Cassius even plundered the Temple. Then after a few years they met with their deserts in receiving a foreigner, Herod, for their king; and it was in his reign that Christ was born. For now had come the fullness of time signified by the prophetic spirit through the mouth of the patriarch Jacob, when he said, "There shall not fail to be a prince out of Judah, nor a leader from his loins, until he comes for whom it is reserved; and he will be the expectation of the Gentiles." (Genesis 49:10) Thus in fact there did not fail to be a prince of the Jews up to the time of this Herod, whom they received as their first king of foreign birth. This therefore was now the time when he should come for whom was reserved that which was promised under the new covenant, so that he should be the expectation of the Gentiles. . . . When Herod was on the throne of Judaea, and when Caesar Augustus was emperor, after a change in the Roman constitution, and when the emperor's rule had established a world-wide peace, Christ was born, in accordance with a prophecy of earlier times, in Bethlehem of Judah.[45]

Fulbert's three sermons *Contra Judaeos* are all based on Genesis 49:10 and, taken together, constitute the longest explication of this text found in Christian exegesis from the Latin West.[46] The sermons are found in the earliest collections of his writings and have always been taken as authentic; this is apparently borne out by the fact that in the course of the writings he mentions himself by name as the author. The three works, published in the *Patrologia Latina* as a single treatise, have received little attention from scholars. An essay by Gilbert Dahan, which serves as a preface to the sermons, has appeared in the French translation of Fulbert's works published by the Société Archéologique d'Eure-et-Loir in 2006, "Les Traités Contre les Juifs de Fulbert." Bernard Blumenkranz (1952, 1977) tried to associate the works with events in Fulbert's lifetime, dating them to the time when Count Ragenfredus styled himself king of the Jews in Sens. In spite of the dislike many felt for this notorious figure, who at one time in his life was harbored by Count Odo of Chartres, the treatises do not make sense merely as a polemic against him. Whatever Fulbert's motivation for writing the works might have been, they are primarily a group of sermons directly inspired by the Advent liturgy. They may have been written at the time Fulbert learned more about Jewish exegesis, when Troyes and its large and learned community of Jews were acquired by the Thibaudians around 1020; if Fulbert was trained by Gerbert in the cathedral school at Reims, converted Jews were among his fellow students.[47] He surely knew of the community in Troyes, for it produced the famous scholar Rashi in the generation after Fulbert and had the energy and wherewithal to send him to the Rhineland for his schooling and subsequently to welcome him back to teach in Troyes once he had completed his studies.[48] Fulbert apparently possessed a rudimentary understanding of Jewish exegetical arguments, enough to feel directly challenged by them. Several of the arguments Fulbert makes are addressed in Rashi's commentary on Genesis, which suggests that the Jewish–Christian polemic may have shaped exegetical ideas in Fulbert's era. Direct connection between their schools cannot be assumed, but the parallels demonstrate that these ideas were of concern to both Jewish and Christian exegetes in the lands of the Thibaudians in the eleventh century. Fulbert's sermons show the importance of understanding scriptural exegesis in the context of the liturgy and also point to exegetical and liturgical concepts as fundamental to contemporary views of inheritance and lineage.

Fulbert's explication of the Advent chant text Genesis 49:10 extends the Augustinian understanding of the coming of the Messiah as a turning point in time and history, one that required Juda to fail on three accounts: kingship, priesthood, and prophecy. The failure of the Judaeans to produce valid successors in any of these three realms is cited as a powerful demonstration to non-Christians that Jesus is indeed the Messiah, one who was to come precisely at that point in history when Jewish royal lineage had transferred to a foreigner, Herod. In his works, Fulbert adopts

the commonplace tactic among Christian polemicists of using the Old Testament as a weapon against Jewish ideas about the Christian Messiah. Of course, as Jewish scholars knew full well, Christian polemicists usually worked from Jerome's Christianized translations of the Septuagint and thus used texts deliberately shaped to undergird their reasoning. The polemic between Jews and Christians in the Middle Ages shows little common ground concerning translations of the texts, each group making its arguments in words whose authenticity was denied by the other side.[49] Until the time of the First Crusade, both sides were able to celebrate their own polemics without turning them into cudgels. The sermons reveal a great deal about what Fulbert took to be major arguments by Jewish exegetes against the Christian Messiah and demonstrate his understanding of early Christian history through an imagination shaped by the Advent liturgy. The basic intent of his works is much the same as that of Quodvultdeus, whose works he knew from the Advent liturgy, and in direct connection with the chant text upon which the sermons are based. Fulbert's explanation is much more concentrated, however, and at least pretends to have contemporary scholastic sophistication underlying its mode of argument.[50] The ideas themselves are not difficult to follow: a fundamentally common argument is advanced in each, although differing biblical texts are used in each case to explicate the basic proof text.

Genesis 49:10, in a translation from the Vulgate, reads, "The Sceptre shall not be taken away from Juda, nor a ruler from his thigh, till he come that is to be sent, and he shall be the expectation of nations."[51] Fulbert emphasizes that this prophecy, spoken by Jacob as he foretells the future of each of his twelve sons, refers to a single scepter, making the rulership one, not something that could belong to many at the same time. Power had to be transferred directly down a particular line of kings: the king must be of the tribe of Juda, he must rule a group of people in Jerusalem, the "land of Juda," and he must be anointed by priests, who are "the effective cause" of the kings. When the people lost their priests, along with their place for sacrificing, they lost their kings: "When there is no effective cause, the effect that comes of it can in no way exist."

Fulbert also knows the Jewish polemics on this text: that the scepter of Juda was lost in the Babylonian captivity and subsequently regained did not mean that Judaean kingship had failed forever or that the Messiah had come. Instead it suggested that the Judaeans might regain the scepter at some future time.[52] Fulbert counters that the scepter did not actually depart during the deportation to Babylon, but that leaders of the people of their own stock existed during that time, filled with God and "more excellent than the kings themselves," and he includes in this group of rulers the prophets Jeremiah and Daniel. After the return from Babylon, the Jews were led by "the well-disciplined rule of priests." The true breaker of the tradition, both of kings and of priests, was not the Babylonian captivity, but Herod. Herod

was a foreigner who was king of the Jews by decree, who "did not appoint priests by ancient right—that is through legitimate succession of the stock."[53]

The final week of Advent builds toward the fulfillment of Christmas, in which at Chartres the lineage of the new line of kings had a major role, one underscored by the singing of the "Laudes regiae" during Mass.[54] The matins service for Christmas day, long and ornate, lasted almost until dawn. Following it, a procession took place with the cross, the Gospel, thuribles, and candelabras. On the high pulpit—the structure which by the thirteenth century had evolved into the jubé separating the nave from the choir—the deacon proclaimed the text of Matthew 1:1–18. The proclamation of this text was the public declaration that Christmas had arrived, that the Messiah had appeared in human flesh, being descended from the house of David as a new royal line. This dramatic intonation took place just before the Office of Lauds, while dawn was breaking through the windows of the cathedral.

Matthew 1:1–18 was a text of extraordinary liturgical significance in medieval Chartres. Its importance extended beyond the transition from Advent to Christmas, straight to the heart of the patronal feast, the feast of the Nativity of the Blessed Virgin. The Gospel text for Mary's Nativity had been changed by Carolingian reformers from Luke's description of the Visitation (of Mary to her cousin Elizabeth) to Matthew 1:1–18, and this change proclaimed with the voice of liturgical authority that the messianic flesh reviewed by Matthew belonged to the Virgin Mary as well.[55] It was also a text that was a sticking point in the Jewish–Christian polemic, especially when compared with the genealogy of Christ as found in Luke, which was also read in Chartres during the Christmas season. The *Nizzahon Vetus* discusses the discrepancies between these two texts in the exegesis of Genesis 49:10, a probable reflection of refracted knowledge of Christian liturgical practices, and coaching Jews how to respond:[56]

> If he will tell you that all of these verses refer to Jesus, who stemmed from the tribe of Judah and the house of David, ask him how he knows this genealogy. After all, in all the genealogies of Matthew and Luke one does not find that of Jesus and Mary, for it is written in the Gospel of Matthew, "So-and-so begat so-and-so, and so-and-so begat so-and-so" until "Jacob begat Joseph virum Mariae," i.e., the husband of Mary (Matt. 1:2–16). Now, if, as you say, Jesus was not Joseph's son, then he has no relationship to this genealogy. If, however, you trace his lineage through Joseph, then you must admit that he had a father. But unless you trace his lineage through Joseph, how can you prove that he stemmed from Judah and David?

Fulbert's three Advent sermons were part of a larger exegetical stance, one also shown in his sermons for the Virgin. His work was to defend Mary's lineage and to offer Christ the flesh of the kings of Judah, working through the liturgy. This became the central goal of the Virgin's cult at Chartres, as it grew from its Fulbertian

roots. The past recreated at Chartres was directly dependent upon the establishment of lineage and of characters based upon a particular heritage. The sermons by Fulbert ensured a localized interpretation of Advent in the cathedral town of Chartres, one related to the cult of the Virgin developing there in the same period and yet linked as well to views of kingship and authority also under revision. At the end of Advent, we find the lineage of Christ coming to him through his only human parent, Mary, and at Chartres, where she was the patron saint, the need was increasingly felt to know more about her, and to proclaim her identity. There is no evidence that the sermons were actually incorporated into readings for the liturgy at Chartres, but they were surely known and revered there, at least as readings, and the author intended that they be preached and may have written them as possible lessons for matins of Advent.

## FULBERT'S DISCIPLES AND THE FIRST MYTH OF CREATION

The complex manuscript Chartres, BM Na4 (see appendix B) was not lost in the fire of 1944 because it had been stolen centuries before. The manuscript was taken from Chartres in the late eighteenth century by a canon of Chartres, Antoine Courbon du Terney, and sold when his books were dispersed. It ended up eventually in the municipal library of St. Étienne (Loire), Courbon du Terney's hometown (see MSC iv–vi). The manuscript was edited and published in 1893 by René Merlet and Alexandre Clerval, who used various typefaces to indicate the layers of additions to the original necrology.[57] After the fire of 1944 the manuscript was returned to the municipal library in Chartres, where it is now listed as Nouvelle acquisition 4 (Na4). The necrology is a witness to the activities of Bishop Fulbert's own clerics and those who survived his death in 1028 and provides the first evidence of an attempt to idealize him and probably, at this early stage, to make him a saint. There were problems in doing so in the traditional way: as Fulbert was buried at St. Père, the cathedral did not possess his relics. Other ways of connecting him to the cathedral would be necessary: the cult-building activities of the eleventh century had this work as a primary goal.

Chartres, BM Na4 is essentially a martyrology/necrology. As such, it and its later sister sources represent a major facet of the history-making enterprise in the central Middle Ages. The Roman martyrologies, or registers of martyrs and other recognized saints, were standardized twice in the ninth century, and the second of these standardizations was adopted at Chartres but with regional and local variations.[58] Martyrologies were important not only because they commemorated figures from the past, along with their histories, but also because cantors often introduced local people into them, as here. This was a kind of "canonization" made by local hands before the shift in the later twelfth and thirteenth centuries that made such action difficult to justify or implement, thereby fundamentally changing the character of

history making.[59] Necrologies, the records of the deaths of local people, clergy and laity alike, for whom memorial and anniversary prayers were to be said by the clergy, are among the most important of all the extant histories from the Middle Ages. They were commonly compiled by cantors or their assistants. Some scholars distinguish necrologies from obituaries, although the terms are commonly used interchangeably. Purists might argue that a necrology is a liturgical book, whose entries are arranged according to the calendar; they are designed for liturgical reading, usually at the Office of Prime.[60] Obituaries, on the other hand, list the dead as found in the margins of a calendar for the sake of general commemorations; these names were read out in church in a group, and the revenues collected from their pledges were distributed during the week. The books of the Norman cantor Symeon, working at Durham in the late eleventh and early twelfth centuries, are a sterling example of the sorts of materials compiled by a cantor in this period and related to the liturgical and musical practices he supervised; Symeon was also an important historian, one whose contributions have been much studied.[61]

To demonstrate the importance of a book such as Na4 I turn to an introductory study by Nicolas Huyghebaert (1972), whose discussion is to be supplemented by Jean-Loup Lemaître's introduction to the *Obituaires* (1980). Huyghebaert lists the following ways in which necrologies are valuable and the evidence they supply: (1) for prosopography: they often provide the best and only surviving evidence concerning medieval people, such as when they lived and what their circumstances were; (2) for general history: when famous people lived, how they died, their relationships to other people and institutions; (3) for genealogies: family trees; (4) as evidence of social history: especially of what people had to contribute as donors to churches, what they deemed worthy of giving, and why; (5) for philology: words and their uses, place names, etc.; (6) for statistics: the number of monks, the number of artists, etc.; (7) for economic history: who owned what, who gave what; (8) for the history of institutions; (9) for liturgical history and the history of religious feeling; (10) for the history of archeology and art; (11) for the history of manuscripts and of libraries; (12) as monastic and cathedral history. To these I would add, (13) the history of the cults of the saints; (14) legal history; (15) the history of religious reform; and (16) the history and development of local legends. In that so much vital material is contained in liturgical necrologies, it is telling that the cantor, the second-ranked official after the dean in the cathedral hierarchy, was the individual who usually prepared them; this is yet another way the cantor was in control of the history-making enterprise, in both monastic and secular churches.[62] Martyrologies and necrologies provided, in addition, important sources for chronicles, a historiographical genre of special importance for monasteries, these too often written by cantors.[63]

The table of contents of Na4 (see appendix B) shows the sorts of materials an eleventh-century cantor generated as a matter of course, with many important additions from after the time of the original compiler. Judging by its date and its

dedication to Fulbert, the compilation can likely be attributed to Magister Sigo, the beloved disciple of Fulbert who was the famed cantor of the cathedral during the opening decades of the eleventh century.[64]

Sigo's work included computations of liturgical feasts, the copying of a martyrology with contemporary additions featuring a magnificent memorial display for Fulbert, and the making of a necrology containing obituaries of donors to the cathedral and important personnel. Sigo commissioned lavish illuminations from Andrew of Mici, one of which survives.[65] This collection of several kinds of written materials, all of which reflect liturgical practices, provides the first understanding of the history of Chartres Cathedral in written documents. Sigo's efforts relate to both his training as a cantor and his affection for Fulbert—and probably for his colleague Dean Albert, who was elected Fulbert's successor but was ousted from the position for political reasons.

The artwork Sigo commissioned shows the first attempt in Chartres at turning a historical understanding made in the liturgy into a work of art that also expressed historical circumstances.[66] In the illumination Fulbert is standing in front of a completed splendid cathedral of Chartres, a building he apparently did not actually complete and did not live to see dedicated, if indeed the painting represents him later in life, as his appearance indicates.[67] Above the roof the golden letters against a purple background offer an epitaph: "Fulbert, venerable pastor, cared for the sheep of the Lord for twenty-one years and six months."[68] The two men pictured with Fulbert are clerics, garbed in liturgical robes as deacon and subdeacon and ready to serve Mass. They may represent the dean and the cantor, who were the first and second ranking dignitaries of the chapter; they were independent of the bishop, although the dean was appointed by him.[69] The secular figures opposite them may represent the count, who in this case would be Odo II of Chartres/Blois/Tours and perhaps his cousin William V of Aquitaine; both were major donors to the building project, as was King Cnut of England and Denmark (see Nichols, 1989; Gelting, 2008). The portrait may be a nostalgic exercise that completes what Sigo wished could have been: that Fulbert had lived long enough to complete the building and that he, Albert, and other youthful members of the loyal band could have lived to stand with him in the new church. The point here is that Na4 offered a liturgical framework of time created by cantors that was kept up to date until the middle of the twelfth century and consulted long after that. This source supported the fundamental history-making ventures of Chartres, and my study suggests that the past was already being reshaped by those responsible for the first additions to this book:

> In the year of the Incarnation of our Lord, 1028, iiii Ides of April [April 10], died our Father Fulbert, of revered memory, beloved of God and men, adornment of the priesthood of his time, exceedingly bright light given by God to the world, sustainer of the poor, consoler of the afflicted, restrainer of brigands and robbers, a man most

Figure 4.1. Fulbert and his cathedral. Illumination from Bmun, N4.
Médiathèque de Chartres.

Figure 4.2. Fulbert and his cathedral, restoration of illumination in Bmun, Na4.
From Merlet and Clerval (1893).

DU XIᵉ SIÈCLE

Figure 4.3. Plan of Fulbert's crypt. From Merlet and Clerval (1893).

eloquent and wise both in the sacred books and in those of the liberal arts. For the restoration of the holy temple of his diocese, which he began to rebuild from the foundation after the fire, he left a goodly portion of his own gold and silver; and he illuminated that place with beams of discipline and wisdom; and he did his clergy much good.[70]

The eulogy Sigo wrote for his teacher was added to Na4 soon after Fulbert's death. It is part of the attempt of Sigo and that of other disciples as well to lionize Fulbert and perhaps (in the case of Sigo) to make him a saint. A long elegy by Adelman of Liège ("Poème") is another well-known record of Fulbert's accomplishments. Adelman surrounds the paragon of learning with a constellation of brilliant pupils, including the heretic Berengar of Tours; Berengar's name was effaced in the

author's second edition and replaced by that of the cantor Sigo, who had died in the meanwhile.[71] Sigo's eulogy and Adelman's elegy attest to the attempts of Fulbert's school to perpetuate his memory as a master of the liberal arts.[72] Sigo also used the bishop's role in the construction of the cathedral as a major point, both in words and in the famous image of Fulbert standing in the midst of a splendid and completely rebuilt church, a church that was in actuality incomplete at Fulbert's death. Sigo signed the work with other verses, these too painted in gold; they form a heartwarming endorsement of interdisciplinary enterprise and are part of a longer poem that survives in a later copy:

> The last of the clerics of Fulbert, Sigo by name,
> with the hands of Andrew of Micy, painted these words
> that a united hope in the world might give them rest in paradise.[73]

As Sigo's epitaph in the Chartrain necrology attests, it was he who constructed his mentor's tomb: "July 11. Sigo died. He was a priest, illustrious by reason of his wisdom, venerable for his life, and the most beloved cantor of this church of the holy Mother. He was the intimate counselor of Fulbert while the holy bishop lived; when he died, [Sigo] had a splendid tomb made for him, as can be seen [in the choir of the Abbey of St. Peter's of Chartres]."[74]

The efforts of Sigo and others of Fulbert's students to ensure his reputation and that of his school may relate to the way in which his succession was handled. Soon after Fulbert's death on April 11, 1028, the dean of Chartres Cathedral, Albert, was chosen by the canons to succeed Fulbert. As one of his letters suggests, Albert was a strong-willed administrator who ran the diocese and served as official spokesman when Fulbert was ill or absent; he must have been the bishop's right-hand man (see *LPFC* 110–13). King Robert II, doubtless feeling the need to have an ally in the position during those troubled times, blocked Albert's election; he had the head sacristan, Thierry, made bishop, an action that infuriated the canons.[75] Three letters by the canons survive, and each asks that the receiver keep the contents confidential: one is the chapter's letter to Odilo, abbot of Cluny; another is to those bishops who would be responsible for Thierry's consecration; the third is to Archbishop Leothericus of Sens, who actually did consecrate Thierry.[76]

This controversy broke out when King Robert and Count Odo were beginning to fight over control of Sens, and the distrust between them at that time was great. After Robert's death in 1031 the controversy led to open warfare, Odo joining with the vicount of Sens and with a most unlikely ally, Queen Constance; she was fighting against her own son, King Henry I, in hopes of promoting his younger brother, Robert, whom she had always favored.[77] The canons were angry because their time-honored right of election had been usurped and their authority denied, but they also wrote of Thierry as a man not suited to the post and not properly educated, although they make only this second point to the three bishops: "We are laying our

complaint before you, fathers, as regards our Archbishop and the King, who wish to force on us a bishop who is (as you know) illiterate, and both unworthy of such an office and unacquainted with its duties. . . . You may know for a truth that to the three of you who are guarding the gates a fourth guard is added in Count Odo, and that he will never receive [Thierry] into his city unless you first examine him and decide whether he ought to be received or not" (*Ep.* 129; *LPFC* 234–35). Clearly Odo was ready to fight on the side of the canons of Chartres Cathedral.

The canons lost their fight, and Dean Albert departed for Marmoutier, a monastery especially favored by the Thibaudians, where he later became an abbot of great distinction. The "illiterate" Thierry (who left the cathedral a "great supply of books" on his death) would serve for twenty years, almost as long as Fulbert. There may have been a degree of truth in the canons' accusations: Thierry's training for the position was somewhat unusual, and he may not have been suited to carrying on the tradition of the cathedral school. He is the only bishop in the history of the cathedral known to have been the head sacristan just before he took the mitre, and this means that although he had administrative abilities, he had not come up through the customary ecclesiastical ranks.[78] Thierry's special skills, however, may have been what was needed for the perpetuation of Mary's cult and the further development of the patronal feast championed by Fulbert.

The church Fulbert was rebuilding from its foundations after the fire of 1020 did not wholly survive him. In 1030 yet another devastating fire wracked the old cathedral town, as reported in the vita of Saint Anianus: "The fourth fire took place in 1030, the 11th of September, during the second year of the episcopate of Thierry."[79] How much of Fulbert's work survived this fire cannot be told, but apparently the crypts did and perhaps part of the upper story as well.[80] Thierry was responsible for finishing the work, and he also had to do whatever was necessary to develop further the patronal feast and to elevate the relic's prominence. Yet the obituary written not long after his death in 1048 as an addition to the original in Chartres, BM N₄4 makes no mention of his building activities in the cathedral, although he was bishop in 1037 when the church is said to have been dedicated.[81] The obituaries depict him as the man who gathered a library and the many things necessary for carrying on the work of liturgy and cult: "xvi kal. mai. [16 April] Lord Thierry, the bishop, died. He enriched this church with a great supply of books and adornments of many kinds, and, for the benefit of the brethren, left his freehold [*alodum suum*] in Sazeray, a church in Vilette with its altar, and a church in Luplanté with its altar, two vineyard closes, one of fifty-two and the other of twelve arpents [*agripennia*], with what is necessary for taking care of the house and the brothers' wine" (*MSC* 159; *CNDC* 3:90). Thierry's obituary at St. Peter's, like that of Fulbert at the same institution, is simple, even though he was buried there: "Lord Thierry, bishop of Chartres, died. May his soul abide in paradise" (*OPSSP* 187C). Only Paul of St. Peter (who surely knew people who remembered Bishop Thierry, even if he had

not known him himself) speaks of Thierry's role as builder. In one of his gossipy patches of writing (found between collections of charters) where local lore seems to come strongly into play, Paul takes the reader on a stroll through the church of St. Peter. He writes charmingly of Fulbert's and Thierry's tombs, both near blessed Bishop Gantelmus, and mentions Thierry's role as builder of the church and feeder of its flock: "Then [comes] Fulbert, a bishop worthy of remembrance, who was of such great wisdom that his brilliant hagiographical writings make their way into his readers with marvelous sweetness. And to the right [lies] Bishop Thierry, whose Ambrosial riches, flowing like a torrent—completing the splendid court of the loving mother of the Lord, and unfailingly supplying a place of Gobbledom and of Drinkland for the poor—brought about something worthy of holy praise."[82]

Paul had the epitaph on Thierry's tomb before his eyes but did not quote from it directly. The actual words were first edited centuries later by Lucien Merlet, as he found them copied in an eleventh-century collection of inscriptions from the tombs in the church of St. Peter. The inscription suggests that Thierry was not only a builder but also a patron of the arts and that he favored light from abundant windows. These allusions to his work made Merlet wonder if Count Odo's entry in the necrology referred to the windows Thierry had executed in the upper church:[83]

> A bishop is here, Thierry by name,
> But having become dust he lies lifeless.
> Virgin Mother of God, he covered your temple,
> Whose upper work he had dressed by windows.
> Productive in life, he bestowed, see! what shines with light;
> O Peter, he gave holy gifts to your monks.
> The tired Ram, Phoebus's husband, when he would lay aside the heat,
> Gave his limbs to his mother, what is spiritual to his Father.[84]

Two views of Fulbert's legacy emerge in these documents. In the cathedral records the builder is Fulbert, and Thierry's important role in actually completing the building is passed over. In the documents from the Abbey of St. Peter, Fulbert's successor receives his due and is styled a major patron of the arts. The reason Thierry was successful at completing the Virgin's temple, as it had now become known, may have to do with the very training Fulbert's pupils had considered a liability. In fact, Thierry's work may have been to promote the cult of the Virgin as well as the power of the office he had once held, giving the sacristan a major role as supervisor of the sumptuous artworks which even then were being described in the necrology. Bishop Thierry is likely to have continued the magnification of the Virgin's cult, for he had been the officer in charge of her relic and reliquary before becoming bishop.

As the position of head sacristan evolved over the course of the eleventh and twelfth centuries, responsibility for the cult became ever greater, as a description of

the office at its peak reveals (see chapter 9). Indeed, the head sacristan—the *cheficier* in French, the *custos sacri scrinii* ("keeper of the holy reliquary"), *claviger*, or *archiclavus* ("head keykeeper") in Latin—grew increasingly important at Chartres, at least until the end of the twelfth century. As the Virgin's cult intensified under Fulbert and immediately after, it was the sacristan who cared for the chemise, its reliquary, and all the church furnishings. He also came to manage the unique liturgical collection associated with the cult and to oversee the personnel responsible for the physical well-being of all connected to the veneration of the relic.

The myth of Fulbert as builder was established in the decades just after his death. His letters reveal that he cultivated donors carefully, reaching out across vast geographical distances to find them. His probable major donor, however, was a local figure, Count Odo II, who would have been alive to contribute to Thierry's campaigns as well. Evidence for Thierry's campaign suggests not only that Thierry completed the work on Fulbert's design, but also that he promoted a campaign of his own, adding to and reworking the building that would serve the diocese until it burned in 1194. Entries in the necrology not only attest to this activity, but also suggest a shift in donation patterns. Thierry was doubtless a very wealthy man; he dug deeply into his own pockets for the work of restoration, and he must have expected his colleagues to do the same. There is no evidence he sought donors from outside his intimate circle in the way Fulbert had. No canons who gave for the work of building before Fulbert's death in 1028 are listed, and only two donors who specifically supported work on the fabric of the church. One of these two gave to Bishop Odo's campaign, and the other cannot be precisely dated.[85] Besides Teudo from the tenth century, the only artist or builder mentioned in the pre-Thierry period is Manoald of Brittany (May 10), the *carpentarius* of St. Mary.[86]

During Thierry's reign several donors to the fabric of the church emerge, all of them local men of considerable wealth—canons, church officials, and perhaps in one instance a layman—and also the names of the artisans who worked with them. Builders, artisans, and donors from this period include the following: "John, the carpenter of St. Mary's, who among other things necessary for the restoration of this church constructed a bell of five thousand pounds" (MSC 165); "Odo, worthy priest of God, canon of St. Mary the holy genetrix of God, who offered much for the restoration of this church and of many others" (MSC 168); "Stephen, succentor of this church, who offered much for its restoration" (MSC 179); and also the man who doubtless oversaw Thierry's ambitious project, Beringarius, the "good master builder [*artifex*] of this mother church" (October 28).[87] The master builder was a contemporary of one of the men who helped to pay him, the canon Ragembold. Ragembold's entry in Na4, written around 1050, shows him to have been a major contributor, continuing the tradition begun by Teudo that the front of the church, the west entrance, was worthy of lavish attention: "Id. Apr. [April 13] Ragemboldus, subdeacon and canon of St. Mary, died. He gave the great part of his possessions for

the building of the vestibule for the front of this church, and covered with gold the front of the reliquary of Saint Piat, and gave seven arpents [*agripennos*] of vineyards for the use of the brethren, with a house and a winepress" (*MSC* 159–60).[88]

Although Thierry's reign fell during a low period in the history of the Thibaudians—whose nadir in the central Middle Ages was the loss of Tours to Fulk Nerra and the Angevins in 1044—there is no evidence that adverse political circumstances affected the fortunes of the cathedral of Chartres or that attention to art and cult were lacking. Instead, the myths surrounding the cathedral building and its power to define regional identity were growing stronger as the building project was completed and new decorations were added to the vast edifice envisioned by Bishop Fulbert.

# THE VIRGIN IN THE SECOND HALF
# OF THE ELEVENTH CENTURY
## Fulbert Becomes a Liturgist

The shoot of Jesse produced a rod, and the rod a flower; and now over the flower rests a nurturing spirit. The shoot is the virgin genetrix of God, and the flower is her Son.

—*Responsory for the feast of the Virgin's Nativity, attributed to Fulbert of Chartres*

In recent decades students of the Middle Ages have turned increasingly to hagiography, finding in the lives of the saints a vast body of evidence that has long lain fallow, evidence concerning all aspects of medieval culture.[1] This shift has taken place throughout the disciplines and across a chronological range: from the early Christian period, where Peter Brown's work on late antique cults has been seminal, to the later Middle Ages and the work of André Vauchez, who wrote about changes in the process of canonization in the later Middle Ages and the new breed of saints begotten as a result.[2] Although the work of the saints in binding communities together and in helping to create identity has been transforming the field of medieval studies for decades, most of the scholarship has not focused upon the saints as contextualized within the liturgy. In the central Middle Ages, the saints generated power and authority not only through shrines and artworks, but also through the liturgical readings and chants that served to memorialize their lives, attributes, and historic connections to particular places. This lacuna in the scholarship is presently addressed in a variety of ways as musicologists and liturgical scholars have turned increasingly to the saints; their efforts are leading to new series of liturgical vitae, and the study of a variety of Offices that include attention to the musical dimensions of hagiography.[3] The late tenth and early eleventh centuries were crucial periods for the formation and standardization of the Divine Office in many regions and churches, and developments at Chartres are emblematic. They also point us in the direction of trying to situate the visual arts in their liturgical and hagiographical contexts, and these were established in many places by eleventh-century developments.[4] The history of cults of major saints and the history of most places and insti-

tutions were one in the eleventh century. Understandings of the past developed at
this time provided the fundamental materials for commemorative artworks created
by and for twelfth-century Christian communities. Partly because of the interest in
hagiography, Mariology—a field of study long foundering between academic mod-
ernism, with its cynical distaste for devotional practices, and popular writing for the
faithful often lacking in rigor—has been renewed.[5] The central Middle Ages offer
significant opportunities for the study of Mary: she became an increasingly com-
plex figure in the eleventh and twelfth centuries, as every region, town, religious
order, and church increasingly sought her patronage and fostered liturgical and
devotional practices capable of making her identity resonate with its own. During
the eleventh century new materials for liturgical veneration of the Virgin prolifer-
ated, and by the end of the twelfth century most churches had daily masses and
hours of prayer dedicated to her honor, paralleling those of the general observance,
Saturday having become Mary's day.[6] In an age fostering new ways of honoring the
Virgin, the Chartrain sources and those related to them offer evidence of the high-
est order for the kinds of development occurring in the second half of the eleventh
century, a formative period that is comparatively unstudied.[7]

The relics of the saints and their natures shaped local history-making projects in
the central Middle Ages. In Chartres the cult of the Virgin was based on a relic that
was not a body part, so work had to be done to make connections between Mary's
person and her garment, promoting its symbolic value.[8] The relic was understood
as her garment from the first mentions of it in the tenth century, but its nature was
not defined or its meanings explained in the first legends. Similar problems can be
found with the history of the cathedral's most famous bishop: Fulbert's body lay
down in the valley at the Benedictine abbey dedicated to St. Peter. Any attempt
to elevate cult based on his remains—short of stealing them—would not help the
cathedral of Notre Dame. Those who wished to make history at the cathedral of
Notre Dame through the Virgin's cult and Fulbert's reputation needed ways of
enshrining these figures that transcended the usual association of cult with holy
bones. During the course of the eleventh century, Fulbert's character and history
were linked to Chartres Cathedral through a new kind of life for the Virgin Mary,
one that was a compilation of liturgical materials that appeared to have been writ-
ten by Fulbert himself. This Fulbertian Marian liturgy can be studied both through
these readings, as found in Chartres, BM 162, and through three responsories for
the Virgin's Nativity, the texts of which appear in an early collection of Fulbert's
writings with close connections to the cantor Sigo (Paris, BN lat. 14167). It was
through materials such as these that the cantors and sacristans of Chartres laid the
foundation for the Virgin's cult within the liturgy itself and made Fulbert its cham-
pion. The contents of Chartres, BM 162 would also help explain the nature of the
Virgin's relic, associating it with particular events in her life, but giving it a more
universal set of meanings as well.

## CHARTRES, BM 162: THE BOOK OF THE CULT

Chartres, BM 162 was an early example of a shrine book, in its case comprised primarily of readings that might have been used in a variety of ways. In the twelfth century the most deluxe examples, such as the Codex Calixtinus found in Compostela, contained liturgical materials, including chants, a *vita*, miracles, and cycles of illuminations (Stones, 1992 is an introduction to the type). The Chartrain book was destroyed in the fire of 1944, but its contents can be reconstructed from Delaporte's notes (see appendix E).[9] It can be called the Book of the Cult because of its connection to the specific themes developed at Chartres to promote the relic of the holy cloth and the Virgin's connection to it and to Bishop Fulbert. The book's mode of organization makes it a forerunner to the kinds of devotional materials required to celebrate the mysteries of the Virgin's life in their chronological sequence, an aspect of her veneration that would prove important in the various miracle collections and cycles of Hours of the Virgin from the later Middle Ages and early modern period. It was during this formative time, the eleventh century, when numerous new texts and music for rejuvenated or new cults were created, local cultic identities were shaped, and the sense of time found in the liturgy was enlivened and connected to local circumstances with an ever-increasing number of characters.

Chartres, 162 is the counterpart to other materials introduced into the liturgy of Chartres Cathedral in the eleventh century: sequences such as "Sonent regi nato" (see chapter 3), the texts and music of the Marian responses attributed to Fulbert discussed below, and the five Marian antiphons most probably put in place in the eleventh century at Chartres Cathedral for First Vespers of all Marian feasts (see below and chapter 10). Such materials provide eleventh-century evidence concerning the nature of the liturgical veneration of Mary specific to Chartres Cathedral and allow us to go beyond the earlier materials of Advent and the Marian feasts inherited from the Carolingian period. The existence of special services for the Virgin is not in itself a striking innovation: during the course of the twelfth century most places adapted some memorial or Little Office for Mary after the main Matins service of the day and elsewhere in the liturgy.[10] But Chartres was more ambitious than other centers in the mid-eleventh century, and its fame as a shrine for the Virgin would come to depend upon the liturgical innovations studied here, carefully connected to Fulbert as they were. The nascent development is present in Chartres before a proliferation of feasts had led to the steady truncation of Office readings, a time when individual readings of considerable length were reduced to snippets of two or three sentences in length in most places.[11] The history-making force of these eleventh-century liturgical innovations is proven by the fact that they remained impervious to change over the later eleventh, twelfth, and thirteenth centuries, although the uses to which they were put may have evolved.

Chartres, 162 belonged to the chapter of the cathedral of Notre Dame of Char-

Figure 5.1. Chartres, Bmun, 162, fol. 56v. Second half of the eleventh century, depicting the Prologue to the *Libellus*. Archives diocésaines de Chartres. Credit, Delaporte.

tres and seems to have been kept by the head sacristan, as the necrologies suggest.[12] Its 256 parchment pages, measuring 340 x 245 mm, were written in seventeen long lines. The script has been dated to the second half of the eleventh century; the photograph Delaporte took of a single page suggests its elegant beauty and deluxe nature and establishes the general date of its copying. The book was brought up to date in the thirteenth century by the addition of special Matins readings for Saint Anne, the mother of the Virgin; the sequence written in her honor at Chartres in the early thirteenth century continues themes prevalent in the materials studied in this chapter and in my analysis of the capital frieze (see chapter 11; and see appendix D for the text and music of the sequence). The readings for Saint Anne were taken from the apocrypha and show the attention still paid in the early thirteenth century at Chartres both to the *Libellus* and to the Latin version of the *Protevangelium of James*.[13] Chartres, 162, which contains only prayers and readings for Masses and for Matins, is a special kind of history book, forming a story of the Virgin's life. Through this book her history was shaped to promote the patronal feast of Chartres Cathedral; it was designed to emphasize ideas relevant to the major relic and to the general themes of lineage, birth, and regeneration as well as to promote Fulbert's role in the development of her unique liturgy at Chartres.

The overall structure of Chartres, 162 stands apart from the traditional calendar of the church year. In fact, the book is a kind of vita, but one made of liturgical materials, primarily sermons, some of them local productions and others by familiar early authors whose works had been featured in the omnipresent ninth-century homiliary of Paul the Deacon.[14] The church year offers a loosely chronological narrative depending upon events in the life of Christ. Liturgical time flows from Advent to Christmas, the Circumcision, and the Purification and then jumps dramatically to the Passion, Death, Resurrection, Ascension, and Pentecost, Trinity Sunday marking an end to the winter cycle, just as a second feast of the Trinity immediately before Advent in some early calendars marked the end of the second half of the year.[15]

The four major Marian feasts established by the Carolingians from the Roman use are the Nativity, Annunciation, Purification, and Assumption.[16] In Chartres, 162 they are ordered according to a Marian timeline, with the Nativity of the Virgin (September 8) coming first and, as the patronal feast, having the largest selection of readings, occupying folios 7–97, or over one-third of the book. This is followed by the feast of the Annunciation (March 25), commemorating Gabriel's announcement to Mary and her acceptance of his words, and the child's conception. Subsequently there are readings for the feast of the Purification (February 2), which interpret Mary's act in bringing her child into the Temple. The final feast in the order established by the collection is the Assumption (August 15); it proves to be the least innovative segment of the work at Chartres. Chartres, 162 has been compiled by a person or persons who wished to emphasize the feasts of incarnation and birth,

especially as they related to the Virgin Mary. Those who ordered this liturgical vita of the Virgin arranged feasts chronologically in accordance with events in her life rather than calendrically in accord with the church year. At the head of the book, then, stands the first (and most significant) of these feasts, the Nativity of the Virgin Mary.

Chartres, 162 is unique for its time: in it the feast of Mary's Nativity has been expanded beyond what is found in similar regional collections (see below). Even more important, these and other Marian sermons have been extracted from a widespread tradition and placed in a book of their own, a collection dedicated to the Virgin and meant for liturgical use. The existence of this anthology at such an early date demonstrates that great energy was expended at Chartres Cathedral to develop the cult, and it may be assumed that the ordering of the book was part of a broader agenda to give prominence to the cult and to ascribe its ideals and origins to Bishop Fulbert. As can be seen from the table of contents (see appendix E), the book opens with Fulbert's sermon *Approbate consuetudinis* for the feast of Mary's Nativity, establishing his authority from the start and advancing Mary's character as he shaped it in this famous work.

Themes established in *Approbate consuetudinis* relate to the interpretation of lineage and the understanding of prophecy, transferred here from Advent to the feast of the Virgin's Nativity. As noted in chapter 4, Fulbert emphasized that Mary's lineage was revealed through the interpretation and fulfillment of miraculous prophecies. He argued that he could go beyond the biblical texts because the apocryphal lives of the Virgin that circulated, while not canonical, certainly might be true. Accordingly, miracles and prophetic oracles are both appropriate and necessary for understanding Mary's life and continue the work of the Bible itself. He speaks of the *linea generationis humanae* (the lineage of human generation), which is both defined and broken by the miracle of the virgin birth. Focus is placed upon the wondrous flowering of Aaron's rod as a miraculous oracle of her birth, and her ability to produce fruit although "dry," although a virgin. She fulfills the prophecy and explains the miracle for she is *paritura* (about to bear). And she is human, a lily among the thorns, chaste among the flock of human sinners. She forms a model for humans to follow, just as the polestar leads travelers safely home.

In this view, Mary transforms the reading of history: her example brings constant hope for renewal and change, a theme of great importance in Marian sequences from the period (see chapter 2). The wisdom of the Father is revealed and proclaimed here, offering new knowledge and an understanding of goodness not known before. Mary's birth offers both continuity and fulfillment as it suggests at once a steady progression of prophecy along with dramatic reversal. Mary is a mirror in which all time can be seen, and yet she is singular, unique. The line of human creatures recorded in Scripture exists to produce and shape her flesh, and she sub-

sequently continues the heritage but changes and rearranges it, creating a new line from the old one. The miraculous effects of her goodness can be seen in the stories of Basil and of Theophilus mentioned in *Approbate* and also in Fulbert's prayer (see chapter 4).

The works chosen to complete the series of eight festive readings for the Nativity of the Virgin in Chartres, 162 constitute an octave of readings for Matins, but one that grows thematically from Fulbert's introductory sermon. The second sermon, *Mutuae dilectionis*, is even longer than *Approbate* and, like it, was originally intended to provide readings for the feast of Mary's Nativity.[17] This sermon was of a length to provide six or nine readings for Matins, so allowing for the incorporation of a Gospel text with commentary or not. It expands upon the framework of understanding central to Fulbert's characterization of Mary: the miracles of Scripture constitute a mystical history for her being and the events of her life. The historical viewpoint is instructive: Mary, as the place where human and divine meet and fuse, has been preknown throughout the ages; she has a past that refers to her coming; this theme was also prominent in the contemporary Christmas sequence "Sonent regi nato" (see chapter 3). In addition, those parents who procreated her are themselves especially to be blessed. The age in which she was born, that fullness of time predicted of old, is sacred, for in its bosom was born the church. Like *Approbate*, this sermon provides Marian miracles rooted in scripture, a tactic explicitly promoted by Fulbert.

Thus Mary's lineage and childhood are worthy of serious contemplation. Mary's time, like that of her Son, relates old to new, just as her body was a crucible for a new and different flesh. The defense of the legend of her parents, Joachim and Anna, found here is even stronger than that found in *Approbate consuetudinis*. The middle part of the sermon is followed by a long description of the joy appropriate to the celebration of the feast by all ranks of people, men and women, old and young, virgin and married, but with special emphasis upon virgins, whose special feast this becomes through this interpretation.

The third sermon, *Gloriosam sollempnitatem*, is a lyrical statement of joy in Mary's gifts and her fulfilling beauty, and of the importance given to Mary as the great reflector of the sun, the bearer of the *Sol iustitiae*, the "Sun of justice."[18] The splendor of the Virgin set forth here is typical of this sermon, which, in an Akathistos-like manner, catalogues her attributes and those of her son.[19] This sermon resonates strongly with one of the three Fulbertian responsories discussed below and may well be of Chartrain origin.

*Nativitas gloriosae genitricis dei*, the fourth sermon in the group, has been attributed to Bernier of Homblières, who was abbot there from 949 to 982.[20] The work is in his hagiographical vein, which consisted of creating saints' lives to strengthen the historical sense and identity of his abbey. Homblières was located in the Ver-

mandois, the territory of Albert the Pious (943–987/88), brother of the Countess Leutgard of Chartres/Blois; she was a contemporary of Abbot Bernier (also known as Berner).

The sermon is long and complex; it lays out the stages of time, with the nativity of the Virgin as the defining point of history, while offering several interconnected understandings of time: the days of creation found in Genesis 1, the ages of human-kind, and the way both foreshadow the coming of the Virgin and the miraculous birth of the Messiah. In his introduction the author states his belief that "he that liveth for ever created all things together" (Sir 18:1) in a monumental gesture. Al-though time and all the meanings of time are one and created with a single stroke, yet the Virgin provokes the study and knowledge of temporal progressions, and this kind of knowledge is in accordance with divine will: "Almighty God wished that certain hidden things of his disposition, which he judged ought to be known by mortals, might be written and presented step by step for people's notice according to their capacity."[21] Bernier is concerned with the ways in which God blessed the Virgin throughout time: "The very holy body of the Mother of God was predestined from before time for the generating of God's son, and was blessed by the fathers named here, even though she was born near the end of the world."[22] He also finds the sacraments of the faith foreshadowed in these earlier events, making the ser-mon a liturgical commentary as well as an explication of the past.

Most important for the themes of the Chartrain collection as a whole is the way in which *Nativitas gloriosae genitricis dei* emphasizes the Davidic heritage of the Virgin, thus underscoring the ideas of *Approbate consuetudinis* and supporting, if indirectly, the life of the Virgin offered in the *Libellus*, which follows Bernier's sermon in this collection, as well as the three responsories attributed to Fulbert. Discussion of Mary's lineage unfolds during the exposition of day four in Genesis, the day on which the sun was created. Bernier says,

> The prophet sang, with the Holy Spirit speaking in him, that the blessed mother of God and perpetual virgin Mary, the annual feast of whose nativity we celebrate today, rose from a root of Jesse. A rod will go out, he is saying, from the root of Jesse, and a flower will ascend from its root. The root of Jesse is the family of the Judaeans; the rod, Mary; the light-filled flower, remaining ever unaffected in the vigor of her chastity, virginal in body, with the Holy Spirit aiding, truly produced what was made for the world, our lord Jesus Christ. Therefore Mary, the blessed mother of God, was born from the shoot of the holy patriarchs, whose succession so often has been divinely blessed, from which just as the same blessing upon so many nations of the earth may be about to go forth, as the pages of so many writings of the ancient record testify inwardly.[23]

The "light-filled flower" was what Jesus would become in the Styrps Jesse window of the twelfth century.

The fifth text featured in the Nativity texts is the *Libellus of the Blessed Virgin Mary*, an apocryphal life of the Virgin written around the year 1000 (see chapter 4). In *Approbate consuetudinis* Fulbert championed liturgical readings taken from apocryphal legends of the Virgin and then used his sermon to establish this particular text. The placement of the *Libellus* here underscores his belief in its importance and gives the apocryphal stories of Mary's early life credence, wedding her early history to the cult of the Virgin of Chartres and to Fulbert's work. This was one of the earliest surviving copies of the *Libellus*, an authoritative version of the text.[24]

Following the *Libellus* are two short sermons, the second of which is very likely by Fulbert; it was found among his works in the mid-eleventh-century collection of his papers (Paris, BN lat. 14167) discussed below.[25] *Fratres karissimi . . . natale gloriosae dominae* adds details of Mary's life not found in Fulbert's other securely attributed sermon; it mentions her life in the Temple until the age of fourteen, and the fact that she was always with the Lord from the time of his conception (at the Annunciation), through the events of his life, his Passion, Resurrection, and Ascension, themes that would influence twelfth-century artistic programs at Chartres. The sermon connects her to John the Evangelist and speaks of their burial places: in the valley of Josaphat for Mary, where a church was built in her honor, and in Ephesus for John. When religious Christians went to look after the physical remains of Mary, they found the tomb empty; when they later sought the body of John the Evangelist, they found nothing except manna. It is believed that Christ breathed life into his mother and took her above the heavens, and that John, virgin and evangelist, who ministered to her on earth, merited to share in her glory in heaven.[26] The sermon ends, as does *Approbate*, with miracles of the Virgin witnessed to by Basil of Caesarea and Theophilus.

The last group of readings dedicated to the feast of Mary's Nativity is made up of a section of Rabanus Maurus's commentary on the Gospel according to Matthew.[27] The Gospel for the feast of Mary's Nativity is Matthew 1:1–18, the genealogy of Christ from the house of David and of the tribe of Juda; the readings are Rabanus's remarks on that passage, which actually make up chapter one of his commentary. Rabanus was the Carolingian writer instrumental in promoting the idea that Matthew wrote a life of the Virgin as well as the Gospel, and thus his inclusion in Chartres, BM 162 accords with the picture of Mary's life and the importance of the apocrypha as witness to her early development.[28] The chapter bursts out with themes championed in the works attributed to Fulbert of Chartres: it provides a thorough exegetical compilation of all strains of the messianic lineage, kingly and priestly, forming a veritable catalogue of scriptural allusions used to explicate the genealogy of Mary and Jesus (see especially col. 732A). The text is concerned with the ways in which a line of ancestors depicts history, and Rabanus raises many problems with the history found in Matthew 1:1–18 itself. The opening line of the biblical text states that the book contains the genealogy of Jesus Christ, son of David, son of

Abraham, and this "reversed ordering" reveals that the lineages must be intertwined (col. 732B). The women in the genealogy are of interest: each of them—Ruth, Bathsheba, Thamar, and Rahab—conceives under strange circumstances, the better to set off the differences between them and the Virgin Mary, while also offering a kind of foreshadowing (cols. 732–33).

The chapter forms a short treatise divided into three parts, if one discounts the introduction. The first section marches the reader through the genealogy twice, once by explicating the various sections of the progression, and the other by explaining the mystical meaning of each name in the line. The second part is concerned with the people involved and the group; it offers mystical meanings for many configurations of time. In his interpretation of history and motion through time, continued in the third part, Rabanus is interested in the way in which lineage looks both backward, from the most recent dates to the point of origin, and forward, from the earliest known time to the present. The former is exemplified by the genealogy provided by Luke, which moves backward from Christ, and the latter by Matthew, which begins with Abraham and progresses forward in time. In this section Rabanus states that anyone bothered by the problem that the lineage is that of Joseph, who is not Jesus' father, should note that several women are included in the genealogy, which is not normal for biblical genealogies, and this is proof that Mary is indicated.[29] Then too, Mary and Joseph were of the same Davidic tribe, a point on which Rabanus presents various kinds of evidence. His sympathetic treatment of Joseph and the praise of his tender care of the Virgin found in this treatise were surely influential in the cult for Joseph that developed at Chartres in the later Middle Ages. The arguments Fulbert developed in *Approbate* and his particular polemical concerns would have resonated powerfully in this Carolingian commentary on the text that was newly adopted in the ninth century to be the Gospel reading on the feast of Mary's Nativity.

### OTHER MARIAN FEASTS IN CHARTRES, BM 162

Chartres, BM 162 was an unbalanced collection, as can be seen from its table of contents, with the feast of the Nativity of the Virgin occupying significantly more folia than any other. The patronal feast and the relic associated with it as representative of Mary's flesh took precedence in this collection. Through such materials associations of the relic with birth and annunciation were made; this understanding related as well to the emphasis upon the reading of Matthew's genealogy. The inclusion of so many newly written sermons, works from the late tenth and eleventh centuries, suggests that a vacuum was being filled by works supplied at Chartres and collected there in the eleventh century. To explain Mary's lineage, as the feast of her Nativity and this collection do, was to explain her DNA, the genetic makeup represented through and in the cloth relic of Chartres Cathedral. By this time it

may have been understood as the robe she wore at the Annunciation and at the Birth of Jesus, but much more importantly was its power to represent lineage, a divinely ordered heritage that would clothe the divine nature.

All the other Marian feasts contained in Chartres, 162 are provided with readings from older layers of standard homiliaries or are compilations of texts from Scripture and thus form a contrast to the sermons for the Virgin's Nativity. The list of readings in appendix E indicates both the age and the relative popularity of each text, using as indices of comparison Barré's reconstruction of the Carolingian homiliary of St. Peter's in Chartres (Barré, 1962), Grégoire's catalogue of Paul the Deacon (1980), and Étaix's listing of the contents of contemporary and slightly later collections from Cluny and Corbie (1994). The tabulations demonstrate that none of the texts for any Marian feast, except those for the Nativity found in Chartres, 162, were written after the Carolingian period and that few of the texts are unusual. The unusual texts were chosen carefully and ordered to further explain the themes advanced in the opening section dedicated to the Nativity of the Virgin. Chartres, 162 is a deliberate compilation, something that took work and study and that built upon what was established in the opening section for the patronal feast.

The Annunciation has two sets of readings. The second is the sermon by Bede written for the feast, a text that circulated widely as part of the homiliary of Paul the Deacon, initially as the reading for the feast of Wednesday in Ember week of Advent; this (as mentioned above) was dedicated to the Annunciation to the Virgin and was the original Roman feast for the celebration of that event (see Grégoire, 1980, 432).

At Chartres, Bede's sermon was bumped into the second place, ostensibly for the Octave, when a series of readings from the prophet Isaiah became the text for the day. As can been seen in the table of contents, many themes that had been developed previously as central to the cult of the Virgin of Chartres are emphasized here, including Isaiah 11, the "root of Jesse" passage that heralds the Virgin's Davidic lineage. The texts are filled with allusions to adventus (see chapter 3), with lush flowers and fruit, and allusions to the kingly line. The final passage, which comes from Deutero-Isaiah, refers to the anointed liberator King Cyrus, here seen as a type of Christ, whose right hand is grasped by the Lord.[30]

The Virgin's life is presented here in the way that Carolingian reformers had made a history for her assumption from Song of Songs texts, using a series of biblical verses in a particular sequence to announce the meaning of an event and to describe its happening in time, its history.[31] The Annunciation is the greatest single mystical moment in Christian history, the moment when a long-awaited shoot blooms suddenly with a royal flower. Isaiah sang of a mighty king and yet knew not precisely who the Messiah was and was mistaken and disappointed in his lifetime (Cyrus, for example, reverted to the gods of Babylon). This blocked vision was commonplace in medieval Christian depictions of Isaiah, as we saw in chapter 4. Isaiah

is a foil for the prophet Simeon, who does understand fully, a prophet who has been graced with immediate recognition of what he sees.

The next event in the life of the Virgin for which there is a series of readings in Chartres, 162 is the Purification, February 2, the feast commemorating Mary's bringing of her child into the temple, forty days after giving birth, in order to be ritually purified. This feast was one of the most dramatic in the entire church year, and many elements of the liturgy for the day can be traced to its eastern origins. In the East the Purification was a feast of the Lord (as in the Roman Catholic rite with the revisions of the Second Vatican Council) rather than a Marian feast and was tied to the date of the Epiphany, January 6, rather than to December 25. The feast was celebrated at Chartres, as it would have been anywhere during this period, with an elaborate procession involving all the Christian townspeople and featuring lighted candles that represented Mary's bringing of the light into the Temple. The twelfth-century ordinal (OV) and the early thirteenth-century ordinal (OC) supply references to several of the well-known chants that were featured on this day. Three processional antiphons, "Ave gracia," "Adorna thalamum," and "Responsum accepit symeon," refer to the Gospel of the day, Luke 2:25–39. These hail the Virgin and then describe Mary and Joseph bringing Christ into the Temple, there to be greeted by the ancient Simeon; recognizing that the child was the long-awaited Messiah, Simeon burst forth with one of the greatest of the biblical canticles, the "Nunc Dimittis." The text of this canticle was proper to the hour of Compline and thus colored the final liturgical Hour of every day.

On the feast day at Chartres Cathedral in the twelfth century, the canons moved through the church to these chants, carrying lighted candles distributed by the head sacrist. They made a great circle inside the church and then went outside to stand in front of the Royal Portal for the singing of "Responsum accepit symeon." The music and action expand the familiar picture of Simeon, who was ready to die with joy as he received the Lord in his arms, through a parallel with the reception of the Virgin Mary into the temple. The texts of the antiphons show how the ideas play upon each other as two figures are welcomed into the temple according to the biblical text: Mary and Jesus. The bridal chamber that welcomes both is Sion, the new Jerusalem, a type of the church. The people carrying candles become Mary, holding the new light that will fill the church. Mary's action and Simeon's acknowledgment and welcome make this an adventus procession for the mother holding the child.[32] The connection between the portal, the chants, and ceremonial action was carefully stipulated by the cantor and others who prepared the earliest surviving ordinal in the middle of the twelfth century.

> *Ave gracia.* Hail, full of grace, virgin Genetrix of God: from you has risen the Sun of justice, illuminating those who are in darkness; rejoice, you just old man, as you take Jesus, the liberator of our souls, in your arms, while he bestows the resurrection on us.

*Adorna thalamum.* Adorn your bridal bed, Sion, and receive the anointed one, the king; embrace Mary, who is the gate of heaven, for she carries the king of glory with new light; remaining ever a virgin, she brings in her hands the Son begotten before the daystar; whom Simeon, taking him into his arms, proclaimed to the people to be the Lord God of life and death, and the Saviour of the world.

*Responsum accepit symeon.* Simeon received an answer from the Holy Spirit that he would not see death until he had seen the Anointed of the Lord; and when they brought the child into the temple, he took him into his arms and blessed God and said: Now, Lord, dismiss your servant in peace.

This first set of readings for the Purification found in Chartres, 162 offers a mystical exploration of the relationship between Mary, Christ, and the church through the text of the Song of Songs; each of the passages is assigned to a character so that Christ, Mary, the Synagogue, and the Church converse about the meaning of purification, but in the charged language of love; the work could have been read as a liturgical play on the feast. In the final reading the Church speaks of Christ, saying she found him and will not let him go until she brings him "into my mother's house, and into the chamber of her that bore me."[33] The womb of the Virgin is the long-awaited place, and the church has longed to have Christ there. The text has a visual counterpart in an unusual illumination from a manuscript in Trent that reveals the currency of a complex of ideas regarding the establishment of the church and, by implicit or direct implication, the downfall of the synagogue. The image was used as a preface to the Wisdom books in a Bible (see Cahn, 1982). The cloth of the chemise surrounded the Virgin and the Messiah, but also was the birthing cloth of the church itself.

Themes initiated in the sermons for Mary's Nativity appear in the remaining texts for the Purification as well. Augustine's sermon *Hodiernus dies ad habendam* for Christmas is here adapted for the Purification by eliminating the first paragraph and beginning with the section that refers to Simeon, Anna the prophetess, and the act of seeing the Messiah and recognizing him: "Know, brothers, what great desire the ancient holy ones had for seeing Christ. They knew that he was about to come, and all who lived piously said, 'O if that nativity might come now with me here! O if what I believe in the writings of God, I might see with my eyes!' And so that you may know how great was the desire the holy ones had who knew the sacred Scripture, that a virgin was about to give birth [*parituram*] just as you read in Isaiah: Behold a Virgin will conceive" (PL 39:1658).

Another set of readings was adapted from a section of Ambrose's commentary on Luke. As might be expected in a patristic commentary, the work stays close to the text, with mention of Elizabeth, the mother of John the Baptist, as well as of Simeon and Anna the prophetess. Another set, by Ambrosius Autpertus, is a Carolingian sermon for the Purification and seems directly supportive of the themes of lineage favored at Chartres. The act of bringing Christ into the temple is a fulfill-

ment of his line of kings and priests: "Offer [him], then, most blessed Virgin, in the temple, as one observing the law. . . . Who is this whom you bore? Let him appear humble for now, a stone cut from the mountain without hands, so that he may be rejected by the builders. . . . Let him grow into a great mountain, and fill the whole earth. . . . She who bore him grew as a rod [*virga*] out of the people Israel; a rod arose from the root of Jesse, and the rod of Aaron flowered, grew leaves, and bore fruit" (*Sermo*, 1294). Ambrosius emphasizes the new Jerusalem. Through these references to events in the Hebrew Bible, history repeats itself, with new meanings.

The sermons offered for the feast of the Assumption provide little that is new to the compilations then circulating in Francia, and indeed they are all present in the homiliary of Paul the Deacon and its tradition. Yves Delaporte has studied the way in which the feast of the Assumption was present at Chartres, demonstrating its importance, but the sermons offer nothing to compete with the patronal feast of the Nativity as established through Chartres, 162 in the mid-eleventh century, clearly the feast of interest to the compilers of this collection.[34]

At the close of this catalogue of contents, two questions remain concerning this new vita of the Virgin of Chartres: what is its source, and what parts of it are Chartrain? and second, what kind of Virgin was made by Chartres, 162, and what views of history were promoted by her particular character? Here is Mary of Chartres as conceived in the second half of the eleventh century, in a work that continued to be the direct inspiration for the cult of the Virgin of Chartres for at least one hundred fifty years after its compilation—that is, during the time that the west façade was constructed and the thirteenth-century cathedral behind it was designed and built. This book of sermons was compiled to serve the relic of the chemise and to speak liturgically about what it meant to the community of Chartres Cathedral.

Many of the readings contained in Chartres, 162 and their ordering belong to a small group of manuscripts containing the earliest textual witnesses to the *Little Book of the Birth of the Virgin* (the *Libellus* discussed in chapter 4, with possible attribution to Fulbert or a member of his school) and to a small group of Marian sermons that often circulated under Fulbert's name.[35] Each source has ties to the diocese of Chartres and to persons who would have known about or were even connected with the liturgical materials evolving there in the mid-eleventh century, whether at the cathedral or at St. Peter's (where the writings of Fulbert were apparently first preserved and served as a primary source for the development of the cult). The choice and ordering of the Marian sermons in these collections help situate the texts found in Chartres, 162 itself. They also suggest that this collection as well as Chartrain Mariological ideals were influential beyond the liturgical and cultic practices of the cathedral of Notre Dame.

Rouen, BM U 36 is now thought to have been prepared by scribes from Saint-Aubin of Angers for the abbey of Beaulieu-lès-Loches, to complete its sermon collection.[36] Fulbert's student Bernard was active in Angers from around 1010; he dedi-

cated his life of Saint Foi to Fulbert and prefaced the collection with a letter to his master.[37] This homiliary from the town where Bernard worked, although prepared in the generation after him, may reflect developments in Chartres itself.[38] The Marian section contains the following texts, in this order: the *Libellus, Gloriosam sollempnitatem* for the Nativity, *Si subtiliter* for the Purification, and *Adest nobis, dilectissimi* for the Assumption, all found in Chartres, 162 as well.

Rouen, BM A 271, the collection on which Canal based his editions of Fulbert's sermons, is thought to have been written at La Trinité de Fecamp during the abbacy of John of Ravenna (1028–78);[39] this was a time when the Norman–Chartrian connection was flourishing. Folios 80–106 of this collection contain Marian works, including, in the same order as in Chartres, 162, *Approbate consuetudinis, Mutuae dilectionis amore, Gloriosam sollempnitatem, Nativitas gloriosae genitricis,* and the *Libellus.* This group for the Nativity of the Virgin is followed by Ambrose Aupertus's *Si subtiliter* for the Purification and *Conditor mundi* for the Assumption.[40]

An eleventh-century source from La Trinité of the Vendôme (Vendôme, BM 42) is a collection of homilies and sermons based for the most part on the work of Alan of Farfa and Paul the Deacon.[41] The Marian collection, written in several eleventh-century hands, is found on folios 130–95 and has been organized by feasts beginning with the Nativity of the Virgin, then progressing through the Annunciation, the Purification, and the Assumption, as in Chartres, 162. The section for the Nativity begins with a homily by Rabanus Maurus on the opening of Matthew (*PL* 107:731–38) and is followed by the four Marian sermons also found in Rouen, BM A 271 and as ordered in Chartres, 162: *Approbate consuetudinis, Mutuae dilectionis amore, Gloriosam sollempnitatem,* and *Nativitas gloriosae genitricis,* followed by the *Libellus,* also as in Chartres, 162. These five works formed a kind of core of readings for the feast, and it is not surprising to find them in the eleventh-century Marian collection from Chartres as well.

The overall structure of Chartres, 162 suggests that it was initially compiled in the mid-eleventh century, and its unusual ordering was found in at least one other source, Vendôme, 42 from La Trinité, where many Chartrain officials are known to have been active; the oratory of La Trinité preserved the liturgy of Chartres Cathedral even in the later Middle Ages, and Vendôme, 42 may well have been influenced by developments at Chartres rather than the other way around. In any case, all the contents of the book were extant by the mid-eleventh century and many of them much earlier. All the works that are closest to Chartres, 162 were compiled in places served by a student of Fulbert or under the liturgical sway of Chartres Cathedral. If these sources are contemporaries of and related to earlier ancestors of Chartres, 162, they suggest that the collection it represents was already forming in the years of Fulbert's lifetime and immediately thereafter.

The section for Mary's Nativity in Chartres, 162 contains a full octave of readings as well as prayers appropriate for a Mass in honor of the Virgin. The traditional

reading found at the Abbey of St. Peter in the tenth century, an excerpt from the *Protevangelium of James*, is not present, although, as its presence at St. Peter's demonstrates, the text was known in Chartres. In place of this older reading stands a full octave of lectionary readings, some early, some written in the eleventh century. *Approbate* leads the group and establishes the tone; it is followed immediately by three sermons and the *Libellus*. Fulbert's sermon *Approbate* is famous for introducing several elements of the *Libellus* into a liturgical sermon and for defending the inclusion of apocryphal readings in liturgical services. Chartres, 162 demonstrates that Fulbert's ideals won out, as least at Chartres Cathedral, where the *Libellus* was included as part of the book that most probably lay upon the main altar in the eleventh century and was directly associated with the cult of the Virgin of Chartres. As analysis of these materials proves, the person of Fulbert and the cult of the Virgin had become one by the mid-eleventh century. History makers in Chartres would continue to deepen the connection in centuries to follow.

## CHARTRAIN RESPONSORIES FOR THE VIRGIN'S NATIVITY

The choice and ordering of the readings found in Chartres, 162 give special prominence to sermons for the Virgin's Nativity ascribed to Fulbert of Chartres and his immediate circle and to the themes found in the most widespread of the sermons attributed to him, *Approbate consuetudinis*. The popularity of this sermon in the later eleventh and twelfth centuries constitutes only part of the story of how Fulbert's stature grew from the roots laid by his disciples in the early eleventh century. Just as important to the Virgin's cult at Chartres and to Fulbert's reputation was the ultimate acceptance of the three responsories for the feast of Mary's Nativity attributed to him at least from the time of Paris, BN lat. 14167, a manuscript that belongs to the circle of Fulbert's disciples.[42]

The editor of Fulbert's letters, Frederick Behrends, suggests that the cantor Sigo was responsible for the care of Fulbert's materials and perhaps even for their first edition, made sometime after 1037. This is the date of the notice of the election of Abbot Bernard of Montier-la-Celle, a document that became part of the letter collection after that time.[43] Early collections of Fulbert's writings demonstrate institutional management of a literary legacy by a school of disciples headed by Sigo, whose career introduces the several ways in which cantors made history: by composing funereal documents for important figures and by preserving, supplementing, and organizing their liturgical materials, actions that would form the bases for cultic practices and for myths of liturgical creation. Behrends says of Fulbert's papers, "The format of the corpus was that of collected papers only loosely kept together. It could be, and was, rearranged. Several copies were made of it in the following years [that is, when Sigo took it over after about 1030]. . . . Not long after 1037, an edited version was produced in which the corpus was tidied up. . . . Though it is not certain

that this was one by Sigo, it would seem to be the version which was intended for publication.[44] It was in fact the most widely diffused and before the end of the century was to go through a second revised edition" (*LPFC* xxxix). The nature of these early materials demonstrates the kinds of sources that cantors in the second half of the eleventh century in Chartres would have possessed as they continued the work of building the Virgin's cult and magnifying Fulbert's role as Mary's champion. Such a source is Paris, BN lat. 14167, an early collection of Fulbert's writings.

Paris, BN lat. 14167 was prepared and copied in the mid-eleventh century, probably from the first compilation of Fulbert's writings described above. This humble manuscript begins with the fuller version of Sigo's *tumulus*, or written memorial text, for Fulbert, thus linking the corpus to Sigo's hagiographical activities and his management of the collection. Behrends believes that the memorial verses found in Paris, lat. 14167 and those found in Chartres, Na4 were copied from Sigo's original draft of the poem, which seems to have been made at St. Peter's at midcentury (*LPFC* xliii). Paris, BN lat. 14167 originally belonged to the library of St. Peter's, another indication that it was copied there from originals on site.

This and other eleventh-century sources of Fulbert's writings have been studied primarily by scholars interested in his letters, but the sermons are represented in the collection as well. In addition to Fulbert's sermons *Contra Judaeos* (see chapter 4), two Marian sermons are found in this anthology, one of which is *Approbate consuetudinis* for the Nativity of the Virgin. The nature of this preparation may have affected reception of the chants attributed to Fulbert as well, most importantly three responsories for the feast of Mary's Nativity (see below). If Sigo shaped the collection from which Paris, BN lat. 14167 was copied, he is likely responsible for making the texts of the three responsories part of the corpus by including them among Fulbert's writings. In Paris, BN lat. 14167 the texts of the three responsories appear just before one of the sections containing Fulbert's poetry, in a hand practiced at writing liturgical chant texts.[45] This is one of the earliest copies of the famous chant texts, and already they are attributed to Fulbert through inclusion as the first among his poetic works in this Chartrain source.

In addition to Sigo, the best known of them all, there were several students in Fulbert's entourage who were musicians. Arnoul (Arnulfus), cantor after Sigo, was a powerful figure who served also as archdeacon of Blois while cantor and became the abbot of St. John in the Valley.[46] He may well have written the unique Office for the feast of John the Baptist, whose text is found in the twelfth-century ordinal from that place, as well as the set of tropes at the cathedral for the saint, one of the few sets with uniquely Chartrain elements. Oderic Vitalis mentions him as a skilled composer who wrote an Office for the patron of his monastery, Saint Evroult.[47] He notated the Office, but the monks could not read the notation, so they went back to Chartres to be taught. Chartres was a place known for the skill of its musicians in the composition of new Offices.[48] Rainaud, another of Fulbert's pupils, moved

to Angers, where he composed a text for the Office of Saint Florent.[49] Angelran, of St. Riquier, frequented Chartres while Fulbert was bishop and is known for writing Offices for Saint Valery and for Saint Vulfran.[50] Olbert, abbot of Gembloux and then of St. Jacques in Liège, was another who may have been inspired by what he learned at Chartres in the eleventh century; his vita states that he composed Offices for Saints Geron and Waltrude.[51]

The teaching of music theory in the eleventh century is represented by early treatises and by a set of glosses on Boethius sometimes mistakenly attributed to Fulbert.[52] As Delaporte's catalogue, *Fragments* (Palaéographie musicale 17), and his authoritative work on the repertory (1957) demonstrate, the study of actual eleventh-century compositions from Chartres itself is difficult, as few sources survive. Michel Huglo believes that the monk Hartwic introduced the three Marian responsories discussed here into the liturgy of Saint Emmeram, as witnessed to in Munich, MS lat. 14372.[53] Hartwic also had a likeness of Fulbert painted on the first folio of this source: two angels lower a halo on his head, demonstrating the hopes his students had for his canonization.[54] The precious doodling of an eleventh-century Chartrain musician proves that the music for at least one of the three Marian responsories was known in the town at that time, and so the music for the others was probably circulating there as well.[55] By the mid-twelfth century the three chant texts listed among Fulbert's works in Paris, lat. 14167 had become well known as his compositions and were in place in the cathedral liturgy. Their connection with the themes featured in Chartres, 162 suggests that they may have been used for experiments with an Office of the Virgin that was said on some regular basis at Chartres at during the late eleventh and twelfth centuries.

Much of the modern scholarship on these three famous pieces has centered on their musical modality and what this aspect of their style may tell about their "original use" in the liturgy. Because the three chants represent the first three church modes, they appear to be the opening part of a modally ordered set. In the common practice for modally ordered sets, chants progressed in pairs through the church modes, that is, from two works on d (modes 1 and 2), to two works on e (modes 3 and 4), to two works on f (modes 5 and 6), to two works on g (modes 7 and 8), with some sort of return on the ninth responsory, usually to mode 1.[56] The singing of a modally ordered set was a musical tour de force, and eleventh-century composers often created new sets of responsories in this way.[57] Surely the skilled musicians at Chartres Cathedral were used to this kind of display on major feast days; the series of responsories for Saint Giles included at the back of Sigo's book is modally ordered, although not in the usual way, and represents the kind of composition favored at the time the chants attributed to Fulbert were composed.[58]

The musical modes in which the three Chartrain Marian responsories are written can be arranged numerically: "Solem iusticiae," mode 1; "Styrps Jesse," mode 2; "Ad nutum Domini," mode 3. The texts are presented in this order in Paris, BN lat.

14167, and this may indicate that they were indeed initially intended to form a set or part of a now-lost or incomplete set (see Dobszay, 2000). The way in which they were used in the feast of Mary's Nativity at Chartres Cathedral, however, does not follow this order. The pieces are used in the key positions at the end of each nocturn as numbers three, six, and nine, the most famous of the chants, "Styrps Jesse" being number three, "Ad nutum" six, and "Solem iusticiae" nine (see appendix F).[59]

This ordering has led to questions about whether or not the responsories are of Chartrain origin. In actuality, however, the final order of the responsories at Chartres may well relate not to musical modes but to meanings unfolding within the readings as they evolved in the Marian liturgy. It seems likely that the pieces were rearranged after they were composed in order to fit the liturgy as finally standardized in the Chartrain ordinals. The sources suggest that a good deal of experimentation was going on in the eleventh century at Chartres in regard to the Marian cult and liturgical sources associated with it, and the pieces were probably tried out in a variety of liturgical positions. The way in which this happened cannot be studied, for the transitional materials themselves do not survive.[60] Yet this kind of liturgical experimentation contributed to the development of strong local cults, and eventually the use of chants and the sermon *Approbate consuetudinis* together in the feast of Mary's Nativity not only increased the splendor of Marian veneration in Chartres, but also spread the fame of Fulbert and Mary of Chartres through diverse regions of Europe.

When the chants are placed in the context of the sermons in Chartres, 162, it is clear that they are closely tied to the themes developed there, forming reflective poetic and musical commentaries upon the meaning of the Virgin's Nativity. The most famous of the chants, "Styrps Jesse," functioned as a pithy summary of the popular opening of the sermon *Approbate consuetudinis*.[61] The respond's opening section presents the Old Testament sources: the shoot from Jesse produced a rod, and the rod produced a flower. Numbers 17 and Isaiah 11 are fused into one statement, and the spirit of Isaiah 11 rests above the flower of Numbers 17. The verse of the chant explains the Old Testament mystery in New Testament terms, with a play upon *virga* and *virgo*: the rod is the Genetrix of God, and the flower is her Son. The *styrps David* mentioned by Jerome and Fulbert has in the chant become the *styrps Jesse*, a term not found in the work of either writer. This popular chant, which spread throughout Europe in the late eleventh and early twelfth centuries and became a frequent source for polyphonic works and various kinds of paraphrase, gave the image "styrps Jesse" its name in the twelfth century.

The exquisite melody for the chant is unique; it was composed for this text, unlike the majority of earlier medieval responsory melodies, which were commonly adaptations of well-known formulaic patterns arranged in a particular order according to mode.[62] The musical style is typical of Great Responsories from around the year 1000; it is melismatic, with occasional dramatic leaps to punctuate the text,

and runs through the whole range of the mode, as for example the lofty melodic arch on *eius* (see the transcription in appendix D). Key words in the text are emphasized, and the music proclaims the sense units found in the text, with intense musical underscoring for the flower, who is Christ, and *eius*, the word for "her." The verse and the Gloria of the chant are set to the same melody, a common practice at this time in northern France; it was especially favored by Fulbert and musicians in his school, as can be seen from the responsories for Saint Giles referred to above and incorporated into Chartres, Na4.

The manner of performance is particularly important for understanding this chant as a source for the visual depictions of the *styrps Jesse* in the twelfth century. The transcription (see appendix D) lays out the chant in full, with the customary repetitions and with the second half of the respond becoming a refrain for the chant as a whole. This repetition, which fuses sections of the chant, creates a powerful linkage between the first part of the respond and the verse, allowing the Holy Spirit to rest on both the Old Testament figures and their Gospel counterparts, drawing them together through the musical rendering. The musical binding of the verse to the *Gloria* creates yet another kind of parallel, allowing the Trinitarian blessing to find voice along with the virginal rod and her flower. The singers of such a piece and their learned audience had much to contemplate if they desired prayerful reverie at the end of Fulbert's discussion of Mary's lineage as found in *Approbate consuetudinis*.

The responsory "Ad nutum Domini" works to proclaim Mary's distinctive nature as the human being chosen to bear the Messiah. The chant is related directly to the *Approbate* through the parallel texts *sit matrem suam peccatores habere cognatos, inter quos speciosa velut inter spinas lilium appareret* in the sermon (Canal, "Texto crítico," p. 58, lines 73–74) and *sicut spina rosam, genuit Judaea Mariam* in the chant (see also the thirteenth-century sequence for St. Anne, "Mater Matris," which utilizes these themes). Mary's lineage has two related aspects: the sinful nature of all humankind and her Jewish heritage. She is the turning point for human nature: from Jew to Gentile, from synagogue to church (see chapters 10 and 11). Fulbert's three sermons *Contra Judeaos* show him to have been fascinated by the idea of lineage and by Mary as a link as well as a transition between the ancient family tree and a new heritage. The verse of the respond makes this point as well: "virtue overwhelms trespass, and grace the ancient fault." The chant is a summation of themes found in the works contained in Chartres, 162, notably those that may have been by Fulbert and his associates.

The responsory "Solem iustitiae" serves a similar function, resonating with several of the sermons for Mary's Nativity and with the Gospel of the day, Matthew 1:1–18. This exegetical distillation also refers to an antiphon that would have been sung at Lauds on Mary's Nativity, the Office sung shortly after Matins. The theme is expounded on several levels in this extraordinary chant, some textual, others musi-

cal. As we saw in chapter 4, the sermon *Approbate* paraphrases the hymn of the day, "Ave maris stella." "Solem iustitiae" refers directly in the second section of the respond to the hymn text, but the entire responsory is suffused with light imagery: Christ is the "sun of justice"; Mary is the "star of the sea"; the faithful are charged to rejoice at the sight of divine light. The Mary reflected upon in this chant looks back on her lineage—that of the New Testament, expounded in the sermon at the opening along with the miracles to follow, and of the Old Testament in the Gospel reading. The refrain of the responsory is, as would be the case in any such piece, the second half of the respond. This part of the chant would have been sung three times: as part of the respond, after the singing of the verse, and at the close of the Gloria Patri, which was usually sung for the last responsory of each nocturn.

The composer has the chant refer not only to the text of the hymn "Ave maris stella," but perhaps to its music as well, as the mode naturally echoes what could be heard as phrases from the well-known hymn melody, with special concentration upon its opening notes (see appendix D). In this way, the music, like the text, is suffused with light. The purpose of chanting the Divine Office was not only to praise, but also to reflect, and the rhythm was ever between intoned texts (psalms and readings), short melodies (antiphons and hymns), and long, elaborate responsories. Responsories were deliberately designed as times for pondering the readings, and the relationship between the two was central to how religious sensibilities and imaginations were formed. The responsory commonly drew out the meaning of the text it followed or anticipated a text to come; neither text nor chant existed in isolation.

The responsories of Fulbert, in the context of his sermons, exemplify the centrality of the art of music in the contemplation of the past. Chants are resting places for reflecting upon meaning. They break the time line; they stop the action of the narrative; they force consideration of larger meanings. Because of this the texts set to music were inspirational to those who designed the visual arts of the eleventh and twelfth centuries. Surviving art from the twelfth century at Chartres Cathedral offers profound examples of the translation of musical and liturgical ideas into the visual arts, and vital to this work were the responsories attributed to Fulbert. When their themes were proclaimed, the presence of this historic figure was announced as well. When all the chants in the Chartrain liturgy are surveyed, none is as important for the visual arts as the responsory "Styrps Jesse," and to proclaim it in multifold ways was to praise Fulbert as well, to whom it was attributed.

Chartres, 162 happens to be earlier than other witnesses to the full Office liturgy of the cathedral of Notre Dame. It is the probable contemporary of mid- to late eleventh-century sources no longer extant that were available for the copying of the Ordo Veridicus; this ordinal, although dating from after the fire of 1134, is based on an eleventh-century core that must have been standardized when the elements created by Fulbert and his students were put in place, for they are fully integrated

within it. If we look to that core we find chants that worked in ways that are similar to ideas prominent in Chartres, 162 and to its overall agenda as well. In the Book of the Cult materials have been chosen from new and local texts that emphasize themes of Mary's lineage and the *styrps Jesse* motive. So too in the OV: the Marian liturgy has been shaped to put Fulbert's materials in the most prominent positions and to sustain an illusion that he wrote more of the works than he did, by emphasizing works either attributed to him or written on the themes he championed. Repetition of chants that were especially connected to him and related thematically to these works is characteristic. The responsories that came to be attributed to him, for example, were used in a variety of ways on every Marian feast, including the Assumption, and this made the Nativity of the Virgin appear to be a fountain of influence for the liturgies of all the others.

A group of five antiphons, their texts situated in the liturgy of the Nativity of the Virgin (see appendix F), shows the unifying principle of repetition and the use of favored themes. The texts apparently are used in this way only in the Chartrain liturgy, although the Carmelites, influenced as they were by this use, followed the same ideal.[63] For all four Marian feasts First Vespers has the same set of antiphons, which are filled with themes of birth and renewal and of the protective powers of a clear familial heritage. The first in the set, "Hec est Regina," came to refer to all five in the liturgical books (see appendix D for the music of "Hec est Regina"). They were so familiar at Chartres that often they were not copied out, and recovery of the music in an authentic Chartrain version is difficult. I have taken the texts from later Chartrain sources, which are plentiful and demonstrate their longevity and the degree to which they were loved in Chartres (see appendix F, the feast of Mary's Nativity at Chartres). Their prominence at the beginning of every Marian feast and their use as processional chants (see chapter 10) continued the restatement of the thematic complex emphasized by the compilers of Chartres, 162. The Marian liturgy at Chartres was designed to appear as the product of Fulbert and his disciples (and indeed many elements of it must have originated with them). The organizing of liturgical materials in this way is at the center of the history-making process at Chartres, and it was a sure way of creating prominent characters whose influence and reputations could grow stronger in later centuries.

The nature of the book's use at Chartres in the eleventh and twelfth centuries remains a matter of speculation. The collection suggests the desire for a daily Matins for the Virgin by the time it was compiled sometime in the mid-eleventh century, this in addition to the regular, daily Matins service. A charter dating from 1232 (*CNDC* 2:124) mentions Matins for the Virgin as well as for the dead, saying that those who did not stay after the regular hours to sing these would lose income. Chartres, 162 may have contained the texts intoned for that special Marian use, for "the Matins and other Hours of the Virgin" that the ordinal stipulates were sung beginning after the Octave of Epiphany (*OC* 90). Doubtless the responsories attrib-

uted to Fulbert and the five Marian antiphons sung at first Vespers for all Marian feasts were employed in this daily Marian Matins as well. More evidence concerning those responsible for this Office will emerge in our study of the twelfth century. This collection of texts would also have been useful for the four major Marian feasts and their octaves, and for readings for the special celebrations of the Virgin on Saturdays throughout the year, a service that is not documented in the twelfth century. However it was used, this carefully compiled collection of readings was the matrix of the Virgin's cult at Chartres, a textbook for historical understanding, an exegesis on the profound meanings of the relic, and a guide for the visual arts that would come to decorate her shrine and her temple in the twelfth century and later. The sequence "Lux fulget" would have been added to the Chartrain liturgy in the eleventh century too (see text and music in Appendix D). The many ways this Christmas piece celebrated Mary's flesh and its lineage demonstrate yet another means by which eleventh-century liturgists were promoting the cult of the Virgin and the relic of the cloth.

# POLITICS AND RELIGIOUS FERVOR IN TWELFTH-CENTURY CHARTRES

6

# New Modes of Seeing
## Ideals of Reform in the Early Twelfth Century

Blessed is that homeland which knows nothing but joy,
for its citizens unceasingly sing praise—
citizens whom that sweetness affects which no sorrow infects,
whom no enemy attacks, and no mob alarms.

*—from the Chartrain sequence for*
*Saint Augustine, "Interni festi gaudia"*

The sequence "Interni festi gaudia" for Saint Augustine was likely written in Chartres during the time of Bishop Ivo or in the years just after his death when the canons of St. John in the Valley were compiling Office texts in his honor.[1] The strophe quoted above depicts a heaven whose citizens sing joyously, freed from the torments of sorrow, of enemies, and of mobs. Ivo of Chartres would surely have appreciated the description: while bishop he was exiled and imprisoned and worked among a divided group of polarized canons at the cathedral of Notre Dame. None of his accomplishments and failures, either before or after his death in 1116, seems at first examination to relate directly to the development of the Virgin's cult.[2] Even though nothing indicates that he attempted to promote the Virgin Mary—or any saint, for that matter—the importance of Chartres as a center for the Virgin's cult in the twelfth century developed in the context of his widely circulating views concerning the liturgy and the visual arts. While Ivo sought peace at home, the partisans of the First Crusade provoked the population to warfare in distant lands. Both of these phenomena were directly tied to the ways in which history was written and reenacted in the early twelfth century in this northern cathedral town. Liturgical texts written in the period played out at home and in the Holy Land; "Interni festi," though probably written in Chartres, was first evidenced in a Chartrain ordinal copied for a community of Augustinians in Sidon (in modern-day Lebanon).[3]

Ivo of Chartres was born around 1040 and seems to have been educated at Bec under Lanfranc; his correspondence reveals a sustaining network of friends who

were powerful Anglo-Norman churchmen.[4] By the time of his election to the see of Chartres his credentials as a reformer were well established: he had been abbot of the Augustinian Abbey of St. Quentin in Beauvais before coming to Chartres in 1090 and may have played a role in developing a customary, or rule of life, for the reformed canons there.[5] Indeed, like the Countess Berta of Blois (the second) in the decades just before, both Ivo of Chartres and Countess Adela of Chartres/Blois looked to Norman alliances in the governing of the region during this period, with the Angevins ever poised to ambush their varied activities.[6] The political situation in Chartres during Ivo's time suggests telling parallels with events in the eleventh century, and comparison leads once again to views of royal lineage as served by an understanding of Advent. History and politics were markedly different in the early twelfth century from what had come before: any commemoration of the past would unfold within the context of events in the Holy Land that were continually stirring the imaginations of Christians left at home.

## IVO AS BISHOP: STONES AND SERMONS

Ivo's troubles as bishop seem inevitable: he had a high-minded penchant for religious reform and an abiding interest in legal matters, and he had been elected to a see that had become notorious for its abuses in the second half of the eleventh century, especially in regard to simony. Ivo entered almost immediately into a protracted struggle with King Philip I, who had insisted upon marrying his mistress, Bertrade of Montfort, the wife of Fulk le Rechin, count of Anjou, while his first wife and the countess's husband were both still alive.[7] In addition, at the beginning of his reign Ivo brought upon himself the wrath of the powerful Le Puiset family, the viscounts of Chartres; they were vassals of both king and count as well as allies of Ivo's immediate predecessor, the deposed bishop of Chartres, Geoffrey of Boulogne.[8] It was the Le Puiset family who held Ivo in its dungeon during his first year as bishop of Chartres, and family members continued to harass him long after that.[9] Geoffrey of Boulogne had been removed from his office as bishop of Chartres by Pope Urban II (1088–99) for reasons of simony, but he battled for years to regain his post and almost succeeded.[10] Geoffrey's case produced a rancorous cloud of ill will and left a legacy of unreformed canons in the chapter. Ivo's long letter to a recalcitrant archbishop of Sens, a supporter of the king who had refused to consecrate him as bishop, shows the tenor of the times as well as Ivo's desire to protect the office of bishop (*Ep.* 8, 26–37). Ivo's embroilments with the king—he helped persuade the papal legate to excommunicate the king—were his explanation for not joining the crusaders himself (see Sprandel, 1962, and LoPrete, 2007).

Ivo's actions are explained by episcopal vulnerability, often referred to in the letters of Fulbert, in accord with the customs of the time regarding the bishop's palace, servants, and goods. A bishop's death signaled a rampage of destruction—

the so-called *ius spolii*—that Ivo was determined to prevent in the future and whose results he doubtless witnessed when he took over the bishop's complex in Chartres; it must have been in utter ruin, the physical equivalent of a ravaged slavewoman (as the obituary puts it in a disturbing and telling analogy). He secured a promise from Count Stephen-Henry of Chartres/Blois to cease the depredation of episcopal property and, further, to protect it from other secular powers. The promise came probably late in 1099, just before the count's second departure for the Holy Land, when he and the countess Adela were regulating his affairs in preparation for the inevitability that he would not return.[11] Ivo apparently had key phrases carved on the doorway of his rebuilt palace as a proclamation and a warning to any persons who doubted the seriousness of the document's intent. Souchet claimed that the words could still be made out in his lifetime (1589–1651), even though the palace had been repeatedly rebuilt by then and they must have been some sort of copy: "From the authority of the almighty Father and of the Son and of the Holy Spirit, and of the blessed Mary ever virgin and of the holy saints Peter and Paul and of the apostolic see and of our office and the entire ecclesiastical order, we excommunicate and we bar from the gates of heaven and we lay open the gate of hell to whoever takes away from this episcopal house and its additions stone, wood, iron, lead, or glass, or violates or disgraces their integrity. Daimbert, archbishop of Sens, confirmed this anathema with his suffragens at a council in Étampes; likewise in Rome Pope Pascal, with the cardinals of the Church of Rome, confirmed it."[12]

This and other milestones in Ivo's career are described in his detailed obituary, a copy of which was entered into Chartres, Na4 (see appendix G). As can been seen in the excerpt below, the work bears the marks of sophisticated legal training, and it is not too far-fetched to suppose that Ivo himself may have suggested its contents and language in the final years of his life, concerned as he was with protecting his hard-won gains:

> He rebuilt from its foundations, beautiful and of stone, the bishop's house, which had been worthless and of wood—which, upon the death or absence of bishops, by some wicked customs introduced by the violence of the counts of Chartres, he had found in the condition of a female slave—along with all that pertained to it, whether moveable or immoveable. From slavery he rendered it free, and that freedom he confirmed by an agreement as to prerogatives from the Roman see, from the king, and from the count, which is held in the archives of this church. To increase the size of this same house he acquired certain ground contiguous to it from the vidame, and he enclosed this property with a wall (*MSC* 185–86).

The obituary suggests that Ivo's work on securing episcopal properties from pillage went hand in hand with his rebuilding and fortification of the bishop's complex: his palace was expanded, and the material was changed from the customary wood to stone; he acquired adjacent land for the project and fortified the property

with a stone wall. The rebuilt, expanded palace complex, which probably included not only the bishop's domicile but also his private chapel and administrative offices, must have transformed the landscape of the cathedral grounds dramatically, bringing greater institutional security as well as splendor to the bishop's see. In order to complete this work he apparently relied upon a master builder, a certain Vitalis, called "artifex huius sanctæ ecclesiæ" in the Chartrian necrology of N&4. Vitalis's status and devotion to the cathedral inspired him to leave vineyards to the chapter upon the early death of his son, Ebrardus.[13]

Ivo's sermons and the liturgical changes that must have been wrought during his tenure testify to his ambitions as a reformer no less than his building campaign. The sermons, his only known liturgical compositions, were especially prized at the cathedral of Chartres itself, where they were copied in a mid-twelfth-century homiliary as if they were the next works to be added to the liturgy. This suggests that Ivo's sermons were being read in the mid-twelfth century as viable experiments, and if not within the Office itself at least in the chapter or refectory.[14] Those who designed the iconographical program of the sculptures of the west portal of the cathedral in the mid-twelfth century surely thought within the theological context of these writings.

Ivo's sermons offer a rare opportunity to look at a bishop's view of history in the early twelfth century and also at the way in which liturgical understanding informed and offered materials for a reformer's sense of the past. Ivo's view is powerfully pedagogical as he reaches out to instruct the pastors of the numerous and varied flock in his diocese. He made the annual synod of the clergy of his diocese a showcase for his pastoral ideas, and his sermon collection begins with a series of works composed for the occasion. These are the words of a powerful reforming bishop who is working to instruct and inspire his clergy.[15] The sermons also recall the importance of the cathedral to local clergy, who traveled there frequently and often had been trained in its school, and to the liturgical arts on display as part of the teaching program of the bishop.

Ivo's first sermon, *Quoniam populus ad fidem vocatus*, offers his view of the past as being linked to his sacramental theology. With this work he lays down a foundation that sustains the entire collection. He begins with the importance of the sacraments as visual signs of inner realities, signs that the clergy must explain to the people. As many cannot read, what people see is of major importance; the clergy need to be able to say what this seeing means and how it relates to the past as well as the present. Ivo's sacramental theology is an analysis of the coming of the agents of salvation into the temporal world, and proper explanation of the sacraments is a communal history lesson. Sermon 1 begins as follows:

> Since people called to the faith have to be instructed by visible sacraments so that
> through the showing of what is visible they can reach an understanding of what is

invisible, priests of the Lord, who handle these sacraments, must know their mode of working and their order of presentation, as well as the truth of what they signify. Otherwise, the dispensers of such great mysteries are like blind leaders of the blind: they will be useful insofar as they are like beasts of burden that carry bread for others to eat, given that divine grace cannot be absent from any sacrament since through them is worked the salvation of the people. . . . So it is that from the very beginning of time, and in every age, that the sacraments of Christ and of the church have been celebrated, the sacraments by which the people might be sustained and the means of our redemption be made known.[16]

Ivo then discusses the stages of history through sacraments and their power in Christian initiation and formation, introducing themes of special appeal for the time of crusade. He lays out seven ages; these unfold in ways that reveal the power of the sacraments in ancient times and in the present and offer an understanding of how time was perceived by the canons of Chartres and the priests of the diocese in the early twelfth century.[17] In the first age Adam was formed from mother earth, just as in the present age humans are reformed through Christ, who was made from an earthly mother. For "consonance," the side of Adam, from which Eve came, is like the side of Christ, from which flowed blood and water to sanctify the church. The age of Noah saw eight beings saved in the ark. This prefigures the church, which offers the hope of resurrection in the eighth hour (or age) through the waters of baptism. In the third age the rod of Moses struck the Red Sea, just as in the present age the redness of Christ's blood sanctifies the baptismal waters and allows for sins to be drowned. Next, Jerusalem comes to the fore as David's royal city; these two, Jerusalem and David, foreshadow the church and Christ. The fifth age is marked by the Babylonian captivity, a time of confusion and lack of knowledge, and this is followed by the sixth, which marks a return to Jerusalem. At the end of the sixth age Christ was born, and this event ushers in the seventh and final age of history.

The seventh age of time, which for Ivo includes the present, requires a new way of performing sacramental action. He says that when Christianity began in the pagan world of the first centuries, adults had to go through various modes of learning to prepare for the understanding appropriate to receiving the sacrament of baptism. Later, when most adults were raised in the tradition, only babies were without the saving sacraments. Ivo knew that the custom had long been for Christians to baptize their children as babes and that, as the ceremony evolved, the adults present had to offer the responses that those receiving the sacrament were as yet unable to give themselves (PL 162:506). This meant that Christians were no longer catechized before baptism, and they experienced the sacrament's power with no understanding of its meaning. As this has become typical, Ivo says, the clergy presently bear the burden of teaching the people as uncatechized adults, especially in regard to the meaning of the sacraments, their history, and their role in the life of the church.

*Quia Christianam militiam in baptismate,* the second sermon in the collection, is on the seven holy orders and the way in which each was ordained by Christ and exemplified in his life (PL 162:513A–517D). In this work Ivo explained to the assembled clergy of all orders the ways in which their work was a part of the action that sustains and builds the body of Christ. The Old Testament type of each clerical order gives it a sense of mission and importance and was meant to encourage and inspire.

In sermon three, *Quia sanctitas ministerii sanctitatem,* the clothing appropriate to each order and its significance are revealed. The idea of a holy cloth as representative of the Virgin's flesh and, by inheritance, of messianic flesh as well is given a counterpart here. Clerical vestments as replications of those that Moses and Aaron found appropriate for approaching the Holy of Holies indicate that the outer appearance of the clergy should be matched by their inner holiness (PL 162:520B). Ivo's description of the clergy is strikingly visual; he points to inscribed stones and brilliantly interwoven colors, all of them part of understanding the ornamental cloth of clerical ceremony and sacramental action. As he explores the symbolic power of clothing Ivo concentrates upon the meaning of chaste clerical flesh and the abstinence and denial necessary to create and preserve celibacy. The vestments represent what they contain: a male sexuality that is transformed by and for the sake of the priestly office, yet reminiscent of the Virgin's flesh as well:

> Of the other virtues—fortitude, justice, humility, gentleness, generosity—others too can judge, but the conscience alone knows chastity. Human eyes cannot be certain judges of this, apart from those who, like brute animals, are indiscriminately swept away into lust. Hence the Apostle [Paul] says, "Now concerning virgins, I have no command of the Lord" (1 Cor 7:25), and in the Gospel, when the Lord speaks of willing and unwilling eunuchs, he says at the end, "Let anyone accept this who can" (Matt 19:12). As for what are called breeches [see Exod 28:42–43], I do not clothe you in them, nor do I require them of anyone. Let one who wants to be a priest clothe himself, let him fortify himself with chastity. Therefore let us put on breeches, let us cover our shameful parts, let us not seek the notice of others. Let us so cover our genitals that when we enter the Holy of Holies nothing indecent may appear, lest we die (PL 162:524B).

Ivo's sermons steadily focus upon the importance of having outward modes of action that harmonize with inner spiritual states and with the teaching and transforming power of what the people are able to see. The clergy are responsible not only for living rightly but for allowing their way of life and the work of the sacraments to be made visually comprehensible through their actions. He constantly describes both clerical action and sacramental action in the terms of the visual arts and of their ability to teach expressively. The ideal of *docere verbo et exemplo* (to teach by word and example) has been said by many scholars to underlie the work

of Augustinian canons regular in the twelfth century, and Ivo was surely the most influential teacher the order had in northern France in the late eleventh and very early twelfth century, that is, during the time of the First Crusade and its aftermath, which involved the establishment of the Latin Kingdom.[18] His movement from the ages of time to clerical orders to sacraments was the kind of teaching that would inspire reforming Augustinians such as Hugh of St. Victor in the next generation and that would have been heard by those who would assume the leadership of Chartres Cathedral in the years immediately after his death. It would also be inspirational to those who designed art for the new kingdom in the East and to those who yearned for its imagined glories at home.

Ivo's sermon on the dedication of a church (sermon 4, *Quoniam ad dedicationem*, PL 162:527B–535D) explicates various features of church buildings and their exegetical powers, with emphasis on the presence of the bishop and on his historical counterparts in Old Testament times. Throughout his long tenure as bishop of Chartres these are the sentiments that were preached every time a new building was dedicated in the diocese. Because the ceremony required much anointing, this action and the potency of blessed wine, water, and oil offer both continuity with the past and insurance for future sacramental force. In this ceremony the church and its altar are baptized, another example of sacramental power and of its origin.[19] Ivo continues his references to holy cloth in this sermon, perhaps pointing to other ways in which the great relic of Chartres has counterparts in the sacraments of local churches tied to the cathedral of Chartres: "'Happy are those who dwell in your house; ever singing your praise' (Ps 83:5/84:4). Rejoicing and festive, he [the worshiper] will be present at this delightful and festive dedication, he who, in this temple made by hands, when he has accepted the nuptial garment, God's temple, which he is to keep holy and inviolate until this eternal and imperishable dedication" (PL 162:535C). In this image the cloth of the church building is the body of Christ, and he takes it on to himself as a high priest. Although Ivo does not say so, the cloth of his robe is that offered by the Virgin's flesh, as celebrated in song and ceremony at Chartres.

Ivo's extensive sermon on the ways in which the sacrificial modes of the Christian Old Testament foreshadow the sacraments of the New Testament and the church of his day (*Beneficia, quae pro salvandorum*, sermon 5, PL 162:535D–562A) offers near its opening a discussion of the central biblical themes of the Chartrain Marian cult. Ivo treats the themes in ways that make his sermon mesh well with the cult as established by Fulbert's school in the mid-eleventh century, with its emphasis on the ever-pregnant sense of Advent and the regal nature of the Virgin "about to bear." Ivo speaks of the end of the old and the beginning of the new with intensity worthy of Fulbert, but he invokes Jeremiah rather than Isaiah. Whereas Fulbert emphasized the end of the kingly line and the coming of the Christ and pointed to the priestly strain in his flesh, Ivo concentrates upon the order of priests in the

new Jerusalem and the holy sanctuary of the Anointed. Taken together, these two bodies of sermons promote balanced views of the kingly and priestly heritage of the flesh represented by the Virgin's birthing robe. That such messages were preached at Chartres during the time of the First Crusade and its aftermath helps explain the frenzy surrounding Bohemond of Antioch's call to action (see below). The year Bohemond preached the crusade (1106), Easter fell on the feast of the Annunciation, a festive occurrence with powerful symbolic resonance in the cathedral of Chartres.

Ivo's sermons show an awareness of the cult of the Virgin at Chartres, especially through their allusions to cloth and also through discussion of the *paritura*. He uses this locution not only for the Virgin herself, but also for the church she typifies, as seen in his sermon for the beginning of Lent (*Hodie mater ecclesia*, sermon 13, *PL* 162:579C–581C).[20] The collection contains two sermons for the Virgin, for the feasts of the Purification and of the Annunciation, but none for the patronal feast, Mary's Nativity. Ivo may have thought that Chartres had enough sermons to celebrate the Virgin's birth and her Assumption; Chartres, BM 162 placed emphasis on the Virgin's nativity, and Ivo surely knew this collection. Ivo's Marian sermons were apparently meant to complement Fulbert's rather than supplant them.

Yet his words on the Virgin seem to cry out for the visualization these very themes would receive in the next generation and doubtless were receiving in the lost art of Ivo's period—the *pulpitum* he had built, the tapestries, and the wall paintings that surely decorated the church in his time. In the opening of the sermon for the Purification (*Consuetudo ecclesiastica*, sermon 11, *PL* 162:575D–577A) Ivo invokes the power of the decorative arts and compares it to the power of moving images made by processions into the church and the importance of representing the "reality of the events":

> Ecclesiastical custom preserves many likenesses of events that once happened. Through them it represents the reality of the events, and rouses the hearts of simple folk to piety. By this means what they venerate externally may carry them away to love of what is interior. So it is that we erect crosses in church for recalling the Lord's Passion; that in an eminent place in the church, as if in a triumphal arch, we raise banners on high at the time of the Ascension to signify the triumph of Christ; that we record the miraculous deeds of the saints and their martyrdoms by their representation in paintings. By a custom of this kind it has been established that on this festive day [the Purification] the faithful people process with lighted candles into the church (*PL* 162:575D).

The purity of the beeswax customarily used in the Middle Ages for candles used in the church represents the state that people should aspire to when approaching Christ and joining him through the eucharistic sacrifice; the symbol leads Ivo to speak of a favored theme discussed above as well, sexual purity. The image of Christ

that each person carries within should be borne in a pure body ornamented with the virtues of a well-led life. In this sermon Ivo emphasizes the dramatic verses of the Song of Songs, saying that on this day the church is shown under the "type of the bride" who adorns the bridal chamber and receives Christ, the king of kings (*PL* 162:576D).[21] The lover is the Lord; he will rest in the holy ways of the chaste mind just as the bridegroom rests delightfully in the ornamented bedchamber. Here Ivo joins various strands of understanding, working with readings prominent in the development of the Virgin's cult at Chartres as found in Chartres, 162, with the most famous chant text for the procession, and with what the people see, smell, taste, and do as the necessary counterparts to liturgical song. All these things are used to recreate the history of a past event as the people move through a church building that requires their well-informed action to complete its celebratory work of remembrance and commemoration. With Ivo's rubrics as guides, the people make history through commemorative action and place their own lives against the backdrop of commemorated sacred events, especially as explained in the Book of the Cult, Chartres, 162 (see chapter 5).

In his sermon for the feast of the Annunciation (*Gaudeamus in Domino*, number 15, *PL* 162:583B–586C), Ivo emphasizes the freedom the Incarnation offers to human servitude, working, as is his custom, with the way in which the unseen is made manifest in what is seen. Just as the preacher expresses his truths through various rhetorical displays, so the supreme doctor and preacher, God, expressed his Son, his Word, who is a living, visible manifestation of God's love (*PL* 162:584B). The flesh of the Virgin, offered to the Christ, is a sign of the mystery of reversal from sin to health, from death to life, from impoverishment to a shared royalty. The kingliness of the Anointed, the queenliness of the Virgin, mean that all human flesh is made splendid in the incarnational instant: through Christ's flesh joining ours, Ivo says, "we have suckled majesty."[22] The wonders of the Incarnation are displayed through and in the actions of Mary's miraculous and unique begetting of the Christ, and these events are central to the meaning of history. Ivo's sermons stretch out the mystery of change to those who acknowledge it and, as a result, are transformed. This idea would prove central to the art designed at Chartres in the mid-twelfth century; it suggests the ways in which ordinary Christian people were encouraged to embrace the gold and jewels of holy robes as belonging to them as well.

Like his most famous predecessor, Fulbert, Ivo uses the miracles of the First Testament to justify those of the Second:

> In this conception no pleasure of carnal concupiscence was mingled. . . . The Virgin conceived the Word by hearing, and with the Holy Spirit fructifying the Virgin's heart in the virginal bridal bed, divine Sublimity associated itself to our humility in a unity of person. In this splendor is the Son of God conceived, by this purity is he

begotten. No sorrow could befall the one conceiving, no pain the one giving birth: he who had come to gladden the sad world must not darken the hospitality of the womb. As therefore this conception was without any corruption, so—whatever the heretics may chatter—in conceiving and in giving birth the Virgin's womb remained undefiled. Christian gentleness is able to comprehend this without doubt, and prove it to others through the exercise of reason, making the change from lesser to greater, and from earlier to later. For if a ray of the sun penetrating a crystal neither breaks it coming in nor destroys it going out, how much more does the closed and integral virginal womb abide the coming in and going out of the true and eternal Sun.[23] So too the bush that in burning was not consumed is said to have shown Moses a type of unspoiled virginity. So did the rod of Aaron the high priest, prefiguring the same thing, produce flowers and fruit, although by nature it lacked sap and fecund seed. What reason have we, then, not to believe that God could make a human being of a woman without a man's involvement, who once made the first human being of neither a man nor a woman? . . . In this conception, dearest brothers, is contained a great and miraculous mystery . . . the divine and the human are bound together, and they become two in one flesh, that is, Christ and the Church. For this joining the Virgin's womb served as a bridal chamber; from it, nine months having passed according to the laws of birth, like a bridegroom coming forth from the bridal chamber with his bride, that is, with our flesh, he has set his tabernacle, that is our assumed flesh, in the sun.[24]

Accordingly, Christ's person is a sacrament, the final "disclosure" in a long series of explications unfolding within time: Ivo brings into the light the miraculous flesh of the Virgin so that it can be seen and explained. He turns to glass and rays of light to make the point, alluding to the foreshadowings and the small miracles that reveal larger truths as the product of good teaching. The final joining of human and divine essences is the lesson, and it must be learned through history, sacraments, and the revelations offered through the human effort of teaching.

Ivo offers his ideas on the nature of the bishop's office and the importance of teaching through revelation in his sermon for Saint Peter's Chair (*Non inconvenienter, fratres*, sermon 21, PL 162:595C–599C), celebrated on February 22, a day in which the bishop's office was especially explored and celebrated in Chartres and in other places as well.[25] Ivo speaks here of the ways in which the meaning of the office of bishop is made manifest and celebrated; this forms a culmination to his many observations on the priesthood and its importance. He begins with a call to celebrate, to join in the stylized dance, the *tripudium*, that took place on this day: "Brothers, it is fitting that the verse of a Psalm once sung by divine presentiment is inserted into the dance of today's celebration, a day on which the blessed man is set in the episcopal chair."[26] In accord with Ivo's usual way of discussing clerical offices, he heralds Saint Peter as the doorkeeper, the one who has charge of the keys, with reference to the idea of Christ as the door as found in John 10:9: "I am the door. By

me, if any man enter in, he shall be saved: and he shall go in, and go out, and shall find pastures."[27] Peter, the keeper of the keys, has charge of binding and loosing, of penitence and forgiveness. Ivo emphasizes the power of the bishop to keep the door of the church barred to those unworthy of entrance; he, as bishop, has used his most powerful means of controlling secular leaders, the power of excommunication.

Ivo's sermons demonstrate his belief that bishops and the priests serving in the diocese, who are members of the bishop's flock, are one in their offices with the positions established through the actions of Christ on earth. Their job is not only to carry out the offices designed through Christ's modes of action, but also to explain what the offices mean: they are to carry out their clerical duties with the people and their instruction in mind. The work of the prelates and priests is to be both at one with the people and apart from the people; to teach and be a model for them, yet at the same time to be remote from them. This paradox was at the heart of Ivo's work on the liturgy and the liturgical arts. In his view, history had to be taught through sacramental action, and the sacraments revealed that Christ and human-kind were one through the Incarnation. The mixing of human and divine needed to be seen, not only through the lessons of revealed history and the sacraments, but also through the witness of Christ's actual person and its skillful representation. This is a recipe that would nourish and sustain the arts of the twelfth century, especially at Chartres.[28]

As could be expected from a reformer of the time, Ivo was concerned about making sure that members of the priesthood lived holy and chaste lives, appropriately apart from the people they served. The ancient priestly order, represented by Melchisedech and Aaron as well as by Christ and his apostles, was inspired at this time more by the divine than by the human strain of Christ's office and person. Yet the priesthood Ivo defines was to be "reformed" at a time when teaching the people was claimed to be its major task. This enforced separation in a period of intense evangelization demanded the arts of the twelfth century; it provoked the powers of visual and dramatic arts in a variety of ways. Individual manifestations of this large, commonly held ideal drew upon the unique cults and circumstances of each place. So it was in Chartres too, where decisions about art and liturgy were ever made with at least some attention to the cult of the *Virgo paritura*.

## THE THIBAUDIANS AND THE FIRST CRUSADE

In his relationship with the Thibaudian family, and especially with the Countess Adela, Ivo succeeded in promoting good governance and peaceful collaboration. Adela was the daughter of William the Conqueror and thus firmly within the web of Norman influence that made it possible for Ivo to govern with what success he had and to win the concessions he gained from Count Stephen-Henry, Adela's husband. Although they had their differences, Ivo and Adela enjoyed an abiding mutual re-

spect that worked to promote the peace alliance. Peace was important to the count-
ess, especially during the early years of the twelfth century, when she was a widow
with young children.[29] To protect her vast territories from the family's traditional
enemies, the Angevins, she relied upon both her efforts to promote the peace, and
upon the trusted Norman–Thibaudian alliance that had been successful so many
times in earlier generations. Adela cared deeply about history and the reputation of
her family. She was a fierce defender of her husband's honor and was apparently not
inclined to remarry after his death. She promoted her sons and daughters for high
positions and supported historians and poets, several of whom dedicated works to
her. Adela was ready to work to keep the peace, and continued her family's dedica-
tion to Chartres Cathedral and to the Virgin's cult, using the cathedral as a site for
a royal marriage and for preaching the crusade.

The family may well have looked to Chartres Cathedral, as Adela seems to have
done, as a memorial to her own marriage and her lineage at a time when crusaders'
gossip and some written histories questioned her husband's honor.[30] She was proud
to be the daughter of a king, and the mother of sons and daughters for whom she
had high expectations. The long poem written for her by Baudri of Bourgueil has
been translated into English by Monika Otter. Shirley Brown (1988) believes that
the poem may refer to the so-called Bayeux tapestry (embroidery); this depiction of
history favored Adela's father and her family, including her uncle, Odo, the bishop
of Bayeux.[31] If the embroidery can be associated with Adela, it would only have
heightened the sense she possessed of her family and its past. In any case, the de-
scription of her room in Baudri's poem demonstrates Adela's interest in using the
arts to depict history and suggest her family's place within it, whether or not it re-
lates to the tapestry.

Some early donations made around the time of Adela's marriage to Stephen-
Henry of Chartres/Blois included a bell tower given by William the Conqueror
himself before his death in 1087, in honor of a daughter who had died in about
1075. It is assumed to have been made of wood (MSC 83): "(Dec. 8). Adeliza died,
the daughter of the king of the Anglos, for whose soul her father, the king, among
other outstanding and regal benefactions, had built a costly and well-made bell
tower above the church" (MSC 184). Adela's mother, Queen Mathilda, who died
in 1083, seems to be the figure whose obituary is found in Na4 on October 31:
"Mathilda, queen of the English, died. Embracing this church and venerating it
with the privilege of love, she embellished the roof with lead, and, in addition to
many other gifts, gave it a golden box and forty pounds of coins for the use of the
brethren."[32]

Ivo maintained the relationship with Adela's family, as two letters to her sister-
in-law, Queen Matilda, reveal. The first refers to a request for help (*Ep.* 107, *PL*
162:125D–126A), and the second to the roof of the cathedral (*Ep.* 142, *PL* 162:148D–
149C); the letters demonstrate how he engaged powerful female donors. Earlier

bishops had used the Virgin's cult to help with building campaigns, and the high-minded Ivo was no exception. Ivo's letter to the queen draws parallels between Mathilda and the Virgin, the one being queen of the Anglos and the other Queen of the Angels.[33] Ivo's dedication to sacramental action is also seen in the first letter, which thanks the queen for a gift of precious vestments: "Formerly we knew you to be one with the company of wise women by your common reputation, you yourself being far away, but when you were with us, you demonstrated the odor of this fine opinion, and inspired our love."

In an early letter to the Countess Adela, Ivo, adopted the methods of his predecessor Fulbert. His intention when dealing with Adela, as with her mother and her sister-in-law, was to appeal to the Virgin's cult to win favor for himself and his cathedral. Adela, like both her mother, Queen Mathilda, and her brother's wife of the same name, was also pledged to the ongoing work of repairing the cathedral's roof. When one of Adela's sons, Odo, died in the early twelfth century, in his memory the countess secured the restoration by buying out a market near the cathedral where excessive traffic had blocked the delivery of supplies to the workers and impeded their progress: "Odo, son of count Stephen, died. For his soul Adela, the noble countess, his mother, at the request of the canons of this church, directed that a certain market in front of the Porta Nova be demolished, and she conceded that it not be rebuilt later in this location, for the shop held back the great overflow of our carts and wagons that were coming and going for the sake of repairing the roof of this church, turned them back to our barn, and greatly hindered progress."[34] A mother's grief was commemorated in aiding a building project to which other female relatives had contributed.

Donations made by Adela for her husband suggest her affection for him and her recognition that he had achieved his goal through sacrifice: "On this day (May 19, 1102), Stephen died, the Palatine count, in defense of the church of Jerusalem, he who conferred freedom on the episcopal dwellings. For his soul Adela, the noble countess, conceded to the canons of St. Mary the *vicarium* that Geoffrey the Breton sold to them, and she did many other good things."[35]

Adela ruled as head of the family from Stephen's death until 1120 and remained influential as an adviser to her sons and to her brother, King Henry I of England (who died on December 1, 1135). She died on March 8, 1137, the only member of her family's generation whose death notice at the cathedral of Notre Dame recognizes the Virgin's cult. Her obituary can be found in many liturgical necrologies and in other sources as well, including a single line in Na4, unusual in that the book basically was closed in 1134. The entry in the twelfth-century necrology of Chartres Cathedral, the book that continued the work of Na4 after the fire of 1134, is considerably longer and more detailed than her other extant obituaries: "Adela, noble countess of Blois, daughter of William, king of the English; loving the present church with the whole affection of her heart, she conceded independence to epis-

copal houses along with her husband Count Henry and her sons. She also gave this church two candelabra made with elegant workmanship, and the three gems set into the holy reliquary [of the blessed Virgin Mary], and gave an oven and whatever rights she had pertaining to it to the four clerics caring for the altar [of the blessed Virgin Mary]; in return for holding it, these same clerics, for the sake of her soul, were to place two candles before the holy reliquary every Saturday on the best coverlet."[36] The endowing of a special group of clerics under the leadership of the sacristan and dedicated to the altar of the Virgin Mary and her cult began with the Countess Adela.

The agreement for future protection Ivo secured from the Thibaudians would have enhanced his powers as much as his magnificent new building project did. The splendor of the cathedral made it a place where both Ivo and the Countess Adela could host spectacular events, one of which was described in sufficient detail to take us into the cathedral of Notre Dame during the time of Ivo and the countess. Ivo's detailed obituary notes that he gave tapestries "for the decoration of this church" and that he constructed a *pulpitum*. Described as "a work of marvelous beauty" this pulpitum would have been used for the Gospel procession and for the intoning of the Gospel and other texts, as references to it in the OV demonstrate. It also would have provided a place from which the bishop could teach and preach, in full view, and, it might be imagined, with artistic decoration that emphasized Ivo's favored themes.

Marjorie Chibnall believes that the historian Orderic Vitalis, a monk of St. Evroul, may have attended the wedding ceremony in Chartres of Count Mark Bohemond to Constance, the daughter of King Philip I, in 1106, so often does he refer to it in his history.[37] As Bohemond was prince of Antioch, the importance of the Chartrain liturgy in that center may have resulted from these early twelfth-century connections; among the members of the Chartrain community who had already fought with him in the crusade were members of the Boel family, holders of the office of vidame of Chartres.[38] Orderic's account has the immediacy of an eyewitness to a ceremony within Chartres Cathedral during the tenure of Bishop Ivo, and we can see that the pulpitum (called an *orcistra* in Orderic's work) is given a prominent role to play; its location was in front of the main altar of the cathedral, then still apparently the altar on which the reliquary of the holy cloth was kept:

> Prince Bohemond had an interview with King Philip and asked for the hand of his daughter Constance in marriage. He finally married her at Chartres after Easter, and the Countess Adela provided a splendid wedding feast for everyone. The king of France attended with a great retinue and gave away his daughter to Bohemond. He had caused her marriage with Hugh, count of Troyes, to be annulled for some reason unknown to me. Then the duke, who made a fine figure even among the greatest, proceeded to the church, mounted the pulpit before the altar of the blessed Virgin and Mother, and there related to the huge throng that had assembled all his

deeds and adventures, urged all who bore arms to attack the Emperor with him, and promised his chosen adjutants wealthy kingdoms and castles. Many were kindled by his words.[39]

One cannot assume that this pulpitum was an actual jubé, a choir screen that separated the nave from the choir, although it may have been an early example of that type of structure. A sense of its height can be gained from a comment concerning the end of rogations and the ceremonial refreshment served to the tired members of the community. From the OV: "Prayers in our church. The dean serves nectar and a sweet drink to those on high in the pulpitum, while the subdean [serves] to the others in the chapter."[40] The pulpitum was mentioned in Ivo's obituary, and as a result he eventually came to be thought of as the builder of the magnificent choir screen constructed in the mid-thirteenth century, long after the fire of 1194.[41] The pulpitum was mentioned more frequently in the OC than in the OV, and Delaporte believed that at least a temporary jubé must have been built after the fire of 1194 for the sake of the liturgy described in the later ordinal. If the OC was compiled in the 1220s, as Delaporte argues with cogent reasons, and if the thirteenth-century jubé dates from the midcentury, then some kind of massive pulpitum was present in Chartres for the many liturgical activities dependent upon it; was this the pulpitum built by Ivo, perhaps expanded or otherwise made usable after the fire of 1194? Was Ivo's pulpit replaced at some other date in the twelfth century? or was it destroyed completely in the fire of 1194, to be replaced at some rate of construction by the new and magnificent jubè of the thirteenth century, whose fragments have survived to the present time? Who can know? But it is clear from the sermons what themes were preached when Bishop Ivo climbed up into the structure he had built.

## SEEING AND BELIEVING IN THE HOLY LAND

Ivo developed his ideas about teaching and learning about the past during the years that various Latin Kingdoms were established in the East. The histories made in the East and put in circulation back home and the knowledge that Christian liturgies had been established in the Holy Land provided connections with departed friends and loved ones whom "enemies attacked." These enemies, unlike those met in earlier centuries, could not be seen, touched, or smelled by those who remained at home. Drawing on scenes he witnessed probably in Chartres and other nearby towns during the time of Bishop Ivo, Fulcher of Chartres described the parting of crusaders from their wives:

> Then husband told wife the time he expected to return, assuring her that if by God's grace he survived he would come back home to her. He commended her to the Lord, kissed her lingeringly, and promised her as she wept that he would return. She,

though, fearing that she would never see him again, could not stand but swooned to the ground, mourning her loved one whom she was losing in this life as if he were already dead. He, however, like one who had no pity—although he had—and as if he were not moved by the tears of his wife nor the grief of any of his friends—yet secretly moved in his heart—departed with firm resolution. Sadness was the lot of those who remained, elation, of those who departed. When then can we say further? "This is the Lord's doing, and it is marvelous in our eyes" (Psalm 117:23 and Matt 21:42).[42]

The ways in which ecclesial art and buildings were funded at Chartres in this period, especially as related to the fabric of the cathedral and the cult of the Virgin, are a case study for understanding northern Europe in the late eleventh and early twelfth centuries. At that time a major rethinking of the representation of the past occurred, in part as a result of the First Crusade.[43] All of the characters required to understand this development are present in late eleventh- and early twelfth-century Chartres: a brilliant and ambitious reformer as bishop; a powerful countess with a strong agenda for preserving the honor of her lineage and a willingness to join in the bishop's cause;[44] old families accustomed to controlling the church and its property and giving lavishly to support it; a well-established cult ready to be magnified for the spiritual and economic gain of the town and the region; and a powerful association with the Holy Land. This last was a result of the military movement led by the count of Chartres/Blois who, in the eyes of some, returned a coward and who, in the company of local men, had returned to the Holy Land in order to redeem his honor.[45] The major historian of the First Crusade, Fulcher, was himself Chartrain (or at least from the Beauce), and his influence upon religious reforms in the Holy Land in the early decades of the twelfth century may have been significant. This doubtless helps explain the influence the liturgy of Chartres was to have in the Latin kingdom.[46]

Given that Ivo's interests in religious reform and liturgical pedagogy led to the exploration of ideals of governance and the nature of the priesthood, the Chartrain stage becomes one of the most interesting in all of Europe. If one wonders what life was like back home for those who lived in communities closely tied to the crusaders, especially during the first half of the twelfth century, before the wars came to be fought primarily by professional soldiers, Chartres will have answers.

The liturgy of Chartres as practiced during the time of Bishop Ivo was among the best represented of the various Anglo-Norman uses that were being transplanted to the Latin Kingdom in the early decades of the twelfth century. One of the major figures responsible for its influence was the historian Fulcher.[47] He was born circa 1058, which means he was around forty when he departed with Count Stephen-Henry on his initial journey. Fulcher became the chaplain to Baldwin, count of Boulogne, in Edessa in 1097 (which accounts for his absence from the siege of Jerusalem). Late in 1099 he was an eyewitness to the journey of Mark Bohemond

to Antioch and Baldwin, who had become count of Edessa, to Jerusalem; perhaps he had a hand in planning the ceremony for Baldwin's coronation as king of the Latin Kingdom of Jerusalem in Bethlehem, December 25, 1101. From that time on he was active in and around Jerusalem; when Baldwin II was consecrated on Easter day, 1118, and crowned on Christmas Day, 1119, Fulcher was there; he was present in Jerusalem from then until 1127, at which point he falls silent.

Fulcher of Chartres offers a historian's views of the liturgical reenactment of time in the Holy Land during the opening years of the twelfth century, views that were constantly shipped home to inspire those who stayed back; if these local men were not to join the crusaders, at least they could pray for them. Fulcher came to see himself as a new citizen in his adopted land, and he described his new life in terms made to persuade others to join him, to see what he saw, and to share in his experiences of holy places and salvific events.[48] The way in which lands the crusaders were attempting to "reconquer" were made to resonate with the familiar stories of the Bible, reenacted in songs and stories, artworks, and liturgical ceremonies and processions is expressed in the descriptions of the holy places found at the close of the anonymous history of the deeds of the Franks, one of Fulcher's sources for the siege of Jerusalem (at which, as noted, he was not present). Through stational liturgies such as those celebrated in Chartres and other northern towns, the populace could be in ceremonial solidarity with the lands they believed their long-lost loved ones were fighting and dying to recapture:

> If anyone, coming from the western lands, wishes to go to Jerusalem, let him direct his course due eastwards, and in this way he will find the stations for prayer in the lands in and around Jerusalem, as they are noted here. In Jerusalem is a little cell, roofed with one stone, where Solomon wrote the Book of Wisdom. And there, between the temple and the altar, on the marble pavement before the holy place, the blood of Zechariah was shed . . . at the Nablus gate is Pilate's judgment-seat, where Christ was judged by the chief priests. Not far off is Golgotha, that is "The place of a skull," where Christ the Son of God was crucified, and where the first Adam was buried, and where Abraham offered his sacrifice to God. From thence, a stone's throw to the west, is the place where Joseph of Arimathea buried the holy Body of the Lord Jesus, and on this site there is a church, beautifully built by Constantine the King. From Mount Calvary the navel of the world lies thirteen feet to the west. If you turn north you will find the prison where Christ was imprisoned, and if south, near the Sepulchre, there lies the Latin monastery built in honour of St. Mary the Virgin, whose house stood there. There is in that monastery an altar built on the spot where stood Mary the Virgin Mother, and with her Mary the wife of Cleophas, her mother's sister, and Mary Magdalen, weeping and mourning when they saw the Lord hanging on the cross. . . . Two bowshots away from this place, going eastward, is the Temple of the Lord built by Solomon, in which Christ was presented by the righ-

teous Simeon. . . . Between the Lord's Temple and the Mount of Olives is the Valley
of Jehoshaphat, where the Virgin Mary was buried by the disciples. This is the valley
in which the Lord will come to judge the world.[49]

In the Holy Land, the liturgy recreated a time long past in a recaptured place;
through this action, past and present could be newly united through dramatic acts
of memorialization. Fulcher was a historian who had been trained at Chartres, who
knew Bishop Ivo, and who was a maker of the liturgies from Chartres that were
recreated in far-removed lands. Fulcher not only was from Chartres, he also seems
to have been with Ivo at the Council of Clermont in 1095, at which the First Cru-
sade was preached; his knowledge of its details is profound and served as a guide for
later historians of the crusades. He became a canon of the Holy Sepulchre around
1114 and was probably in charge of the relics and reliquaries in that church during
the time Ansellus of Turre was the cantor. As such, he would have played a role in
the wrangling over the customs of the canons.[50]

Fulcher's history demonstrates that he was a religious reformer in his ecclesiasti-
cal sympathies, as could be expected of an attendant of Ivo. Harold Fink discusses
Fulcher's admiration for Pope Urban II, who preached the First Crusade, himself
a reformer.[51] As chaplain to King Baldwin I of Jerusalem and later as sacristan of
the Holy Sepulchre, Fulcher would have been frequently in charge of liturgical
celebrations, relics, and reliquaries, and his writings reveal that worship in the Holy
Land had a special connection with its own memorials and with the history of
events in the life of Christ, the disciples, and the Virgin Mary. Fulcher makes the
desire to join past and present the major reason for his departure from home to join
the crusade: "What then shall I say? The islands of the seas and all the kingdoms of
the earth were so moved that one believed the prophecy of David fulfilled who said
in his Psalm, 'All the nations whom Thou hast made shall come and worship before
Thee, O Lord,' [Psalm 85: 9], and what those who arrived later deservedly said, '*We
shall worship in the place where His feet have stood*' [Psalm 131:7]" (I, vi, 10, pp.
73–74).

That the crusaders joined past and present through their deeds is expressed more
than once in Fulcher's writings about the ceremonies of the liturgy, apparently jus-
tifying in his mind the acts of bloodshed he witnessed all around him. He seems to
have believed that alignment of place and ceremony offered a special kind of tri-
umph. None of these "triumphs" was more dramatic than Tancred's plunder of the
temple of Jerusalem in 1099 and the infamous reports of slaughter that took place
as a result of the taking of the city. For Fulcher, the occupation of the Christians'
historic places by another faith tradition had made those places unclean; it sullied
his view of the past:

Then the clergy and laity, going to the Lord's Sepulcher and His most glorious
Temple, singing a new canticle to the Lord in a resounding voice of exultation, and

making offerings and most humble supplications, joyously visited the holy places as they had long desired to do. Oh, day so ardently desired! Oh time of times the most memorable! O deed before all other deeds! . . . It was a time truly memorable and justly so because in this place everything that the Lord God our Jesus Christ did or taught on earth, as man living amongst men, was recalled and renewed in the memory of true believers (I, xxix, 3–4, p. 123).

In his mind renewal occurs through joining memory and actuality into an ideal of praise, one that can be exported through ritual action and song.

As can be seen in this passage, the history composed by this maker of liturgies in the Holy Land was inspired by a passion for the immediate and by a belief that if he, as cleric and historian, were to die in the practice of his craft, he would as a matter of course join the ranks of the martyrs whose lives he recounted day by day. This linking of present to past action and a belief in present time as constant witness to the ministry of Christ drive his work. His report of a man he considered a martyr makes the point: "For example, one man, as some of our people heard and saw while we were around Antioch, when he heard the name of God blasphemed with great irreverence by a certain pagan, was stirred by a fiery zeal to contradict him in word and deed. He immediately put spurs to his horse and eagerly asked those standing around, 'If any of you wish to sup in Paradise, let him now come and eat with me for I am about to go there'" (II, xxvii, 11, p. 179).

## "INTERNI FESTI GAUDIA" AND "MANU PLAUDANT"

The sequence "Interni festi gaudia," apparently written in Chartres for Saint Augustine, patron of the canons regular, proclaims the view of history encapsulated in the liturgy of Chartres in the first half of the twelfth century as apparently created by local poets; the sequence "Manu plaudant" was written for the feast of the Retaking of Jerusalem (July 15) as celebrated in the Church of the Holy Sepulchre, where Fulcher of Chartres served as sacristan and worked to institute the liturgy and customs of the canons regular. The date of "Manu plaudant" is not known, but it contains references to historians of the First Crusade; the readings for the celebration of the feast itself were passages from Fulcher's own history. Comparison of these two texts gives an intimate view of the relationship of liturgical reenactment of the past as celebrated in Chartres and in the Holy Land in the twelfth century, and they have many themes in common. Together they help explain a great deal about twelfth-century Christian art, liturgy, and history making in this period. The tension between beauty and terror the Byzantine Princess Anna saw in Bohemond's person appears in the liturgy and liturgical arts as well.

The poem written by the Augustinians of St. John's of Chartres for their patron describes the historical narrative offered by the church in its liturgy and grounds it in the past actions of the saints and their hopes in heaven, making them pal-

pable through the action of prayer and praise. This piece transports the reader to the liturgy of Chartres in the middle of the twelfth century, expressing sensibilities heightened through praise offered within a richly laden liturgical memory. The poem speaks of the kinds of problems besieging Bishop Ivo—infected by sorrow, attacked by enemies, alarmed by mobs—as well as those experienced by the crusaders as reported by men from Chartres who knew them. The past is reestablished within liturgical time through the sounds of praise, calling the present toward a better future. The reward of the martyrs found here is to "gaze upon the King," as was promised to those who, like Count Stephen-Henry, traveled far to be redeemed through their deaths. The themes in this liturgical poem grow directly from the time in which it was written and the concerns of the communities that sang it, for it was sung not only in Chartres but also in the Holy Land, where at least one community of Augustinian canons followed the rule of St. John in the Valley, or at least had it copied for their use. Augustine is introduced at the end as a crown for action and sacrifice, drawing him into the spiritual sphere of the first crusaders.

"INTERNI FESTI GAUDIA," A SEQUENCE FOR SAINT AUGUSTINE, SUNG AT CHARTRES AND IN THE HOLY LAND IN THE MID-TWELFTH CENTURY.

The text is arranged to demonstrate the lines linked by musical repetition. The text is as found in Chartres, BM 529, an early fourteenth-century gradual from St. John's. It was destroyed in the fire of 1944, but a microfilm survives:

1a. Interni festi gaudia nostra sonet armonia
1b. Quo mens in se pacifica vera frequentet sabbata
(Let the harmony of our internal feast express our joy in sound,
through which the spirit, at peace within itself, may keep a true Sabbath.)

2a. Mundi cordis letitia odorans vera gaudia
2b. Quibus pregustat avida que sit sanctorum gloria
(The happiness of a pure heart perfumes the true joys
through which a fervent mind foretastes what the glory of the saints may be,)

3a. Qua letatur in patria celicolarum curia
3b. Regem donantem premia sua cernens in gloria
(with which joy the court of heavenly beings rejoices in their homeland,
gazing in glory upon a king offering his own rewards.)

4a. Beata illa patria que nescit nisi gaudia
4b. nam cives huius patrie non cessant laudes canere
(Blessed is that homeland which knows nothing but joy,
for its citizens unceasingly sing praise)

5a. Quos ille dulcor afficit quem nullus meror inficit
5b. quos nullus hostis impetit nullusque turbo concutit.

(citizens whom that sweetness affects which no sorrow infects,
whom no enemy attacks, and no mob alarms.)

6a. Ubi dies clarissima melior est quam milia luce lucens prefulgida plena Dei
   notitia
6b. Quam mens humana capere nec lingua valet promere donec vitae victoria
   commutet mortalia
(There a most brilliant day, brighter than a thousand days, shines with a light
   exceeding all, full of a knowledge of God that the human mind cannot grasp,
   nor the tongue disclose, until the victory of life transforms these mortal things,)

7a. Quando Deus est omnia: vita, virtus, scientia,
7b. Victus, vestis et cetera, que velle potest mens pia.
(when God is all things: life, strength, knowledge,
sustenance, garments, and other things a holy mind can wish for.)

8a. Hoc in hac valle misera meditetur mens sobria hoc per soporem sentiat hoc
   attendat dum vigilat.
(In this wretched valley a sober mind ponders this, that it may experience it through
   drowsiness, and await it while remaining vigilant,)
8b. Quo mundi post exsilia coronetur in patria ac in decoris gloria regem laudet per
   secula
(with which, after periods of exile from the world, it may be crowned in its
   homeland, and, in the glory of beauty, may praise the king throughout all ages.)

9a. Harum laudum preconia imitatur ecclesia
9b. Cum recensentur annua sanctorum natalitia.
(The church imitates the expressions of these praises
when the yearly birthdays of the saints are narrated,)

10a. Cum post peracta proelia digna redduntur premia
10b. Pro passione rosea pro castitate candida.
(when, after the battles are finished, fitting prizes are returned
for roseate passion, for brilliant white chastity,)

11a. Datur et torques aurea pro doctrina catholica
11b. Qua prefulget Augustinus in summi regis curia.
(and a golden wreathe is given for the catholic teaching
by which Augustine is resplendent in the court of the supreme king.)

12a. Cuius librorum copia fides firmatur unica
12b. Hinc et mater ecclesia vitat errorum devia.
(By the abundance of his books the one faith is strengthened,
and by them Mother Church avoids the devious ways of error.)

13a. Huius sequi vestigia ac predicare dogmata
13b. Fide recta ac fervida det nobis mater gratia.
(May our Mother grant us to follow in his footsteps and proclaim his teachings
by grace and with right and fervent faith.)

The themes found in "Interni festi" are magnified in "Manu plaudant," the se-
quence written in Jerusalem for the feast of the Retaking of the City.[52] In this poem,
which exists in a single copy, without notation (except for the opening line in un-
heightened neumes), one finds the histories of Fulcher and others turned into song.
Here, those who come to Jerusalem to see the places of actual sacrifice and burial
and fight for them are saved: "Now the office of praises and the one sacrificed is
opened." Experiences of the Holy Land make the past a living reality, one to be
fought for, died for, and preserved, with the hope of drawing present experience
into eternal praise. This is a new song, written for "new miracles."[53] It reveals a fright-
eningly triumphalist religiosity, one that uses the texts of scripture and the actions
of praise to justify bellicose action under the aegis of the cross.

"MANU PLAUDANT OMNES," A SEQUENCE SUNG AT THE HOLY SEPULCHRE IN
JERUSALEM FOR THE FEAST OF THE RETAKING OF THE CITY:

1a. Manu plaudant omnes gentes, ad nova miracula;
1b. Vicit lupos truculentos agnus sine macula.
(Let all peoples clap their hands with joy at the new miracles:
a Lamb without blemish conquers the truculent wolves.)

2a. Paganorum nunc est facta humilis superbia;
2b. Quam reflexit virtus dei ad nostra servicia.
(Now is the pride of the pagans made humble, pride
that the power of God bends back into our service.)

3a. O nova milicia, paucis multa milia sunt devicta
3b. Venit hec victoria a Christi potentia benedicta.
(O new soldiery! Many thousands are defeated by a few.
This victory comes blessed by the power of Christ.)

4a. Ecce signum est levantum ab antiqua presignatum prophetia;
4b. Quisquis portat signum crucis dum requirit summi ducis loca pia.
(Behold, a conspicuous standard is raised by the ancient prophecy:
the one who bears the sign of the cross while he seeks the holy places of our
    supreme leader.)

5a. Redde sancta civitas laudes deo debitas;
Ecce tui filii et filie, de longinquo veniunt cotidie;
Ad te porta glorie pro culparum venia.
(Holy city, render the praises you owe to God;

behold, your sons and daughters come from afar today
to you, the gate of glory, for pardon of their faults.)
5b. Ecce honor debitus est sepulchro redditus
Quod propheta presciens sic loquitur "et sepulcrum eius honorabitur."
Nunc munus resolvitur atque laudum hostia.
(Behold, due honor is rendered to the tomb
which the foreknowing prophet spoke of saying: "And you will give honor to his
    tomb."
Now is the gift and the sacrifice of praise resolved.)

6a. Crucifixum adoremus,
Per quem daemonum videmus
Destructa imperia.
(Let us adore the Crucified
through whom we see the
empire of the demons destroyed.)
6b. Adoremus resurgentem,
Iter nobis facientem
Ad regna caelestia.
(Let us adore the one who is rising,
making with us the journey
to the heavenly kingdom.)

7a. O imperator unice,
Quod inchoasti, perfice,
Ut sub tua custodia
Pax crescat et victoria.
(O unique Emperor,
complete what you have begun,
so that with your help
peace and victory may grow.)
7b. Fac christianos crescere
Et impios tabescere,
Ut regna subdat omnia
Tua omnipotentia.
(Make Christians increase in strength,
and the impious waste away,
so that the entire kingdom may be subdued
by your almighty power.)

# 7

## Intrigue, Fervor, and the Building of Churches

Hail, door, resplendent with perpetual light,
Shining star of the sea and mother of God, Mary, ever virgin,
Pre-elected by her very grace before the ages of time.[1]

— *From the sequence "Salve porta" for the octave of the*
*Dedication of a Church at Chartres Cathedral*

"Salve porta perpetue lucis," a West Frankish sequence from the tenth century also sung in England, was originally a sequence for either Christmas or the Annunciation, and was one of two that might be sung at the Cathedral of Chartres on the Octave of the Assumption.[2] "Claris vocibus" was a sequence sung for the Purification; "Hac clara die" was sung on the Annunciation. Yet all three of these chants were also sung at Chartres Cathedral during the Dedication feast or within the week following to give the occasion and its octave a distinctly Marian cast. While the Augustinians of St. John's church were bringing the late eleventh-century Dedication sequence "Clara chorus" (discussed in chapter 9) into their liturgies at midcentury, the canons at the cathedral remained faithful to these three Marian sequences; later in the century they too would adopt "Clara chorus" for the feast of the Dedication, as can be seen in the noted missal from the second quarter of the thirteenth century, Chartres, BM 520. All four of these sequence texts were associated with the Dedication feast in the mid-twelfth century during the time the new west façade was designed and constructed; the poems offer a Mariological reading of the feast in this place and suggest ways in which liturgical poetry was inspirational to those designing new architectural features and planning their decoration.

In "Salve porta," for example, God's eternal begetting of the Son and Mary's pre-ordained role in transforming time are placed in parallel. At Chartres, these interwoven themes link the symbolism of Mary's flesh to the relic of her birthing gown and the mystery of creation. There is reference in this sequence to Hebrews 9 as well, a text much commented upon in twelfth-century art designed for Chartres

156

Cathedral. This text too is about seeing: in it the secretive nature of the first tabernacle, hidden from view and mysterious, is contrasted with Christian beliefs about divinity made visible by taking on flesh. As a result, the Christian "tabernacle" is deliberately distinguished from that described in the Jewish scriptures as Christians translated and interpreted them. In older times "the way into the holies was not yet made manifest," and as long as "the former tabernacle was yet standing" the way would not be plain (Hebrews 9:8).[3]

But what was the exegetical stance for medieval Christians when the tabernacle burned or when a town was destroyed? The miracles and mysterious events tied to the Virgin's cult at midcentury unfolded in the midst of a complete rebuilding of the city of Chartres. The building campaign at the cathedral—which can be traced in some detail from local cartularies and necrologies—was related to two fires, one that was held in check through the Virgin's intercession and another that was not. Both the Marian miracle of 1119 and the fire of 1134 underscore the shifting and unpredictable nature of the political and demographic landscapes in mid-twelfth-century Chartres and point to clerical promotion of and interest in the miraculous, especially as associated with the cult of the Virgin Mary. The period between the deaths of Ivo in 1116 and of Bishop Robert in 1164 included reports of major Marian miracles, the gain and loss of a kingdom, and the preaching of a second crusade in which the Thibaudians were once again major players, as they had been in the First Crusade (see chapter 6).[4] It also was an era when the position of females in the genealogies of kings was of crucial importance to the recreation of the past, both on the Continent and in England. The feast of the Dedication of a Church provided a time for honoring buildings embodying histories of the Christian tradition, of the cult of the Virgin, and of local affairs. The midcentury history related here unfolded while the jamb statues of the Royal Portal were carved for the "door resplendent with perpetual light"; the earliest of these statues were carved at a time when no one knew who would be king of the English or whether the Capetian king Louis VII would produce a son and heir. The reconstruction of the Abbey of St. Denis surely related to this same situation: Eleanor had just married Louis (1137) and the expectations for the flourishing of that particular *styrps* would have been intense; high hopes prevailed until the birth of a second daughter in 1151 doomed an already difficult relationship.[5]

## POLITICAL TURMOIL AT MIDCENTURY:
## A THIBAUDIAN BECOMES KING

In 1119, four years into the pontificate of Ivo's successor, Bishop Geoffrey of Lèves, military skirmishes in the region placed Chartres in the cross hairs of destruction, where it remained for decades. King Louis the Fat had suffered several embarrassing defeats at the hands of Henry I, the king of England, and his Norman allies.

Among these was the English king's nephew, Count Thibaut IV of Chartres, the son of King Henry's sister Adela. At this time the count was around thirty years of age and had yet to acquire his epithet "the Great" or to become the pious supporter of Saint Bernard and a builder of churches.[6] Thibaut's reputation around this time was surely colored by his brutal attempt to establish control of the cathedral after Ivo's death. He apparently schemed to have Ivo's duly elected successor removed, and the wrangling was laid to rest and conflict further avoided only through the intercession of devout local figures, most notably the monk Bernard of Tiron and his friend Robert of Arbrissel.[7] Thibaut seemed to match the ancestral profile drawn by the family's detractors in the eleventh century (see chapter 2): extreme good looks, ready cunning (often at royal expense), and, in his case, a brashness befitting one who was both a Thibaudian and a grandson of William the Conqueror. Allies of the French king, as would be expected at this time, had little good to say of him: the contemporary *Chronicle of Morigny* describes him as "swollen with pride from his riches and his nobility"; from Suger's equally negative depiction it would seem that the Trickster rode once more.[8] But the Norman Orderic Vitalis, who writes sympathetically of Thibaut's early and constant troubles, says he was "descended from the stock of kings and counts" and was "one of the greatest magnates in Gaul."[9] Orderic offers another perspective on the warfare in the region as well. He attributes some of the turmoil to the actions of the viscounts of Chartres, the Le Puisets. Early sieges and the destruction of successive castles belonging to the Le Puisets by Louis VI wreaked havoc on the figure of Hugh III of Le Puiset, a leader of brigands and outlaws, "handsome but evil."[10] Suger concurs: "He was like a snake amid eels, which torments and stirs them up and enjoys the taste of its own sort of bitterness, as if it were absinthe."[11]

In 1119 King Louis VI, increasingly frustrated by his military losses and finding himself unable to discover a ready foe upon which to turn his wrath, marched toward Chartres, planning revenge upon his vassal by destroying his revered cathedral town.[12] According to the story as reported by Suger in his *Deeds of Louis the Fat*, Mary saved her church and the town on this occasion just as she sometimes had in the past. The nature of the narrative suggests that Suger received the tale from Chartrain sources, perhaps from his friend Bishop Geoffrey of Lèves, for it is cast in the mold of well-known legends involving Bishop Gantelmus and the breaking of the siege in 911 and reveals a contemporary taste for the miraculous:

> He [Louis VI] lingered in the land for a little while but found neither the king of the English nor anyone else on whom he might take adequate revenge for the insult he had suffered. So he turned his attention to Count Theobald, withdrew to Chartres, and launched a powerful attack against the city, striving to burn it with fire. Then, all of a sudden, the clergy and the townspeople came up to him bearing the tunic of the blessed Mother of God before them. They devoutly begged that he be merciful and,

as chief protector of her church, spare them out of love for her, imploring that he not take revenge on them for a wrong committed by others. The king made the loftiness of his royal majesty bow down before their pleas; and to prevent the noble church of the blessed Mary and the city from being burned down, he ordered Count Charles of Flanders to call back the host and spare the city out of the love and reverence he bore the church.[13]

The event is also mentioned in book 2 of *The Chronicle of Morigny* where Chartres is reported as being partly burned upon this occasion. This is not in contradiction of Suger, who says that those doing the burning were called off.[14] The author of the vita of Saint Anianus passes over the date; if a fire of any consequence occurred around this time, it was never acknowledged in Chartres.[15]

In 1119 the destruction of Chartres was avoided; a disaster in the following year was not. On November 25, 1120, the "White Ship," bearing a huge number of partying and rejoicing youths, foundered upon the rocks tragically near the safety of shore. Four children of King Henry I of England, all nephews and nieces of Countess Adela, drowned, among them William Aethling, the king's only legitimate male heir. Countess Adela nearly lost her son, Stephen, as well; suffering a bout of dysentery, he had decided at the last minute not to board. She did, however, lose her daughter Mahaut, who perished along with her husband, Richard d'Avranches, earl of Chester. Over three hundred flowers of Anglo-Norman nobility and their servants were lost.[16] It is said that from this time until his death in 1135 King Henry never smiled.

The king's attempt to produce an heir later in life failed, and there was steady speculation about the lands won by the Conqueror among all the relatives, including, of course, his closest surviving male relatives from the younger generation, his Thibaudian nephews.[17] Whereas the wreck of the White Ship brought grief to the family, it also made way for a possible Thibaudian triumph. Adela of Chartres/Blois was yet another in the unbroken line of ambitious Thibaudian women longing for royal status for their sons and daughters, like Queen Berta in the early eleventh century and also her granddaughter Countess Berta, who had arranged the marriage at Chartres between her nephew Count Stephen-Henry and Adela, daughter of the Conqueror.[18] As is clear from a letter written to Adela by Peter the Venerable, abbot of Cluny, the death of her brother in 1135 was not only a cause for sorrow, but capped her concern over his successor and the expectation that one of her sons would gain the throne.[19] Much changed between 1120 and 1135, and by the time King Henry died there were three choices for his successor (if one discounts his ambitious daughter), two of them Thibaudian, the third Angevin. Thus the long-awaited decision, even when it came, would offer little hope for resolution and only stirred the coals of animosity between these families that had glowed and flamed for centuries before and that would burn on for centuries after.

Adela and Stephen-Henry seem to have produced eight children (see appendix H). The naming of the sons may be reflective of Adela's strategies, or at least of her desires. The first son was named William, for the Conqueror. It was customary in royal families to name first sons after their grandfathers,[20] and Adela was always conscious (as were those she patronized) of her stature. She was, as might have been expected, at first attentive to the Anglo-Norman heritage, linking her children to their royal grandparents. William, however, seems not to have been of the temperament to succeed his father as count; he was married young to the heiress of the domain of Sully-sur-Loire and effectively left the stage.[21] Thibaut, the second son, named to establish the long heritage of his father's family, came of age around 1107; he was from his early years treated like a first son and therefore heir to the county. Stephen, the third son, named after his father, was put forward vigorously as a potential heir to Henry I after 1120. He was frequently at court, and the king showed him great favor, relying on him for crucial military support once he became count of Mortain.[22] But Count Thibaut, the elder brother, was also a close friend of his uncle and could not be discounted. Adela's youngest son, Henry, was named for her brother but destined for the church; after being trained at Cluny, he was established first in England as abbot of Glastonbury in 1126, a position he continued to hold even after he became bishop of Winchester; his role was to shore up the family's activities across the Channel, and he exceeded all expectations.[23]

Fueling the fires of speculation throughout the 1120s and early 1130s was the situation of King Henry I's only surviving legitimate child, his daughter Matilda, who had been Holy Roman empress until the death of her husband, Henry V, in 1125; she retained the title all her life.[24] In 1127 negotiations went forth for a second marriage, to Geoffrey of Anjou, then a boy more than ten years her junior. The marriage took place, but Matilda soon left her husband for Normandy, not to return to him until 1131. By then the relationship had improved to a sufficient degree for her to bear two sons. And so, upon King Henry's death in 1135 the Thibaudian sons were in contention not only with each other but also with their first cousin, the empress Matilda, her husband, Count Geoffrey of Anjou, and their infant son and heir, named Henry for his maternal grandfather, the king.[25]

The ancient rivalry between Thibaudians and Angevins traced throughout this book was at no time keener than during the war for succession in the mid-twelfth century: the family that won would wear the crown of the Anglo-Norman kingdom, and male candidates from both families were related to the throne through women alone. This situation called up various themes related to the Virgin's cult as a matter of course and gave new resonance to depictions of the lineage of Jesse, as in the lancet window of the west façade of Chartres Cathedral and the chanting of the "Laudes regiae" at the Chartrain bishop's masses on Christmas, Easter, and Pentecost.[26]

A substantial number of Norman barons were pleased with the idea of Count

Thibaut's succession, and upon King Henry's death they initiated negotiations to have him crowned.[27] But his younger brother Stephen, count of Mortain and Boulogne, set sail immediately for England and marched to London.[28] Welcomed by the youngest Thibaudian brother, Henry, the bishop of Winchester, Stephen assumed the crown in a coup that Count Thibaut was neither prepared for nor inclined to war against. The review of family character from the tenth to the twelfth centuries found in this book offers few occasions when Thibaudian brothers fought among themselves. Stephen and Thibaut were especially close; there may have been anger, but in this instance the younger brother paid a substantial monetary tribute to the elder in exchange for his renunciation of the English crown.[29] Part of the tribute seems to have included the jewels that ended up decorating the great cross of St. Denis, another of the several examples of Thibaudian patronage of the Cistercians and of Suger's efforts at decorating his church as well.[30] Historians frequently speculate about the course history might have taken had the more talented Thibaut been made king instead of his younger brother; but the situation Stephen inherited conspired against success, and Thibaut may have chosen the better part. The real heir to the throne of an Anglo-Norman kingdom had perished at sea and, in truth, so too had the hope for a unified realm spanning the Channel.[31]

## THE FIRE OF 1134

In the year before King Henry died, with the crisis of leadership looming, Chartres met its greatest disaster of the mid-twelfth century in the fire of 1134. It appears the entire town, except for the cathedral, was lost. There are many references to this fire in Chartrain sources, and it is described in the vita of Saint Anianus as destroying the entire town but sparing the cathedral (see chapter 1 and appendix C). Like the fire that burned Fulbert's church in 1020, it took place just before the feast of the Nativity of the Virgin Mary, when the town and the cathedral would have swarmed with people and blazed with lamps and candles in readiness for the fair and festive celebrations. It is not possible to say how the fire started: it may have been a result of military activities in the region, for the king's men and those of Count Thibaut were engaged sporadically throughout these years. In any case, descriptions of the fire recall Fulbert's circumstances and his work as bishop, liturgist, and builder (see chapter 4). Although the fire of 1134 is said to have left the cathedral standing, necrologies and other documents suggest that at least some damage occurred to the west part of the building planned by Fulbert and completed by his successor Thierry and later expanded in the second half of the eleventh century (see chapter 5). The Hôtel-Dieu, the almshouse founded by Countess Berta II in the late eleventh century and standing nearby, was destroyed.[32]

The rebuilding of the town must have begun immediately, as the documents discussed below testify. As it went forward, so too did the saga of Adela's sons. In

spite of the fact that Count Thibaut IV and Louis the Fat had been seriously at odds at various times throughout the twenties and thirties, it was the count, along with the "famous negotiator" Bishop Geoffrey of Chartres, Peter the Venerable, and the abbot Suger who accompanied the dauphin Louis VII to southern France for his marriage with Eleanor of Aquitaine in 1137.[33] The old king knew whom he could entrust with his children, and Thibaut was, after all, the Palatine count. Within the octave of the marriage, Louis VI, who had remained in Paris, died of dysentery (August 1, 1137). As the Morigny chronicler tells it, the new king returned home immediately, with Queen Eleanor coming a bit later escorted by Bishop Geoffrey of Chartres.[34]

The initial good will between Louis VII and his vassal Count Thibaut of Chartres was challenged in the early years of the new king's reign. Louis had not been raised to be a king but was the second son and probably destined for a clerical career. He had only emerged from the cloister in 1131 when his older brother Philip, the anointed associate king, died in an accidental fall from his horse.[35] Arbois de Jubanville, who knew the primary sources well, depicts an increasingly pious count engaged with a youthful, inexperienced, and impetuous king.

As he cut his military teeth, Louis made errors that changed his understanding of power. Foremost among them was the disastrous effect of one of his ill-reasoned campaigns, which led to the burning of the town of Vitry in 1143 and the purported death of over one thousand of its citizens (see also chapter 11).[36] Part of the reason that King Louis VII was determined to join the Second Crusade was his need for expiation, and it was on that crusade that he was joined by the sons of Count Thibaut IV, Thibaut (the future Thibaut V of Chartres/Blois, "the Good") and Henry (the future "Liberal," count of Champagne). Surely they had been told stories about the death of their grandfather Count Stephen-Henry in the Holy Land; both of them would have known their grandmother the countess Adela, who was still alive when they were boys and ever eager to explain and defend the heritage of her family and the honor of her husband.[37] Friendships were created on the journey that would prove to be of great importance to the immediate future of Chartres/Blois. The journey also took place during a time of great political instability in the Near East and when noble adventurers who sallied forth could hope for honors and wealth—the reality being that they more often squandered both.[38]

The English branch of the family, now headed by King Stephen, fared less well than did Thibaudians on the continent. Stephen's years were marked by a brutal civil war, a period known ever after as the Anarchy. He has been viewed in the popular historiography of England as an evil usurper, one who tried to steal rule from the rightful line of kings. This is far from the truth: his claim was legitimate, however it is couched by the historians of the times. He had as much of the Conqueror's blood in his veins as did his rival, and both were related to the line through females. King Stephen faced complex and exceedingly difficult circumstances and, failing in his

attempt to consolidate his position, was eventually forced to renounce the throne.[39] He lost his kingdom in two stages: first he gave up Normandy through an official ceremony of renunciation in 1142. His subsequent giving up of the English crown allowed him to reign until his death. He was succeeded in both offices by his young first cousin (once removed), the empress's son, the Angevin Henry II. Heartbroken by the death of his son and heir Eustace,[40] King Stephen had lost his will to fight, and the final stages of his renunciation of the throne were negotiated by his brother Henry of Blois, bishop of Winchester. Under the circumstances Henry did the best he could for his family, for Cluny (to which he remained a loyal son) and for himself.[41] It would seem that although Henry II was the greatest warrior of the lot, his cousin Henry, bishop of Winchester, was the greatest administrator, and it must have been painful for him to wield the seal of doom for his family's hopes. The two Henries were on opposite sides in every historian's narrative; Thomas Becket, consecrated by Henry of Blois and protected by the Thibaudians during his exile on the Continent, was one of the figures caught in the complex strivings between them. Their disputes were only mitigated at the end by King Henry's familial distractions and Bishop Henry's old age; Henry II visited the bishop's deathbed, apparently asking forgiveness for Becket's murder.

So it is that at the time the west portal of Chartres Cathedral was being built and the twin towers were rising, the Thibaudians were caught in a heated phase of the ancient struggle involving the dukes of Normandy, the counts of Chartres/ Blois, the counts of Anjou, and the Capetian kings of France. During this period all the factions, one way or another, achieved (or retained) the power of kingship and posted claims of victory, and the rivalry between the Thibaudians and Angevins had been guaranteed another riveting chapter. To sum up the situation in the mid-twelfth century is not hard: Count Thibaut IV and Louis VII had their difficulties, but Thibaut's son Henry (eventually count of Champagne) soothed them, and the two leaders came to see that Henry II (known as Plantagenet after the fifteenth century), grandson of King Henry I through his mother, the empress Mathilda, and Count of Anjou through his father, Geoffrey, was the real danger to them both.[42] Henry of Anjou came of age just in time to become, in rapid succession, duke of Normandy, count of Anjou, duke of Aquitaine, and king of England.[43] Henry II also sought to add a range of territories farther south to complement those brought to him through his queen, Louis VII's first wife; these included Barcelona, Toulouse, Castille, Navarre, and Savoy.[44]

Like all the Angevins before him, however, Henry was ultimately checked by a Thibaudian-Capetian alliance, this time through intermarriage, and ultimately by the son born to Louis VII by Adela of Champagne, daughter of Count Thibaut IV; this was Philip II, born in 1165. Marriages and fertility counted as much as horsemen and fortifications, and the laws of nature, which did especially well by the Thibaudians during this period, proved decisive. Through the granddaughter of

Adela of Chartres/Blois, the Robertian line was insured at the last by the family that
had borne its standard centuries before.[45] The artworks established in Chartres at
the time, filled as they are with lineage and depictions of a king who takes his heri-
tage from his mother, would have pleased the Thibaudian bishop William of the
Whitehands and his uncle Henry of Blois, Bishop of Winchester, who by the time
of Philip Augustus's auspicious birth was the last living son of Adela and Stephen-
Henry.

Several members of the Thibaudian family made donations to the cathedral of
Chartres during the mid-twelfth century. Of them all Count Thibaut IV and to an
even greater degree his brother Henry of Blois, bishop of Winchester, stand out
as the most likely supporters of the mid-twelfth-century building campaign. Thi-
baut IV was a major builder of churches in the region and was frequently in resi-
dence in his castle in Chartres.[46] By the time the towers and portal were designed
and at least partly executed, he had become a deeply religious man, a close friend of
both Bernard of Clairvaux and Bishop Geoffrey of Lèves. He died in 1152, while the
work was still under way. His son Thibaut V left income from wine sales to establish
memorials in the cathedral for his parents, Thibaut and Matilde, and for himself as
well.[47]

Bishop Henry of Winchester (in some ways Suger's counterpart in England, at
least during the reign of King Stephen) was the greatest patron of the arts in the
mid-twelfth century; his love of lavish furnishings and refined sculpture earned him
the rebuke of Bernard of Clairvaux, who called him on separate occasions "the wiz-
ard" and, worse, "the whore" of Winchester.[48] Political turmoil in England made
it necessary for Henry of Blois, bishop of Winchester, to visit the Continent more
than he would have done otherwise and to spend time in exile at Cluny soon after
the accession of Henry II, and after the deaths of both his prominent older brothers.
For almost twenty years following his brothers' deaths in 1152 and 1154, respectively,
Henry was the elder statesman of the family, uncle to an enormous group of nieces
and nephews, some of whom he patronized directly. His knowledge and love of
the arts and of building are shown by his many ambitious projects in England, his
lavish endowments at Cluny in the mid-twelfth century, and his numerous gifts to
the cathedral of Chartres.[49] John of Salisbury's portrait of him in Rome is worth
recalling for its colorful details, and its digs at the Romans and their love of fine art
and luxury:

> When the bishop realized that he could hope for nothing more than absolution,
> he obtained permission to leave, bought ancient statues at Rome, and had them
> taken back to Winchester. So when a certain grammarian saw him, conspicuous in
> the papal court for his long beard and philosophical solemnity, engaged in buying
> up idols, carefully made by the heathen in the error of their hands rather than their
> minds, he mocked him thus: "Buying old busts is Damasippus' craze" (Horace,

*Satires*, II.iii 64). The same man aimed another jest at the bishop, when he had heard his reply to a request for advice during a discussion. He said, "for this good counsel, Damasippus, may gods and goddesses grant you a barber" (ibid., 16, 17). It was this man who was to reply for the bishop, unprompted but perhaps expressing his point of view: that he had been doing his best to deprive the Romans of their gods to prevent them restoring the ancient rites of worship, as they seemed all too ready to do, since their inborn, inveterate and ineradicable avarice already made them idol-worshippers in spirit.[50]

The sources and the circumstances at midcentury suggest that both Count Thibaut and his brother, Bishop Henry, would have been directly interested in and contributors to the mid-twelfth-century building campaign at Chartres Cathedral. They not only patronized massive building campaigns throughout their territories, but also supported the production of illuminated Bibles and other deluxe books, some of which may have been prepared in Chartres (see chapter 12).

## MARY, THE MIRACULOUS, AND POPULAR PIETY

The western façade of Chartres Cathedral was designed as a backdrop for the miraculous; the rising towers and their bells announced the presence of the saints and their acts just as they called out the hours of services and tolled for the dead. A sense of the power of sound and of the playing out of extraordinary events in the mid-twelfth century is found in the legend of a triple miracle written down in the 1140s by Hermann of Laon. Hermann was recalling the story of the traveling canons of Laon, who took their relics of the Virgin on the road to raise money for their church, stopping at Chartres Cathedral during the tenure of Bishop Ivo. In this legend, written down some thirty years after it supposedly took place, Ivo and the canons create a procession of welcome and demonstrate the ways in which the miraculous was celebrated in Chartres, with a major emphasis on the role of bells. The fervent emotionality belongs to the mid-twelfth century and announces the presence of the Virgin in Chartres, as did the sculptural program, its contemporary:

> On the vigil of the Nativity of Saint Mary, before Vespers, the [bearers of the reliquary] came to Chartres, and were received most honorably by Lord Ivo, bishop of Chartres. As a full procession of canons met them outside the city near the vineyards, the reliquary was placed on the altar of Saint Mary in the cathedral. And behold, a certain crippled woman in the city, whom the bishop had supported for five years in a house where his bread was baked, used to lie in such a crooked state because of her great infirmity that she could only go to the bathroom if she was carried by two people. Then in the first hour of the night Our Lady appeared to her in her sleep, instructing her that she should arise forthwith, go to the cathedral, and look for

her reliquary of Laon. Waking at once, she rose up well, and running to the church through the streets she cried out joyfully, "Lady Saint Mary! Lady Saint Mary!" The bishop's household followed her, and the bishop himself arose from sleep, listening and rejoicing at the needy woman's healing. The woman restored to health entered the church, asking loudly where the reliquary of Saint Mary of Laon was. Standing opposite it, she gave thanks to her, and told everyone how she had appeared to her.

Immediately the bishop ordered that all the bells be quickly rung, and he himself intoned "Te Deum laudamus." While it was being sung, behold another crippled woman, well known to the bishop as well as to many others, entered the church healed. Coming directly to the reliquary, she placed on the altar two little footstools with which (for balance and support) she used to move around while begging. Standing opposite the people she gave thanks to God and to his holy Mother. Immediately the bishop again commanded that all the bells be rung, while beginning again "Te Deum laudamus."

Before it was finished, it pleased the Divine Goodness to add a third miracle. A certain young soldier, a son of the vidame of Chartres, who had been captured, was being kept bound in chains in a certain fortress. Suddenly and unexpectedly he entered the church and, as his mother met him with the soldiers and citizens, he came joyfully to the altar, and on bent knees before the reliquary said that through our Lord he had escaped, and he immediately brought forty solidi to it. The bishop, seeing this, commanded that all the bells be rung for a long time throughout the entire city, not only in the cathedral but also in all the other churches, even the very small ones, giving direct orders that praises be sung to God, before himself beginning "Te Deum laudamus" for the third time. The great noise and clamor of the bells throughout the entire city, that sound of joy, as well as the rivers of sweet tears poured out by both sexes and all ages, pious reader, could easily move even us who stood by silent.

Thus then our brothers, gladdened by the miracles of blessed Mary and enriched by the gifts of the faithful, returned to us with joy around the feast of Saint Matthew the evangelist; greatly delighting the entire city of Laon with such reports, they brought us new joy after the grief of tribulation. Blessed through all things be God, who lives and reigns for ever and ever.[51]

As Ivo explained in his sermons, the mysteries of the faith had been revealed slowly to adult catechumens in ancient times and kept away from the uninitiated (see chapter 6); new ways were needed for initiation and explanation as well as for making sure that the meaning was theologically sound. The solutions eventually arrived at for popular instruction, however, which often depended upon the promises found in miracle stories, especially those surrounding the Virgin Mary, were perhaps not what Ivo had in mind. What seems to have emerged is an intricate and exegetically complicated art created to instruct and inspire, one that would also be used to support the popular legends of the times. The visual programs of

the twelfth century put the sacred histories and their mystical meaning on public display for contemplation by all. At the same time clerics were preaching miracles and attempting to inspire through boldly dramatic ceremonial as well.[52]

The few surviving twelfth-century cathedrals lack the evidence of their ornaments, partitions, and elevations, their complexes of related buildings, their many stucco statues and artifacts, and their brightly painted surfaces. In some cases, only the evidence of liturgical books survives to explain patterns of use. New buildings and new artworks created in this age of religious reform served to teach as well as to associate Christian worshipers with the Holy Land and its biblical history. A report given by John of Worcester, part of which was attributed to the Thibaudian Henry, bishop of Winchester, illustrates the frantic tenor of the times. It also reveals the role clerics played in popularizing artworks in conjunction with miraculous tales and the desire to inspire a second crusade expressed throughout the 1140s. In this legend the cross is nervous and worried about its fate, perhaps reflecting the wonder and concern felt over Jerusalem and its possible recapture in the mid-twelfth century:

> Many saw that the cross on the altar was moving from right to left and from left to right in the manner of people in distress. This happened three times. Then for almost half an hour the whole cross moved and was bathed in pouring sweat before taking up its former equilibrium. At the archiepiscopal township of Southwell, a grave was dug for a burial, and there were found the relics of saints and a glass flask with very clear water flowing from its sides as though from cracks. When the water was given to the sick and drunk by them, they were restored to their earlier good health. I have learnt that Bishop Henry of Winchester narrated the first story, and Thurstan, archbishop of York, the second (both in the hearing of many).[53]

On the minds of those clerics planning liturgies and artworks was the religious fervor incited among the people through the increasingly popular collections of miracles associated with the Virgin Mary.[54] These stories bridged the gap between the actions of historical figures in the land of the crusaders and their direct influence upon events at home. The miracle literature of the time is liturgical commentary for the uneducated and those who preached to them and who talked to them about the meaning of the buildings in which they worshiped. Most important to the general population was involvement with projects that would bring the favor of powerful saints and miraculous intervention for their most severe troubles, especially for sickness and the ravages of war. In the thirteenth century bishops and canons at Chartres promoted Marian miracles in part to secure the funds needed to complete the cathedral after the fire of 1194, and it would seem that this happened in the mid-twelfth century as well.[55] The building of a new church, and the concomitant renewal of cult, occasioned significant history making, especially given that an audience of builders, workmen, devout laity, and other onlookers was ever

present at the site of this and other holy endeavors.[56] The liturgy for the dedication of churches meant that the building of a church was the recreation of an image of the past and of events that took place in the Holy Land; this action was of special significance to the families and friends of crusaders in the first half of the twelfth century. In Chartres many churches had to be rebuilt following the fire of 1134, while a substantial project was undertaken at the cathedral as well. Multiple construction sites must have dominated the landscape, including the area in front of the cathedral, where the building project and the miraculous intervention of the Virgin often were joined in a web of action such as that described in the miracle story above.

The so-called cult of the carts, a phenomenon long linked in the writings of modern historians to Chartres Cathedral, was apparently a widespread phenomenon growing from the emotionally charged decades between the First and Second Crusades, a time when the call to leave for the Holy Land resounded. This reached fever pitch when Bernard of Clairvaux was assigned by the pope to preach a second crusade in the 1140s. As happened in Chartres, the construction of new churches sometimes involved humans willingly volunteering to serve as beasts of burden, carting stones and other materials to the sites of construction.[57] Suger speaks briefly of people dragging columns from a quarry in Pontoise to provide material for his rebuilding efforts.[58] In a letter dated 1145, Hugh, archbishop of Rouen, writes to a fellow bishop, "At Chartres, men began in their humility to drag carts and wagons for the building of the cathedral; and their humility was even illuminated by miracles."[59] The *Chronicles* of Robert of Torigny, in a passage dated 1144, speaks of events in Chartres along with other locales:

> In this year, also, men began (for the first time) to drag wagons laden with stones, timber, grain and other articles for the building of the church at Chartres, the towers of which were then being erected. The man who has not seen this, will not see the like [elsewhere]. And not there only, but throughout nearly the whole of France and Normandy, and in many other places, there was everywhere humility and affliction,—everywhere penance and the remission of sins,—everywhere grief and contrition. You might have seen women and men dragging themselves upon their knees through deep morasses, smitten with scourges; everywhere were frequent miracles, and hymns of rejoicing offered up to God. Upon this unprecedented state of affairs, there is extant an epistle written by Hugh, archbishop of Rouen, addressed to Theodric, bishop of Amiens, who consulted him thereupon. "The spirit of the living creature was in the wheels" [Ezek 1:20].[60]

The most dramatically detailed source concerning this apparent mass hysteria is a letter written by Haymo, abbot of St. Pierre-sur-Dives in Normandy, to monks in the priory of Tutbury. Haymo attributes the beginning of such activities to Chartres but then moves on to a purported eyewitness account from his own region in

Normandy of what sounds like a spirited religious revival tied to the work of building a church. His description also relates directly to Archbishop Hugh's description of events in Chartres, where, he says, the movement began. The purpose of the penance and request for mercy has to do with healing, and the entire episode is a large-scale, dramatic communal prayer for the sick people in the wagons, with hopes for intervention from the Virgin. Each healing was declared a miracle, and the people healed, in turn, provided proof of Mary's miraculous presence. Acts of penance, faith healing, and the "new fashion of prayer" converged in miraculous showings of divine favor:

> When they were come to the church, then the wagons were arrayed around it like a spiritual fortress; and all that night following, this army of the Lord kept watch with psalms and hymns. Then waxen tapers and lights were kindled in each wagon; then the sick and infirm were set apart; then the relics of the saints were brought to their relief; then mystical processions were made by priests and clergy, and followed with all devotion by the people who earnestly implored the Lord's mercy and that of his Blessed Mother, for their restoration to health. If, however, the healing were but a little delayed, nor followed forthwith after their vows, then all might have been seen putting off their clothes; men and women alike, naked from the loins upward, casting away all bashfulness and lying upon the earth. Moreover, their example was followed even more devoutly by the children and infants who, groveling on the ground, not so much crept from the church porch upon their hands and knees, but rather dragged themselves flat upon their bellies, first to the high altar and then to all the others, calling upon the Mother of Mercy in the new fashion of prayer, and there exhorting from her surely and forthwith the pious desires of their petitions. . . . The priests stood over them, shedding tears while they beat with their scourges upon the tender limbs thus exposed, while the children besought them not to spare their strokes, nor withhold their hand in too great mercy. All voices echoed the same cry, "smite, scourge, lash, and spare not. . . ." After each miracle a solemn procession is held to the high altar; the bells are rung; praise and thanks are rendered to the Mother of Mercy. This is the manner of their vigils; these are their divine night-watches; such is the order of the fortresses of the Lord; these are the forms of a new religion; these are the rites, the heaven-taught rites. In their secret watches nothing of the flesh, not a thing may be seen of the earth, but all completed is divine; heavenly altogether are such vigils, wherein nothing is heard but hymns, and lauds, and thanks. The beginning of the sacred institution of this ritual is the church at Chartres, and then it was established here with numerous powers, and afterwards far and wide throughout Normandy especially in those places concerned with calling upon the Mother of Mercy.[61]

The descriptions by Abbot Haymo, along with those of Hugh of Rouen and Robert of Torigny, testify that Chartres was the *locus primus* of a new movement and a new style of adoration and penance that involved singing and ritual action, a kind of Office for penitent laity. Hicks (2007) has discussed these new rites as an

opening up of sacred space to women, and there is indeed no discussion of sepa-
rating the sexes in these descriptions. Centered on the Virgin's cult, the rites stirred
emotional pleas for intervention and aid and joined them to building campaigns
and the actions of the community and perhaps (although more difficult to prove)
of pilgrims as well. Churches created in the midst of such displays became religious
sites for crowds of workmen, of laity and of clergy, providing the atmosphere for
calling up miracles as well as stimulating communal prayer and cries of penance.
The legends that evolved became, as in the case of Chartres, views of local history
that informed architectural understanding long after the buildings themselves were
completed and dedicated.[62]

The very act of rebuilding an entire town and many of its churches would surely
have created an atmosphere of popular piety, piety largely experienced out of doors
and well suited to ceremonial and preaching. Numbers of workmen and their wives
and families were constantly about, as were all their helpers. In their introduction
to the *Works* of Gilbert Crispin, Abulafia and Evans describe the social situation
around a rebuilding at Westminster in the early twelfth century: "One of the most
momentous repercussions of all this, at least as in Gilbert's interpretation, was the
presence of workmen about the abbey buildings. The abbey became something of a
public thoroughfare." Osbert of Clare, who was disappointed of the abbacy in suc-
cession to Gilbert by the appointment of Herbert, wrote voluminous letters to ease
his hurt pride. In one of them he describes how he used to preach sermons to large
mixed crowds of "citizens," including religious and lay people of both sexes. He ex-
pounded the law of God to them "partim in ecclesia, partim in capitulo—partly in
the church and partly in the chapter" (xxxiii). The situation in Chartres during the
mid-twelfth century must have been similar to that described by Osbert of Clare,
and it helps round out one's perceptions of the nature of the audience for artworks
then being decorated. All kinds of people were around, interested, watching, listen-
ing, learning.

The concerns for the sick and the need for cures relate to the diseases of the times
that terrified human souls. Worst among them were leprosy (served by a house for
lepers in Chartres from the mid-twelfth century)[63] and the "fires" of ergotism.[64]
Ergotism—*mal des ardents* or "sacred fire" (*ignus sacer*)—seared the flesh with a
hideous burning. Hugh Farsit offers a detailed, eyewitness account of the effects
of ergot poisoning on the population of the Soissonais during a significant out-
break in 1128.[65] This story of miraculous healing was paralleled in Chartres, as in a
local version of the legend dating from the thirteenth century.[66] As this particular
miracle, reported in Soissons, was first associated with the feast of the Nativity of
Mary, the Chartrains apparently took special interest in adapting it to their own cir-
cumstances and promoting their patronal feast thereby. The miracle was important
enough to be placed first in the mid-thirteenth-century collection as translated by
Jean le Merchant, and the woman cured at Soissons is told that the actual agent of

her healing was the Virgin of Chartres. Evelyn Wilson describes the disease and links pleas for help to the feast of Mary's Nativity, September 8: "It was a wasting disease, spreading under the skin, separating the flesh from the bones and consuming it. First destroying the extremities, the swift fire invaded the vital organs. What is most remarkable was that the fire was without heat. It afflicted its victims with glacial cold, and when the cold had fled, a burning cancer appeared. It was horrible to look upon the distorted features of the sick or those recently healed."[67]

The twelfth century is the first time that preexisting Marian miracles and the telling of other saints' miracles were gathered in collections for popular consumption, especially, it can be assumed, for the use of preachers and for furthering interest in local connections to saints' cults (see Kienzle, ed., 2000). During this century the Marian miracles of Chartres were developed and probably written down in *libelli*, many of them doubtless related closely to freely circulating legends from other locales. A miracle collection written down by Walter of Cluny was influenced by discussion with Bishop Geoffrey of Chartres and is a good example of the tales told there in the mid-twelfth century; that Henry of Blois, bishop of Winchester, was raised at Cluny and was a frequent visitor would have further linked Walter's collection to local tradition.[68] The first miracle reported involves a healing of ergotism and a statue of the Virgin. The miracles emphasize interaction between people in trouble and images of the Virgin that were blessed and empowered with God's grace. Additions made to the history of Paul of St. Peter's in the twelfth century are the first to suggest that a shrine had been established in the crypt of the cathedral and that the well at the "strong place" was a scene of frequent miracles. Chartrain miracle stories that must have circulated orally and in smaller collections that do not survive were compiled and standardized first in Latin in the early thirteenth century; the Old French version was prepared by Jean le Merchant in 1252–62.[69] The antiphons most powerfully associated with the feast of the Virgin of Chartres, the series beginning "Hec est regina," are pleas for intervention, help, and comfort, the musical counterpart of the legends. One antiphon requests special help for the clergy and for "the female sex" (see chapters 5 and 10).

Such frequently repeated melodies and texts were surely in the minds and on the lips of the afflicted and those who cared for them in Chartres. Arnold of Bonneval knew the cathedral of Chartres well and was doubtless present to witness the various stages of the twelfth-century campaign discussed here (see below). He speaks to the brethren of penance and the journey toward spiritual health in terms of moving through a labyrinth; this suggests the ideas driving people's understanding of labyrinth patterns in the floor of Chartres and other churches. The date of the Chartres labyrinth, usually assumed to be sometime in the thirteenth century, has never been securely established; it, or an earlier version of it, may have existed by the twelfth century. In any case, this call to penance and to the inner journey represented by an allegory for the movement of the body through physical space takes us

to the region of Chartres in the mid-twelfth century. The path of good action coils against the treacherous wrong path into which a traveler can slip, both physically and mentally, at any moment:

> Wisdom is not found in the land of those who live an easy life, just as Job said, for in moist places, and in the covert of the reed, sleeping under the shadow, Satan lurks (see Job 40:16). Isaiah predicts "spare bread and short water" (Is 30:20), and David walked through hard places out of God's word and through the Holy Spirit. In much wisdom is much indignation, and one who adds knowledge adds sorrow (see Ecclesiastes 1:18), for impatient reason contends ever against the embrace of vanities, and holiness struggles, lest soundness of mind be corrupted by tickling flattery. None of this effort is for the effeminate and soft, who extend themselves toward every kind of corruption. In our propensity to temptations the strength of God's servants is perfected and increased, and from the affliction of compunction saintly devotion begets joy. The penitent move in a circle, and through the intimate recesses of their souls, having drawn back, they heap up tears and bind up the faggots of their faults. Circling is against circling, because the coiling snake turns against the inconstant body; intricate enlacements drive the wandering and unwary into a labyrinth, and shut up those immersed in darkness in an abyss of despair.[70]

In reports of miracles at Chartres, the nave offered a place to experience a symbolic and difficult crawl from the major portals in the west to the main altar in the eastern end of the church and then to the many other altars and shrines of the church, each of which would have had its own character and artistic display. The cathedral had become a place for the citizens of Chartres to witness the sites of miraculous interventions of the saints, especially for the blessing of the Virgin Mary. During this age of crusading, situating her in the history of the Holy Land as Christians of the time understood it would have been of special importance in this place and indeed became a goal of the artistic program.[71] The construction of the new west façade of Chartres Cathedral, gray and stolid as it may appear at first sight today, was a vibrant display created for times of political intrigue and religious intensity.

## THE FEAST OF THE DEDICATION OF THE CHURCH AT CHARTRES

The feast of the dedication of a church was the builders' liturgy of the Middle Ages; it would have been repeatedly celebrated in Chartres as church after church was repaired and rededicated during the rebuilding at midcentury. The feast's liturgical texts and liturgical sermons based upon these texts formed an ever-present guidebook to the history of God's house and explained the significance of new buildings, new furnishings, and new artworks for Christian worshipers.[72] The ceremony and liturgy surrounding the dedication of churches existed in two guises: one was

the initial dedication (or rededication) carried out by the bishop, the clergy, and the people in the presence of the relics of the saint or saints to whom the church was dedicated; through this act of consecration a building became holy and suitable for the sacraments. The other was the Office and Mass of the dedication of the church, a feast that took place every year on the anniversary of the first dedication ritual. The Dedication feast of every church was a time of commemorating the past of a particular community. The event would be celebrated for an entire week (the octave of the Dedication) as the community recalled historic themes and as local texts and traditions allowed each church to remember when its edifice was built, who made it, and in whose honor it was consecrated.[73] Many churches had their dedication ceremonies within a month of the feast of their patron saint, emphasizing their own building and its significance and drawing the cult of the saint more deeply into the commemorative act.

The texts commonly used in consecration ceremonies and on the feast of the dedication throughout the Middle Ages created the sense that the church is reconstituted symbolically from elements of the Temple in Jerusalem;[74] this gave it special significance in a period of crusade and Christian settlement in the Holy Land. The description of the Temple in 2 Chronicles 6–8 (referred to as 2 Paralipomenon in the Vulgate and its English translation) and sermons upon this text were read at Chartres throughout the octave of the feast, as they were in many other places (see OC 183). To focus on the Temple and its tabernacle, the feast draws extensively upon the figures of David and Solomon as well as on descriptions of the Ark of the Covenant within the Temple.

The opening prayer of the Mass liturgy at Chartres (and throughout much of Europe) is directly dependent upon the idea of church as temple, remade but also directly linked to the prototype. It establishes the feast as a recollection of time past: "O God, you who year by year renew for us the day your holy temple was consecrated, and bring us back in good health to your sacred mysteries: hear the prayers of your people, and grant that all who enter this temple seeking favors may rejoice to have found all that they ask."[75] 2 Paralipomenon records that Solomon wanted many kinds of workers, including strangers, and "he numbered out seventy thousand men to bear burdens." He asked for "a skillful man, that knoweth how to work in gold, and in silver, in brass, and in iron, in purple, and scarlet and in blue." He wanted timber and wheat, barley, oil, and wine. According to scripture, people who worked in metals and in blue and scarlet, people who would cut and hew and bear burdens, were what the Temple required; the miraculous tales as well as donors' records surrounding Chartres Cathedral and the artworks themselves testify to these kinds of actions, these colors, these sorts of supplies and craftsmen. Other details from the building of the Temple by Solomon were elemental to the work of medieval designers as well. The Temple was overlaid with gold and decorated with angels; at its front it had two freestanding pillars, that on the left called

Booz and that on the right Jachin (2 Chr 3:7 and 17). The idea of pillars making a church occurs again in Paul's letter to the Galatians: "James and Cephas and John, who seemed to be pillars, gave to me and Barnabas the right hands of fellowship" (2:9).

The cantors and sacristans who wrote necrologies and histories throughout Europe were steeped in the texts and music of the Dedication feast and the biblical passages associated with the feast; so too were many donors, whose wishes are recorded in the documents. Thus it is not surprising that allusions to the texts were woven into medieval records surrounding donations to building projects.[76] The dependence upon historical models and the blending of artworks and biblical stories often make it difficult to enter into real time, as it were, when studying the writings of contemporary chroniclers, including Suger of St. Denis, who clearly had these texts in mind as he wrote the history of his own church building and its dedication.[77] Those who gathered and preserved the evidence in the twelfth century were making history as they emphasized actions and circumstances that created parallels between ancient architectural endeavors and contemporary ones. This is true of the cult of the carts, for example, which must be taken both as a popular movement and as an action recorded by clerics as parallel to the Old Testament description of temple building.[78] The allusion to the pillar found in Geoffrey of Lèves's obituary is both to the Temple of Solomon and to Geoffrey's work as a builder and sustainer of churches and ecclesial communities. Through such a statement he becomes one of the two freestanding pillars at the door of the Temple; he was surely one of those who commissioned the building of the Royal Portal, and this passage may refer to his work both as donor and as commissioner as well as to his notable career as an administrator.[79]

Divisions between a biblical and liturgical understanding of the past, and the past as it had recently unfolded in reports from the eleventh and twelfth centuries, are often difficult to discern. Such obscurity is especially true when it comes to building and the symbols associated with churches as new temples. Models, both real and imagined, of buildings from ancient times and from earlier in the Middle Ages were ever on the minds of those who constructed churches in the twelfth century. Architectural historians study the Romanesque models that inspired early twelfth-century buildings; the work of the historian of the liturgy is to examine the models that appeared in scripture and, just as important, in the feast of the Dedication of the church, where they were recalled and celebrated in every town and region, year in and year out, and to suggest ways in which these texts and ceremonies may have inspired artistic programs.

Geoffrey of Lèves was widely traveled, and he and his entourage would have known of the architectural experiments carried out in other regions during the first decades of the twelfth century, especially as regards the decoration of portals and

façades. Like other Romanesque patrons of the period, Geoffrey had been through southern France and northern Italy and had traveled to Rome. He and many others had seen the sumptuous triumphal arches of military victory and the great Christian churches of antiquity, and they were alluding to these monuments in the façades of the churches they built in the mid-twelfth century.[80] But because of the Dedication feast, the most important model remained that of the imagined Temple in Jerusalem, in one or another of its several scriptural and ceremonial/liturgical guises. It was not a literal replica that medieval designers and builders were seeking; their model rose from the liturgical texts themselves, tempered by what they knew and had seen, and was open to transformation.

The art of the mid-twelfth century was made at a time when the Dedication feast was celebrated in the Holy Land for new churches constructed by the patriarchs and kings of the Latin Kingdom. Christine Dondi (2004) has established that the Dedication liturgy especially favored in the East was that of the diocese of Chartres. The liturgical commemoration of the dedication of churches in northern Europe had special meaning in the mid-twelfth century for those who celebrated it and who could think of its universality in a new way. For the first time in centuries, the kings and priests of the Old Testament, encountered year in and year out in the Dedication feast of the Latin rite, had living counterparts in the Holy Land itself. There was a new sense of the past as a result, and fresh ideas about how to represent history arose as well. The Thibaudian brothers Thibaut and Henry—sons of Thibaut IV—rode with the young King Louis VII at the launching of the short-lived and disastrous Second Crusade in 1147 and doubtless had high hopes of achieving political gains. Louis is known to have been inspired by reading a copy of Fulcher of Chartres's *Historia*, especially compiled to goad him to action.[81] Artworks with life-sized statues of the ancient kings and queens of Christ's lineage must have been inspiring to a Frankish king and his companions who believed they were returning to reclaim their heritage.

At Chartres, where the cult of the Virgin was primary, the patron saint was herself a model for the church more generally. An elemental change in the feast of the Dedication took place in the diocese of Chartres in the early eleventh century, and this too bound local history and the cult of the Virgin ever more closely. With the building and rededication of the new cathedral at that time, the date of the feast was changed: before Fulbert and Thierry the Dedication of Chartres Cathedral was celebrated on May 13, which was also the Roman feast commemorating the dedication of the Pantheon as a church in honor of the Virgin Mary.[82] The newly built church, apparently consecrated in the 1030s, was dedicated on October 17. The newly instituted October feast would have been celebrated—or at least commemorated—throughout the diocese of Chartres, linking the history of the cathedral to that of the region and to the new building associated with Fulbert. The historic

burning and rebuilding of the church and the new feast would have prompted a revision of all the books in the diocese, and this in turn would have caused a reconfiguration of local history. Through these reforms the Dedication feast in Chartres came to be shaped by different chants and ceremonies that gave it further connection to the cult of the Virgin as this developed in the course of the eleventh century. The role of the feast in local understandings of history will be discussed in chapter 12 as well: the texts and music were revised again after the fire of 1194 to become even more closely tied to the cult of the Virgin and to the historiography of Chartres.

Most liturgical texts for the ceremony of dedication and for the feast that recalled it were taken from scripture, with a fairly high degree of standardization throughout northern Europe. For example, the readings for the feast, beginning with the scriptural passages and biblical exegesis by the Venerable Bede found in the Office, were assembled in Carolingian times.[83] The Old Testament reading from 2 Chronicles, mentioned above, described the Temple. The Gospel reading of the day was taken from Luke 19, introducing themes that played against those of Solomon, David, and the Ark of the Covenant. In the Lucan text Jesus comes into the "house," into Jerusalem; it includes the story of Zacheus, who climbs a tree to see Jesus and welcomes him into his house as Jesus notes that "this day is salvation come to this house, because he also is a son of Abraham." There is as well a foreshadowing in the Gospel of the procession of the palms and the entrance into Jerusalem.[84] In Chartres the incorporation of liturgical texts from the eleventh and twelfth centuries to supplement those inherited from the Carolingians moved toward a more dramatically visual sense of historical remembrance as found in a program of liturgical artworks and development of ways of seeing as basic to appreciating the meaning of the church and its liturgical arts.[85]

References to the Temple of Solomon in the liturgy of the Dedication were elaborated upon at Chartres in several ways. The feast and its traditional readings from scripture were embellished with references to the Virgin Mary as a type of the Church and also with baptismal imagery recalling the feast as the moment in which a particular church was born. These common strategies were used by liturgists at Chartres to direct attention to the main altar of the church as the new tabernacle, transporting images from both the Ark of David and the Temple of Solomon to the Christian church. Woven into this understanding were other liturgical texts, especially the story of Jacob's dream, the stone, and the ladder as found in Genesis chapter 28, themes that can be seen in the pontifical ceremony of dedication as well as in "Clara Chorus" (see chapter 9).[86] In "Clara Chorus" the Christ is the Solomon who describes the beauties of his bride the Church in a language that is from the Song of Songs fused with familiar vocabulary from Marian texts used in the liturgy. The wonders of the Virgin as Church include details that may have inspired the religious arts:[87]

6.1. Turris supra montem sita indissolubili fundatur bitumine uallo perhenni munita
6.2. Atque aurea columpna mirris ac uariis lapidibus constructa stilo subtili polita.

(6.1. A tower placed upon the mountain with undissolving mortar, safe in an eternal valley,

6.2. And golden columns made with strange and varied stones, marked with a skilled pen.)

The varied columns at the bases of some jambs statues in Chartres are mindful of the sequence text. The Royal Portal with its vast array of carvings calls up the parallel description 3 (1) Kings 6:29: "And all the walls of the temple round about he carved with divers figures and carvings."

This dedication ceremony would have been celebrated many times in Chartres and throughout the diocese during the twelfth century, as churches were rebuilt or refurbished and consequently reconsecrated. The Temple and its dedication provided symbolic and historical understandings that were manipulated through liturgy and the arts to proclaim renewal and change and, at Chartres, to teach the people about the striking difference between the Temple—as these Christians understood it—and the church and the art they made for it. Just as important as the specific texts and music was the strategy of viewing developed with these arts.

Descriptions of the Temple and the tabernacle found in Exodus, 2 Chronicles, Kings, and the Psalms were interpreted repeatedly by Christian exegetes, especially as they knew these texts in the liturgy from the Carolingian period on. These allusions can be seen not only in liturgical commentaries such as that of Suger of St. Denis and in obituary notices such as that for Geoffrey of Lèves and Milo of Muzy, but also, and most powerfully, in the arts decorating twelfth-century churches and the system of liturgical understanding that informs them. The necrologies offer evidence that the candelabrum near the main altar at Chartres was like that placed in the Holy of Holies, a replica of the flowering rod of Aaron, first described in Numbers 17; this gleamed within the tabernacle as a symbol of the priesthood that won God's favor.

This image garnered special attention at Chartres in the twelfth century because of its association with Bishop Fulbert and the eleventh-century Chartrain texts for the feast of Mary's Nativity. These liturgical texts featured the symbolism of the flowering rod fused with the *styrps Jesse* and were related to the apocryphal legends surrounding events in the life of the Virgin (see chapter 4). The Old Testament view of the Temple and its inner sanctum was alluded to in several places in the New Testament, but the most important of these at Chartres was Hebrews 9, in which Jesus becomes the new sacrifice and the new occupant of the holiest of places.[88] In fact, this text is central to understanding the twelfth-century work of church building, especially as regards the ornamentation of the inner sanctum of the building, the tabernacle, which corresponded to the main altar of the church. The new taber-

nacle was depicted repeatedly in various artistic configurations at Chartres and linked both to the Incarnation and to the burial and Resurrection of Christ. Interpreted within the framework of liturgical understanding offered in Hebrews 9, the altar became the matrix from which all else evolved in the arts of the midcentury. Christians had descriptions from the Old Testament as well as the mystical and allegorical interpretations of the New, and at Chartres they drew them into new visions of the church, rethinking time and the meaning of the sanctuary in the process.[89] Claudine Lautier (2009) has called the ark of the temple the "first reliquary." To impose Mary's womb upon it liturgically, exegetically, musically, and visually was the primary goal of artists and patrons depicting the past at Chartres in the twelfth century.

# THE CAMPAIGN AT MIDCENTURY

## Bishops, Dignitaries, and Canons

The little one cries from within the narrow confines of the crib,
Whom neither the heavens alone, nor hell, nor the extent of all creation
  could contain;
He who clothes all people, is covered with tight wrapping;
He who feeds all now sucks the virginal breasts, and, thundering, glows red
  in the heavens.

*—From the eleventh-century Christmas sequence "Lux fulget" sung
at Chartres Cathedral in the mid-twelfth century*

In his autobiography, written around 1115, Guibert of Nogent recounts his pious
mother's vision of the Virgin Mary: "While she was mourning my plight and that of
such a church, suddenly a woman of beauty and majesty beyond measure advanced
through the midst of the church and right up to the altar, followed by one like a
young girl whose appearance was in its deference appropriate to her whom she fol-
lowed. Being very curious to know who the lady was, my mother was told that she
was the Lady of Chartres. At once she interpreted this to mean the blessed Mother
of God, whose name and relics at Chartres are venerated throughout almost all
the Latin world."[1] Guibert's story suggests that the Virgin of Chartres had become
a figure of transregional importance in the early twelfth century; other churches
would refer to her special powers, just as the Chartrains would usurp stories from
elsewhere and adapt them to their own needs. The cult of her holy tunic resonates
with the Christmas sequence quoted above, whose notice of Christ's cloth wrap-
pings is also found in the depiction of the baby in the southern tympanum of the
west portal (see chapter 9). Divinity—sequence and sculpture both say—has been
bound with flesh.[2] Mary was to be magnified in succeeding decades through a gran-
diose history-making venture in Chartres. The administration that ran the diocese
during the midcentury decades when the visual arts flourished in Chartres was
tightly bound itself.

In the mid-twelfth century the diocese of Chartres was led successively by three bishops, related by blood, or by bonds of long-standing administrative service. These individuals had a sustained plan for the refurbishment and rebuilding of the west end of the cathedral, and the plan was integrated within the goals of an even larger campaign. The ambitious campaign under way during the period can be outlined through study of cathedral necrologies, and the contributions reveal that general funds were established for three specific projects and that a fourth must have been encouraged as well: (1) the construction of the towers and connecting façade (the so-called "opus turris"); (2) establishment of an endowment for choral offices and major enhancement of liturgical activities and singing, usually called "opus surgentium ad matutinas" (this endowment doubtless inspired the production of liturgical books and the standardization of the liturgy found in the twelfth-century ordinal); and (3) the repair and enlargement of a large gold and silver crucifix bedecked with jewels (various wordings were used for this project, most commonly "ad crucifixum reparandum"); (4) the fourth major component of the midcentury campaign was an attempt to solicit donations for a program of stained-glass windows.

So common are these elements of the campaign in the obituaries of dignitaries that they are useful in dating the notices of less well-known persons whose names are missing from cartularies. Enlargement of the main altar and other altars and the further enrichment of the major reliquary, that containing the chemise of the blessed Virgin, were ongoing at this time as well, the donations resembling those of earlier centuries. Many of the details concerning donors to the building campaign have been noticed by other scholars and are scattered through many publications. However, no one has outlined the components of the campaign or drawn the donors' activities together into a single, coherent view of the activity in and around Chartres Cathedral throughout the several decades of refurbishment and new construction at midcentury. It is vital to the study of the twelfth-century artwork that survives at Chartres to understand that it was planned during a time of administrative cohesion and that it was created in concert with a major effort to enhance the liturgy, not apparently through new works, but through a better-funded choral establishment to sing works that were already highly revered.

The necrologies and recordings of anniversaries studied here were used in worship, read out in Chartres Cathedral day by day at the hour of Prime as the church year unfolded.[3] Thus the entries in the necrologies formed a particular kind of history, one that described the physical space of the church and its decorations as the offerings of these bishops, dignitaries, and other persons were remembered. Those who were of the same office or the same family would have a special anniversary of remembrance and could often see and touch the works supported (or at least supposedly supported) by their predecessors and ancestors. While buildings and artworks were destroyed or replaced in Chartres (most significantly in the rebuilding after the fire of 1194, discussed briefly in chapter 12), the necrologies remained

and may have served as guidebooks to what had been and to what should be. The necrologies, then, were interactive with building and rebuilding and with artworks, old and new.

## THE BISHOPS OF CHARTRES IN THE MID-TWELFTH CENTURY

The bishops of midcentury were an ambitious and energetic group of men, consisting of a triumvirate that ruled in succession from 1116 to 1164: Geoffrey (or Godfrey) of Lèves; Goslen of Muzy, Geoffrey's nephew; and Robert, sometimes called "the Breton." They were followed by the first Thibaudian bishop, William of Chartres. William was a grandson of Countess Adela, the son of Thibaut IV, count of Chartres/Blois, and the brother of Count Thibaut V. The first three bishops formed a tightly knit ecclesiastical dynasty. They were all members of the chapter before taking office, and they filled the ranks of dignitaries with family members and friends during their episcopal tenures, which mitigated the tension rising from opposition from some of the canons to the reformers' agenda (see Smits, 1982). The election of William (later known as "of the Whitehands") in 1164 was contested. He became bishop only after first serving as bishop-elect because of his youth, and he continued to hold the office of bishop of Chartres even after he became archbishop of Sens, not relinquishing it until 1173, when he became archbishop of Reims. Thus the final stages of the midcentury campaign unfolded with a young man in charge, one who was the protégé of his uncle Henry of Blois, bishop of Winchester, who died in 1171.

The lack of leadership and continuity after the death of Bishop Robert was apparently addressed by the longevity and power of Geoffrey of Berou, who served as dean for decades. He held his position of leadership throughout the final years of William's time as resident bishop, through his years of governing in absentia, on through the years of John of Salisbury (served 1177–80) and Peter of Celle (served 1180–82), and then into the tenure of the Thibaudian Reginald of Mouçon, bishop from 1183 to 1217. Geoffrey was in office from 1166 to 1202, the longest-serving official ever to hold the post of dean, and he began his tenure with one Thibaudian as bishop and ended with another.[4] He and other like-minded administrators would have been responsible for preserving twelfth-century spolia after the cathedral burned in 1194, surely with the idea of incorporating them into the new edifice that rose fairly swiftly to replace the lost eleventh-century cathedral (see chapter 12).

Bishop Ivo had not depended upon close relationships between his administration and leading local families, with the exception of the family of the vidame and his close, generally positive relationship with the countess Adela. It appears he himself was not from Chartres, and part of his reformer's mission was to break the links between local wealth and the purchase of ecclesial offices; his strained relationship with the Le Puiset family is well known (see chapter 6). A somewhat different

regime followed Ivo's with the election of a bishop from a locally prominent family, the Lèves, whose story is central to Chartrain history making in the mid-twelfth century. Grégory Combalbert (2007) has evaluated the legal proceedings and decision making of Ivo of Chartres and the three bishops at mid-twelfth century. Because the diocese was far-flung and contained lands held by the crown and other families besides the Thibaudians, the bishops of Chartres were major arbitrators of peace throughout the period. Their negotiations moderated between secular and ecclesial parties as well as between churches and monasteries, and the Lèves/Muzy bishops, who were founders and reformers of churches as well as close relatives of local landholders, seem to have been specially well suited for the work.[5]

Our knowledge of the history of the Lèves begins tenuously in the middle of the eleventh century. In his study of charters from St. Martin-des-Champs in Paris, Joseph Depoin demonstrated that the Lèves of Chartres were a branch of the powerful Riche family (often found in the Latin as well, Dives). Goslen I, the patriarch of the Chartrain branch, is listed as a witness to a charter of King Henry I, dated 1048: "Signum Gaulini Casati Carnotensis" (*CNDC* 1:91). He was a contemporary of Bishop Agobert, according to Paul of St. Peter's (*CSP* 31), and signed other documents in the entourages of Kings Henry I and Philip I, the last dated to 1060.[6] A noteworthy citation appears at the close of a suspiciously generous charter ostensibly issued by the tenth-century Bishop Ragenfredus for the monks of St. Peter's. At its close Paul the Scribe recounts many instances of retreat from its tenets; among the perpetrators of these various crimes is a local landholder, Goslen of Lèves, who stubbornly held on to the income from vineyards given to the monks by Bishop Hugh I.[7] Paul and his heirs apparently used this past report to try to obtain money, land, and fees from the Lèves; this strategy often met with success, not only for St. Peter's, but for other churches as well.[8]

By the mid-twelfth century the Lèves were at the pinnacle of their success, with two successive bishops of Chartres and several other family members among the high-ranking dignitaries of the cathedral. They had intermarried with families of both the vidame and the viscount of Chartres, and this surely accounted in part for the control they seem to have wielded over the diocese and the cathedral; a Lèves daughter had married into a well-placed family from Dreux. The preponderance of important local figures among the Lèves named Goslen (which has a variety of spellings) is due in part to both sons and daughters favoring the patriarchal name, as did servants of the family.[9] Other family names, Milo and Geoffrey, were part of the *namengut* of the extended clan studied by Depoin just as they were among the branch from Chartres.

The legend of the Virgin Mary regarding the dispatch of the Normans in 911 concerns the family land of the Lèves. The Normans came to Chartres via the river Eure, which winds from the southwest on its route to the even more serpentine Seine; this it joins just upstream of Rouen, the Norman capital. As appears from the

legend of Rollo added to the collection of Paul of St. Peter's in the twelfth century, the battle of 911 raged upon a plateau at the "mons Leugarum," adjacent to the river, which offered a quick departure route for the foes.[10] The plateau is almost due north of Chartres; other streams join the Eure as it flows through Lèves, making it wider and increasing its value for transportation. According to Métais, Thibaut the Trickster, a great builder of castles and dungeons throughout his realm, constructed a fortress in Lèves as a way of protecting the town's northern flank from those who approached via the river. The Riche family eventually was chosen as the keepers of this fortress and the lands around it, at least in part because of their strategic position on the waterway and involvement in both transportation and milling.[11] Métais was able to locate the ancient donjon or castrum of the Lèves family and reported his visit there, where he walked through the expansive cellars.[12]

The intricate ways in which the Lèves family were tied to the cathedral and its various mid-twelfth-century campaigns begin with Bishop Geoffrey. In addition to serving as bishop of Chartres, Geoffrey was a papal legate to the provinces of Bourges, Bordeaux, Tours, and Dol from 1132 until at least 1143, and probably until 1145; he was one of the most powerful figures in the mid-twelfth-century northern European church, renowned for his preaching and diplomatic skills.[13] Bernard of Clairvaux praised Geoffrey's high moral standards and good sense in the *De consideratione*, a treatise written to advise Pope Eugene I:

> What a delight it is for me to have occasion to recall and to mention a man, the memory of whom is most pleasant, I speak of the bishop, Geoffrey of Chartres, who at his own expense vigorously administered the legation to the regions of Aquitaine, and for so many years! I speak of something I saw myself. I was with him when a certain priest presented him with a fish which they commonly call a sturgeon. The Legate asked how much it cost and said, "I do not accept it unless you accept payment." And he gave five solidi to the reluctant and shame-faced priest. Another time, when we were in a certain village the lady of that village as a sign of reverence offered him with a towel two or three dishes which were beautiful even though made of wood. This man of scrupulous conscience examined them for some time and praised them, but he did not agree to accept them. . . . O that there might be an abundance of such men as this one was and as those were whom we described to you before![14]

Geoffrey's obituary in the cathedral necrology was put in its final form long after his death, as the young Philip Augustus (b. 1165) is mentioned as king designate, placing the document (or at least this version of it) in 1179 or 1180. As it was based on earlier sources, the document provides a useful catalogue of Geoffrey's deeds, organizing and validating them for the claims of subsequent bishops and dignitaries. The charters bearing his name demonstrate that he worked by advancing members of his own family to church office and by drawing upon the financial and other resources of his family for the good of the church. In addition to the abbey of Josaphat, he

and his nephew and successor, Goslen of Muzy, reformed the collegial churches of La Madeleine of Châteaudun and St. Cheron of Chartres, both of which became communities of canons regular after their reforms. As the study of liturgical materials bears out, St. Cheron was affiliated with St. John in the Valley and, like it and the Madeleine of Châteaudun, followed practices similar to those of the cathedral.[15] The standardization and promulgation of the cathedral liturgy mentioned above in conjunction with the raising of a choral endowment was doubtless carried out under the orders of the ambitious Lèves/Muzy bishops and their protégé Robert, who wished to cement through the liturgy the relationships between the churches they reformed and the cathedral; as noted in chapter 6, they surely inherited liturgical materials that privileged the Augustinians from the time of Ivo.[16] The earliest complete copy of the ordinal, the recently rediscovered Châteaudun 13, is a pure cathedral book; it was copied for the Hôtel-Dieu in Châteaudun, which was built by Count Thibaut IV (see chapter 7). As Geoffrey of Lèves reformed La Madeleine in Châteaudun, the Hôtel Dieu likely got its liturgical practice from that church, which came to it, in turn, from Chartres Cathedral.

Bishop Geoffrey was the most prominent member of the Lèves family, and its prestige rises toward him and descends after him. He was the only Lèves who became well known outside the region and who exerted major power within a broader sphere, especially as papal legate later in his life. Souchet and Lépinois after him relate that Bishop Geoffrey's election as bishop was initially not favored by the Thibaudian count; Souchet speaks of the charge of simony.[17] Legend has it that Geoffrey built the abbey of Josaphat in expiation for a vow to go on pilgrimage to Jerusalem, a vow he could not fulfill as bishop of Chartres, but one that would encourage the recreation of a Holy Land at home. Geoffrey's name for the church he founded went beyond a desire to recreate in Chartres the topographical circumstances of biblical history in Jerusalem; he also chose a name featured in a sermon found in the Book of the Cult of the Virgin of Chartres, describing the place of the Virgin's burial (see chapter 5). Thus the abbey of Josaphat was created to complement the cult of the cathedral, which under this campaign became in its artistic programs even more intensely about Mary's conception and birth, while the emphasis at the new Josaphat was upon the Virgin's life after the Resurrection, her Assumption, and her afterlife as queen of heaven. Geoffrey, his brother and cofounder Goslen IV, lord of Lèves, and all their clan would be buried with the Virgin in a place recalling the historic resting place from which her body was assumed into heaven. Josaphat became a necropolis that served most of the bishops of Chartres until the French Revolution.[18]

The records of many donations made by Geoffrey of Lèves and his family members to the cathedral and to other important local projects survive in necrologies and, to a lesser degree, in cartularies of the region. The lords of Lèves themselves all continued, with their spouses, to be generous donors. Goslen IV, brother of Bishop

Geoffrey, gave the land for Josaphat, carving it out of the family estate, and added many other gifts, including rights to mills and rents upon vineyards and their products.[19] Through these generous gifts Goslen IV followed in the vein of his father and grandfather, both of whom had been donors to the cathedral and to St. Peter's. Lèves women were involved in the donations too, both as outright givers and, more commonly, as witnesses to donation charters.

Both bishops in the family gave to the church and were major builders, constructing an episcopal house in the town where the quarry was located. Goslen's obituary mentions the house at Berchères-l'Évêque as well as his rebuilding of the *domos episcopales* in sumptuous fashion; his desire to be close to the quarry and his attention to these building projects suggest his interests in architecture.[20] Bishops Goslen and Robert both left lavish liturgical artworks; the gold, jewels, and carvings represent devotion to the Virgin's cult as celebrated in the decorative arts. Goslen, who died in 1155, gave one hundred pounds—a significant amount—*ad opus turris*, the probable name for the account used to finance construction on the western façade generally.[21]

The donations of other members of the family as related to building projects and the cult also prove a high level of interest in the work. Hugh the subdean is described in his obituary as a vigorous person: "a venerable priest and subdean, expedient in administering things he did outside and inside, lively in speech, prudent in counsel, energetic in action."[22] First a provost and then active as subdean from the later 1130s until the early 1160s, Hugh gave generously to the cult of the Virgin of Chartres, providing "the sacrosanct temple of the Genetrix of God" with a most precious stained-glass window and a splendidly decorated pallium and cope.[23] The archdeacon of Chartres ("Grand Archidiacre"), Milo of Muzy, brother of Bishop Goslen, outlived his sibling by at least a decade. According to his obituary in the cathedral necrology he decorated the left capital frieze of the church with a beautiful relief carving.[24] If this means that he paid for part of the frieze, then he is one of the few canons whose direct involvement in artwork connected to the cathedral is documented in the surviving sources, and he joins his cousin Hugh the provost both in time of service and in donation of a specific artwork. Geoffrey of Lèves, the provost, according to his obituary in the cathedral necrology, also served as the treasurer of Tours.[25] He left the cathedral vestments and the income on property he developed at Villamarchés to those who say the Office of his anniversary ("et eam reliquit usibus fratrum qui eius anniversario intererunt"). Provost Rahier left important income on lands (*OPS*1032 35DE).

The Lèves gave so much to the church that they surely depleted the family's vast resources in the process. Yet in the early thirteenth century the family was still important enough to marry well. Geoffrey, grandson of Goslen IV, married Marguerite of Bruières, who gave a window, dedicated to her namesake Saint Margaret, in the new cathedral.[26] In Bishop Geoffrey of Lèves and his immediate successors and

family members the Virgin's cult found dynamic champions, the equal of Bishop Fulbert. This group of men flourished at a time when liturgical themes associated with Fulbert and the feast he promoted were championed anew in a view of history enshrined in the visual arts.

Bishop Robert, who succeeded Goslen of Muzy, was not a Lèves, but his career demonstrates his lifelong association with the leading members of the family. If only the few cathedral charters that survive from the period were consulted, Robert "the Breton" would not be known in his early years of service to the cathedral. He is a steady presence in Josaphat charters, however, and he is one of several dignitaries whose careers can be traced through these documents. In his case the charters allow for a progression of years and help to distinguish him from other men bearing the same name, one of whom held the office of archdeacon during his lifetime.[27] The charters not only outline the years of his career, but also tell us something about him, for he was also the bishop's chaplain during his early years and went directly from this position to being an archdeacon, apparently the archdeacon of Chartres. This means that he supervised the bishop's chapel and its liturgy as a young man and that he was a close member of Geoffrey's personal retinue.

A Robert who might be this figure first appears in *JC* LXXX, a charter dated to around 1131 and signed by a Robert "capellanus canonicus," the chaplain of the canons. Robert has become the bishop's chaplain, signing *JC* XCVIII, from around 1137, in that capacity. That Robert the archdeacon and Robert the bishop's chaplain are indeed the same person is proven by *JC* CXIII, dated to September 28, 1141, for he is called there "Robertus archidiaconus capellanus ipsius episcopi." In some charters from the period Robert has become an archdeacon, but he had been the bishop's chaplain long enough to make the title chaplain part of his profile. The kinds of charters he signs are telling too, for they include many of great importance, such as *JC* CLVII, where he is called a chaplain, although he had become an archdeacon. Later, as dean, he stood witness with the bishop's close family members, who included the bishop's brother Goslen, a cofounder of the Josaphat, his nephew Goslen, who would be bishop, and other close relatives. The kinds of detailed information the Josaphat charters provide for Robert are representative of the wealth of information available concerning the cathedral administration during the mid-twelfth century.

The period immediately after the death of Bishop Robert in 1164 was dominated by the great Thibaudian churchman William of the Whitehands.[28] His elaborate obituary in the necrology (OPS1032 89–90) reveals that he was the member of the family in his generation who donated the most to the cathedral. Just before he became bishop-elect he had been located in England and may be represented in a charter produced for his uncle, the bishop of Winchester.[29] Both he and his cousin Hugh of Le Puiset were chosen by Henry to shore up the family's powers in the English church, as was his half-brother Hugh (see Cline, 2007). With King

Stephen's fall from power and death in 1154, other plans were doubtless made for William's career. William was first bishop-elect and then bishop of Chartres from 1164 to 1168, subsequently archbishop of Sens, and then, in 1173, as noted, archbishop of Reims;[30] he was a papal legate as well. His high ecclesial offices and his significant role in the early years of the reign of his nephew King Philip Augustus, and later as regent while the king was on crusade, suggest that he may have had an influence on iconographical programs of portal sculpture throughout the Île-de-France in the second half of the twelfth century. William's success was a sign that the relationship between Capetians and Thibaudians was no longer volatile as it had been in past centuries. He was able to strengthen his family's position in the church and to fill numerous offices, including that of bishop of Chartres, with his nephews, grandnephews, and cousins (they were often members of both families, so deeply joined were Thibaudians and Capetians through intermarriage in this period). By the time of his death in 1202 the sculpted portals with large-sized jambs found at Chartres and Étampes had become the trademark of the churches in the Capetian realm and the lands of Thibaudians, but, as his obituary demonstrates, Archbishop William was ever interested in and protective of his first episcopal seat, the cathedral of Chartres.

William's obituary at Chartres is not the only document that proves the significance of having a queen and king in the comital family. Two martyrologies from Josaphat, one copied before the fire of 1134 and the other afterward, are detailed plans for the way the history of the region and the history of the Roman martyrs were entwined to define past centuries.[31] The later of the two liturgical books, Paris, Bibl. de l'Arsenal 938, is made up of three parts: a thirteenth-century necrology from Josaphat, the martyrology, and a copy of the Rule of Saint Benedict. A page dividing the martyrology from the Rule includes a genealogy of King Philip Augustus, with emphasis upon his having been born of a Thibaudian mother. The marriage, pregnancy, and birth took place during the tenure of Bishop Robert, but the immediate commemoration of these momentous events would have been carried out while William was bishop-elect and subsequently the bishop of Chartres.

## DONORS TO EACH COMPONENT OF THE CAMPAIGN

The contributions of dignitaries and other canons to the midcentury campaign show that a significant group of these men joined the bishops and members of the Lèves family in the campaign. Their contributions fall predominantly into the three major categories noted above, and it is useful to examine each of them for the numbers of contributions and for the dates of those who made them as well as for their donations to the enlargement of altars and the enrichment of the Virgin's Chasse. A listing of the leading canons who gave to the work, the administration to which each person belonged (when known), and those gifts that are related directly

to building, ornamentation, and the Virgin's cult appears in appendix H.[32] The appendix also lists donors by the office they held. Many of these donors gave lands as well as books and vestments (the latter are not listed in the appendix). Bishop Ivo of Chartres' gifts of tapestries to the cathedral were typical of the contributions made by wealthy donors in the eleventh century. The absence of tapestries among the mid-twelfth-century donations represents a shift; contributions were made rather for the arts of glass, metalwork, and sculpture.[33] As revealed by their donations, the men who gave to the twelfth-century campaign were building not only new towers and a façade, but also a new Holy of Holies, the center of which was the reliquary of the *camisia* of the Virgin Mary, a sign of the incarnational power of the sacraments throughout all time (see chapter 9). Both Eastern and Western Christians in the Middle Ages conceived of their altars as a reestablishment of the Jewish Holy of Holies, but to do so at Chartres in the mid-twelfth century also related to Crusaders' ideas about the Holy Land and Christian presence within it.

### TOWERS AND FAÇADE: "OPUS TURRIS"

The number of known donors to the construction of the west façade, including Bishop Goslen, was fifteen. As there were so many contributors to the "opus turris," we assume that there was a general fund for this project and that it included the entire west façade, the two towers, the portals, and their sculptural program. The older of the towers is the north tower, but because it was damaged early in the sixteenth century and its upper portion rebuilt by Jehan de Beauce (d. 1529), it is called the new tower. The south tower, which is a complete twelfth-century structure, is called the old tower, although it actually was begun later than the north tower. As ecclesial donors range from high-ranking dignitaries of the chapter (*personae*, as they are styled in the charters) to canons without major offices, it seems that the chapter as a whole was deeply invested in the campaign—although if one considers that there may have been as many as seventy-two canons, the number of those found in the necrologies and listed among the donors is relatively small, as is the total amount of funds accountable.

The work on the towers is frequently mentioned in the scholarship. Merlet's observations in his comments on Na4 are of major importance for furthering a claim that there were no contributors to this project during the time of Ivo or even before the fire of 1134 (MSC 86–87). Although authorities disagree about the various stages in which the west façade was constructed (see chapter 10) there is agreement concerning the concentrated attention given to the project by leading members of the cathedral chapter. The first men known to have donated to the work of the towers were the archdeacon of Chartres, Gauterius, who died around 1134, and the archdeacon of Blois, Ansgerius, who died in the late 1130s or early 1140s. Both men were close associates of Bishop Geoffrey and signed numerous charters at Josaphat

by his side.[34] Their obituaries imply that they contributed to the building of the towers while they were alive, which, if true, indicates that work was well under way in the 1130s.[35] This assumption is borne out by a charter dated 1137 that mentions "a peddler's stall" located "at the foot of the tower."[36] Unless it is an earlier structure not well documented, this suggests that a substantial portion of the north tower had been constructed by that date; the reading in this document is not the familiar and generic "ad opus turris" but rather describes an actual structure.

The next group to give for the towers and façade, proceeding chronologically, is a group of men who served in their offices through around 1149, some beginning their work as early as the 1120s. They are Henry the provost, an appointment of Bishop Ivo; Hamelin the cantor; Ernaldus the chancellor; Richer, the archdeacon of Châteaudun; and Rainerius the archdeacon of Blois. As several of them served for only a few years and seem to have died in office, they may have contributed to Chartrain building projects before they were assigned the administrative positions by which they are presently known, for they were doubtless influential canons before being appointed. The obituary of the provost Henry is especially detailed because he was in office for thirty-five years. The notice says that he loved the church very much while alive and left many memorials of himself even while dying. His devotion to the cult is shown by his gift of a gold necklace with a precious emerald for the reliquary of the blessed Virgin, but he gave much more, especially to the work on the towers. The verb used is *dimitto*, which is likely to mean that he forewent income from his prebend and other sources for this particular work. This particular translation suggests that he gave this money while he was alive and thus that both towers were under construction at some point during his time of service, that is, between 1115 and 1149 (this is in keeping with present understanding of the dating of these towers).[37]

Of Henry's contemporaries, Hamelin the cantor, who served in 1147–49 (see *DIGS* 33) may have bequeathed money for the tower, or he may have gathered or assigned this money, each being acceptable translations for the verb *lego*.[38] Ernaldus the chancellor, who was in service in 1149, gave some property while dying; he gave one hundred *solidos* for the tower, though precisely when, before death or while dying, cannot be told.[39] Richer, the archdeacon of Châteaudun, who served from at least 1126 to 1152–56, was actively involved in decorating the entrance to the cathedral, "introitum hujus ecclesiæ," with a statue of the Virgin Mary covered with gold. This means that the façade was far enough along in some phase of its construction to permit a major figural sculpture within his lifetime, that is, no later than January 1, 1156.[40] Rainerius, the archdeacon of Blois (d. October 2, 1150), also gave his income for "the building of the towers" while he was still alive.[41]

Chronologically the next group of men includes those who, although they were doubtless active as canons during Bishop Geoffrey's lifetime, were appointed to

their administrative positions after Geoffrey's death, during the tenures of Bishops Goslen (1149–55) and Robert (1155–64). Hugh the cantor, who served from 1152 to not later than 1163, was succeeded by Amauric Goald, whose gift for the tower project seems to have been a bequest. Odo, provost of Fontenay-sur-Eure, who served until at least 1161, gave for both towers while he was living.[42] Milo of Muzy, the provost (1149–61, and maybe longer), whose substantial contributions are discussed above, also gave for the tower, as did four canons: the deacon Simon (fl. 1153) and three whose dates are not known more precisely, Adam, Guy, and Theobald.[43] Bishop Goslen also gave specifically for the tower fund during his lifetime and is the only bishop known to have done so.

Evidence for expansion of the crypt during this period is slightly later; the major donor is the chancellor Robert, who served from 1159 until at least 1173, perhaps until 1176. He is an especially interesting figure for this study because he was a musician and served as succentor after he was chancellor from at least 1173 until 1176. He took the place of Richerius the succentor, who became cantor in 1176.[44] He knew about music and ceremony, was something of a scholar, and also cared about building projects. The kinds of contributions and their dates have prompted varying histories of the construction, but the evidence must be used with great care. The towers were undoubtedly a long time in the making, and this suggests that the connecting façade evolved over a substantial period of time as well. Some work was seemingly taking place at Chartres even before the fire of 1134, and the evidence may be skewed by the problems Bishop Geoffrey had with naming officials to high office, with the result that several high-ranking administrative positions were vacant during the late 1120s and 1130s.[45] The evidence suggests that a major effort of the campaign, although begun in the earlier decades of Geoffrey's tenure, took place from the late 1130s through the 1160s. This does not help us date the sculpture program, long assumed to fall within this period, although it is consistently dated by authorities to slightly later than Suger's campaign for the west front of St. Denis.[46] The truth is that so little remains of contemporary and comparable works of art from other churches, and so much work needs to be done on what does remain, that at present a reliable overview of features of decorative style in the region during the mid-twelfth century has yet to be attempted; John James (2002–06) has begun to archive and publish photographs of architectural details. The total amounts of money given for the rebuilding campaign by the bishops and canons, however, were surely not sufficient to support the work, and the unrecorded contributions of the Thibaudians, in addition to those discussed in chapter 7, must have been important. As I suggest in later chapters, artists in the employ of Henry of Blois, bishop of Winchester, and his brother Thibaut IV, both of whom were great patrons of the arts and of significant building campaigns, may have played a role in the work, although here too we know little about the ways in which artists who worked for the Thibaudians were trained, supported, paid, and assigned to various projects or

whether there were direct conversations between the brothers concerning the arts and artistic production.

THE ENDOWMENT FOR THOSE RISING TO SING MATINS:
"OPUS SURGENTIUM AD MATUTINAS"

Also of great importance to the canons was the raising of funds to permanently endow singers to "rise for Matins," which is seemingly a generic term for those who sing the Office, the most elaborate of the hours being that of Matins. There is evidence that in the late eleventh and early twelfth centuries two services were sung every day at Matins, one for the church year and a special Matins for the blessed Virgin Mary (see chapter 6), as indicated in Chartres, BM 162. The twelfth century was a time of expansion of the Virgin's cult and of prominence for themes contained in the book of special readings that lay on the main altar and that celebrated the history of her life within liturgical commemoration (see the analysis of artworks in chapters 9–12). The two ongoing Matins services gave Chartres Cathedral parallel ways of reckoning time and of remembering the past. The great emphasis on the campaign to support the singers is part of this broader mission, and the links between the building campaign and the musical campaign are made not only in the necrologies, but also in the iconography of the façade, with its significant number of musical subjects. The upper galleries in the new west end were doubtless used for singing; the construction of the towers and the casting of new bells would have increased the prominence of music in general.[47]

The number of canons whose obituaries mention a gift for "opus surgentium ad matutinas" is nine, but others gave as well, including the countess Adela, who must have known about the campaign to endow those paid to sing and to care for the altar of the Virgin (see chapter 6). Often donors gave both for the towers and for those "who rise to say Matins." The two efforts must have been linked in the minds of the canons and cathedral administrators (see chapter 10); these people sought to elevate cult and depict history through both what was outside the church and what was inside, with processions encouraging correspondence between the two. The musical forces of Chartres were also buoyed by artists who were building upon the reputation that Chartres Cathedral had for music in the eleventh century (see chapters 6 and 7). A charter from Josaphat dating from 1138–43 shows Goslen, lord of Lèves, along with his three sons and three daughters, offering income for the soul of his wife, Lucia, (perhaps recently) buried at the abbey, "ubi sepulta est." Among the witnesses is Fulcaudus, *organista*, probably to be interpreted as a person who performs and improvises organum.[48] The presence of this man attests to specialized musical expertise in the community in the mid-twelfth century, the time when an endowment for those who sang for the Virgin and cared for her altar was a major focus of the cathedral canons' attempts to raise monies for an integrated program of specific projects. The early polyphonic repertories of Chartres survive only in

fragments, yet it is clear that improvising in parts was a regular part of the cathedral liturgy, and vestiges of this practice are mentioned in the twelfth- and thirteenth-century ordinals, the pieces cited related to the fragments. Chartrain polyphony (see Arlt, 1993) may have been on the cutting edge in the eleventh century, but that these pieces were apparently still being sung in Chartres Cathedral in the twelfth and thirteenth centuries offers yet another testimony to the conservative nature of the liturgy and music of this place.

### THE CRUCIFIX, STAINED GLASS, AND OTHER DELUXE ARTWORKS

The work on the façade and the liturgically magnificent Offices that complemented and commemorated the art of the façade stimulated the decorative arts. Repairs for the crucifix ("ad crucifixum reparandum") of this crusaders' temple are mentioned several times in the obituaries of mid-twelfth-century donors.[49] The restoration of the great cross to what must have been extraordinary glory, given the significant contributions for the work, was doubtless carried out by goldsmiths. In Chartres at least one of them was a wealthy and highly respected man; unlike so many of the craftsmen whose names appear in Josaphat charters, he can be tied directly to the cathedral. About 1131 two goldsmiths, Robert and Haudric, were found in distinguished company as witnesses for a document regarding a barn beyond the Porte Drouaise (*in suburbio Carnoti extra portam Drocensem*), the city gate closest to Josaphat (JC LXXVII). Radulf the goldsmith stands with Bernard the sacristan and others around 1130 as witness to a charter concerning a gift of a vineyard by Girard d'Ecublé.[50] Perhaps the same figure is a Robert the goldsmith, cited in a charter from sometime before 1137 as donating to the cathedral vineyards he apparently held from the bishop; this suggests his close connection with the Lèves family, as does his association with Goslen later in the document (JC XCVIII). The monks (and the bishop, who is present and presumably acting in his brother's interests as well as his own) want it made clear that Geoffrey and Goslen will still be owed their rent by the new owners. Robert, it appears, was still working in the area around 1143, the date of a charter witnessed by his servant (*famulus*) Grimold (JC CXX, 151). Robert's period of activity matches the period during which the work on the restoration of the crucifix was receiving major donations. His name is found in two charters from St. Peter's as well, one dated to around 1116 (CSP 317, 342), which makes him a contemporary of Bishop Geoffrey. Robert the goldsmith was a well-placed and wealthy man, as is shown by his obituary in the cathedral necrology: "27 Feb. Robert the goldsmith died, who gave to this church a plot of land he had in our cloister, it being held that a priest/canon might always live on it."[51]

At this time stained glass is more frequently mentioned in donations than any other kind of artwork, and many donors offered money to what must have been a campaign for large, deluxe windows, four of which survive from the twelfth century in various states of restoration. From the time of Bishop Ivo to the end of the

residential tenure of Bishop William of the Whitehands, in 1168, fifteen stained-glass windows were given, some referred to as being very precious and beautiful. Because very few charters that survive from the cathedral can be dated to the mid-twelfth century, direct evidence of various personnel is scarce. However, at nearby Josaphat the situation is quite different: many of the charters prepared there were witnessed by members of the Lèves family and by dignitaries of the cathedral. The Lèves supported a large number of workmen and craftsmen at the monastery.[52] The degree to which these men were involved with the program at the cathedral can seldom be demonstrated, but there were craftsmen in residence at Josaphat who worked in glass during the time of the campaign at the cathedral. Around 1130 Giraldus *"vitreator"* was a witness to a charter for the monks of Josaphat.[53] A charter of Bishop Robert concerns a donation of property by Robert the glass painter, who was retiring to become a monk there.[54] Yet another maker of stained-glass windows, Jacobus *"Vitrearius,"* is mentioned in the Josaphat necrology, but he is probably a later figure.[55]

The twelfth-century obituaries reveal that canons and other donors continued to offer gold, silver, and, especially, precious jewels. Judging by surviving representations, there seems to have been a practice of affixing rings, jewels, and other valuables to the body of the Chasse, enhancing its worth as a local treasury, an object the entire community could take delight in viewing. To have such gifts mentioned in the liturgical necrology meant that every year particular donors and the jewels they gave were associated with it again, a process that held true for all gifts. Ten donors from the period gave treasures for the reliquary, or for expansion of the altar table, or for the doors in front of it (see appendix H). Other canons gave sculptures or contributed to the expansion of canons' houses, or for repairs to the roof of the chevet (which was apparently in bad condition in the mid-twelfth century), or for the roof more generally; marble paving was in demand for various areas of the church, and this too was provided for in the legacies of canons, including that of Bishop Robert, who gave for the beautiful paving in front of the entrance of the choir. The vidamess of Chartres, Elizabeth, who died in April of 1150, gave income to support two candles that were to burn before the reliquary of the blessed Virgin Mary; this gift shows the connection that wealthy, powerful local women continued to have with Mary and her relic.[56]

## SCHOLARS AS DONORS

Much speculation exists about the involvement of scholars in the planning of the iconographic program of the west façade of Chartres Cathedral. The extent of this involvement was predicated on the identities and degree of importance of mid-twelfth-century Chartrain masters and the relationships between them. The classic history of the cathedral school of Chartres, written by Alexandre Clerval

in the late nineteenth century, was well regarded until Richard Southern set off heated debates concerning the nature and influence of Chartrain scholars in the twelfth century.[57] Southern proposed that no real school existed at Chartres in the mid-twelfth century and that the work attributed to a group of Chartrain masters, characterized by an emphasis on Plato and Neoplatonists and glosses of Boethius in particular, must be seen as belonging to men who sometimes taught there but were more frequently working in Paris. Even more serious was Southern's dim view of twelfth-century Platonists.[58]

Although the scholarly community was generally, if grudgingly, accepting of Southern's arguments, several counterclaims have been made. Modifications suggested by Peter Dronke, Nicholas Häring, and Edouard Jeauneau have pointed to difficulties in Southern's arguments and have restored the prestige of mid-twelfth-century Platonism in general.[59] Regarding the importance of the so-called School of Chartres in the mid-twelfth century, a position somewhere between Southern and his detractors is tenable: although Chartres was not nearly as important a center as Clerval and others once made it out to be, still the cathedral school was not an utter backwater. A good deal of evidence remains to be studied about its importance in the production of deluxe books and other arts. A small group of influential scholars was in residence there at midcentury, Master Thierry being the most important of them, and they did write commentaries on Plato and Boethius with some awareness of each other's investigations. Moreover, their thought was sometimes subtle and original in its philosophical content and modes of reasoning and is certainly worthy of study today.[60] The biblical commentaries of Gilbert, who left Chartres to become bishop of Poitiers, point to a school of biblical study as well.

Not enough evidence exists to prove that masters at Chartres in the mid-twelfth century had sufficient mutual understanding to constitute a true school of thought, or that they were capable of drawing significant numbers of students. A river of students and masters flowed into Paris, and no cathedral town in northern France in the mid-twelfth century could rival it, although some criticized its limitations and the superficiality of learning sometimes offered there. One critic of the Parisian schools was Thierry of Chartres, who, before his retirement to become a Cistercian monk, was chancellor of the cathedral school of Chartres in the mid-twelfth century. Thierry wrote, "I have carried out my resolve to shut out, at my whim, the ignorant mob and the mish-mash of the schools. For those who counterfeit genius, hating study, and those who claim to study at home, pretending to be teachers, and the clowns of scholastic disputation, armed with fistfuls of inane words . . . such in truth are my camp-followers. But let them stay barred from my palace, these men whom only the aura of my name has brought here, so that in their own region, in their eagerness for fallacious arguments, they may lie about Thierry!"[61]

The writings of Arnold of Bonneval, a figure doubtless shaped by the putative School of Chartres in the mid-twelfth century (see below), demonstrate the theo-

logical interests of someone from the region, as does the testimony of John of Salisbury, who probably studied at Chartres in his youth.[62] John, who served as bishop of Chartres in the last few years of his life, was present when Becket was murdered, and he was responsible for augmenting the saint's cult in Chartres. John describes life under the tutelage of Bernard of Chartres, who may have been Master Thierry's brother and who was chancellor in the early 1120s:[63]

> Bernard of Chartres, the greatest font of literary learning in Gaul in recent times, used to teach grammar in the following way. He would point out, in reading the authors, what was simple and according to rule. On the other hand, he would explain grammatical figures, rhetorical embellishment, and sophistical quibbling, as well as the relation of given passages to other studies. He would do so, however, without trying to teach everything at one time. On the contrary, he would dispense his instruction to his hearers gradually, in a manner commensurate with their powers of assimilation. And since diction is lustrous either because the words are well chosen, and the adjectives and verbs admirably suited to the nouns with which they are used, or because of the employment of metaphors, whereby speech is transferred to some beyond-the-ordinary meaning for sufficient reason, Bernard used to inculcate this in the minds of his hearers whenever he had the opportunity. In view of the fact that exercise both strengthens and sharpens our mind, Bernard would bend every effort to bring his students to imitate what they were hearing. In some cases he would rely on exhortation, in others he would resort to punishments, such as flogging. Each student was daily required to recite part of what he had heard on the previous day. Some would recite more, others less. Each succeeding day thus became the disciple of its predecessor. . . . Anyone would become thoroughly familiar with the method of speaking and writing, and would not be at a loss to comprehend expressions in general use. Since, however, it is not right to allow any school or day to be without religion, subject matter was presented to foster faith, to build up morals, and to inspire those present at this quasi-collation to perform good works. This declination or philosophical collation closed with the pious commendation of the souls of the departed to their Redeemer, by the devout recitation of the Sixth Penitential Psalm [Ps 129, "Out of the Depths"] and the Lord's Prayer (*Metalogicon* 1:24, p. 68).

Chartres was no Paris, but it was an important cathedral school in the twelfth century, with a handful of talented students studying with masters, some of whom were well known for their teaching. The most important aspect of teaching and learning at Chartres was in the training of the young men in grammar, liturgy and singing, and the liberal arts, just as had been the case since the time of Fulbert. During the twelfth century some masters who taught there were experts in Platonism, but their works on this subject were likely shared by few. Masters such as Thierry were aware that learning was changing during their lifetime, and they looked to a time when the slow, careful training offered to the young was the basis for further study by a

handful of advanced and genuinely talented students. The rest would have received what they needed to work for the church or the court, knowledge resting upon solid understanding of basic texts committed to memory through constant repetition in the liturgy or in the classroom (see Boynton, 1998, 2000).

The gifts left by chancellors to the cathedral of Chartres demonstrate that these men were scholars, rich in books and knowledge, and that they cared about the quality of the library available to the students and masters of the cathedral. Bernard of Chartres was chancellor in the early 1120s.[64] His obituary is a simple bequest of what was most precious to him: "June 2. Bernard died, subdeacon and chancellor of Saint Mary, who gave his books to this church" (MSC 165; OPS 13F).

Following Bernard as chancellor was Gilbert, often known as Porretanus (de la Porrée in the French literature), or of Poitiers. He was born in Poitiers, studied in Laon and Chartres, and after his time as chancellor of the cathedral school of Chartres from 1126 to 1141 became first *scholasticus* at Paris, then bishop of Poitiers; he remained in that office until his death in 1154 and may have initiated a building campaign there.[65] Problems with his teachings on the Trinity led to a council in Reims in 1148, but he removed questionable passages from his commentary on Boethius and suffered no harm from the challenges.[66] Gilbert's presence in several charters proves his close association with the members of Bishop Geoffrey's administration; his commentary on the psalms shows his interest in these fundamental texts, but from a scholastic rather than a liturgical perspective. His obituary at Chartres reveals the care he took of the books of the library while he was in residence: "[Sept. 4.] ii nonas. On the same day Gislebertus [Gilbert] died, first canon of this church, then most learned chancellor, finally the venerable bishop of Poitiers, who gave to this church two silver *bassinos*, most precious and weighing eight marks, for daily use at the altar; and, lest they be removed from this use, he confirmed them under an anathema; and he diligently emended and improved in many ways the books of the library, and honored all the clerics of this church, canons or not, in whatever way he could" (OPS1032 89D).

Master Thierry of Chartres, who left the cathedral chapter in 1148 to become a monk at the Cistercian monastery of Les Vaux-de-Cernay (in the forest of the Chevreuse, between Chartres and Paris), appears in the cathedral necrology as well (see Vernet, 1955). The emphasis on the teaching of the liberal arts at the cathedral school of Chartres is well represented here, for it includes the sources for Thierry's vast unpublished compendium on the liberal arts which was used in the school: "[Nov. 5.] Master Thierry died, chancellor and archdeacon of nourishing Mary, who gave to this church a library of the seven liberal arts, the *Institutes* of Justinian concerning the Roman laws, his *Novellae* and *Digest*, and fifty-five volumes besides" (OPS1032 108C). Ernald, the chancellor, who gave generously at midcentury to the clerks of the choir and to the building campaign, was apparently a scholar, although no works by him have survived.[67] Bernard of Quimper was the next chancellor; he

did not give to projects at Chartres. His successor, Robert, another figure without surviving writings, gave income on land and money for the "work of the church's crypts" (*OPS*1032 100D, B: "ad opus criptarum ecclesie XV libras fecit distribui"). He is described in his obituary as "completely erudite in sacred scripture as well as in the liberal arts" (tam divinarum scripturarum quam liberalium artium disciplinis ad plenum eruditus), a profile honored at Chartres at the time he is known to have served, that is, between 1159 and 1173. The obituaries and writings of the men mentioned above provide no evidence of donations to the building project at midcentury that produced the Royal Portal, or of support for endowing the liturgy, or for enhancing the cult of the Virgin Mary, although this does not mean that they did not contribute. The prominence of the liberal arts in the famed archivolts of the southern portal suggests celebration of their intellectual contributions and the continuation of the work attributed to Fulbert both as scholar and as teacher. The interest in books evidenced in their obituaries meshes with what is known of book production in Chartres (see chapter 12). The extent to which production of Gilbert's commentaries was carried on in Chartres and other centers supported by the Thibaudians is a matter of interest to art historians.

## REVELATIONS OF TIME: HISTORICAL UNDERSTANDING AND BUILDING IN MID-TWELFTH-CENTURY CHARTRES

"See," wrote Arnold of Bonneval, "how it is that the voice of one watching and explaining is like that of one admiring and exclaiming!" This opening to a series of sermons on Psalm 133—which as Psalm 132 in the Vulgate Latin formed the great song of monastic brotherhood—provides a taste of Arnold's energetic explanation of spiritual seeing and the joys of divine illumination. He ends the series with Genesis 1 and God's creation of light, which inspires a desire to hasten to the ultimate Sabbath, the goal of which will be to see how sweet is God, who lives and reigns throughout the ages of time (see *PL* 189:1569). Arnold is deeply engaged with the visual metaphor and its centrality as a vehicle for expression of and teaching about God's relationship with humans within the unfolding of history. That he does so through the text of a liturgical song—and that he writes about what it means to sing the song of knowing and of seeing—is also emblematic of his age and of his work as head of a Benedictine abbey about thirty kilometers southeast of the cathedral town of Chartres. He flourished in the mid-twelfth century, during the decades in which a new façade for the cathedral was designed and executed; he surely knew Bishop Geoffrey of Lèves and his successors Goslen of Muzy and Robert the Dean. References to Plato and to Platonic interpretations in his writings suggest he studied at the cathedral of Chartres,[68] and among his works is an early life of Saint Bernard, who was himself a frequent visitor at Chartres.[69]

Finding an enthusiastic and sophisticated defense of spiritual seeing in mid-

twelfth-century Chartres is a boon to the student of the liturgical arts but is not sur-
prising. Bishop Geoffrey and the canons of Chartres were history makers, fully en-
gaged with their building campaign and its design and the ways in which local and
universal (as Christians understood it) history was revealed through the arts. The
life of Saint Anianus lays out a history of the town, one based on local writings and
testimonies (see chapter 1); the lessons composed in the twelfth century describe
Bishop Geoffrey as he rededicated the altar of the church and used the miraculous
preservation of the body of an early bishop to testify to God's love for a particular
parish church and its people; lessons added in the thirteenth century continue in
the same vein (see chapter 12). The twelfth-century additions to Paul of St. Peter's
history of Chartres are all concerned with the Virgin's cult as related to the history
of the cathedral and suggest that the bishop and canons were promoting the Vir-
gin's healing powers.[70] It is not surprising to find other evidence of their interest in
the past and its artistic representation. Geoffrey commissioned a poet to versify the
Old Testament books of Kings and Maccabees, the parts of the Bible that describe
the construction and reconstruction of the Temple and rituals of dedication at the
very time that a new façade was built for their own "temple" at Chartres. Although
the poet commissioned by the bishop mentions both commentaries, only that for
Kings survives, found in a thirteenth-century copy in Paris, BN lat. 14758. As the
author informs us, these poetic exercises were commissioned by Bishop Geoffrey
of Chartres and the archdeacon Robert, who is none other than Robert the Breton,
who became bishop on the death of Geoffrey's nephew Bishop Goslen.

   The unknown poet's reference to Robert as archdeacon dates the surviving work
to those years when the west portal was being designed and the work on it begun.
The preface reveals the interest of Geoffrey and his protégé in the kings of Juda and
is suggestive of discussions between clergy and others that might have influenced
the iconographic program of the west portals, especially, perhaps, that of the jamb
statues.[71] The unknown author speaks of the interests of Geoffrey and Robert in the
subject, and this makes clear that there was a continuity of understanding at the
time between the bishop who began the project and the man who undoubtedly saw
the work completed. The preface addressed to Geoffrey begins as follows:

> Great Pontiff, standard bearer of the court of Rome, glory and father of the city of
> Chartres, I salute you. I speak to you of this work begun under your inspiration and
> finished in ten months. It is you, I remember, who gave it to me when I offered you
> the first verses of the books of Maccabees. You asked me to versify the ancient histo-
> ries, and to put great facts into little verses. Archdeacon Robert is also the cause of
> this work, who aided me with his ideas to compose it. . . . Confident in your orders
> rather than in my talent, I put my hand to the deeds of the kings of Israel. I recounted
> the acts of these heroes in my distiches, following a method differing from that of the
> great poets, who often mix fable and truth.

The man who wrote on the kings of the Old Testament for Bishop Geoffrey and Archdeacon Robert was creating a literal transcription of the past as found in the Bible, and his poem is simple exegesis of a past time and past characters. Yet as he attempts to ignore his own times and their fables, he provides a history that is selective and his own.

The most ambitious historical study commissioned by Bishop Geoffrey (besides the west portal itself) is the life of Bernard of Tiron, a work that indicates the bishop's goals as a patron of religious art. The modern editor of the work, Bernard Beck, agrees with Lucien Merlet, the editor of the charters of Tiron, that Bishop Geoffrey's interest in the monastery was established early in his career. As provost of the region in which the house was established at Tiron-Gardais, he was present at the founding in 1114.[72] Beck suggests that just before he died in 1117 Bernard of Tiron worked to reconcile the young Count Thibaut to the election of Bishop Geoffrey of Lèves, which, according to Andrea of Fontevraud's vita of Robert of Arbrissel, the count had vigorously contested.[73] Merlet believed the author was Geoffrey the Fat, chancellor of the Tiron; he signed a charter in 1126, was apparently from Chartres, and used an earlier vita (now lost) as one of his sources.[74] Ruth Cline, the work's translator, has verified that "the Fat" in this case is a family name, Grossus, rather than an epithet.[75] Beck describes the life as one of the longest and most prolix in all of medieval hagiography; it was doubtless written during the time the west façade was designed and work on it begun (*Saint Bernard*, 293). In it one gains another sense of how local history was written in Chartres at midcentury.

The life of Bernard of Tiron takes its reader to Chartres in the mid-twelfth century as its author recollects events from the immediate past and recalls people, many of whom were still living when he wrote. The following passage offers perceptions of the Virgin of Chartres and of the canons' relationship to her cult and presents Geoffrey of Lèves as well, in the years just before he was elected as bishop:

And so [Bernard] went to the celebrated church of Chartres, consecrated to the holy and ever-virgin Mary, and there addressed the venerable Bishop Ivo and the canons of the time. He asked that they give him a portion of the land they possessed next to his own modest plot for establishing his monastery. There was a small villa called Gardais (Sarzeia) belonging to the canons near the land which Count Rotrou [of Perche] had given to the man of God. The canons received the servant of God with appropriate reverence, listened to him with tranquil kindness, and, in accord with the magnificence of their nobility and the liberality of their largess, gave Bernard more land than he had requested. After the donation had been made they drew up a charter, and directed Lord Geoffrey, a canon of that church and provost of the district, along with some other persons, to point out the land. . . . Now at the same time a woman of royal blood, Adela, countess of Blois, was offering Saint Bernard land more vast and much more favorably located for his monastery. He, however,

refused, preferring to have his monastery in a place under the protection of blessed Mary ever virgin, rather than under the legal protection of any secular person. The canons themselves were overjoyed with having received such a guest on the estate of their church; for the rest of his life they loved him with deeply holy affection, and gave him many benefices and ecclesial ornaments. They were careful to watch over the possessions of the monastery placed under their patronage with active vigilance, shrewdly setting the shield of their defense against certain aggressors. When Bernard had laid the foundations of his dwelling in the possession of the blessed Genetrix of God, he was eager to venerate her henceforth with such affection that he instituted a special Mass in her honor, to be celebrated every day in perpetuity, for the well-being of all the benefactors of his monastery, and particularly for the canons, which is celebrated up to the present day.[76]

Bernard's connection to the cathedral of Notre Dame, its art and liturgy, and to the Virgin of Chartres was well-established, and his relationship with Bishop Geoffrey of Lèves was essential from the very beginning. When he became a papal legate, Bishop Geoffrey was in a position to work for the sanctification of his mentor, Bernard of Tiron, and the life he commissioned would have advanced that goal. Geoffrey Grossus offers a contemporary view of Geoffrey of Lèves and his artistic and religious interests in the dedication of the treatise (see below). Through these passages the author appeals to the arts and to the ways in which events of the Old Testament, depicted in liturgical art and architecture, hide the mysteries of people and events of the New Testament and of the church to come. That Geoffrey Grossus addresses his patron in this way and with these images suggests he was knowledgeable about the bishop's ambitious building campaign and may even allude to the iconographic program employed. The author, who would have known the texts and chants of the Dedication feast, refers to the ancient temple of Solomon, showing how that historical building presaged the Virgin Mary; she, in turn, is the archetype of this new dwelling place, offering her womb as a new Holy of Holies for a God that deigned to take on human flesh.[77] The prologue reads in part as follows:

> To the most reverend father, Lord Geoffrey, by the grace of God bishop of Chartres and legate of the Apostolic See, Geoffrey, the most humble of all the monks, addresses this salutation: Most blessed Father, the wisdom of your sublimity is clearly and perfectly familiar with the words spoken to Tobias by the Archangel Raphael (Tobit 12:7): "it is good to hide the secret of a King, but honorable to reveal and confess the works of God," that invite us to write down the deeds of holy people, and to transmit them in collections for the use of posterity. . . . Cap. 2. The canonical writings in their totality come to the same thing: the books of the Old Testament strive to represent in their complex and marvelous descriptions of material works, in the obscurities of their enigmas, in their relationships to sacred mysteries, in their portraits and their symbols, the yet unknown life, customs, actions, conversations,

works, exertions of battles, of struggles, the constancies, the triumphs of victories, the triumphant palms of rewards of all the saints of the New Testament. In fact God commanded Moses to carefully perfect as an exemplar, in accordance with what he saw on the mountain, all the works of testimony, prefiguring in them the form of the life of the saints, and that he make bowls, cups, the laver of the table, the branches of the candlesticks, other cups and bowls, crisp lilies, candle snuffers, and all the other things that Scripture names one by one (Exodus 25, 30, 31). He also describes, with their measurements and in great detail, the totality of the Temple of Solomon, not only the buildings but all the carvings on the buildings, so as not to pass over the cornices of the columns and their capitals, nor the nets of these latter, nor the axletrees, spokes, rims, and hubs of the wheels (3 Kings 6:32; 7:17 and 30). And as for Ezechiel (ch. 40), the building of a city, bending toward the south, was seen in the spirit with great subtlety so that he would not omit the engravings of palm trees, nor pass over even the enormous sill of the portal. All these things, as the apostle [Paul] testifies, were the shadow of things to come (Col 2:17). Cap. 3. And this is the reason that Providence, in her divine wisdom, distinguishing the times of appearances from those of realities, wished and ordained with such zeal that figures and signs be represented by people of the present time (see Beck's edition, 312–16).

I quote again for emphasis the first phrase of chapter 3: "And this is the reason that Providence, in her divine wisdom, distinguishing the times of appearances from those of realities . . ." Understanding the sense of "realities" in the unfolding of time is central to knowing how to read the history depicted in the surviving art from mid-twelfth-century Chartres. The dignitaries of Chartres and the members of the Muzy family mentioned here were surely involved in planning the complex program for the façade of Chartres Cathedral. As they consulted with artists and with members of the Thibaudian family, they made the gates to a new Temple, one that would proclaim both local and universal understandings of history and remembrance.

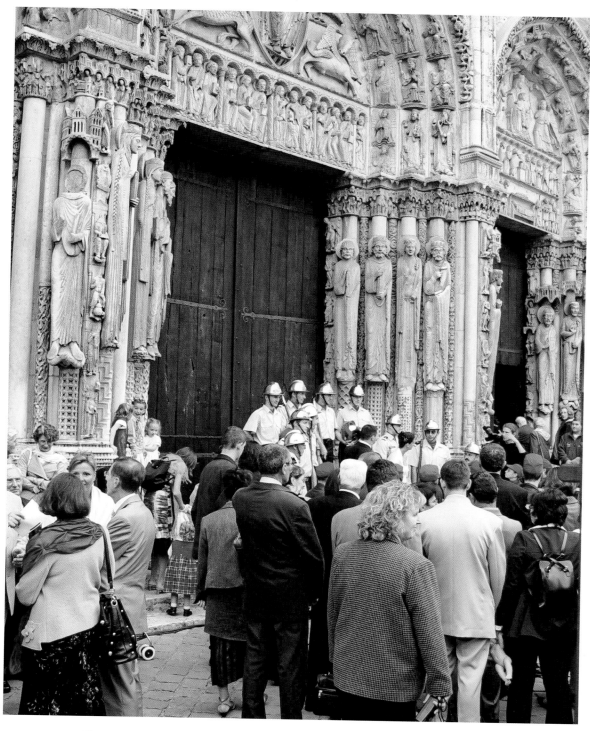

Plate 1. *Devant la Cathédrale*: A wedding party before the Royal Portal, Cathedral of
Notre Dame, Chartres. 2006. Credit, de Feraudy.

Plate 2. *Son et lumière*, the light show with music that takes place in Chartres throughout the summer months: Fulbert, as depicted in Chartres, BM N4, shown against the south wall of St. Peter's church, 2006. Credit, de Feraudy.

Plate 3. Twelfth-century seal: Archives départementales d'Eure-et-Loir,
collection des sceaux détachés, sceau de Notre-Dame de Chartres, 1170.
Credit, cliché Archives départementales d'Eure et Loir.

Plate 4. Belle Verrière, south choir, mid-twelfth-century core. Credit, de Feraudy.

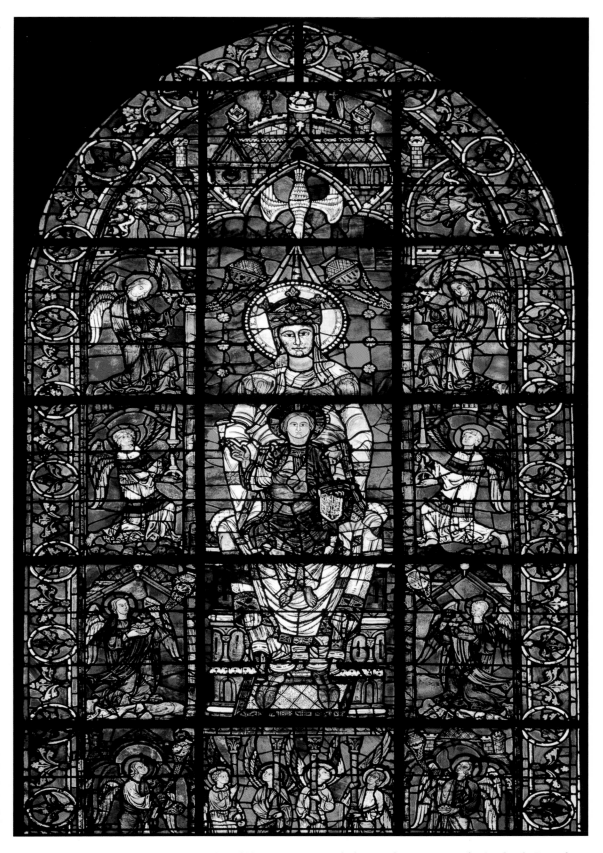

Plate 5. Belle Verrière, south choir, mid-twelfth-century core with thirteenth-century angels. Credit, de Feraudy.

Plate 6. Head of Belle Verrière, being transported in 2006. Credit, de Feraudy.

Plate 7. Thirteenth-century angel holding a pot of manna, Belle Verrière, south choir. Credit, de Feraudy.

Plate 8. Four angels supporting the tabernacle, thirteenth century, Belle Verrière, south choir. Credit, de Feraudy.

Plate 9. Thirteenth-century panels, Belle Verrière, south choir. Credit, de Feraudy.

Plate 10. The west lancets, mid-twelfth century, Chartres Cathedral. Credit, de Feraudy.

Plate 11. The Styrps Jesse lancet, north, mid-twelfth century, west façade, Chartres Cathedral. Credit, de Feraudy.

Plate 12. Virgin Mary in the Styrps Jesse lancet, north lancet, panel 17. Credit, de Feraudy.

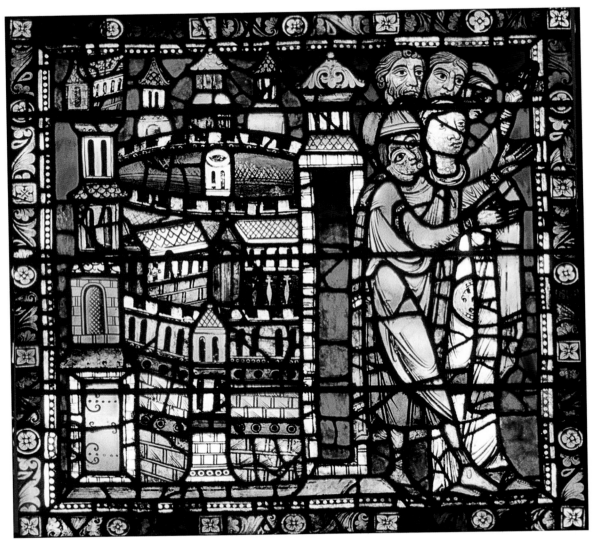

Plate 13. A city welcomes the Holy Family, center lancet, panel 19. Credit, de Feraudy.

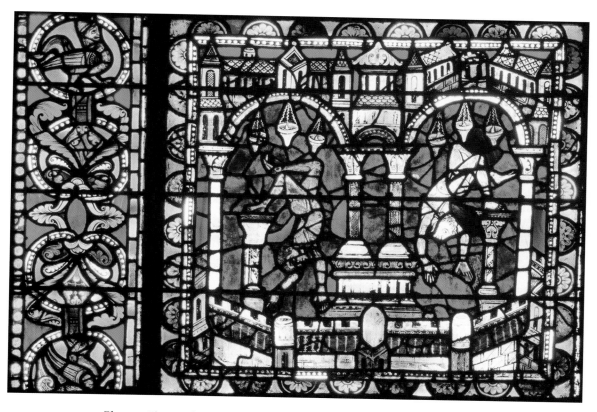

Plate 14. The toppling of the idols, center lancet, panel 17. Credit, de Feraudy.

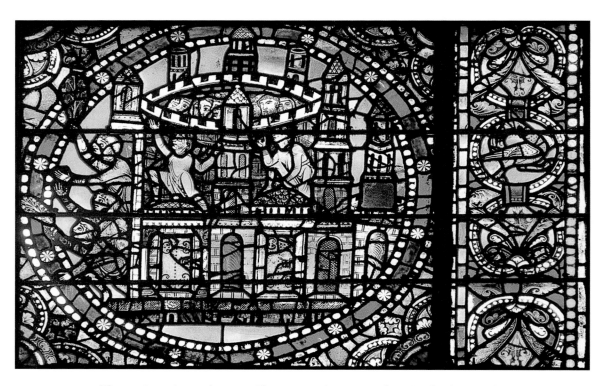

Plate 15. Jerusalem welcoming Christ, center lancet, panel 24. Credit, de Feraudy.

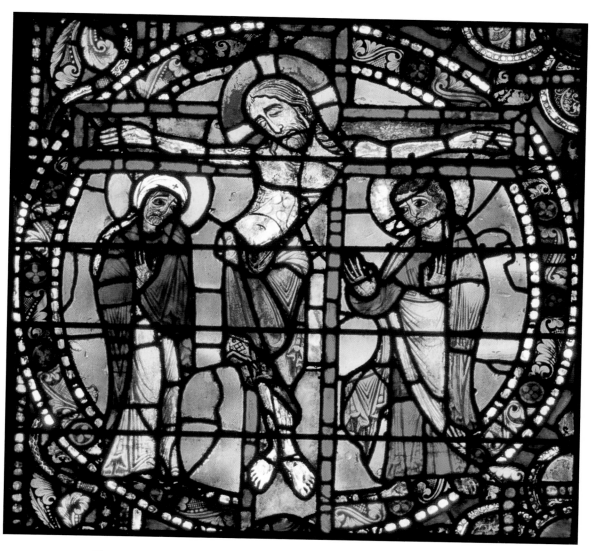

Plate 16. The Cross as the Tree of Life, south lancet, panel 7. Credit, de Feraudy.

*Part Four*

# HISTORY REVEALED

The Cult of the Virgin and the
Visual Arts in the Mid-Twelfth Century

---✦---

# THE VIRGIN AND THE TABERNACLE

O blessed courtyard, crowned with heavenly armies,
alternating the sweetest songs with the divine word:
This is the house about which ancient history resounded
and which asks the modern book to speak of Christ,
since it was chosen, a throne without blemish:
This will be my resting place throughout all ages.

*—from "Clara chorus," a late eleventh-century sequence
for the feast of the Dedication*

The late eleventh-century sequence "Clara chorus," first sung in Chartres at the Augustinian Abbey of St. John and later adopted in the cathedral liturgy as well, circulated in Chartres during the mid-twelfth century.[1] Through the use of familiar Marian imagery and allusions to the Song of Songs—emphasized in Chartrian liturgical texts for Marian feasts, both in the ordinals and also as expounded in Chartres, BM 162—the Virgin becomes architectural symbol with many attributes. Mary, as type of the church, is a "throne without blemish," whom Christ calls "my resting place throughout all ages." The resting place for all the ages is also the Mercy Seat found within the Temple of Solomon, an architectural setting for the Holy of Holies. Both testaments locate the Godhead there, within the sanctuary and in the midst of worship. In this age of crusade, when new Christian churches were built throughout the Holy Land and new energy was focused upon the liturgy established in Jerusalem, Chartrains used the liturgical arts to superimpose the historical idea of the Mercy Seat upon their own main altar and its famous relic. The ways in which liturgy recreated earlier historical circumstances had renewed vitality when the places studied in the Bible were believed to have been identified and made visible and stories about biblical locations and people circulated with renewed intensity. Well-known texts from the Patristic period were present in medi-

eval libraries to fire visual imaginations, none more important than the writings of
Eusebius on the Holy Land, which embodied his own agenda for using the Holy
Land to promote Christian ideals. Eusebius described Constantine's church as the
"new Jerusalem facing the far famed Jerusalem of old time" and the tomb of Christ
in its apse as the Holy of Holies.[2]

"Clara chorus" speaks of church and its liturgy both as a history teacher and as
a subject for history.[3] In this view the Virgin Mary, type of the church, mothers
historical understanding just as she inspires recounting the past. Mary as Christ's
resting place or throne located in the center of a history-teaching church became
the most important theme of the campaign undertaken by Chartrain patrons and
the artists who worked with them in the mid-twelfth century. The church is where
one "recounts the debts" as well as a place where time no longer matters. Reli-
gious art negotiates between these competing understandings of time and history:
mid-twelfth-century artworks of Chartres Cathedral respond by emphasizing the
miraculous flesh of the Virgin both as eternally elected "throughout the ages" and
as the membrane separating the ages, a membrane replicated by the cloth relic
upon the main altar. The goal of mid-twelfth-century art from Chartres Cathedral
is to find physical situations and modes of expression for this Marian membrane, the
cloth relic situated between two understandings of time. Places in the church were
chosen where art could be located on lines of separation: in glass, which divides the
outside from the inside; in portals, where one enters from one world to another;
and through zones within the plan of the façade itself, especially on the seams be-
tween one section and another. These moments of change and transformation were
manifested as well in those feasts and seasons linked tightly to cult and relic and
so venerated with special nuances in twelfth-century Chartres: Advent, Christmas,
the Purification, the feast of Mary's Nativity, and the Dedication of the Church. In
accordance with Christian belief, the "new temple" redecorated at Chartres in the
mid-twelfth century was not a goal in itself but a commemoration designed to teach
and inspire.[4] The divinity it celebrated was said to work within the human heart,
reforming those who accept and understand. And so, the art is designed to embrace
the imagination, to provoke it to undergo transformation through the act of seeing
a new sacrifice within a new sacred space:

> But Christ, being come an high priest of the good things to come, by a greater and
> more perfect tabernacle not made with hands, that is, not of this creation: neither by
> the blood of goats, or of calves, but by his own blood, entered once into the Holy of
> Holies, having obtained eternal redemption. For if the blood of goats and of oxen,
> and the ashes of an heifer being sprinkled, sanctify such as are defiled, to the cleans-
> ing of the flesh: how much more shall the blood of Christ, who by the Holy Ghost
> offered himself unspotted unto God, cleanse our conscience from dead works, to
> serve the living God? (Heb 9:11–14).

To make their particular Mary, a woman of biblical, liturgical, and political history, twelfth-century Chartrains took the most popular vehicle for Marian devotion in northern Europe in the mid- and late twelfth century, the *Sedes sapientiae* (the throne of wisdom) and linked it to the reliquary of the Virgin and the main altar of the cathedral through artistic design and liturgical interpretations of the past. The image depicts the membrane itself, dividing Mary from her son and joining them as well. Through a system of recontextualization, twelfth century donors and artists used this image repeatedly and developed a strategy of looking and believing that encouraged meditation and the art of memory, as the observer moved from the liturgy, to the various media, to events of past and present ages, and back to the liturgy again. A seal traditionally dated to the twelfth century belonged to the chapter in general, or to some member of it, and depicts the *Sedes sapientiae* (see plate 3).[5] Its beauties, reflected both in design and in details, suggest the care and attention given to this theme in twelfth-century Chartres. The first depiction of the image directly referred to in documents is a predecessor of the window known as Notre Dame de la Belle Verrière (see below). The extant window's early core may be a later version of the work of art mentioned in a document from 1137 copied at Josaphat but witnessed in the chapterhouse of the cathedral; the glass surrounding the twelfth-century core, which itself has been repainted and heavily restored, is of the early thirteenth century, usually dated to the 1220s or 1230s (see note 42 below). Scholars have supposed that the original window may have been near the main altar of the church before the fire of 1194, perhaps forming the apex of the view down the nave toward the apse. To have a glass icon of the Virgin in place was part of cultic understanding at the time, and the window, even as it survives today, forms a crucial guide to interpreting art and liturgy and the representation of time in the mid-twelfth century at Chartres; it also offers a view of how a twelfth-century representation of the Virgin was reinterpreted through reframing in the early thirteenth century.[6] Claudine Lautier (2009) demonstrates how the idea of the Virgin as the Ark of the Covenant is repeated in the program of glass from the thirteenth century. She argues as well that later windows contain numerous allusions to the cloth relic, the most famous of these being the Charlemagne window studied by Elizabeth C. Pastan (2008) for its references to the relic. Twelfth-century explications of the relic and its multiple meanings would inspire the visual arts after the destruction of 1194.

## THE VIRGIN AS THE SEAT OF WISDOM

Notre Dame de la Belle Verrière is modeled to a significant degree upon the popular small, wooden *Sedes* images carved in France in the mid- to late twelfth century. These objects survive especially in the Auvergne, although they have been

found in one configuration or another all over Europe. In the majority of those still extant from central and northern France, which historians have dated to the twelfth century, Mary holds her child squarely on the throne of her regal lap, and she is sometimes crowned.[7] The posture aligns the two faces and enhances parallels between them, even as her body surrounds the child's; the image proclaims the mingling of the human and the divine within the Virgin's womb and provides a vehicle for pondering the mysteries of incarnation and nativity. In this image, a translation of the theological understanding of Theotokos, "one who gave birth to God," the Word becomes flesh in time and, as a result, time and history are recast. The great and small depictions of this image in Rome would have inspired religious leaders of the eleventh and twelfth centuries;[8] twelfth-century crusaders saw such Virgins in the East in the context of church buildings. This is an eternal indwelling: Christ is not an infant but a miniature man who shows none of the childish play seen in later depictions of Madonna and Child.[9] He is a small and thoughtful king, sometimes crowned, more often not. From the beginning of time he has had the reins of creation and of power in his hands; his forward gaze matches his mother's, with the tender, almost amusing correspondences often seen in the facial features of mothers and sons. It is as if one thing is manifested in two ways, in the female and in the male, yet in a fashion that is transcendent: the Son mixes the Davidic humanity of his mother with the eternal power of the triune God, as can been seen in a twelfth-century *Sedes* from Aubusson.[10] Mary at the moment of the Incarnation is "full of Grace," as the angel Gabriel said in his address to her; this image represents indwelling throughout time, fusing the individual acts of incarnation and birth within the context of ever-present hope. The statues sometimes functioned as reliquaries, with niches cut in them for cloth, hair, or other special items believed to have belonged to the Virgin or to have been a part of her body.[11] To privilege the image at Chartres Cathedral was to make general reference to the primary relic, one that both local people and pilgrims would readily have understood, and would associate the Virgin's chemise with both the Annunciation and the Nativity of Christ. But the robe was not only clothing that touched Mary's flesh during these moments of mystery; it was also emblematic of the history of the Christian people, from the beginning of time to an ever-changing present. And this history was best understood at Chartres.

The *Sedes* image promotes the timeless Virgin, too, as proclaimed in the late-eleventh-century "Clara chorus" and in the tropes for the Dedication feast at Chartres: Mary herself was eternally foreknown by the Godhead, eternally elected, eternally to be born, eternally beloved. Her choice to have a son was of her free will, but God knew what her decision would be; Christ the prophet proclaimed her beauty in the Song of Songs in "Clara chorus," a text that also resonated with the Styrps Jesse window (see chapter 12), and joining his voice to that of Solomon in the Song of Songs:[12]

Figure 9.1. Twelfth-century *Sedes* from Aubusson.

7.1 Ave, mater preelecta Christus ad quam fatur ita prophete facundia:
7.2 Sponsa mea speciosa super filias formosa super solem splendida
[Hail, preelected mother, to whom Christ speaks thus with the eloquence of a
prophet: "My lovely bride, beautiful above the daughters, splendid above the sun."]

In this image the Begotten, enfleshed and enframed, is caught in historical mo-
ments of conception, indwelling, and birth, yet understood through the powers of
prophecy to be outside time as well. Christ and Mary, like eternity and time and
divinity and humanity, are fused, yet also separate. In this vision of foreknowing,
fully developed in the liturgical texts of Advent and Christmas, both understand
and accept what lies ahead with equanimity, even with a guarded eagerness. In their
mutual love and acceptance, the historical church is born. Ilene Forsyth comments
as follows: "The statue combines the majesty of male and female figures in one
image. The Child-King, the divine ruler of the Christian world, is enthroned in the

lap of the Queen of Heaven. These two figures may be understood as the Logos of
the New Dispensation with the seat of the Wisdom of Solomon from the Old, or
as the Godhead with his Church. Male and female provinces interlock as do the
figures. Mother-child divinities are to be found in ancient art, but they invariably
stress only one or a few of the many ideas which meet and merge in the Roman-
esque statue" (1972, 29).

The small wooden statues studied by Forsyth were often located in the crypts of
churches and sometimes in special small shrines outside. It was common for these
*Sedes* figures to be carried in processions and also to be not only the objects to
which processions traveled, but also the places where stations, or stops, were made.
A pilgrim reports on a visit to one of these, in Aubusson-d'Auvergne, in the late
nineteenth century, doubtless in connection with the very *Sedes* depicted above.
Although his description is cast in an ultraromantic vein, this eyewitness connects
the cult of the Virgin and the telling of local history through a ceremony of popular
devotion that alludes to an imagined pagan source underlying the procession of this
humanized goddess:

> The holy oratory stood up like a tall fortress on the summit of a small abutment and
> in the midst of a charming site. Ancient trees surrounded it as if a sacred grove. A
> stream with limpid waves nestled about the foot of the hill, and its sweet murmuring
> harmonized with the birdsong, bearing the soul to the gathering and inviting it to
> prayer. On the green lawn on its banks, in the shadow of full-grown trees, the pro-
> cession was organized. . . . It went forward slowly in the empty roadway, perfumed
> by the scents of heather and buckwheat. The parish standard led the procession . . .
> from poor mothers presenting their sick children at the passing of the Virgin and
> confidently begging a blessing on the little ones. Finally, we see again the doorway
> of the ancient church.[13]

The several manifestations of this image found at Chartres Cathedral have tra-
ditionally been related to a supposed twelfth-century wooden statue of Virgin and
Child in the crypt. That one was located there at this time is likely, but we have no
sure evidence that Chartres Cathedral possessed such a statue at this period, or, if it
did, that it had become a significant cult object by the mid-twelfth century.[14] Mod-
ern scholars have presented a narrative that places an eleventh- or twelfth-century
wooden statue of the *Sedes sapientiae* near the Well of the Brave Saints (its ever-
evolving name in the fourteenth century), even, sometimes, with the relic of the
Virgin's chemise in a grotto nearby—but such a story derives from later Chartrain
historians (see chapter 12).[15]

The disclaimers of Bernard of Angers, a student of Fulbert of Chartres, suggest that
there was no Marian statue in Chartres Cathedral in the early eleventh century.[16]
Although eleventh-, twelfth-, and thirteenth-century sources, including necrologies
and cartularies, contain no mention of a wooden statue in the crypt, miracles of

healing nevertheless took place in the crypt and elsewhere in the cathedral, and one assumes that the cult of the Virgin must have had a locus for these events.[17] Scholars have long assumed that the wooden statue of the Virgin burned during the Revolution was a twelfth-century *Sedes sapientiae* and that the present-day statue in the crypt is a copy of that original; other statues found locally are also described as copies of the *Sedes* at Chartres.[18] If there was an important statue in the crypt, some mention of it in the miracle collection would seem likely. The miracle collection, though based on earlier written and oral legends, was assembled and written in Latin in the early thirteenth century and then translated into French in the mid-thirteenth century by Jean le Marchant.[19] Yet both the Latin and the French collections concentrate all the action upon the main altar and the chemise. In Miracle III (Latin I), which relates a story concerning the fire of 1194, the Chasse with the relic was swiftly transported from the high altar into the crypt via an internal staircase that connected the upper and lower churches. Fire raged above and molten lead streamed down from the roof, but stopped just short of destroying the relic and its trembling guardians. This miracle is compared to stories concerning Noah in the Ark, Jonah in the whale, Daniel in the den of lions, and the three boys in the fiery furnace.[20] This is the only time the crypt is featured in the miracle collection.

The description of the replacing of the Chasse on the main altar after the desecration of 1210 and turmoil in Chartres between some factions of clergy and laity suggests the location of the relic in the early thirteenth century. In this time of demonstration against the dean of the chapter there was property damage, and the relics of the saints, including the Sainte Chasse of the Holy Cloth, were removed from their altars to show displeasure (for further discussion of the location of the reliquary in the thirteenth century, see Lautier, 2009, and chapter 12). The reconsecration ceremony features the responsory "Gaude Maria." The chant text, although different in melody and mode and having slightly different words, relates to one of the five Marian antiphons featured at all First Vespers for Marian feasts, the text of which begins in the same way:[21]

> When these things were completed, the clergy, preparing themselves to process, first celebrated certain liturgies, which the ordinal indicates are to be performed for the re-consecration of holy places. When these ceremonies had been completed, a multitude of laymen who were standing there flocked together in order to sound the bells of the church, and the responsory "Gaude, Maria" [Rejoice, Mary] was sung repeatedly with the loudest of voices before the altar of the glorious Virgin. Truly, with the altar having been decently decorated in the interim, the most holy reliquary was repositioned on it, the containers holding the relics of the saints were lifted off of the ground and carried back to their own places with joy, exultation and songs, and the image of the Crucifix was repositioned in a more eminent place, just as it used to be before the riot. And thus this happened to the great joy of the clergy, but to the great confusion of the people, [who were] still [filled] with great iniquity and sin.[22]

The text of the responsory "Gaude Maria" was well chosen for this ceremony, as Mary rejoices that her church has been rescued from those who would do it harm and that the liturgy is restored to her altar: "Rejoice, Mary, virgin, you alone have destroyed all heresies. You believed in the words of the Archangel Gabriel that you, while a virgin, have given birth to the God-man, and that after the birth you have remained an inviolate virgin. Alleluia." [Gaude Maria virgo cunctas haereses sola interemisti quae Gabrielis archangeli dictis credidisti dum virgo deum et hominem genuisti et post partum virgo inviolata permansisti, alleluia.] Mary remains inviolate, as does her church, which can be restored in spite of assaults and depredation. Ceremonies such as that described here bound up the wounds of history, at least for some segments of the population. The responsory, as described in the miracle of Gautier de Coinci, "brings back life and sight."[23] Relics restored to their accustomed, rightful positions were visual signals that the salvific sacraments operated once again.

## THE NEW TABERNACLE

Until new evidence emerges, the meaning of twelfth-century art associated with the Virgin's cult properly begins in the context of the main altar and with the ancient reliquary containing the chemise located there. Descriptions of the early eighteenth-century opening of this box indicate that it contained more than the holy cloth: here was kept the oldest Bible possessed by the cathedral of Chartres, a sixth-century Gospel of John;[24] here too was a stick that could represent the flowering rods of Jesse and of Joseph, central objects in the legendary narrative of the Virgin's life and of Chartrain identity. The Chasse contained historically appropriate objects for creating a new Tabernacle.[25] The art studied here brought the contents out of the box and displayed and explained them, making them part of the historical framework of time.

The Tabernacle of the Temple was the holiest place on earth to Jews and also to Christians, who followed after and reinterpreted the ancient sacred understanding for a different faith tradition. It contained the Mercy Seat, the throne on which the eternal living God resided in the midst of the people, with an angel on either side and with the testament within as well. The cloud sometimes enveloped it to indicate God's presence, and appropriate human ritual was designed to please God. It was closely connected with the sacrifice of the Temple priests and with the singing of the cantors, as the descriptive passage from 2 Paralipomenon (Chronicles) demonstrates.[26] Here during the dedication the ark is relocated in a new place:

> And when all the ancients of Israel were come, the Levites took up the ark, and brought it in, together with all the furniture of the tabernacle. And the priests with the Levites carried the vessels of the sanctuary, which were in the tabernacle. And

King Solomon and all the assembly of Israel, and all that were gathered together be-
fore the ark, sacrificed rams, and oxen without number: so great was the multitude
of the victims. And the priests brought in the ark of the covenant of the Lord into its
place, that is, to the oracle of the Temple, into the Holy of Holies under the wings of
the cherubims: so that the cherubims spread their wings over the place, in which the
ark was set, and covered the ark itself and its staves. . . . Both the Levites and the sing-
ing men, that is, both they that were under Asaph, and they that were under Heman,
and they that were under Idithun, with their sons, and their brethren, clothed with
fine linen, sounded with cymbals, and psalteries, and harps, standing on the east side
of the altar, and with them a hundred and twenty priests, sounding with trumpets.
So when they all sounded together, both with trumpets, and voice, and cymbals,
and organs, and with divers kind of musical instruments, and lifted up their voice on
high: the sound was heard afar off, so that when they began to praise the Lord, and to
say: Give glory to the Lord for he is good, for his mercy endureth for ever: the house
of God was filled with a cloud (2 Par 5:4–8, 12–13).[27]

The medieval Christian equivalent of this place within the Temple sometimes
was represented through the *Sedes sapientiae* image. Two angels that guarded the
Mercy Seat are occasionally incorporated into wooden *Sedes*, as can be seen in ex-
amples from Jouy-en-Josas and Limay.[28] It is this tradition that was depicted in vari-
ous guises in the twelfth-century *Sedes* of Chartres. The medieval depiction of the
throne is testimony to the belief that Christ and Mary seen together represented a
new sense of the past, a new relationship between the divine and the human that
took place in the Incarnation. Proof texts for incarnation and birth relate directly
to ideas concerning the lines of kings, priests, and prophets discussed by Fulbert of
Chartres in his sermons, not only for Advent, but also for the feast of Mary's Nativity
as well. Arguments about events, characters, and places—all three—concerned exe-
gesis; medieval Christian scholars generally claimed that their Jewish counterparts
were overly literal in their strategies of interpretation, whereas Christians were able
to read more deeply, mystically.[29] Attitudes toward the visual manifestations of God
were another point of contention; this was closely tied to attacks from both Jewish
and Christian scholars on Christians' veneration of images.[30] The classic represen-
tation of the arguments from the early twelfth century is found in Gilbert Crispin's
*Dispute between a Jew and a Christian*, in which, as might be expected, the Jew gets
the worst of it.[31] Kalman Bland reports on the section of the argument over images,
using the arguments of Rabbi Joseph Bekhor Shor of Orleans as a foil and situating
the polemic in early twelfth-century Anglo-Norman Europe. Gilbert's Christian
has the last word. The response of the Jew, if there was any, is not recorded. It is un-
likely, however, that the Jew was any more persuaded by Gilbert's reasonable Chris-
tian that Christian images are not idolatrous than Christians were persuaded by
Rabbi Joseph's arguments that Jews are innocent of idolatry. Defending themselves

against similar charges, twelfth-century Jews and Christians resorted to similar re-
sponses to the charges against them: Rabbi Joseph claimed that the ancient Israel-
ites were merely honoring the calf, not worshiping it as if it were an idol pretending
to be God. Some Benedictines, perhaps in response to iconoclastic charges from
Cistercians, claimed that contemporary Christians merely honor the cross; they do
not worship it as if it were an idol simulating God.[32]

The Christian polemic against the Jews as related to the Incarnation depends
on a key biblical text: "Thou canst not see my face: for man shall not see me and
live."[33] Christ as God incarnate appeared in the world of time, and those who saw
him as what Christians believed him to be did not die. Depictions of Christ were
not, of course, believed to contain his actual person; rather, pictorial art reminds
Christians of incarnation and of God's appearance in the flesh in time. All surviv-
ing art from twelfth-century Chartres embodies this theme; the connection is not
between seeing and believing solely through the images themselves. In order to
make their meanings the images must be taken into the tabernacle and displayed.
The art makes a statement about history: the Incarnation took place, and it trans-
formed the past; the bodies of Christ and Mary ascended or were assumed and did
not die. Though the art survives in bits and pieces, heavily restored, enough remains
to demonstrate that sophisticated modes of viewing depictions of the Incarnation
grew out of a liturgical understanding of knowledge as revealed in time, especially
as found in the season of Advent and in the feast of the Nativity of the Virgin Mary.
The liturgy of Chartres as witness to historic events in the Holy Land was especially
related to an ideal that sought to place a triumphal present in historical parallel with
persons and events reestablishing a Latin kingdom and a Christian Temple in the
Near East.[34]

## BERNARD THE SACRISTAN AND BLESSED MARY OF
## THE STAINED-GLASS WINDOW

At Chartres at least one of the figures who promoted the clairvoyant aesthetic
discussed here can be identified, as can several of his projects. A document from
around 1137 mentions a stained-glass window and relates it to the cult of the Virgin
of Chartres:[35]

> Bernard the sacristan [*capicerius*] has given a certain peddler's stall, which he held
> as his own at the foot of the tower, to the office of the sacristan of Blessed Mary,
> so that in the future sacristans of the church may provide before the stained-glass
> image the lamp, the oil, and the candles that the aforementioned provider of alms
> was wont to contribute. And so we establish and confirm, that the one who holds the
> office of sacristan may more fully perform this service for the image of Blessed Mary
> of the Stained-Glass Window by lighting the lamp with oil, and with candles, as has

been established. And let whoever defies or infringes on our statute be subjected to anathema. This is done in our presence in the same chapterhouse, with our venerable brethren standing by and in agreement: Zachary the dean, Salomon the cantor, Drogo and Theodore the archdeacons, Bernard the sacristan, Samson the provost, Henry the provost, Goslen the provost, Robert the chaplain, Rainaud the priest, Hugh the priest, William the deacon, Master Paganus the deacon, Guido the nephew of the chancellor, Drogo the father of Samson the provost, Ivo "Mercato," and many others.[36]

Bernard the sacristan was a wealthy, powerful figure in the administration of Bishop Geoffrey of Lèves; his first known appearance in the office of sacristan is in 1119.[37] Few documents were witnessed by him at the cathedral or at St. Peter, but numerous citations occur in the charters from Josaphat.[38] Doubtless from a wealthy family and entrepreneurial in nature, Bernard the sacristan contributed the monies for rebuilding the almshouse (or *hôtel-dieu*) after the fire of 1134 destroyed it and also paid for the roof of the cathedral (this too apparently damaged by the fire), as is revealed in his obituary from the cathedral.[39] In addition, he was a builder of the refectory at Josaphat.[40] In their lengthy definition of the office of sacristan (*CNDC* 1), compiled primarily from later documents, Lépinois and Merlet mention that the sacristan was the officer in charge of the stalls outside the cathedral doors and the recipient of their income. The charter of circa 1137 is the first evidence of that ownership. It proves that Bernard assigned the income from one of the stalls (that came to him as the official in charge of relics and reliquaries) to specific needs of the cult of the Virgin of the chemise; thus income from his stall outside the cathedral at the foot of a tower was devoted to the work of the Virgin's cult inside the church. Dedication to and interest in the cult of the Virgin had surely become an important means of drawing people to the cathedral, and outside the cathedral, in stalls near the doors, were objects for sale to encourage their devotion. The sacristan Bernard wanted to make sure that some of the income accrued would be used to serve the needs of the cult of the Virgin.

Bernard's obituaries show that he possessed deluxe liturgical books, and that one of them was a book containing readings for feasts of the Virgin Mary. This book was very likely a copy of the Book of the Cult of the Virgin, a cousin of Chartres, 162, if not Chartres, 162 itself (see chapter 5). Fully committed to the mid-twelfth-century campaign to elevate the cult by supporting the liturgy more fully as well as by acquiring new artworks, Bernard also contributed to the campaign to endow the choristers; he himself, as the manager of the Virgin's reliquary and the special services connected with it, would have had charge of those especially assigned to the work of this altar. The many angels depicted singing, playing, and holding liturgical implements in the artworks of the cathedral of Chartres at midcentury were, in one sense, the youths whose work was being endowed as part of the campaign.

This link between music, liturgy, art, and Mary as Mother of Mercy calls up images of caretaking and feeding and also fuses them with lamps, candles, and light imagery. Those who heard Bernard the sacristan's obituary read out year after year were made aware of his reverence both for the Virgin's cult and for a window containing her image, an image enshrined in the history of the cathedral and the people who served its rituals. A thematic link between the works of art inside the church, the artwork decorating the portals, and the items for sale in stalls by the doors was made through the office of sacristan, the person responsible for selling pilgrims' souvenirs and for maintaining the cult inside. Income from the stalls, where pilgrims and townspeople, at least by this time if not earlier, could purchase mementos of ceremonies, prayers, and other religious experiences in Chartres, was part of the larger enterprise, as managed by the sacristan. The art of the glass and portals that inspired devotion also inspired the contributions that maintained and safeguarded the decorative arts themselves, creating a direct link between what was seen and experienced in front of the west portals and the art and action of the main altar and its reliquary.

The importance of Bernard's use of money from the stalls to support the cult is attested by the witnesses to the charter, all of whom were prominent officials. In addition, all three men who would serve as bishop during the time the west façade was designed and constructed were present: Geoffrey of Lèves, who was bishop at the time, Goslen of Muzy, who was then an archdeacon, and Robert the Breton, who was the bishop's chaplain and presumably the person in charge of the liturgy in the bishop's chapel and when he traveled.[41] The charter proves that the earliest known predecessor of Notre Dame de la Belle Verrière (the Derembles [2003], 50, say the title is used only from the fifteenth century) was an important part of the liturgical and devotional life of the cathedral by the mid-twelfth century. It must have been associated with the cult of the holy cloth and the high altar; apparently it was looked after by the same group of youths who said the special Office of the Virgin Mary every day.

The relationship between the window mentioned in the Josaphat charter of 1136–37 cited above and the extant window can only be surmised, with much depending upon dating. Notre Dame de la Belle Verrière is a vast quilt of glass that has been constantly patched and otherwise repaired from the twelfth century to the present time (it was restored and cleaned in the 1970s and again in 2006). The core of the work is ancient, although most of the painting is modern; experts are agreed it dates from the twelfth century, although exactly when in the century remains a matter of dispute.[42] The authoritative team of Chantal Bouchon, Catherine Brisac, Yolanta Zaluska, and Claudine Lautier (1979) believes the core dates from around 1180. Hervé Pinoteau (2000) has argued that its most ancient elements may be earlier by a generation, pushing some aspects of the work closer to the time the west façade was under construction and to the charter discussed above (Pinoteau's expertise lies

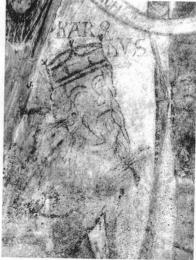

Top: Figure 9.2. Crown of Charles the Bald; detail of engraving from Michel Félibien, *Histoire de l'abbaye royale de Saint-Denys en France* (1706).

Top right: Figure 9.3. Charlemagne's crown in the St. Clement Chapel, north wall of the South Crypt. Credit, de Feraudy.

Bottom right: Figure 9.4. Detail of Belle Verrière, crown, south choir. Credit, de Feraudy.

in history rather than in art history, however, and specialists will have to evaluate the arguments). The constant refashioning and repairing of the work make it diffi-cult to be sure about many aspects of it. It is assuredly an ancient cult object; the basic shape of its core has remained the same since the twelfth century, and Char-trains have cared about it for over eight hundred years.[43]

The first thing to notice about the window is the emphasis on the Virgin's robe.[44] As the light comes through the window, the blue robe enshrines the Virgin's body with a gleaming cloud. Bouchon and her colleagues explain that the brilliance of the blue glass robe was achieved by the introduction of generous amounts of air during the glass-making process, with this special effect in mind; Grodecki (1977) offers another study of the process.[45] The Christ Child's body, clothed in the purple appropriate to his royal stature, is framed by that of his mother, whose shimmering garment completely surrounds him like a cloth halo made splendid by light. Radiant too is her restored head, surrounded as it is by a beaded orb of light that is the same radiant blue as her robe. This backlighting of the Virgin's head emphasizes her crown, which is, next to her garment, the most magnificent ob-ject in the core of the window (see plate 4). Pinoteau argues that there is a spe-cial reason for this emphasis: Mary may wear an object that would have been

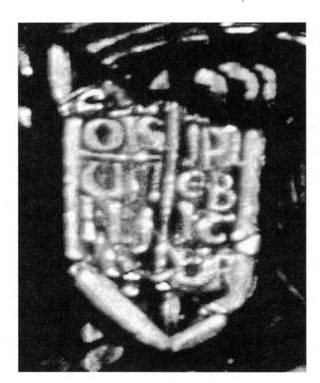

Figure 9.5. Detail of Belle Verrière, *Omnis vallis implebitur*, south choir. Credit, de Feraudy.

well known regionally. Her crown apparently was designed to allude to the object Charles the Bald supposedly presented as gift to St. Denis, a treasure displayed during the period the window was designed; through such an allusion, the Virgin's crown belongs to the man who, legend has it, donated Mary's robe to Chartres (see chapter 1).[46]

Taken together, the crown and the radiant robe speak of the Virgin's historic relationship to this particular church and recall the earliest histories of the town, several of which were vehicles for understanding the mysteries and their meanings. The elongated shape of the Virgin's body became necessary when the three-dimensional *Sedes* was remade as a one-dimensional object. By a lengthening of the body and thus opening up of the lap the robe could be fully displayed (see plate 5). Around the Virgin and Child is rich ruby-red glass, the bejeweled counterpart to the luminous blue robe, which shines all the more brightly because of the contrast. The tent of the tabernacle was red (see Exodus 26:14), and the use of the color here may be symbolic.[47] In this design the blue robe creates an oval mandorla, indicating Christ in majesty, and recalls the twelfth-century art still extant at Chartres Cathedral that also shows this image or a variation of it; taken together, the several Chartrain *Sedes* images provide a complex statement about the nature of the Incarnation and its manifestation and celebration through the Virgin's cult.

The *Sedes* depicted in the Belle Verrière is the only such image directly linked to the liturgy through a surviving inscription. The Child holds a book that deliberately

resembles a tablet, and on it is written in uncial letters, "Omnis Vallis Implebitur" ("Every valley shall be filled": Luke 3:5). These are the opening words of the antiphon sung for the canticle at Lauds on Ember Saturday in Advent. This Advent feast (described in chapter 3; transcription of melody in appendix D) abounds in Marian imagery, with special emphasis upon the Davidic lineage of her flesh and with liturgical texts concerning the rod of Jesse that directly inspired the liturgical chants attributed to Bishop Fulbert. The learned designers of the window's twelfth-century core knew that this antiphon was sung in the Chartrain liturgy with the canticle of Zachary, the father of John the Baptist (Luke 1:68–78). This canticle, always sung at Lauds in the Latin rite of the Middle Ages, relates the window to the imagery of the Temple on several counts. Clerical and monastic observers of the window in the Middle Ages would have completed the antiphon text in their liturgically conditioned imaginations and repositioned it within its liturgical context.

The texts, music, and position in the liturgy of biblical passages used as sources for medieval art not only help explain why the artworks are designed as they are, but also suggest the audience's reception. Many who saw this window could supply the rest of the text on the book Christ holds because it was sung in the liturgy and hence was well known, and the window explores the meaning of Advent and nativity in a special Chartrain vein. Those who saw it might strain to read the text, as we do today: "Every valley shall be filled" continues by proclaiming, "all flesh shall see the salvation of God." The mystery is *seen*: the very act of seeing means that history has changed, and a new Holy of Holies has been built within the Temple. The art itself, through its nature, announces that the past has been transformed and it does so in a way that recalls the sermons of Fulbert and the chants and liturgies written in Chartres for Advent and for Mary's Nativity. Fulbert argued in his Advent sermons on Genesis 49:10 that the end of the Jewish kings and prophets was a sign that the Messiah had indeed come. Notre Dame de la Belle Verrière offers another way of saying the same thing, in accordance with the prophecy of Hebrews 9. "To see the salvation of God" within the Tabernacle meant that a new order had come to it, and what had been a closed and invisible mystery had been offered to human senses.[48]

In this window the cloud within the Tabernacle is lifted from the Godhead through depiction of the *Sedes*, with all its complex layers of meaning. A new sense of history rises from visibility and understanding. In an age when many Christians longed for the Holy Land, where they believed real circumstances from biblical history could still be seen, art existed that proclaimed the importance of visualization, even for those who stayed home. The failure of the Second Crusade made such artworks even more important in the second half of the twelfth century. Peter, abbot of Celle, bishop of Chartres in 1180–82, mentor and close friend to John of Salisbury,[49] was a thinker whose writings would have been known in the region during and after the time the window was designed (depending on when one dates it, something that has not yet been done by art historians with precision). He, like

those in the generations of theologians immediately before him, was deeply inter-
ested in the meaning of tabernacles, in his case, that of Moses. A patron of art and
architecture, Peter of Celle says (in a translation from Otto von Simson) "let us
visualize the historical Tabernacle that Moses built, as a means of guiding our atten-
tion from things visible to things invisible."[50] Ivo Rauch (2004) has expanded upon
previous scholarship, drawing this and other windows more deeply into the theo-
logical understandings of Peter of Celle and also showing that the crusaders often
fancied themselves to be like the tribes of Israel, come to place their new ark in the
Temple. Through the particular chant text held by Jesus on the Virgin's lap deep
within the Tabernacle, art, music, and liturgy proclaim incarnation in an elaborate
counterpoint between image, function, text, and song.[51]

The window's thirteenth-century margins also explore the idea of the *Sedes* as a
new seat for the Godhead and demonstrate ways in which twelfth-century artworks
were repositioned and reframed within the new cathedral building, with older
visual and theological ideas extended further through new contexts. In the original
core two thuribles that may also date from the twelfth century swing high above
the Virgin's head (see plate 6; see also plate 5). The thuribles must once have been
held by two angels, each of whom would have been significantly larger than their
two present-day, thirteenth-century counterparts, whose heads are smaller than the
thuribles they swing (Lautier is now preparing a study of the window and will offer
further comments on the dating of these details). The likely original angels faced
each other, as the angels in the Holy of Holies are said to have done.[52] They provide
the appropriate cloud of incense and point to the "table of incense" that was promi-
nent in Old Testament descriptions. But the smoke enhances rather than obscures
the Godhead in the Chartrain window.

The presence of the Holy Spirit in the form of a dove overshadowing the taber-
nacle is richly symbolic and points to a Christian reworking of earlier understand-
ings of the tabernacle (see plate 5). Indeed, the very act of overshadowing recalls
both the Old Testament tabernacle and the incarnation described in Luke 1. Mary,
when overshadowed by the Holy Spirit, becomes the new tabernacle filled with
the eternally begotten Godhead. Her body contains the flesh of Christ but also, as
he is one with the rest of the Trinity, encompasses the Trinity itself.[53] A Victorine
sequence, written around the time the window was designed, presents a contempo-
rary view:

> Salve, mater pietatis
> Et totius trinitatis
> Nobile triclinium,
> Verbi tamen incarnati
> Speciale maiestati
> Praeparans hospitium.

[Hail, mother of piety and noble resting place of the entire Trinity, yet with special majesty preparing a welcome for the incarnate Word.][54]

The thirteenth-century angels that attend the throne of the new David hold not only the twelfth-century thuribles but also other items related to the new tabernacle (see plate 5). They also are reminders of the numerous contributions for choral endowments to support those who sing and the special youths chosen to attend the altar of the Virgin: these angels are their visual counterparts. There are eight attending angels to the left and right of the core, and these can be divided into four pairs by location, gaze, dress, and the objects they hold. The top two angels reach toward the twelfth-century thuribles described above and also hold pots of manna in their hands (see plate 7). The next pair holds candles, for a total of four candles. The next two pairs swing smaller thuribles and hold pots of manna as well. Instead of the sacrifices of animals that filled the Ark of the Temple, this new ark has only bread and thus it witnesses to the Christian Eucharist as the new sacrifice. The golden urn containing manna is found only in the description of the tabernacle in Hebrews 9, and this is a visual sign that the viewer has entered the holiest place of a New Testament configuration of the Temple.[55]

Directly below the core are four more angels, distinguished by their dress and stance (see plate 8). Each of these angels holds a golden pillar, lifting it toward the base of the ark as if to support it. These seem to be associated with the veil of the tabernacle, alluding to the cloth relic of Mary's robe, which was a veil for the tabernacle of her body. The four pillars, positioned as they are, recall the text of Exodus 26:31–33 (and its parallel in Exodus 36:35–37): "Thou shalt make also a veil of violet and purple, and scarlet twice dyed, and fine twisted linen, wrought with embroidered work, and goodly variety: and thou shalt hang it up before four pillars of setim wood, which themselves also shall be overlaid with gold, and shall have heads of gold, but sockets of silver. And the veils shall be hanged on with rings, and within it thou shalt put the ark of the testimony, and the sanctuary, and the Holy of Holies shall be divided with it."

The thirteenth-century depictions of the temptations of Christ and the marriage of Cana, below the four angels who carry the columns, also serve to situate the image more deeply within the Gospel narrative and relate directly to the Gospel text found near the center of the image on the tablet carried by Jesus. The antiphon text from Luke 3:5 is part of John the Baptist's cry to the multitudes; it is spoken in the Bible just before the baptism of Jesus and the Lord's genealogy as found in Luke. This genealogy was a central text at Chartres because of its parallels with the genealogy of Matthew, the Gospel text for the feast of Mary's Nativity. The art further explicates the theme, and it is immediately after this genealogy that temptations of Christ by the devil take place, expressed in the lower band of the window, which is dated to the second quarter of the thirteenth century (see plate 9).

One reads the narrative from the bottom up and from left to right. In the lowest band, to the left, the devil asks Christ in the desert to transform a stone into bread (Luke 4:3), which makes a parallel with Mary's request to turn water into wine and reinforces the eucharistic imagery of the window's core. Subsequently (on the viewer's right) the devil and Christ go to a high mountain where all the kingdoms shown in an instant of time are promised (Luke 4:5). In the final temptation (center), the devil takes Jesus to Jerusalem, then to the very pinnacle of the temple (Luke 4:9), and says, "If thou be the Son of God, cast thyself from hence."

In the Gospel according to John the baptismal scene is not followed by the temptations of Jesus, as in Luke and the other synoptics. Rather, it is followed by the first call to the disciples and then, at the opening of chapter 2, by the miracle at the wedding in Cana (John 2:1–11). The juxtaposition of these postbaptismal stories in the window recalls the nature of early requests for miracles. The devil asks Jesus to perform the kinds of miracles that later, in different guises, Jesus will enact, but when he is ready. Mary, on the other hand, asks for a miracle as well, and even though the time has not yet come, Jesus obeys her. The narrative explores the interaction between Mary and Jesus in an artwork that is about their relationship. The eucharistic themes found in the stories are also related to the manna mentioned in Hebrews 9 and are emphasized through the manna carried by the angels surrounding the new tabernacle.[56] Christ within the tabernacle is the new sacrifice, and the bread and wine become that sacrifice through the act of consecration at the Mass liturgy. The next to lowest band of glass begins the story of the miracle at Cana: to the left, Christ approaches; in the center, the banquet runs out of wine; and to the right, Mary tells her son the problem. In the band above, to the left, Mary tells the servants to do as Jesus asks them; in the center he turns the water into wine; and at the far right, the wine is served. If the original context of the window's core had been its location near the main altar, the later commentary provided on the mysteries of the Eucharist after the window was repositioned would have explained liturgical action within the context of the Virgin's cult.

So on the axis below the "tabernacle" of the twelfth-century core, the thirteenth-century glass comments upon the miracle of visualization. Directly below the angels Christ changes water into wine, astounding those who taste and see. Yet farther down, Christ stands on the pinnacle of the temple; he will not jump at the devil's command, but he will reign over the new temple at the proper time.[57] The irony of Christ's standing on the temple in the lower register, whereas above he is seated within the holiest of places, was surely powerful in medieval times. In the upper central core of the window, Christ sits at the center of a new temple; in the lowest register he stands on the highest pinnacle of the building for which he will become "the cornerstone" at the proper time, as he is positioned even in this miniature scene as a kind of capstone on top of the temple's roof. The interrelationships between the scenes and the artists' depictions of them, especially as they relate to

the twelfth-century core, point to goals of patrons who were reshaping the cult through new artworks in the early decades of the thirteenth century and relating new works to spolia from the destroyed church of Fulbert and its twelfth-century additions.

## THE *SEDES* OF THE SOUTHERN TYMPANUM

The sculpture of the *Sedes sapientiae* found in the tympanum of the southern portal of the west façade is often considered the oldest surviving Chartrain depiction of this central image.[58] Whatever the date of the sculpture in the tympanum—commonly dated by art historians to the mid-twelfth century—the context suggests that the artwork was conditioned by interpretations of the Dedication rite celebrated repeatedly at Chartres in the decades after the burning of the town in 1134.[59] As in Belle Verrière, Christ takes his place as the new high priest in a new temple of rededicated architecture: the imagery emphasizes the reconstituted Mercy Seat of the tabernacle and the Marian themes found in Christian exegesis and in Chartrain liturgical texts about this ancient place and its meanings. The *Sedes* of the southern tympanum has been surrounded by many references to the liturgical texts and actions discussed earlier in regard to the Dedication feast and Belle Verrière. In the window, with the twelfth-century context destroyed, the thirteenth-century additions comment on the core image. In the southern portal of the west façade a different but compatible interpretation can be discerned.

The theme of the two lintels and the tympanum is a variation of themes employed in the design of Belle Verrière. Here too the designers and artists have created a work that draws the viewer into completing a narrative: a new Temple is built because God has become incarnate, has become visible; but the story requires looking to make its meaning. The window transforms believing viewers into participants in the history: to acknowledge that what was once seen summons a new presence within the tabernacle. This acknowledgment is appropriate to the sacrament of communion and to the command to "Taste, and see."[60] The mystical depiction of Belle Verrière belongs inside the temple itself and near the mysteries of the Eucharist. In the portal, on the other hand, the viewer studies the reactions of other viewers and is encouraged to join in their recognition of the Incarnate with a spirit not unlike that advanced by Arnold of Bonneval (see chapter 8 and below) concerning visualization. The mysteries of the altar and the Virgin's cloth relic have been brought out of doors.

Much of the iconography depends upon processions of figures (this idea is explored here and in the wider view of the entire façade found in chapters 10 and 11). Through the processions the viewer is placed inside or outside of particular groups of people who parade in various guises across the horizontal planes of the façade. Thus the viewer is welcomed within but is not yet initiated to the power of Belle

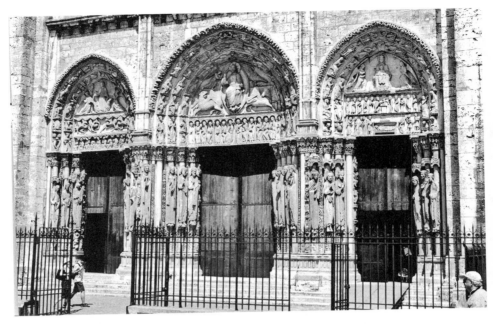

Figure 9.6. Triple portal, west façade, Chartres Cathedral. Credit, Jens Ulff-Moller.

Verrière. Belle Verrière provokes many meanings by placing the *Sedes* within the Tabernacle. The south portal sculpture places the *Sedes* at the apex of human events unfolding in time, all of which relate to the deeper meaning of incarnation, birth, and salvation. The eye can travel in a variety of ways as one interacts with the art, but the major theme emerges from consideration of the central vertical axis, dominated as it is by the positioning of the *Sedes* at the top, the point to which all meanings tend. As the eye moves upward, from the center of the lower lintel to the middle and then to the *Sedes* in the tympanum, it sees first the body of the Virgin wrapped in the sacred cloth relic. Lying above Mary is the Christchild, swaddled in Mary's Davidic flesh, a reference to manna, sacrifice, and Eucharist.[61] Directly above the body of the baby is the altar of the temple. Here the prophet Simeon receives from the Virgin Mary's own hands the offering he has waited for all his life. Directly above this ancient but transformed altar—upon which a visible God is now seen and recognized—Christ sits on the lap of the Virgin. In the middle lintel Christ is brought to the door of the Tabernacle; in the tympanum proper he is within the Holy of Holies, he has stepped through the door of Leviticus 12. The throne has received Wisdom; the church is born from knowing, seeing, and recognition; the rod of Jesse has bloomed within a new liturgical space; and the Temple has become the church.

The horizontal planes of the three axial images also proclaim the significance of seeing in the transformation of time; the sculptures are restored versions of the originals, and yet something of the original intent is plain. To the north of the crib

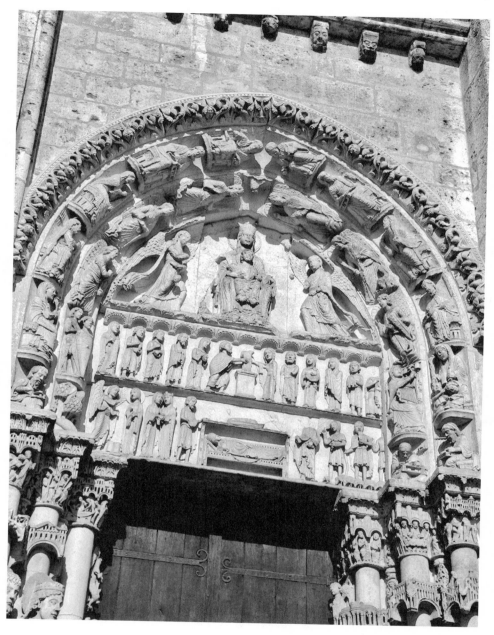

Figure 9.7. Tympanum and lintels, RPS. Credit, de Feraudy.

in the lower lintel are two scenes. In the first is the Annunciation, here compared with the same scene at Charité-sur-Loire (see below). The Virgin transforms time by her action and is hailed as being "full of grace" by the angel Gabriel, who then tells Mary of "the throne" that Christian exegetes would identify as her body: "He shall be great and shall be called the Son of the most High; and the Lord God shall give unto him the throne of David his father; and he shall reign in the house of

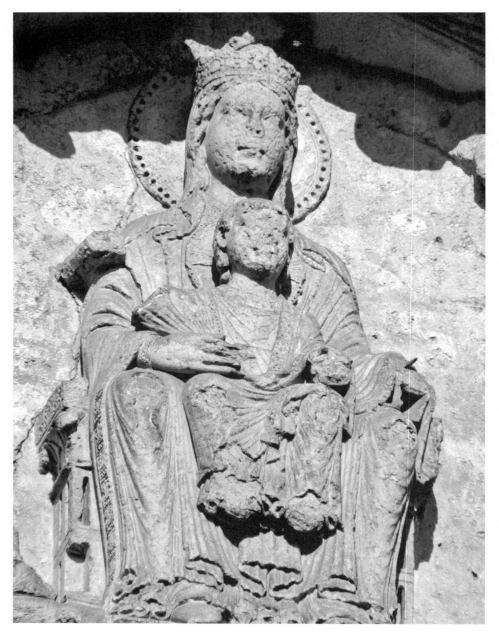

Figure 9.8. *Sedes* in the southern tympanum, RPS, west façade. Credit, de Feraudy.

Jacob forever" (Luke 1:30). The second scene of the lintel, which works chronologically from north to south, depicts the Visitation, another point of recognition. John the Baptist, the baby in Elizabeth's womb, leapt for joy upon sensing Christ, also *in utero*. When Elizabeth reported the miracle apprehended by her body, the Virgin sang her canticle, the Magnificat, the greatest Marian text in the Christian liturgy and a text sung at every Vespers service. The crown on the virgin's head in this scene

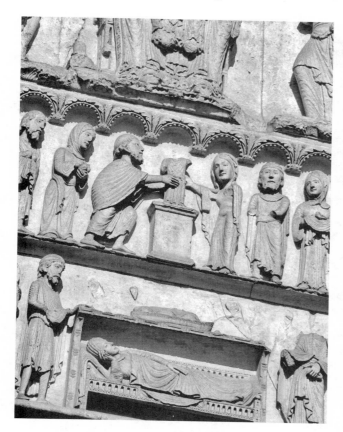

Figure 9.9. The central axis of the southern tympanum, RPS. Credit, de Feraudy.

signifies the promise of a new divine seat: "He hath put down the mighty from their seat, and hath exalted the humble. He hath filled the hungry with good things; and the rich he hath sent empty away. He hath received Israel his servant being mindful of his mercy: as he spoke to our fathers, to Abraham and to his seed forever" (Luke 1:52–55). To the right of these two scenes stands Joseph, whose rod has flowered indeed and who looks at the miracle of Mary's childbirth but whose attributes are lost. His garb, if what remains is original, may signify his lineage, for whereas he wears a costume similar to that of the shepherds, his skullcap is more like that of the prophet Simeon in the lintel above.

The lintel is about seeing and knowing. To the north, Mary, Elizabeth, John the Baptist, and Joseph are all depicted in moments of recognition. The emphasis on seeing is acted out on the lintel by the shepherds too: although the shepherd nearest the angel signals toward the nativity scene with a gesture of recognition and acknowledgment, the second shepherd has frozen in the midst of understanding, looking outward toward his audience, pipe to unpursed lips. He will not play in this instant, for his eyes have seen the glory. Seeing, he understands "of the word" and is in awe. The viewer is, in turn, told by this shepherd and his counterparts (for there are two others), and the viewer, too, is supposed to wonder. This dumbstruck

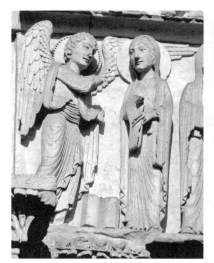

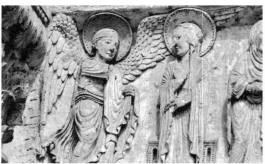

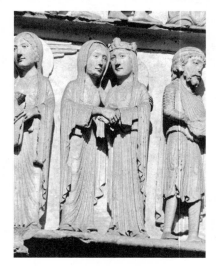

Top: Figure 9.10. Lower lintel, RPS: Annunciation. Credit, de Feraudy.

Top right: Figure 9.11. Annunciation from Notre-Dame de La Charité-sur-Loire, façade, mid-twelfth century. Credit, de Feraudy.

Middle right: Figure 9.12. Lower lintel, RPS: Visitation. Credit, de Feraudy.

Bottom right: Figure 9.13. Lower lintel, RPS: Joseph. Credit, de Feraudy.

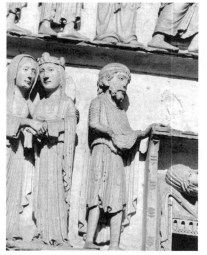

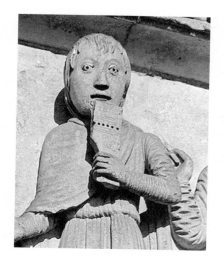

Figure 9.14. Lower lintel, RPS: Piping shepherd. Credit, de Feraudy.

shepherd whose eyes are filled with knowing reveals what all Chartrain art from the mid-twelfth century is about: the centrality of sight and recognition to the Christian mystery.[62]

The Christmas story as found in Luke 2:8–19 offers the details incorporated in the art, especially that the shepherds were to see what the Lord had showed, and all that heard wondered, as in the depiction:

And there were in the same country shepherds watching, and keeping the night watches over their flock. And behold an angel of the Lord stood by them, and the brightness of God shone round about them; and they feared with a great fear. And the angel said to them: Fear not; for, behold, I bring you good tidings of great joy, that shall be to all the people: For, this day, is born to you a Saviour, who is Christ the Lord, in the city of David. And this shall be a sign unto you: You shall find the infant wrapped in swaddling clothes, and laid in a manger. And suddenly there was with the angel a multitude of the heavenly army, praising God, and saying: Glory to God in the highest; and on earth peace to men of good will. And it came to pass, after the angels departed from them into heaven, the shepherds said one to another: Let us go over to Bethlehem, and let us see this word that is come to pass, which the Lord hath shewed to us. And they came with haste; and they found Mary and Joseph, and the infant lying in the manger. *And seeing, they understood of the word* that had been spoken to them concerning this child. And all that heard, wondered; and at those things that were told them by the shepherds. But *Mary kept all these words, pondering them* in her heart.

This is the standard liturgical reading for the feast of Christmas and the Christmas octave, at Chartres and most other churches, and the lintel embodies the story in ways that relate it to the Virgin's cult as well, making the Virgin one of those who wonders at what she sees, but in especially profound ways. To the south, nearest the crib as Joseph's counterpart, stands a magnificent angel, from whom time has stolen various details, including his head. There were undoubtedly an ox and ass in this scene, watching over the crib and warming it with their breathing; some sort of quasi-liturgical interplay between Joseph and the angels who stand to either side of the tabernacle crib—a kind of mercy seat itself—was likely part of the design as well. The angel is also related to the heavenly creatures who inhabit the archivolts,

mingled with the human representatives of the liberal arts, but he has bunched up his robe in his hand and is thus holding a wad of cloth. Mary lies in the center of the lintel, in a posture that calls to mind her progenitor, Jesse, as depicted in the north lancet Styrps Jesse window (see chapter 12). But, unlike Jesse, she is not asleep. The Christmas Gospel from Luke 2 describes Mary pondering in her heart as she stares directly ahead, with the deeply bored eyes that characterize the style of the lintel sculpture. And what would she ponder if not what is on the axis of the entire work? Undoubtedly she is depicted as viewing time in a mystical way: the altar above contains her newborn as both human sacrifice and as divine. Her gaze directs viewer's eyes from the cloth that wraps her body toward the explanation in the scenes above of its multifold meanings. With her as a guide and teacher, the viewer, too, looks through layers of time. She is wrapped in the gown that became the relic of Chartres Cathedral, and its voluminous folds spill out of her birthing bed, art defining the relic as the gown she wore when she gave birth. As in the sequence "Alle celeste necnon" (strophe 6; see Appendix D), she is enthralled in her birthing bed, knowing that she has borne a king. In this depiction Mary fuses, knits, draws together the flesh she was born with and the divine she has embraced.

Arnold of Bonneval, in *De laudibus beatae Mariae virginis*, a Marian treatise written in the diocese of Chartres at the time the façade was designed and executed, explains the scene. It is the only surviving work of its type composed at this time and in this place; his exegesis doubtless developed as a result of long contact with Mary's cult in his own diocese. His writings suggest the meaning of liturgically inspired art and the view of history it contains, as these were known in the region at the time the west façade and twelfth-century glass programs were planned and executed. His view of the tabernacle of the temple puts the Virgin Mary at its center, just as she would have been in mid-twelfth-century Chartres Cathedral, where her relic and reliquary were situated on the high altar.

Arnold comments upon sermons by Bede also found in the liturgy of Chartres and adds his own interpretations, fusing passages found in Paralipomenon (Chronicles) with the tabernacle of Hebrews 9 and the church as bride in Apocalypse (Revelation) 21. Of special importance is his commentary upon the Christmas and presentation scenes. Appearance matters profoundly to him, and he concentrates, for example, upon the wondrous events when angels actually appeared to persons in the Gospel, for example, Gabriel to Mary at the Annunciation; he says that these appearances distinguish the action of encounter found in the New Testament from those in the Old (*PL* 189:1728). After discussing other angelic showings, he describes the miracle of birth, alluding to the Tabernacle of Hebrews 9 and drawing it into the context of the Christmas texts discussed above, and the meaning of the *Sedes*. Arnold offers a sense of how this artwork might have been used in preaching and instruction in the mid-twelfth century at Chartres:

Figure 9.15. Lower lintel, RPS: Mary's birthing bed. Credit, de Feraudy.

The flesh of Mary and of Christ is one; so too the spirit, and the charity, of which it is said: "The Lord is with you," a promise and a gift that will continue inseparably. Unity does not brook division, nor can it be divided into parts, and if from two is made one, that cannot be cut apart. . . . Behold the tabernacle of God, having within it the Holy of Holies, the rod of the signs, the tablets of the testament, the altar of incense, the twin cherubim gazing at each other, the manna, and the Mercy Seat fully exposed without the cloud. The shrine that is the Virgin contained these things in itself, not in figure, but in very truth, revealing law and discipline to the world, the sweet smell of zeal, the fragrance of chastity, the concord of the testaments, the bread of life, a food not completely consumable, sanctity, humility, and the sacrifice of obedience, the safe port of repentance for all the shipwrecked.[63]

From the Christmas scene of the first lintel, the viewer follows Mary's gaze to the second lintel, finding a scene from one of the most important liturgical processions of the church year, the only one that is part of a Marian feast, that of the Purification.[64] The themes of the feast as interpreted in Chartres are found in Chartres, BM 162, in which the texts contain frequent allusions to the temple transformed (see chapter 5). Both ordinals, the one compiled near the time the portal was constructed and the one from the thirteenth century, describe the importance of the west portal and its artwork in the procession. The bishop and canons, carrying candles representing the new light brought into the new temple, led the people in making a great circle inside the church. Subsequently, all processed outside to stand in front of the Royal Portal for the singing of the processional antiphon, "Responsum accepit symeon." The text of this musically elaborate chant emphasizes the temple and the

act of seeing, and the way the music parses out the text insists upon contemplation of each phrase: "Simeon received an answer from the Holy Spirit that he would not see death before he had seen the Anointed of the Lord; and when they brought the child into the Temple, he took him into his arms and blessed God and said, 'Now, Lord, dismiss your servant in peace.'"[65]

The liturgical setting of Purification texts found at Chartres depends upon both chants and readings. Both emphasize the number of people present to witness Simeon's acceptance of the Anointed. A uniquely Chartrain twist is found in the tropes for the Introit of the feast, "Suscepimus." The opening set of tropes, "O nova res," was common in centers throughout northern Europe. It was complemented by a second, Chartrain set that introduces the prophetess Anna and places her in parallel with Simeon. The Introit text from Psalm 47:10–11 (48:9–10) was sung throughout northern Europe; it was chosen not only because of the idea of taking up God's mercy, but also because it resonates with the verse of Psalm 97 (98) that formed the text of both the Gradual and the Communion chants at Chartres Cathedral: "All the ends of the earth have seen the salvation of our God," promoting the idea of group recognition. The Introit text with tropes is as follows, the second set being the product of Chartrain cantors and liturgists:

O NOVEL THING, BEHOLD, A VIRGIN COMES BEARING A CHILD AND WE,
We have received thy mercy, O God,
WE SEE WHAT THE FATHERS DESIRED BUT WERE NOT TO SEE.
in the midst of thy temple.
O KING, MERCIFUL CHRIST, MAY YOUR NAME BE ALWAYS HONORED.
According to thy name, O God, so also is thy praise unto the ends of the earth.
    Thy right hand is full of justice.
BEHOLD CHRIST, BORN OF A VIRGIN,
HAS COME INTO HIS HOLY TEMPLE.
LET US ALL REJOICE, SAYING:
We have received thy mercy, O God,
THE ONE THE RIGHTEOUS OLD MAN, SIMEON, RECEIVED WITH JOY
in the midst of thy temple. According to thy name, O God, so also is thy praise
ANNA, THE WIDOW, RECOGNIZED THAT CHRIST HAD COME.
unto the ends of the earth.
PRAISE, VIRTUE, AND HONOR TO OUR GOD
IN THESE HOLY SOLEMNITIES.
Thy right hand is full of justice.

[O, NOVA RES, EN VIRGO VENIT, PARTUM GERIT, ET NOS
Suscepimus, Deus, misericordiam tuam,
QUOD NON VISURI PATRES CUPIERE, VIDEMUS
in medio templi tui.

REX PIE CHRISTUM, TUUM SIT NOMEN SEMPER HONESTUM.

Secundum nomen tuum, Deus, ita et laus tua in fines terre. Justitia plena est
   dextera tua.

ECCE VENIT AD TEMPLUM SANCTUM SUUM

CHRISTUS NATUS EX VIRGINE

GAUDEAMUS OMNES DICENTES:

Suscepimus, Deus, misericordiam tuam,

QUEM SENEX IUSTUS SIMEON GAUDENS SUSCEPIT

in medio templi tui. Secundum nomen tuum, Deus, ita et laus tua

ANNA VIDUA CHRISTUM AGNOVIT ADVENISSE

in fines terre.

LAUS, VIRTUS ET HONOR DEO NOSTRO

IN HIS SACRIS SOLLEMNIIS.

Iustitia plena est dextera tua.][66]

Sermons for the feast found in the ordinals and in Chartres, 162 also emphasize
the groups of people who are represented in this time and place, and what the act
of recognition means to each of them. As indicated in the ordinals, the sermon for
the Matins Office of the Purification was "Ecce homo erat," taken from Ambrose's
commentary upon Luke. The text sets the stage for the Chartrain interpretation
found in the crowded second lintel of the portal:

> "And behold there was a man in Jerusalem whose name was Simeon, and this man
> was righteous and humble, awaiting the consolation of Israel." The birth of the Lord
> was testified to not only by angels and prophets, by shepherds and his relatives, but
> also by the old and righteous. Every age and each sex builds up our faith by wondrous
> happenings: a virgin conceives, a sterile person gives birth, a mute person speaks,
> Elisabeth prophesies, the wise man adores, the closed womb exults, the widow ac-
> knowledges, the righteous man waits. And well did the righteous man, who was not
> seeking his own but the people's grace, longing to be freed from the chains of bodily
> weakness, but waiting to see the promised one, know indeed that "blessed are those
> eyes that see" (Luke 10:23).[67]

The readings from Chartres, BM 162 (discussed in chapter 5 and catalogued in
appendix E) further comment on the interpretations found in the Ambrose excerpt.
All the sermons for the feast in Chartres, BM 162 emphasize themes especially con-
sonant with the sermons attributed to Fulbert for the feast of Mary's Nativity; they
also bring themes of discovery and seeing and allude to the throne of David that
inspired the *Sedes sapientiae*. Most important is the dialogue drawn from the Song
of Songs, which was interpreted in the Middle Ages as written by King Solomon for
his beloved queen and by Christ for the Church. The beloved hides and cannot be
seen, but in the end he is found when he comes "into the chamber of her that bore
me," for Christians a reference to the Virgin's womb:

My beloved to me, and I to him who feedeth among the lilies, till the day break, and the shadows retire. Return: be like, my beloved, to a roe, or to a young hart upon the mountains of Bether. In my bed by night I sought him whom my soul loveth: I sought him, and found him not. I will rise, and will go about the city: in the streets and the broad ways I will seek him whom my soul loveth: I sought him, and I found him not. The watchmen who keep the city, found me.[68]

Have you seen him, whom my soul loveth? When I had a little passed by them, I found him whom my soul loveth: I held him: and I will not let him go, till I bring him into my mother's house, and into the chamber of her that bore me. I adjure you, O daughters of Jerusalem, by the roes and the harts of the fields, that you stir not up, nor awake my beloved, till she please.[69]

One of the readings found in Chartres, BM 162, "Subtiliter a fidelibus" by Ambrosius Autpertus, refers to groups of persons found at the purification in the Temple, continuing in the vein of the work of Ambrose that was especially featured in the feast (see above).[70] "Subtiliter a fidelibus" also contains substantial exegesis upon the offering of turtledoves brought by the family who were, in accordance with a view of the Temple law, too poor to provide a lamb.[71] The lamb in the recreated Lucan scene is the child, but the doves themselves are significant to Christian exegesis as well. In a long passage Ambrosius speaks of the doves and the pigeons as representative of the sacrifices of faith and love appropriate to Christians who enter into the sacraments of the church.[72] Everyone who joins with Mary and her relatives and friends in bringing doves to the altar brings the appropriate Christian sacrifice of a pure body and a loving heart. Among Mary's friends, in the apocryphal texts formed at Chartres, were the other consecrated virgins of the temple. These too may be depicted here, as they are alluded to in the antiphon "Hec est Regina," often sung at the portal (see chapter 10). Several of the figures in the restored Chartrain lintel, both males and females, bear two birds in their hands. The hands are often covered with cloth, indicative of the reverent way in which medieval people approached the communion altar. Those in the procession who bring symbolic gifts are about to receive the new lamb upon the altar of the tabernacle and explain the inner state appropriate to this liturgical action through the gifts they bear. The people who stand with Mary at the Purification in the second lintel are evocative of texts found in liturgical chants and readings. The scene makes it seem that "all the ends of the earth" are indeed present and that, as Ambrose, Bede, Ambrosius Autpertus, and other sermon writers included in the "Book of the Cult" argue, representative members of both sexes and of appropriate types are found here, including the relatives and friends of Jesus and Mary. Prophets stand with Simeon, for the men here have the flowing hair typical of that caste, and we can assume that one of the female figures is the prophetess Anna, featured in the sermon literature and especially in the Chartrain Introit trope. On Mary's side of the altar are found

Figure 9.16. Second lintel, RPS: Mary and her companions.
Credit, de Feraudy.

Figure 9.17. Second lintel, RPS: Simeon and his companions.
Credit, de Feraudy.

the priestly heritage from which she and her cousin Elizabeth were descended; the men wear the skullcaps used in the portal iconography to represent the priestly line.

The priests and prophets in the horizontal band of the procession in the upper lintel make a cross at the altar of the Tabernacle in the Purification scene with the kingly heritage of the child's flesh; this rises vertically and has its fulfillment in the new throne of David, the *Sedes sapientiae*, at the crown of the work. Like the sermons of Fulbert, the iconography features the three strains represented in the Messiah: the priestly, the prophetic, and the kingly. Here they are all shown coming into a regenerated space to begin a new tradition of faith, a tradition that is characterized by representation and visualization of the living God. The actual story of the

presentation in the temple in Luke 2:25–38 says nothing of an altar as part of the scene; its presence in the artwork is a Chartrain addition, creating a powerful liturgical sense in order to comment upon sacrifice and the meaning of the new altar dedicated by the reception of the child within the Temple.

Seeing and recognizing were the central themes in a program of art that surely influenced the design of Chartres, that found in the lintels and tympana of La Charité-sur-Loire, dated to the 1130s or at least to the mid-twelfth century. In this program, which Marie-Louise Thérel (1975) has argued was inspired by the liturgical innovations of Peter the Venerable surrounding the feast of the Transfiguration, the shepherds' scene in particular seems directly related to that of Chartres. Above the Nativity scene, which also resembles that of the southern lintel, Christ lowers his body into a throne of flesh offered by the Virgin Mary. The closeness of these works of art, whenever in the mid-twelfth century they were made, calls to mind the patronage of the Thibaudian Henry of Blois, who was in residence at Cluny in his youth and in later life as well and who would have held its daughter church in special favor. The models and copybooks that artists and patrons used for artworks in the mid-twelfth century contained iconographical archetypes; in this they resembled the liturgical texts that often inspired them. But each local practice had its own way of adapting the well-known texts, chants, and visual archetypes, especially to emphasize the cults of local saints and to resonate with the political situations of the times and the desires of patrons; so too at Chartres in the mid-twelfth century.

The idea of a new altar and a new Tabernacle is especially emphasized in the Chartrain liturgy by the trope for the Communion antiphon of Christmas. This text, which is rare and may well have been composed at Chartres, is consistent with the emphasis placed there upon the blooming rod that is the Virgin. The trope is to a text already studied in connection with the feast, from Psalm 97 (98): "All the ends of the earth have seen the salvation of our God. Sing joyfully to God, all the earth." "The Lord hath made known his salvation: he hath revealed his justice in the sight of the Gentiles."[73] This text was also used for the Gradual chant, and the Communion antiphon proclaims it in truncated form. The entirety, psalm verse and trope, can be seen below, with the trope text in capital letters:

Trope to the Communion Antiphon for Christmas at Chartres Cathedral:

THE ROOT OF JESSE, THE VIRGIN, BLOOMED WITH A FLOWER

BECAUSE THE VIRGIN MARY BORE GOD FOR US,

THE ONE WHOM GOD PROMISED TO THE PATRIARCHS AND PREFIGURED WITH
 SIGNS

HAS LET THE GRIEF DECREED BY THE ANCIENT LAW CEASE TO EXIST SINCE,
 BEHOLD:

All the ends of the earth have seen

SEE HOW THE WORD OF THE LORD MERITS THAT WE SING the salvation.

All the ends of the earth have seen the salvation of God.[74]

Figure 9.18. Nativity from Notre-Dame de La Charité-sur-Loire, façade, mid-twelfth century. Credit, de Feraudy.

This chant is consonant with the meaning of the entire south portal: tympanum, lintels, and archivolts. The new altar and new tabernacle are a result of seeing and knowing, rather than of sheltering hidden meanings. In the archivolts are found the representatives of the seven liberal arts, the *quadrivium:* music, arithmetic, astronomy, and geometry; and the *trivium:* grammar, rhetoric, and dialectic. These are the new tools for knowledge, and their mistress is theology; a theme proclaimed in the textbook compiled at Chartres by Master Thierry, who was chancellor during the time the portal was designed. There has been much scholarly study of the meaning of the liberal arts in this portal;[75] the basic theme of seeing and knowing promoted by the liturgical themes presented here and the view of time changed are well served by such discussion. The presence of the arts here is yet another way of emphasizing the importance of knowing and that the Incarnation offers a model of Christian understanding. Prominent in the sculpture are the two arts represented by women, grammar and music, arts that were fundamental to the teaching of the texts and music of sung liturgical texts.

Newman (2003) (especially at 194–206) provides an excellent introduction to the use of Wisdom texts in Latin liturgies for the Virgin Mary. At Chartres, the Virgin was defined more as Sedes than as Sapientia, as every attempt was made to herald her flesh (and her chemise) as a historically developed substance, pregnant with meaning, and with emphasis on it as a point of contact between the human and the divine. The Wisdom lauded by the liberal arts in the southern tympanum of the West Portal is Christ on his maternal throne, the relationship proclaimed as the essence of knowing. The knowledge this pair offers is "in time," acquired over the ages, as can be seen in its artistic context. Yet it is also instantaneous, an eternal spark, represented by the candles and other lamps associated with visual representations of the *Sedes sapientiae* and with the procession at the Purification.

The art of music and the Mariology depicted in this portal, and indeed in the themes of the façade as a whole, are advanced in the sequence "Claris vocibus," sung at Chartres Cathedral for the feast of the Purification as well as for the Feast

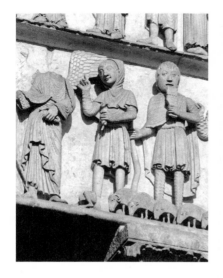

Figure 9.19. Lower lintel, RPS: Shepherds. Credit, de Feraudy.

of the Dedication and on most days of its octave. This late tenth-century work creates a musical metaphor for the Virgin Mary in its structure. The opening strophes describe what a sequence is, neumes with words, the heavenly or divine fused with the human addition of speech. The Virgin is compared to a texted song and its singing, for she drew God and humankind together in her womb, making a special kind of praise. This sequence for the Purification/Dedication provides liturgical music and musical iconography with a special Marian cast; through the singing of this sequence these themes were brought into the Christian Temple both on the day calling up the presentation and on the day in which the dedication of that space was celebrated. To breathe out songs of the Virgin in praise was, according to this view, to make incarnate again the historical act of her womb, giving song and sound a similar power to that expressed in the visual expressions of Mary as well.

The depictions of the two *Sedes* found at Chartres in the twelfth century and the emphasis upon seeing and acts of recognition promote not only the primary dedicatee of the cathedral of Chartres, but also the secondary one, John the Baptist, the prophet who understood, the angel who went before the Christ. Jean Villette (1994, 22) has argued that there was a *trumeau* on the portal with a sculpture of John the Baptist. The emphasis on Mary and John the Baptist may also account for the position of two scenes of the zodiac in the first, lower archivolt of the southern tympanum, apart from the other signs that are found surrounding the north tympanum. The months represented by these two, namely Pisces, the fish, as representative of March, and Gemini, the twins, as representative of June, may have been symbolic. The first related to the Annunciation, March 25, the instant in which Mary saw, knew, and said yes to God; the second to the birth of John the Baptist, which took place June 24, the secondary feast of the cathedral. John apprehended Christ before he was born and recognized Mary and her child for who they were.[76]

The Dedication feast brought together the making of the Ark of the Covenant and the Temple of Solomon; the making of the new temple, the church, from the Davidic flesh of Christ; and the remaking of individual souls, as people entered into a new covenant with history and with the future. At Chartres, the builders of the west façade and the makers of other new artworks drew the Virgin and her cult into the framework of time created by the Dedication feast, joining it to the patronal feast, the Nativity of the Blessed Virgin. The arrangement of thirteenth-century

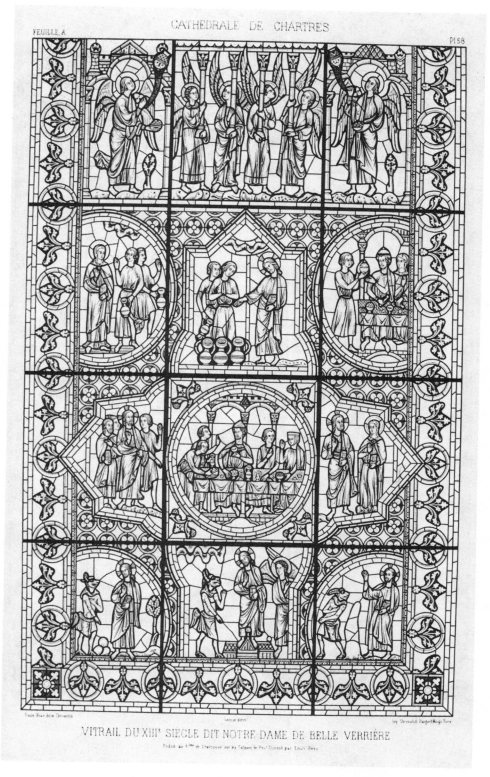

Figure 9.20. Nineteenth-century drawing of lower panels of Belle Verrière.
From J. B. A. Lassus, *Monographie de la cathédrale de Chartres, publiée par les soins du ministre de l'instruction publique. Atlas* (Paris, 1867). Sterling Memorial Library, Yale University. Credit, Laura and Randolph Miles.

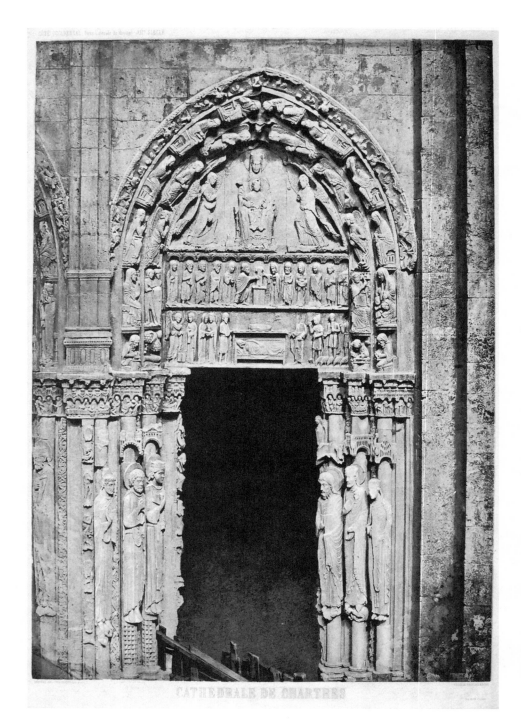

Figure 9.21. RP, south door, as photographed in the nineteenth century.
From J. B. A. Lassus, *Monographie de la cathédrale de Chartres, publiée par les soins du ministre de l'instruction publique. Atlas* (Paris, 1867). Sterling Memorial Library, Yale University. Credit, Laura and Randolph Miles.

glass enframing the core of Belle Verrière demonstrates that this understanding was of importance later, after the fire of 1194 (see chapter 12). The *Sedes sapientiae*, the Throne of Wisdom, was a provocative visualization of that moment in time most celebrated in the history made at Chartres Cathedral, a theme sustained from the late twelfth century into the thirteenth and held in place by the liturgical framework of time developed in that place.

# *ADVENTUS* AND LINEAGE

## The Meanings of the Jamb Statues

This is the Queen of virgins, who bore the king, even as a beauteous rose, the virgin Genetrix of God, through whom we find God and humanity. Nurturing Virgin, intercede for us all!

*— Marian antiphon, "Hec est Regina"*

What would have come into view as a liturgical procession approached the Royal Portal of Chartres Cathedral around 1164?[1] Not what comes into view today. The work the mid-twelfth-century donors supported—which included the twin towers, the triple portal with its sculptural program, the lancet windows, and (the core of) Belle Verrière—was part of a church that no longer exists (except for its crypt), and scholars have been left to wonder how these twelfth-century elements were once part of an eleventh-century building. Theories about the state of affairs around the time Bishop Robert died in 1164 suggest further questions concerning what happened to these twelfth-century remains when they became part of the fabric of yet another edifice, the church that was built to replace the eleventh-century cathedral, damaged in 1134 and destroyed in 1194. What kind of changes took place in the process of adaptive reuse? and to what extent were thematic concerns in play when decisions were made in the late twelfth and early thirteenth centuries? Paul Crossley (2009) and Claudine Lautier (2009) have offered views of processional action in the thirteenth-century cathedral. Such imaginings are of a different nature within the context of the twelfth century: the church building does not survive and so one works with architectural remnants and the liturgy.

The liturgy cannot help us reconstruct how the portal and other features of the façade were arranged in the twelfth century. But liturgical sources can suggest how chant and processional movement defined the area in which the surviving sculptures were located and continued to define this space after the fire of 1194 as well. For this reason, specific liturgical materials can be used to read iconography and to explore the strategies employed in the twelfth-century design of the program, espe-

cially as found generally in the jamb statues studied here and more specifically in the pilasters and the capital frieze (see chapter 11) as well as in attitudes toward cult in the formative early decades of the thirteenth century (see chapter 12). Enough of the twelfth-century ensemble remains to support the argument that well-considered aesthetic ideals were in play and that there was an overarching sense of design and method, however much particular elements shifted, even during the twelfth century itself. These thematic concerns and visual strategies depend upon and grow out of liturgical principles operating at Chartres in the mid-twelfth century as well as upon identifiable texts sung for important actions and feasts of the Virgin Mary. Like the illuminations in a glossed Bible, the twelfth-century art of the west façade is constructed with layers of meanings from the First and Second Testaments, but the difference between this and the art of the page is that people walked through it, singing. Processions were surrounded by exegetical explications of their action. The chants sung during the act of processing and the motion through the doors formed the "text" to be glossed by portal iconography.

## AVE PORTA: MARY AND ENTRANCE

The west façade included the main door to the cathedral, a triple portal, and, in spite of the fact that specific mentions of the portal itself are few, the ordinals offer detailed information about how the space was used and about the music and ceremony associated with it in the mid-twelfth century.[2] Yves Delaporte compared citations in the twelfth-century ordinal—compiled when the façade was part of Fulbert's church—to those found in the ordinal assembled in the second quarter of the thirteenth century, while another building was being constructed to replace it (see OC 26–27). In the twelfth-century book (with one exception that mentions the Royal Portal) processions departed and returned through "the center door of the tower"; in the thirteenth-century ordinal this phrase was not used, but comparable references were to the Royal Portal. Delaporte believed that this meant that the earlier ordinal was compiled when the Royal Portal was under construction, and so there had to be another place to enter; he thought that this would have been through the north tower, whose base would have been completed by midcentury. Accordingly, the procession at the Purification feast could have taken place in relationship to the Royal Portal because it did not require moving in and out of the as-yet-uncompleted door.

### TWELFTH- AND THIRTEENTH-CENTURY PROCESSIONS COMPARED

Following are passages regarding the western door in the twelfth-century Ordo Veridicus (OV) and in the thirteenth-century ordinal from Chartres, BM 1058 edited and published by Delaporte in his *L'ordinaire chartrain du XIIIe siècle* (OC):

1. Ash Wednesday, Procession to St. Sergius

OV:

> With Sext having been sung, let a procession be made with candles and cross with-
> out the Gospel to St. Sergius and return through the crypts with the litany. It leaves
> through the middle door of the tower and returns through the same.

OC:

> With Sext having been sung, let a procession be made with candles and cross
> without the Gospel to St. Sergius, leave through the Royal Portal, return through the
> crypts singing the litany, and enter through the same portal (ed. Delaporte, 97).

2. First Monday of Lent, Procession to St. Stephen (and the same for all ferial proces-
   sions in Lent)

OV:

> After Sext a procession to St. Stephen with the ivory Gospel and candles without
> the cross . . . it goes through the middle door of the tower and reenters through the
> same.

OC:

> After Sext a procession to St. Stephen with the ivory Gospel and candles without
> the cross. . . . It leaves through the Royal Portal and reenters through the same (99–
> 100).

3. Monday of Rogations

OV: [The procession] leaves through the new door, through the middle door of the
tower. [The "new door" refers to the southern door of the cloister, the one nearest
the cathedral.]

OC:

> The procession leaves from the church through the Royal Portal and from the
> cloister through the new door (123).

4. Purification

OV:

> With all standing before the Royal Portal . . .

OC:

> With all standing before the Royal Portal . . . (149)

The evidence, though sparse, is valuable. The OV appears to contain eleventh-
century reforms with subsequent additions put in place in the first half of the
twelfth century, during the last years of Ivo's tenure, or at least during a time when
reform-minded associates of the Augustinians were in charge of planning the pro-
cessions outlined in the ordinal (see chapter 6); the reforms of mid-twelfth-century
bishops would only deepen this emphasis.[3] Fulbert's cathedral is believed to have
been fronted by a single tower, an example of the so-called *tour porche* character-
istic of many eleventh-century churches, examples of which survive into modern
times.[4] Lucien Merlet in *MSC* (1893) drew a picture of the cathedral depicted in

the drawing commissioned by the cantor Sigo, as compared to the drawing in chapter 4. In an essay on the cathedral (1969) Robert Branner introduces his influential collection of translated documents, excerpted texts, and essays. Branner supported the view that the eleventh-century painting of Fulbert found in Chartres, BM Na4 shows his church fronted by a tower and that this structure was expanded later in the century.[5] The wall painting in the St. Clement chapel in the crypt of the cathedral may depict an understanding of the eleventh-century cathedral as well, but from a somewhat later viewpoint and showing only the top gallery of windows, the lower half of the church being cut off by the large figures. If the view is indeed from the south, then there is a single tower forming a porch with multiple doors cut into it. The long building to the left, up against the tower in this depiction, would be the Hôtel Dieu, which was located in the southwest near the so-called Old Tower, and the buildings to the far right would represent the bishop's palace complex. Here too one sees the front of the church graced by a large tower with doors and forming a kind of porch in the west end of the church. Accordingly, the expression "middle door of the tower" as found in the OV could be a survival from an earlier textual layer or an earlier nomenclature applied when this was the main door of the church: the familiar term may have been extrapolated from earlier use and applied to the ongoing building of the west end of Fulbert's church taking place in the mid-twelfth century. The liturgical landscape of Chartres Cathedral was deeply conservative after the reforms of the eleventh century (see chapter 5), and the continued use of time-honored designations for well-known features of church architecture fits the profile.

Donors who contributed to the building project at midcentury usually earmarked their gifts for "repair of the tower" or "for the tower," even when both new towers were under construction. Contributions to "the towers" (plural) are found as well, but the phrase is rare and does not seem to help date aspects of the program beyond the general suggestion that the campaign was ongoing during this time.[6] In its mid-twelfth-century phase of construction, calling the project "the tower" and referring to its "middle door," which was also being planned and rebuilt, is not out of the question. OV was copied from Chartrain sources for the use of another town within the diocese, and earlier vocabulary might well have been employed. It was once believed that the present sculptural program of the west façade was found inside a covered arcade of some sort, and there have long been theories that the entire complex was moved from an earlier location (see Fels, 1955, for example). Delaporte's ingenious suggestion that the OV reflects a portal undergoing construction, with the use of the north tower as a place of exit and entrance, is only one of several possible interpretations. There is not enough evidence to support a particular history of construction from the liturgical books; there is much for architectural historians yet to decide about the heavily altered area just behind the façade and the lower adjoining sections of the twelfth-century towers. Grodecki (1977, 17–18) summed

VUE DE LA CATHÉDRALE DE FULBERT, D'APRÈS ANDRÉ DE MICI

VUE PERSPECTIVE DE LA CATHÉDRALE DE FULBERT RESTITUÉE

Figure 10.1. Hypothetical reconstructions of the eleventh-century church. From Merlet and Clerval (1893).

up a view held by others as well that there was a tribunal inside the west end in the mid-twelfth century that allowed viewers to climb up and view the windows more closely. He believed that the decades at midcentury were spent constructing "a monumental porch, made from 1135–1155 at the entrance of the great nave of the Romanesque church of Fulbert" (see chapter 12). It is also possible that there was a connection between the door of the north tower and the cloister, and one that may have been useful for processions (see Krüger, 2005, on the connection between the cloister door and the portal arcade at Cluny in the twelfth century).

The ordinals and other related books may contribute little to our understanding of the midcentury building campaign and its progress, but they contain much evidence for understanding what the door signified in the twelfth and thirteenth centuries; this well-formed sense of its meaning doubtless was inspirational both in the choice of iconographic themes and in their modes of display as well as in keeping the portal intact to support liturgical sources after the church burned in 1194. Just as there are several zones of sculpture in the portal's design (see chapter 11), so too there were layers of chant defining the idea of entrance at Chartres. At episcopal masses for major feasts, for example, the Mass liturgy opened with long,

Figure 10.2. View of the cathedral from the St. Clement Chapel, South Crypt, later eleventh century? Credit, de Feraudy.

highly decorated Introit tropes. In the twelfth century this music was crucial for the idea of *adventus* celebrated at Chartres and hailed the coming of the Messiah.[7] The Introit tropes were carefully indicated in the OV at the time the portal was designed and constructed, and they were copied in later books as well, for instance in Provins 12 and the OC. As the singing of proper tropes was generally waning in Northern Francia in this period, the attention paid to the tropes in the twelfth and thirteenth centuries is yet another sign of the highly conservative nature of the Chartrain liturgy and its music. The trope texts are filled with themes of prophecy and foreshadowing, ideas found more generally in the portal sculpture at Chartres, itself a study in revelation. The tropes are songs that Fulbert's generation may have put in place in the early eleventh century, later supplemented by his disciples, who added chants and texts associated with the famous bishop to the Office liturgy as well.

To study the tropes, and liturgical commentaries upon the act of entering, is one way of understanding the west portal as a general embodiment of adventus.[8] The powerful Christological meaning of Romanesque portals has been studied through their inscriptions by Calvin Kendall, who points to the steady use of John 10:9, "I am the door. By me, if any man enter in, he shall be saved," as a defining phrase.[9] At Chartres this traditional understanding was recontextualized to emphasize yet another theme, the Virgin as portal. The rich musical iconography at the door, which includes not only a plethora of angelic choristers but also the elders of the apocalypse with their display of twelfth-century instruments, suggests that music making at the portal was of major importance. A study still to be accomplished of the complex architectural situation just behind the doors and in the bases of the towers may reveal more information about the ways in which the musicians could have been singing as processions entered the door. In any case, the musical iconography of the portal makes this area the courtyard of the Virgin, the aula, and Mary and Jesus look down on it from on high, as described in the sequence "Alle celeste necnon" for the Virgin's Nativity, the patronal feast in the mid-twelfth century: "For you rule over everything as queen and judge of the world; with your son you judge all things in all times and are supported from on high in glory, elected from the hosts of cherubim and seraphim and your throne placed near your son on his shining right hand, its power glows and unites. So on this day annually your nativity comes to us with joy, and the courtyard resounds with songs in your praise, Virgin Mary" (see appendix D for the complete text). This is the theme of the entire west façade, and all of its elements relate to it, including the jambs (see below).

There were many entrance songs besides the tropes opening the episcopal Mass liturgy, and these refined the meanings expressed in the tropes. As the main door of the church, the Royal Portal served as the point of exit and entrance for the daily and weekly processions that marked the coming and going of the clergy and choir clerks into the neighborhood and throughout the town for visitations and stations.

Music was always provided for these occasions, and it defined the motion, its points of destination and return. Study of the liturgical texts associated with common processions is basic to understanding this space as it functioned in the twelfth century, and here, as with the Introit tropes, liturgical action and the texts associated with it would have served as inspiration for those commissioning and designing the new program. Chants sung at the door were known by everyone in Chartres, not only because of their constant repetition at Marian feasts, but especially because they were used to mark the reentry of processions through the portal on major feasts and for numerous other occasions as well. Unlike the Introit tropes, each of which was proper to a particular feast and usually sung but once a year, many reentry songs were short chants performed at the portal day in and day out. These were the songs that informed the imaginations of medieval people—both lettered and unlettered—and offered an elemental sense of what the ceremonies of departure and entrance were about. Songs of entrance express the fervent popular pleas discussed in chapter 7, for they are filled with hope for miraculous intercession from the Virgin Mother and for the successful bloom of lineage through pregnancy and birth.

In many cases the choice of chants for entry through the west portal after an external procession must have been made by the cantor or his representative, but frequently the ordinal is more specific; these instructions explain the range of appropriate choices and also indicate those occasions when the usual emphasis at the entrance of the cathedral was suspended.[10] The early sections of a medieval ordinal often leave out details of common practice, as these elements were constantly repeated and well known; the very things modern readers most want to know about daily liturgical life are frequently omitted.[11] Fortunately, later references to the cantor's choices for exceptions to common practices offer enough information to reconstruct an accurate sense of the repertory. The cantor could exercise choice, but study of the ordinals shows that there were expectations for his decisions.

Three Hours of the cathedral day were regularly associated with processions, the Hours of Terce (before the main Mass of the day), Sext (around noon), and Vespers (around sunset, at the close of the working day and at the time of the lighting of lamps and cooking fires). At the Vespers procession, for example, if the saint were titular for a chapel in the cathedral or its crypt, the procession went there to make a station; if the saint had no particular chapel or altar, then the "procession moved, in accordance with the case, to the chapel of apostles, in the case of apostles; to the chapel for martyrs, in the case of martyrs; and to the chapel of confessors, in the case of confessors" (*OC*, Delaporte's introduction, 39). The three radiating chapels in the east end of the cathedral were dedicated to these three categories of saints; they were used continuously for processions and stations and must have been lavishly decorated.[12] They also created a powerful correspondence between the architecture of Fulbert's cathedral and the liturgy found in the twelfth-century OV; it would seem that the building was designed with this liturgical purpose in mind,

making the prongs of the chapels a kind of crown for the Virgin of the main altar and her Son.

Although the eleventh-century cathedral of Chartres was not the first building in the region laid out in this way (see Crook, 2000), it was the most famous, and clergy who implemented this liturgical practice throughout the enormous diocese of Chartres would have had strong reasons for adapting Fulbert's footprint for new building campaigns. Several churches constructed in the first half of the twelfth century in the region around Chartres/Blois were characterized by this layout: a long nave, with no transept (although axial chapels were common), ending in an apse with an ambulatory connected to three (and sometimes more—Marmoutier had five) deep radiating chapels. Stephen Gardner (1984b, 1986) studied several examples, many known only through early drawings or later excavations: the late eleventh-century priory church of St. Denis in Nogent-le-Rotrou; the turn-of-the-century St. Thomas of Epernon; Notre-Dame of Cunault, just east of Angers, from the second quarter of the twelfth century (see Mallet, 1995); St. Lomer of Blois, patronized by the Thibaudians; St. Peter's in the Valley, which was rebuilt following the fire of 1134;[13] and (as Gardner, 1984b, believed) originally at La Madeleine of Châteaudun (see below for further discussion of this church). These churches were within or near the diocese of Chartres; others in the region were Fontgombault (see Henriet, 1984); Airvault (see Orlowski, 1991); Preuilly-sur-Claise (see Fleury, 1999); St. Stephen in Dreux (Gardner, 1984b); and the cathedral of Avranches, consecrated in 1121. Notre-Dame of Josaphat, founded by Bishop Geoffrey of Lèves and his brother in the early twelfth century, was of this type as well. When Notre Dame of Chartres was rebuilt in the thirteenth century the south portal was decorated to emphasize the upper radiating chapels; the apostles, martyrs, and confessors to whom the radiating chapels were dedicated remained as in the twelfth century, venerated liturgically in their respective chapels.

If the feast were for a saint especially honored in the town at a church or chapel the procession would move outside the cathedral, and the canons and choral vicars would celebrate Vespers at the appropriate place for the community of that church. These external Vespers processions usually took place on the eve of feasts, at the beginning of Vespers, the hour of the day that always featured the singing of the Magnificat, Mary's song of understanding and prophecy from Luke 1. The procession moved toward the place of the station accompanied by the Magnificat and its antiphon, the latter in honor of the place to which the procession was going, followed by an appropriate versicle and a prayer. On the return, the antiphon, versicle, and prayer were in honor of the Virgin (OC 39); to enter the door of the cathedral of Chartres was to hail Mary, singing within her courtyard. In all cases, both for internal and external processions, a large-scale, dramatic gesture ended with homage to the Virgin as the group reentered the cathedral; then the choir reassembled around the main altar that contained Mary's relic in its venerable Chasse.[14]

The regular processions before Terce were also crucial to the ceremonial life of the cathedral. One took place every Sunday, and it featured an asperges ceremony, the sprinkling of the holy water being representative of the power of baptism and its renewal among the faithful. For this ceremony the canons and clerks normally walked to either the church of St. Stephen or of St. Sergius, which flanked the eastern end of the building on the south and on the north; on other Sundays the procession might move to another church, depending on the feast or season (see map in appendix A). Whatever the case, the return to the cathedral and to the choir was characterized by chants for the Virgin, a versicle, and a prayer, and these are noted in the ordinals, frequently by name.

Through their references to the Virgin on entry, the processions connected with Vespers and Terce proclaimed that the cathedral of Chartres was dedicated to Mary as they moved east toward the main altar, where her relic was kept. Chants for the Virgin on entering were suspended only for a few weeks immediately after Easter, when music associated with either the Resurrection of the Lord and the descent of the Holy Spirit or the Trinity was substituted; these exceptions prove the rule.[15] The ordinals describe the resumption of Marian music for processions, and in doing so often give the titles of the chants most commonly sung on reentry through the Royal Portal and most powerfully associated with it.

"Hec est Regina," often sung with the versicle "Post partum," was featured throughout Lent for processions before Terce (with one exception to be discussed below). "Hec est Regina" is based on the appellation queen of the virgins that appeared early in the *Pseudo-Matthew* (VIII, line 10 in Gijsel's edition). It was used there when Mary, the youngest and most humble of the virgins living in the temple in Jerusalem, was assigned to weave the purple cloth for the veil of the Temple. The other young women were jealous and began to call her "queen of the virgins" in mockery, but an angel appeared in their midst and said that theirs was actually the truest of prophecies. Then they were afraid and begged Mary's pardon. For those learned Chartrains who knew the text of the *Pseudo-Matthew*, the antiphon would have invoked the story that placed Mary in the Temple and made her a queen as well, adding to the sense that the liturgy of Chartres was a safe haven for apocryphal texts.

"Hec est Regina" was also commonly sung on the return of Vespers processions honoring female saints; for example, it was mentioned for Saint Mary Magdalene and for Saint Anne, and so would have made a liturgical link between the Virgin and her mother. The chant, which proclaimed the Virgin's royal heritage and asked for her protection, associated entrance into the cathedral with the patronal feast, the Nativity of the Virgin, for this chant was sung prominently on that day and throughout the octave and in a variety of settings.[16] "Hec est Regina" belongs to the set of five antiphons used for first Vespers of every Marian feast, at least from the time of the eleventh-century reforms (see chapter 5).[17] The processions strengthen

the idea that this group of five Marian antiphons constituted the vital "signature"
chants of Chartres Cathedral, along with the responsories attributed to Fulbert,
with which their texts mesh thematically. The regal Mary of the first in the series,
"Hec est Regina," gives the group its name, and the chants were so popular and
well known that Chartrain liturgical books often do not contain them or their texts
but merely the incipit of the opening chant, "Hec est Regina," to indicate that the
set was to be performed. To find "Hec est Regina" closely associated with the Royal
Portal is a strong indication that Mary's royal or Davidic lineage, which shapes the
nature of the liturgy at Chartres in so many ways, was defining for the portal as well.
The Virgin is the queen who bears the king; she allows the mixing of human and
divine elements into one flesh, as she sustains and protects. Along with the versicle
and the prayer, these were the liturgical materials most commonly associated with
the new portal of Chartres Cathedral in the mid-twelfth century, and it was de-
signed with them in mind:

> Antiphon "Hec est Regina":
> This is the Queen of virgins, who bore the king, even as a beauteous rose, the vir-
> gin Genetrix of God, through whom we find God and humanity. Nurturing Virgin,
> intercede for us all![18]

> Versicle:
> After bearing, you remained an inviolate virgin. Genetrix of God, intercede for us.[19]

> Prayer:
> Lord, we beseech you, forgive the faults of your servants, and we who are unable to
> please you through our own actions may be saved by the intercession of the Genetrix
> of your Son, our Lord God.[20]

The chant featured in place of "Hec est Regina" for the reentry on the fourth
Sunday of Lent was "Beata Dei Genetrix," another of the set of five, and also a piece
found in the Little Office of the Virgin on Saturdays for the Benedictus of Lauds
in the later Middle Ages.[21] The text emphasizes that Mary is the "temple of God," a
theme especially favored at Chartres in the mid-twelfth century:

> Blessed Genetrix of God, Mary, perpetual virgin, temple of the Lord, shrine of the
> Holy Spirit: you alone, without an exemplar, were pleasing to the Lord Jesus Christ.
> Pray for the people, intervene for the clergy, intercede for the faithful female sex.[22]

Another Marian antiphon designated frequently for entrance was "Letare virgo
Maria," commonly sung on the return of processions before Terce on Sundays from
Trinity to Advent. The text is a rare one outside of Chartres in this period; it con-
tains themes especially favored at the cathedral through the responsories attributed
to Bishop Fulbert and employs a variant of the epithet *paritura*, which became
even more prominent at Chartres in the later Middle Ages:

Rejoice, Virgin Mary, from you has come forth the beautiful flower that fills the heavens with its fragrance and feeds the angels with its fruit; from your obscurity a light lights up one who was neither begotten before heaven nor brought forth after the earth. Therefore you have reason to rejoice that from you Christ has been born, the creator of the stars, and the expectation of the peoples, alleluia, alleluia.[23]

Exceptions to the singing of this chant during the designated period involve two texts with similar themes, directly ascribed to Bishop Fulbert. If the procession was to St. Stephen, the responsory "Styrps Jesse" was sung upon returning to the cathedral; if the procession was to St. Sergius, the Fulbertian responsory "Ad nutum" was sung on the return.[24] If rain prevented these usual external processions, an internal procession was made instead, and the return to the choir was marked by a Marian antiphon chosen by the cantor. These chants, along with Fulbert's responsories, create a thematic complex emphasizing the fruitful lineage of the Virgin Mary.

Mary was the primary dedicatee of the cathedral of Chartres, but the secondary dedicatee was John the Baptist, depicted in the Gospel of Luke as moving joyfully within the womb at the first recognition of Christ. On his nativity, June 24, a procession was made after Vespers to his altar in the crypt, and reentry was marked by the singing of the antiphon "Laetare virgo" (see OC 160). This chant was sung for other reentry processions as well, for example, that of Thomas of Canterbury (in OC but not in the earlier OV).[25] From their consistent designation when chants are described for this purpose we can assume that the "Hec est Regina" set of antiphons and the responsories attributed to Fulbert were the common fund of chants from which the cantor or succentor chose the requisite Marian music for processions back to the cathedral, day in and day out and throughout most seasons as well. The themes proclaimed at the great door were of Mary as a woman of royal and Davidic lineage, born on a feast championed by Fulbert of Chartres, and of her tender care for those who entered to worship.

## THE JAMB STATUES

Members of a procession before the Royal Portal of Chartres Cathedral today might find the jambs its most dramatic feature. Because of their size and position, turned slightly toward anyone who enters, they offer a welcome fashioned in the twelfth century and a liturgical sense that is strikingly well focused.[26] As a photograph taken by Delaporte in the early twentieth century shows, the façade provides a magnificent backdrop for the display of a large reliquary in procession on a major feast day, and, whatever their original configuration, these statues "await" in the mode of a medieval adventus ceremony. A photograph of a wedding in Chartres suggests that people who process by these statues or stand before them are incorporated into their definition of time, either completing it or otherwise interacting with

the historical sense embodied in the statues themselves (see plate 1). Those who walk up to or pass beyond these statues and enter the church appear to join them, an illusion of central importance at Chartres Cathedral. Study of liturgical sources proves that, as they approached the portal, processions in the twelfth and thirteenth centuries sang of prophecy (tropes) or of Mary (antiphons and responsories); the statues were designed to hail the coming of Mary and to predict the portentous advent of her son, the themes emphasized in chants the processions sang before and while moving through the portals themselves.

The jambs are not alone in creating a framework for processions: they are surrounded by other figures that complete the exegetical framework for processions through several layers of detail. Whoever designed these surviving elements of the twelfth-century façade wanted crowds standing out of doors to be well occupied as well as instructed. The jamb figures form a framework for those whom they await: they look out at those who pass them by, angled through a sophisticated sense of perspective to receive each person or group entering the church at any of the three doors. Calm and reflective, some seem to smile as they watch passing processions. In the twelfth century they, like the rest of the façade figures, were painted in bright colors, only traces of which remain.[27] Now colorless, maimed, reshuffled, replaced, and heavily restored, they have survived in sufficient quantity and quality to provide the first and most important challenge to the viewer of the Royal Portal at Chartres: who are these people? and why are they in such a prominent place? To answer these questions as they pertain to Chartres, where contemporary liturgical materials and surviving art make explanation possible, provides a surer understanding of what became common iconography for the doors of many northern European churches in the decades to follow. What context allowed this display to take hold so quickly?

Many studies of the iconography of the portal exist, both of its general meaning and of specific details. Local scholars of the sixteenth and seventeenth centuries had opinions that differ greatly from those of twentieth-century scholars; men of the eighteenth and nineteenth centuries are usually more respected today for the drawings they had made than for their ideas about meaning. The late seventeenth-century work by Vincent Sablon, *Histoire de l'auguste et venerable église de Chartres*, was heavily edited by Lucien Merlet, who offers a late nineteenth-century view of the Royal Portal from a scholar who lived in Chartres.[28] His view is still in touch, although certainly not in accord, with various medieval interpretations of the program. The following excerpts concentrate on earlier understanding of the jamb statues:

> On the door in the middle, called the Royal Portal because it is through this door that the kings of France were received into this church, one sees on the part above the ledge, Jesus Christ, in a luminous oval, seated on his throne, holding in his left hand the book of the seven seals, and having his right hand raised as for giving a blessing . . . below this sculpture, the figures of the prophets, numbering fourteen,

Figure 10.3. Early twentieth-century procession in front of the triple portal.
Archives diocésaines de Chartres. Credit, Delaporte.

are placed in a single line . . . [these are the twelve apostles, with Enoch and Elijah on either side of them]; the lateral sides of this door are ornamented with large statues placed in the following order: on the left there are first two queens and then a king, followed by another king and a saint who are the nearest to the door. All bear the nimbus or luminous circle; one of the two kings holds a book, the two queens as well; an ordinary mark in that time for designating founders or benefactors was the scroll, which is also held by the kings and queens and indicates the consent or permission that they gave for building . . . the second door on the right depicts several scenes from the life of the Virgin . . . on the lateral sides of this door were placed six statues of kings and of queens whose names are no longer known. The third door on the left depicts Jesus Christ above the door, his right hand raised, accompanied by two angels, and below the four angels mentioned in the seventh chapter of the Apocalypse . . . on the lateral sides of the door are six large statues, three on each side, representing the major benefactors of this church. All the statues that decorate the three doors are most interesting for the history of art and for the history of costume in the eleventh and twelfth centuries. They are clothed in long tunics covered with a kind of cloak that, sometimes opened in the front, reveals rich belting and very beautifully embossed fabric. One should notice the variety of crowns as well as the long braids of hair, some of which are covered with ribbons, as worn by most queens and princesses (12–14).

Sablon/Merlet thought the kings and queens of the portal represented the donors who supported the building program in the Middle Ages, and that saints were mixed in with them. Bernard de Montfaucon (1655–1741) expressed different views, which were accompanied by influential drawings of jamb statues from Chartres and many other churches. Because much of the art he had drawn has subsequently disappeared, his work sometimes contains the only evidence that remains and has been much discussed by art historians.[29] Following Jean Mabillon, whom he admired immensely, Montfaucon believed that medieval portal statues generally represented Merovingian and Carolingian kings and queens and were crude but highly useful evidence of the period from the late fifth to the ninth century.[30] As a result of his work, which grew out of a love of antiquity and is crucial for the work it records, "historians of French art were thus thrown off the right track for the best part of a century."[31] The Benedictine scholar Dom Urbain Plancher advanced the idea found in Sablon/Merlet that these are twelfth-century kings and queens.[32] The historian Vanuxem (1957) credits Abbé Jean Lebeuf (1687–1760) with finally laying to rest Montfaucon's influential theories by proposing that the sculptures on the doorways of the churches represent biblical figures rather than kings and queens of France. The pioneering iconographer of the early twentieth century Émile Mâle writes of the jamb figures in the west portal of Chartres as elegant kings and queens whose sculptor has studied contemporary clothing with loving care and an observant eye; Mâle especially praises the females in the ensemble.[33]

Students of the jambs in recent decades have consistently interpreted them as biblical figures and made highly successful attempts to relate them to the cult of the Virgin, with an eye to how they fit into the program of the façade as a whole. Peter Kidson, for example, works with horizontal zones, the jamb statues of the first, or bottom, zone offering the most dramatic aspect of the entire work. He sees the portal as a representation of time and advances a theme he found to be championed in liturgical understanding, especially as developed at Chartres, namely, that the Incarnation is the great dividing line between the ages:

> The major horizontal division of the Portail may be taken to express the fundamental cleavage of time wrought by the Incarnation. The theme of the Incarnation itself, as befits its double significance, is treated twice, once above the line, summarily, on the side tympana, where it is specifically related to the Second Coming; and again, below the line, this time more extensively, on the frieze of the capitals, where it appears as the culmination of the Old Testament and the fulfillment of its innumerable prophesies. This iconographical function of the capitals is faithfully underlined by their visual function as logical terminals for the columns in the jambs. On this reading, the Old Testament should be represented by everything else in the lower half of the Portail, and in particular by the column figures (Kidson, 1958, 1974, 21).

In a work appearing just after Kidson's, Adolf Katzenellenbogen (1959) developed the standard modern interpretation of the meaning of the jamb statues, speaking briefly about Ivo of Chartres and mentioning his contemporary Hugh of Fleury in passing. According to Katzenellenbogen, the statues represent *regnum et sacerdotium*, kingship and priesthood: "Time and again he [Ivo] pointed out the necessity of harmony between kingship and priesthood. He gave a grim picture of disunity between the two powers and its disastrous effects on the Church" (32). Although Katzenellenbogen is sure that there are both kings and queens in the program—obvious from their crowns and scepters—he is less sure about the identities of the priests, musing about whether their prototypes are actually priests or prophets of the Old Testament (33). He recognizes that the program of jamb statues found at St. Denis, destroyed in the Revolution but appearing in drawings commissioned by Montfaucon, was different from that at Chartres, and he assumes that the now-missing group of statues at St. Denis preceded the Chartrain jambs and inspired them.[34] To put kings and queens in the door of a church identified them and their governance powerfully with service to God, and this in a time when the Thibaudian family had both a king and a bishop serving the church in England. At midcentury, the centuries-old march of the family toward the throne was achieved, only to die without a whimper and then to rise immediately in a different guise through marriage into the lineage of the Capetians.

Since Katzenellenbogen other scholars have tried to go further by identifying the particular figures making up the jambs at Chartres. Roland Halfen, one of the more

recent in a venerable line of scholars, works in the traditional way by reading the Bible and trying to find groups of figures that fit the program, proceeding chronologically one way or another.[35] Halfen moves from the northern jambs to the central portal, from "Abraham (?)" to "Samuel (?)," and then from the south central jambs on to those farther south, which he suggests are John the Baptist, Constantine, and Helena.[36] Halfen has been influenced by Adelheid Heimann, whose detailed analysis of the small sculptures of the pilasters (1968) suggests how they relate to the subjects of the capital frieze and provides various typologies for the actions of the narrative.[37] Heimann herself suggested that others try to do for the jamb statues what she did for the pilasters and offers the frieze as a keystone by which the meaning of the entire façade may be unlocked.

If, however, a program existed that identified every jamb statue particularly, it may be very difficult to recover. The jambs have been taken down, moved, and removed, and five of the twenty-four are missing, a significant number. The sculptures have also been restored and transformed in the process. For example, the first figure on the north (and perhaps two others in this group) has a later head.[38] That one jamb figure had wings added to it and was placed on the southern tower to function as an angel supporting a sundial has long been suggested.[39] In spite of the revised state of the statues, there is significant evidence to identify the major sources of inspiration that stand behind the number of the statues and their general appearances.

## THE VIRGIN OF CHARTRES AND THE JAMBS

Understanding the jambs may not require ferreting out a name for every column; a contemporary program in the liturgy itself, flexible in nature, once existed to explain their meanings. The jamb statues at St. Denis have long been studied from Montfaucon's commissioned drawings, and what seem to have been fragments of these statues have also been considered in studying the style and meaning of the St. Denis ensemble. The Thibaudian Henry of Winchester had ideas about the relationship between kingship and priesthood that may have influenced this and other works in the realm of the Thibaudians at midcentury. It has been said that Thomas Becket, who was consecrated by Henry of Winchester, and who spent much of his exile (1164–70) in the lands of the Thibaudians, was profoundly shaped in his views of the balance of power by Bishop Henry, in spite of the differences between them at various times in their lives.[40]

The modern scholars mentioned above are not mistaken in their views of "regnum and sacerdotium" and the importance of Christ's lineage as embodied in the jambs. Much more evidence, within certain well-established liturgical practices from twelfth-century Chartres, exists to deepen the meanings and to suggest the importance of their modes of presentation. As in the case of Notre Dame de la

Belle Verrière (see chapter 9) and the pilasters and tympana (see chapter 11), the liturgy confirms that particular ways of understanding history prevailed and that these inform the arts created to serve liturgical practice. The general plan of the Royal Portal seems to grow, almost organically, from an understanding of the feast of the Virgin's Nativity, which itself was rooted in the season of Advent (see chapters 7 and 9), even if one is cognizant of the fact that this sculpture is spolia, put in place and perhaps reconfigured in the early thirteenth century. These festive events were foundational to the workings of the imaginations of those steeped in this cult and its expression at mid-twelfth-century Chartres and later on as well.

The entire complex of meanings begins with the Gospel reading of Mary's Nativity, Matthew 1:1–16, featured in the Office throughout the week of the feast and in the Mass liturgy. Simply to see a "line" of ancestors would have immediately recalled that text to any medieval Christian and would also have called to mind two festive occasions: the end of Advent and the coming of Christ and the feast of the Nativity of the Virgin Mary. At the same time the door was being constructed, artists in a variety of media were applying their talents to making the letter *L* that begins the Gospel according to Matthew ("Liber generationis"), a statement about lineage, and finding ways of visualizing the *styrps Jesse* of Fulbert's chant.[41] Chartres, BM 139, an early thirteenth-century Bible from Chartres produced by a Parisian atelier, still survives, though in greatly damaged condition; it contains a beautifully decorated *L* for the opening of Matthew's Gospel. The Winchester Psalter, produced under the patronage of Henry of Winchester, contains a magnificent Jesse tree as part of a series of historiated miniatures, demonstrating Thibaudian interest in the image.[42]

The jamb figures embody a loosely conceived program, one maintained throughout the years required for its design and realization. Art historians have argued that several styles are represented in the ensemble and, as a result, that it was carved over a number of years or that it contains the spolia of several artistic programs that survived the fire of 1194. Four kinds of figures are represented in the surviving statues comprising this lineage: kings (7), queens (5), prophets (4), and priests (2). Their distinctive headdresses are the most important surviving clue: the queens and kings have crowns; the prophets have loose flowing hair and beards and no hat; the priests wear skullcaps that closely resemble those worn by the figures of the procession in the temple on the southern tympanum (see chapter 9). The surviving figures appear as given in the table below, with question marks indicating missing heads and X entire missing statues. Statues that have been replaced by reproductions in modern times (the originals are now stored in the crypt) are in boldface.

Regularly sung processional chants defined the Royal Portal as the entrance to Mary's church and proclaimed Mary of Chartres through her lineage: she was the matrix for the human and the divine and the model of the new temple. The evidence of the chants selected for processions—"Hec est Regina" and other Marian

Figure 10.4. Initial *L*, early thirteenth-century Bible from Chartres, Bmun, 139, fol. 137. Médiathèque de Chartres. Credit, Delaporte.

antiphons associated with it as well as chants written by Fulbert for the Virgin's Nativity—were filled with allusions to the royal lineage of the Virgin and connected the door with Fulbert, the supposed builder of the cathedral and the composer of texts and chants for Mary's Nativity. The most common message proclaimed as people passed through the door was "This is the Queen!" The ceremonial entrance of the bishop for the liturgy of Mass was characterized by tropes for major feasts, and these speak of foreshadowing and prophecy, linking the portal to the great adventus ceremony of coming, entering, and transformation that is basic to the rhythms of the Christian understanding of time and—at Chartres with its powerful Mariological cast—of history. The texts, chants, and themes associated at Chartres with the time-transforming event of Mary's birth, subsequently placed in parallel with the births of John the Baptist and of Christ, supply the themes found in the jamb statues and relate as well to the various pilasters that surround them. The jambs are the old line of kings, queens, prophets, and priests, as related to, yet different from, their contemporary progeny. Christ, Mary, and John the Baptist are the new line, and when their direct heirs march through the portals they both continue and renew the ancient order of things. Mary is the door in her ancient lineage, and processions march through her opening toward sacraments of font and altar.

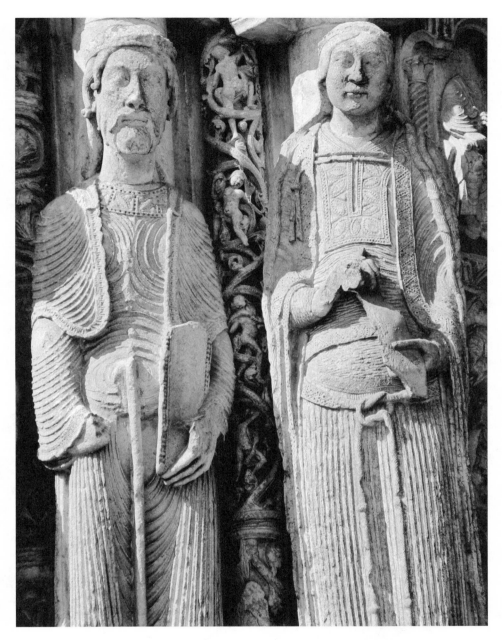

Figure 10.5. King and queen, RPN, left splay. Credit, de Feraudy.

How was the idea of lineage interpreted at Chartres through the arts in the mid-twelfth century? William of Malmesbury, who was patronized by Henry of Blois, demonstrates in his writings that in the mid-twelfth century Fulbert was championed as the builder of Chartres Cathedral and that the chants ascribed to him were integrated into the understanding of the Virgin's cult at Chartres; if this was his

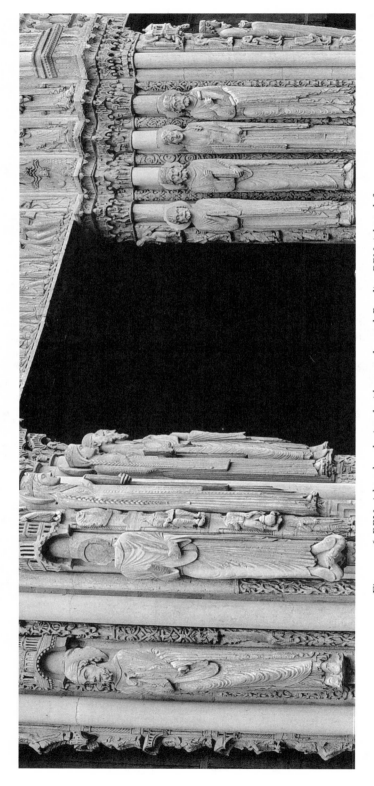

Figure 10.6. RPN, right splay, depicted with central portal. Reading RPN right to left: Headless statue (prophet?); missing statue; priest; missing statue. Credit, de Feraudy.

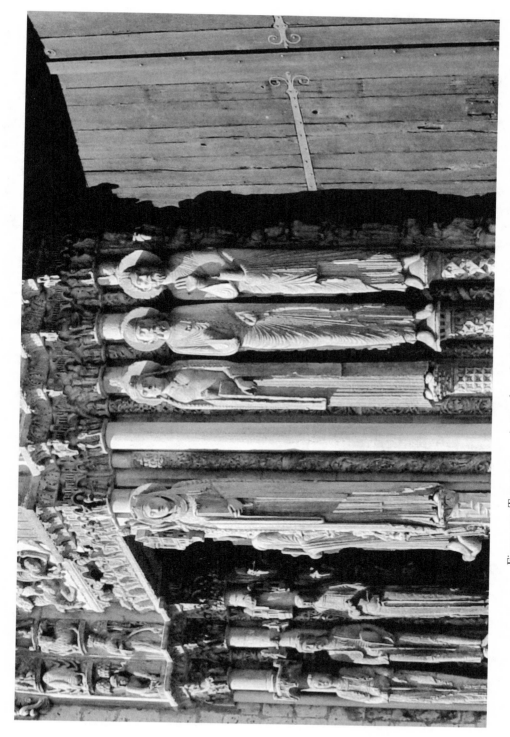

Figure 10.7. Two queens, priest, and prophet, RPC, left splay. Credit, de Feraudy.

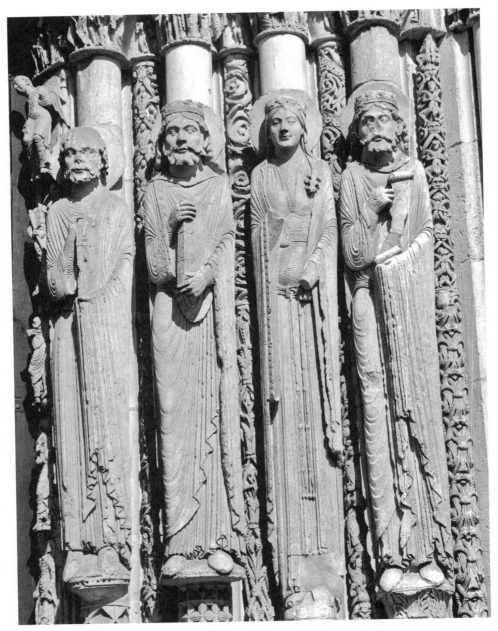

Figure 10.8. Prophet, king, queen, king, RPC, right splay. Credit, de Feraudy.

understanding, it was surely Bishop Henry's as well, who certainly would have promoted the association between Chartres and an early English king, one who was buried in Winchester and especially venerated there as a donor and supporter:[43]

By the advice of said archbishop [i.e., Ethelnoth, d. 1038] also, the king, sending money to foreign churches, very much enriched Chartres, where at that time flour-

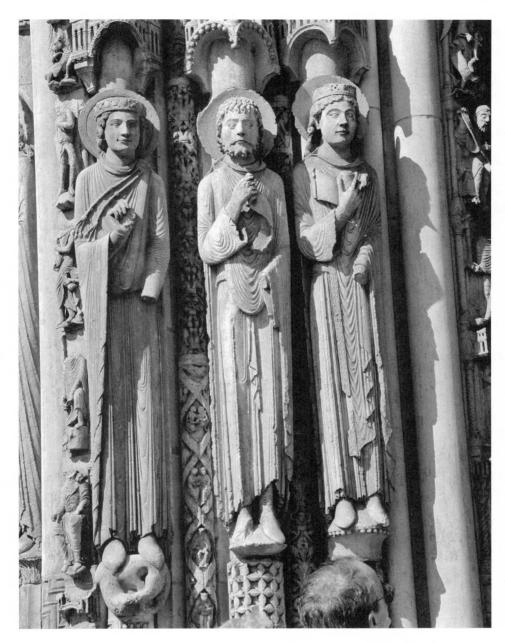

Figure 10.9. King, prophet, king, missing statue, RPS, left splay. Credit, de Feraudy.

ished bishop Fulbert, most renowned for sanctity and learning. Who, among other demonstrations of his diligence, very magnificently completed the church of our lady St. Mary, the foundations of which he had laid: and which moreover, in his zeal to do everything he could for its honour, he rendered celebrated by many musical modulations. The man who had heard his chants, breathing only celestial vows, is best able to conceive the love he manifested in honor of the Virgin. Among his other

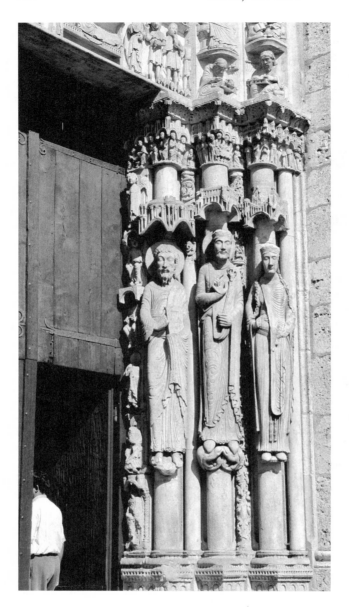

Figure 10.10. Prophet, king, queen, RPS, right splay. Credit, de Feraudy.

works, a volume of epistles is extant; in one of which, he thanks that most magnificent king Canute, for pouring out the bowels of his generosity in donations to the church of Chartres.[44]

Fulbert, liturgical poet, composer, and builder of the cathedral, provided themes for the construction and decoration that took place in the twelfth century, as did liturgical texts for the Virgin's Nativity, the feast profoundly associated with Fulbert and, as a result, with the church he was thought to have built, King Canute being a major donor. Writings associated with Bishop Fulbert repeatedly emphasize the lineage of Mary, John, and Jesus, further linking him to the feast and its meanings.

## Table 10.1. The Jamb Statues of the West Façade of Chartres Cathedral

X = whole statue is missing
Bold: original is in the crypt

| North | Center | South |
|---|---|---|


                                    DOOR
              DOOR           Prophet   Prophet            DOOR
       Queen      X          Priest    King          X      Prophet
       King     Priest       Queen     Queen       King      King
       King?      X            X       King      Prophet     Queen
               Male?  Queen            King      X   King


The proposed identification of the jambs according to Halfen (2001) and Klinkenberg (2008), moving from the center toward the north, and then from the center toward the south:

| Type | Halfen | Klinkenberg |
|---|---|---|
| *Center left (right to left)* | | |
| Prophet | Samuel? | Abraham |
| Priest | Boas? | Aaron |
| Queen | Ruth? | Queen from Saba |
| Missing statue | | |
| Queen | Esther | Abisag |
| *North right (right to left)* | | |
| Headless Male | Not identified | Melchisedech |
| Missing Statue | | |
| Priest | Moses | Moses |
| Missing Statue | | |
| *North left (right to left)* | | |
| Queen | Sara | Rachel |
| King | Isaac | Josaphat |
| King (with female head) | Abraham | Ezechial |
| *Center right (left to right)* | | |
| Prophet | Jesse | Samuel |
| King | David | David |
| Queen | Queen from Saba | Bathsheba |
| King | Solomon | Solomon |
| Missing Statue | | |
| *South left (left to right)* | | |
| King | Hezekiah? | Josias |
| Prophet | Isaiah? | Jacob |
| King | Josais? | Jeconias |
| Missing Statue | | |
| *South right (left to right)* | | |
| Prophet | John? | Joshua |
| King | Constantine? | Saul |
| Queen | Helena? | Abigail |

Fulbert's most famous sermon, *Approbate consuetudinis*, for the Nativity of the Virgin, is a good example of his emphasis upon prophecy, kings, and priests, a famous text that any Chartrain citizen in the twelfth century could have pointed to with pride. This is the opening lesson, sung throughout Europe in the Office for the Feast of Mary's Nativity, a text recognized interregionally as having been written by the bishop of Chartres who built the cathedral:

> The most blessed Virgin was born, then, as we read, of a father from Nazareth and a mother from Bethlehem. The prophets were not silent concerning the towns appointed for the birth and daily life of Christ. Mary descended from the root of the man with the faith of noble Abraham, to whom the blessing of all peoples in his seed was promised from above, and from the stock of David, whom God exalted with exceptional praise on account of the goodness he noted in him, saying: "I have found a man according to my own heart" (Acts 13:22).
>
> Mary, who was about to bear the supreme king and priest, took her origin from the royal tribe and, at the same time, the priestly one as well.[45]

After Fulbert's chants and sermons, the most important text for understanding the way the feast of the Virgin's Nativity was explained in the mid-twelfth century is the commentary on Matthew 1:1–18 by the Carolingian exegete Rabanus Maurus, a text doubtless inspirational to Fulbert as well. It was read throughout the octave of the feast of Mary's Nativity and is included both in the Book of the Cult and in Chartres, BM 138, a collection of sermons read at the cathedral of Chartres during the time the Royal Portal was constructed.[46] Rabanus relates the Gospel to the feast through a Mariology that expresses the meaning of the genealogy of Christ laid out in Matthew 1:1–18. The women found in the lineage suggest that this is the genealogy of Mary, a relative of Joseph, as well as that of Joseph himself. The jambs at Chartres have more women proportionately than any other such display from the mid-twelfth century; they are especially focused upon announcing the Mariology of the Davidic heritage, another important theme of the feast of Mary's Nativity as explained by Rabanus. He claims that the genealogy of Christ is unusual because of its emphasis upon women:

> And so with the series of the generations ended, as if recollecting the past [Matthew] said, "Now the generation of Christ was in this wise," as if to say, "In this wise was the line of the human generation of Christ through his parents, reaching all the way to God." Joined to this is what follows concerning the espousal of his mother, how before she was joined to her spouse "she was found with child of the Holy Ghost." In this way how different the generation of Christ is from others is revealed, for whereas any other comes from the union of man and woman, he was born into the world through the Virgin as the Son of God. Anyone who wants to ask how the line of generations leading to Joseph—since Joseph is not the father of our Lord and Saviour— relates to him, should be aware first of all that it is not the custom of the Scriptures

that a line of women be woven into the generations, and then that Joseph and Mary were from the same tribe, from which the law required him to take her, as a relative, and that they are reckoned together in Bethlehem as generated from the same ancestral shoot.[47]

Rabanus's commentary not only explains the inclusion of women in the genealogy of Christ but also promotes a flexible reading of Matthew 1:1–18. Rabanus compares the genealogy of Matthew 1 to that found in Luke 3, discussing what it means that one moves from the beginning to the fulfillment, and the other begins with Christ and moves backward to Adam. When things are out of order and scrambled, this is for mystical reasons that cause us to ponder events of the past as something other than simple narratives with only a chronological order. His approach, which is mindful of the view of time found in the medieval liturgy more generally, can be seen in the following passage, in which the exegetical reins are held loosely in his skillful hands:

> "The son of David, the son of Abraham" (Matt 1:1). The order is inverted, but the change was necessary: if Abraham had been put first, and afterward David, Abraham would have had to be repeated for the sequence of generations to be assembled. Therefore skipping over the others he is called the son of these [two] since only to them was the promise concerning Christ made: to Abraham, "In thy seed shall all the nations be blessed" (Gen. 22:18); to David: "Of the fruit of thy womb I will set upon thy throne" (Psalm 131:11/132:11).[48]

Rabanus also speaks of the various kinds of people making up the lineage of Christ. He divides them into three ages, using the number of persons making up the line, forty-two. The passage demonstrates how he, like so many Christian exegetes before him, believed that time and numbers are linked and that the way history unfolds is often manifested in the relationship between units of time, all of which are counted out in the mind of God:[49]

> "Abraham begot Isaac. And Isaac begot Jacob" (Matt 1:2). Matthew pursues the human generation of Christ from the very beginning of the promise of Christ. That is, from Abraham he lists the begetters, whom he carries through to "Joseph the husband of Mary, of whom was born Jesus" (Matt 1:16). Mystically too he shows how from the darkness of the gentiles, as if from Egyptian servitude, through forty-two men, as if from houses of the same number, to the Virgin Mary, flowing with the full flood of the Holy Spirit as an intelligible Jordan, with the Lord Jesus Christ leading like Joshua, son of Nun, it might be accomplished.[50]

Rabanus was no literalist. He read the mystical number forty-two from a number of angles, each of which found resonance in theological interpretations of the feast of Mary's Nativity and the history of humankind. Most important for the Royal Portal is his breakdown of the number into its threefold components, fourteen plus

fourteen plus fourteen, and ten, four, three, and one, which is also the Pythagorean unity important in the teaching of music.

> "So," he says, "all the generations, from Abraham to David, are fourteen generations. And from David to the transmigration of Babylon, are fourteen generations. And from the transmigration of Babylon to Christ are fourteen generations" (Matt 1:17). These divisions will stand if the first fourteen, beginning from Abraham, ends with David, while the second, beginning from David—that is, just after David, from Salomon—ends with the first Jechonias, that is, the father (who is called Joakim by the Hebrews), and the third, taking its start from the second Jechonias, that is the son of Joakim (who in Hebrew is called Joachin) extends to Christ, so that Christ himself is counted. The fourteen placed in the whole genealogy articulate the periods of three distinct Hebrew populations, the first of which lived under the patriarchs, priests, and judges, before the kings; the second under the kings, prophets, and priests; and the third under chiefs, prophets, and priests, after the kings. But mystically, and with the divine gift of perfect fullness, all can be reduced to one. For ten recalls the Decalogue; four, the Gospels; and three the faith in the Trinity. And all these things come together in the same mystery, for just as three times four and then times ten [one hundred twenty], or four times ten and then times three [one hundred twenty] agree numerically,[51] so too the law and the Gospels are supported by faith in the holy Trinity, and by the law and the Gospels faith in the Holy Trinity is declared.[52]

Turning to the jamb statues and their display on the Royal Portal with Rabanus's mystical numbers in mind is instructive. While he mentions other numbers and arrangements of numbers, one might expect fourteen—which, times three, represents the three ages of the Hebrews and also the genealogy of Christ through his mother, Mary—to figure into the order of the priests, prophets, kings, and queens found there. The numbers favored by Rabanus in this key liturgical text for the Virgin's Nativity are embodied in this lineage in two ways; both allusions were a way of making the exegesis on the Gospel of Mary's Nativity come to life—actually to resound—in the portal that was the entrance to her church.

To understand how the numbers work, the viewer must reenter the action of a medieval procession, singing of Mary, the Virgin Queen, on the way back into the cathedral. Members of such a procession toward the center door witnessed ten statues, that is, five on the right, plus five on the left. Those ten of the center portal, plus the four from one side or the four from the other side, make two groups of fourteen. The arrangement of the capital frieze instructs viewers to think in this way as well, for the historical narrative moves from the center portal outward, first to the left and then to the right.[53] In addition, thematic links exist in the tympana between the north and the south portals, the most obvious being the displacement of two signs of the zodiac from the north and their inclusion in the archivolts of the

south tympanum. The seven jamb statues of the north added to the seven of the south offer another group of fourteen. When the generic identities of the statues and their numbers are repositioned in the context of the understanding of history found in Rabanus's commentary on Matthew 1, there is an underlying strategy that cannot be denied: the arrangement of the jambs and their numbers may well have been designed to embody the three groups of fourteen that represent the three generations of Christ but displayed so that the female strand of the line is emphasized along with the priestly, prophetic, and regal, as in the sermons of Fulbert and the exegesis of Rabanus. The art functions not through literal identifications of the figures (although in the twelfth century names may have been assigned), but through mystical number symbolism related to the unfolding of the generations in Scripture. The plan works less well with a strictly literal interpretation, for, according to Rabanus, only the middle fourteen contained kings; Fulbert, however, draws out the line of kings up to Herod, so that the prophecy of Genesis 49:10 can be fulfilled by Christ. The statues are also arranged in ways that prefigure the mystical numbers singled out by Rabanus: three, four, and ten, the numbers symbolizing the Trinity, the Gospels, and the Decalogue. The center portal has two groups of five statues, making ten; the north and south portals are composed of groups of three and four. (Figure 10.5 gives a sense of what it is like to approach the central door from the left, looking up at the central jambs.) The entire display is composed of combinations of the numbers making up Rabanus's mystical concordance. Rabanus's text also offers support for the idea that the line generating Mary's flesh is ended by a hook holding Christ. In the reading for the feast of Mary's Nativity we also find this mystical sense of events in time, following right after the discussion of the meaning of Christ's genealogy:

> Christ himself is said to have been born of Mary, Christ, who like a hook at the end of a net is thus placed at the end of the genealogy; sent by the Father into the sea of this world, when slain he killed the winding dragon [*draco*, the word used in the Ordinal on the feast of the Ascension] that was hooked, and who, having died, put to death the death of the human race. And likewise as with a doubled rope, that is, with the name of each person repeated, the genealogy is woven like a net until from his beginning of the genealogy, that is from Abraham, it arrives at the hook, that is, Christ, of whom it was said to holy Job, "Will you hook the Leviathan with your hook, or bore through his jaws with a ring?" [Job 40:20–21, probably from memory]. Therefore by the hook of the Incarnation of Christ this one [the dragon/Leviathan] was captured, since when he desired the bait, the body, he was transfixed with the barb of the divinity.[54]

Rabanus's text offers many views of time and suggests ways of interpreting history adapted for artistic display in mid-twelfth-century Chartres. Within his explication of lineage is a view of mystical numbers chanted as part of the festive week celebrat-

ing the patronal feast of Chartres Cathedral. Guy Villette studied the numbers of
the west façade; he spent his life pondering the art of the cathedral and its meanings
and focused a short paper on the numbers ten, as the number of Pythagorean per-
fection, and fourteen, as the messianic number found in the genealogies of Christ.[55]
He said that the idea of the Royal Portal was unique to Chartres and related not
to the coming and going of royalty but to expressing Christ's royal lineage.[56] If the
jamb figures are taken as a group, rather than as individuals, they represent a long
line of men and women who sensed God in the flesh, but through a glass dimly,
and who read the future in their own times just as the people of Chartres read the
present in the past presented by the statues.[57]

In their largest sense, then, the jamb statues form a crowd of ancestors that stand
at the door to welcome countless processions back into the cathedral. They are not
dry embodiments of number symbolism from the Gospel and Rabanus's commen-
tary upon on it; they are people, arranged numerically to announce their identities
as lineage of Christ, come to him through his mother, and so with a strong empha-
sis on the feminine. This lineage, as Fulbert was at great pains to pronounce in his
sermons and songs, was woven from a triple strand: the royal, the priestly, and the
prophetic. The Christian Messiah could be all these things because his mother was
all of them; he took his flesh from her.

To place the procession of lineage at the portal made the point in ways that would
have drawn people into the mystery: Mary was the door, and the door embodied
her lineage. Several beloved medieval chants, texts set to tunes known to all, fea-
ture the image of her as the door. The magnificent antiphon "Ave Regina celorum"
(Hail, Queen of the heavens) cries out to her, "Hail root, hail door, from whom light
is risen for the world!" and the hymn "Ave, Maris stella," sung at Chartres on the
feast of the Nativity of the Virgin, uses the theme at its opening: "Hail, Star of the
Sea, nurturing Mother of God, ever Virgin, joyful door of heaven." The liturgy em-
phasized that Mary's body is the door through which God in the flesh entered the
world of time; in the Marian antiphons sung at the portal she appears as a type of
the church, opening to embrace those who come to her to be nurtured. Christians
who stepped through openings in this carved "membrane" representative of the
Virgin herself were potentially ingrafted as new shoots of the ancient lineage clus-
tered around them in a special ceremony of adventus.[58] They would, to quote from
Ivo of Chartres, "suckle majesty," stepping through Mary into a new understanding
of the ages.

## JAMBS IN ANOTHER MODE

The jamb statues of Chartres are deeply rooted in liturgical understanding and in
a sense of history nurtured by the liturgy; these themes would have been paramount
to the canons, dignitaries, and bishops who surely helped plan the program. Study

of the liturgy, especially the commentary by Rabanus Maurus on Matthew 1, read throughout the octave of the Virgin's Nativity, suggests a flexible program. Once established and understood by the designers, the number symbolism embodied in the display of statuary could lend itself well to substitution of individual elements, as long as the numbers remained fixed. Whitney Stoddard, who has studied the sculptural styles found in the program for his entire professional life, states that there was only one campaign and four major sculptors, identified by him as follows: "the Saint-Denis master, the Étampes Master, the Headmaster, and the Angel Master." He believes five assistants served these masters and that they did their work in a probable space of around six years, in accordance with a design plan: "The division of labor has a logic that precludes the possibility of designating any parts of the portals to an earlier campaign."[59] Jean Wirth's recent work on the dating of medieval sculpture is in accord with the idea that there was a plan; he thinks it was supervised by one person, alongside of whom others, his artistic equals, worked, supported by skilled apprentices.[60] So, although different styles are displayed, the quality is uniformly high. Changes in style displayed in the jambs could be studied through analysis of many local sculptural styles and changes within them; the way to begin would be through a catalogue of surviving twelfth-century sculpture from the immediate region.

At Chartres, although there may have been some changes in the northern tympanum, the general plan was apparently fairly well agreed upon throughout the campaign, although several artists were involved. Later there was some substitution, and restoration has been ongoing; some heads were added even in the medieval period. After the fire of 1194 the entire complex must have been refitted to some degree. Although this is a famous and much-discussed monument, a great deal of work remains to be done by art and architectural historians on the dating of the elements of this and other related local works; until new studies are published, scholars reaffirm the traditional dating between 1145 and 1155, with some years perhaps to be added to the beginning and end of the decade. This is concordant with the outline of the campaign presented in chapter 8 and with the widely believed idea that the Royal Portal of Chartres Cathedral postdates the work at St. Denis, consecrated in 1140 by Abbot Suger.[61] Little, however, is secure about the dating of the few surviving monuments in this so-called cradle of early Gothic architecture; the number of churches that have been lost will always make any precise understanding of how developments unfolded very difficult.

Given that the triple portal seems to have been designed and executed during the time that several children of Countess Adela and Count Stephen-Henry were still alive, one wonders what these dramatic statues might have meant for the members of the Thibaudian family, great patrons of the arts and builders of churches in the mid-twelfth century. What other projects were the Thibaudians engaged in locally during this period that bear some correspondence and may help further under-

standing? The Madeleine of Châteaudun offers evidence to connect both Count Thibaut and Bishop Geoffrey with the style of the jamb statues. Early written evidence proves that life-sized bas-reliefs of kings and queens were displayed across the northern façade of this church, which fell under the jurisdiction of the Thibaudians and was located in the diocese of Chartres. The church was reformed as a house of canons regular between 1118 and 1120, and Geoffrey of Lèves had a powerful presence there, as did Count Thibaut IV.[62] From her study of drawings and engravings Sophie Baratte-Bévillard (1972) has dated the bas-reliefs between 1140 and 1150. She describes the shapes of the sculptures (which were destroyed in 1793) from descriptions by Antoine Lancelot published in 1742 with engravings by Charles or Louis Simonneau; these depict the north façade with the statues in place and offer descriptions of each statue. For comparison Baratte-Bévillard uses a drawing of the church made in 1654 and found today in the Bibliothèque Nationale.[63] In the eighteenth century the figures were associated by Lancelot with famous kings of the past—King Childebert, Charlemagne, King Louis the Debonnaire, and others—as was traditional in the interpretations of his time.[64] The Châteaudun statues were not jambs but were nonetheless of the general style of those carved for the northernmost splay at Chartres and for the south portal of Notre Dame of Étampes, also dated to this period. There were thirteen of them, and although of different sizes they were in the same style and were arrayed in symmetrical patterns to decorate doors and windows, especially the central door of the tripartite portal, which had a figure to the right and left of the archivolts and four others mounted on a sill above them. In the entire ensemble kings prevailed, and they held either swords and their scabbards or scepters, and in two cases both. There was but a small number of queens and one figure that appears to have been of the priestly cast. After studying the surviving pictorial evidence, Baratte-Bévillard says,

> On the designs of the reliefs of Châteaudun, one sees traits found also in the column statues [of Chartres and Étampes]: in both cases, these are slender figures, elongated, the elbows close up to the bodies and the forearms angling up toward the breast; the garment folds are tight and in parallel, arrayed in concentric patterns on the belly, the knees, the breast. Some reliefs of Châteaudun offer such a resemblance to the statue columns of the Royal Portal of Chartres and with those of Étampes that one could attribute them to the Étampes master. But how to imagine that one sculptor or one group of sculptors could have executed, at the same time, both statue columns and bas-reliefs? These two types of sculptures correspond to two conceptions for the decoration of a façade: in one, the sculpture was flattened against a wall that overlaps and contains it; in the other the sculpture reinforced outlines of the structure of the building and, freed from the wall, little by little acquired a third dimension. The earliest column statues, in particular those on the northern splay of the north door of the Royal Portal of Chartres, are not liberated from the form of the bas-relief: the

arms flat against the body, the concentric folds that underline fleshly sections of the body, draw on techniques for representing human figures in bas-relief. And the first statue columns, without doubt because of the techniques of bas-relief in which the sculptors were trained, reference the bas-relief above the column. It is therefore not surprising that the same sculptors made the statue columns of Étampes and Chartres who carved the reliefs of Châteaudun. And how would it have been possible that the direction to execute in bas-relief might be given to an atelier that had just worked on a portal with statue columns? It is certain that reliefs flat against a wall were not missing from façades that had portals with statue columns: at Notre Dame of Étampes, two angels decorate the cornerstones of the southern portal; by their placement and sense of motion, they seem to have been made for the curve of the archivolts (115–16).

Witnesses to the lost sculpture of La Madeleine of Châteaudun not only offer important evidence for evaluating the artistic nature and date of the jamb statues of the west façade at Chartres; they also suggest that the themes embodied in these statues mattered to Bishop Geoffrey of Chartres and to Count Thibaut IV of Chartres/Blois, both of whom were patrons of these two churches. Charters from the mid-twelfth century demonstrate the connections the two men had with the Madeleine and also proclaim the superiority of it to all other churches in Châteaudun.[65] Count Thibaut built the Hôtel Dieu for the Madeleine, and this is the establishment for which the recently recovered ordinal in Châteaudun, 13 (OV) was copied. The Madeleine was the only church in the town in which legal writs of accusation could be lodged; if, after this had been done and Mass had subsequently been said, the parties still could not reach agreement, there would be a procession out of the church to the count's castle, where a duel would be fought or some other trial offered.[66] The documents suggest that to have statues of kings, queens, and ecclesial authorities at the doors of the church signaled that justice was meted out there, through the partnership established by legal contract between ecclesial and secular authorities. If one stands in Châteaudun facing outward from the north façade, the site of the count's castle is located directly in front; it is still marked by a massive twelfth-century tower said to have been constructed by Count Thibaut V, son of the builder of the Hotel-Dieu and patron of the Madeleine.[67] Above the door of the façade of the Madeleine the remnant of an angel serves to remind viewers of the large program of sculpture that once graced this church and looked across the way to the ramparts.

The style of the façade sculptures has long been compared to the northernmost jambs at Chartres Cathedral as well as to those found on the south portal of Notre Dame of Étampes. Stoddard (1987) pointed out that Étampes was a highly favored Capetian city and that "the road which still passes along the southern side of Notre-Dame led directly to the royal residence," a vast chateau constructed by King

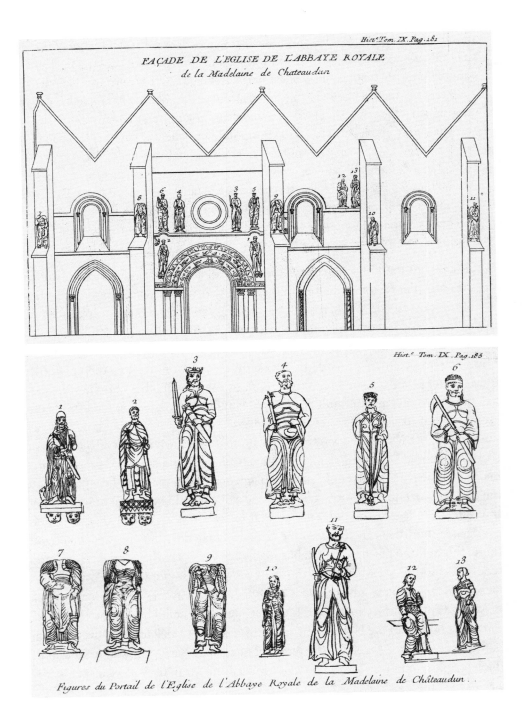

Top: Figure 10.11. Engraving of the northern façade of the Madeleine of Châteaudun, mid-twelfth century. From Lancelot (1742).

Bottom: Figure 10.12. Details from the engraving of the northern façade. From Lancelot (1742).

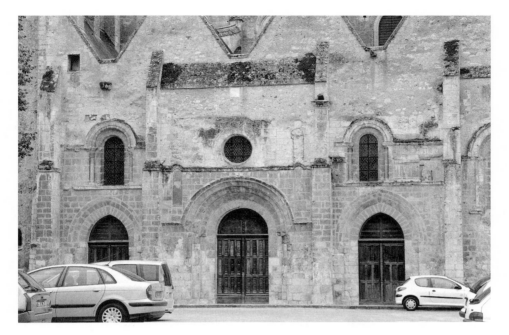

Figure 10.13. Northern façade of the Madeleine of Châteaudun. Credit, de Feraudy.

Figure 10.14. Detail, remains of an angel over the central portal at the Madeleine of Châteaudun, mid-twelfth century. Credit, de Feraudy.

Louis VI and his sons. Henry of France, Louis VII's younger brother, was abbot of the collegiate community of Notre Dame of Étampes from 1137 to 1146 or 1147. Here too, as at Châteaudun, these regal figures, mixed with prophets and priests, signified the powers of church and state in a town with twin fortresses of church and secular authority. The façade statues at Châteaudun and Étampes were another version of the earliest jambs at Chartres and were created by artists who knew each other's works, who even, some have said, belonged to the same school. Because sculptures from Étampes and Chartres survive, the parallels can still be observed, but the questions remain as to why and how this happened and what the sculptures in each church represented.

The jambs, more than any other element of the façade sculpture except the northern tympanum, were capable of representing more than one set of ideas in the twelfth century. At Chartres their primary meanings related to the liturgical function of adventus and the meaning of the processions into and out of the cathedral. They were of Mary and about Mary. But they were also larger-than-life replicas of human figures that resonated with the ideas of contemporary donors and that wore their beautifully cut clothing.[68] Expanding upon views I presented in an early paper,[69] I now believe that the northern tympanum of the west façade and its lintel present three interrelated groups of themes: those related to the Ascension and those referring to the first and second comings of Christ. The meanings of the north tympanum balance the appearance in the flesh depicted in the southern tympanum and advance the trope of seeing which is central to the meaning of the façade as a whole; the prominent cloud in which Christ appears, disappears, and (by implication) will reappear is related to the flesh that sustains the divinity it both hides and reveals.

The themes of coming and going and the importance of relating them to one another are found in several texts sung or intoned at Chartres on Ascension day, and, once again, the quality of action at the portal itself can be of help in interpreting its iconography. The sequence "Rex Omnipotens" was specifically prescribed for singing before the door on Ascension day. It begins, "Today the all-powerful King, with the world redeemed by his redemptive power, ascended to heaven from whence he had descended."[70] In this song the historic action of the Ascension recalls both the long waiting during Advent and the events of Birth and Incarnation depicted in the southern lintels and tympanum. The Epistle of the day, from Acts 1, which announced that Jesus would come again in the way he departed, points to the second coming of the central tympanum. Verse 11 of the Epistle text was sung as the Introit chant for the Mass liturgy, the speakers of the chant being the two men clothed in white of verse 10, who stood by the apostles: "Ye men of Galilee, why stand you looking up [*aspicientes*] to heaven? This Jesus who is taken up from you into heaven, shall so come, as you have seen him going into heaven. Alleluia, alleluia, alleluia!" The participle "looking up" recalls the Advent liturgy and its most famous

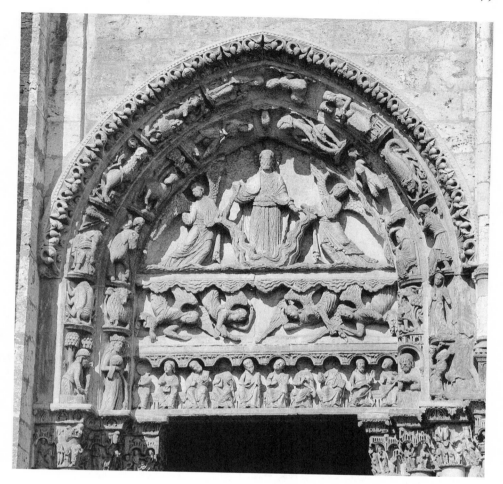

Figure 10.15. Tympanum and lintels, RPN. Credit, de Feraudy.

and prominent chant text, the great responsory that begins the season, "Aspiciens a longe."[71] Common in liturgical manuscripts from the later Middle Ages are large initial A's at the beginning of the Office of Advent, decorating "Aspiciens a longe," the crossbar of the A serving as a cloud.[72] The cloud in which Jesus appears and the cloud in which he departs have kept him hidden from the ages; the cloud is the flesh of the Virgin Mary, in which he was wrapped and then became visible—able to come, able to ascend, able to come again.[73]

This mystery is at the heart of much discussion of what it means that God came into time and elected to submit to history. In orthodox Christian theology, worked out over the course of the fourth and fifth centuries, Christ's human nature came to be understood as the part of him that could be visualized, whereas his divine nature could not be seen or comprehended by human beings. The Ascension broaches the crucial subject of the two natures head-on, and a sermon attributed to Augustine and read at Chartres Cathedral on Ascension discusses what "the word was

made flesh" (John 1:14) means.[74] Augustine restates John 3:13: "And no man hath ascended into heaven, but he that descended from heaven, the Son of man who is in heaven." Accordingly, before his Incarnation Christ was without human flesh: this he took from his mother at the Incarnation. When he ascended, he took that flesh to heaven with him and thereby offered the promise of heaven to all humankind.[75] The great sacrament is revealed by the relationship between Christ and the Church: "They were no longer two, but one flesh" (Matt 19:6).[76]

The mystery of the Ascension is directly related to those of Advent and of the second coming. The cloud of flesh offered to Christ was that of the Virgin; she received him when he came; he departs the world, having glorified the cloud. Yet the divinity within the cloud remained ever hidden, ever a mystery to human sense and to human reason. The Ascension scene at Chartres, then, is about much more than this feast. It incorporates the ideas of Advent and of second coming and illuminates the cloud that is the Virgin's flesh and gives it striking visual prominence. Such a representation may also be suggestive of cloth, the fleshly wrappings offered to Christ, and represented by the cloth that touched him and her at the moments of Annunciation and Birth: the relic of the sacred cloth as defined through art and exegesis was at the heart of this mystery at Chartres Cathedral. The cloud allows humans to witness the Divine Being, and yet it shields him from the dull eyes of mortals, who would be blinded by his majesty. The angels to the left and right, holding the cloud, are like those who incense the holy of holies on the southern tympanum. They look away, reminding those who see the form of Christ that they do not see his entire being, as they cannot do so; even the angels cannot gaze upon this aspect of the Godhead. The angelic posture offers a warning: "You can see, but also you cannot!" The four angels below challenge viewers to rejoice in their own remaking and to embrace the work it demands, a charge preached by Bishop Ivo of Chartres in his sermon for the Ascension:

> Brothers, today the victory of Christ is completed, today his triumphant banners are raised up: Hell grieves with its leader over its plundering; the heavenly army rejoices over the restoration of its damned. Today that flesh which was lifted up from earth was gathered to the right hand of the Father, and placed before that of every other creature, and the entire principalities and powers bowed before it. Today the new way of which the Apostle spoke (Hebrews 10) is initiated for us because through flesh of Christ the way to heaven, which formerly no flesh could enter, is unlocked.[77]

So, like the northern tympanum, the jambs have more than one meaning. Fundamentally they are about the lineage of the Virgin Mary and her Son. They also doubtless reminded their audiences of those who meted out justice on earth. But they may also have referred to the attitudes and appearances of their donors, who would have appeared in the guise of Old Testament women and men. Over the time of design and construction the donors may have modified their original inten-

tions, especially as the political situation shifted during the time of building, with one kingdom lost and another gained on the distaff side (see chapter 7). The jambs and their welcoming display of adventus were successful because they could mean many things to many people in the twelfth and thirteenth centuries, just as they did in the eighteenth-century literature reviewed above and as they have to the art historians Villette (1994), Halfen (2001), and Klinkenberg (2008). History makers in the central Middle Ages were most successful when they created a view of the past containing many levels of meaning, and the jambs, functioning first and foremost through the plan of lineage described by Rabanus Maurus, offered various views of history, some of which must have resonated powerfully with ideas promoted by the donors, both ecclesial and secular. They stand open to negotiation and reinterpretation, representatives of the royal, priestly, and prophetic lineage of the Virgin.

---

# REALITY AND PROPHECY
## Exegetical Narrative in the West Façade

The most blessed Virgin was born, then, as we read, of a father from Nazareth and a mother from Bethlehem. The prophets were not silent concerning the towns appointed for the birth and daily life of Christ. Mary descended from the root of the man with the faith of noble Abraham, to whom the blessing of all peoples in his seed was promised from above, and from the stock of David, whom God exalted with exceptional praise.

*—from* Approbate consuetudinis, *a sermon for the Virgin's*
*Nativity by Fulbert of Chartres*

In the introduction to a paper on Romanesque sculpture and the spectator, Walter Cahn addressed reception theory, the study of how the characteristics of artworks are "registered by the audience." He said that "it is fair to say that the object of art-historical study is still overwhelmingly the work of art itself and its maker, not a hypothetical viewing public, whose identity and concerns are bound to remain, as a practical matter, largely hidden from us" (1992, 45). A statement by Jeffrey Hamburger a decade later reveals how attitudes shifted: "Today, the power of the image is located less exclusively in the image itself than in what, following [Ernst] Gombrich, is called the 'beholder's share,' construed, however, largely in affective, rather than purely perceptual terms: the way in which works of art structure imaginative, religious, even physical responses or, at another level, in which heightened artistic self-consciousness itself can elicit a corresponding self-consciousness in the viewer" (2000). At the present time, Cahn and Hamburger both engage with the art itself, as they study perception and audience as well. Many art historians no longer regard artworks and their reception as either/or, and that is the most useful attitude for regarding the west portal sculpture of Chartres Cathedral. In fact, perhaps more than any other surviving monument from the twelfth century, this program offers unique opportunities to combine study of the art with attention to concerns of audience and reception.[1]

Much of the art, both sculpture and glass, can still be experienced in its location, however altered, and can be situated through study of surviving liturgical materials extant from the time it was made. The portal sculpture has been designed to proclaim — but in a particular way. It teaches through modes of understanding the past, ways of thought designed both to reshape believers' imaginations and to offer them a role in completing the program through their interactions with it. This is an art made of constantly unfolding parallels and symmetries, many shaped by liturgical understanding. Contemporary viewers can line up the statues and compare them through the art of photography, but medieval audiences needed to engage their memories and imaginations as they viewed one side of the façade and then the other, the design of the artworks encouraging constant comparison and reflection upon deliberate visual and exegetical parallels. A counterpart to the spiritual journey initiated out of doors was found inside, in a program of glass, some of which remains, although many times restored. All was created to serve a purpose, that of initiation into the mysteries of the faith tradition through historical narrative, here as conditioned by the cult of the Virgin Mary. This is cathedral art; its projected audience ranged from pilgrims, who had infrequent opportunities to experience the special presence of the Virgin of Chartres, to local people, priests, and parishioners, who explored the cult and its meaning throughout their lives, during what was an era of deep association with the crusaders' mission.[2] The "beholder's share" was clouded by the wooden stalls and other structures crowded around these artworks in medieval times, walling off some areas and giving prominence to others, as well as by the soot generated by constantly burning candles and lamps that dimmed the glass.[3] Countless details have been destroyed, from the painted surfaces to the tapestries, vestments, liturgical vessels, furnishings, altars, and reliquaries that were all significant to the working of the liturgy and the liturgical arts.[4] Yet the figures depicted here relate to one another in ways that serve a particular vision of history, and enough of the evidence remains in situ to be explored within the context of liturgical functions.

There is a persistent understanding in the scholarship of modern times that intricate art was for the learned only and could not have been appreciated or understood by the common Christian people who milled about medieval churches on the numerous feasts at which their presence was mandated or who were involved in the kinds of religious activities described in chapter 7. But it is wrong to assume that uneducated, illiterate people were generally lacking in intelligence and in the desire to learn and to study, or that they could not wish to explore the mysteries of human existence and experience. Intelligence and intellectual energy belong to all kinds of people, regardless of the social class into which they happened to be born, and this was especially true in the Latin Middle Ages, when opportunities for education were denied to most people, especially to women. Anyone who has grown up in a community in which the expectation was that people would labor, not seek

higher learning, has heard high-level speculation and seen extraordinary curiosity in people who lack great formal educations. Most Christians in the Middle Ages knew many of the characters depicted in the west portal of Chartres Cathedral; they knew their stories; they knew the saints, whose lives were filled with deeds that resonated with those found in scripture. The viewer may have been a learned prelate who designed the portal, or a parish priest who used it every year for exempla in his sermons, or a pilgrim who had come to venerate the Virgin and pray for a sick family member, or one of the people of the town, in any walk of life, including the numerous masons and their families who worked on building projects and were constantly on site, or a mother whose son had made his way into the cathedral school. The audience for the art of a great cathedral, one in which crusades were preached and fairs were held every year during times of major feasts, cannot be precisely defined. The separation of the sexes in the viewing of medieval art has been much discussed, with evidence presented from various locales; Dawn Hayes (2003) concentrates on Chartres Cathedral but is concerned for the most part with the thirteenth century and later. It may well be that people were kept from the grand portals of twelfth-century cathedrals in a variety of ways, but there is no evidence to prove it or even to suggest it.

The portal sculpture invites the viewer to experience adventus in the closely argued details of the frieze as well as in the massive welcoming jamb statues, whose most common purpose was to greet processions singing of Mary, the Virgin Queen (see chapter 10). Unlike the furnishings of altars, much of the pilasters and the entire frieze were tucked away, able to resist destruction in ways that portable objects could not. Still, that the pilasters and frieze survive at all is a miracle, and they have much to reveal about the working of the liturgical arts as designed by patrons and executed by craftsmen who were highly skilled and intellectually astute. One would wish to have some record of the conversations that must have taken place between patrons or relatives of patrons and those responsible for designing and creating these complicated works of art.

## APPROACHING REALITY: MARY'S LIFE IN THE WEST FAÇADE

The jamb statues of the West Portal (see chapter 10) are surrounded by two series of smaller columns, and these help explain this lower zone of time as that prophesying the "realities" of Mary and Jesus depicted in the capital frieze above. I only briefly mention here the first of these groupings, the colonnettes, as work on them is just beginning, led by Vibeke Olson. They contain a full set of the signs of the zodiac as well as symbols from the natural and mythical world and are now thought to have been precut works that show the styles of several craftsmen (see Olson, 2003). These narrow shafts of stone are sometimes difficult to see, either because they have been covered by larger columns and statues or because time and the

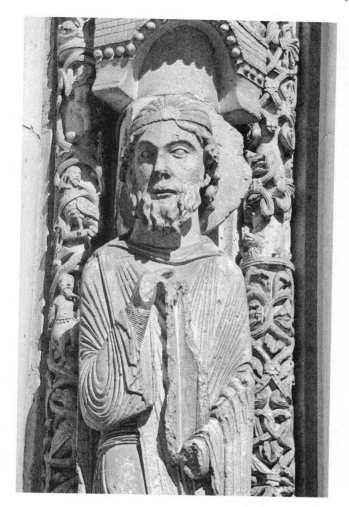

Figure 11.1. Priest, with colonettes to either side, RPN, right splay. Credit, de Feraudy.

weather have worn them away; some have been replaced by modern replicas, the originals being stored in the crypt. The kinds of decoration they contain may provide clues to the identification of stylistic affiliations between Chartres' west façade and other contemporary works, not only in sculpture, but also in glazing and manuscript illumination.[5]

The eight pilasters, the expressive, decorative counterparts of the jamb statues that dominate the bottom zone (or zone 1, as Peter Kidson defines it), are also in a poor state of repair. None of the group of eight survives complete, yet enough of them remains to have inspired the detailed iconographic investigation of Adelheid Heimann (1968).[6] Each pilaster contains a set of images presented as foreshadowings, every case offering archetypes for the scenes depicted in the frieze immediately above.[7] Few of the forty-eight statues (six per column) can be securely identified, however; painting has worn away without a trace, and so too have some heads, hands, and other attributes. The pilasters must be studied in relationship with the

frieze and its narrative, just as figured initials in illuminated Bibles are defined by
their position within the book and the texts they introduce. My work is deeply de-
pendent upon Heimann's expertise as an art historian. I have, however, done differ-
ent things with the identifications she made: they are placed within the context of
the ways in which the frieze tells us it should be read, as if we are part of an arrested
liturgical procession up to the central door of the portal, and so my argument is
organized completely differently. Also, I have found much liturgical evidence to
support Heimann's arguments and in some cases to add new arguments and also to
further substantiate the close connections between the pilasters and the frieze that
she made. Unlike her, I see the entire work as an exercise in teaching about history
and about explaining the force of the Christian sacraments, ideas that come out of
Fulbert and Ivo as well as other writers celebrated in Chartres. I have also put analy-
sis of the visuals in the context of the cult of the Virgin of Chartres, with close study
of texts and music that were associated with it; among all the texts that were pro-
claimed in the liturgy of Marian feasts, the most important for the study of the west
portal sculpture is the text intoned throughout the octave of the Virgin's Nativity,
the commentary of Rabanus Maurus on Matthew 1, the Gospel of the feast (see
also chapter 10). With this text in mind, I revisit the theme of adventus found in
the jambs and relate the general understanding of them to the pilasters and frieze
as well as to the motion of the processions below. Reception and conception are
integrated in my discussion.

   This art was carefully designed to encourage reflection in everyone who came to
see it. Heimann points out that as the viewer's eyes travel upward, each successive
carving in every one of the pilasters becomes "more modeled in the round" and
more detailed, less generic, and with identifiable attributes.[8] Such design suggests
an artistic strategy encouraging viewers to move from a general understanding to
more specific knowledge the closer they move to the slice of time depicted in the
frieze; as they look up, they are taught a basic understanding about history and the
unfolding of time, one similar to that expressed in the Advent liturgy (see chap-
ter 3). Here the Advent dawning is of Mary and of Christ, an expansion of time
developed for this building and its liturgical cult. In the following discussion I offer
reasons for particular depictions of time found in the pilasters as part of an overall
strategy of making history. The pilasters are actually Advent commentaries, related
both to the lively action of the frieze and to the action of the liturgy, that is, to the
processions being welcomed into the church.[9] This is a portal: people were to ap-
proach and observe something new emerge beyond, as they walked into sacralized
space. There are many parallels between the pilasters and their modes of revelation
and the opening chants of the Advent season, works like "Aspiciens a longe" which
is a door to the church year itself, an initiation into sacred time.[10]

   Each pilaster forms an exegetical "arrow" pointing upward to the frieze, with
its narrative of events in the lives of the Virgin Mary and Christ. The frieze statues

are in contrast to their Old Testament counterparts in the jambs, with their stolid bodies and frozen gazes. The action, as it were, is located in Apocryphal/New Testament time alone; in that time zone people interact, with each other and with the presence of the divine, denying, excluding, embracing, and accepting. There is motion as well as emotion, many scenes involving travel, greetings, and farewells. I noted in chapter 10 that the portal is like the frontispiece of a grand illuminated Bible, glossing the action of the processions.

Time is divided by the birth of the Virgin and the fulfillment of her lineage and by the modes of knowing required for particular comprehensions of the past. Biblical commentary is upon texts; liturgical commentary is upon action in time: here these modes of understanding are fused. Each of the eight pilasters is initiated by a prophet at the bottom; the scroll or book in the hand can be seen, but none of these figures can be identified precisely. They do indicate, however, that viewers are to understand the entire group of eight pilasters as a series. The meaning of this series is prophetic and scriptural, like the fundamental message expressed by Moses and the prophets in the scriptures of the Old Testament, as described by Geoffrey Grossus, a local contemporary (see chapter 8). The lineage explained in the commentary on the action of the frieze relates as well to the action of Mary's lineage, believed by Christian interpreters in the twelfth century to be coming and going through the doors below, learning to model their actions upon the lives of their counterparts in the frieze, thereby creating symmetry between past and ongoing present.

### THE CENTRAL DOOR, MOVING TOWARD THE NORTH DOOR

Viewers should approach this history book in stone as though within a procession moving toward the central door of the portal. On arriving at the threshold the procession stops, and its members look first to the left (north). This is where the story of the frieze begins, and so too the set of pilasters designed to work in conjunction with it: the art and its narrative were modeled around the action of the traditional liturgical procession through the center portal, which most often entered while singing the antiphon "This is the Queen."

The first thing to be seen looking left (or northward) from the central door is the pilaster buttressing it. The bottom statue of the pilaster portrays a flat, generic prophet, a figure indistinguishable from his seven counterparts at the bottom of the other pilasters. Then, the viewer's eyes move upward, offering an adventus that grows nearer to understanding as the textures of the figures change and more and more details can be discerned. Who are the most rounded figures, the two at the top of the first pilaster? and to what scenes on the frieze above do they relate? These are the statues that initiate the journey provided by the history book of the frieze and so offer keys to the meanings of the entire ensemble. Just below the topmost figure of the first pilaster is an angel carrying a censer, to which it points for emphasis; in her discussion, Heimann (91) states that this is the only angel on the entire west

Figure 11.2. Prophet at the bottom of the pilaster buttressing the north door, RPN, right. Credit, de Feraudy.

façade who holds a boat-shaped censer, and it stands upon two small seraphim. This, Heimann believes, can only be the angel of Isaiah 6, who cleanses the lips of the prophet with a burning coal in order that he may speak the prophecies that follow, central to the portal sculpture and to the cult of the Virgin of Chartres:

> In the year that king Ozias died, I saw the Lord sitting upon a throne high and elevated: and his train filled the temple. Upon it stood the seraphims [*sic*]: the one had six wings, and the other had six wings: with two they covered his face, and with two they covered his feet, and with two they flew. And they cried one to another, and said: Holy, holy, holy, the Lord God of hosts, all the earth is full of his glory. And the lintels of the doors were moved at the voice of him that cried, and the house was filled with smoke. And I said, Woe is me, because I have held my peace; because I am a man of unclean lips, and I dwell in the midst of a people that hath unclean lips, and I have seen with my eyes the King the Lord of hosts. And one of the seraphims flew to me, and in his hand was a live coal, which he had taken with the tongs off the altar. And he touched my mouth, and said: Behold this hath touched thy lips, and thy iniquities shall be taken away, and thy sin shall be cleansed. And I heard the voice of the Lord, saying: Whom shall I send: and who shall go for us? And I said: Lo, here am I, send me (Isaiah 6:1–8).

Figure 11.3. Angel with boat-shaped censer, RPC, left pilaster. Credit, de Feraudy.

Figure 11.4. Isaiah with scroll, RPC, left pilaster. Credit, de Feraudy.

The text's centrality is underscored by the design of these small statues: the angel points to the censer mentioned in the text, and the prophet above him points with a slender finger to the text he holds. Why is this the text that initiates the history proclaimed in the portal sculpture? Here is a reference to the lintels of doors that move and to a house filled with smoke—portal art is often self-referential, as are liturgical objects.[11] Far above on the central tympanum is Christ in majesty, as found in both Isaiah and in Revelation. But the text also announces the central message of all twelfth-century art at Chartres Cathedral: "I have seen with my eyes the King the Lord of hosts," in this case, the figure reigning above the entire portal in the central tympanum. In addition, Isaiah is the quintessential prophet of Advent, and two quotations from him were central to the Virgin's cult at Chartres, especially as enshrined in sermons and chants attributed to Bishop Fulbert: "Behold a virgin shall conceive, and bear a son, and his name shall be called Emmanuel" (7:14) and "And there shall come forth a rod out of the root of Jesse, and a flower shall rise up out of his root. And the spirit of the Lord shall rest upon him: the spirit of wisdom, and of understanding, the spirit of counsel, and of fortitude, the spirit of knowledge, and of godliness" (11:1–2).[12] Surely one of these was once inscribed on the prophet's scroll in the twelfth century. Those about to view have the searing coal raised to their mouths as well; they are to become prophets, gaining the ability to look through time and read history.

The pilaster directs viewers toward the first act of the narrative on the capital frieze, just above Isaiah's head: the story of Mary's parents, Joachim and Anna, and their struggle to beget the maiden foretold in Isaiah 7:14. The very first scene in this retelling of history (and of the entire frieze narrative) is the story of Anna and Joachim, with their offering of lambs, being turned away by the priest because the couple is barren.[13] The liveliness of the frieze sculptures can be seen in the details, as the priest shoves his hand in the face of Joachim's lamb to reject it, and the lamb held by Anna bleats, seemingly in protest. Laura Spitzer has justified the attention this scene receives through her thesis that the frieze is concerned primarily with the Virgin as a patron saint of women who needed intercession in matters relating to conception and birth. Study of liturgical documents shows that one of the antiphons sung at the door and at every Marian feast in the cathedral (and churches dependent on its liturgy) asked that the Virgin "intercede for the faithful female sex" (see chapter 10). The essential theme of appropriate sacrifice and the priestly office broached here plays out throughout the entire frieze.

Symmetry between the infancy narratives of the Virgin Mary and of her son was achieved through inclusion of readings from the apocryphal *Libellus* of the Virgin in Chartres, BM 162, at the very opening of the collection (see chapter 5). A similar strategy has been adopted by those who planned the narrative in the frieze section above the Isaiah pilaster. The opening scenes draw upon apocryphal texts to tell the story of Mary's conception and birth through events that parallel those in the in-

Top: Figure 11.5A. Joachim and Anna rejected, capital frieze, scene 1. Credit, de Feraudy.

Bottom: Figure 11.5B. Joachim's dream and the embrace, capital frieze, scenes 3, 4.
Credit, de Feraudy.

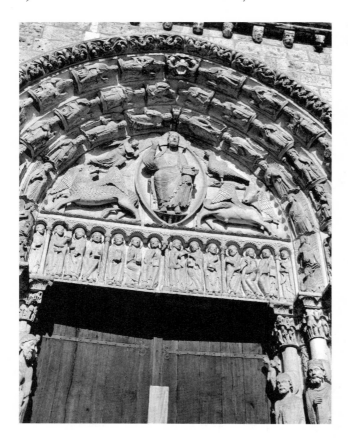

Figure 11.6. Christ in majesty, tympanum, RPC. Credit, de Feraudy.

fancy narrative of Christ. After the rejection scene, Joachim has an "annunciation" dream;[14] after receiving the announcement he returns to Anna and they embrace. This is shown at Chartres by the touching of hands, as Anna also places a hand on her breast as if to say, "Who, me?"[15] Knowledge of the identity of Mary's mother, Anna (Saint Anne), is emphasized in the *Libellus* as well (as in Fulbert's sermon *Approbate consuetudinis* and in Chartres, 162): "For the blessed and most glorious Mary, ever virgin, arose from royal stock, from the family of David, born in the city of Nazareth, and raised in the temple of God in Jerusalem" (*Libellus*, ed. Beyers, I.i, pp. 276–79). In this part of the frieze Mary's birth is represented by her bath, a visual counterpart to the baptism of Jesus on the other side of the façade. Both scenes demonstrate the centrality of the sacraments and their institution during the time represented in the frieze and of the parallel lives of Mary and Christ as prototypes of sacramental action: Mary as archetype of the church, and Jesus as the great high priest.[16]

The symmetry is further developed with the scene of Mary in the temple, a parallel to that of Jesus, who teaches there later in the narrative on the southern side of the frieze. In the *Protevangelium of James*, Anna and Joachim take her to the temple at age three, and the priest receives her joyfully: "And he placed her on the

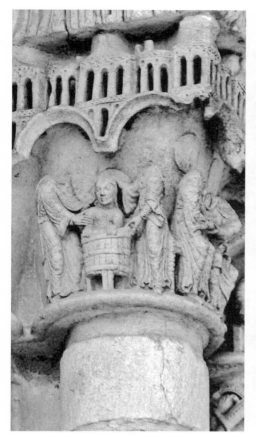

Left: Figure 11.7A. Mary's bath, capital frieze, scene 5. Credit, de Feraudy.

Right: Figure 11.7B. The baptism of Jesus (mutilated), capital frieze, scene 26a. Credit, de Feraudy.

third step of the altar, and the Lord God put grace upon her and she danced with her feet, and the whole house of Israel loved her" (7.3, trans. Elliott, p. 60). In the *Pseudo-Matthew* and the *Libellus* Mary climbs fifteen steps, corresponding to the fifteen gradual psalms, but the frieze iconographer apparently has in mind the older source.[17] This scene shows that the planners of the frieze did not simply follow the *Libellus*, although they privileged it in some aspects. They were rather students of the entire Marian tradition as found in the apocryphal texts, or they had knowledge of models, either textual or visual, not yet identified.[18] The *Libellus* is the apparent source for the next scene, that of the Virgin in the temple.[19] In this scene the priest tells all the virgins who have been living in the temple that they must now depart and be married. Three of the figures are smaller and seated (two virgins and Mary), and the fourth (the priest) is standing and in ornate robes. Mary explains that she cannot marry because she is consecrated to God, shown here by her pointing up-

Figure 11.8. *Right to left:* Mary on the temple steps; Mary telling the priest she is consecrated; Joseph with his rod, capital frieze, scenes 7–9. Credit, de Feraudy.

ward (Beyers, ed., *Libellus* VII 4–5, pp. 304–05). In the next scene Joseph is represented by his flowering rod, this too a reference to the *Libellus* VIII 1 (pp. 310–13). In an extensive note, Beyers provides bibliography for the interpretation of marriage within the context of Joseph's and Mary's relationship. None of the scenes of the Virgin's early life finds its counterpart in the surviving twelfth-century glass, but one can speculate that they may have been part of the original program before the fire of 1194, which must have destroyed many deluxe windows (see chapter 8).

The second pilaster encountered as one moves to the left (north) buttresses the seam between the central and the northern portal. It too forms an index of interpretation for the frieze above it. The frieze statuary extends here across a long plane, depicting the Annunciation, the Visitation, and the Nativity of Christ. The Nativity is characterized by the figure of Joseph seated nearby, holding the rod of the new lineage and resting a hand protectively upon the crib; the two midwives are present, making this resemble a small scene from a Christmas play and representing the birth as described in the *Protevangelium of James* and in *Pseudo-Matthew* (but not in the *Libellus*, which ends with the announcement of Christ's birth and has no midwives).[20] Three of the statues in the pilaster leading up to these interrelated scenes of Christ's infancy can be identified by their attributes.[21] On the bottom is the relatively flat statue of a prophet, lacking a recoverable identity. Next, moving upward, is a man with a staff, most likely Aaron; his presence invokes the flowering rod of Numbers 17, the text fused with that of Isaiah 11:1–2 and with apocryphal legends of the flowering rod of Joseph.[22] Above Aaron on the pilaster is another figure whose action in scripture was commonly taken to foreshadow the Virgin birth: Gideon, who wrings his dripping fleece into a jar.[23] Two unidentified writers

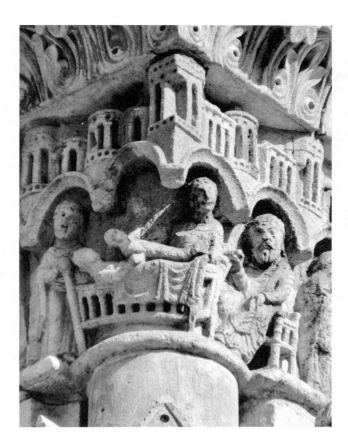

Figure 11.9. Nativity scene, capital frieze, scene 14. Credit, de Feraudy.

Figure 11.10. Gideon wrings his fleece, pilaster buttressing central and northern doors. Credit, de Feraudy.

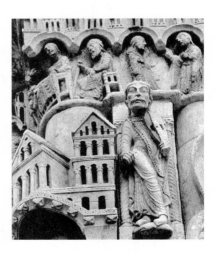

Figure 11.11. David fiddles before the new ark, top of pilaster buttressing central and northern doors. Credit, de Feraudy.

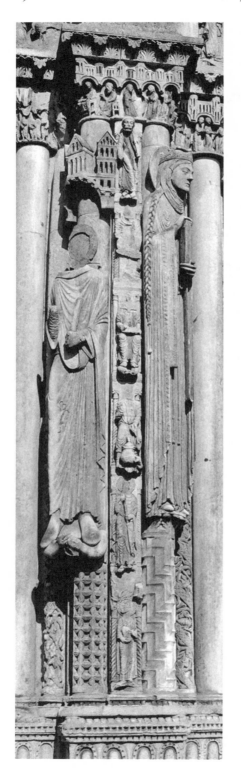

Figure 11.12. Pilaster between the northern and central doors, RP. Credit, de Feraudy.

of scripture do their work next, and then the wonderful topmost figure appears: David, about to put bow to fiddle as he plays with joy before the ark of the covenant and for the arrival of his offspring.[24] Here David the king welcomes the birth of the new king and heralds his dwelling place. A new tabernacle, the Virgin Mary, is the resting place for a visible God in the frieze just above.[25]

### THE NORTHERN DOOR

The interaction between the narrative of the frieze and the progression of statues in the pilasters below it continues in the northern portal as well. The artists and their patrons designed a way of glossing biblical stories of the apocrypha and New Testament through sculptural display; their innovations no doubt delighted their audiences as well as themselves. The next section of the frieze depicts scenes in a short play about Herod, but with numerous twists that underscore themes favored by the Chartrains.[26] In the first scene, Herod converses with the magi prior to their journey to greet the new king. One of the magi reaches a hand toward Herod's thigh, while the king points confidently to his scepter and, to the right, two of his counselors ponder. Viewers would have known from these gestures what text they were discussing, namely, the text featured by Fulbert of Chartres in his three Advent sermons: Genesis 49:10, "The scepter shall not be taken away from Juda, nor a ruler from his thigh, till he come that is to be sent, and he shall be the expectation of

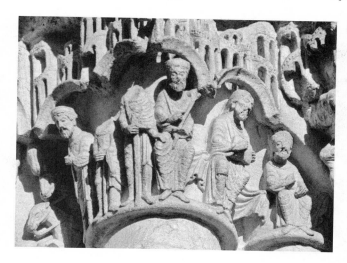

Figure 11.13. Herod pointing to his scepter as a magus points to Herod's thigh, capital frieze, scene 16b. Credit, de Feraudy.

nations."[27] Central to Fulbert's interpretation of this passage is the idea both that Herod was the last king to reign over Judah and that the end of his line signaled the coming of Christ. The parade of scepters held by the kings in the jamb statues also alludes to Genesis 49:10.[28] Herod's scepter is ironic too because of the prominence given to Joseph's rod, which signifies a new order of rule, one which will combine the scepter of kingship with the rod of the priesthood, as in the woven strands of Mary's dual lineage.

The next scene on the frieze is pushed up against the right side of the northern door. Just below it is the third pilaster on the northern side, buttressing the door on its right side. The upper statue of this pilaster has been identified by Heimann (91–92): the youthful appearance of the figure and the stone he holds show that this is Daniel the prophet, and the allusion is to Daniel 2:34. In this text the prophet explains to King Nabuchodonosor the meaning of a dream wherein a huge statue is destroyed by a stone hewn "without hands" from the mountain.[29] Like Herod, Nabuchodonosor is a king destined to fail. In later exegesis this stone is commonly associated with the cornerstone of Psalm 117 (118):22 — "The stone which the builders rejected; the same is become the head of the corner" — and interpreted as referring to Christ as the king to come.[30]

The designers and master sculptors of the Royal Portal have made the point visually and scored a reference to a favorite twelfth-century Chartrain depiction of the Virgin Mary as well. The eye moves from the statue of Daniel at the top of the pilaster, with the stone cradled on his knees, to the scene on the frieze directly above it, where Mary holds Jesus on her lap in the very *Sedes* position discussed above (see chapter 9) and reflected in Daniel's *Sedes* posture on the pilaster below. Just to the right, the three magi have come with gifts for the newborn king. Daniel holds the stone; just above him, Mary holds the Christ: the image from the past creates a visual parallel to the time of its fulfillment, and the viewer looks through time from

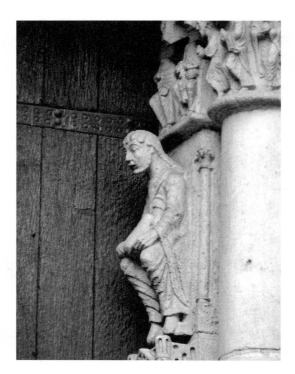

Figure 11.14. Daniel holds the stone below Mary holding Jesus, right pilaster RPN. Credit, de Feraudy.

one age to another, with the most important of all Marian images as the fulfillment and connection made through the liturgy for Mary's Nativity at Chartres. Through this strategy Jesus "becomes" the cornerstone, and the *Sedes sapientiae* posture found on the southern tympanum and in Belle Verrière is explored and explained. This is the kind of idea that preachers in the Middle Ages were used to offering to their audiences, as they explained how figures in the so-called Old Testament were types for realities found in the Gospels.

Of the six figures on the northernmost pilaster, to the far left of the door, only one can be identified with assurance: Moses is the third from the bottom, holding tablets of the law. Heimann suggests that he is located there because the flight into Egypt on the frieze above relates to his flight into Midian, the one foreshadowing the other; the Egyptian city of Sotinen is featured in a scene from the twelfth-century center lancet (see chapter 12). Heimann says that the topmost statue is Ezechiel, writing on his desk, because he was "the great prophet of exile . . . led from Palestine to Babylon in 597 BC" (92–93). Although her suggestions have not so far been accepted with confidence, the Chartrain liturgy bears them out: Rabanus's commentary on Matthew 1, the text intoned throughout the octave of Mary's Nativity at Chartres, offers quotations from Ezechiel before and after discussion of Daniel 2, creating a link between these very texts in the liturgy itself.[31]

The area of the frieze above offers the longest display in the entire zone: statues from the far left to the right, with the exception of the final departure into Egypt,

present the slaughter of the innocents in graphic and moving detail. At the center of this dramatic and gory episode sits the bloodthirsty protagonist of the entire complex, King Herod, cross-legged, one hand on his hip, holding his sword aloft in a gesture of defiant insolence.[32] The slaughter recalls the plays of Holy Innocents, December 28, creating yet another parallel between contemporary liturgical events and the action of the frieze.[33] The mourning women also create a powerful parallel to the women on the frieze who mourn at the tomb, but whose sorrow turns to Easter joy, in the last scene of the frieze, leading up to the southern portal and before the door itself intrudes (see below).

Contemporary events, especially the wanton cruelty of King Louis VII in his youthful arrogance, may have inspired one level of meaning of this display, executed at a time when he was about to make his own journey to the Holy Land in expiation for his slaughter of women and children within the territories of the Thibaudians. Saint Bernard's letter to the king recalls his actions in terms that would have evoked the biblical event: "From whom but the devil could this advice come under which you are acting, advice which causes burnings upon burnings, and slaughter upon slaughter, and the voice of the poor and the groans of captives and the blood of the slain to echo once more in the ears of the Father of orphans and the Judge of widows."[34]

### THE CENTRAL DOOR, MOVING TOWARD THE SOUTHERN DOOR

The pilasters on the southern side of the façade promote the parallelism alluded to in the analysis above. Standing again at the central portal and looking right, the first thing the viewer sees is the pilaster buttressing the central portal on its southern side. Above it is shown the hiding of Elizabeth and John the Baptist, who have escaped the slaughter of the innocents depicted on the northernmost section of the frieze. Angels predominate in this pilaster, and Heimann has identified the topmost statue as Michael the Archangel, slaying a dragon; in the third statue down, an angel tramples on a dragon. The presence of Elizabeth and John in hiding signals yet again that the designers of the frieze had access to an understanding—either visual or textual—of legends from the *Protevangelium of James*, as this is the source of the story of John and Elizabeth. The scene as found in the *Protevangelium* is a key to the overarching meaning of the narrative: it leads from the slaying of John's father, Zacharias, to the appointing of Simeon as priest, and also demonstrates the end of yet another line of succession, that of priesthood, an idea developed by Fulbert in his sermons on Genesis 49:10. The passage describing the hiding emphasizes angelic assistance to John and his mother, and this too is reflected in the pilaster: "But Elizabeth, when she heard that John was sought for, took him and went up into the hill-country. And she looked around to see where she could hide him, and there was no hiding place. And Elizabeth groaned aloud and said, 'O mountain of God, receive a mother with a child.' For Elizabeth could not ascend. And immedi-

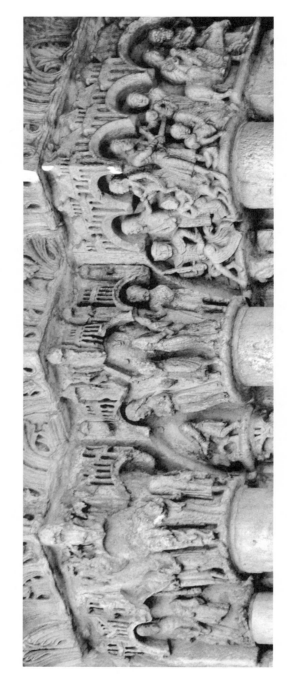

Figure 11.15. Innocents and flight to Egypt, capital frieze, scenes 19–20h. Credit, de Feraudy.

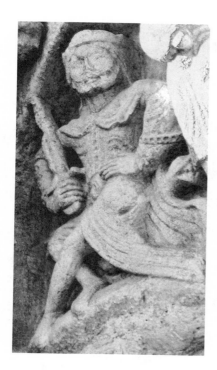

Figure 11.16. Herod defiant, corner
of the northern capital frieze,
scene 20b. Credit, de Feraudy.

Figure 11.18. Herod in the center lancet, panel 5.
Credit, de Feraudy.

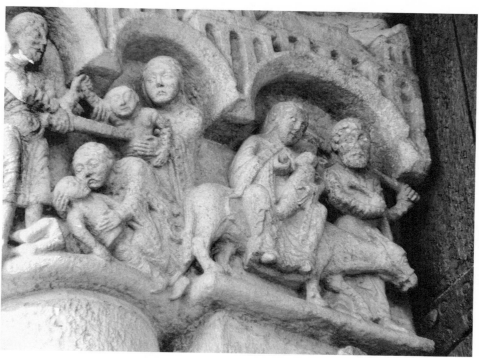

Figure 11.17. Women losing their children, northern capital frieze, scenes 20a–20h.
Credit, de Feraudy.

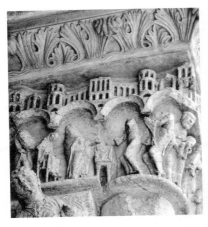

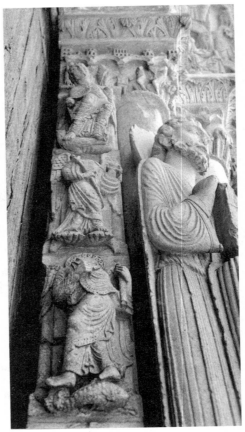

Top: Figure 11.19. Elizabeth and John
in hiding, capital frieze, scene 21.
Credit, de Feraudy.

Right: Figure 11.20. Angels on
the south-central pilaster. Credit,
de Feraudy.

ately the mountain was rent asunder and received her. And a light was shining for them; for an angel of the Lord was with them and protected them."[35]

This story recalls Revelation 12 and makes a link between John the Baptist and the archangel Michael. Here the woman of the Apocalypse is described in terms alluding to John and Elizabeth in hiding, as Michael the Archangel fights the devil on a cosmic plane of action: "And the woman fled into the wilderness, where she had a place prepared by God, that there they should feed her a thousand two hundred sixty days. And there was a great battle in heaven, Michael and his angels fought with the dragon, and the dragon fought and his angels" (Apoc 12:6–7). The story calls up the violent struggle on a grand scale that medieval Christians were encouraged to believe was taking place between good and evil throughout the lives of Mary, John, and Jesus, with the future of the world hanging in the balance. Every action was alive with decisions and events that affected the course of history, and the repeated allusions to devils and evil throughout the frieze make this point.[36] The struggle was met every year in the liturgy of the Roman rite, and the emphasis on the miraculous encouraged belief in its ongoing presence in contemporary life (see chapter 7).[37] The iconography of John's hiding is not as described in the *Prot-*

*evangelium*, where a mountain opens to receive him and his mother. Rather, John sits in a chair, and Elizabeth is about to put him under her cloak.[38] The protective power of cloth to hide would resonate with the great relic of Chartres, emblematic as it was of the flesh that hid the Divine.

If the three pilasters associated with the north portal and the northern part of the frieze seem concerned with kingship and the coming of a new king, and the two center pilasters are dominated by angels and prophecies and the coming of Mary, Jesus, and John—all of whom were heralded by angels in the Gospels and Apocrypha—then the southernmost pilasters and the frieze above them concentrate upon the end of the ancient priesthood and the coming of the priesthood of Christ, another theme emphasized by Bishop Fulbert in his Advent sermons. The subjects of the glazing program embody these three categories as well: kingship in the Styrps Jesse window; infancy and coming in the central lancet; and the new sacrifice in the Passion lancet on the south. The categories of statues found in the jambs are found in the frieze as well but expressed in a different visual mode. The relationship between the subjects of frieze and tympanum studied in the north side is rearranged here: on the north, the frieze scenes emphasize the Virgin Mary, and Christ is depicted in the northern tympanum; on the south side, the frieze scenes concern events in the life of Christ and his disciples, especially as related to seeing and knowing, and to scenes featured in the liturgy and liturgical dramas, while the tympanum and lintels of the southern door are dedicated to the Virgin Mary, especially in her role as the *Sedes sapientiae* (see chapter 9).

Coming up to the area between the central and southern doors is an experience unlike any other for viewers of the capital frieze. The frieze above depicts the Last Supper, the visual counterpart to the annunciation, visitation, and nativity on the comparable part of the frieze to the north: Mary gives her flesh to Christ on the left; on the right Christ offers his flesh at the archetypal communion meal.[39] The flesh created in Mary's womb, the bait on the hook set up to catch the devil, is offered in the model of sacerdotal action, Christ serving as both priest and victim. In this place in the frieze the chronological movement from left to right, as established in the right (or southern) half of the triple portal, is broken, and instead motion comes both from left to right and from right to left, with focus on the Last Supper as a result.[40] The viewer is to stop here and ponder the meaning of this scene, beginning with the exegesis of the pilaster below that leads the prophetic eye upward, and notice from the start the emphasis given to Judas, who appears to the left and to the right of the Last Supper as well as in the center of the scene itself.

On the pilaster just below the Last Supper, as Heimann noted, a priest from the ancient temple is sacrificing a red heifer, the *vacca rufa* of Numbers 19:1–5a:

And the Lord spoke to Moses and Aaron, saying: This is the observance of the victim, which the Lord hath ordained. Command the children of Israel, that they bring unto

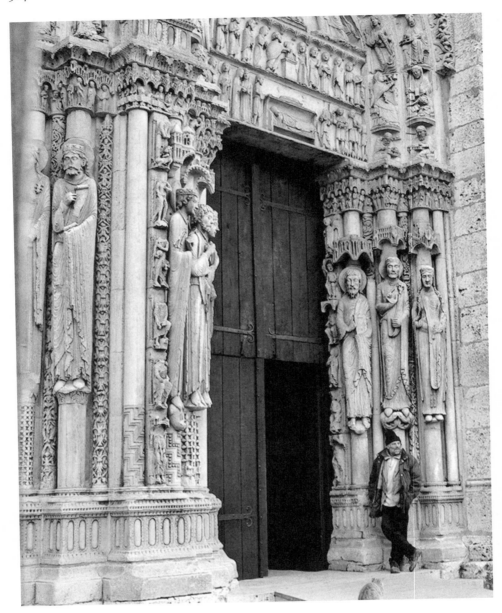

Figure 11.21. The southern door of the Royal Portal. Credit, de Feraudy.

thee a red cow of full age, in which there is no blemish, and which hath not carried the yoke: And you shall deliver her to Eleazar the priest, who shall bring her forth without the camp, and shall immolate her in the sight of all: and dipping his finger in her blood, shall sprinkle it over against the door of the tabernacle seven times, and shall burn her in the sight of all.

As the victim offered in the Christian reenactment is also without blemish and is killed "without the camp" and "in the sight of all," the use of the image in the pilas-

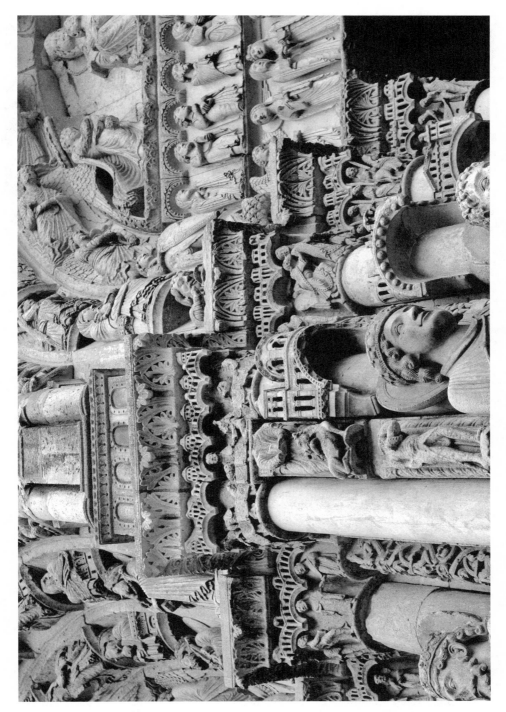

Figure 11.22. *Vacca rufa* (red heifer), just below the Last Supper on the capital frieze. Credit, de Feraudy.

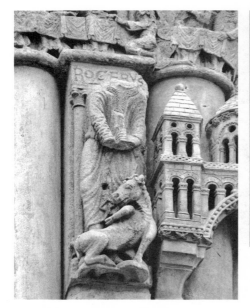

Figure 11.24. Last Supper in south lancet, panel 3, west façade. Credit, de Feraudy.

Figure 11.23. *Vacca rufa* (red heifer), detail. Credit, de Feraudy.

ter points to the crucifixion to come; the text also speaks of Christ the victim in language that evokes Mary as well, so often hailed as being without blemish.[41] In the Floreffe Bible (London, BL Add. 17738), the crucifixion is shown on a page above the sacrifice of the red heifer.[42] The parallels between the Last Supper scene in the south lancet and this one on the frieze are telling: the Last Supper in the lancet is just above the Transfiguration, where Jesus reveals himself to Peter, James, and John, and Moses and Elijah look on (Mark 9:2–8 and parallels). Knowing who Christ is through revelation and the breaking of the bread are placed in parallel here at a time when Peter the Venerable of Cluny, Henry of Blois's close friend, had instituted the feast of the Transfiguration.[43] To give the subject such prominence in the window suggests Henry's influence. Another provocative feature of the Last Supper in the glass is the presence of a figure to the far right who holds a chalice. Who is this beardless figure? and how much has the face been restored? Could it be the Virgin Mary, who shows up in the anointing scene as well, intruding her presence into the narrative in unexpected ways?[44] The face is, according to Perrot, a fifteenth-century restoration, so the state of the original cannot be told. But Mary is present in two other scenes as well in the glass, both the anointing of Christ's body (where John is also present) and in the "Noli tangere" along with Magdalene. The eleventh-century sermon *Fratres karissimi . . . natale gloriosae dominae*, which may be by Fulbert, emphasizes that Mary was beside Christ in every event of his life, passion, and death, a theme also of importance to Arnold of Bonneval (see Fulton, 2003, 425).

The statue below the sacrifice of the red heifer on the pilaster Heimann identifies

Figure 11.26. Virgin Mary at the Anointing, south lancet, panel 9, west façade. Credit, de Feraudy.

Figure 11.27. Virgin Mary with Magdalene and Jesus in the Garden, south lancet, panel 12, west façade. Credit, de Feraudy.

Figure 11.25. Virgin Mary (?) at the Last Supper, detail, south lancet, west façade. Credit, de Feraudy.

as Noah in a state of drunkenness, with his cloak thrown back. Noah appeared in this state just after making a covenant with God, and the vine he planted and the wine were said to spread like his seed throughout the world. This forms an oblique allusion to the text of the Magnificat, and so to Mary. Noah's wine is interpreted by Christian exegetes as referring to the wine of communion, and this explains his

Left: Figure 11.28. Noah in drunkenness, pilaster below Last Supper. Credit, de Feraudy.

Right: Figure 11.29. Man with host accosted by a devil, pilaster below Last Supper.
Credit, de Feraudy.

presence below the Last Supper.[45] The connection between the Last Supper and
the sacrament of the Eucharist is strengthened by the third figure on the pilaster,
counting downward. He holds the eucharistic host, while to his left a small devil
with a pouch and rake represents the vice of greed, trying to dissuade him.

Together these figures refer to Judas, who is dipping the sop in the Last Supper
on the frieze above (Luke 22:21: "But yet behold, the hand of him that betrayeth
me is with me on the table") and who made the wrong choice. Judas's action comes
from the devil who entered into him and provoked his greed for money, a greed
mirrored by the devil's own greed for the flesh of Christ.[46] This greed was part of the
idea that Christ on the cross is the bait that causes the devil to kill him and hence
be ensnared himself. This legend is elaborated within the liturgy of Chartres during
the octave of the feast of Mary's Nativity (see chapter 10), and the theme continues
in the frieze to either side of the buttressing pilaster depicting the Last Supper. On
the frieze, moving left toward the southern door, the Last Supper is followed by the
slicing of Malchus's ear, then by Judas's kiss of betrayal, and then by the triumphal
entry into Jerusalem.[47] On the northern, or left, side Christ is tempted: the devil's
head in Christ's temptation scene is carved and positioned like a corbel to make
the point that temptations are everywhere, especially in the walls and nooks of the
outsides of churches. A face similar to the tempting devil in the cathedral frieze is
found in a corbel on the west façade of the twelfth-century church of St. Andrew

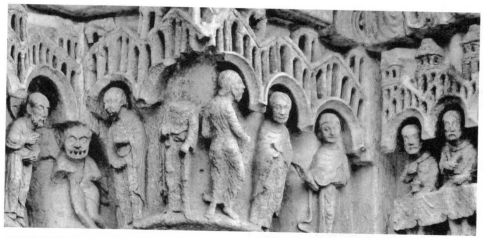

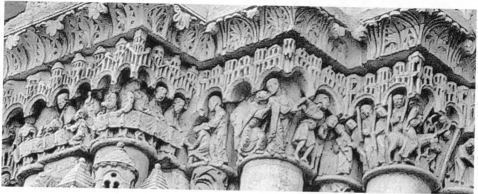

Top: Figure 11.30. Approaching the Last Supper from the north. Credit, de Feraudy.

Bottom: Figure 11.31. Coming toward the Last Supper from the south. Credit, de Feraudy.

in Chartres. Then Judas is tempted, and he gives in, accepting the payment for his betrayal.[48] To the right, or southern, side of the frieze Judas appears in his most dramatic pose, giving the kiss, as Christ looks back at him sorrowfully. Judas's body has become dramatically lithe in its representation, especially in the kiss of betrayal, showing that the serpentine power of the devil has entered his musculature.[49] Like adventus itself, the scene asks about Judas and Satan and about the viewer's own life of choices. One can imagine the dramatic materials such visuals would have provided to local preachers in the mid-twelfth century.

### THE SOUTHERN DOOR

The overriding theme of sacraments and the priestly vocation modeled by Christ continues in the frieze to the far right, where the scene in the frieze unfolds above the pilaster buttressing the southern door to the left. The entombment scene creates a powerful parallel with the Last Supper and serves to deepen the emphasis on the

Top: Figure 11.32. Corbel from the west façade, St. Andrew, Chartres. Credit, de Feraudy.

Middle: Figure 11.33. Judas giving the kiss of betrayal, capital frieze, south, scenes 32a and b. Credit, de Feraudy.

Bottom: Figure 11.34. Kiss of Judas, south lancet, panel 5, west façade. Credit, de Feraudy.

theme of priesthood and Christ's presence as presider and as victim. Here a flask, now broken off, demonstrates the anointing of the body taking place before the burial.[50] Fulbert's argument about the beginning of the Christian priesthood is structured around the importance of a new anointing. The emphasis on Christ's being "the anointed" (the meaning of his name) is also carried through by the lamp, which symbolizes an anointed person and is often found near him.[51] The dramatic scene of the three Marys at the sepulcher, and the display of the empty burial cloth, abuts the door, and above the empty burial cloth pointed to by the attending angel hangs the representative lamp. The anointing scene found in the south lancet has another telling feature: the table on which Jesus' body is laid is supported by four golden pillars (most of the right-most pillar is twelfth century, showing that gold was the original color). These refer to the Holy of Holies and form an iconographic parallel to those supporting the *Sedes sapientiae* of Belle Verrière: Christ is located upon the table of a new Holy of Holies (see chapter 9). A lamp is prominent in the scene with

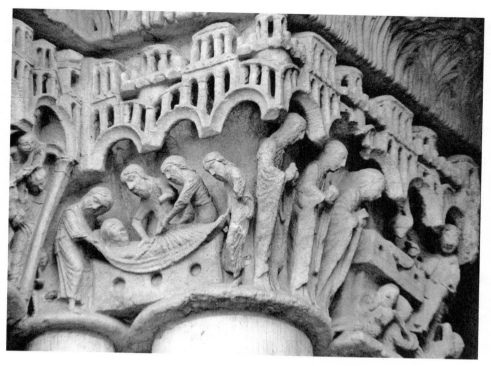

Figure 11.35. Anointing of the body, capital frieze, scene 34. Credit, de Feraudy.

the three Marys and the angel, as it is, with two accompanying lamps, in the comparable scene in the south lancet.

The pilaster supporting the scene of the empty tomb continues the theme of resurrection as revealed through typology. This was the first pilaster Heimann discussed (89), and this is because she found at the top "an easily decipherable group," one that relates obviously to the three Marys on the frieze above. An angel transports a soul to heaven while trampling a demon, while another angel rushes to attack below. Thus the pilaster recalls to its viewers the Harrowing of Hell, that most dramatic of Christian scenes, one commemorated liturgically on the night before Easter morning.[52] At Chartres Cathedral the idea of descent was reenacted as traditional themes of baptism were being proclaimed: just before the dramatic proclamation of the first Easter texts and the ringing of the bells, there was a procession to the crypt, a blessing of the fonts, and a naming of all the saints associated with them; it is especially noted that the break for the procession took place in that part of the litany devoted to the Virgin Mary (see OC 111–12). Descent and subsequent triumph are also represented on the pilaster just below the trampling angel. Here sits the prophet Jeremiah, the only one whose identifying tag survives. Heimann says he is there because he was cast into a dungeon, from which he was brought out alive after the space of several days, as told in chapter 38 of his prophetic book. But the reference is also to Lamentations 3:53, "My life is fallen into the pit, and they

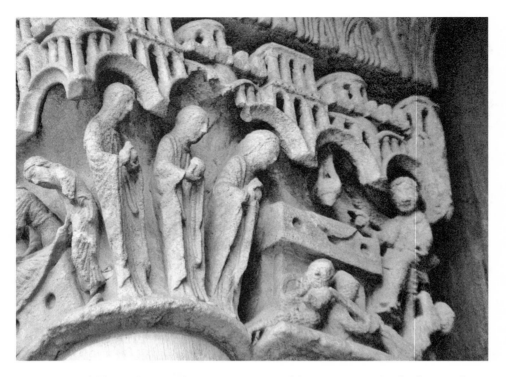

Figure 11.36. Three Marys on Easter morning, capital frieze, scene 35. Credit, de Feraudy.

have laid a stone over me," a text that refers directly to the burial of Christ and the resurrection scene above and to the many Easter texts that mention the stone that was rolled away.[53]

The eighth and final pilaster buttresses the right seams of the south portal. The frieze above it reveals the many ways in which Jesus prepared the disciples to perform the work of a newly established priesthood, and it appears at first examination to be confused, operating as it does outside a strict chronological progression. But the liturgy at Chartres suggests an important clue concerning the way history is depicted here: the themes are ordered in the way that Peter expressed Christ's actions to the disciples. The elaborate instructions for the Easter week liturgy indicate that the same texts were read at Mass every day throughout the week, and they were "Aperiens Petrus" from Acts 10 as the Epistle and "Duo ex discipulis" as the Gospel.[54] In Acts 10, beginning with verse 34, Peter, "opening his mouth," says that now the disciples can understand the meaning of Jesus' life on earth, beginning with his baptism. As Peter remembers, he emphasizes the times Jesus appeared to them and ate and drank with them:

> And Peter opening his mouth, said: In very deed I perceive, that God is not a respecter of persons. But in every nation, he that feareth him, and worketh justice, is acceptable to him. God sent the word to the children of Israel, preaching peace by

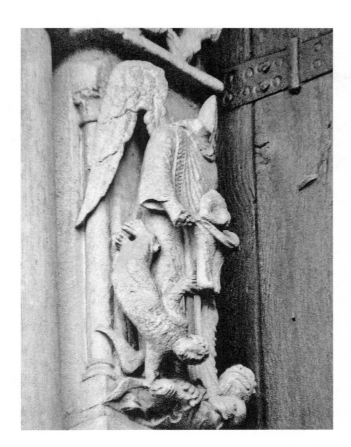

Figure 11.37. Angels with souls, top of pilaster below the three Marys. Credit, de Feraudy.

Figure 11.38. The prophet Jeremiah, pilaster below the three Marys. Credit, de Feraudy.

Figure 11.39. Christ washes Peter's foot, capital frieze, scene 36a. Credit, de Feraudy.

Jesus Christ . . . it began from Galilee, after the baptism . . . and we are witnesses of all things that he did . . . Him God raised up the third day, and gave him to be made manifest, not to all the people, but to witnesses preordained by God, even to us, who did eat and drink with him after he arose again from the dead; and he commanded us to preach to the people, and to testify that it is he who was appointed by God, to be judge of the living and the dead (Acts 10:34–42).

The Gospel text read repeatedly in the Easter octave is the story of the two disciples on the journey to Emmaus, also referred to in Acts 10; they encounter Christ on the road, eat with him, and recognize him in the breaking of the bread. Just as they see him for who he is, he disappears; the scene is a foreshadowing of the Ascension itself.[55] The scenes in the frieze have been identified by Heimann: an emphasis on the sacraments of Baptism and Eucharist can be seen in Peter's recollection of what Jesus did for the disciples, and what he now understands it to mean. First, and nearest the door, is a footwashing scene; the tub for washing is shaped like a font, and the leg held is Peter's; in the south lancet, by contrast, the foot-washing scene takes place in the midst of the disciples and is adjacent to the Last Supper scene. The next major scene in the frieze is of the meal at Emmaus. Positioning the foot washing before this meal makes the point that now Christ can be recognized in the breaking of the bread. Attention to Peter continues with a flashback to his denial of Christ in the scene with the maid servant (Matthew 26) that followed the Last Supper and the visit to Gethsemani. Jesus had asked the disciples to tarry with him, but they fell asleep. This too is connected to the meal at Emmaus, for the two disciples asked Jesus to stay with them as it was "towards evening"; these are the words of the antiphon sung at Chartres on Easter Monday when the event was commemorated liturgically throughout the entire day, and not just with readings, as during the rest of the week. The depiction of events in time is conditioned by liturgical modes of presentation and commemoration, and these drive the shape and substance of the frieze narrative at this point, heavy as it is with sacramental theology.[56] The actions remembered by Peter place Emmaus in the context of the Last Supper, to which

Figure 11.40. The meal at Emmaus, capital frieze, scene 38. Credit, de Feraudy.

so much attention was given earlier in the frieze. Peter denied then; now he recalls and understands.

The imagery in the frieze alludes to Baptism and Eucharist, with an emphasis on water and feeding, and to the conversation with Peter, in which Christ tells him to "feed my sheep." The topmost statue of the pilaster below the frieze refers to the purpose of the new priesthood. Because the figure holds a jar, Heimann says he is Raphael the Archangel, whose name means "God heals" (93). His presence here represents the power of healing referred to in the book of Tobias and recalls the restorative powers of Christ the high priest, transferred by him to those who serve the church: "And because thou wast acceptable to God, it was necessary that temptation should prove thee. And now the Lord hath sent me to heal thee, and to deliver Sara thy son's wife from the devil. For I am the angel Raphael, one of the seven, who stand before the Lord" (Tob 12:13–15). The frieze ends its long narrative with the newly commissioned priests about to begin their work and holding their staves. Staves—the priestly counterpart to the scepters and swords featured in the iconography of kings—are the predecessors of bishops' croziers, symbols of the high priest and pastor. The various interactions between Christ and Peter pictured here in the scenes surrounding Emmaus also point to the idea of founding and building the church. Such imagery was important at Chartres, where the bishop at the time the work was designed, Geoffrey of Lèves, was a papal legate, and where

Figure 11.41. Raphael holds a jar, pilaster below the footwashing. Credit, de Feraudy.

the coming and going of high-ranking men of the church was common. Chartres had a long tradition of celebrating the clerical orders and of welcoming all the priests of the region for synods of instruction. Bishop Ivo of Chartres wrote some of his most important sermons for those occasions, and the liturgical importance of the event is made clear from prayers for the occasion at the beginning of the twelfth-century Chartrain pontifical Orleans, Ms. 144.[57] The ways the sacraments and the priestly order are commemorated in the frieze is consonant with Ivo's sermons and their emphases (see chapter 6).

## THE SENSE OF TIME IN THE FRIEZE

The frieze, designed and constructed with extraordinary care, and the only part of the entire sculptural program of the façade in which every scene can be securely identified, is the key to the program of the façade as a whole. All that is below the frieze tends toward it and foreshadows its vivid action; all that is above is related to it and defined by it. The "reality" represented in the frieze was surely replicated by contemporary dramatic action in processions, in all their details, in commemorative feasts and festivals and in the actual plays that doubtless took place in the church and around its portals.[58] Spaces outside churches became the setting for liturgical drama in the twelfth century, drawing texts and music out to the portals, where there may have been interaction between drama, music, and sculptural programs.[59] Some scholars have demonstrated various kinds of mutual dependence throughout a broad geographical range.[60]

The frieze at Chartres depicts history but does so in a way that calls contemporary viewers to join in the action it portrays through their own mimesis and to use action as an exercise in corporate remembering. Unlike many other depictions of Christ's life on earth, the frieze adds a full complement of scenes from the life of the Virgin Mary, and these relate to the lives of both clergy and laity as well as to the Book of the Cult, Chartres, 162, and the sermons of Fulbert. The Virgin anticipates both the future of the church, through her dedication to temple ritual, and incidents in the life of Christ, through the actions of her parents and herself. In an article on the frieze at Chartres, Kathleen Nolan considers what it means that so many of the scenes on the frieze find counterparts in the liturgy and sacred drama

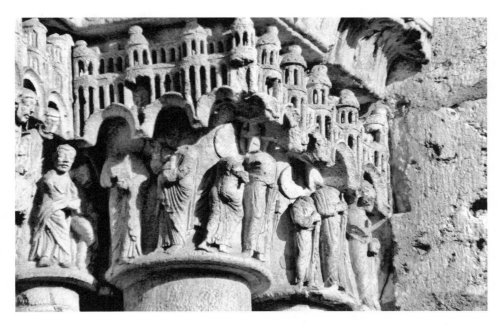

Figure 11.42. The Apostles set off, capital frieze, scene 42. Credit, de Feraudy.

from the period. In the same way that the frieze bridges the gap between the upper and lower zones of the façade, so too, Nolan believes, did the actions it portrays create a space in which both clerical and lay components of the audience could find meanings: "Lay and clerical viewers also shared an awareness of the many processions of the liturgical year, which parallel the narrative in the capital frieze in their evocation of sacred sites and events. The processions that made their way through the entire town were a highly visible aspect of the liturgy in which the general population occasionally took part. While the processions were probably understood most fully by the literate canons who regularly participated in them, even the lay public must have had a grasp of their function as symbolic pilgrimage and reenactment of sacred events" (1994, 65). Nolan mentions the sense of motion that pervades the frieze. The work of Laura Spitzer (1994) (and also Rachel Dressler, 1992) complements what Nolan says in several ways through emphasis upon the way the Virgin and other female figures appear in the frieze. Spitzer suggests that the actions and interactions of several figures reflect a variety of movements and deeply felt emotions and demonstrate relationships as well, especially as related to marriage and parenting. The work of these scholars helps us appreciate the ways in which the narrative of the frieze was deliberately enlivened by those who designed it in hopes of inspiring those milling and marching below to make histories in synchronization with those of first-century characters who lived in the time of "realities." As shown in the life of Bernard of Tiron (see chapter 8), supposed real time was the time described in the lives of the Virgin, of John, and of Jesus. The past tended toward it;

the present looks back upon it. The events of the Christian Gospel condition time through liturgical action and the visual arts.

The frieze depicts that period of time in which Mary, John, and Jesus walked the earth, and every hour mattered in ways it had not before and would not again. The frieze called Christians to recapture these intense years by journeying to the Holy Land, in actual pilgrimage or within the liturgy, and to reenter that special temporal space, the space from which the meaning of the contemporary age was thought to have evolved. The varied action beneath the frieze, accompanied by the many liturgical texts and chants upon which it was based, provided its counterpart in time. Through art designed to enframe liturgical action, each generation was encouraged to make history within liturgy and ceremony, using the frieze as its guide to what was important in the recreation of the past, especially as reflected in the sacraments of the church and in the cult of the Virgin Mary.

A close look at details of the frieze suggests that the three horizontal zones of the west façade—jambs and accompanying pilasters (zone 1), frieze and lintels (zone 2), and tympana and archivolts (zone 3)—are loosely organized into times of appearances and times of realities; the theme of seeing and believing, so crucial to the art designed at Chartres in the mid-twelfth century, drives this understanding of past, present, and future and its modes of representation.[61] The past before the coming of Mary, John the Baptist, and Christ—the culmination of the lineage depicted in the jambs—is filled with enigmas, all of which operated on two levels: first, events and people who existed in a far distant past that can be known and is worthy of study; second, and more important to Christian exegetes of the period, these events and people embodied understandings of a later time as well, the time of realities. Reality is brief in this view of history, although at Chartres, with its Book of the Cult, a bit longer than in contemporary understanding elsewhere: it is the time of the New Testament, but reckoned from the apocryphal narratives of the infancy of Mary, John, and Jesus to the acts of the apostles and the presaging information found in the Apocalypse, believed to have been written by John the Evangelist, the Virgin's surrogate son. Particular moments thick with meaning are selected from the real time depicted on the frieze and displayed on the lintels of each of the three doors making up the portal as a whole.

After the initial time of realities, when the Virgin, John the Baptist, Jesus, and the disciples were alive, a future beckons, offering a second reality, one that will stand outside time and will roll up the construct like a scroll. Thus time after the events of the lives of Mary and Jesus constitutes yet another long and difficult period of waiting, before God will be seen once again face to face, as he was by those who lived in New Testament time. During this second period of waiting the prophets of the here and now—preachers and teachers and saints of all types—play an essential role, much as the prophets did in Old Testament time. These zones of time,

encountered in my discussion of Advent (see chapter 3), grow out of contemporary and regional views of history, as seen in Geoffrey's life of Bernard of Tiron.

Medieval Christians looked back to the realities of the New Testament in their ritual reenactments of time, from the central sacraments of Baptism and Eucharist to the many sacramental displays found in processions within and without the church on feast days throughout the year. Recollecting was believed to occur with the grace provided through these actions, and the act of recreating time offered solace to those who waited, putting them in touch with the intensely lived moments of New Testament time and interpreting their meaning for the present age. The view of time depicted on the west portal of Chartres Cathedral is not a static view. Rather the art is deliberately shaped to allow believers to interact with the depiction of history and to be enlivened by its revelations as the audience's actions complement meanings. The people who process through the door, who stop, who wonder, who look and learn, form the fourth zone of time, the zone of the ever-changing present.

Commentary on the act of seeing emerges as central to the artworks themselves (see chapter 10). Here, too, the ability of people to complete the lineage of Mary, John, and Christ through entrance into the church building explains the design of the jamb statues crowding around the doors. Three horizontal "time zones" running across the entire façade complement the vertical zones created by each door within the whole portal and contextualize the fourth zone of present understanding as anticipated in the twelfth and thirteenth centuries. Mary, as would be expected in this particular church, is instrumental in the shaping of each zone and each door in the portal and in the interrelationships between the doors, especially as determined by the capital frieze. The jamb statues and their counterparts in the pilasters are for the most part frozen witnesses to time past, with the action-packed narrative of the frieze serving as a deliberate foil for their outward, expressionless gaze. In the lower zone Mary's lineage is presented, especially as described in sermons read on the feast of her Nativity and in chants sung on that day; the pilasters lead directly to the frieze with themes foreshadowing Mary, John the Baptist, and Jesus and the founding of the church. The frieze offers an impressive solution to the problem of detailed narrative wrestled with by portal designers throughout the early decades of the century.[62] The people in the fourth zone mingle with Mary's lineage as they are called to be part of the action in the frieze through contemplation and moral betterment and through understanding of the sacraments.

Through such a design, many scenes can be displayed in ways that allow the eye to follow a modified chronological flow, while the context allows for other layers of historical time to operate as well, proclaiming Fulbert's division of the ancestors of Christ into the royal, the prophetic, and the priestly. To the north, King Herod's wicked actions are countermanded by the Virgin birth and the flight to Egypt; in

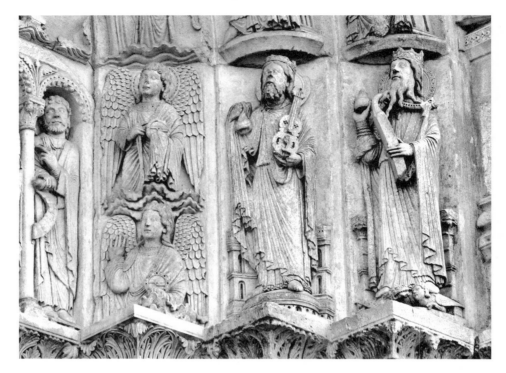

Figure 11.43. Elders of the Apocalypse in the central archivolts. Credit, de Feraudy.

the center, the prophet John the Baptist survives the slaughter and lives long enough to announce who Christ is and to be present at the miracle of baptism; to the south, the frieze concentrates upon symbols relating to the sacrament of Eucharist and to the early formation of the bishops and clerics who will save souls through the healing power of sacramental action, a theme favored in the preaching of Bishop Ivo of Chartres and represented in the lintels and tympanum of the south door as well.

The capital frieze of Chartres Cathedral and the zones above and below it are not only depictions of time. They also suggest how to learn about the past, and they demonstrate that visualization and modes of looking at, through, and into history are what the program of the west façade at Chartres is actually about. Bishop Geoffrey of Lèves's actions and the writings he supported were central to the history making carried out in mid-twelfth-century Chartres; these ideals were apparently brought forward during the tenures of his immediate successors and are consequently reflected in the twelfth-century glazing program that, like the sculpted portal, was a major feature of the campaign supported by dignitaries of the cathedral and the bishops of the midcentury. It seems the glass (varied though it is) was generally later than the portal sculpture, although secure dating is not available; it is also possible that some or all of it was moved to present locations in the thirteenth century, and so it does not necessarily follow that all three lancets postdate the capital frieze. Bishops Goslen (Geoffrey's nephew) and Robert (once Geoffrey's chaplain and his

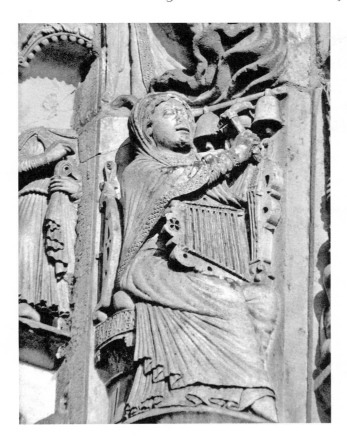

Figure 11.44. Lady Musica in the southern archivolt, RPS. Credit, de Feraudy.

dean) would doubtless have been involved in the initial planning and were capable of promoting a sense of unity between the outside and the inside aspects of the campaign (see chapter 8).

The sculptural program makes history by inviting the believing viewer to know and be transformed; to become capable of prophetic understanding. It greets the viewer with icons that sound, filled as it is with the elders of the apocalypse; holding their jars of oil and their instruments in the central archivolts, as well as with angels arrayed in many guises. This was especially important for the musical sense of those vigorous singers of the northern upper lintel and of Lady Musica herself, energetically striking bells and holding three stringed instruments in the southern archivolt. This art functions between massive bell towers and was part of a campaign to build them (and surely to cast their bells) and to endow choristers. Bells pealed and Te Deums rang out when miracles occurred (see chapter 8). The singing and playing Lady Musica and her counterparts in the archivolts of the central tympanum, as well as the angels found throughout, are mindful of the role the miraculous played in Chartrain history during the mid-twelfth century and also of the role of the Virgin in the central Christian miracle. Mary and the miraculous are signified by sound as well as by sight: to behold instruments and singers evokes the

miracle of incarnation and birth celebrated by the fiddling David on the northern pilaster and suggests miracles that had happened both recently and long ago, while anticipating miracles to come. When Mary inspired the miraculous as described in the numerous legends of the times, or as coming into persons who were touched and transformed, music played in heaven and on earth; and the statues and glass of the west façade shuddered to the sounds of the bells.[63]

# History Retold

## From the West Lancets to the Afterlife of the Cult

I am the alpha and omega, the earliest and the most recent,
The beginning and the end, I who live before the beginning of the world
And for ages of ages in eternity.

—*From the processional antiphon "Ego sum alpha"*

It is difficult to believe that the master plans underlying medieval art and architecture, when or if they existed at all, can still be discerned, especially given the fragmentary and chronologically layered nature of most surviving artistic programs.[1] Expectations are low rather than high for artistic integration, but when schematic themes emerge, accepting them is no less problematic than ignoring them. Every church will present a unique situation depending on how much can be known about the liturgy and the persons and politics involved and on how much of the art survives and in what condition. In surviving twelfth-century art from Chartres Cathedral there are many examples of continuity and of discontinuity side by side: although the same group of administrators was in charge of the cathedral for almost fifty years, all twelfth-century art that survives was deliberately preserved after the fire of 1194, and some of it surely was rearranged to suit the desires of later builders. It should not be surprising, then, that a group of favored themes seems to predominate and that there were strategies emphasizing particular modes of seeing, but also that some layers of the work cohere whereas others apparently do not. The relationships between the frieze and the pilasters are the most tightly drawn, for example. The numbers and purposes of the jambs, too, are reflective of identifiable liturgical texts, whereas many details have been lost, as is the case with Notre Dame de la Belle Verrière. Discerning ideas behind the tympana, lintels, and archivolts, in contrast, is problematic, at least in some aspects of the work. Although the ways thematic and artistic strategies found at Chartres were developed under the influence of St. Denis and then, in turn, influenced other churches later in the twelfth

century have been much studied (see chapter 10, note 61),[2] the sculpture of the west façade as a thematic model both for the lancet windows and for developments in the thirteenth century remains underexplored.[3]

Earlier I placed Notre Dame de la Belle Verrière both in the context of liturgical understanding and in the framework of thirteenth-century glass (see chapter 9). Even more contextual work can be begun with the west façade. Comparing the sculpture of the west façade to the program of stained glass in the three lancet windows offers a unique opportunity to study iconographic themes and strategic ways of displaying time and history in two different media from approximately the same time period, in the same church building, both dependent upon the same conservative liturgical practice. This chapter deals with the ways in which ideas treated in chapters 10 and 11 had various afterlives, from their immediate reinterpretation in the lancet windows, to themes developed in the thirteenth-century liturgy, to the long history of the cult of the Virgin of Chartres in the late medieval and early modern period. Any of these topics could occupy a book of its own, and the present discussion merely offers some summarizing suggestions that may be helpful to other scholars as well as to those thousands who come to Chartres every month to ponder its mysteries.

## THE LANCET WINDOWS: AN OVERVIEW OF MAJOR THEMES

A summary of the meaning of the sculptural program of the west façade is found in the three lancet windows, often dated between 1145 and 1155.[4] The windows offer a contemporary reinterpretation of the sculptural program; the parallelism and symmetries characterizing the narrative outside continue on the inside. Out of doors, the central tympanum portrays Christ in majesty, reigning over the entirety, its themes and artistic strategies radiating outward from the center. Inside, on the verso of the page, so to speak, Mary is seated at the top of the central window, with Christ on her lap, overseeing the whole of her lineage, from Jesse's root to the Cross and Resurrection of the flesh she offered to her Son (see plate 10).[5] The positioning of the artworks makes the two adults enthroned "together," one on the front, one on the back, but only within the viewers' memories, as they walk from one side to the other. The juxtapositions from back to front and back again could take a lifetime of study and contemplation, providing both pilgrims and local people plentiful opportunities to think about history and the meanings of events and people in various modes of understanding and representation. Strategies that called upon the memories of audience members must have been typical of the twelfth century, but very little art survives in situ and with parallel themes expressed in multiple media from the same era.

The ensemble bears the marks of heavy restoration: much of the painting is modern; the south lancet has no border and is cut off at the top; the styles of the win-

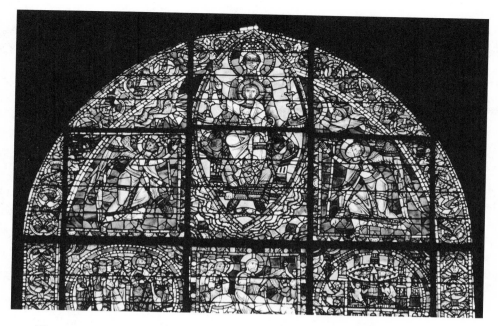

Figure 12.1. Mary and Jesus at the top of the central lancet, panels 29, 30, west façade.
Credit, de Feraudy.

dows are not precisely identical, and this suggests slightly different dates for each of them.[6] Enough remains to indicate the original program of each window, although it cannot be said for sure where these surviving works were originally located in what was a twelfth-century addition to an eleventh-century church. Many of the themes and ideas transferred from outside to inside appear in different guises and yet show a jagged consistency in purpose, altered as well by the change in medium. There is, however, no discernable strategy adopted for the glass that teaches in the profound ways found in the pilasters and accompanying frieze. The original modes of display for the numerous windows commissioned in the twelfth century (see chapter 8) are not known, and what survives belonged to a lavish and undoubtedly complex glazing campaign. The original intentions and modes of display, which perhaps included a viewing gallery, may well have once offered a sophistication of ideas comparable to that discernable in the portal sculpture, especially as seen in the increasingly rounded pilasters and their relationships to the frieze.

The window to the right is an embodiment of the sermon *Approbate consue-tudinis* and of the three responsories attributed to Bishop Fulbert, especially of the most famous of these, "Styrps Jesse" (see plate 11).[7] The window is a celebration of the feast of Mary's Nativity as championed by Bishop Fulbert of Chartres and so proclaims the local connection with the Virgin Mary, promoting many associations with her relic and its historic meaning as well as with Fulbert as builder of the cathedral. That this work survived the fire of 1194 and was then saved by the builders

Figure 12.2. Jesse, bottom of the north lancet, panel 2, west façade. Credit, de Feraudy.

of the new cathedral set the tone for the future and for Fulbert's role in the history of the cathedral building.[8]

The rod of Mary's lineage rises from Jesse's body and makes the flower that is Christ, who is crowned by the seven gifts of the Holy Spirit as in the text from Isaiah (11:1–3).[9] The parallels between the nativity scenes of the southern lintel and frieze and the Jesse "nativity" at the bottom of the northern lancet find restatement in the nativity scene of the central window. Visual strategies employed here depend upon viewers whose memories operated within a framework of liturgical knowing and action, but, as mentioned above, with the sculptural program in mind as well. The two depictions of the nativity of Christ, in the southern lintel and on the frieze, for example, are restated in the glass but with allusion to the figure of Jesse at the bottom of the northern lancet window and to Joseph's dream in the center lancet. The lancets themselves are self-referential. The three scenes in the windows each depict reclining figures, in the case of Jesse and Joseph, both resting on the right side, facing outward, and in the case of Jesse and Mary with progeny arrayed above. Jesse is in the posture of Mary, yet he resembles Joseph too. The theological point, central to the feast of Mary's Nativity is made: the Virgin is of the house of David, as was her husband Joseph.[10]

The qualities of action in the lancet windows relate as well to the sculptural program of the west façade. The right, or northern, window is the thematic companion to the jamb statues and depicts the regal, prophetic, and priestly nature of Christ in a different medium, translating ideas in a host of engaging ways (see chapter

Top: Figure 12.3. The Nativity, center lancet, panel 3, west façade. Credit, de Feraudy.

Bottom: Figure 12.4. Joseph's dream, center lancet, panel 18, west façade. Credit, de Feraudy.

10). Jesse, the father of David the king, lies with the rod of his lineage sprouting from his loins.[11] The sermons of Bishop Fulbert and Rabanus Maurus teach how to read this bottom image, which may reflect the composition of the twelfth-century original: the tree of Mary's lineage has two parallel shafts, one of priesthood and one of kingship. The lamp to Jesse's left is symbolic of the priesthood; the billowing curtain to the right recalls the Nativity scene on the southern lintel. It is also the veil that the Virgin Mary was chosen to weave as a consecrated virgin, which was purple for the kingship. The prophetic heritage emphasized so strongly by Fulbert is depicted to either side of the "tree" as the prophets, all of whom are named, gaze upon the mysteries they foretold.[12] (These colors may or may not represent the original understanding of the scene.) Yet another way has been found to represent the triple lineage of priesthood, kingship, and prophecy, central to Fulbert's sermons (especially *Approbate consuetudinis*) and to the sculptural program of the Royal Portal. This triple understanding related as well to the Virgin's flesh and to the relic of Chartres.

The number symbolism from Rabanus Maurus's commentary on Matthew 1, the text read throughout the octave of Mary's Nativity and embodied in the organization of the jamb statues (see chapter 10), is also embodied in the Styrps Jesse window, making it, like the array of the triple portal, a study in number symbolism through generic figures representing Mary's lineage. According to Matthew 1, the ancestors of Christ were forty-two in number. There are six groups of seven in the window: seven prophets; seven flowers representing the priesthood; seven figures from Jesse to Christ representing kingship; seven more flowers, representative of kingship; another group of seven prophets; and finally the seven gifts of the Spirit crowning Christ.[13] The vibrant colors of the glass were surely matched at one time by the painted robes and jeweled ornaments of the sculptural program, but those can no longer be compared for correspondences. The prophets who gaze onto the stem of the tree are the counterparts of the figures in the pilasters, but usually without their attributes and nuances.[14] The generic aspect of the prophets demonstrates the problems with identification found in the jambs statues as well: the letters are very hard to read, and the traditional subscriptions in the scholarship are in some cases wrong or the scrolls have been repainted since Andrew Watson did his groundbreaking work on this iconographical theme. There seems to be, for example, a problem with the labeling of the second and third lower left-hand prophets. In Watson, in Johnson, and even in Alison Stones's stunning electronic compendium of art at Chartres, the second prophet up is called Samuel and the third up Ezechiel; but clearly the second up is named Ezechiel and the third up Samuel according to the scrolls as photographed in 2005. Most scrolls are difficult to read, and the degree to which they are restored or repainted or both varies. In any case, if the prophet to the left of Mary is Isaiah and the one to her right is Daniel, as appears to be the case, they have been chosen to make parallels with the exegetical themes found in

Figure 12.5. Mary holding the flowers of kingship and priesthood, north lancet, panel 17.
Credit, de Feraudy.

the pilasters of the Royal Portal. It is wonderful that Daniel has a young, beardless face, true to his usual iconographic representation (although this is a late medieval restoration) (see fig. 12.5 and plate 12).

The panes of the center window pick up where the Jesse tree leaves off, moving from a representation of lineage to Gospel action: the Incarnation, Visitation, and Nativity of Christ and related narratives associated with life in the Holy Land. Here, as in the capital frieze, the events are revealed in lively action and filled with references to processions and dramas of reenactment. In the portal, the jambs of lineage were related to the frieze by the exegetical arrows of the pilasters. In the triple lancets, the postures of bodies make these connections, as do the ways in which the twisting vines and flowers of Jesse's loins grow into the wood of the cross in the southern lancet. The same grammar of liveliness found in the central lancet dominates in the left lancet, the window relating the story of Christ's Passion and Resurrection. The stolid, frozen figures of the jambs mirrored in the Styrps Jesse window are missing in these windows, except at the very top of the central lancet, where Christ sits on the Virgin's lap.

This sense of immediacy is created not only through the physical appearances of the people in the narrative, but also by the emphasis on travel and crowds. The action is found, as in the capital frieze, in places known to the crusaders and their families, making the themes announced in the glass directly connected to places of great importance within this church and region and its steady engagement with far-

Top: Figure 12.6. Christ in the branches of Jesse's lineage, north lancet, panels 20, 22. Credit, de Feraudy.

Bottom: Figure 12.7. Ezechiel, second up in the left row of prophets, north lancet, panel 4. Credit, de Feraudy.

off wars and settlements throughout the twelfth century. The central window pictures three cities. The dramatic toppling of pagan statues, a scene from the *Pseudo-Matthew*, takes place in the city of Sotinen in Egypt; the scene fulfills the prophecy in Isaiah 19:1: "The burden of Egypt: Behold the Lord will ascend upon a swift cloud, and will enter into Egypt, and the idols of Egypt shall be moved at his presence, and the heart of Egypt shall melt in the midst thereof." The city to which the holy family returns, perhaps a replica of Bethlehem, shows a welcoming crowd at the city gate. Last, chronologically, is Christ's triumphal entrance into Jerusalem, showing the rejoicing city with welcoming groups of people. The idea of travelers being received joyously, as if they were liberating those who received them, is found in both the return of the Holy Family and the triumphal entrance (see plates 13, 14, 15). The crusaders believed that they too traveled to regain holy ground, building a new Jerusalem and restoring rightful worship, a point made here through the toppling of the idols and their unlit lamps.[15] Justification for the wars prevailing in the histories of the First Crusade circulated to inspire the Second Crusade (see chapter 6).[16] The disaster of the Second Crusade was followed by an attempt to preach a crusade once again at Chartres (and elsewhere) in 1150.[17] The windows seem designed to offer propaganda for this failed attempt to stir people once again, just as was done in the time of Bohemond with greater success, however painful the result. Ivo's pulpit, known to have been "of wondrous beauty" (see chapter 6), was there when this twelfth-century art was designed, and one wonders anew what scenes were pictured upon it.

The sculpture of the west façade is a history framed by liturgical understanding; this is true of the western lancets as well, also closely connected to the major relic and what at that time seems to have been the patronal feast. The feast of Mary's Nativity took place on September 8, in harvest season; the next major festival after it was the feast of the Exaltation of the Cross, September 14. The legend of the lineage of the Virgin, with the hook at the end, described and celebrated on the octave of her Nativity in the readings, is one of the stories driving the program of the west façade. Another related and complementary legend informs the glazing program, one joining the actions of Eden and the Fall to the Passion and Resurrection. Nicholas of Clairvaux was a composer of liturgical chants as well as a writer of sermons; he was secretary to Bernard of Clairvaux and later to Count Henry the Liberal of Champagne, brother to Thibaut V of Chartres; Count Henry's wife, Marie, has an obituary at the cathedral acknowledging her love of and contributions to cathedral furnishing (see appendix H).[18] Nicholas wrote sermons for both feasts, Mary's Nativity and the Exaltation of the Cross, drawing them together by imagining the root of Jesse and the wood of the Cross as parts of the same miraculous Tree of Life. His sermons on these subjects were copied at Chartres and studied there during the time the twelfth-century program was designed and executed. Chartres,

BM 121 and 123 were collections of Marian sermons, both destroyed in 1944. From these sources greater understanding of how sermons were received, copied, and studied at Chartres in the eleventh, twelfth, and thirteenth centuries could have been discerned. Notes describing these manuscripts indicate that Chartres, BM 123 included the several sermons by Nicholas of Clairvaux for the two feasts. Finding a history in the various types of wood in the Bible was a popular undertaking in the mid-twelfth century; the great sequence "Laudes crucis," then the most popular new liturgical song in all of Europe, depended upon this conceit, although it does not mention the "styrps Jesse."[19] Nicholas works in much the same way and even mentions some of the same images. But his major purpose is to associate the feast of Mary's Nativity with the rod of Jesse and then to ponder how this rod ("virga") leads to the cross: "From the rod of Jesse we come to the rod of the cross, and we bring the beginning to its conclusion, which is redemption. From this rod, the Virgin, Jesus Christ, was wondrously brought forth by a virgin; on it the Martyr, chief of all martyrs and exemplar of martyrdom, was shamefully hung. This is the rod of uprightness, the rod of thy kingdom [reference to Psalm 44:7]."[20] The overall design of the three lancets also would have resonated powerfully with the sequence "Ecce uicit," sung in the liturgy of Chartres cathedral during the Easter octave. This piece, which dates from the late tenth century, was not generally widespread in Anglo-Norman repertories and was not edited by David Hiley among early sequences in this tradition. The piece may have been of Italian origin and seems to have been chosen by cantors of Chartres because of the many ways it complements themes advocated in the sermons and liturgical chants championed by Bishop Fulbert and his disciples. As can be seen from the text (see appendix D), this sequence too joins the wood of the Fall with the wood of the Cross and also references the greedy desire of death to feed on Christ's flesh. An early strophe joins the idea of the wood of the tree in the Garden of Eden to the styrps of Christ's lineage. In this verse Christ opens "the Doors of paradise which had been shut through the forbidden tree and deadly sin in the beginning of time. The One whom death united with our first parents, set those fortunate ones free through the substance of his lineage [styrps]." This text, which also refers to the Harrowing of Hell, would have complemented the sermon by Nicholas of Clairvaux as well as other contemporary understandings of the Cross as a descendent of an ancient biblical root.[21]

As the lancets are now arranged, the strategy is to imagine events from the Old Testament prophesying those in the life of Christ up to the cross, identifying the wood of the Jesse tree with the Tree of Life and associating both with the Virgin Mary, herself a scion of Jesse, a *virgo/virga*, a Virgin/rod.[22] The Passion window, the southernmost lancet, is the most heavily restored of the three, but most of the new panels were fitted into the twelfth-century design and were put in place in the thirteenth century (Perrot's drawing, 1977, 42); perhaps this window was more heavily damaged by the fire of 1194 than the other two. In any case the use of green glass in

the cross imagery is telling here, and enough shreds remain to hypothesize that this was the original color, making the Tree of Life imagery strong (see plate 16).

The emphasis on the cross through connections between Mary's Nativity and the Feast of the Cross, with references to the Passion and Easter, played out in church furniture that was part of the twelfth-century renovations in ceremony and the use of liturgical space. The twelfth-century ordinal (OV) and the building campaign (see chapter 8) demonstrate the importance of what must have been a very large gold and silver cross.[23] Processions coming through the Royal Portal made their way toward this apparently deluxe object, newly refurbished and doubtless gleaming triumphantly from the eastern end of the church, another beacon to the crusaders who took it as their symbol. If that cross was planted on the floor, another cross would have been featured atop the jubé, or pulpitum: below this cross the carcass of the dragon was hung (at least by the early thirteenth century) on Ascension day, and great numbers of stations were made each week just before the ceremonial entrance to the choir in every season.[24] The entrance to the church belonged to Mary, but the entrance to the choir and to the altar bearing her relic was marked by crosses as well. On those occasions when the customary Marian processional music of entrance to the choir was suspended, for the sake of Easter and Eastertide, the triumph of the Cross was celebrated in a liturgical space and in actions customarily used to honor the Virgin (see chapter 10). At the first stational Vespers of Easter week, which had a procession to the font in the crypt, the antiphon on the return was "Ego sum Alpha."[25] The southern arm of the crypt, dedicated to John the Baptist, is where the font or fonts were located in the twelfth century; an example from the period survives, still positioned within this arm of Fulbert's crypt. After the visit to the font, the canons stood in order before the crucifix and concluded the antiphon with the versicle "Dicite in nationibus" and the prayer "Presta quesumus omnipotens ut qui gratiam." Nothing was said when entering the choir on this occasion. Then the bishop blessed them, and they prepared for the next day's liturgy. The work of the cross and the historical events represented by it took worshipers to the Holy Land, joining them with family and friends who were leaving or had gone, who had died or were still fighting.

"Ego sum alpha," processional antiphon sung before the entrance to the choir throughout Easter week at Chartres Cathedral:[26]

> I am the alpha and omega, the earliest and the most recent,
> The beginning and the end, I who live before the beginning of the world
> And for ages of ages in eternity.

> And my hands which fashioned you were fixed with nails
> And on account of you I was cut with whipping and crowned with thorns
> And hanging I sought water and they offered vinegar.

For food they gave bile and in my side a lance,
And I died and was buried, I arose and am with you.
See that I am He and none is God except me.
Alleluia.

The verse sung with the antiphon before the cross was "Dicite in nationibus": "Say unto the nations that the Lord has reigned from the wood, alleluia, alleluia, alleluia."[27] The wood of the Cross was honored in the liturgical situation in which Marian antiphons as well as "Styrps Jesse" were customarily sung as processional pieces. Through such a ceremonial use of music, working in well-informed memories, the wood of the Cross and the wood of Jesse's rod were fused by association with the same liturgical space, and the music and its liturgical situation formed a reflection of the program developed for the lancet windows. Experiments from the mid-twelfth century relating lineage to the wood of the Cross abound, and that found at Chartres is one of the most striking among them.[28] The program of glass arranged in the thirteenth century from three twelfth-century lancets stretches time from the early beginnings of lineage to the end of Christ's life on earth in a program that encourages the viewer to stack the windows one on top of the other to build a chronology. Through the power of its liturgical resonances, this view stretches the wood of the root into the Cross, foretelling "ages of ages in eternity."

## THE ARTISTIC CAMPAIGN AND ITS DONORS

I discussed the identifiable donors of the midcentury campaign earlier (see chapters 7 and 8). Closer study of the artworks themselves leads back to this subject, if only to raise further questions. Some things are clear: the midcentury campaign in Chartres presented a negotiated view of the past, one in which various desires—of the clergy for a liturgical sense of time, of the people for miracles, and of the Thibaudians to celebrate and recall their lineage—were all in play. The parts of the program that survive suggest that it was designed so that the act of seeing became pregnant with historical meaning, and history itself subsequently would be remade within the minds of many kinds of observers. In accordance with this understanding of history and art, merely to see certain events of history meant that time had been transformed by the viewer, whose looking and understanding might acknowledge and complete meanings only partly expressed in visual manifestations.

This particular history, then, was revealed rather than told; it was created through the interaction of art and audience, and without participation it lost its narrative thread. It was part of an act of initiation into the mysteries of the faith, something that had been desired by Ivo of Chartres and expressed many times in his popular sermons, which were well-known and copied at Chartres in the mid-twelfth century. As the sequence quoted at the beginning of chapter 9 states, the church "is the

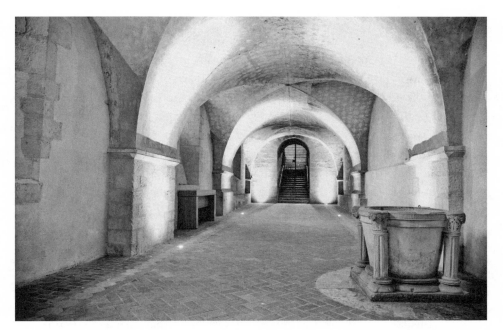

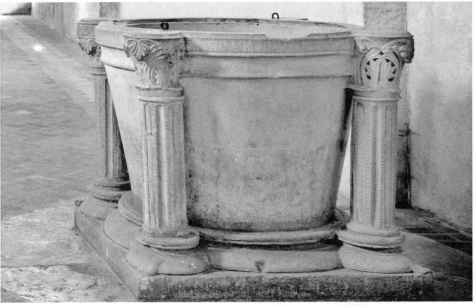

Top: Figure 12.8. The crypt of St. John, looking westward. Credit, de Feraudy.

Bottom: Figure 12.9. The twelfth-century font located in the crypt. Credit, de Feraudy.

house about which ancient history resounded," but knowing that past demanded a "modern book." This modern book was not only the Gospel; it was also a history book that could speak and could explain and was, of necessity, validated through understanding. Through such designs the visual displays of deluxe Bibles and glossed Bibles leapt from their pages and spread out over the outsides and insides of buildings; liturgical action became the ultimate subject of such exegesis, and priests and preachers were afforded abundant materials to reference in their work. Human knowing completed narratives, and without it the stories lacked their final scenes, scenes that pointed to a period of waiting, which in itself was part of the story. This exploration of revelation within historic change is a crucial part of the background for the miracle literature of the twelfth and thirteenth centuries and for the way in which Christians of the times desired to know God through visions.[29] It is crucial too for the artworks studied in this book. When the skills of biblical and liturgical exegetes were employed in portal sculpture and other decorative arts, action became the text to be glossed. The highly skilled artists and thoughtful patrons present at Chartres in the mid-twelfth century apparently sought to involve worshipers as dramatically and directly as they could through an art that was defined and completed by the motion of processions, the sounds of singing and praying, and the exertion of memory. Although there is no direct evidence for twelfth-century dramas from Chartres, the scene was clearly set liturgically for their production, and the art of the façade and glass anticipates their action and scenes. Where they would have been produced in a building that was crammed with the arts, both outside and inside, is a matter of conjecture, but some of them or elements of them could have been offered within processions themselves, taking full advantage of galleries, permanent and temporary, and the abundant artworks.

The only contributors to particular elements of the midcentury campaign whose names are known are bishops and dignitaries of Chartres Cathedral, although their recorded gifts, added together, would hardly account for the enormous expense of the undertaking. Overall themes found in this twelfth-century art and the design of the west portal sculpture and Belle Verrière suggest the influence of the bishops and dignitaries. Some aspects of this program could have been created only by persons who understood the liturgy of Chartres Cathedral and the cult of the Virgin as celebrated there. The west portal and the core of Belle Verrière were planned in consultation with people who knew how the liturgy of Advent worked and how it resonated with the sense of history found in the chants and sermons attributed to Fulbert and the texts found in the book of the cult of the Virgin. Whoever thought of the pilasters of the west portal sculpture, with their gradually appearing revelations leading to the narrative frieze, profoundly related as they are to Advent and the Virgin's Nativity as celebrated at Chartres, was a creative thinker of the highest order; he (or they) worked with persons who understood the cult and the liturgy, persons who wished to have ideas championed by Fulbert and Ivo on display as part

of the fabric of the cathedral. The history embodied in this art was informed by later interpretations of these two famous bishops, and their influence would dominate history-making efforts long after, but only because significant amounts of the art commissioned by the midcentury campaign survived and their characters could be read within it. I have already demonstrated (see chapter 8) the particular interests of Bishops Geoffrey and Robert, and it is not difficult to imagine that they were influential in the shaping of the subtle and liturgically well-informed art created at midcentury.

This book has shown that much work remains to be done on establishing liturgical and political contexts for the art of Chartres Cathedral. The Thibaudian family and its patronage of the arts cry out for further attention. Such a study might help explain not only the connections of the family to the cathedral and its art, but also relate to the choice of materials, the nature of the design and style, and the kinds of artists available in and around Chartres or brought in from elsewhere. Is there sufficient evidence to decide if Bishop Henry and King Stephen in England and their brother Count Thibaut in Chartres/Blois and the Champagne were sharing ideas, model books, and artists? Were the brothers and other family members in conversation about works of art and their relationship to the history of the family and the region? Cluny, where Henry often was in residence and where he was a major donor, can be brought into the picture as well; so can the Cistercians, who were patronized by Count Thibaut. Members of the next generations were also important patrons of the arts: Count Thibaut V; Thibaut's brothers William of the Whitehands and Henry the Liberal, count of Champagne, along with his wife, Marie of Champagne, daughter of Louis VII; and Hugh of Le Puiset, Thibaut's nephew. What of the persistent relationships in the mid-twelfth century surrounding works of art and the Thibaudians, Suger, and Prince Henry of France? These might reach from visits to liturgical celebrations, donations of materials, and the possible sharing of artists and expertise on contemporary or near-contemporary campaigns. What would it have meant to the artistic campaign when Louis VII married a Thibaudian woman, who in turn preserved his lineage by producing a son? What would people think about seeing a king emerge from the head of woman in the Styrps Jesse window in 1165, the year Philip Augustus was born during the octave of the Assumption? One of the ways the art produced in Chartres needs to be studied is by comparing it to the many other churches under Thibaudian sway in the second half of the twelfth century. The work by Horste (1987) on the St. Anne Portal at Notre Dame in Paris describes the jubilation surrounding the birth of Philip Augustus and argues that the tympanum depicts Louis VII adoring the Virgin of Chartres; perhaps this was another way to praise the Thibaudian lineage of his productive wife, Adela.[30] The Assumption was especially favored by King Philip and was featured in special music and ceremony in the music of his chapel in the late twelfth century, where the "Styrps Jesse" was also often used as chant for elaborate settings. The Jesse trees of

St. Denis and Chartres had become branches of a single tree, both in an artwork such as the St. Anne Portal at Notre Dame in Paris and in polyphonic settings of chants. The association of the Capetians with birth and the continuity of their lineage persisted: Guillaume le Breton, chaplain to Philip Augustus, states that King Louis VIII, another long-awaited heir, first stirred in his mother's womb while she was in prayer at Chartres.[31] The long association with royal lineage and fecundity, celebrated especially at Chartres since the time of Fulbert and the growth of a cult whose central relic became defined through liturgy and art as a conception/birthing gown, was reshaped and reused for new situations.

Closely related to the role of the Thibaudians as patrons is the subject of manuscript production and illumination in Chartres itself, a study that, as Patricia Stirnemann has said, is "still in its infancy" (1997, 91). She and others have suggested that deluxe Bibles and glossed books of the Bible, in which works by Gilbert of Poitiers play such an important role at midcentury, point to Chartres as an important center for production of illuminated manuscripts; the collection of ornate glossed books of the Bible in the medieval library at Chartres was large and significant. The arguments are not well developed, but twelfth-century Bibles and glossed Bibles produced in the Thibaudian centers of Troyes, Chartres, and Winchester have various features in common, including, in some instances, a sharing of illuminators; works appearing in other centers, including Boulogne, where Stephen was count, and in Sens and Reims, where William of the Whitehands was bishop and archbishop in succession, would require attention.[32] After Gilbert, chancellor of Chartres Cathedral, was elected bishop of Poitiers in 1142, the style of illumination there shifted, showing the penetration of northern features.[33] Still to be examined with greater care are the relationships between the set of deluxe commentaries produced for Prince Henry of France, some of which Stirnemann suggests show the work of Chartrain artists (89). What can be learned from close study of Paris, BN lat. 55 and 116, the two sections of a deluxe mid-twelfth-century Bible that may have been illuminated in Chartres?[34] Comparison of the works of individual artists, including the one who worked on both English and continental books (for example Oxford, Bod. Lib. Auct E and Paris, BN lat. 1626),[35] will continue to be important, as will understanding the Byzantine influence exhibited in many of the artworks produced under the patronage of Henry of Blois, whose court at Winchester was surely a place where artists came and went and materials were evaluated and carefully chosen.[36] What was the crossover in design and modes of decoration from illuminated manuscripts to glass and sculpture? How many stylistic layers are there in the three lancet windows? and do they relate to the sculpture of the frieze differently, with the Styrps Jesse perhaps being the oldest? The ways in which styles of metalwork may have influenced design in sculpture and glass have long been recognized and call for more study, especially given that Henry of Blois was known to have employed Mosan enamellers in England.[37] Art in the so-called Channel style

calls up the Thibaudians, as much a Channel family in the mid-twelfth century as their Angevin counterparts. The ways in which the styles apparently championed by members of the Thibaudian family related to the differing sculptural styles in and around Chartres are an especially fruitful arena, with fragmentary evidence from many twelfth-century churches surviving from the regions of Chartres and of Blois.[38]

## FULBERT AS THE BUILDER OF THE THIRTEENTH-CENTURY CATHEDRAL

In 1194 the cathedral of Notre Dame of Chartres burned. This building and the histories of the town, of the Virgin's cult, of the Thibaudian family, and of the supposed builder and author of the Virgin's cult, Bishop Fulbert, were tightly woven together in the liturgy and in artworks of the twelfth-century campaign. The nature of the relic itself, defined over time through historical actions and liturgical texts and music attributed to Bishop Fulbert, would be challenged by the loss of the church building also believed to be his. What happens to the history of a place when its mode of remembering goes up in smoke? How much of the eleventh-century building actually burned is a matter of speculation, but at least the twelfth-century west façade and twin towers survived and were subsequently preserved and incorporated into the thirteenth-century building. The twelfth-century art and its role in the ongoing history-making ventures in Chartres were assured by those responsible for preserving the triple portal and some of the twelfth-century glass, which included notably a major statement of cult (Belle Verrière); the window most closely related to Fulbert's liturgical texts (Styrps Jesse); and glass that found strong programmatic counterparts in the capital frieze (the Infancy of Christ and the Passion of Christ windows), and the survival of the relic itself and its reliquary, as reported in the miracle collection.[39]

The western lancets and the core of Belle Verrière may be all that survived in 1194 from the more than fifteen windows mentioned in twelfth-century documents, but it is just as possible that late twelfth-century planners were selective, restoring only the spolia they most desired to reuse in conjunction with broader thematic intentions, attempts to continue the history of Bishop Fulbert, the Virgin's cult, and the liturgy as well as the themes that had been prevalent in the earlier building and in artworks from the mid-twelfth century. Perhaps, too, the ideals of kingship and lineage were valued by the Thibaudians at a time when they had achieved a long-hoped-for goal of marrying into the royal family, one that made them especially powerful in the late twelfth century but that eventually doomed them; certainly Philip Augustus and his wife were frequently in Chartres and cared greatly about the cathedral. Count Thibaut V died in 1191, fighting alongside his brother-in-law Philip Augustus on the Third Crusade; his son Count Louis, who brought the head

ti pedes de apto ⁊ baculi

Secta mansio ē
pmū tendunt tabna
pͭat tabnacta. ut tenū
tabnacta figͥ nī. scien
uuentiū accetandū q

Tercia mansio
in qua pmū uidͭ dͫs
sana fortitudo. ut pͥset
tes pfectū robur. ut u
xp̄i lumͥ appareat. di
cibʒ ad tͥram pmissio

Quarta mansio
pͭat os nobiluū. ut assi
tͤpnentes beelsephon
declinantes. ab hac m.
mare in desͭtum. uidi
pcinentem in tmpar

Quinta ē mar
um ⁊ in tͥpi amarituu
la migͭrituum: p̄ fidē
uenīt ad amaritudi
oine tͥmmetur ⁊ p cͥ
ꝯpenseatͭ.

dualͥ. que dicūtur. ut uerba domini
penseatur.     ⁊ sapientissimū hebreoͤ

est dͫs ad moysen in de
serto synai: in tabnacu

Figure 12.10. Initial, from Chartres, Bmun 182. Médiathèque de Chartres.
Credit, Delaporte and de Feraudy.

of St. Anne to Chartres, died in 1205 in the Fourth Crusade. Louis's son, Thibaut VI, who ruled from 1205 until 1218, died on the Albigensian crusade; he was a leper and died without issue. Chartres/Blois descended to Thibaut's paternal aunts: Isabelle, who was childless, took Chartres, and Marguerite took Blois, which descended to the Châtillon family through her husband. Chartres became a royal fief in 1234 and was sold by the count of Champagne to King Philip IV in 1286.[40] The idea of the count/bishop developed in the later historiography of Chartres (especially in the *Vieille Chronique*) would have filled a need: Chartres was an abandoned child.

In order to understand decisions made by those who preserved the west façade in the early thirteenth century careful architectural study is needed. Several theories exist about how the thirteenth-century cathedral was constructed.[41] Some scholars also believe that the west portal was originally supposed to be scrapped and was saved only after an initial plan was rejected. Brigitte Kurmann-Schwarz and Peter Kurmann disagree: "In contrast to some scholars, who posit an initial, but later discarded, plan for a totally new building, we would argue that the twelfth-century west façade and the crypt, with its Romanesque and pre-Romanesque fabric, were intended to be incorporated into the new building from the very outset" (1995, 133). Many elements of the later program are closely related to twelfth-century themes, and this supports the ideas of those who believe an early decision was made to preserve the twelfth-century spolia, or certain parts of it. The best that can be said is that there is more work to be done on the stages of construction of the thirteenth-century cathedral, but I follow the summary of Christine Lautier (2009, 178) as to the state of present scholarship on the major issues: "Following the fire in the Romanesque cathedral in 1194, rebuilding began in the nave, which was erected on the foundations of Fulbert's crypt and placed against the twelfth-century western façade and towers. Once completed, the nave served as the cult space while the Romanesque chevet was destroyed and its crypt modified to accommodate additional chapels." The rebuilding of the chevet necessitated a provisional choir in the nave, which must have been walled off by a temporary choir screen needed for liturgical functions and located at the western crossing piers. The canons were not installed in their new choir until around 1221, as witnessed by a charter from that year reaffirming the rights of the cantor to assign the places in the new choir stalls (see *CNDC* 2, no. 237, 95–96.).

It may have been a good thing for the survival of mid-twelfth-century artworks that those planning the new cathedral building and its decoration had deep ties both to earlier Thibaudians and to historic bishops and dignitaries from twelfth-century Chartres. William of the Whitehands retained his bishopric for some years after he left to become archbishop of Sens. The bishop of Chartres in 1194 was Reginald of Mouçon, William of the Whitehand's nephew, son of his sister Agnes; William and Agnes were both children of Count Thibaut IV, who was surely a major donor for the twelfth-century campaign.[42] Apart from the years during which John

of Salisbury and Peter of Celle held the see in immediate succession (1177–83), the bishops of Chartres for almost fifty years were Thibaudians, beginning with William in 1164. During many of those years a single person held the office of dean, Geoffrey of Berou, who served in his high office from 1166 until his death in 1202. As he was from a prominent local family, he doubtless had known some of the dignitaries who supported the mid-twelfth-century campaign.[43] He was succeeded by another figure who would have offered substantial continuity: a canon named William was subdean or dean for almost twenty years, from 1194 to 1212. He gave many gifts for the restoration of the church and its decorations (*OPS*1032 73–74 and *DIGS* 13 and 53). There was long-term continuity in music and liturgy with Richerius, who was precenter from at least 1167 until 1173 and then cantor from 1173 to 1188 (*DIGS* 34); his apparent successor, Crispin of Dreux, would have been in office during the year of the great fire, although the duration of his office cannot be given with greater precision than 1193–98 (*DIGS* 34–35). Not long after, however, there was another long-serving cantor, Goslen of Ouarville (served from at least 1206 until 1221, *DIGS* 35), who would have been in charge of the liturgy until just before the time that the *OC* was produced and continuity with the liturgical past assured.[44] This cantor surely played an essential role in the ways that liturgy and the new programs of sculpture and glazing related to earlier works of art, and the expanded cult of St. Anne, the north portal sculpture, and the new sequence for the feast (see below) were all created during his time of office.

In light of such continuity and connections to the midcentury work, there would have been many reasons for trying to maintain ties with the immediate past. As has been demonstrated in several ways, the cathedral liturgy changed little in the course of the late twelfth and early thirteenth centuries, even though a new building arose behind the preserved façade. Attitudes toward the liturgy also signal an attitude toward continuity. The liturgy, of course, unlike the building that contained it, was not destroyed by fire, and so the task of rebuilding was both essentially different and far easier. Nothing in any of the surviving liturgical documents reveals a taste for change or reform—in fact, quite the opposite—and the liturgy would have offered a body of evidence to history makers who sought to create a sense of the connection between Fulbert and the new cathedral building. Additions to this history were useful for bridging the gap between the periods before and after 1194 as a handful of new feasts came in and others were upgraded. Three of these additions are telling pieces of evidence for the ways in which the liturgy expanded upon historical understanding in the thirteenth century.

Of the new feasts added in Chartres in the course of the thirteenth century (see appendix B for a list of them), most important for this study are continuations of the Virgin's cult or pronouncements concerning local history as found in three of them: the memorial feast celebrated from sometime after the fire in 1194 on the feast of the Dedication; the feast of Saint Anne (July 26), instituted around 1205;

and the second translation of Saint Anianus, instituted after the fire of 1262. All three feasts contributed to an exercise in history making that took place over the course of the thirteenth century: Fulbert was given a major role as the builder of the new cathedral that rose in the thirteenth century on the crypts he did design, a building fronted by a façade once attached to the eleventh-century building.

A special memorial to the lost church (*Commemoratio beatae Mariae quae loco dedicationis Ecclesiae Carnotensis dicitur* [a commemoration of blessed Mary that is sung in place of the dedication of the Church of Chartres]) was created in the liturgy of Chartres Cathedral for the feast of the Dedication (October 17), perhaps initially because the upper church was incapacitated immediately after the fire, and for some time the liturgy was displaced; the crypts, however, remained and could be used for services until the provisional choir in the nave was established.[45] The memorial is a Marian Mass and Office composed of Marian chants favored at Chartres, including the set of five antiphons that begin with "Hec est regina," sung at every Marian feast in Chartres Cathedral during this period (see appendix F). The *Commemoratio* served to give a strong Mariological cast to the feast of the Dedication of the church, made a statement about Chartres Cathedral and its history, and also itself offered a kind of history fashioned out of Marian chants. It also suggests that the feast of the Assumption had already begun to replace the Nativity of the Virgin as the favored Marian celebration in Chartres Cathedral.[46] Chants commemorating events early in the Virgin's life come first at First Vespers, with "Styrps Jesse" also closing out the first nocturne. The readings at this special Office were taken from the Song of Songs. In the early thirteenth century this memorial coexisted in the liturgy with the medieval dedication chants and readings (see OC 182–83); but after the newly rebuilt cathedral was rededicated in 1260; it came to replace entirely the customary chants and readings found in service books from the twelfth and thirteenth centuries. Given such a transformation, the Dedication feast could be readily understood as yet another of Fulbert's works, composed in sorrow at the loss of his church in 1020. This interpretation would underscore the idea that he built the thirteenth-century cathedral and perhaps eventually inspire the idea, as Souchet disdainfully reported in the seventeenth century, that the Virgin herself, through a miracle, dedicated this church in her own honor (Souchet 3:49, in his discussion of Bishop Peter of Mincy, served 1260–76). In any case, the revised Dedication feast linked the church to the cult of the Virgin through a unique liturgy remembering the cathedral's history and helped strengthen legends surrounding Fulbert and the Virgin and their special connections with the thirteenth-century edifice, a church that came to have a feast in Mary's honor on its dedication remembrance instead of that followed throughout the rest of Europe.[47] To use chants linked to all Marian feasts also drew these multiple meanings into the history of the relic and its nature, as related to annunciation and birth but also as emblematic of human flesh that was beyond time.

The development of the cult of Saint Anne in the first decade of the thirteenth century at Chartres was a result of the reception of the relic of her head by Count Louis, who sent the precious object to the cathedral from Byzantium in 1205 just before his own death (*CNDC* 3:189 and *OC*, 54–55, 166–67). Delaporte believed that the Office and the sequence for Saint Anne found at Chartres were composed there. The readings were taken from apocryphal literature, making a strong connection with the cult of the Virgin Mary as historically celebrated in Chartres. The sequence "Mater Matris Domini" (see appendix D) falls into two sections, the first of which emphasizes stories about Mary's parents taken from the infancy of the Virgin Mary and sings in harmony with the scenes on the capital frieze of the west portal and the liturgy of the Virgin's Nativity; Chartres, 162, the book of the cult, also received the addition of lessons from the apocryphal literature for Saint Anne's feast, tying her celebration to the special offices of the Virgin (see chapter 5). The second half of "Mater Matris Domini" is also grafted on to the styrps Jesse theme, using some of the same language found in Fulbert's sermons and chants. The tone in this work, written at Chartres in the reign of Philip Augustus during a time of expulsion and mistreatment of Jews that exceeded anything previously attempted in this region, differs from the anti-Jewishness found in texts from the eleventh and twelfth centuries: "This is the grace-filled rose that, from the thorns, depredations, and savage hatred of the ancient Jews was born" is an anti-Jewish gloss upon an earlier text such as "Styrps Jesse," and the turn from the twelfth to the thirteenth century is as powerful in what is heard as in what was seen in the north portal where there was a statue representing the synagogue.[48] There was a deliberate attempt both liturgically and artistically to build directly on the cult of the Virgin as established in the eleventh and twelfth centuries, but translation was also transformation, accounting for new styles and new politics. Both the portals emphasize crownings: in the earlier west portal, angels in the archivolts fly toward Christ in the central tympanum, bearing a crown; in the north, a crowned Mary is glorified by her Son, surrounded by the lineage of the Styrps Jesse in the archivolts. In the Saint Anne sequence, faithful worshipers join in the crowning themselves.[49]

The fires of Chartres recounted in the lessons for the feast of Saint Anianus (Aignan), written just after the fire of 1134, numbered five and included the fire of 1020 that burned Fulbert's cathedral (see appendix C for the complete lessons translated into English). In 1262 the entire town of Chartres burned again, but the cathedral, which had been dedicated in 1260, was spared.[50] This fire, like that of 1134, demanded the rebuilding of many local churches, one of which was that of St. Aignan. Relics were retranslated, and a second feast for the saint was established, with new lessons added to the earlier texts. These described the fire of 1262 but left out the fire of 1194. Whoever wrote these additions to the original saint's life did not—or could not bring himself to—acknowledge the fire of 1194, and the loss of the building designed by Fulbert. In the decades after the compilation of the

Chartain miracles this fire was omitted from the history of the town. From the time the supplemented vita of Saint Anianus was introduced into the cathedral liturgy, only six fires were recounted in the history of Chartres. With the fire of 1194 excised from local history, the thirteenth-century cathedral eventually became the edifice built by Bishop Fulbert. In the fourteenth century the canons revised the miracle literature to accord with this view of the past:

> And now let us come to the most certain and novel proofs of his [Saint Anianus's] virtues and sanctity, and to the subject of today's feast. After those five burnings of this city of Chartres, listed carefully in the history of the winter translation of this glorious high priest, and after one hundred and twenty-eight turnings of the years, a sixth fire took hold of the city of Chartres. Another, a new miracle now succeeded the earlier ancient one, not unlike it in kind, for the praise of God who in his saints is ever glorious and wondrous—a miracle worthy to be joined to it, proclaimed in church, and kept continually in mind.
>
> In the time of our venerable father, Lord Peter, seventy-third bishop of Chartres, in the year of the incarnate Word 1262, on the tenth day of the month of June, the vigil of Saint Barnabus the apostle, almost the entire city of Chartres was subjected to divine but hidden judgment. Although all other churches were burned, by the mercy of God those of the glorious Genetrix of God and of the blessed apostle Andrew were in some way saved from the fire."[51]

Feasts such as these strengthened the connections between the architectural elements that survived the fire of 1194—most importantly Fulbert's crypt, and the west façade and twin towers—with the thirteenth-century church. The second translation of Saint Anianus went even further, removing the fire of 1194 from local history. History embodied within the liturgy itself shaped the understanding of the past more powerfully than any other force, and historians in the fourteenth century took their cues from such works when they compiled the *Vieille Chronique* in 1389 and revised the Marian miracle collection accordingly; by that time, Fulbert had surely become the architect of the thirteenth-century building. In the present age, when art historians can date buildings within a decade or so by style, architecture, and, more recently, carbon analysis, such a construction would be unthinkable. But in the early modern period such techniques did not exist, and ancient buildings could have legends attached to them more readily, especially when the liturgy was there to provide the framework of historical understanding. In the *Vieille Chronique*, which has its roots in the history of the town provided for by the feasts of Saint Anianus, Fulbert, with his chants and sermons and building activities, becomes the model for Druid priests who are prototypes of a particular devotion to the Virgin's cult.

The afterlife of Fulbert was embodied in a magnificent artwork, the choir screen begun in the early sixteenth century by Jehan de Beauce. Work on it continued until the eighteenth century; Fulbert's statue is believed to have been created in

Figure 12.11. Fulbert in
the eighteenth century,
south choir screen. Credit,
de Feraudy.

the last stages.[52] Fulbert appears in full majesty, with flowing hair and beard, in
full liturgical vestments, and in his hands he holds a depiction of the cathedral
erected in the thirteenth century, viewed from the south portal. The idea that the
cathedral of Chartres was built by him, a legend that grew slowly from the eleventh
century onward, was not about to die, even in an age of enlightenment. The Virgin
Mary would have her champion, the man who wrote the texts for her feasts and the
chants to accompany them and who created her temple as well, the one she herself
dedicated. Only the work of scholars a century later would finally sever the ties.[53]

## THE WELL AND THE VIRGIN OF THE UNDERCROFT

Every book must come to an end, and other scholars will write the second and
third volumes about the cult of the Virgin of Chartres in later eras. I conclude by
summarizing developments in the Virgin's cult that took place after the twelfth
century, discerning their shadows in the well of the crypt, the most famous and
mysterious feature of cathedral topography. In my recounting of its legends, many

Figure 12.12. Detail, the Gothic cathedral in Fulbert's hands, eighteenth century, south choir screen. Credit, de Feraudy.

figures already met will return as the bones within the well. Bishop Frotbald, first encountered in the mid-ninth-century *Annals of St-Bertin*, never left Chartres, but he moved around considerably. In the ninth century he was drowned in the Eure while fleeing the Vikings; in the early eleventh-century martyrology/necrology from Chartres, he died a hero in the company of other clergy. In the late eleventh-century *historia cum cartis* by the monk Paul of St. Peter's Abbey, the Virgin Mary intercedes. In a life of St. Savinien, the earliest copy of which comes from eleventh-century Bonneval, the well receives the bones of early Christian martyrs.[54] In a twelfth-century addition to Paul's history (translated in chapter 1), Frotbald's bones and those of both monks and clerics were deposited in a well in the crypt of Chartres Cathedral.[55] The sorting out of the competing legends would be the work of later centuries, most importantly of the fourteenth.

The location of the well in the crypt is near what was once apparently a fortified northern tower. The tower, which some architectural historians believe was part of the Carolingian church, would have been a likely place for citizens and clergy to seek refuge during military attack, and every early cathedral site required a source

Figure 12.13. The well
in the crypt. Credit,
de Feraudy.

of water.[56] Thus the linking of the well (necessary to provide water in time of siege in
addition to other needs) with the story of battle and with the design of the cathedral
in earlier centuries is not surprising.[57] Its prominence in local history is unusual,
however and in accord with associations from the eleventh-century forward with
the prehistory of Chartres and in the twelfth-century with the cult of the Virgin
Mary.

On All Saints' Day, November 1, the twelfth- and thirteenth-century Chartrain
ordinals mention a liturgical ceremony featuring the well.[58] A procession was made
after First Vespers to "the strong holy place" (*ad sanctum locum fortem*) on this
solemn day.[59] As the clergy and their attendants processed to make the station, the
antiphon "Laudem dicite" was sung with the Magnificat, along with other appro-
priate antiphons sung on the return to the choir.[60] These details demonstrate that
the well had become a shrine dedicated to the first martyrs of Chartres, and the
presence of their charred bones had been incorporated into the major liturgical

commemoration of holy men and women. On the feast honoring all the saints who rejoice in heaven, homage was paid by a liturgical visit to that place, with appropriate chants, readings, and prayers. The cult, or veneration, of these local saints had found its way into the standardized cathedral liturgy, and it remained there into the thirteenth century and long after. The history, coupled with the evidence of the ordinals, suggests that there was an underground cult of these martyrs at Chartres by at least the mid-twelfth century (and probably somewhat earlier) and that people descended to the crypt to offer various prayers for their troubles near the shrine of the well throughout the year. On occasions when the choir processed to the crypt, the music would have magnified the effect tenfold. The eleventh-century crypt of Chartres Cathedral is an extraordinary space in which to sing and to hear texts proclaimed, even when it is crammed with pilgrims as is so often the case today. It was perfectly adapted to the veneration of the saints because enormous numbers of people could hear the sounds from any altar within it, no matter where in the structure they happened to be standing. They might not be able to see, but they could always hear.

By the mid-twelfth century pilgrims could pass through passageways in the crypt that took them near the main altar above, near which was enshrined the chemise of the blessed Virgin.[61] Their route took them past the well and perhaps past a wooden statue of the Virgin in close proximity to it (although see chapter 9 for evaluation of the evidence for this statue in the twelfth century). The stories of these cult objects would become entwined in the history of the town and the cathedral in the centuries to follow. What happened below, in the crypt, was deliberately related to what rested above on the main altar; for pilgrims to feel a physical nearness to the relic they had come to venerate was essential; even though the access to the main altar was by stairs forbidden to pilgrims, and the area directly underneath the main altar was not open, still the crypt's shape matched that of the famous church above.[62] Walking close to sacred areas in the crypt, especially in a place where there were ceremonies and prayers related to healing, reminded those at prayer that there was one Virgin and that Chartres had special claim to her. The nearness of the well to the main altar above it brought the cult of the martyrs and the cult of the Virgin into constant proximity, and interplay was bound to occur. But her cult in the crypt was shaped by the well and its legends, too.

The late fourteenth-century *Vieille Chronique* of Chartres offers another account of the well and demonstrates further transformation that would color history writing at Chartres for centuries to follow.[63] The entry concerning Bishop Frotbald in the *Chronique* contains no reference to sieges and skirmishes of either 857/8 or 886, but an attempt has been made to connect the bishop's story with the siege of 911 (all are discussed above in chapter 1). The description of the battle names two pagans, Beyer and Hasting; it reports that Hasting returned to Francia after a rampage in Italy and made peace with Charles the Bald, a peace that was to endure

until the time of Rollo, thus setting the scene for the reception of the relic of the holy chemise.[64] The battle of Chartres here becomes, as will be the case in regard to the siege of 911, a turning point in the general history of Europe, ushering in a time of peace, and the "ur-Count" Hasting has become a player in this desired state of affairs. Although connections with the Virgin abound, nothing directly links Frotbald and the Chartrain martyrs with the major relic of Chartres Cathedral, and the miracle of the martyrs is not reported in the thirteenth-century Chartrain miracle collection, in either the Latin or the Old French versions.

If the restless bones in the well are no longer those of Frotbald and his associates, whose bones have they become by the fourteenth century? A major purpose of the late fourteenth-century *Vieille Chronique* was to extend the history of Chartres backward into ancient times, drawing upon legends already found in the readings for the feast of Saint Anianus and building upon the second redaction of the life of Saint Savinien as well. Through such legends, the Virgin's cult was seen to exist even before the time of Mary herself and to be connected directly to her and to the apostles in the first century.[65] This history presents yet another view of the well and shows that its name has been transformed as it has become more closely linked to attempts to push the history of Chartres back in time to the first century and just before. The first part of the *Vieille Chronique* describes the earliest bishops of Chartres—although Bishop Adventinus was the first to be consecrated, the claim is made that he had predecessors, pagans who were bishops of an edifice dedicated to the Virgin before the time of Christ's birth. Just as histories from the eleventh century needed Carolingian heroes, so too did they require saints of the apostolic succession. Major churches sought historic links to the time of Jesus, Mary, and the great commission through new cults. The early priests are students of the very texts that would come to be featured in Fulbert's championing of the feast of the Virgin's Nativity.

The story of the apostles who converted Chartres began in the eleventh century with the cult of Saints Savinian and Potentian.[66] This cult first became important in the region in the early eleventh century when Queen Constance, third wife of King Robert the Pious, established it in Sens, working with liturgist/historians from St-Pierre-le-Vif.[67] The queen, rival of Countess Berta of Blois/Chartres, engaged the king in this cultic elevation, which promoted the idea of the religious leadership of Sens.[68] The association of these apostles with Sens, and their conversion of surrounding towns including Chartres, offered a framework for reworking the history of the first century. This fourteenth-century account of the legend at Chartres trumps the story of the conversion by the martyrs of Sens by showing that the Chartrains were already Christians (of a sort) when the apostles arrived from Sens:[69]

> Adventinus was the first consecrated bishop of the holy church of Chartres, as we read in the legend of Saint Anianus. It did not speak of other unconsecrated bishops, for it is held that the said church was founded before Christ was born, in honor

of a virgin about to bear [*paritura*], and was governed by priests of idols. After the Ascension of the Lord into heaven, directed by blessed Peter, prince of the apostles, and the still living blessed and glorious Virgin, Saints Savinian and Potentian came to the city of Sens, and themselves sent Saints Altinus and Eodaldus, their associates, to Orleans with great swiftness, where many were converted to Christ. And then, coming to the city of Chartres, they found the great part of the people already Christian, and the cathedral already established in honor of Mary, the Mother of God (*CNDC* 1:1–2).[70]

This pre-Christian display of faith and the consecration of the church angered the pagan Romans and their head priests greatly. A great slaughter at Chartres followed, and the bodies of the martyrs were thrown into a deep well located inside the church (*CNDC* 1:2). Thus the primordial history of Chartres as conceived in the late fourteenth century was connected with the well through its first-century importance as a burying place for newly converted pagan martyrs, and the Roman Christian missionaries who had connections to Mary and the apostles. The story of the Viking siege and slaughter, further developed in the course of the eleventh and twelfth centuries, has been stripped away, both from the life of Bishop Frotbald, who is no longer connected with the well, and from reports of the ninth-century invasions. The well in the crypt, clearly still an important feature of cathedral topography, has become the burial place not of Frotbald and the Carolingian martyrs of Chartres, but of people who lived in antiquity, were already involved in the Virgin's cult, and were killed by Roman tyrants. So the well became a site for the veneration of all saints, as well as for recalling a pre-Christian past, one associated with the Virgin.[71] The Cult of St. Modesta grows from these stories in the thirteenth century.

A description of the well and of its cult further on in the *Chronique* has been couched in the language of this opening legend, demonstrating that the historians responsible were careful to synchronize the various sections of their work: "In the aforementioned crypts is a hospice; it is called *Sanctus-locus-Forcium* [Holy place of the brave ones] in that long ago a multitude of martyrs suffered martyrdom there. By the rulers' command their bodies were thrown into a well of great depth that was made there. This place is still of miraculous holiness. The sick come to it from everywhere; they are called *ardentes* [the ardent], and are enfeebled by the sacred fire that is called *ignis Beate-Marie* [fire of blessed Mary]. But by the grace of [God] and of his Mother, within the nine days that they remain there they are either completely cured or, in a few cases, they quickly die."[72]

## THE DRUIDS OF CHARTRES AND THE VIRGIN MARY

The tale of the well of the holy martyrs of the first century as found in the late fourteenth-century *Vieille Chronique* inspired later historians.[73] Evidence of its transformation is found in the writings of Jean Gerson, a theologian and chancel-

lor of Paris, who devoted much of his life to fostering the cult of Saint Joseph. He is the first writer known to have claimed that the priests mentioned in the *Vieille Chronique* could be identified as Druids.[74] Gerson, who carried on correspondence with Canon Dominique Petit, briefly a cantor of the cathedral of Notre Dame of Chartres, may have had actual information about the Chartrain liturgy and the Marian cult. The *Vieille Chronique* mentions "priests of idols," not Druids; Gerson, however, knows about Druids who celebrated there in pre-Christian times, venerating a virgin about to give birth (*paritura*).[75] Even if Gerson did not initiate the idea himself, the early fifteenth century was when this aspect of the cult was selected and intensified.[76]

The idea of druidic priests was embraced by several Chartrain historians who wrote in the sixteenth and early seventeenth centuries—Duparc, Prévost, and, finally and most powerfully, Sebastian Roulliard, who became obsessed with the idea and whose writings were to shape seventeenth-century understanding of the cult in Chartres.

Rouillard's *Parthénie*, which appeared in 1609, summarizes the earlier work of Prévost and Duparc but adds much material concerning the Druids. In a stunning example of the way liturgical understanding continued to shape history making in the seventeenth century, Rouillard synthesizes ancient ritual practices through the liturgy of the cathedral of Notre Dame of Chartres, especially regarding the cult of the Virgin as it was characterized in the *Vieille Chronique*, adding devotion to the cross. His topics are as follows: (1) Egyptian priests adored Christ under the letter TAU, which was according to them the sign of life to come; (2) the Chartrain Druids, well before the birth of the Messiah, venerated the image of the Virgin who gave birth, the Virgin about to bear; (3) one must hold this tradition as authentic, like many others that concern the antiquity of the Christian religion; (4) concerning the Druids: why they are called such, the nature of their place of dwelling, their language, the letters of their scripture, their doctrine; how Pythagoras was their disciple as were other philosophers; (5) refutation of the errors of Julius Caesar regarding the gods which he said were adored by the Gauls; (6) how the Teutonic gods were interpreted as Mercury, Mars, Jupiter, etc.; (7) the Romans and other idolaters adapted to their false religion that of other peoples, especially of Jews and Christians; the case of the Druids is parallel; (8) the Druids adored only one god; they had neither temples nor idols for demons; the Romans introduced these into Gaul after they subjugated the Druids; (9) the Druids, at the sixth moon—that is to say, according to their calculations, the first Friday of years and of months—adored the cross under the form of the chestnut tree; (10) the legend of the mistletoe; (11) their century ended on the thirtieth moon, in accord with the foreknowledge that the Son of the future Virgin ended his life in the thirtieth year of his age and in order to publicly proclaim faith in the Gospel; (12) they sacrificed bread and wine and used white copes as a sign of purity or as servers of the Virgin to be.

Table 12.1. Select Sixteenth- and Seventeenth-Century Histories of Chartres
(with emphasis upon ecclesiastic traditions)
All these works are discussed in VdM, with further bibliography.

| Author/date written | | Brief Title | Interest/Viewpoint Regarding Cult |
|---|---|---|---|
| Prévost | 1558 | *Petit traicté* | A canon of Notre Dame; Emphasis on the Chemise[a] |
| Duparc | 1568 | *Histoire Chartrain*[b] | Cathedral cults; Unpublished defense of the ancient Catholicity of Chartres, and extremely influential with locals |
| Rouillard | 1609 | *Parthénie* | Champion of Druids |
| Souchet | 1650–54 | *Histoire du Diocèse* | Champion of the new chapel; First early modern historian to seriously investigate evidence of charters, necrologies, and histories |
| Sablon | 1671 | *Histoire* | Popularized Rouillard, went through over twenty editions |
| Challine | 1640–78 | *Recherches* | Scared off by Souchet; Relatives eventually published his work, which is in the Rouillardian vein |
| Savard | 1664 | Manuscript | Local merchant |
| A. Félibien | 1681 | *Mémoires* | Maps; fabric of the building |
| Thiers | 1679 | *Superstitions* | Reforming canon; Critiques many late medieval and sixteenth-century practices |
| de Larmessin | 1697 | "Le Triomphe" | Annotations by Louis Moquet; Supported the cult of the new chapel, without forgetting the well |

*Notes*
a. Sanfaçon (1988), 340, cites an anonymous treatise from the early sixteenth century entitled *Carnutesis ecclesie principium*, which was apparently an important precursor of Prévost. He also mentions the lawyer Jean Coignet, a member of the Parliament of Paris, who wrote of the Druidic temple of Chartres and the cult of the Virgin.
b. Delaporte cited France, BN fr.5986 as a contemporary copy or perhaps an autograph. See VdM, 619–20, and Sanfaçon (1988), 341–42, who cites Chartres, BM SA 43, t. 7, fols. 5–137.

Roulliard's title page includes a picture of the Virgin's chemise in the form of a pendant, and inside it is placed the Renaissance statue of the Virgin and Child that he later places on the Druids' altar. In another engraving the adoration scene is placed in a grotto with the well nearby, a well that Roulliard believed contained the bones of his Druidic ancestors. He also used the well as a vehicle for a Marian miracle, perpetuating the idea found in the *Vieille Chronique* that the liturgy of Chartres was recognized in the courts of heaven:

One still hears the story of a miracle that happened, as we believe, in the time of Geoffrey [of Lèves], sixty-first bishop of Chartres in the year 1116, and founder of the

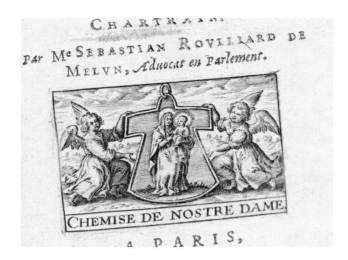

Figure 12.14. Rouillard, *Parthénie* (1609), title page. Médiathèque de Chartres. Credit, de Feraudy.

Abbey of St. Josaphat on the outskirts of Chartres. On the Vigil of All Saints, while a devout and solemn procession to the grotto of the holy places was taking place in the accustomed way (a custom still observed), one of the choirboys who carried a chandelier, being careless, fell into the well of the brave saints as he was attending the altar of the Virgin. Uninjured, and not even shaken by the experience, he was brought back by the aid and support of the Virgin herself (as we will see in similar examples in our chapter on miracles). When people asked him what had happened to him at the bottom of the well, he replied that among other things he had heard angels jubilating and responding to the public prayers that are offered in the Cathedral of Chartres (*Parthénie*, 165).

This passage from Roulliard's report demonstrates his dependence on medieval traditions and suggests that in the early seventeenth century the well and the altar dedicated to the Virgin in an area underneath the main altar were in very close approximation; "grotto" is a transformation of crypt, after all (see Guy Villette, 1988). The boy, who was helping carry the abundance of candles—apparently the main feature of this procession on All Saints' Day—into the depths of the crypts, fell into the well while serving this altar. This accident could have taken place in the Middle Ages as well as in the late sixteenth century, Roulliard's time, for liturgical action held the history and the miracle in place. As can be seen from the engraving, his view of druidic adoration also places the statue of the Virgin very near the well.

## THE VIRGIN AND THE ENLIGHTENED

For Roulliard and other Chartrain historians shortly before and after him, the Druids were proto-Christians in the Chartrain mode, pagans who, like the prophets of the Old Testament, foretold the coming of the Messiah through their beliefs

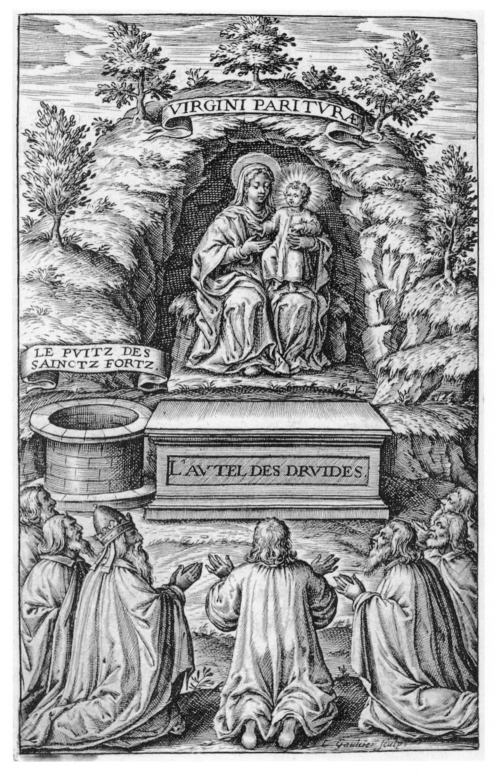

Figure 12.15. Engraving from Rouillard's *Parthénie*, depicting the Virgin and Druid priests. Médiathèque de Chartres. Credit, de Feraudy.

and actions. In creating this cultic history, a thinker such a Roulliard was making use of contemporary research into the pre-Christian past of the region but superimposing it upon the medieval framework of writings about the Virgin Mary, the saints, and the liturgy. The result would madden religious reformers in the seventeenth and eighteenth centuries, who were challenged by the Reformation to excise these examples of late medieval piety. Yet this was the time when European writers were coming to know more about the non-Roman, pagan past of their regions, and they wished to make it a part of history (see Sheridan and Ross, 1975). The miracle legends of the Middle Ages took on new life in the hands of such historians, but their new context made them even more likely prey for secular thinkers of the enlightenment. Here, as is so often the case, reformers and scholars of the seventeenth and eighteenth centuries attacked the Middle Ages for ideas that were actually developed in the late fourteenth, fifteenth, and sixteenth centuries.

In the sixteenth century, histories of Chartres were written by men like Roulliard who, although operating within the framework of the late Middle Ages, needed to incorporate an understanding of non-Roman, pagan antiquity into their views of the past. In the seventeenth century several kinds of local histories were written: Sablon wrote to make the historicized fables of the sixteenth century more widely available; Thiers, a religious reformer in the post-Counciliar vein, served as critic of practices he thought were in need of change; and Souchet wrote the first history of Chartres based on archival and historical evidence. Thus a polarization existed among local histories written in the seventeenth century, one not found in the sixteenth century; people began to have to take sides on issues of what happened and what did not, what was popular superstition, what was and was not based on "fact." This trend only increased in the eighteenth century, as the critics of cult became ever more vigorous, losing contact with the very different sense of the past that flourished in the Middle Ages and that made sense of cult but had no Druids. This was true in the liturgy as well, for canons of Chartres were, in many ways, the servants of the Council of Trent and were active reformers of their liturgy on the eve of the Revolution.

Attitudes toward the well in the crypt, a cultic "hot spot," and the supposed historical circumstances surrounding it provide a touchstone for comparing writers who lived in the sixteenth century with those who worked in the seventeenth. Roulliard's imaginative ideas did not die easily, particularly because his history had been popularized by Sablon and was available to anyone who could read; it was very much a part of local unwritten tradition as well.

In order to change attitudes toward the cults of the saints, to unclutter the popular understanding of them, religious reformers trusted not only to their own writings but also to the physical circumstances of presentation and veneration. The mid-seventeenth century was a time of dramatic change, and Charles Challine,

who often criticizes the work of reforming canons, is especially useful in understanding it. Challine's description of the events involving the well demonstrates not only that the physical circumstances of the cult had changed by his time, but also that some attempt was made to tip the hat in the direction of earlier practices. This was probably to satisfy popular demand, which may have been, we imagine, kept alive by the women who served as keepers of the cult *sous-terre* and who lived in the crypt of the cathedral by that time. From Challine on, historians mention these women in the crypt, who supposedly in early centuries took care of the shrine of the well and the altar and tended to the needs of the many sick who came, not just for brief prayers but—some of them—to stay for several days, and others to die.[77] During the Terror the women of the crypt were accused of smuggling priests there to say Mass and were officially investigated by the tribune.

Challine shows that the change was not dramatic and total, but proceeded by degrees. The well had been minimized but not yet completely removed from view, and people still knew enough about it to want to see it (hence the special importance of Nicholas de Larmessin's engraving [see below], which alludes to what could apparently no longer be seen):

The man [the tyrant Quirinus] there carried out the edict, for having found several Christians secretly assembled in the grotto of Chartres, he had them shut in as if it were a prison. Among them the most visible were Saints Potentien, Albin, and Edoal. [Quirinus] did not spare his own daughter, Modeste: having placed herself among the Christians, and not wishing to renounce the faith she had promised to God, she was first put to death with many other martyrs. Having steadfastly endured death, they were called "Les saints-fort"; their bodies were thrown in a well enclosed in the grotto, which for all time was called the Well of the saints-forts. *At present it is filled in, and can only be seen from behind a rail.*[78]

The minimization of the well surely related to the building of a splendid new chapel in the crypt, dedicated to the Virgin Mary, in the mid-seventeenth century. Clerval (1908) described the chapel in his study of "The Triumph of the Holy Virgin in the Church of Chartres," the engraving by Larmessin discussed below. He reports that the chapel was begun in 1645 and was still being worked on in 1652. The importance of this chapel, which had the statue of the Virgo Paritura on its altar, is emphasized through its position as the centerpiece of the engraving, with the Chasse depicted above it and the city of Chartres below. Before this time, the cult in the crypt had been closely associated with the well: by moving the wooden statue and its veneration out into a more open and lavish space Mary could be cut off from some of the more excessive medieval legends.

Other changes were afoot in the mid-seventeenth century besides the filling in of the well and the building of a new chapel in the crypt. Challine reports the events

of 1661, claiming that what happened was illegal and was carried out because a few canons wished it. It was surely not what he wished:

> On Monday, May 16, 1661, after noon, the doors of the church of Notre Dame were closed, not to be reopened until Wednesday following Matins. During this time there were no services, and both days and nights were given over to the demolition of all the altars attached to pillars in the church, in the nave, in the transept, in front of the jubé, and around the choir. . . . This proposition had been rejected by a general chapter meeting, but, nonetheless [was carried out]. . . . The pretext was that it would make the church more beautiful. Without consideration that all the chapels were founded by kings, counts, and other persons of stature, and that they had been charged to celebrate Masses which were said there on stations at certain days, nonetheless the altars were razed. The statues of saints found there were, for the most part, moved to altars against the walls, all around the church.[79]

This desire to be rid of saintly baggage, and for more light within the building—which was common to all regions in the period and was powerful enough to lead to the destruction of the thirteenth-century jubé in the next century in Chartres—was surely a factor in the relocation of the cult of the Virgin sous-terre. Perhaps getting Mary out of the space directly beneath the main altar was part of the liturgical and architectural aesthetic of the seventeenth century. Indeed, Van der Meulen believes that the change was masterminded by the historian Souchet, a contemporary of Challine, or, at least, that Souchet supported this cultic transformation: "Originally written around 1640, the extremely reliable study by the canon Souchet, who was responsible for the initial building work relative to the suppression of the original sanctuary of Notre-Dame de Sous-Terre, was later supplemented by himself, but decisive sections were destroyed by the cathedral chapter after his death in 1654, the year of the final relocation of the altar to a place removed from the pagan well. It is this mutilated version of his manuscript which perforce was published by Lecocq in four volumes" (VdM 6).

Souchet's four-volume history, whatever his editors may have done to it, offers a very different sense of the past from that found in the writings of the men who worked in the century before him and of his contemporary Challine (who actually survived him by twenty years). Souchet has much less in his work about the Druids, who so interested Prevost, Duparc, and, above all, Roulliard and his popularizer Sablon.

Souchet's history is the result of decades of painstaking archival work, especially study of charters and necrologies, and long reading in the chronicles and other histories of the Middle Ages. He is the only Chartrain historian from the early modern period to have control of the medieval sources, and his work on these materials, in spite of its many imperfections, is still genuinely useful. In addition, he knows the miracle literature well and the saints' lives, and he uses these materials when he

needs them; he also speaks of the oral tradition and can remember many wonderful details about what the local population of his time thought of various figures from the past. He alters various aspects of the Virgin's cult as it came to be described by his sixteenth-century predecessors, especially in regard to liturgical myths, claiming, for example, that a hymn to the Virgin purportedly sung by the Druids was actually written in the seventh century by Fortunatus, bishop of Poitiers.[80] Souchet's discussion of the martyrs of the first century is succinct, and the "well of the very brave saints," a central element in the tale for centuries, is no longer a major factor in the story. He tells the story in two parts, criticizing various claims regarding cult; later he disassociates the cult of the *Virgo paritura* from the well of the martyrs, something his sixteenth-century predecessors never would have done. Because he knows the medieval liturgical sources, he recognizes that the druidic cult had no place within them: "The legendaries of the Church of Chartres say only that Saint Altin and Saint Eoald converted many of the inhabitants of the place by their preaching; they dedicated a chapel or oratory in the grotto where the virgin about to give birth was revered, and they ordained a bishop and clergy, in order that there they might sing the praises of God." He describes the well in a subsequent paragraph and repeats the story that a Roman governor had the worshiping assembly slaughtered and their bodies thrown in a very deep well that was "near to the place where they congregated" (*Histoire*, 2; vol. 1:315).

The Chartrain historian Pintard, writing around 1700, describes the statue of the Virgin Mary after it had been moved to the newly constructed chapel pictured by Larmessin in the late seventeenth-century engraving.[81] To paraphrase the salient points of his examination: the Madonna was made of pear wood, blackened over the centuries by the smoke of incessantly burning candles. Gone is the idea that the statue was Druidic and that its fabricators chose dark wood because of aspects of their liturgical practices.[82] She sat on a throne with the child on her knees; the child offered a blessing with his right hand and held in his left hand a round globe. Mary was carved in a robe with an overgarment, styled in the manner of a dalmatic, and wore a veil reaching from her head to her shoulders as well as a crown garnished with florets; the throne was made of four pillars, of which the two in back were taller than those in front. All of this is purely descriptive. Pintard keeps the medieval sense of the statue but strips away all druidic context. His description is another example of the way in which reformers in the mid-seventeenth century were keen to disassociate the veneration of the Virgin sous-terre from the well and from the druidic legends that embarrassed them.

The apparent displacement of the statue and the altar from the so-called grotto beneath the main altar of the cathedral, where it was immediately adjacent to the well of the fortified place, and their relocation within the midcentury chapel depicted in the center of Larmessin's engraving have been much discussed by scholars in the late nineteenth and twentieth centuries.[83] Although the well could not be

found throughout most of the nineteenth century, yet another phase of its history began late in that century when it was rediscovered, and a new reworking of the older legends associated with its cult began.[84] Its location and its role in Chartrain history served as a point of dispute throughout the twentieth century. The stories of the Druids associated with it have not gone unnoticed either, and there has been some speculation by modern scholars that the Druid's cult had its roots in pagan antiquity and that it was kept alive for centuries by Chartrains who had folklike remembrances of pre-Christian times (see, for example, Spitzer, 1994). Who was this Mary of the well and grotto, a goddess whose powers were cherished by women who lived in the crypt and who for centuries made a place where women could glimpse the powers of their pagan past? The well and its Roulliardian interpretation also had a role in the postmodern age. The local historian and bookseller Jean Markale turned the story of the well into a long speculation, which included a story of Bishop Fulbert, stricken by the "mal des ardents," being nourished by sacred water from the well (Markale, 1988, 272). His approach was criticized by the Chartrain historian Guy Villette in a review published in *Notre Dame de Chartres* (1988). Markale trades in legends, but later ones from the nineteenth century; Villette knows the facts of earlier history-making processes. The well has long sustained both points of view.

## CONCLUSION: LITURGY AND IDENTITY

The above-referenced engraving made for the canons of Chartres Cathedral in 1697 by Nicholas de Larmessin offers a view of the history of Chartres, making the Virgin's cult the force that has shaped the past in this place. This large-scale statement about Chartrain history is frequently studied today for its unique evidence. It offers the only surviving picture of the Chasse of the Virgin's tunic and the only view of the thirteenth-century jubé. It includes a view of the burning of Fulbert's cathedral in 1020 and the miracle of the saving of Mary's relic (but not, of course, of the fire of 1194, when the miracle was actually first reported). Thus in this engraving, as in all histories of the period, the thirteenth-century cathedral continues to be that built by Fulbert.

Larmessin depicts the cult associated with the underground well three times in his history of Chartres. The first is in the center of the entire picture, and the cult is placed in what Van der Meulen and earlier historians believe to have been a new location in the mid-seventeenth century, perhaps provoked by the canons' disapproval of having quarters for the Virgin directly below the main altar and surely because the more enlightened among these canons disliked the legend of the well. The new altar and the chapel established for it were lavishly made and decorated, yet on top of the altar was positioned what was thought to be an ancient statue dedicated to *Virgini pariturae*, "to the virgin about to give birth." The title refers to

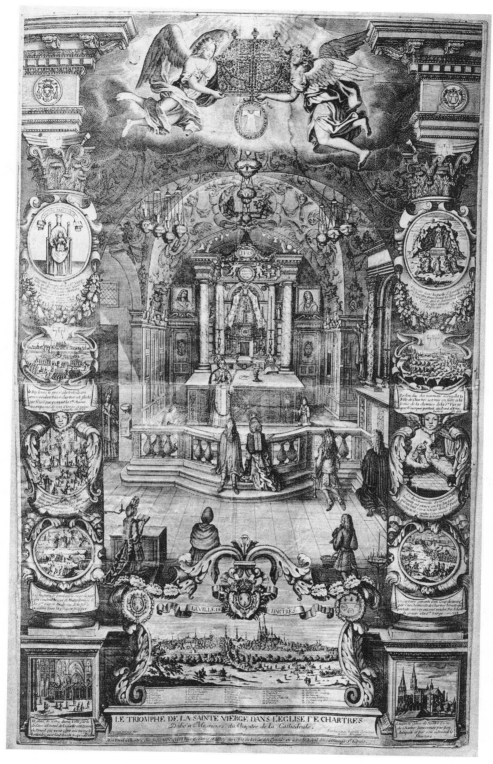

Figure 12.16. "Triumph of the Blessed Virgin in the Church of Chartres," engraving by
Nicholas de Larmessin, 1697. Archives diocésaines de Chartres. Credit, de Feraudy.

Top: Figure 12.17. The Chasse. From de Larmessin, 1697. Archives diocésaines de Chartres. Credit, de Feraudy.

Bottom: Figure 12.18. The jubé, or pulpitum. From de Larmessin, 1697. Archives diocésaines de Chartres. Credit, de Feraudy.

Figure 12.19. The altar in the crypt. From de Larmessin, 1697. Archives diocésaines de Chartres. Credit, de Feraudy.

Figure 12.20. The burning of the cathedral in 1020, here described in terms of the fire of 1194. From de Larmessin, 1697. Archives diocésaines de Chartres. Credit, de Feraudy.

Figure 12.21. The Virgin Mary nurses Fulbert. From de Larmessin, 1697. Archives diocésaines de Chartres. Credit, de Feraudy.

Figure 12.22. The cathedral dominating the landscape of Chartres. From de Larmessin, 1697. Archives diocésaines de Chartres. Credit, de Feraudy.

the cult surrounding this object of veneration and to the old tales once associated with it: yet it has other meanings as well, going back to a sermon by Bishop Fulbert, *Approbate consuetudinis*, written for the feast of the Virgin's Nativity. To the right of the chapel in the engraving can be seen the statue of a bishop gazing at the statue, crozier in hand; this is apparently Potentian, whose altar was nearby. Later historians made Potentian one of the Chartrain martyrs; locating his cult near the Virgin's altar was yet another way of transforming, yet preserving, suppressed stories of the well.

The well and its legend, and its association with a druidic past, are not missing from Larmessin's engraving. To the right is a portrait based on that found in Roulliard three generations before: Druids still venerate a virgin about to bear, and the well of their cult is nearby. The statue of the virgin found in the druidic grotto is exactly the same as that depicted to the far left and called "to the Virgin about to bear" or "Virgini pariturae." The point is made visually: the statue that was once near the well and was an ancient druidic work of sacred art is the same as that now moved away from the well and into the new chapel, above the altar, where she is also labeled "Virgini pariturae." The old traditions were still revered at the time of the engraving, at least by some canons; the engraving has placed the new chapel in the center but has retained the older history in the margins.

The new location of the Virgin in this mid-seventeenth-century chapel ultimately disassociated her cult from the ancient well in the crypt. Although tales of the well may have survived in the oral tradition, they eventually died out. The liturgical framework remained in place until very late, however. The processional of the cathedral, published on the eve of the Revolution and after significant liturgical renovations by Bishop Jean-Baptiste-Joseph de Lubersac, contained the procession

Figure 12.23. Druid priests venerate Mary at an altar to the Virgin about to bear (Virgini Paritvrae). From de Larmessin, 1697. Archives diocésaines de Chartres. Credit, de Feraudy.

Figure 12.24. The ancient statue of the Virgin in the crypt, near the well. From de Larmessin, 1697. Archives diocésaines de Chartres. Credit, de Feraudy.

Figure 12.25. The ancient statue of the Virgin, relocated to the new altar in the crypt chapel. From de Larmessin, 1697. Archives diocésaines de Chartres. Credit, de Feraudy.

on the Vigil of All Saints to the "Chapel of the Blessed Virgin, which is in the subterranean church." En route, the Magnificat was chanted in faux-bourdon, followed by a motet. The procession back to the choir was accompanied by Psalm 149, "Sing to the Lord a new song" (see *Processionale*, 330–31). The song was new and the well was gone, but the bones it once was believed to have contained were still remembered. All else could change, but not the liturgy, at least not at Chartres.

Around one hundred years before the Revolution, Challine was able to reclaim the powerful sense of Chartrain identity associated with this ceremony of liturgical veneration that took place each year on November 1, and the various myths and miracles surrounding the well of the fortified place in the Middle Ages and in his own time: "Below this entrance to the church one could see at the top of a pillar that joined this entrance to the interior a remarkable figure, which served to remind people of a pilgrim in Jerusalem who said to a religious of the Holy Sepulcher that he was Chartrain. When the religious demanded that the pilgrim prove that he was Chartrain, the man described the procession that took place every year on the Vigil of All Saints in which people carried a chandelier in the form of a papal crown,

filled with a great number of lighted candles, which passed through the portal to descend into the Grotto of Notre Dame" (*Recherches*, 131–32).

This idealized pilgrim's identity, fashioned from liturgical action and historical understanding, is like Challine's own identity. It resembles that of any person who comes to know the history-making ventures of local historians at Chartres, whenever they did their work, from the eleventh century to the present time. Challine's pilgrim to the Holy Land proves who he is by what he knows about the liturgy of Chartres Cathedral. He had acted these things out in personal patterns of remembrance, processing each year to the darkest part of the cathedral by the light of candles and looking into the dangerous well, whose miraculous stories he knew by heart. Without liturgy and history remade through liturgical reenactments of past events, and historical texts and historical legends defined within these contexts, the restless bones of the Chartrain martyrs crumble, taking time and identity for the Christians who lived there with them. Behind this elaborate façade of fabricated histories, changing century by century in this place, are two modes of reality and to know how history was made in the Middle Ages requires knowing both. One is made of proclaimed facts, and, in the case of the well at Chartres, can be dismantled so that nothing remains of people or of actual events. The other includes the centuries of people who concentrated their stories, liturgies, chants, and artworks upon this spot, and, like Challine's pilgrim, found themselves.

# APPENDIX A:

# THE LITURGICAL SOURCES FROM THE
# MEDIEVAL DIOCESE OF CHARTRES

*Most Manuscripts Represent the Chartrian Use*

*(Important MSS not originally designed for Chartres but clearly used there
later are included. Books of Hours not included. Many of these sources are
discussed in Delaporte's edition of Chartres, BM 1058.)*

| Type of Book | Present Location | Date | Secondary Sources | Original Location |
|---|---|---|---|---|
| *Sources for celebrating the Mass: Missals, Graduals, Sacramentaries, etc.* | | | | |
| 1. Gospel Book | Paris, BN lat. 9386 | IX | A | 8 |
| 2. Comes of Alcuin | Paris, BN lat. 9452 | IX[2] | AC | 8 |
| 3. Gradual | Chartres, 47 (Pal.Mus. XI) | X | ACKLM | 8 |
| (For later additions which are Chartrain, see O) | | | | |
| 4. Sacramentary | Reims, BM 307 | XII | AD | 9 |
| 5. Sacramentary | Paris, BN 1096 | XII | ADH | 7 |
| 6. Sacramentary | Evreux, BM 27 | XII | AD | 3 |
| 7. Noted Missal | Troyes, BM 894 | XII[1] | DK | 2 |
| 8. Gradual | Provins 12 | XIII[1] | K | 6 |
| 9. Noted Missal | Chartres, 520 | XIII[1] | ADLM | 6 |
| (Films made for Jacques Handschin and for Bruno Stablein for the Erlangen Archive. Facsimile edition with introduction and notes by David Hiley: *Missale Carnotense Chartres Codex, Monumenta Monodica Medii Aevi*, vol. VI, parts 1 and 2, Kassel, 1992.) | | | | |
| 10. Noted Missal | Paris, BN lat. 17310 | XIII (mid) | ADK | 6 |
| 11. Kyriale, Sequentiary | Rome, Bibl. Ang. 435 | XIII | A | 4 |
| 12. Gradual | Chartres, BM 529 | XIII/XIV | Del, Le St. J | 3 |
| 13. Missal | Oxford, Bodl. misc. lit. 344 | XIV | A | 9 |
| 14. Missal | Paris, Ste. Genevieve 92 | 1380 | ADJ | 6 |
| 15. Missal | Ricketts 73 (Chicago) | XV (mid) | | 6 |

| | | | | |
|---|---|---|---|---|
| 16. Ordo Missae | Paris, BN lat. 1116A | 1577 | AGH | 6 |
| 17. Gradual | Madrid, BN Vitrina 20.4 | 1150 | (Represents elements of Chartrian use as transported to Norman-Sicily) | |

*Completely destroyed or barely usable; not existing in any copy, but sometimes contents can be reconstructed from Delaporte's notes: Inv=Inventories of Delaporte studied by Fassler and by Cavet, who has transcribed many of Delaporte's notes as related to Marian feasts (Inv/LC).*

| | | | | |
|---|---|---|---|---|
| 18. Composite (list of sequences, prefaces, etc.) | Chartres, BM 424 | XIV (late) | Inv | 1 |
| 19. Epistolary | Chartres, BM 197 | XII | Inv | 1 |
| 20. Epistolary | Chartres, BM 532 | XV | Inv | 1 |
| 21. Evangeliary | Chartres, BM 578 | XI (early) | Inv | 1 |
| 22. Lectionary | Chartres, BM 326 | XIV | Inv | 1 |
| 23. Missal | Chartres, BM 502 | XIV (early) | Inv | 1 |
| 24. Missal | Chartres, BM 509 | XIV (early) | Inv | 1 |
| 25. Missal | Chartres, BM 523 | XIV | Inv | |
| 26. Missal | Chartres, BM 526 | XIV | Inv | 1 |
| 27. Missal | Chartres, BM 530 | XIV | Inv/LC | |
| 28. Missal (Probably a copy of a 12th-century book) | Chartres, BM 583 | XIII | Inv/LC | 1 |
| 29. Missal | Chartres, BM 584 | XIV (first half) | Inv/LC | |
| 30. Missal | Chartres, BM 591 | XIV (late) | Inv/LC | 1 |

(belonged to the chapel of the three Marys, founded in 1367, by Charles V (1364–80)

*Sources for Celebrating the Office and for Devotional Readings*

| | | | | |
|---|---|---|---|---|
| 31. Diurnal | Paris, BN lat. 17300 | XII | A | 3 |
| 32. Noted Breviary (Winter only) | Rome, Bibl. Vat. lat. 4756 | XIII (mid) | A | 10 |
| | Index being prepared by Margot Fassler and Peter Jeffery | | | |
| 33. Breviary (Summer only) | Paris, Bibl. Arsenal 103 | XIV[1] | AEI | 5 |
| 34. Breviary (Summer only) | Vendôme, BM 280 | XIV[2] | AE | 6 |
| 35. Breviary (Winter only) | Paris, BN lat. 1297 | XIV[2] | AEH | 6 |
| 36. Breviary | Paris, BN lat. 1053 | XV | AEH | 1 |
| 37. Breviary | Paris, BN lat. 1265 | XV | AEH | 6 |
| 38. Breviary | Paris, BN lat. 13240 | XV | AE | 6 |
| 39. Breviary | Le Mans, BM 184 | XV (first half) | AE | 6 |
| 40. Breviary | Évreux 31 | XIV | Coulombs | |
| 41. Lectionary | Chartres, BM 8 | XII | LM | 2 |
| 42. Lectionary | Chartres, BM 138 | XII | LM | 1 |
| 43. Lectionary | Chartres, BM 141, 142, 144 | XIII | LM | 1 |
| 44. Antiphoner (Dominican) | Victoria, Ms *096.1 R66A | XIV | Poissy | |

Online at the La Trobe Medieval Music Library (accessed April, 2009)

*Completely destroyed or barely usable Office books; not existing in any copy, but sometimes contents can be reconstructed from Delaporte's notes, as in LC. Inv=Inventories of Delaporte and Leroquais, also often found in LC*

| | | | | |
|---|---|---|---|---|
| 45. Lectionary | Chartres, 11 | XII | Inv | 1 |
| 46. Votive Collection | Chartres, 162 | XI | Inv | 1 |
| 47. Lectionary | Chartres, BM 499 | XII (early) | Inv | 1 |
| 48. Legendary | Chartres, BM 500 | XII (mid) | Inv | 1 |
| (Copied between 1136 and 1173). | | | | |
| 49. Legendary | Chartres, BM 501 | XII | Inv | 1 |
| 50. Legendary | Chartres, BM 507 | X | Inv | 1 |
| 51. Legendary | Chartres, BM 511 | XV | Inv | 1 |
| 52. Legendary | Chartres, BM 516 | XV | Inv | 1 |
| 54. Book for the Chapter at Prime | Chartres, BM 1033 | XIII (early) | LC | 1 |
| 55. Book for the Chapter at Prime | Chartres, BM 1034 | XIV | LC | 1 |

*Destroyed and unusable breviaries*

| | | | | |
|---|---|---|---|---|
| Breviary | Chartres, BM 513 | 1326–47 | Leroq/LC | 1 |
| Breviary | Chartres, BM 531 | XIV | Leroq/LC | 1 |
| Breviary | Chartres, BM 556 | XV | Inv/LC | |
| Breviary | Chartres, BM 563 | XV (early) | Inv/LC | Morancé |
| Breviary | Chartres, BM 566 | XV | Inv/LC | 1 |
| Breviary | Chartres, BM 567 | XV | Inv/LC | 1 |
| Breviary | Chartres, BM 570 | XV | LC | St. Jean |
| Breviary | Chartres, BM 571 | XV | LC | |
| Breviary | Chartres, BM 576 | XV | LC | |
| Breviary | Chartres, BM 579 | XII | | 2 |
| Breviary | Chartres, BM 588 | 1264–98 | Inv/LC | 1 |

*Ordinals and Pontificals*

| | | | | |
|---|---|---|---|---|
| 56. Two Ordinals | Châteaudun, Arch. Hot. Dieu 13 | XII | A | 1 |
| (Recently rediscovered; being restored and article forthcoming by Olivier Legendre) | | | | |
| 57. Ordinal | Paris, BN lat. 1794 | XII | AH | 3 (in Sidon) |
| 58. Ordinal | Paris, Ste. Geneviève 1256 | XII | AGH | 7 |
| 59. Ordinal | Chartres, 1058, ed. in A | XIII[1] | ALM | 1 |
| (Destroyed in 1944; photos survive) | | | | |
| 60. Ordinal | Blois, Arch Dep. H. 011 | XIII–XIV | Blois | |
| 61. Ordinal | Paris, Arsenal 838 | XV | AI | 7 |
| 62. Ordinal | Chartres, 81 | XVI | A | 4 |
| (destroyed) | | | | |
| 63. Pontifical | Paris, BN lat. 945 | XII (end) | AFGH | 1 |
| (Notation never supplied) | | | | |
| 64. Pontifical | Orleans, BM 144 | XII (end) | ABF | 1 |
| (Fully notated) | | | | |
| 65. Pontifical | Le Mans, BM 432 | 1531 | AF | 9 |

| 66. Pontifical | Reims, BM 342 | XII (end) | Reims Cathedral, but with some Chartrain features (influence of Archbishop William) | |
|---|---|---|---|---|

*Martyrologies, Necrologies, Lives, and Miracles*

| 67. Lectionary | Chartres, BM 506 (burned) | X | Dreux (chapter) | |
|---|---|---|---|---|
| 68. Martyrology/ Necrology | Chartres, BM Na4 | XI[1] | A | |
| 69. Obituary | Paris, BN lat. 991 | XII | AH | 3 |
| 70. Martyrology | Paris, BN lat. 5241 | XII | | 3 |
| 71. Necrology/ Martyrology | Paris, BN lat. 5250 | XIII, XII | A | 7 |
| 72. Martyrology | Paris, BN lat. 5280 | XII/XIII | AN | 6 |
| 73. Martyrology/ Necrology | Paris, BN lat. 10104 | XII/ | | |
| 74. Martyrology | Paris, Arsenal 1008 | XII | | 11 |
| 75. Martyrology | Paris, Arsenal 933 | XII | | 11 |
| 76. Saints' Lives | Chartres, BM 137 | XII | LM | 1 |
| 77. Book for the Chapter at Prime | Chartres, BM 1027 (burned) | 1356–64 | Inv | 1 |

Contents: 1–51 Miracles de Notre-Dame de Chartres; 51–87. Diverse notes on the History of Chartres. 87–183. Necrology. 183–214. Usuard, Recension A (second part)

*Numbers Representing Original Locations*

1 The Cathedral of Notre Dame of Chartres
2 The Abbey of St. Peter (Bendictine)
3 St. John in the Valley (Augustinian)
4 St. Chéron (Augustinian)
5 St. Martin in the Valley (Benedictine)
6 Chartrian, but actual church still to be determined
7 Elements of use, but not actually
8 Not originally Chartrian, but used in Chartres
9 Originally Chartrian, but later adapted for another place
10 St. Andrew (Augustinian)
11 Notre Dame of Josaphat (Benedictine)

*Secondary Sources Containing Descriptions of Chartrian MSS*

A Delaporte, Yves. *L'Ordinaire chartrain du XIIIe siècle.* Société Archeologique d'Eure-et-Loir: Mémoires 19 (1953).
B *Corpus Benedictionum Pontificalium.* Ed. Dom Eugene Moeller. Corpus Christianorum Series Latina, 162 (in four: 162, 162A–C). Turnhout, 1971–79.
C Gamber, Klaus. *Codices Liturgici Latini Antiquiores,* 2d ed. Freiburg, 1968.
D Leroquais, Victor. *Les Sacramentaires et les missels manuscrits des bibliothèques publiques de France.* 3 vols. Paris, 1924.
E ———. *Les Breviaires manuscrits des bibliothèques publiques de France.* 5 vols. Paris, 1934.
F ———. *Les Pontificaux manuscrits des bibliothèques publiques de France.* 3 vols. Paris, 1937.
G *Catalogue des manuscrits en écriture latine portant des indications de date, de lieu or de copiste.* Ed. C. Samaran and R. Marichal. 6 vols. Paris, 1959–

H *Bibliothèque Nationale. Catalogue général des manuscrits latins.* 6 vols. to date (through no. 3775). Paris, 1939–

I *Catalogue des manuscrits de la Bibl. de l'Arsenal.* Ed. Henry Martin, et al. 9 vols. in 11. Paris, 1885–95.

J *Catalogue des manuscrits de la Bibl. Sainte-Geneviève.* Ed. Ch. Kohler. 2 vols. Paris, 1893–96.

K *Le Graduel romain:* II *Les sources.* Ed. Michel Huglo. Solesmes, 1957.

L *Catalogue Général des manuscrits des bibliothèques publiques de France.* Vol. 11: *Chartres.* Paris, 1889.

M *Catalogue Général des manuscrits des bibliothèques publiques de France.* Vol. 53: *Manuscrits des Bibliothèques Sinistrées de 1940 à 1944.* Paris, 1962.

LC Cavet, Laurent. "Le Culte de la Vièrge à Chartres," M.A. Thesis. Sorbonne, 1999.

N De Smedt, C. *An Boll* 8 (1889): 1–208.

Subsidia Hagiographia 6, 70.

Don Dondi, Cristina. *The Liturgy of the Canons Regular of the Holy Sepluchre of Jerusalem.* Bibliotheca Victorina XVI. Turnhout, 2004.

*Sources exclusively devoted to MSS from the now-destroyed library at Chartres*

O *Fragments des MSS de Chartres.* Ed. Yves Delaporte. Pal. Mus. Ser. 1, Vol. 17. Solesmes, 1958.

P *Les Manuscrits enluminés de la Bibliothèque de Chartres.* Ed. Yves Delaporte. Chartres, 1929.

(Further discussions of several MSS are found in select vols. of *Société Archeologique d'Eure-et-Loir: Memoires.*)

*Photographed Fragments*

Closer Description of Noted Fragments in Pal. Mus. Ser. 1 17 (Listed by notation type, following Delaporte)

*Adiastematic Neumes*

| | | | |
|---|---|---|---|
| Chartres 4, f1 | Jerome, *Eight Books on Isaiah.* | St. Peter (IX–X). | Eleventh-century neumes, discant voice, with signifying letters. See Gushee Vat. Reg. 586, fol. 87 for comparison |
| Chartres 23 | Gospels | St. Peter (X–XI) | Intoning of Matthew for Christmas Matins has a noted salutation "Dominus vobiscum" and neumed verses 1–18. The notator has transformed earlier accentual markings into neumes and sometimes erased them when necessary |
| Chartres 24 | *Liber Comitis* (Liturgical readings) | St. Peter (IX) | Script of Tours; neumes for epistles of Stephen and John may have been added at St. Peter |
| Chartres 25 | Rabanus, Autpertus, Saints, Charter | St. Peter (XXI) | F.118v Neumed copy of the Offertory for St. Stephen, "Elegerunt" |
| Chartres 31 | Collection of the Fathers | St. Peter (IX) | Guard leaf, pen trials with eleventh-century neumes |
| Chartres 39 | Augustine's *Confessions* | St. Peter (X) | Guard leaf, "Pastori summo," Invitatory for St. Peter, but not used at St. Peter |
| Chartres 44 | Haimo of Auxerre, Commentaries | St. Peter (X) | Fols. 1 and 2 Neumed hymns from the eleventh century |
| Chartres 57 | Lectionary | St. Peter (X–XI) | Fol. 221v chants with neumes from various time periods |

| | | | |
|---|---|---|---|
| Chartres 65 | Gregory, *Pastoral Rule*, etc. | St. Peter (IX) | Fol. 107v Various eleventh-century neumed chants |
| Chartres 78 | Augustine, *Opuscula* | St. Peter (X–XI) | Fol. 1, Various Benedicamus settings, 11th-century neumes |
| Chartres 89 | Gregory, *Dialogues* | St. Peter (X) | Various neumed additions from the 11th century |
| Chartres 95 | Jerome, *Commentary on Daniel* | St. Peter (X) | Fol. 87v Neumed antiphon and Benedicamus, 11th century |
| Chartres 111 | Jerome/Daniel and Fulbert | Cathedral (IX–XI) | First words of a poem have 11th-century neumes |
| Chartres 115 | Lives of the Saints | St. Peter (IX–X) | Intoned opening of Saint's life has 11th-century neumes |
| Chartres 126 | Jerome, *Against Jovinian* | Cathedral (X) | Fol. 135v Neumed alleluia verses and a responsory, 11th century |
| Chartres 130 | Theory treatises | St. Peter (IX-X) | Some of the works on Fol. 50 are not polyphonic |
| Chartres 507 | Legendary and Martyrology (Adon) | Cathedral (X) | Pen trials in margins include neumes |
| Chartres 577 | Sacramentary | St. Peter (X) | Neumation for various texts, including the Exsultet |
| Chartres 579 | Breviary | St. Peter (XII) | Book was prepared for neumation that was never added except in a handful of places |
| Chartres Na 4 | Martyrology/Necrology (extant) | Cathedral (XI) | The Office of St. Giles in eleventh-century neumes |
| Orleans 148 | Sermons of St. Ambrose | Fleury to Blois? | Sequence for St. Carileff in late 10th-century neumes |

*Breton Neumes*

| | | | |
|---|---|---|---|
| Chartres 21 | Collations of John Cassian | St. Peter (IX–X). | Fol.7 Sequence "Ad celebres" in Breton neumes |

Chartres 47 (PalMus XI)

| | | | |
|---|---|---|---|
| Chartres 110 | Various Fathers copied from X–XII | St. Peter | Fol. 88 First words of a hymn, neumed in the 11th century |

Chartres, Archives Departmentales d'Eure-et-Loir. Fragment

*Transitional between Breton and French neumes*

| | | | |
|---|---|---|---|
| Chartres 152 | *De Trinitate*, Augustine | St. Peter (X) | Three antiphons for Office of Trinity added before the epitaph of Abbot Landri (d.14 March 1070) |

*Norman Neumes*

| | | | |
|---|---|---|---|
| Chartres 162 | Book of the Cult of the Virgin Mary | Cathedral (IX) | An Assumption antiphon has Norman neumes added (mid twelfth?) |

*French neumes arrayed against a single dry-point line*

| | | | |
|---|---|---|---|
| Chartres 71 | Aristotle, Cicero, Boethius | St. Peter (IX) | Guard leaf has responsories for St. Giles in 11th-century neumes |

*French neumes with more than one dry-point line*

| | | | |
|---|---|---|---|
| Chartres 57 (see above) | | | |
| Chartres 109 (Fr-Messine) | Opuscula of Augustine | St. Peter (IX–X) | Guard leaf at end has polyphonic works; not in notation characteristic of Chartres but rather French-Messine in character |
| Chartres 130 (addition, f. 50v) | Theory treatises | St. Peter (IX–X) | Fol. 50 Polyphonic pieces, all Alleluias, with 11th-century neumes |

*French neumes against 4 dry-point lines, two of which are colored, yellow for do and green for fa*

| | | | |
|---|---|---|---|
| Chartres 47 (13th-century additions) | | Cathedral | Additions are for the Consecration of Oils, Pontifical Mass of Holy Thursday |
| Chartres 195 | Chartrain Pontifical (see above) | Cathedral | |
| Chartres 520 | (see above) | | |
| Chartres 525 | Dominican Missal | Dominicans | Covers backed by pages of a twelfth-century monastic breviary |
| Chartres 528 | Liturgical collections (mostly XIV) | Cathedral | Two folios were photographed, opening of the Exultet (XIV) and the preface for Holy Thursday with illuminated initials (XIII), the latter belongs to this category |
| Chartres 583 | Unnoted Missal, first part (XIII) | Cathedral | On two folios chants were added by a contemporary hand |
| Chartres 1056 | Necrology (XIII) | St. Saturnin | Capitula, antiphons, and hymns (2 pages) |
| Paris BN lat. 5583 | Lives of the Saints (XII) | | Fol. 120 Fragments of an antiphoner in Chartrain notation (not in PM XVII) |

*Square notation on 4 lines, with green for fa and yellow for do*

| | | | |
|---|---|---|---|
| Chartres 519 | Missal of St. Peter (XIV) | | Prefaces only are noted; some Gloria intonations added in XIV. |
| Chartres 521 | Missal of St. Peter (XIII) | | Noted prefaces and two Sanctus and one Agnus |

Left: Figure App.A.1. Yves Delaporte, self-portrait. Archives diocésaines de Chartres. Credit, Delaporte.

Below: Figure App.A.2. Late nineteenth-century map of the diocese of Chartres as it would have been before the divisions of 1697.

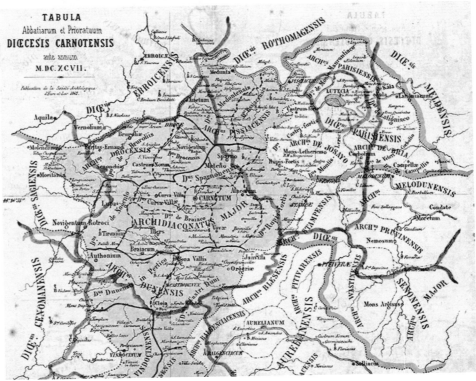

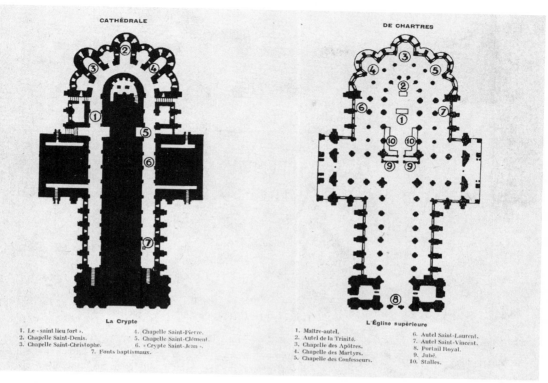

DE CHARTRES

La Crypte

1. Le « saint lieu fort ».
2. Chapelle Saint-Denis.
3. Chapelle Saint-Christophe.
4. Chapelle Saint-Pierre.
5. Chapelle Saint-Clément.
6. « Crypte Saint-Jean ».
7. Fonts baptismaux.

L'Église supérieure

1. Maître-autel.
2. Autel de la Trinité.
3. Chapelle des Apôtres.
4. Chapelle des Martyrs.
5. Chapelle des Confesseurs.
6. Autel Saint-Laurent.
7. Autel Saint-Vincent.
8. Portail Royal.
9. Jubé.
10. Stalles.

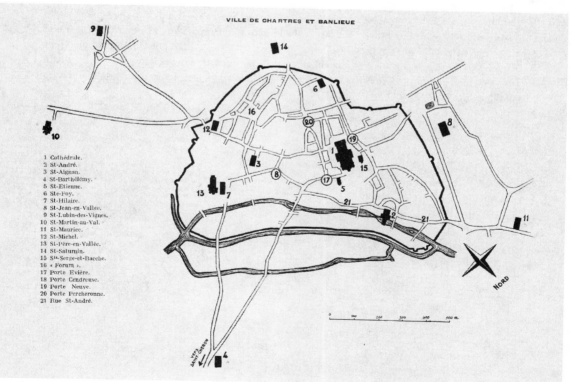

VILLE DE CHARTRES ET BANLIEUE

1 Cathédrale.
2 St-André.
3 St-Aignan.
4 St-Barthélémy.
5 St-Etienne.
6 Ste-Foy.
7 St-Hilaire.
8 St-Jean-en-Vallée.
9 St-Lubin-des-Vignes.
10 St-Martin-au-Val.
11 St-Maurice.
12 St-Michel.
13 St-Père-en-Vallée.
14 St-Saturnin.
15 Sts-Serge-et-Bacche.
16 « Forum ».
17 Porte Evière.
18 Porte Cendreuse.
19 Porte Neuve.
20 Porte Percheronne.
21 Rue St-André.

Top: Figure App. A.3. Plan of the cathedral showing altar locations. From Delaporte, *OC.* Société Archéologique d'Eure-et-Loir, Chartres. For a more detailed map, see Lautier (2009).

Bottom: Figure App. A.4. Map of the town, showing the location of churches. From Delaporte, *OC.* Société Archéologique d'Eure-et-Loir, Chartres.

# APPENDIX B:
# INVENTORY OF CHARTRES NA4; DESCRIPTION AND
# TABLE OF CONTENTS OF VAT. LAT. 4756

### INVENTORY OF CHARTRES NA4

The complex manuscript Chartres, Na4, whose contents are tabulated below, survived the fire of 1944 because it was stolen long ago. The manuscript was taken from Chartres in the late eighteenth century by a canon of Chartres, Antoine Courbon du Terney, and sold when his books were dispersed. It ended up eventually in the municipal library of St-Etienne (Loire), Courbon du Terney's hometown.[1] The work was edited and published in 1893 by René Merlet and Alexandre Clerval, who used various typefaces to indicate the layers of additions to the original necrology.[2] After the fire of 1944 the manuscript was returned to Chartres, where it is now listed as Nouvelle Acquisition 4 (our Na4). The necrology, a witness to the activities of Bishop Fulbert's own clerics and to those who survived his death in 1028, provides the first evidence of an attempt to lionize this particular bishop of Chartres.

*Contents of* Chartres Na4
3–8v Tables and a treatise on the computing of Easter (XI–XII)
9–32v Martyrology of Usuard (recension A)
33–34r Fulbert's obit, inserted soon after his death in 1028
34v–96 Martyrology of Usuard (recension A) continued
96–98 Office of St. Giles (XI)
98v Death notice
99–130v Necrology
131 Death notice of Ivo, inserted soon after his death in 1116
131v Charter prepared by Hugh of Gallardon, cantor from 1149 until 1159 (DIGS 33)
132 blank
132v Document of the canons of the cathedral (c.1121)
133–133v Litanies (XII)
133v Prayers after the litany (XII)
134–135v Clamor (XII)
135–139 Readings and prayers for the Office of the Dead
139v–140 Collects and chapters for feasts of Mary
140v Document of a provost at Chartres (1070)
141 blank
142 Obituary table of benefactors of the chapter (18th century)

## DESCRIPTION AND TABLE OF CONTENTS OF ROME, VAT. LAT. 4756

Vat. lat. 4756: A Thirteenth-Century Notated Breviary from Chartres
(Prepared by Margot Fassler with Susan Boynton)

*Binding:* loose, modern stamped-leather

*Dimensions:* 363 ff., 140 x 115 mm. (115 x 77)

*Pages:* Main body of the MS. Fine parchment ruled across the page on hair side with a dry point. Pages are 2 columns, 47–49 lines; each column: ca. 34 mm. wide; space between columns: ca. 10 mm. The two columns of writing are ruled in lead pencil: inner and outer single horizontal boundary lines and double or triple vertical boundary lines at top and bottom of page; some prickings are still visible.
Departures:
ff. 41–52: 1 column; lines ruled in very faded pale-brown ink with single horizontal and vertical boundary lines
ff. 266–268: 1 column; various lines

*Quire signatures:*   A. In the lower right of verso
B. Beginning on f. 269 lower right of recto

*Foliation:* modern, in light-brown ink in upper right-hand corner

*Ink:* main body of text in varying shades of dark brown ink; later additions are either lighter (ff.266v–268v; ff.357v–359r) or darker (ff.350r–357r)

*Decoration:*
*Lettres d'attente* visible throughout;
Flourished initials occupying two to five lines, red flourished with light green, blue flourished with red or green flourished with red. Simple flourishing on upper and lower lines of some scribes' work, showing the influence of chancery training. These occasional pen flourishes on terminals of letters are often decorated with red.
A few gold-painted initials outlined in black with mauve or blue infilling and a background of mauve or blue outlined in black. In other cases the gold letter is on a segmented mauve-and-blue ground with white-line filigree decoration. Kalendar letters on segmented red-and-blue ground with white-line decoration. Painted initials are found in the Calendar and Psalter, for several feasts in the Temporale, and for saints Andrew (2), Nicholas (2), Tiburcius and Valerian (1), and Cheron (2).

*Music notation:* 4-line staff with green F-line (which corresponds to a line of ruling) and light-yellow C-line. C or F clefs; no custos. Many staves have no clefs.

*Annotation on f. 357r:* "Messer Philibert Leblont chapelain en l'eglise de Meux"

*Contents:* (Sections not indented, although in a variety of hands, are contemporary; indented sections are a variety of later supplements, which have been labeled "S" and numbered in order of appearance, rather than chronologically.)

ff.1–3v Calendar; ff.4–36v Psalter; ff.36v–40 Canticles and litany; f.40v Blank

[Supplements]

S1: ff.41–52v Rubrics followed by votive offices, the office of Peter Celestine (cd 1313), and a Saturday office for the Virgin Mary (not noted)

ff.53–348v

Winter Breviary (with but few exceptions, fully notated and with plentiful rubrics): Temporale beginning with Advent I (ff.53–252v); Common of Saints; Office of the Dead (ff.253–265v, not notated);

S2 and S3: two later additions: ff.266v–267r Second Translation of St. Aignan (not noted); ff. 267v–268v Translation of St. Nicholas (not noted) Sanctorale (ff.269–349v)

S4: ff.350–357 Later appendix to the Sanctorale

S5: ff.357v–363v Various late additions, including the Office of Corpus Christi

269r Rubrics explaining what to do when the feast of Andrew interferes with Advent

269v Large gilt initial for Andrew

270r Second large gilted initial for Andrew

273v What happens to Tugdale and Andrew if first Sunday of Advent interferes. See also OC p. 191

Presence/Absence of Feasts Useful for Dating Chartrain MSS in Vat.lat. 4756

Key: Add.=Added to Cal. by a later hand; XX=Outside the scope of this Winter Breviary; Supplements (in order of appearance rather than by date)=S1, etc.

| Feast | Date in Chartres | Calendar (12 months) | Main text (Dec–May) | Supplements (Dec–May) |
|---|---|---|---|---|
| Corpus Christi | By 1326 | No | No | S5 |
| William of Bourges Jan 10 | After 1218 | Add. | No | S4 |
| Ambrose April 4 | After 1298 | Add. | No | S4 |
| Trans. Odilio April 12 | After 1348 | No | No | No |
| John at Latin Gate May 6 | Raised to 9 lc during 13th C. | Yes | 3 lc | S4 |
| Trans. Nicholas May 9 | Add during 13th | No | No | S3 |
| Peter Celestine May 19 | After 1313 | Add. | No | S1 |
| Ivo of Brittany May 21 | After 1347 | No | No | No |
| Mary Jacoby May 22 | 1385 | No | No | No |
| 2 Tran. Aignan June 10 | 1264 | Add. | XX | S2 |
| Margaret July 20 | During 13th | Add. | XX | XX |
| Anne July 26 | 1205 | Add. | XX | XX |

| | | | | |
|---|---|---|---|---|
| Bethus<br>Moved from<br>Aug. 1 to 2 | 9 lc in<br>1368 | Raised to Mem.<br>only on<br>Aug 1 | XX | XX |
| ND of Snows<br>August 5 | 1376 | No | XX | XX |
| Trans. Holy Crown<br>August 11 | 1239 | No | XX | XX |
| Louis<br>August 25 | 1297 | No | XX | XX |
| Theclus<br>Sept. 23 | During 13th | No | XX | XX |
| Francis<br>October 4 | After 1228 | No | XX | XX |
| Mary Salome<br>October 22 | 1385 | No | XX | XX |
| Presentation BVM<br>November 21 | After 1372 | No | XX | XX |
| Eloi<br>Dec 2 at ND; Dec 1<br>at St. Jean | During 13th | Yes<br>Yes: Dec 1<br>Add. Dec 2 | Yes | No |
| Conception BVM<br>December 8 | Around 1300 | Add. | No | S4 |
| Thomas of Canterbury<br>December 29 | Soon after 1173 | Yes | Yes<br>Unnoted,<br>although space<br>was left for music | No |

# APPENDIX C:
# READINGS FOR THE FIRST AND SECOND
# TRANSLATIONS OF SAINT ANIANUS

*"Translationes S.Aniani Carnotensis episcopi annis 1136 et 1264 factae,"*
*ed. Alexandre Clerval.* Analecta Bolandiana 7 (1888), 327–35.

PREFACE

In the year of the Lord 1134, a great fire took place in Chartres. The church of blessed Anianus, confessor and bishop of Chartres, was burnt, and the fire came right up to his tomb. But, by the mercy of God, his bones were saved like gold tested by fire [1 Peter 1:7] so that they are, as we ourselves have seen, even more beautiful. When part of the church had been restored, as we were standing by, Lord Geoffrey, the first bishop to rule the church of Chartres after Bishop Ivo, transferred the bones of blessed Anianus, confessor and our bishop, to the most honorable place in the church, where they now rest. It was then decreed by the aforementioned bishop and the church of Chartres, that the feast of the translation should be celebrated in perpetuity on the seventh of December. Because we know these things through a sure revelation, we have set them down to be read by those who come after us.

1. This man, the most blessed Anianus, was of distinguished birth. He was remarkable for the wide extent of his lands, pleasant in manner, and celebrated for the glories of his learning. He was strong in faith, chaste but humble, and outstanding for the ardor of his charity, and he was considered admirable on account of his reputation for devotion, not only among his own people, but also among those in neighboring cities. And so when blessed Martin, bishop of the city of Chartres, a man of great merits and virtues, had entered the doorway of eternal bliss, holy Anianus was chosen by the universal consent of all the clergy, secular rulers, and people. He had long deserved this for his auspicious merits. On the episcopal throne, with great magnificence and divine praises, he was carried to the church of Mary, the most blessed Genetrix of God. There he was consecrated by the bishops, to the Lord's decree and delight [*jubente simul et juvante*], and he received the name and office of shepherd and spouse, to the end that he feed and protect the Lord's sheep.

2. Once the lamp was lit and placed on a lampstand in the Lord's house, it began to spread the rays of its holiness more widely and brightly, enkindling the ardor of the faith of his love in the hearts of his hearers by the word of catholic preaching and the example of holy action. Once Anianus had attained the episcopal throne, he renounced all worldly pleasures, cares, concerns, and pomps, by action and attitude of mind and of body; he was the first to manifest what he taught and the first to fulfill what he commanded. He accepted a new planting in the Lord's vineyard: the less rooted

and cultivated it was, the more laboriously did he exert himself. He was concerned to eradicate the thorns and briars that had grown over it from the error of a paganism only recently converted, and, through the fecundity of good works, he never ceased to make it a faithful planting, its sprouts a delight to the Lord.

3. Standard-bearer for the celestial army and herald of the judgment to come, the venerable Bishop Anianus admonished the children entrusted to his care by coaxing, frightening, and appealing to them; he balanced his words with such careful discernment that he never shattered people's hope by frightening them, nor made them negligent by flattering them. He restored peoples who were crude and still belching up the undigested barbarity of ancient error with the novel antidote of evangelical preaching and spiritual doctrine, and, lest the preacher fall away, he chastised his flesh by sanctity of life joined to abstinence from food; he persuaded the obstinate minds of some by reason, and shaped those of others by his example. The truth of his words was confirmed by the persistent power of his signs; things not yet discovered, even though they were written, he caused nonetheless to be believed by his deeds, and they are experienced by their lasting effect even today.

4. Listeners must not be shocked if they fail to find written the life and miracles of such a great man as our patron and bishop Anianus, when, in addition to the spiritual benefits that he bestows daily on the faithful who devotedly ask of him, his paternal authority, episcopal dignity, and the frequent miracles shown forth in our own times all testify to his holiness. By the authority of all the bishops of Chartres who have succeeded him, we know, we believe, and we hold that this glorious patron Anianus is worthy by merit of his sanctity to be venerated and devotedly celebrated; we are also to seek faithfully his pious intervention with God for our faults, since the bishops faithfully and submissively sought the advocacy and mediation before the terrible sentence of the supreme Judge, to whom they were afterwards joined not only by the office of their dignity but also by the merit of sanctity.

5. For one who doubts how great his holy successors believed his merits and holiness to be, let him note that they dedicated in honor of his name the church he himself had founded and constructed. They took his most holy bones reverently from the sarcophagus in which he had been buried, among his sisters in the lower crypt, and they laid them properly on the holy altar in the upper basilica with all honor and reverence, and they deputed seven attendants of the order of canons to sing praises to God before these most holy limbs.

Next let us clearly show that the episcopal dignity commended the merits of his sanctity. When blessed Peter the apostle directed the holy martyrs Savinian and Potentian to the city of Sens, Altinus and Eodaldus, their colleagues and fellow ministers of the word of God, were sent by them to the city of Chartres. The following is written of them in the passion of those martyrs:

> The holy ones of God, seeing that the crowd of believers there was not small, dedicated a church within the walls of the city in veneration of Mary the virgin genetrix of God, with the Lord consecrating it, and in the same place they chose the servers of each office effectually one by one.

6. By these words it is clearly stated that the clerical order was ordained for the people, and the bishops for the clergy. According to the catalogue of bishops, we read and we believe that Adventinus was the first consecrated bishop of this city. He was succeeded by Obtatus, Obtatus by Valentinus, Valentinus by Martinus, and Martinus by this our patron, Anianus. The amount of time that passed as one succeeded the other we can estimate, but not affirm. This however we can say truthfully, that holy Anianus flourished near the time of the apostles and at the time of the martyrs. He took up the episcopal government under the storm of Christian persecution, not with the arrogance of worldly disdain, not with ambition for high rank, not with a voracious desire for corporeal pleasure. It is certain that while the possessions of the episcopate were still meager, and the sufferings inflicted on Christians were insupportable, the episcopal office was not coveted but feared, not desired but fled from. At that time a bishop might receive at a moment's notice threats and abuse, hurts and injuries,

imprisonments and chains, proscription and exile, and at last the exquisite torments of a novel form of death. Although he might end his life in peace, still he was a martyr by his life and his will.

7. It also increases the merits of his holiness not a little, that by his advice and example he incited his three sisters, Ermemilda, Munda, and Dunda, to a vow of perpetual chastity and to the religious life. Thus, abandoning the conjugal embrace, by his hand they entrusted to God the inheritance that had been left to them, and earnestly asked to be consecrated. Benevolently accepting their freely given offering, not, as once, their brother, but as their loving father, he made over the properties of their patrimony—which retain the sisters' names to the present day—for the use of the bishop of Chartres, and he consecrated them to Christ as virgins, instructing them fully in the discipline of chastity. O truly worthy bishop of God, who celebrates the spiritual—not the marital— nuptials of his sisters, desiring them to be fruitful not with heirs, but with virtues! The love of God conquers carnal feeling: it obtains a better patrimony by spending, and it owns most fruitfully by losing.

8. But so that we might come to the most certain and familiar proofs of his powers, let us report what we have observed about the bones of his holy body, to the praise of God and of so glorious a confessor.

These cities have often been chastised by the judgment of divine punishment, a judgment just, indeed, and hidden; chastised sometimes by sterility of the soil, sometimes by plague, insurrection, devastation by war and hostility, or by the burning of an entire city. We have learned from the old people among us, and we have found it, too, in the writings of our forebears, that over a period of fewer than two hundred eighty years this city was burnt five times, with its churches and other buildings almost totally destroyed and raised again in the wilderness. The first of these fires took place in the year 870; the second in 963, in the time of the Huns, who carried out a great massacre of Christians. Among those killed was the venerable bishop Frotbold [*sic*], as well as the greater part of his clergy. The third fire occurred in 1020, the fourth year of the episcopate of Lord Fulbert, on the very night of the Nativity of the Virgin. In this fire the cathedral was not only burnt, but completely destroyed. The glorious Bishop Fulbert then devoted his diligence, his labor, and his money to its reconstruction from the foundations; he made it of an astonishing beauty and grandeur, and left it almost finished. The fourth fire took place in 1030, on the eleventh of September, during the second year of the episcopate of Lord Thierry.

9. The fifth fire took place in the year 1134, on a Wednesday, September fifth. Nearly the entire city was consumed, but by the miraculous mercy of Jesus Christ the church of his Genetrix was spared from the rushing flames. The basilica of blessed Anianus and his holy body—the feet of which were near the wall, but the head supported by the bier of the altar—even as the wood enclosing it was completely consumed, was abandoned by the voracious flames and, by the mercy of God, was preserved unharmed. For, while all the bones of his holy body were falling to the pavement around the burning bier, not one was found broken, nor was any other reduced to dust. And thus God preserved all his bones unharmed so that not one was destroyed. Bishop Geoffrey, the successor of the venerable Ivo of good memory, saw to it that the bones were carefully gathered, and when a new covering had been placed upon the cloth on the holy altar, they were reverently replaced in the crypt.

After two years, the church had been repaired and covered with a beautiful roof. Then, on the second Sunday of Advent, on which was celebrated the feast of Saint Nicholas, [Bishop Geoffrey], bearing the holy bundle in his arms, accompanied by all the clergy and the people of Chartres, preceded by candles and thuribles, and with the venerable abbots of this city coming from different directions to assist him, with hymns and divine praises, replaced [the bones] on the high altar of the basilica, and they were enclosed with due honor and reverence in the very place where they had been, two years and three months having passed since the fire.

Before they were enclosed, earnestly examining each bone with our eyes and admiring equally their brightness and integrity, with the greatest devotion we praised almighty God, who is so won-

drous in his saints, and who had preserved the bones of his holy bishop Anianus uncorrupted and whole through so many cycles of years, from threats from the citizens, destructions of the city, and burnings of his church.

After the customary sermon to the people, the aforementioned Bishop Geoffrey established and ordered that this day of the translation of the holy confessor and bishop Anianus be observed every year on December seventh, and since the feast of Saint Nicholas could then not be celebrated, he moved it to the next day. And so, like the other feasts of saints that fall in the season of the Lord's advent, it would be celebrated not in affliction and fasting but with joy and spiritual delight. And since the days of his ordination [as bishop] and of his burial are not known, at least the festival of the translation might be celebrated by the faithful at a certain time and gain the due prizes of devotion and great honor.

## SECOND TRANSLATION

8. And now let us come to the most certain and novel proofs of his virtues and sanctity, and to the subject of today's feast. After those five burnings of this city of Chartres, listed carefully in the history of the winter translation of this glorious high priest, and after one hundred and twenty-eight turnings of the years, a sixth fire took hold of the city of Chartres. Another, new miracle now succeeded the earlier, ancient one, not unlike it in kind, for the praise of God, who in his saints is ever glorious and wondrous—a miracle worthy to be joined to it, proclaimed in church, and kept continually in mind.

In the time of our venerable father, Lord Peter, seventy-third bishop of Chartres, in the year of the incarnate Word 1262, on the tenth day of the month of June, the vigil of Saint Barnabus the apostle, almost the entire city of Chartres was subjected to divine but hidden judgment. Although all other churches were burned, by the mercy of God those of the glorious Genetrix of God and of the blessed apostle Andrew were in some way saved from the fire. The basilica of our patron was completely burned; the bells of the church were turned to liquid and reduced to a mass; the wooden bier within which the most sacred bones of our patron had been enclosed was surrounded by fire, and his bones, as they fell out on to the pavement of the church, were covered by the whirlwind of stones and burned wood falling upon the bones from above. The people standing by now wept sorrowfully over the remains of our venerable and glorious high priest and thought that they were shattered by fiery rocks falling on them, reduced to cinders by the consuming fire. Yet as fuel and fire declined together and ceased, the people's devotion, made by the fire more eager to seek, with God's help, the relics of this holy father, or at least the ashes or the fragments of his bones, set about to quickly gather up the pile of burned stones.

9. Soon the divine power and grace, which is always present to those worthily invoking it, was made manifest. He who kept the burning bush from being consumed and appeared with the three boys in the fiery furnace as a fourth, checked the heat and nature of the fire and preserved the bones of this his athlete unconsumed and whole. To his faithful people faithfully seeking them, he granted effectively to find them and, like gold proven by fire, to draw them from the furnace of fire and recover them. So with the oversight of lord Peter the bishop, they were gathered diligently and reverently, as was fitting, placed in a very clean pall, and carried off to the church dedicated to the memory of blessed Andrew, there to be conserved pending the repair of the church of this Saint Anianus.

Two years later, with the better part of the church of our patron having been restored, on the feast day of Saint Barnabas the apostle, the lord Peter took the very sacred bones back to the church of holy father Anianus, with the honor and respect owed them, as venerable men stood with the dean and the chapter and all the clergy and people of Chartres, together with the holy abbots and the friars preacher and minor [Dominicans and Franciscans] of the city and of the suburbs of Chartres, with hymns and divine praises. In a pristine place over the altar—that is, the major altar—of

his basilica they were gathered together. In the customary sermon on the word of God in that very church, the bishop proposed and ordered, and in his synod that followed soon after he established and ordained, that a feast be celebrated each year, for all time, on the vigil of blessed Barnabus the apostle for this translation of our holy father and bishop Anianus, for the praise, glory, and honor of the most high and individual Trinity, and for our nourishing bishop Anianus: that with his mind and prayers he may obtain for us, the caretakers of his sacred body thus preserved from the assault of temporal fire, that we be freed from all enemies and dangers to merit and body in the present time, and from the fires of hell in the future, with our Lord Jesus Christ granting this, who with God the Father and the Holy Spirit lives and reigns blessed for all ages. Amen.

# APPENDIX D:
# MUSICAL ANTHOLOGY

Sequences Found in Chartres by the End of the Twelfth
Century for the Virgin or with Themes Related to "Styrps Jesse"
and "Paritura" Motives, following both OV and *OC*

Sequence Texts (orthography as in Chartres BMun 529)

### I. TABLE OF CONTENTS FOR SEQUENCES

| *Feast/title*<br>(Melody type, if known, and sequelae number from Hughes) | *Date and Origin* | *Hiley No.* | *AH* |
|---|---|---|---|
| No. 1 in anthology<br>*Christmas*<br>"Sonent Regi" | 11th century | 10 | 50:282 |
| No. 2 in anthology<br>"Lux fulget hodierna"<br>(Melody: Mater 36) | 11th/12 century/ Chartrain? | 7 | 8:14 |
| No. 3 in anthology<br>*Easter feria*<br>"Ecce uicit"<br>(Melody: Chorus 9) | late 10th century, Italian or French | No | 7:63/53:73 |
| No. 4 in anthology<br>*Purification (Feb. 2) and on the Feast of the Dedication (Oct. 17) and the days of its octave, except on a Sunday within the Octave*<br>"Claris vocibus"<br>(Melody: Adorabo minor 4) | late 10th century, French/English | 47 | 7:118/53:174 |
| No. 5 in anthology<br>*Annunciation (March 25) and on Sunday in the Octave of the Dedication; one of two possibilities for the thirteenth-century feast of the Memoria of the Dedication*<br>"Hac clara die"<br>(Melody: Post Partum 45) | 10th century | 48 | 7:115/53:168 |

Not in anthology
   *Assumption (August 15)*
"Aurea virga"           11th century              46         7:122/53:186
   (Melody: Hodie Maria virgo 26)
Translation and music in Boynton (1994)

No. 6 in anthology
   *Nativity BVM (Sept. 8)*
"Alle celeste necnon"     late 9th century        45         7:111/53:166
   (Melody: Mater sequentiarum 37)

No. 7 in anthology
   *St. Anne (July 26)*
"Mater Matris Domini"   early 13th century/Chartres   No       39:101
   (Melody: Mane Prima Sabbati)

No. 8 in anthology
   *Dedication of the Church and a choice for the Octave of the Assumption*
"Salve porta"           10th century           51         7:123/53:188
   (Melody: Maris stella 35)

No. 9 in anthology
   *Dedication of the Church (not in OV or OC, but at the Abbey of St. John in the twelfth century)*
"Clara chorus"         late 11th century       99         54:138
   (Melody: Congaudentes)

## II. SEQUENCE TEXTS

No. 1
*Christmas*
"Sonent regi"
   1. Sonent regi nato nova cantica
   1. Let us sound forth with a new song to the newborn king
  2.1 Cuius pater fecit omnia mater est virgo sacratissima.
  2.2 Generans nescit hic feminam illa est sine uiro gravida.
   2. Whose Father made all things and whose mother is a most holy virgin; the begetter knowing no woman and she pregnant without a man:
  3.1 Verbum corde patris genitum ante secula.
  3.2 Aluo matris prodit corporatum post tempora.
   3. The Word, begotten from the heart of the father before the ages, came forth enfleshed from the womb of his mother in time.
  4.1 O mira genitura O stupenda natiuitas
  4.2 O proles gloriosa humanata divinitas
   4. O how wonderful this begetting, O how stupendous this nativity! O divinity, a glorious offspring born from a human.
  5.1 Sic te nasciturum fili dei uates tuo docti spiritu dixerant
  5.2 Sic te oriente laudes tibi cantant pacem terris angeli nunciant
   5. The prophets, taught by your spirit, said that you were to be born in this way, Son of God; so, with your coming, angels sing praises to you and announce peace on earth.

6.1 Elementa uultus exhilarant

6.2 Omnes sancti gaudentes iubilant

6. The elements make glad their countenance and all the rejoicing saints jubilate

7.1 Salue clamando nosque salua

7.2 Deitas in personis trina simplex usya.

7. Hail, they cry, and save us, Godhead in three persons,
   in one substance!

No. 2.

*Christmas*

"Lux fulget"

1. Lux fulget hodierna xpistus in qua mundo gaudia

1. This day Christ shines—the light in which is joy for the world.

2.1 Patris dedit noua missus ab arce superna

2.2 Arua petens yma carnea septus trabea.

2. Sent from the highest summit, seeking the lowest plains, enfolded in a fleshly robe, he gives
   news of the Father.

3.1 Seculi pro uita mortalia suscepit et fragilia

3.2 Seruili in forma apparuit regens humanis diuina

3. Eternal ages he exchanged for a mortal and fragile life; He appeared in the form of a servant
   governing things divine with things human.

4.1 Relinquens integra matris et illibata uiscera

4.2 Uirginis aurea prodiit tamquam sponsus ab aula.

4. Leaving the untouched and intact womb of his mother, he comes forward like a bridegroom
   from the golden chamber of the virgin.

5.1 Uagit paruulus presepis inter angustias quem non capiunt ethera sola et infera nec rerum
    omnium spacia.

5.2 Arta tegitur fascia qui uestit omnia pascit qui cuncta suggit ubera uirginea et tonans rutilat in
    ethra.

5.1 The little one cries from within the narrow confines of the crib,
    Whom neither the heavens alone, nor hell, nor the extent of all creation could contain;

5.2 He who clothes all people, is covered with tight wrapping;
    He who feeds all now sucks the virginal breasts, and, thundering, glows red in the heavens.

6.1 Angelica resultant domino gloria in excelsis deo agmina

6.2 Pastoribus gaudia intonant celica uenisse populis interna

6. The angelic armies echo back to the Lord: Glory to God in the highest, and they sing forth to
   the shepherds that heavenly joys have come to people on earth

7.1 Cunabula cuius ad ueneranda stella maris duxit noua trina magos ferentes munera mystica

7.2 Quem callida herodis uersucia perimere seuiebat infancium trucidans millium milia.

7. The star of the sea led the magi, bearing three mystical gifts, to venerate his new cradle, whom
   Herod raged to kill by a crafty trick, slaughtering a thousand thousand babies,

8.1 Felix mater et intacta hunc enixa o uirgo uirginum regina

8.2 Regum natum die ista posce tuis pro nobis filium sedula

8.1 Happy mother and intact, while giving him birth, o Virgin, queen of virgins, ask the King, born
    a son to you on this day, earnestly on our behalf.

9. Ut nostra qui iam uenit tollere crimina

9. That he who comes now to take up our crimes

10. Nos ducat ad celica regna quo letemur in gloria tecum maria.

10. May lead us to the heavenly kingdom, in which we will rejoice in glory with you, Mary.

No. 3

*Feria II, Stational Mass in the Easter Octave, and at vespers for Feria II*

"Ecce uicit"

1.1 Ecce uicit radix david leo de tribu iuda;

1.2 Mors uicit mortem et mors nostra est uita.

 1. Behold, the root of David, the lion from the tribe of Juda, conquers; Death conquers death and
    our death is life.

2.1 Mira bella et stupenda satis inter omnes uictorias

2.2 Ut moriens superaret fortem cum callido uersuciam.

 2. There have been astonishing and stupendous battles enough among all victories
    so that the Dying One might conquer strong cunning with cunning of his own.

3.1 Domum eius ingressus est rex eternus et inferni confregit uasa.

3.2 Dragmam secum que perierat absportauit et patefecit regni claustra.

 3. The eternal King has entered his house and smashed the instruments of hell; He carried out
    with him the drachma that had been lost and opened up the doors of the kingdom,

 4 Paradisi porta que clausa fuerat per lignum uetitum et culpam letalem in primeuo

 4. The Doors of paradise which had been shut through the forbidden tree and deadly sin in the
    beginning of time.

5.1 Quem commisit prothoplaustus reserauit dextra per stipitis materiam.

5.2 Susceperat mors indempnem quem terere nonquam potuerat propter culpam.

 5. The One whom death united with our first parents, set those fortunate ones free through the
    substance of his lineage (*stirps*);
    Death took up an uninjured man, whom it never was able to crush on account of sin.

6.1 Dum ambuit illicita que tenebat iuste perdidit adquisita

6.2 Ampliare uoluerat in successu et remansit euacuata.

 6. While illicit death encircled what He held justly, it lost its prize; Death wanted first to engorge,
    but it remained empty.

7.1 In se refuscata defecit extremitas, ut quibus ad uitam largitus fuerat ingressum donaret et re-
    gressum ad percipendam ueniam

7.2 Ut quibus est agnus legalis qui multis se magnifestauit figuris tandem se pro mundo hostiam
    dedit patri ut redimeret membra sua.

 7. Dark death failed in him, so he might give the entrance to life copiously to them, and a retreat
    for winning favor; for them he is the lawful lamb, who magnified itself in many figures, and
    finally he gave the offering to the Father for the world so he might redeem his own.

8.1 Hic lapis est angularis quem reprobauerunt edificantes

8.2 Iam factus est in caput anguli super omnes in excelso.

 8. He is the cornerstone that the builders rejected, now placed at the apex on high above all.

9. Regnum eius magnum et potestas illius pia per secula.

9. His kingdom is great and his power holy forever.

No. 4

*Purification (Feb. 2) and on the Feast of the Dedication (Oct. 17) and the days of its octave, except
on a Sunday within the Octave*

"Claris uocibus"

1.1 Claris uocibus inclita cane turma sacra melodimata

1.2 Voce mens bene consona sonent uerbis pneumata concordia

 1. Sing the holy, melodious sound with bright voices, you glorious crowd;
    Let the mind sing harmoniously with the voice, and the spirit concordant with the words.

2.1 Diuina robusta tetracorda plectro (*plecto* in MS) manus perite feriat

2.2 Resultet uirtutum pie lira deo nunc dragmata dulcisona.

2. Let the hand skillfully make powerful, holy tetrachords with the quill.
   Let the lyre of virtues now reecho the melliflouous offering devoutly to God.

3.1 Est armonia hec divina sonore uirtutum liquidissima

3.2 Mixta castitas est quas intra hominum coniungens deo federa

3. This is the divine harmony flowing with the sound of virtues;
   Chastity mingles those things within, joining human vows to God.

4.1 Huius uite consistorie in immutabilia

4.2 Que mater est inuiolata uirgo que puerpera.

4. The royal meeting places of this life for unchangable things: this is the mother, who is an untouched virgin birthing a child.

5.1 Iccirco deum tua fuerant digna ferre uiscera

5.2 Quem non celica neque terrena cuncta claudunt spacia.

5. For that reason your womb was worthy to bear God, whom neither heavenly nor earthly spaces were sufficient to enclose.

6.1 Uirginum o regina te canimus maria per quam fulsere clara mundi lumina

6.2 Tu sola orbis alma tu celi porta facta per te seculo uita omni dedita

6. O queen of virgins, Mary, we sing about you, through whom the bright lights of the world shine; you alone are the nurturer of the world; you made the door of heaven, through you life has been given for eternity.

7.1 Celicis terrea tu iungis diuinis humana

7.2 Paradisiaca per te nobis patet ianua.

7. You join earthly things to heavenly, human to divine; through you the heavenly gates lie open to us.

8.1 Adesto famulis piisima in tua iam suspende prece pericula

8.2 Audi fidelia precamina impetratam deferens celitus ueniam.

8. Be near to your handmaidens, most pious one, in your prayer now loosen all dangers; hear our faithful songs quickly, recommending favorable grace;

9.1 Et quiete nobis temporum inclita

9.2 Hac in uita nostra dirige opera

9. And with glorious peace in our time, direct our actions in this life;

10.1 Post funera uranica nos duc ad habitacula

10.2 Quo letemur omnes una tecum per cuncta secula

10. After death, lead us to heavenly dwellings,
    Where we all will be glad, one with you through all ages.

11. Exclament nunc omnigena amen redempta.

11. Let the redeemed of all nations now cry out: amen!

## No. 5

*Annunciation (March 25) and on Sunday in the Octave of the Dedication; one of two possibilities for the thirteenth-century feast of the Memoria of the Dedication*
"Hac clara die"

1.1 Hac clara die turma festiua dat preconia

1.2 Mariam concrepando symphonia nectarea.

1. On this bright day the festive throng gives out the news by rhythmicizing Mary with honeyed harmony.

2.1 Mundi domina que est sola castissima uirginum regina

2.2 Salutis causa uite porta atque celi referta gracia

2. The lady of the world, who alone is the most chaste queen of virgins, for the sake of salvation is the door of life and filled with the grace of heaven.

3.1 Nam ad illam sic nuncia olim facta angelica

3.2 Aue maria gracia dei plena per secula.

3. To her long ago the angelic news was given: hail, Mary, full of the grace of God for all time.

4.1 Mulierum pia agmina intra semper benedicta

4.2 Uirgo et grauida mater intacta prole gloriosa.

4. Always blessed among the pious throng of women, a pregnant virgin, an intact mother, with glorious offspring.

5.1 Cui contra maria hec reddit famina

5.2 In me quomodo tua iam sicut nuncia (*noncia* in MS)?

5. In reply to whom Mary returned these words: How can it be in me as you have said?

6.1 Uiri noui nullam certe copulam

6.2 Ex quo atque nata sum incorrupta

6. Certainly I have known no intercourse with a man and I was born uncorrupted from it.

7.1 Dyua missus ita reddit affata

7.2 Flatu sacro plena fies Maria

7. Thus the messenger offered these divine words: "You will be made pregnant with sacred breath, Mary."

8.1 Noua afferens gaudia celo terre nati per exordia

8.2 Intra tui uteri claustra portas qui gubernat eterna.

8. Bringing new joys to heaven through the announcement of a child on earth, within the enclosure of your womb you bear him who governs the eternal ages,

9. Omnia qui et tempora pacificat.

9. And who brings peace to all times.

No. 6

*Feast of the Nativity of the Virgin*

"Alle celeste necnon"

1. Alle—celeste necnon et perhenne—luia

1. Alle—heavenly and also unceasing—luia!

2.1 Dic paraphonista cum mera symphonia

2.2 Tuba et canora palinodias canta

2. Sing, virtuoso, with sweet harmony; sing; sonorous trumpet; the repeated song;

3.1 Nam omnis usia hanc xpisti genitricem die ista

3.2 Congaudet exortam, per quam sibi sublatam capit uitam

3. For all being rejoices in this woman, the birthmother of Christ, who comes forth on this day, and through whom it seizes an exalted life for itself.

4.1. Davidica stirpe sata Davidis ad sceptra est regenda prole fecundata

4.2 Nec grauidata uiscera sunt tamen per ulla patris membra sed ex fide sola.

4. A daughter from the Davidic shoot, pregnant with a child destined for the kingdom of David; and her womb was not gravid by the organ of any father, but by faith alone.

5.1 Ab arca summa angelus adstat: Maria, inquit, alma, aue plena

5.2. Gracia sacra et benedicta feminas inter omnes paritura.

An angel from the highest vault of heaven came near: Hail kind Mary, he said, full of holy grace and blessed among all women, you will bear . . .

6.1 Regem, qui dyra mortis uincula damnabit mira cum potentia, suum plasma soluens sua atque beatam donans uitam.

6.2 Fit mox puella uerbis credula et puerperam stupet et castam natum gestans speciosum forma regentem cuncta orbis regna

6. A king, who will condemn the dire chains of death with marvelous power, releasing his creation and giving his own blessed life. This is accomplished soon by a maiden, trusting in [the angel's]

word and astounded by her child-bearing and chastity, bearing a son of beautiful appearance, ruling the entire kingdom of the world.

7.1 Hec est uirga non irrigata sed dei gracia florigera

7.2 Hec est sola cunctorum hera materna obscurans piacula

7. This is the unwatered rod, flowering by the grace of God; this alone is the maternal mistress of all, hiding the sin offerings.

8.1 Velut rosa decorans spineta sic quod ledat nil habet maria

8.2 Virgo eua quod contulit prima xpisti sponsa effugat maria.

8. Just like the rose beautifying the thornbushes, so too can nothing harm what Mary possesses; what the first virgin, Eva, brought on, Mary, the spouse of Christ, will escape.

9.1 O uirgo sola mater casta nostra crimina

9.2 Solve dans regna quis beata regnant agmina

9. O Virgin, only chaste mother, dissolve our sins, giving kingdoms, you who rule the heavenly hosts.

10.1 Potes enim cuncta ut mundi regina et iura cum nato omnia decernis in secla et ultra subnixa es in gloria

10.2 Cherubin electa seraphinque agmina nam iuxta filium posita sedes in dextera rutila uirtus lampat et sociat.

10. For you rule over everything as queen and judge of the world; with your son you judge all things in all times and are supported from on high in glory, elected from the hosts of cherubim and seraphim, your throne placed near your son on his shining right hand, its power glows and unites.

11.1 Natiuitas unde gaudia nobis hodie affert annua

11.2 Et resonat camenis aula in laude tua uirgo maria.

11. So on this day annually your nativity comes to us with joy, and the courtyard resounds with songs in your praise, Virgin Mary.

12.1 Gaudet per climata orbis ecclesia

12.2 Dicens alleluia quod et palatia

12. Rejoicing through the regions of the work, singing alleluia, for the palaces

13. Celi clamant dindima usque dancia preconia.

13. Of heaven cry out giving mystical praises.

No. 7
*St. Anne (July 26)*
"Mater matris domini"

1. Mater matris domini, felix felicissime, ioachim consorcia.
1. Mother of the mother of the Lord, glad mother of that most most joyful woman, consort of Joachim,

2.1 Singulari studio pauperum solatio conferens subsidia

2.2 Anna diu sterilis apud deum humilis propter uirum anxia.

2. Who with singular devotion brings help and relief to the poor,
Anne, long sterile, humble before God and worried on account of her husband,

3.1 Qui turbatus nuncium triste per eloquium datum ad altaria

3.2 Propter uerba presulis iuxta uicem exulis fugit ad ouilia.

3. Who, agitated by the warning speech given harshly at his offerings,
became an exile because of the priest's words, fleeing to the sheepfold.

4.1 Quem celestis nuncius pulcher et propicius blanda per eloquia solent a miseria

4.2 Per exempla ueterum cor fouens et miserum reducens ad gaudia ueraci prophetia

4. The beautiful and propitious heavenly messenger comforted Joachim with gentle words used to misery,
Warming his heart through examples of old and turning his misery to joys with a true prophecy,

5.1 Confortauit et monstrauit quod mariam egregiam gigneret ex te pia;

5.2 O parentes quam gaudentes quam laudatos quam beatos nos facit hec filia.

  5. and he revealed that Joachim had begotten singular Mary with you, holy Anne;

    O parents, how joyful, how extolled, how blessed your daughter makes us.

6.1 Hec est rosa gratiosa que de spinis et ruinis et truci inuidia

6.2 Antiquorum iudeorum fuit nata nobis data iuxta uaticinia

  6. This is the grace-filled rose that was born from the thorns, depredations,

    And savage hatred of the ancient Jews, given to us according to prophecy.

7.1 O quam bene genuistis et quam mundo profuistis o quam sublimi gloria
        nobis plaudunt celestia

7.2 Celi arcem obtineris quo tam mortem (MS *martham*) non timeris sed habitis omnia desiderabilia;

  7. O how well you bore, and how you benefited the world! O with what sublime glory the heavens clap with us!

    You reached the vault of heaven, where you will not fear even death, but will have all good things;

8.1 Quo trahatis nos laudantes nos et nobis famulantes licet rei sumus dei confisos clementia

8.2 Ut sit nobis coadiutrix nostra nata dei nutrix que nos ponat et coronet in celesti patria

  8. Where you draw us, praising and serving, so we may trust in the clemency of God;

    So that our co-accomplice, our destined nurse of God, may position us and crown us in the heavenly homeland,

  9. In qua simus coronati cum ipsa in gloria.

  9. Where we may remain, crowned in glory with this same woman!

No. 8

*Dedication of the Church and a Choice for the Octave of the Assumption*

"Salve porta"

  1. Salve porta perpetue lucis fulgida

  1. Hail, door, resplendent with perpetual light

2.1 Maris stella inclita domina uirgo semperque dei maria

2.2 Preelecta ipsius gracia ante secularia tempora

  2. Shinning star of the sea and lady virgin always Maria of God, pre-elected by her very grace before the ages of time.

3.1 Cui missus gabriel archangelus mira detulit a deo famina mundo numquam audita

3.2 Ave tu Maria que totius plena muneris effulgens gratia est nam tecum dominus.

  3. To whom the messenger Gabriel the archangel brought wondrous news from God never heard in the world: Hail radiant Mary, you will be utterly full of grace, for God is with you.

4.1 Ne paueas diuina quia prole letaberis te fore grauidam

4.2 Qua propter es tu sola inter cunctas mulieres uirgo benedicta

  4. Fear not, becoming pregnant, for you will be joyful with a divine offspring

    And so you alone are the virgin blessed among all women.

5.1 Magnus hic erit ihesus filius summi ac throni Davidis gloria et regni meta sui non erit aliqua

5.2 Mox ad hec uerba parens credula corde concipis dominum sabaoth sic uerbum caro factum est ex te uirgo sacra.

  5. Great will be this Jesus, son of the most high and glory of the throne of David, and the span of his reign will be without end; then, ready on hearing these words with a believing heart, you conceived the Lord Sabaoth; so the word is made flesh by you, Holy Virgin.

  6. Te omnes petimus ipsum pro nobis rogita, saluet nos per omnia secula.

  6. So, we all beg you, entreat him for us; that he might save us forever.

No. 9.

*For the Dedication, at the Abbey of St. John in the twelfth century, and in Chartres, BM 520*
"Clara chorus"

1.1 Clara chorus dulce pangat uoce nunc alleluya

1.2 Ad eterni regis laudem qui gubernat omnia.

  1. Let the choir now sing out a bright Alleluia with a sweet voice
     in praise of the eternal king, who rules all things,

2.1 Cui nos uniuersalis sociat ecclesia

2.2 Scala uirens et pertingens ad poli fastigia.

  2. to whom the universal Church unites us—
     a verdant ladder leading to the highest regions of the sky.

3.1 Ad honorem cuius leta psallamus melodia

3.2 Persoluentes hodierna fratres illi debita

  3. Let us psalmodize in his honor with joyful melody,
     recounting today, brethren, the debts owed to him.

4.1 O felix aula quam uicissim confrequentant agmina celica

4.2 Diuini uerbi alternatim iungencia mellea cantica

  4. O blessed courtyard, crowned with heavenly armies,
     alternating the sweetest songs with the divine word:

5.1 Domus hec de qua uetusta sonuit hystoria
    et moderna protestatur xpistum fari pagina.

5.2. Quoniam elego eam thronum sine macula
    requies hec erit mea per eterna secula

  5. This is the house about which the ancient history resounded
     and which asks the modern book to speak of Christ,
     since it was chosen, a throne without blemish:
     This will be my resting place throughout all ages.

6.1 Turris supra montem sita indissolubili fundatur bitumine uallo perhenni munita

6.2 Atque aurea columpna miris ac uariis lapidibus constructa stilo subtili polita.

  6. A tower placed upon the mountain with undissolving mortar, safe in an eternal valley,
     And golden columns made with strange and varied stones, marked with a skilled pen.

7.1 Aue mater preelecta xpistus ad quam fatur ita prophete facundia

7.2 Sponsa mea speciosa inter filias formosa super solem splendida.

  7. Hail, pre-elected mother, to whom Christ speaks thus with the eloquence of a prophet:
     My lovely bride, beautiful among the daughters, more splendid than the sun.

8.1 Caput tuum ut carmelas et ipsius come tincte regis uti purpura

8.2 Oculi ut columbanum gene tui punicorum ceu malorum fragmina

  8. Your head like Mount Carmel and with hair colored by regal purple,
     your eyes like doves, your cheeks like pieces of red apples.

9.1 Mel et lac sub lingua tua fauus dulcis labia

9.2 Collum tuum ut columpna turris et eburnea

  9. Honey and milk under your tongue, your lips sweet honeycomb,
     Your neck like a column and an ivory tower.

10.1 Ergo nobis sponse tue famulantibus o xpiste pietate solita

10.2 Clemens adesse dignare et in tuo salutari nos tibique insita

  10. Therefore to us, the servants of your spouse, O Christ, with accustomed loyalty
     deign to come, merciful one, and graft us to yourself in your salvation.

  11. Ut cantemus in eternum cum sanctis alleluia.
     That we might sing alleluia with the saints for ever.

No. 1 "Sonent regi nato"

A "Sequentia" is included at the opening of every piece. Punctuation is editorial
throughout; in the manuscript there are periods at the end of virtually every line.

1  So - nent re - gi na - to no - ua can - ti - ca  Al - le - lu - ya  a

2.1 Cu - ius pa - ter fe - cit om - ni - a  ma - ter est uir - go sa - cra - tis - si - ma

2.2 Ge - ne - rans ne - scit hic fe - mi - nam il - la est si - ne ui - ro gra - ui - da.

3.1 Uer - bum cor - de pa - tris ge - ni - tum an - te se - cu - la

3.2 Al - uo ma - tris pro - dit cor - po - ra - tum post tem - po - ra.

4.1 O mi - ra ge - ni - tu - ra o stu - pen - da na - ti - ui - tas

4.2 O pro - les glo - ri - o - sa hu - ma - na - ta di - ui - ni - tas.

5.1 Sic te na - sci - tu - rum fi - li de - i ua - tes tu - o doc - ti spi - ri - tu di - xe - rant

5.2 Sic te o - ri - en - te lau - des ti - bi can - tant pa - cem ter - ris an - ge - li nun - ci - ant.

6.1 E - le - men - ta uul - tus ex - hi - la - rant

6.2 Om - nes sanc - ti gau - den - tes iu - bi - lant.

7.1 Sal - ue cla - man - do nos - que sal - ua

7.2 De - i - tas in per - so - nis tri - na sim - plex u - sy - a.

1 Lux  ful - get  ho - di - er - na  xpi - stus  in  qua  mun - do  gau - di - a.

From here on a neumed opening version of the first few notes called a sequentia will be assumed.

Al - le - lu - ya

2.1 Pa - tris  de - dit  no - ua  mis - sus  ab  ar - ce  su - per - na

2.2 Ar - ua  pe - tens  y - ma  car - ne - a  sep - tus  tra - be - a.

3.1 Se - cu - li  pro  ui - ta  mor - ta - li - a  sus - ce - pit  et  fra - gi - li - a

3.2 Ser - ui - li  in  for - ma  ap - pa - ru - it  re - gens  hu - ma - nis  di - ui - na.

4.1 Re - lin - quens  in - te - gra  ma - tris  et  il - li - ba - ta  ui - sce - ra

4.2 Uir - gi - nis  au - re - a  pro - di - it  tam - quam  spon - sus  ab  au - la.

5.1 Ua - git  par - uu - lus  pre - se - pis  in - ter  an - gus - ti - as  Quem non ca - pi - unt  e - the - ra  so - la

(5.1)  et  in - fe - ra  nec  re - rum  om - ni - um  spa - ci - a.

5.2 Ar - ta  te - gi - tur  fa - sci - a  qui ues - tit  om - ni - a  Pa - scit qui cun - cta  sug - git  u - be - ra

(5.2) uir - gi - ne - a  et  to - nans  ru - ti - lat  in  e - thra.

6.1 An - ge - li - ca    re - sul - tant do - mi - no glo - ri - a    in ex - cel - sis de - o    ag - mi - na

6.2 Pas - to - ri - bus    gau - di - a    in - to - nant ce - li - ca    ue - nis - se    po - pu - lis    in - ter - na.

7.1 Cu - na - bu - la    cu - ius ad    ue - ne - ran - da stel - la    ma - ris    du - xit    no - ua

(7.1) tri - na    ma - gos    fe - ren - tes    mu - ne - ra    my - sti - ca.

7.2 Quem cal - li - da    he - ro - dis    uer - su - ci - a    per - i - me - re    se - ui - e - bat

(7.2) in - fan - ci - um    tru - ci - dans mi - li - um    mi - li - a.

8.1 Fe - lix    ma - ter    et in - ta - cta hunc e - ni - xa    o    uir - go    uir - gi - num    re - gi - na

8.2 Re - gum    na - tum    di - e    is - ta    po - sce tu - is    pro no - bis    fi - li - um se - du - la.

9 Ut    no - stra    qui iam    ue - nit    tol - le - re    cri - mi - na

10 Nos    du - cat    ad    ce - li - ca    re - gna quo    le - te - mur    in

(10) glo - ri - a    te - cum    ma - ri - a.

No. 3 "Ecce uicit"    Chartres BMun. 529 (428) 92v-93r

1.1 Ec - ce ui - cit ra - dix da - uid le - o de tri - bu iu - da

1.2 Mors ui - cit mor - tem et mors no - stra est ui - ta.

2.1 Mi - ra bel - la et stu - pen - da sa - tis in - ter om - nes uic - to - ri - as

2.2 Ut mo - ri - ens su - pe - ra - ret for - tem cum cal - li - do uer - su - ci - am.

3.1 Do - mum e - ius in - gres - sus est rex e - ter - nus et in - fer - ni con - fre - git ua - sa.

3.2 Drag - mam se - cum que pe - ri - e - rat abs - por - ta - uit et pa - te - fe - cit reg - ni clau - stra.

4 Pa - ra - di - si por - ta que clau - sa fu - e - rat per lig - num ue - ti - tum et cul - pam le - ta - lem in prim - e - uo.

5.1 Quem com - mi - sit pro - tho - plaus - tus re - ser - a - uit dex - tra per sti - pi - tis ma - te - ri - am

5.2 Su - sce - pe - rat mors in - demp - nem quem te - ne - re non - quam po - tu - e - rat prop - ter cul - pam.

6.1 Dum am - bu - it il - li - ci - ta que te - ne - bat iu - ste per - di - dit ad - qui - si - ta

6.2 Am - pli - a - re uo - lu - e - rat in suc - ces - su et re - man - sit e - ua - cu - a - ta.

7.1 In se re - fu - sca - ta de - fe - cit ex - tre - mi - tas

(7.1) Ut qui - bus ad ui - tam lar - gi - tus fu - e - rat

(7.1) in -gres-sum do - na - ret et re - gres - sum ad per - ci - pi - en-dam ue - ni - am.

7.2 Ut qui - bus est ag - nus le - ga - lis qui mul - tis

(7.2) se mag - ni - fes - ta - uit fi - gu - ris tan - dem se

(7.2) pro mun -do hos - ti - am de - dit pa - tri ut re - di - me -ret mem-bra su - a.

8.1 Hic la - pis est an - gu - la - ris quem re - pro - ba - ue -runt e - di - fi - can - tes

8.2 Iam fac - tus est in ca - put an - gu - li su - per om - nis in ex - cel - so.

9 Re -gnum e - ius mag-num et po - te -stas il - li - us pi - a per se - cu - la.

For further discussion of this sequence, see Richard Crocker (1977), 75-93. An edition with commentary based on Italian sources, can be found in *Early Medieval Chants from Nonantula*, vol. IV, *Sequences*, ed. James Borders, Madison, 1996, especially at xli-xlii.

No. 4 "Claris uocibus"　　　　　　Chartres Bmun. 529 (428) 164v-165r

1.1 Cla - ris uo - ci - bus in - cli - ta ca - ne tur - ma sa - cra me - lo - di - ma - ta
1.2 Uo - ci mens be - ne con - so - na so - nent uer - bis pneu - ma - ta con - cor - di - a.

2.1 Di-ui - na ro - bus - ta te - tra cor - da plec - to [sic]ma - nus pe - ri - te fe - ri - at

2.2 Re - sul - tet uir - tu - tum pi - e li - ra de - o nunc dra - gma - ta dul - ci - so - na.

3.1 Est ar - mo - ni - a hec di - ui - na so - no - re uir - tu - tum li - qui - dis - si - ma
3.2 Mix - ta cas - ti - tas est quas in - tra ho - mi - num con - iun-gens de - o fe - de - ra.

4.1 Hu - ius ui - te con - sis - to - ri - e in im - mu - ta - bi - li - a
4.2 Que ma - ter es in - vi - o - la - ta uir - go que pu - er - pe - ra.

5.1 Ic - cir - co de - um tu - a fu - e - rant dig - na fer - re uis - ce - ra
5.2 Quem non ce - li - ca ne - que ter - re - na cun - cta clau-dunt spa - ci - a.

6.1 Uir - gi - num o re - gi - na te ca - ni-mus ma - ri - a per quam ful - se - re cla - ra mun - di lu - mi - na
6.2 Tu so - la or - bis al - ma tu ce - li por - ta fac - ta per te se - cu - lo ui - ta om - ni de - di - ta.

7.1 Ce - li - cis ter - re - a tu iun - gis di - ui - nis hu - ma - na
7.2 Pa - ra - di - si - a - ca per te no - bis pa - tet ia - nu - a.

8.1 A - des - to fa - mu - lis pi - is - si - ma in tu - a iam sus-pen-de pre - ce pe - ri - cu - la
8.2 Au - di fi - de - li - a pre - ca - mi - na im - pe - tra-tam de - fe - rens ce - li - tus ue - ni - am.

9.1 Et qui - e - te no - bis tem - po - rum in - cli - ta
9.2 Hac in ui - ta nos - tra di - ri - ge o - per - a.

10.1 Post fu - ne - ra u - ra - ni - ca nos duc ad ha - bi - ta - cu - la
10.2 Quo le - te - mur om - nes u - na te - cum per cunc - ta se - cu - la.

11 Ex - cla - ment nunc om - ni - ge - na a - men re - demp - ta.

No. 5 "Hac clara die" Chartres BMun. 529 (428) 115v-116r

1.1 Hac cla - ra di - e tur - ma fe - sti - ua dat pre - co - ni - a

1.2 Ma - ri - am con - cre - pan - do sym - pho - ni - a nec - ta - re - a.

2.1 Mun - di do - mi - na que est so - la ca - stis - si - ma uir - gi - num re - gi - na

2.2 Sa - lu - tis cau - sa ui - te por - ta at - que ce - li re - fer - ta gra - ci - a.

3.1 Nam ad il - lam sic nun - ci - a o - lim fac - ta an - ge - li - ca

3.2 A - ue ma - ri - a gra - ci - a de - i ple - na per se - cu - la.

4.1 Mu - li - er - um pi - a ag - mi - na in - tra sem - per be - ne - dic - ta

4.2 Uir - go et gra - ui - da ma - ter in - tac - ta pro - le glo - ri - o - sa.

5.1 Cu - i con - tra ma - ri - a hec red - dit fa - mi - na

5.2 In me quo - mo - do tu - a iam si - cut non - ci - a.

6.1 Ui - ri no - ui nul-lam cer - te co - pu - lam

6.2 Ex quo at - que na - ta sum in - cor - rup - ta.

7.1 Dy - ua mis - sus i - ta red - dit af - fa - ta

7.2 Fla - tu sa - cro ple - na fi - es ma - ri - a.

8.1 No - ua af - fer - ens gau - di - a ce - lo ter - re na - ti per ex - or - di - a

8.2 In - tra tu - i u - te - ri clau-stra por - tas qui gu - ber - nat e - ter - na.

9 Om - ni - a qui et tem-po - ra pa - ci - fi - cat.

No. 6 "Alle celeste"    Chartres Bmun. 529 (428) 233v-234v

1 Al - le ce - les - te nec-non et per-hen-ne lu — — ia

2.1 Dic pa - ra - pho - nis - ta cum me - ra sym-pho - ni - a

2.2 Tu - ba et ca - no - ra pa - li - no - di - as can - ta.

3.1 Nam om - nis u - sy - a hanc xpi - sti ge - ni - tri - cem di - e i - sta

3.2 Con - gau - det ex - or - tam per quam si - bi sub - la - tam ca - pit ui - tam.

4.1 Da - ui - ti - ca styr - pe sa - ta da - ui - dis ab scep - tra est re - gen - da pro - le fe - cun - da - ta

4.2 Nec gra - ui - da - ta ui - sce - ra sunt ta - men per ul - la pa - tris mem-bra sed ex fi - de so - la.

5.1 Ab ar - ce sum - ma an - ge - lus a - stat ma - ri - a in - quit al - ma a - ue ple - na

5.2 Gra - ci - a sa - cra et be - ne - di - cta fe - mi - nas in - ter om - nes pa - ri - tu - ra

6.1 Re - gem qui dy - ra mor - tis uin - cu - la dampp - na - bit mi - ra cum po - ten - ti - a

(6.1) Su - um pla - sma sol - uens spon - te su - a at - que be - a - tam do - nans ui - ta.

6.2 Fit mox pu - el - la uer - bis cre - du - la et pu - er - pe - ram stu - pet et cas - tam

(6.2) Na - tum ges - tans spe - ci - o - sum for - ma re - gen - tem cun - cta or - bis reg - na.

7.1 Hec est uir - ga non ir - ri - ga - ta sed de - i gra - ci - a flo - ri - ge - ra

7.2 Hec est so - la cun - cto - rum he - ra ma - ter - na ob - scu - rans pi - a - cu - la.

8.1 Ue - lut ro - sa de - co - rans spi - ne - ta sic quod le - dat nil ha - bet ma - ri - a

8.2 Uir - go e - ua quod con - tu - lit pri - ma xpi - sti spon - sa ef - fu - gat ma - ri - a.

9.1 O uir - go so - la ma - ter ca - sta no - stra cri - mi - na

9.2 Sol - ue dans re - gna quis be - a - ta reg - nant ag - mi - na.

10.1 Po - tes e - nim cun - cta ut mun - di re - gi - na et iu - ra

(10.1) Cum na - to om - ni - a de - cer - nis in se - cla et ul - tra

(10.1) sub - ni - xa es in glo - ri - a.

10.2 Cher - u - bin e - lec - ta se - ra - phin - que ag - mi - na nam iu - sta

(10.2) Fi - li - um po - si - ta se - des in dex - te - ra ru - ti - la

(10.2) uir - tus lam - pat et so - ci - a.

11.1 Na - ti - ui - tas un - de gau - di - a no - bis ho - di - e af - fert an - nu - a

11.2 Et re - so - nat ca - me - nis au - la in lau - de tu - a uir - go ma - ri - a.

12.1 Gau - det per cli - ma - ta or - bis ec - cle - si - a

12.2 Di - cens al - le - lu - ia quod et pa - la - ti - a

13 Ce - li cla - mant din - di - ma us - que dan - ci - a pre - co - ni - a.

No. 7 "Mater matris domini"

Chartres BMun. 529 (428) 202r-202v

1 Ma-ter ma-tris do-mi-ni fe-lix fe-li-cis-si-me io-a-chim con-sor-ci - a.

2.1 Sin-gu-la-ri stu-di-o pau-pe-rum so-la-ti-o con-fe-rens_ sub-si-di-a

2.2 An-na di-u ste-ri-lis a-pud de-um hu-mi-lis prop-ter ui-rum anx-i-a.

3.1 Qui tur-ba-tus nun-ci-um tri-ste per e-lo-qui-um da-tum ad al-ta-ri - a

3.2 Prop-ter uer-ba pre-su-lis iux-ta ui-cem ex-u-lis fu-git ad o-ui-li - a.

4.1 Quem ce-le-stis nun-ci-us pul-cher_ et pro-pi-ci-us blan-da per e-lo-qui-a

(4.1) so-lent a mi-se-ri-a

4.2 Per ex-em-pla ue-te-rum cor fo-uens et mi-se-rum re-du-cens ad gau-di - a

(4.2) ue-ra-ci pro-phe-ti-a.

5.1 Con-for-ta-uit et mon-stra-uit quod ma-ri-am e-gre-gi-am

(5.1) gig-ne-ret ex te pi - a.

5.2 O pa-ren-tes quam gau-den-tes quam lau-da-tos quam be-a-tos

(5.2) nos fa-cit hec fi-li - a.

6.1 Hec est ro - sa gra - ti - o - sa que de spi - nis et ru - i - nis et tru - ci in - ui - di - a

6.2 An - ti - quo - rum iu - de - o - rum fu - it na - ta no - bis da - ta iux - ta ua - ti - ci - ni - a.

7.1 O quam be - ne ge - nu - is - tis et quam mun - do pro fu - is - tis o quam su - bli - mi glo - ri - a

(7.1) no - bis plau - dunt ce - le - sti - a

7.2 Ce - li ar - cem ob - ti - ne - ris quo tam mar - tham non ti - me - ris sed ha - be - tis om - ni - a
[sic]

(7.2) de - si - de - ra - bi - li - a.

8.1 Quo tra - ha - tis nos lau - dan - tes nos et no - bis fa - mu lan - tes li - cet re - i su -

(8.1) mus de - i con - fi - sos cle - men - ti - a

8.2 Ut sit no - bis co - ad - iu - trix no - stra na - ta de - i nu - trix que nos po - nat et

(8.2) co - ro - net in ce - le - sti pa - tri - a

9 In qua si - mus co - ro - na - ti cum ip - sa in glo - ri - a.

No. 8 "Salue porta"  Chartres BMun. 529 (428) 18r-18v

1 Sal - ue  por - ta per - pe - tu - e  lu - cis ful - gi - da

2.1 ma - ris stel - la in - cli - ta  do - mi - na uir - go sem - per - que de - i  ma - ri - a

2.2 Pre - e - lec - ta  ip - si - us gra - ci - a  an - te  se - cu - la - ri - a  tem - po - ra.

3.1 Cu - i  mis - sus  ga - bri - el  arch - an - ge - lus  mi - ra  de - tu - lit  a  de - o

(3.1) fa - mi - na  mun - do  num - quam  au - di - ta

3.2 A - ue  tu  ma - ri - a  que to - ti - us  ple - na  mu - ne - ris  ef - ful - gens

(3.2) gra - ti - a  est  nam  te - cum  do - mi - nus.

4.1 Ne pa - ue - as  di - ui - na  qui - a  pro - le  le - ta - be - ris  te  fo - re  gra - ui - dam

4.2 Qua prop - ter  es  tu  so - la  in - ter cunc - tas  mu - li - er - es  uir - go  be - ne - di - cta.

5.1 Mag - nus hic e - rit ihe-sus fi - li - us sum - mi ac thro-ni da - ui - dis glo - ri - a

(5.1) et reg - ni me - ta su - i non e - rit a - li - qua.

5.2 Mox ad hec uer - ba pa-rens cre - du - la cor - de con - ci - pis do - mi-num sa - ba - oth

(5.2) fit uer - bum ca - ro fac - tum ex te uir - go sa - cra.

6 Te om - nes pe - ti - mus ip - sum pro no - bis ro - gi - ta

7 Sal - uet nos per om - ni - a se - cu - la.

No. 9 "Clara chorus"  Chartres BMun. 529 (428) 263r-264r

1.1 Cla - ra cho - rus dul - ce pan - gat uo - ce nunc al - le - lu - ya

1.2 Ad e - ter - ni re - gis lau - dem qui gu - ber - nat om - ni - a.

2.1 Cu - i nos u - ni - uer - sa - lis so - ci - at ec - cle - si - a

2.2 Sca - la ui - rens et per - tin - gens_ ad po - li fa - sti - gi - a.

3.1 Ad ho - no - rem cu - ius le - ta psal - la - mus me - lo - di - a

3.2 Per - sol - uen - tes ho - di - er - na fra - tres il - li de - bi - ta.

4.1 O fe - lix au - la quam ui - cis - sim con - fre - quen - tant ag - mi - na ce - li - ca

4.2 Di - ui - ni uer - bi al - ter - na - tim iun - gen - ci - a mel - le - a can - ti - ca.

5.1 Do - mus hec de qua ue - tu - sta so - nu - it hy - sto - ri - a

(5.1) et mo - der - na pro - tes - ta - tur xpis - tum fa - ri pa - gi - na.

5.2 Quo - ni - am e - le - gi e - am thro-num si - ne ma - cu - la

(5.2) re - qui - es hec e - rit me - a per e - ter - na se - cu - la.

6.1 Tur - ris su - pra mon-tem si - ta in - dis - so - lu - bi - li fun - da - ta bi - tu - mi - ne

(6.1) ual - lo per - hen - ni mu - ni - ta

6.2 At - que au - re - a co - lump - na mi - ris ac ua - ri - is la - pi - di - bus con - struc-ta

(6.2) sti - lo sub - ti - li po - li - ta.

7.1 A - ue ma - ter pre - e - le - cta xpis-tus ad quam fa - tur i - ta pro-phe - te fa - cun - di - a

7.2 Spon - sa me - a spe - ci - o - sa in - ter fi - li - as for - mo - sa su - per so - lem splen-di - da.

8.1 Ca - put tu - um ut car - me - las et ip - si - us co - me tin - cte re - gis u - ti pur - pu - ra

8.2 O - cu - li ut co - lum - ba - rum ge - ne tu - i pu - ni - co - rum ceu ma - lo - rum fra - gmi - na.

9.1 Mel et lac sub lin - gua tu - a fa - uus dul - cis la - bi - a

9.2 Col - lum tu - um ut co - lump - na tur - ris et e - bur - ne - a.

10.1 Er - go no - bis spon - se tu - e fa - mu - lan - ti - bus o xpis - te pi - e - ta - te so - li - ta

10.2 Cle - mens ad - es - se di - gna - re et in tu - o sa - lu - ta - ri nos ti - bi - que in - si - ta

11 Ut can - te - mus in e - ter - num cum san - ctis al - le - lu - ya.

Three responsories attributed to Fulbert as sung for the Feast of Mary's Nativity in Chartres Cathedral

*First nocturn: third responsory (each would have been performed with the doxology and appropriate repetitions):*
Stirps yesse uirgam produxit uirgaque florem et super hunc florum requiescit spiritus almus (cao7709) V. Virga dei genetrix uirgo est flos filius eius (cao7709a)
[The shoot of Jesse produced a rod, and the rod a flower; and now over the flower rests a nurturing spirit. V. The shoot is the virgin Genetrix of God, and the flower is her Son.]

*Second nocturn: third responsory:*
Solem iusticie regem paritura suppremum stella maria maris hodie processit ad ortum (cao7677) V. Cernere diuinum lumen gaudete fideles (cao7677a)
[Today the star of the sea, she who will bear the sun of justice, the supreme king, processes to her rising. V. Rejoice, faithful people, to see the holy light.]

*Third nocturn: third responsory:*
Ad nutum domini nostrum ditantis honorem sicut spina rosam genuit Iudee Mariam (cao6024). V. Ut uitium uirtus operiret gratis culpam (cao6024a)
[At the command of the Lord, enriching our dignity: Just as the thorn bore the rose and Judea bore Mary V. So that virtue might cover vice and thanksgiving our guilt.]

### ADVENT IV

Non auferetur sceptrum de Iuda et dux de femoribus eius donec veniat qui mittendus est et ipse erit expectatio gentium (cao7224) V. Pulchriores oculi eius vino et dentes lacte candidiores (cao7224a)
[The sceptre shall not be taken away from Juda, nor a ruler from his thigh, till he come that is to be sent, and he shall be the expectation of nations. (Gen 49: 10) His eyes are more beautiful than wine, and his teeth whiter than milk. (Gen 49:12)]

### ANTIPHONS RELATED TO THE VIRGIN AND HER LINEAGE AS MANIFESTED IN THE VISUAL ARTS:

Omnis vallis implebitur et omnis mons et collis humiliabitur et videbit omnis caro salutare dei (cao4156).
[Every valley shall be filled and every mountain and hill shall be brought low: (Luke 5a) And all flesh shall see the salvation of God. (Luke 6)]

*Paris, BN lat. 15182, 345r*
Hec est Regina (cao3002): first in the set of five antiphons sung at first Vespers for every Marian feast, and also for the feast of the Dedication instituted in the thirteenth century and the newly instituted Feast of St. Anne. Often sung at processions through the Royal Portal. (see appendix F for text and translation)

"Styrps Jesse" (transcribed with all repeats)

Vat. lat. 4756, 328v-329r

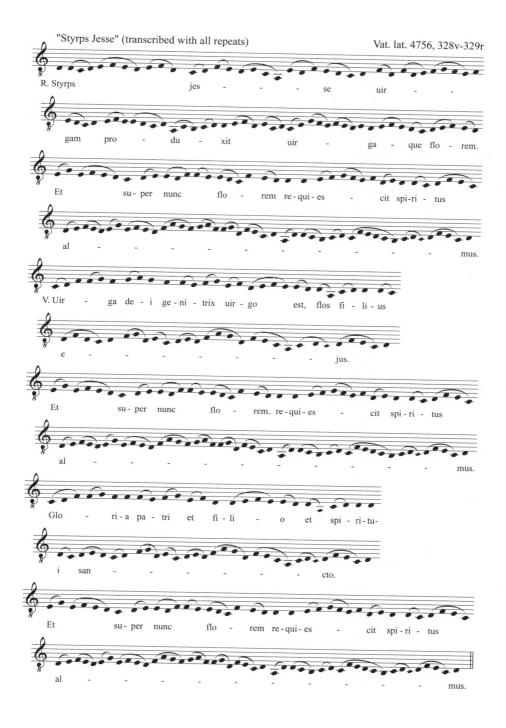

R. Styrps jes - se uir - -

gam pro - du - xit uir - ga - que flo - rem.

Et su - per nunc flo - rem re - qui - es - cit spi - ri - tus

al - - - - - - - - mus.

V. Uir - ga de - i ge - ni - trix uir - go est, flos fi - li - us

e - - - - - - jus.

Et su - per nunc flo - rem re - qui - es - cit spi - ri - tus

al - - - - - - - - mus.

Glo - ri - a pa - tri et fi - li - o et spi - ri - tu-

i san - - - - - cto.

Et su - per nunc flo - rem re - qui - es - cit spi - ri - tus

al - - - - - - - - mus.

"Ad nutum Domini"

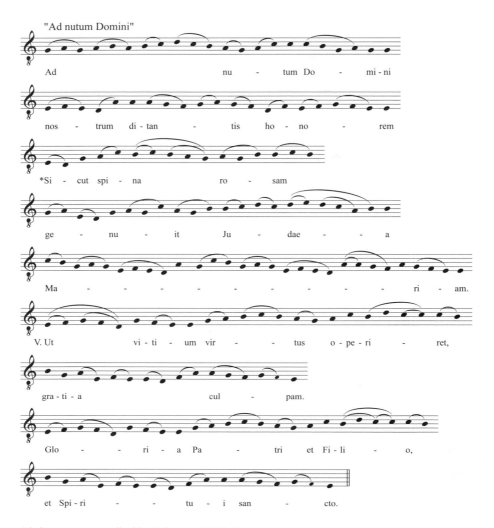

Ad nu - tum Do - mi - ni

nos - trum di - tan - tis ho - no - rem

*Si - cut spi - na ro - sam

ge - nu - it Ju - dae - a

Ma - ri - am.

V. Ut vi - ti - um vir - tus o - pe - ri - ret,

gra - ti - a cul - pam.

Glo - ri - a Pa - tri et Fi - li - o,

et Spi - ri - tu - i san - cto.

Pitches are as transcribed by Delaporte (1957), 65
Published with the permission of St. Peter's Abbey, Solesmes.

"Solem justitiae"

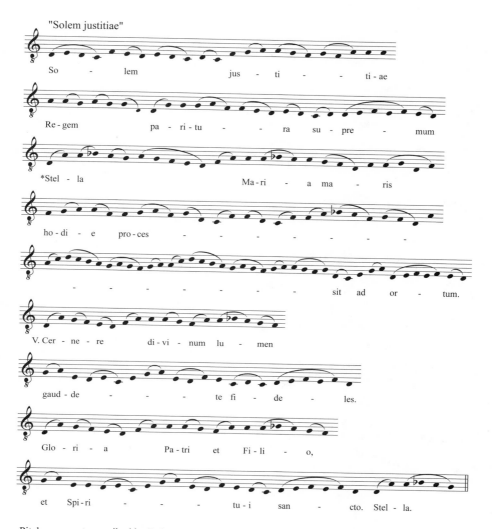

So - lem jus - ti - ti - ae

Re - gem pa - ri - tu - ra su - pre - mum

*Stel - la Ma - ri - a ma - ris

ho - di - e pro - ces - - - - - - - -

- - - - - - - sit ad or - tum.

V. Cer - ne - re di - vi - num lu - men

gaud - de - - - te fi - de - les.

Glo - ri - a Pa - tri et Fi - li - o,

et Spi - ri - - - tu - i san - cto. Stel - la.

Pitches are as transcribed by Delaporte (1957), 64
Published with the permission of St. Peter's Abbey, Solesmes.

"Non auferetur"  Rome Vat. lat. 4756, f.81

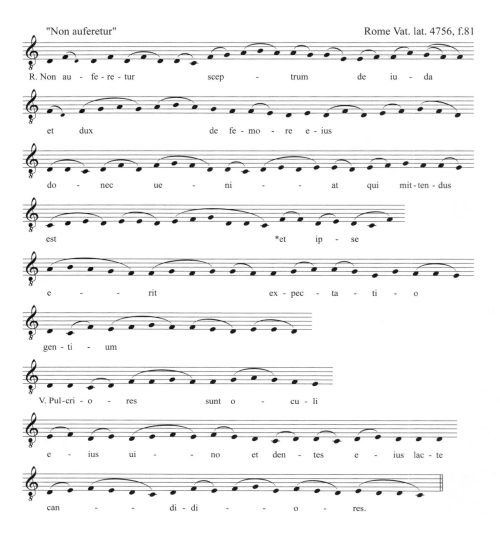

R. Non au - fe - re - tur scep - trum de iu - da

et dux de fe - mo - re e - ius

do - nec ue - ni - at qui mit - ten - dus

est *et ip - se

e - rit ex - pec - ta - ti - o

gen - ti - um

V. Pul-cri - o - res sunt o - cu - li

e - ius ui - no et den - tes e - ius lac - te

can - di - di - o - res.

"Omnes uallis implebitur"    Vat. lat. 4756, f. 75v

Om - nis   ual - lis   im - ple - bi - tur et om - nis mons et col - lis

hu - mi - li - a - bi - tur et ui - de - bit om - nis   ca - ro sa - lu - ta - re   de - i.

"Hec est regina"    B.N. lat. 15182, 345r

Hec est re - gi - na   uir - gi - num que ge - nu - it   re - gem

ue - lud   ro - sa de - co - ra   uir - go

de - i   ge - ni - trix per   quam rep - pe - ri - mus de - um et ho - mi - nem

al - ma uir - go in - ter - ce - de   pro   no - bis om - ni - bus.

Note: The "Hec est regina" set of antiphons are not extant with music in Chartrain sources; B.N. lat. 15182 is a noted breviary from Notre Dame Cathedral, Paris, dated to ca. 1300.

# APPENDIX E:

## INVENTORY OF CHARTRES, BM 162; *APPROBATE CONSUETUDINIS* AND *CONTRA JUDAEOS*

CHARTRES, BM 162 (DESTROYED IN 1944)

Description and contents: Delaporte, Box 10 in the Diocesan Archives of Chartres; Catalogue Générale de Chartres, pp. 84–85; Manuscrits illuminées, 19; and Cavet, I, 72–82.

This book belonged to the chapter of the cathedral of Notre Dame of Chartres. It was comprised of 256 parchment pages, measuring 340 x 245 mm, written in 17 long lines; its script has been dated to the second half of the eleventh century. This book was an essential collection for the celebration and understanding of the Virgin's cult in the cathedral and was kept current in the twelfth and thirteenth centuries by necessary additions. It apparently contained no chants or chant texts, but only texts for prayers and readings, for those aspects of the liturgy that came to be managed by the head sacristan. Delaporte finished his notes on this source on October 31, 1918, as he records on the final page of his work.

In each case, I have noted whether the text is mentioned in the Chartrain Ordinal from the twelfth century (OV) and from the thirteenth century (OC); some texts are found in the twelfth-century homiliary of the cathedral (HC) and the early lectionary from St. Peter (SP); for these sources I have indicated the feast, and, in the case of the ordinals from the cathedral, the actual numberings of the lessons. I have also indicated the presence of any sermon in the early tradition of Paul the Deacon as edited by Grégoire (HLM) and as found in the later traditions of Cluny and Corbie as catalogued by Étaix (HPL). The location of the texts in Canal's edition of Fulbert's sermons is indicated, as is the location of the readings in the *PL* and in the CCSA, CCSL, or CCCM. If a work is found in the earliest compilation of Fulbert's writings, Paris lat. 14167, this too is indicated. Series of lessons comprised of biblical readings have been written out in English from the Douay-Rheims translation.

f.1 Canon of the Mass

f.7 Sermo domni Fulberti, Carnotensis Episcopi, de Nativitate sancte Marie. Approbate consuetudinis est apud christianos . . . o clemens et propitia domina nostra, quo possimus recuperare et habere perpetuam gratiam filii tui Jhesu Christi Domini nostri qui. . . . Divided into 6 readings. (Paris, lat. 14167, 74v–78) OC 1–6 NBVM 174; OV 1–6 NBVM

f. 18v. Sermo de Nativitate sancte Marie. Mutue dilectionis amore et sedule adorationis . . . tantum ut veniam de ipso ac matre eius speretis. . . . *PL* 325–31; Canal: 61–69.

f. 33. Item sermo de eadem festivitate. Gloriosam sollempnitatem sancte Dei genitricis ac virginis . . . Omnium miserere, que omnium Dominum in tuo etero meruisti bajulare, cui . . . Divided into 9 readings. Ps.Fulbert, Canal: 69–72.

f. 37. Item de Nativitate. Nativitas gloriose genitricis Dei ac perpetue virginis . . . tranferat ad celestias palatia regni, quod, beatissima domina nostra, eiusdem genitrice, Maria, interveniente, ipse praestare dignetur, qui . . . Divided into 6 readings. Ps.Fulbert (Bernier d'Homblières), Canal: 72–83.

f. 56. Incipit libellus de Nativitate sancte Marie. Petis a me petiticulam opere quidem levem . . . lectorem moneo memoratum libellum, si bene memini, quantum ad sensum petinet huius modi prefationem habuisse. Prologue to the Libellus on the Nativity of the Virgin, CCSA 10, 270–71.

f. 57v. Chromatio et Eleodoro episcopis Hieronimus. Petitis a me ut uobis rescribam . . . aut consequenter scribi potuerunt. Letter from Bishops Chromatius and Heliodorus to Jerome, CCSA 10, 272–77.

f. 57v. Igitur beata et gloriosa semper virgo Maria de stirpe regia et familia David oriunda . . . sicut evangeliste docuerunt Dominum nostrum Jhesum Christum, qui . . . Divided into 6 or 9 readings. Book on the Nativity of the Blessed Virgin, CCSA 10, 276–333.

f. 70v. Sermo in Nativitate Marie. Adest nobis dilectissimi, optatus dies beate ac venerabilis . . . Sit tibi studium assidue orare pro populo Dei, que meruisti benedicta pretium ferre mundi, qui . . . Ps.Fulbert, Serm. 9, *PL* 141, cols. 336–40.

f. 76v. IV idus septembris. Natalis sancte marie. Supplicationem servorum tuorum . . . Ad missam. Famulis tuis Domine celestis gratie . . . VD eterne Deus. Et te in veneratione sacrarum . . . (preface). Unigeniti tui Domine nobis sucurrat . . . (Secret). Sumpsimus Domine celebritatis annue . . . (postcommunion).

f. 78. Sermo de Nativitate sancte Marie. Fratres charissimi, in hac die celebramus natale gloriose domine nostre Marie . . . habemus plura exempla de utrisque, sed ad presens haec sufficiant. Fulbert of Chartres, Sermon 5, *PL* 141, cols. 324–25. Paris, lat. 14167, 78–79v, with an addition; last sentence reads "sed a presens pauca sufficiant" and examples follow.

f. 82. In nativitate sancte marie. Lectio sancti Evangellii secundum Mattheum Liber generationis Jhesu Christi et relicta. Quo exordio suo satis ostendit generationem Christi secundum carnem, se suscepisse narrandam . . . ex veri Christi vocabulo appelari fecit perenni nomine Christianos. Divided into short readings. Rabanus Maurus, Commentary on Matthew, *PL* 107, cols. 731–54. OC 7–9 NBVM, 174, throughout Octave and Sunday within the Octave as well as the Octave itself, 175, ; OV, 7–9 NBVM, throughout Octave and Sunday within the Octave as well as the Octave itself. Also found in HC.

f. 97v. Lectiones Annunciationis Domini. Erit in novissimis . . . in lumine domini dei nostri (Is 2:1–5); Locutus est Dominus ad Achaz . . . et eligere bonum (Is 7:11–15); Egredietur virga de radice jesse et flos de radice eius ascendet . . . (Is 11: 1–5); Clamabunt ad Dominum . . . et sanabit eos deus dominum (Is 19:20–22); Letabitur in deserto invia . . . in fontes aquarum (Is 35:1–7); Christo meo ciro . . . et vectes ferreos confringam (Is 45:1–2). OC 1–6 AssBVM, 152; Lat. 4756, 1–6 AssBVM, ff. 327v–328v.

Is 2:1–5. And in the last days the mountain of the house of the Lord shall be prepared on the top of the mountains, and it shall be exalted above the hills, and all nations shall flow unto it. And many people shall go, and say: Come and let us go up to the mountain of the Lord, and to the house of the God of Jacob, and he will teach us his ways, and we will walk in his paths: for the law shall come forth from Sion, and the word of the Lord from Jerusalem.

Is 7:10–15. And the Lord spoke again to Achaz saying: Ask thee a sign of the Lord thy God, either unto the depth of hell, or unto the height above. And Achez said: I will not ask, and I will not tempt the Lord. And he said: Hear ye therefore, O house of David: Is it a small thing for you to be grievous to men, that you are grievous to my God also? Therefore the Lord himself shall give you a sign. Behold a virgin shall conceive, and bear a son, and his name shall be called Emmanuel. He shall eat butter and honey, that he may know to refuse the evil, and to choose the good.

Is 11: 1–5. And there shall come forth a rod out of the root of Jesse, and a flower shall rise out of his root. And the spirit of the Lord shall rest upon him: the spirit of wisdom, and of understanding, the spirit of counsel, and of fortitude, the spirit of knowledge, and of godliness. And he shall be filled with the spirit of the fear of the Lord. He shall not judge according to the sight of the eyes, nor reprove according to the hearing of the ears. But he shall judge the poor with justice, and shall reprove with equity for the meek of the earth: and he shall strike the earth with the rod of his mouth, and with the breath of his lips he shall slay the wicked. And justice shall be the girdle of his loins: and faith the girdle of his reins.

Is 19:20B–22. For they shall cry to the Lord because of the oppressor, and he shall send them a Saviour and a defender to deliver them. And the Lord shall be known by Egypt, and the Egyptians shall know the Lord in that day, and shall worship him with sacrifices and offerings: and they shall make vows to the Lord, and perform them. And the Lord shall strike Egypt with a scourge, and shall heal it, and they shall return to the Lord, and he shall be pacified towards them, and heal them.

Is 35: 1–7. The land that was desolate and impassable shall be glad, and the wilderness shall rejoice, and shall flourish like the lily. It shall bud forth and blossom, and shall rejoice with joy and praise: the glory of Libanus is given to it: the beauty of Carmel, and Saron, they shall see the glory of the Lord, and the beauty of our God. Strengthen ye the feeble hands, and confirm the weak knees. Say to the fainthearted: Take courage, and fear not: behold your God will bring the revenge of recompense: God himself will come and will save you. Then shall the eyes of the blind be opened, and the ears of the deaf shall be unstopped. Then shall the lame man leap as a hart, and the tongue of the dumb shall be free: for waters are broken out in the desert, and streams in the wilderness. And that which was dry land, shall become a pool, and the thirsty land springs of water.

Is 45:1–2. Thus saith the Lord to my anointed Cyrus, whose right hand I have taken hold of, to subdue nations before his face, and to turn the backs of kings, and to open the doors before him, and the gates shall not be shut. I will go before thee, and will humble the great ones of the earth: I will break in pieces the gates of brass, and will burst the bonds of iron.

f. 101. VIII kalendas aprilis Annunciationis sancte Marie. Deus qui de beate Marie virginis utero . . . (Collect); VD eterne Deus. Qui per incarnati verbi . . . (Preface); In mentibus nostris quesumus Domine vere . . . (Secret); Gratiam tuam quesumus Doimne mentibus nostris . . . (Postcommunion).

f. 104. Lectio sancti Evangelii secondum lucam. In illo tempore missus est . . . Lc 1:26–38. Omelia domni Bede de eadem lectione. Exordium nostre redemptionis, fratres charissimi, hodierna nobis

sancti evangelii lectio commendat, . . . ipse ad profundam hanc vallem lacrymarum descendere dignatus est Jhesus Christus Dominus noster, qui . . . Bede, Sermon 1, *PL* 94, cols. 9–14; CC 122, 14–20. OC 7–9 AnnBVM, 152; Vat. 4756, 7–9, f. 329 (rubric reads "Same readings as in Wed of Ember Week in Advent" for which see f.71).

f. 116v. Lectiones de Canticis Canticorum in Purificatione. Sancte mariae legende OC 1–3 Pur-BVM; Vat. 4756, PurBVM 1–3, ff. 315v–316. (Divisions added; Delaporte does not say if they are later.) Osculetur me, . . .

The Voice of the Synagogue: Nigra sum . . . post greges sodalium tuorum (Cant 1:1–6);

The Voice of Christ to the Church: Si ignoras te . . . vermiculatas argento (Cant 1:7–10);

The Voice of the Church concerning Christ: Dum esset rex in accubitu . . . et lilium convallium (Cant 1:11–2:1).

Sicut Lilium . . . ipsa vellit (Cant 2:2–7)

The Voice of the Dove: Vox dilecti mei . . . vinae florentes dederunt odorem suum (Cant 2:8–13)

The Voice of Christ: Surge, amica mea . . . nam vinea nostra floruit (Cant 2:13–15)

The Voice of the Church: Dilectus meus mihi . . . qui custodiunt civitatem (Cant 2:16–3:3A)

The Voice of the Church concerning Christ: Num quem . . . donec ipsa velit (Cant 3:3B–5).

Readings of Mary

Cant 1:1–6. Let him kiss me with the kiss of his mouth: for thy breasts are better than wine, smelling sweet of the best ointments. Thy name is as oil poured out: therefore young maidens have loved thee. Draw me: we will run after thee to the odour of thy ointments. The king has brought me into his storerooms: we will be glad and rejoice in thee, remembering thy breasts more than wine: the rightous love thee.

The Voice of the Synagogue

I am black but beautiful, O ye daughters of Jerusalem, as the tents of Cedar, as the curtains of Solomon. Do not consider me that I am brown, because the sun hath altered my color: the sons of my mother have fought against me, they have made me the keeper in the vineyards: my vineyard I have not kept. Shew me, O thou whom my soul loveth, where thou feedest, where thou liest in the midday, lest I begin to wander after the flocks of thy companions.

Voice of Christ to the Church

Cant 1:7–10. If thou know not thyself, O fairest among women, go forth, and follow after the steps of the flocks, and feed thy kids beside the tents of the shepherds. To my company of horsemen, in Pharaoh's chariots, have I likened thee, O my love. Thy cheeks are beautiful as the turtledove's thy neck as jewels. We will make thee chains of gold, inlaid with silver.

The Voice of the Church Concerning Christ

Cant 1:11–2:1. While the king was at his repose, my spikenard sent forth the odour thereof. A bundle of myrrh is my beloved to me, he shall abide between my breasts. A cluster of cypress my love is to me, in the vineyards of Engaddi. Behold thou art fair, O my love, behold thou art fair, thy eyes are as those of doves. Behold thou art fair, my beloved, and comely. Our bed is flourishing. The beams of our house are of cedar, our rafters of cypress trees. I am the flower of the field, and the lily of the valley.

Cant 2:2–7

As the lily among thorns, so is my love among the daughters. As the apple tree among the trees of the woods, so is my beloved among the sons. I sat down under his shadow, whom I desired: and his fruit was sweet to my palate. He brought me into the cellar of wine, he set in order charity in me. Stay me up with flowers, compass me about with apples: because I languish with love. His left hand is under my head, and his right hand shall embrace me. I adjure you, O ye daughters of Jerusalem, by the roes, and the harts of the fields, that you stir not up, nor make the beloved to awake, till she please.

The Voice of the Dove
Cant 2:8–13A

The voice of my beloved, behold he cometh leaping upon the mountains, skipping over the hills. My beloved is like a roe, or a young hart. Behold he standeth behind our wall, looking through the windows, looking through the lattices. Behold my beloved speaketh to me: Arise, and make haste, my love, my dove, my beautiful one, and come. For winter is now past, the rain is over and gone. The flowers have appeared in our land, the time of pruning is come: the voice of the turtle is heard in the land: The fig tree hath put forth her green figs: the vines in flower yield their sweet smell.

The Voice of Christ
Cant 2:13B–15. Arise my love, my beautiful one, and come. My dove in the clefts of the rock, in the hollow places of the wall, shew me thy face, let thy voice sound in my ears: for thy voice is sweet, and they face comely. Catch us the little foxes that destroy the vines: for our vineyard hath flourished.

The Voice of the Church
Cant 2:16–3:3A

My beloved to me, and I to him who feedeth among the lilies, Till the day break, and the shadows retire. Return: be like, my beloved, to a roe, or to a young hart upon the mountains of Bether. In my bed by night I sought him whom my soul loveth: I sought him, and found him not. I will rise, and will go about the city in the streets and the broad ways I will seek him whom my soul loveth: I sought him, and I found him not. The watchmen who keep the city, found me.

The Voice of the Church concerning Christ
Cant 3:3B–5

Have you seen him, whom my soul loveth? When I had a little passed by them, I found him whom my soul loveth: I held him: and I will not let him go, till I bring him into my mother's house, and into the chamber of him that bore me. I adjure you, O daughters of Jerusalem, by the roes and the harts of the fields, that you stir not up, nor awake my beloved, till she please.

f.120. In Purificatione sanctae Mariae. Sermo beati augustini. Exultent virgines; virgo perperit Christum . . . ? Sermo 370, *PL* 39, 1657–58. Complete sermon begins, Hodiernus dies ad habendam . . . ad nos pertineat in illo renasci . . . Paul the Deacon, HLM, 442; Corbie, HPL, 210.

f. 123. Item sermo sancti Ambrosii episcopi. Et ecce homo erat in Ierusalem . . . et duae Quadragesimae sacrum videntur numerum designare. Expositio Evangelii secundum Luca, II, 58–63; CC 14, 56–58. OC 4–6 PBVM, 149. Vat. 4756, 4–6 PBVM, f.316–316v.

f. 125. Item eodem die iiii Nonas Februaris Purificationis Sanctae Mariae. Erudi quaesumus plebem tuam (collect), etc.

f. 127v. Sermo in purificatione sanctae mariae. Si subtiliter a fidelibus quae sit huius diei festivitas perpendatur . . . in secula seculorum Amen. Ambrose Autpertus, Sermo de lectione evangelica, in Purificatione sanctae Mariae, *PL* 89, cols. 1291–1304; CCCM 27B, 1979, 985–1002. HPL: Corbie (222).

f. 157v. In Purificatione Sanctae Mariae lectio sancti evangelii secondum Lucam. Postquam impleti sunt dies . . . (Lc 2:22–32). Omelia domini bedae de eadem lect. Sollemnitatem nobis hodiernae . . . visiones luce reficit Jhesus Christus Dominus noster qui . . . (divided into 9 readings). CCSL Hom 18, 128–33. *OC* 7–9 PBVM, 149. Vat. 4756, 7–9 PBVM, f.317.

f. 167v. Incipit sermo beati Hieronimi presbiteri de Assumptione sanctae Mariae. Fratres Karissimi . . . appareatis in gloria . . . Paschasius Radbertus. Epistola ad Paula et Eustochium. *OC* 1–6 AssBVM, 171;

f.180. Sermo beati Hieronimi de transitu sanctae Mariae. Cogitis me o Paula et Eustochium . . . cum ipso et vos appareatis in gloria in secula seculorum. Amen. Paschasius Radbertus CCCM 56C, 109–62; HPL, 80, 169, 243, 280, 304, 348, 394, 548, 589.

f.223. Lectiones Libri Sapientiae. In omnibus requium quesivi (Sir 24:11–13 and 15–20). Dei filius verbum et sapientiae dei patris, locutus est per Salomonem in persona Sapientiae . . . aut etiam in app . . . Rabanus Maurus, Homilia 149 *PL* 110, 433–35. HPL, 280.

f.228. In vigilia assumptionis Sanctae Mariae. Deus qui virginalem aulam . . . (collect); Magna est apud clementiam tuam (secret); Concede misericors (post communion); In die assumptione eiusdem. Veneranda nobis domine huius est (Collect).

f. 230. In assumptione sanctae mariae. Lectio sancti Evangelii secundum Lucam. Intravit Jhesum in quoddam castellum . . . Conditor mundi pro redemptionis generis humani . . . intentionis suae vestem non mutaverit. Ps. Augustine, Sermo 104, *PL* 38, col. 616–18, with additions from *PL* 47, cols. 1165–67. *OC* 7–9 AssBVM, 171.

f. 232v. Item sermo in assumptione sanctae mariae. Adest nobis, dilectissimi fratres, dies valde venerabilis . . . et expecto omnibus electis suis; ipsi gloria, virtus postestas aeternitas et nunc et semper per immortalia secula seculorum. Ps. Augustine (Ambrose Autpertus), Sermo CCVIII, *PL* 39, cols. 2129–34; HPL, 244, 280, 304, 348, 548; CPPM I 979.

f. 247v. Lectiones cotidiane de Sancta maria. Surge beata virgo maria misericorditer actura pro nobis . . . surge et amplectere matrem redemptoris da preces pro nobis quos cernis offensos ante oculos conditoris. Ps. Anselm de Canterbury, Or. 54, *PL*. 158, col. 960d. Caecos cordium oculos terge, et semitas justitiae ostende . . . impetra cursum quo supernum consequitur bravium. Idem. Or. 55, *PL* 58, col. 961c; O sanctissima virgo maria, nos qui hoc credimus quod virgo et mater Die sis . . . qui confitemur te Deum peperisse et hominem, gaudeaus per te nobis advenisse salutem. Ibid. col. 961d.

ALIE. O beata maria quis digne tibi valeat jura gratiarum et laudum p. . . . rependere . . . cum suscepteris vota, culpas nostras orando excusa. Respond. Beata es virgo. Verse. Ave Maria. Admitte, pissima dei genitrix, nostras preces intra sacratium exauditionis . . . redona quod rogamus, excusa quod timemus. Respond. Cum jocunditate. Verse. Post partum, virgo inviolata. 248v. Sancta Maria, succurre miseris, juva pulsillamines, refove debiles, ora pro populo, interveni pro clero . . . sit tibi studium assidue orare pro populo dei quae meruisti benedicta precium profere mundi. For the en-

tire text of this prayer, divided here into three parts, see Barré (1963), 41–42. The work was included almost in its entirety in a sermon by Ambrose Autpertus, *PL* 39, cols. 2106–07. A source from the lands of the Thibaudians is Troyes; 853, fols. 79v–80. The prayer is doubtless a composite, as can be seen by the appearance of its final section by itself in eleventh-century sources: see Paris, BN lat. 3783, fol. 260v, Vat. lat. 8563, f. 143; and Vat. regin. lat. 488, fol. 131.

Missing Page

249. Antiphons, listed without titles or instructions. Most come from Matins of the Assumption; Delaporte did not list them.

250v. Hymn of Henri Imperatoris on the Cross. Salve crux sancta . . .

252. In handwriting from the thirteenth century, the Office of St. Anne. Delaporte provides incipits of the readings; they demonstrate the importance of the *Libellus* and other apocryphal writings in Chartres in the early thirteenth century, when the feast of St. Anne and her cult were instituted.

## APPROBATE CONSUETUDINIS

Sermo IV: *De nativitate beatissimae Mariae virginis. PL* 141:320B–324B
The approved custom among Christians is to observe the birthdays of our forebears with careful attention, and especially to read aloud in church their virtues, ascribed to them in books, for the praise of God, by whose gift they exist, and for the good of lesser folk. Among all the saints, the memory of the most blessed Virgin is more often and more joyously celebrated, since she is believed to have found more favor with God. Hence the devotion of the faithful, not being content with her other, older feasts, added this day's solemn feast of her nativity. And so it seems that on this day in particular the book that has been found concerning her birth and life ought to be read in church, even though the Fathers decided that it should not be counted among the apocrypha. But since it seemed appropriate to great and wise men, let us — since we read certain other apocryphal texts that are not hostile to the faith — respectfully follow ecclesiastical usage.

Before she was to be born, Mary, the blessed mother of the Lord, and ever virgin, was proclaimed by prophecies and declared by miracles. A child prophetically ordained by her lineage, she shone forth, marked by the privilege of her virtues. She brought forth a Savior by whom she has been glorified in heaven, yet she has never ceased to support those who are on earth. May her story follow this theme in its order.

Let us now recall one of the prophecies already mentioned, and then we can proceed in a few words. The Eternal One said the Old One, God to the Serpent: "I will put enmities between thee and the woman, and thy seed and her seed; she shall crush thy head, and thou shall lie in wait for her heel" (Gen. 3:15). Brothers, what is it, as here, to "crush the head of the serpent," but by resisting to conquer the chief temptation of the devil, i.e., concupiscence?

If we then ask what woman could achieve a victory of that sort, surely there is no one to be found in the lineage of human generation before her, about whom we are now speaking, the holy of holies. But if we ask in what way even she could crush the head of the serpent, of course it is because she offered the sacrifice of her virginity and, at the same time, her humility. By preserving her virginity she demonstrates that she had extinguished the concupiscence of her flesh; with her humility, which makes her poor in spirit (cf. Matt. 5:3), she shows that she had extinguished the concupiscence of her mind. And so, with the chief temptation of the devil conquered, she has crushed the vice-ridden head with the heel of virtue. Yet she has not triumphed by this action alone, but especially by it, for concerning her flesh, furnished with the purest of bodies, Wisdom says: In every way possible she reaches evil, from end to end mightily, and she orders all things sweetly (cf. Wis. 8:1). This then is

the woman to whom the divine prophecy was pointing; when it intimated that she was to be born, it indicated that this would happen in a unique way.

With this prophecy briefly explained, one of the miracles is resolved as well. At the Lord's command holy Moses took from each of the tribes a rod with its name written on it, and placed them in the tabernacle. On the following day one among them, the rod of Aaron, was found to have germinated, flowered, sprouted, and borne almonds. The Lord, knowing this work of his to be a great mystery, ordered the rod to be preserved in a memorial (see Num. 17:1–10). The sons of Israel were instructed by the presence of the rod to seek eagerly what such a wondrous deed might signify. Much later the prophet Isaiah disclosed this: "There shall come forth a rod out of the root of Jesse, and a flower shall rise up out of his root, and the Spirit of the Lord shall rest upon him" (Isa. 11:1–2).

It is as if his listeners, responding to these words, said, "O father Isaiah, you speak obscurely. I beseech you, tell us this openly!" For Isaiah added an explanation, and said, "Behold a virgin shall conceive, and bear a son, and his name will be called Emmanuel," (Isa. 7:14). And he describes the Virgin's son, Emmanuel, plainly: "A child is born to us, and a son is given to us, and his name shall be called Wonderful, Counsellor, God the Mighty, the Father of the world to come, the Prince of Peace. His empire shall be multiplied and his kingdom will have no end" (Isa. 9:6).

What God, therefore, revealed with a miracle, Isaiah pointed out with a sacred prophecy. And what the prophet sang, the outcome confirmed. For just as that rod with no root, without any support of nature or of art, bore fruit, so the Virgin Mary, without the act of marriage, brought forth a son, a son surely designated by the flower and the fruit: the flower on account of beauty, and the fruit on account of usefulness. For he is "beautiful above the sons of men" (Ps 44:3/45:2), and the life-sustaining food not only of humans, but also of angels.

With the first part of the proposition briefly affirmed, we will take up what follows.

The most blessed Virgin was born, then, as we read, of a father from Nazareth and a mother from Bethlehem. The prophets were not silent concerning the towns appointed for the birth and daily life of Christ. Mary descended from the root of the man with the faith of noble Abraham, to whom the blessing of all peoples in his seed was promised from above, and from the stock of David, whom God exalted with exceptional praise on account of the goodness he noted in him, saying: "I have found a man according to my own heart" (Acts 13:22).

Mary, who was about to bear the supreme king and priest, took her origin from the royal tribe and, at the same time, the priestly one as well. We have not said these things, though, because the Lord, who came to call sinners, deigned to have his own mother related to sinners, among whom she might appear beautiful as a lily among thorns (Sg. 2:2). She was chosen and outstanding among the daughters, not by chance, or by the good pleasure of her parents, as so many are, but she received her name by divine dispensation, so that the very form of her name might suggest something great: for it means "star of the sea."

We will demonstrate, using a similitude, the meaning that this mystery bears. Sailors crossing the sea have to observe this star, shining distantly from the highest point of heaven, and from its position they determine and direct their course, so that they may arrive at their destined port. In a similar way, my brothers, all worshippers of Christ, rowing amidst the waves of this world, must pay attention to this star of the sea, i.e., to Mary, who at the highest point of all things is near to God, and to direct the course of their lives by observation of her example. One who does so will not be tossed by the wind of vainglory, nor broken on the crags of adversities, nor sucked in by the Scyllaean deeps of pleasures, but will happily come to the port of eternal peace.

At this point, one might ask, "What qualities, therefore, do you think were once in her soul, or are there now, that this person is put forward so as to be seen and imitated by all the saints?" We respond truly that it can be demonstrated far better by prayer than by our discourse. Nonetheless, lest we be accused of saying nothing where a great supply of words abounds, reserving many great things for the eloquent, we will still say at least a few things on this subject, which may easily be proven when heard. First, therefore, it must be established that the soul and flesh of the one he chose, the dwell-

ing place that the Wisdom of God the Father made for himself, were perfectly free from every evil and impurity, as Scripture affirms: "Wisdom will not enter into a malicious soul, nor dwell in a body subject to sins" (Wis 1:4).

Likewise, we confidently assert the contrary: no virtue can be lacking to one in whom God's messenger asserts there is the fullness of grace. Though the archangel attests this—which no one with a sound mind would discredit—someone might still, with holy longing, seek proofs of her virtues from her words and deeds that Scripture records; indeed, the more easily they come to mind, the more faithful one will be in longing for them. Some among them are evident to almost every Christian. Does anyone not regard with glad admiration the strength of her mature adolescence, her prudence, or her faith during her angelic encounter, where she spoke with such constancy, she questioned so wisely, and she believed so readily? Who does not see, and by seeing wonder at her uprightness, by which she strove to fulfill the universal precepts of divine law, lest she leave unfulfilled things said concerning her? For example, after childbirth she carried out the legal purification that she did not need, for in conceiving she had not known a man.

Concerning her modesty, it was said above that she brought forth the lily of virginity for God in the valley of humility. Since her words and deeds are filled with the abovementioned virtues, it was clearly revealed not only by the angelic word, but also by factual evidence, that no virtue was lacking to the blessed Virgin. The virtues in her thought and in the disposition of her heart drew forth an ineffable harmony, which the Wisdom of God, her very creator and indweller, delighted to hear; outwardly they shone in words and deeds, from which people can rightly glorify God and receive images of salvation. For such and so great a person, what more could be added to the mass of her honors: the Virgin conceived the Son of God—the Virgin, a mother, gave birth—by this dignity she became venerable before the very ranks of holy saints and angels.

With the deed revealed, the great and powerful archangel Gabriel spoke, who before she became God's mother—since he knew the future—anticipated her by saluting her with such veneration. By the same dignity she also became powerful, according to the charity she showed, through her discretion, to those above her and over those beneath her. Many examples proving this have been recorded, from which for the present it will suffice to recall one. She once sent a holy angel to assist the great father Basil, and she revived a dead man, who utterly destroyed Basil's evil-living persecutor, Julian the Apostate. This is well known to history.

Even you, Theophilus, once a sinner, penitent and invoking her aid, Mary snatched powerfully from the very jaws of the devil. How will we be burdened if the restoration from his fall be told in a few words, since listening is the reward of this deed?

This man Theophilus was once walking in the country of a certain bishop of the Cilicians, as certain writings testify, when he fell into sorrow on account of his misfortunes. So he betook himself to a certain evil Jew, seeking his counsel and aid. Through this mediator he in fact spoke with the devil, and he denied Christianity, worshipped the devil, and gave to him by his own act a charter sealed with his ring.

Later, repenting of his deed, and greatly distressed in his mind about what he should do or whither he might turn, having gathered his powers of faith and hope, he betook himself to a certain church dedicated to the memory of blessed Mary, the mother of the Lord, where for forty days, afflicted with regret and with a contrite soul, he continually invoked her name and implored her advocacy. What more need I say? The gracious Mother of mercy had regard for him, and, appearing to him in a vision, she exposed his impiety and urged him back to the faith of Christ. She comforted him in his sorrow by promising forgiveness, and, lest he doubt her promise, having powerfully snatched the above-mentioned charter from the devil, she returned it to the captive as a pledge of his liberty. It is not easy to relate how joyful he was, seeing the charter lying upon his breast as he awoke, how he uttered sounds of exultation and confession with holy feeling. The day following this night was Sunday, and Theophilus, as if rising from the dead with the Lord, presented himself to the bishop before the people, and he revealed the affair as it was.

You should have seen how the people grew fearful at hearing so horrible a transgression, how they wept together when regarding the emaciated face of the penitent. But, when they heard, oh, such pity very quickly followed these other feelings. All of them, who, terrified, had nearly grown faint from bad conscience, breathed again with joy at the hope of pardon. And now, to bring the matter to a brief conclusion, at the bishop's command Theophilus burned the reclaimed document in the fire. Then, led to the altar with the support of the clergy and people, when he received holy communion in his mouth from the hand of the bishop, his face shone like the sun. Three days later, with praises re-echoing in the church of the holy Mother of the Lord, through whom he had been reconciled, he rested from his labors with a blessed end.

Such deeds show that the Lord's Mother is everywhere powerful, everywhere eminent. Certainly, the holy angels are pleased to be sent to serve by her, and for her gracious purpose pacts with devils come to nothing. By these and other blessings without number, whether they be written or experienced everywhere with their continual effect, she is present to both just and sinners who call upon her faithfully, and she never ceases to aid them. Therefore, let the just come to her with Basil, praising and blessing, and asking a speedy result for their holy desires, which without a doubt will be heard. Let sinners come with Theophilus, beating their guilty breasts with inner weeping, and they too, if truly penitent, will attain the desired forgiveness. From their number we stand before you, that now you may deign to relieve and help us. We implore you, O chosen one, O holy one, O venerable and powerful one, O our merciful and gentle Lady, by whom we may be enabled to recover and to have the everlasting grace of your Son our Lord Jesus Christ, who with the Father and the Holy Spirit lives and reigns, one God in eternity. Amen.

## CONTRA JUDAEOS: THE TREATISE AGAINST THE JEWS OF FULBERT, BISHOP OF CHARTRES

[PL 141:305D–318A]

He undertakes to prove that the prophecy of the patriarch Jacob, "The scepter will not be taken away from Juda," and so on, has been fulfilled in Christ Jesus.

### I

The children of the Jews are saying: It is not strange if we are now captives, if—as we do not possess Jerusalem—we do not have our own king. In the same way we were captives for our sins in Babylon, not having our own king; later, when we had returned to our own country, we had kings and princes. This is our hope: that something similar may yet happen to us, when God pleases. Some [Jews] say: Perhaps in a part of the world unknown to us a large number of Jews can have been brought together, who have their own king, and so the scepter has not yet been taken from Juda; others say that wise and powerful Jews exist in certain places, who govern their homes and their families very well with a scepter of uprightness, and therefore the scepter has not been taken from Juda.

To these people my first response is that if we have to take the prophecy in that way, as they say we must, the Messiah has not come, nor will he come, until all the Jewish heads of families have died or become so powerless that not even one of them exists in the world who knows how or is able to rule his own household—which will not come about until that day that is the end of all mortal beings, nor will the Messiah come before that. If this is so, why do we reckon that the Messiah will come on the last day—[is he] to bury all the dead, whom it was hoped that he would come to heal when they were infirm? In this was the expectation of the peoples!—since they ought not to make the scepter of Juda so common, or to make the number of kings equal the number of heads of families among their people, at least not before it happens, nor to represent their patriarch as so senile that an aged man who was soon to die would, with supreme effort, bring forth great trifles when he said, "Gather yourselves together, my sons," and so on (Gen 49:2).

Again, if the prophecy has to be taken in that way, what did the patriarch prophecy to his own Hebrews that any gentile could not prophecy to his fellow pagans? They were not to lack heads of families until the end of time. Again, those who expound it in this way diminish the majesty of the kingdom, weaken the prophecy, [and] give us as a sure sign of the advent of Christ only the destruction of everything good.

In another way, my first response is that they are wrongly interpreting this prophecy. By putting in the plural "the scepter of the kingdom" that has been expressed in the singular, they divide it into the "rods" of individuals. In this way do the false scepters require that the prophet, who was holy and filled with God, be reputed a foolish and senile old man. For what does Israel seem to have prophesied to his own Hebrews that any Greek, Latin, or barbarian could not prophecy to his own people?

Next, just as the first speaker is clearly trying to do, so is he able to escape for all time the saving work of Christ's coming. If he knows that a king from among the Jews exists anywhere, he will deny that Christ has come since he will consider that the scepter has not been taken from Juda; if he does not know, insofar as this will be possible—since he is at liberty not to know—yet when he believes that [such a king] is somewhere, he will believe that Christ has not come. We, however, want so to respond as to demonstrate that it does him no good, for the purpose of denying the coming of Christ, whether he points out one king or many from the Jewish people who are not kings of Juda.

Even when this is demonstrated about those [kings] who are somewhere—if perhaps they can be shown to be somewhere—he will appear to be doing something superfluous. There are three things without which no kingdom can exist: a land, in which the kingdom exists; a people, who inhabit that land; and the person of the chosen king, who can claim the land and rule the people. The land of the kingdom with which we are dealing is the province of Jerusalem, which is called "the land of Juda." The people of this land was the tribe of Juda. Their kings, up until Christ, were all of the tribe of Juda.

As, then, a house is made up of its parts . . . [1] That is the land of Juda, and [it is ruled] by a king of the tribe of Juda, and, just as no house exists if the foundation is lacking, or the walls, or the roof, so no kingdom exists if the land is lacking, or the people, or the king. When a part is lacking, the whole cannot exist, and when the whole exists, all the parts must necessarily be present.

If, then, when one part is lost, the whole does not exist, how much more when all the parts have been lost is it reduced to nothing. The kingdom of Juda was deprived of its land from the time when that land passed into alien hands. It was deprived of its people after the tribe of Juda was scattered among all the nations. Long before that, however, it had been deprived of its king. Thus the kingdom of Juda, when all its parts had been separated off, ceased to be a kingdom. From that time, clearly, the scepter has been taken from Juda, and it was declared that Christ had come.

If, then, you would establish, or falsely suppose, a single Judean—for example, Mordecai—as king in Babylon, or indeed in Samaria, where ten tribes of Jews used to live, possessing their own king, who was called King of Israel—still he will not be king of Juda, but of Israel, or of Babylon, in which the prophecy that says that "the scepter shall not be taken away from Juda" has no interest. Again, the effective cause of the kings[2] of Juda was the priests, who anointed them as kings. The Jewish people lost their priests along with their place for sacrificing; beyond any doubt, then, they lost kingdom and scepter. Where no effective cause exists, the effect that comes of it can in no way exist.

## II

In the desire to make some necessary remarks against the errors of unbelievers, I begin immediately with the Jews. They claim to agree with us Catholics in this, that we worship one Lord, the creator of all things. They do not agree, however, in these: they do not acknowledge the trinity of persons in the unity of the divine nature, they deny that Christ is God, and they say that he has not

yet come. Beginning our counter-argument with this last point, we will come step by step to the loftiest.

The proofs that Christ has come are countless. One of these is the oracle of the patriarch Jacob and the lawgiver Moses, who pointed to the scepter of the kingdom of Juda as a sure sign of his advent when they said, "The scepter shall not be taken away from Juda, nor a ruler from his thigh, till he come that is to be sent, and he shall be the expectation of nations" (Gen 49:10)

We attribute this prophecy to the two men together for this reason, that one of them produced it, and the other reproduced and supported it by writing it down. The one who produced it, the holy patriarch Jacob, was at that time a stranger and sojourner in Egypt along with his sons (Gen 23:4). No royal dignity was observed to pertain to them, but only the promise, which was to be accomplished by their descendants for us. Yet that spiritual man foresaw that there would come into existence out of his stock such a kingdom as we read of in Exodus, when the Lord says to his children, "If therefore you will hear my voice and keep my covenant, you shall be my peculiar possession above all people: for the whole earth is mine. And you shall be to me a priestly kingdom" (Exod 19:5–6). He was foreseeing a priestly kingdom in which sacrifices would be offered to God alone, such sacrifices as could not exist without a priesthood.

Moses points out the place of this kingdom when he says in Deuteronomy, "Beware lest thou offer thy holocausts in every place that thou shalt see: But in the place which the Lord shall choose in one of thy tribes" (Deut 12:13). When the choice of tribe and place had already been made, King [David], God's psalmist, sang of them, "He rejected the tabernacle of Joseph: and chose not the tribe of Ephraim: But he chose the tribe of Juda, Mount Sion which he loved." (Ps 77:67/78:67)

The patriarch, proclaiming an oracle concerning this, and indicating the coming of the Messiah in view of its final purpose, spoke briefly, saying, "The scepter shall not be taken away from Juda, nor a ruler from his thigh, till he come that is to be sent, and he shall be the expectation of nations." The meaning of this prophecy must be so taken, and explained in this way, if in very few words: The house of Juda, which is now of middling size and a sojourner, will at some future time grow into a great people, and will possess its own homeland in the land of the Lord's promise, and kings or leaders from its own stock. Neither the rule nor the guidance of that people will afterwards be taken away, out of the hands of its own stock, so as to be transferred into the hands of a foreign master, until Christ comes.

Jews! When you see the scepter of Juda transferred into the hands of a foreign king, recognize by this sure sign that Christ has come! You should not expect a future temporal kingdom, one that passes away, but rejoice forever to reign with Christ, who has come.

The sequence of events clearly follows the truth of this prophecy. After God chose for himself the place of the priestly kingdom in the land of promise, as Moses had earlier written, and as David sang after the fact, no ruler who was not of the legitimate stock had part in the tribe of Juda until the time of Herod, the foreigner who ruled over Jerusalem after Hyrcanus, under Caesar Augustus. At that time the Lord Jesus was born in Bethlehem of Juda; from that time was the transitory scepter taken away from Juda, and the ruler from his thigh.

Long ago, in accord with prophetic truth, Christ came, who was to rule forever. Even the cessation of sacrifices that came about at his coming demonstrates that Christ has come, as Malachi had prophesied in these words: "I have no pleasure in you, saith the Lord almighty, and I will not accept a sacrifice from your hands. For from the rising of the sun even to the going down, my name is great among the Gentiles, and in every place a pure sacrifice is offered to my name: for my name is great among the Gentiles, saith the Lord almighty" (see Mal 1:10–11).

The predictions of other [prophets] agree amply with this prophecy. But when the Jews were utterly unwilling to acquiesce in them, but were continually longing to slaughter sacrificial victims and to eat their flesh, the Lord curbed their superstition with great force, driving them out of the place of the kingdom, in which alone, and never elsewhere, the law allowed them to offer sacrifice. So at last the unwilling [Jews] saw clearly that [Malachi's] prediction was true of their defunct

priesthood, since they had neither further license to offer sacrifice, nor resources within their former walls.

When the old priesthood, which had been instituted for a period of time, had passed away, the new and sempiternal priesthood of Christ succeeded it. Of this the psalmist had foretold, "The Lord hath sworn, and he will not repent: Thou art a priest for ever according to the order of Melchisedech" (Ps 109:4/110:4).

The change in the law, too, demonstrates that Christ has come, the change accomplished by his very coming, as the divine Isaiah had said earlier in these words: "In the last days the mountain of the house of the Lord will be manifest, prepared on the top of mountains, and it shall be exalted above the hills, and all the nations shall come to it and say: Come, let us go up to the mountain of the Lord, and to the house of the God of Jacob, and he will proclaim to us the way of salvation, and we will enter into it: for the law shall come forth from Sion, and the word of the Lord from Jerusalem" (see Is 2:2–3).

Who is so uneducated as not to understand in these words—the mountain raised above the mountains—that Christ is king above all other rulers? In the coming of this king the prophet saw that the law would go out, not from Mount Sinai, to educate one nation as before, but from Mount Sion, to teach the nations, as we see being done even now.

The old law was given to Moses on the fiftieth day after the sacrifice of the paschal lamb; the new law was breathed into the holy apostles on the fiftieth day after the slaughter and resurrection of the true Lamb. Of this law holy Jeremiah says, "Behold the days shall come, saith the Lord, and I will establish a new covenant concerning the house of Jacob, not according to the covenant which I made with their fathers, in the day that I took them by the hand and to bring them out of the land of Egypt," and so forth (see Jer 31:31–32). Since, then, the prophet had foretold that at Christ's coming a new law was to be proposed by him—and he brought it forth immediately—it is manifest that Christ had also come earlier as a lawgiver.

The most holy Daniel, too, showed not only that Christ had come, but even reckoned the exact time of his anointing and passion, and the end of priesthood and the everlasting desolation of the Jews. He did this in the person of Gabriel the archangel, who spoke to him in these words: "Seventy weeks are shortened upon my people, and upon thy holy city, that transgression may be finished, and sin may have an end, and iniquity may be abolished, and everlasting justice may be brought; and vision and prophecy may be fulfilled; and the saint of saints may be anointed." And after a bit, "Christ shall be slain," he says, "and the people that shall deny him shall not be his"; and after another bit, "And in the half of the week the victim and the sacrifice shall fail; and there shall be in the temple the abomination of desolation: and the desolation shall continue even to the consummation, and to the end" (Dan 9:24, 26, 27).

The summary of this prophecy—as far as pertains to our present account—is that in the seventieth week Christ must be anointed and slain, and the old priesthood would fail. This week was unfolding, and the everlasting desolation was going to follow during the reign of Tiberius, the successor of Augustus, when the Lord Jesus would be baptized and crucified.

Long ago, then, in accord with prophetic truth, not only did Christ come, but he was also anointed and suffered, and the old sacrifices failed while the desolation followed. Again, Christ came, and who Christ was the form of his humility and his passion indicated long ago, described in detail by many seers, and found together only in our Lord Jesus.

I add, as instances, a portion of that description, as that he deigned to be born in Bethlehem, in accord with the prophecy of Micah; that he entered Jerusalem sitting on a donkey, and at the time of his passion was clothed in a red robe—"And like a sheep he was led to the slaughter, and he was numbered with the wicked," as Isaiah had mourned (Is 53:7, 12); that he was sold for thirty pieces of silver (Matt 26:15), crowned with thorns (Matt 27:29), and covered over by a stone, as Jeremiah had lamented (Lam 3:53); that with his hands and feet pierced he was given gall and vinegar to drink, his garments were divided, and over his tunic lots were cast (Matt 27:23, 24); that he was made to

dwell in darkness like the dead of long ago, as David wept (Ps 142:3/143:3); that he was slapped (Matt 26:67) and spat upon (Mark 15:19), and wounded by a lance as John grieved (John 19:34).³ Such a description by the prophets of the humility and passion of Christ, since it was found in its entirety only in our Lord Jesus Christ, shows not only that Christ has come, but that he alone truly is the Christ.

Again, Christ has come, and who Christ was the evidence given at the time by seers contemporary with him shows—seers like Zachary and Elizabeth, Simeon and Anna, whose actions and prophecies were set down in writing, and John the Baptist, who said, "Behold the Lamb of God, behold him who taketh away the sins of the world" (John 1:29). When, then, these people pointed to the Lord Jesus in person, beyond any doubt they were showing not only that Christ has come, but who Christ was.

Again, the signs and wonders that took place as if from without, but yet from a divine source, in the birth, baptism, and passion of our Lord Jesus declare not only that Christ came, but that he truly is the Christ—such things as the visions of angels rejoicing at his birth, the new star shining to show his presence, and the magi coming to his cradle with gifts. These wonders so disturbed the abusive king that out of jealousy of the newborn Christ he brought about the savage massacre of the infants his age. Such things too as the thunder of the Father's voice, and the dove, as an image of the Holy Spirit, at his baptism, and as when the sun was darkened, the earth trembled, and the veil of the temple was torn at his slaying.

Beyond all these things, his works and words show that Christ has come. With these he once confounded the incredulity of the Jews when he said, "If I had not done among them the works that no other man had done, they would not have sin" (John 15:24). With these, too, he strengthened the faith of the disciples of John the Baptist, among others, when he said, "Tell John what you hear and see: the blind see, the lame walk, the lepers are cleansed, the deaf hear, the dead rise again, the poor have the gospel preached to them. And blessed is anyone who shall not be scandalized in me" (Matt 11:4–6). The prophets had foretold that the Christ was going to perform these and many other things. All these, since they were seen to be done by our Lord Jesus Christ, proved that he is truly the Christ.

Another proof of Christ's coming is that the sound of the apostles has gone out into all the earth, and that all the tribes of the earth are seen to be blessed in him (Ps 18:5/19:4; 71:17/72:17). Countless other things I willingly pass over, since I have shown abundantly enough that the proposition is true—that is, that Christ has come at his own time.

The Jew has nothing to say against this. If he says that the scepter has not been taken away from Juda, clearly he is a deceiver, because for about a thousand years Juda has been scattered to all the winds, and foreigners possess the place of the royal priesthood. If he says that his priesthood is not defunct, plainly he is lying, because he has neither license to sacrifice outside Jerusalem nor resources within. If he says that the covenant has not come to an end, this especially is false, because the law of the old covenant is not binding without the blood of sacrifice. If he says that the number [in the book] of Daniel has not been fulfilled in the time stated above, the accounts given in the chronicles easily prove this too to be false. If he says that the one to whom the description given above, along with the testimony of the prophets, applies is not the Christ, even this proves him a deceiver, because there is no one else to whom it could apply. If he tries to growl about new judges and prophets, the old ones, and the radiant miracles of [Christ's] signs, refute him. If he does not believe that the miracles of [Christ's] birth, and the others, were performed, the slaughter of the innocents and many tales reprove him. [The Jew] cannot obscure Christ's great deeds because they have been impressed or expressed by the various signs of books and of buildings so that they cannot disappear apart from the ruin of the world. If the Jew, refuted by such an account, and confuted by such testimonies from the saints, does not give his assent to the legal and prophetic authority, he must be expelled from the synagogue.

That Christ came, and when, and who he is, has been explored up to this point; from here on let me begin to show that he is the true God.

First I consider this, that Christ excels all other human beings. Certain of his glorious characteristics, set down by the prophets, make this clear: like this, that he is a man born of a virgin, as Isaiah testified (see 7:14), and that Christ is "a man without help, free among the dead," as David testified (Ps 87:5–6/88:4–5). The virgin mother bore no other human being, nor did any other rise free from the dead by his own power.

Then there are other things proper to Christ by which he rises immeasurably far above every creature: like this, which was professed with wonder by Isaiah (53:1): "Lord, who hath believed our report? and to whom is the arm of the Lord revealed?" and this by David, "The Lord hath said to me: Thou art my son, this day have I begotten thee" (Ps 2:7). Neither angel, nor any other creature, is God's arm, nor is it God's natural son in an everlasting day. Generous testimonies from theologians exist concerning this divine filiation or generation—hence the wise king posed this wondrously subtle question when he said, "Who hath ascended up into heaven, and descended? who hath held the wind in his hands? who hath bound up the waters together as in a garment? who has raised up all the borders of the earth? what is the name of his son, if thou knowest?" (Prov 30:4).

From the things proper to Christ mentioned above, which separate him from creation, his divinity can be demonstrated in conformity to reason in this way: Whatever exists is either Creator or creature. Hence, what exists, if it is not a creature, is the Creator. Since, then, Christ is God's arm, which is not a creature, indisputably he is the Creator. Again, the natural son, even if he differs from his Father in number because he is another, yet he is by definition one and the same with his natural Father. Christ is the natural son of God; Christ is, therefore, the same as the Father—that is, he is God. Clearly, then, Christ, since he is God's arm, is the Lord; and, since he is God's son, he is God.

Beyond these things, finally, certain oracles concerning Christ's divinity have thus been laid open so that in considering them we have no need to employ our reasoning power. Since clearly by the very name they proclaim him "Lord" with praises worthy of God—although not without being mindful of his humanity—by this it comes about that he is believed to be at once true God and a man. Concerning this David said, "Thy throne, O God, is for ever and ever," and so on, and Isaiah, "A child is born to us, and a son is given to us, and his name shall be called Wonderful, Counsellor, God the Mighty, the Father of the world to come, the Prince of peace. His empire shall be multiplied, and there shall be no end of peace" (Ps 44:7/45:6; Is 9:6).

In these words of Isaiah we have to be on our guard against the false interpretation of the Jews, by which they labor to present this oracle in the name of Ezechias [Hezekiah] when they argue with uneducated Christians. Clearly this is false, because the Hebrew text does not read, "and his name shall be called Ezechias," which means "the mighty one of the Lord," but, "his name shall be called Elgiber [sic]," which means "God the Mighty." This name—that is, "El"—is appropriate only for God, and not for Ezechias, to whom the other [names] that follow are also not appropriate.

Further, in David's oracle we must carefully consider, together with the divinity of Christ, the distinction of Father, Son, and Holy Spirit. When he says, "Thy throne, O God, is for ever and ever: the scepter of thy kingdom is a scepter of uprightness. Thou has loved justice and hated iniquity," he is speaking to the Lord's Son. When he says, "Therefore God, thy God, hath anointed thee," he is speaking of God the Father. When he adds, "with the oil of gladness," he is indicating the Holy Spirit, who is no less God, as will be demonstrated in its place (Ps 44:7–8/45:6–7).

## III

A great disagreement exists among the sons of men, as about many other things, so also about the confession of faith. Seeing this, the Apostle [Paul] said, "We preach Christ crucified, unto the Jews indeed a stumbling block, and unto the Gentiles foolishness: But unto them that are called, both Jews and Greeks, [Christ] the power of God, and the wisdom of God" (1 Cor 1:23–24).

Not only Gentiles and Jews, but also those who wish to be called Christians, have great disagreement among themselves. Although some of these are catholics, others are heretics of many kinds. I,

Fulbert, who am setting down such things, although a sinner and an unworthy bishop, yet—because by faith I desire to be and profess myself to be a catholic—by God's grace wish to render to others, to those I can reach, some small portion of [God's] reasoning, which in me is sufficient and abundantly so, concerning my faith and their error.

And first for the Jews. These say they agree with us in this: we confess one God, the Creator of all things; they disagree, however, concerning many things, but most dangerously concerning these, that they do not acknowledge the Trinity of persons in the unity of the divinity, and that they deny that Christ is God, or say that he has not yet come. The one who could prove them wrong by rational means concerning this last or third point would not, I think, have a very difficult time later concerning the others. When it has been proved that Christ came, such a one could then announce to the inquiring Jew what he ought to think about the other matters, and what he ought to do. Therefore let us now begin.

That Christ has come is proved by the fulfillment of the prophecy that Moses had written in these words, "The scepter shall not be taken away from Juda, nor a ruler from his thigh, till he come that is to be sent, and he shall be the expectation of nations." Rule over the tribe of Juda was not taken away from the hand of his stock, and transferred into the hands of foreign kings, until the coming of our Lord Jesus Christ, whom we catholic Christians acknowledge; in fact, long ago the scepter was taken away from Juda, and was transferred into the foreign hands of this same our Lord Jesus Christ.

Long ago, then, prophetic authority makes clear that he that was to be sent has come—that is, Christ. See how we round off our subject succinctly; now let us lay out briefly its true historical proof.

[I am] showing what kind of rulers the Judean people had from their own stock when they lost them, and how the taking away of rule and the coming of the Messiah came together in the days of Herod. Therefore after Moses, who produced this prophecy, and Jesus [Joshua], his successor, the Judean people had rulers from their own stock, who were called "judges," up until the time of the prophet Samuel. After that were those called "kings," likewise from their own stock—Saul, David, and many others—up until the deportation to Babylon. In that deportation rulers and comforters from their own stock, filled with God and more excellent than the kings themselves, were not lacking, like the prophets Jeremiah and Daniel. After the return from Babylon was, similarly from their own stock, the well-disciplined rule of priests, up until the time of Aristobulus, who was priest of the Judean people, likewise of their own stock; their last king. Pompey, the leader of the Romans, sent this Aristobulus bound to Rome, along with his children, after Jerusalem was conquered, leaving the high priesthood to Hyrcanus, [Aristobulus's] brother. He was the last priest of the whole Judean nation by the legitimate succession of his stock.

Herod, the first of foreign stock, became king of the Jews by decree of the senate while Augustus was governing. At that time Christ was born in Bethlehem in accord with the prophecy. Up to that time, then—that is, up to the reign of Herod, and not after—the Jewish people had rulers legitimately from their own stock; with the kingdom of the Jews disrupted and changed, the priesthood too was disrupted and changed.

Herod, after he received the kingdom of the Jews from the Romans, did not appoint priests by ancient right—that is, through legitimate succession of the stock—but promised the priesthood indiscriminately to certain ignoble people for a period of time. In addition, with the sacred vestment of the high priest shut up under a seal, its use was never permitted to the priests.

Archelaus, his successor, held to this perverse custom after him. From then on Roman commanders held to this until at length, after Christ's passion, with Jerusalem destroyed and the Jewish people scattered, neither their city, nor king, nor priest, nor people existed. This continuing desolation has lasted until the present day. If these things are so—or rather, because they are so—what we had concluded from prophecy we have subsequently established by history: that is, that at the time at which the rule was taken from Juda, and the ruler from his thigh, the Messiah came. Now if the Jews have something to murmur against this, let it be heard.

Here certain Jews from among them are accustomed to give a threefold argument against this account. "First," they say, "we do not believe that Christ has come because we do not think that the rod of rule has been taken from Juda. There are in many regions wealthy and gifted Jews who govern their families actively, and because we see that such rulers still exist we say that the scepter has not been taken from Juda, nor has Christ come yet."

Anyone can mock them with playful affability, and at the same time silence them by reason, in this way: O Jews, made happy by misfortune! If what you say is true, did he abundantly and wonderfully bless you who ruined and scattered you if, when you lost a single king in your own country, you have now in exile found and regained so many thousands of kings? But no one of them has been anointed with legal and spiritual chrism, people follow none of them, nor does one preside over a people—on which account none of them is or can really be called either king or priest, prophet or leader of the tribe of Juda.

Where effective causes are lacking, their effect can in no way exist. O sorrow and laughter! The foolish and unhappy lot of those Jews who, when they insolently and unavowedly think to consign their rule to a crowd, and to congratulate themselves over a multitude of kings, are proven to be utterly without a ruler!

The reasoning I have just presented is enough to confute the first part [of the argument]. But because reasons for the good cause sufficient for us abound, let us not be irked that they oppose us again through what is impossible, in this way: The prophecy we now have in mind either refers to such kings—that is, [kings] in the country, or in private life—or it does not. If it does refer to them, and on account of their present existence in this life establishes among you that Christ has not yet come, it will therefore establish that he will never come until all have been so eliminated that no one of them who governs his own family exists in the world. When will this be? Only in the consummation of the world, when, everyone being dead, no place will exist either of repentance or of forgiveness: and why do we suppose that the Messiah may come then, unless to bury the dead? This, then "shall be the expectation of nations"? And so the prophetic prediction will be reduced to nothing? God forbid! It is impossible that God, who promised in detail to send his Christ to save the human race before the end of the world, should be lying. Therefore they are deceivers who say that this prophecy refers to the end of such rulers as are certain to endure until the end of the world.

With their ideas refuted, these Jews pass on to another argument and say, "We do not believe that Christ has come because we do not think that the scepter has been taken from Juda. Who [knows] whether a multitude of Jews has not assembled in some other part of the world, Jews who have over them an anointed and consecrated king from their own stock?"

To this I respond that no one of either of our parties knows or has heard that a Jewish king is reigning in any part of the world in our days; yet, if any Jew should be reigning in Judea, nevertheless the scepter would now have been taken from Juda. In itself the kingdom of Juda has been separated from other kingdoms, existing in its own region, which is called the land of Juda and Benjamin, with its own king, who is of the tribe of Juda. Any house is composed of its parts—that is, foundation, walls, and roof. If one of these is missing it cannot be a house. So is the kingdom of Juda composed of the parts mentioned above. If a native land, a people, a king be missing, it cannot be a kingdom. Where a part is missing the whole cannot exist; and contrariwise, where the whole exists, so too must the parts. If, when one part is missing, the name of the whole is lost, how much more does the whole come to an end when all together are lost? The kingdom of Juda lost its own land when it fell into the hands of strangers; it was without a people after the population was dispersed into all nations; long before this it had lacked a legitimate king—and so the kingdom of Juda, having lost all of its parts, ceased to be a kingdom. It is, then, manifest that no scepter from Juda belongs to a foreign country, and has been taken from Juda's own authority.

If any foolish person supposes that the kingdom of Juda exists or is spoken of wherever a Jew rules over Jews, he is refuted by both the facts and Scripture. When two kings used to reign over the Jewish people, one in Jerusalem over two tribes, and the other in Samaria over ten tribes, only the one who

reigned in Jerusalem was called, and was, the king of Juda; the one who reigned in Samaria was just the king of Israel. If then the scepter of Juda did not belong to the one who had ruled over the ten tribes of the Jews in Samaria, much less will it belong to the one who mistakenly imagines he is king over some Jews in India.

Let me say again: The king of Juda must be a man rising out of the tribe of Juda, chosen and anointed with sacred chrism by a legitimate priest for the purpose of ruling the people who live in the land of Juda. Every king who is a stranger to this description is a foreigner. Therefore not one of them is king of Juda. They cannot be the same thing if they are described differently.

Moreover, this conclusion begets another. A legitimate king from the tribe of Juda cannot exist unless a priest, himself also anointed and consecrated, consecrates him by a legitimate anointing. No priest, however, existed in the Jewish nation after they lost the chrism and left the place where alone they were allowed to offer sacrifice. After the priests who anointed the kings ceased to exist neither could the kings exist. Where effective causes are lacking their effects cannot exist. And so we conclude that not only has the scepter been taken from Juda, but that no king could afterwards come into existence.

Now I come to a third point. "Such a sign does not apply to us," they say, "that because we are now exiles and without a king—that is, a leader—for this reason we should believe that the Messiah has come. We were in similar circumstances in Babylon, and not only did the Messiah not come, but afterward we returned to Jerusalem and had a kingdom and a priesthood. This then is our hope, that when we have been restored in the same way—at God's good pleasure—these will again come."

I reply that you have said that you are now exiles and without a leader, and that is true. In Babylon the people of Jerusalem—that is the tribes of Juda and Benjamin—had been brought together as one. They had with them their own king, and priests, and prophets, and a promise given by the Lord that after seventy years of penance had passed they would return to their own land, which the Lord had not yet given over for strangers to inhabit, but which had remained, as now, deserted. But now you do not have, as you did then, a people gathered together, or a king, or priests, or prophets, or a deserted land reserved for you, or a promise given by God that after seventy years you would return as you had then. Instead you have a sentence given by the Lord that your desolation would continue unbroken. This has been satisfactorily shown in your own place. This [sentence] has affected you for around a thousand years; it will not deceive you concerning the other things, until the last.

# APPENDIX F:
# THE FEAST OF MARY'S NATIVITY AS FOUND IN CHARTRES, BM 1058 (COMPILED AFTER 1194)

The feast is the same in Chartres, BM 1058 as in Châteaudun, Bibl. HD 13, except for the changes noted below. Psalms are provided with Vulgate numbers; the chants can be referenced in CANTUS (University of Western Ontario) and the LaTrobe Medieval Music Database, with texts and melodies supplied for most of them. The sermon and responsories attributed to Fulbert are featured in this feast. For comparison of the Mass texts found at Chartres Cathedral with books from this and other regions, see Todd Ridder (1993).

September 8. Nativity of Blessed Mary, the entire church is made ready [with tapestries], the rulers of the choir are taken from the fifth or sixth row, two provosts ought to guard the choir.

*At First Vespers:* The antiphon "Hec est Regina," and the others [in the OV the incipits of all five are written out]; the Psalms for the day; chapter, "Nativitas" [in the OV other chapters are offered as options]; Responsory, "Solem iusticie"; Hymn, "Ave Maris Stella"; At the Magnificat, Antiphon "Gloriose virginis"; Prayer: Supplicationem servorum.

*At Compline:* Antiphon, "Quam pulchra es"; Hymn, "O gloriosa femina"; Antiphon "Sub tuam protectionem."

*At Matins:* Invitatory, "Adoramus Christum; Hymn, "Ave maris stella."

*Psalms, Antiphons, and Responsories for the First Nocturn of Matins (in OV the verses of the responsories are given too):* Antiphon, "Hodie; Psalm [8], "Domine dominus noster"; Antiphon, "Beatissime"; Psalm [18], "Celi enarrant"; Antiphon, "Quando nata"; Psalm [23], "Domini est terra"; Versicle, "Diffusa est gratia"; Six readings from the sermon of Lord Fulbert, bishop of Chartres "Approbate consuetudinis" and three readings from the homily on the Gospel "Liber generationis," which is read at Mass. Responsories, "Hodie nata est"; "Beatissime"; "Styrps Iesse."

*Psalms, Antiphons, and Responsories for the Second Nocturn of Matins:* Antiphon "Hodie"; Psalm [44] "Eructavit"; Antiphon, "Dignum"; Psalm [45], "Deus noster refugium"; Antiphon "Benedicta tu"; Psalm [86] "Fundamenta"; Versicle "Specie tua"; Responsories. "Gloriose"; "Nativitas"; "Ad nutum."

*Psalms, Antiphons, and Responsories for the Third Nocturn of Matins:* Antiphon "Nativitas est hodie"; Psalm "Cantate 1"; Antiphon "Ista est speciosa"; Psalm 96, "Dominus regnavit exsultet"; Antiphon "Felix namque est"; Psalm "Cantate 2"; Versicle, "Adiuvabit eam"; Responsories: "Corde et animo"; "Nativitas"; "Solem iustitiae"; In turn the third of the responsories [these are the ones attributed to Fulbert: "Styrps Jesse," "Ad nutum," and "Solem iusticiae"] are sung from the top [which means given the full performance, as shown in the rendition of "Styrps" in the anthology].

*At Lauds:* Antiphons: "Nativitas gloriose," "Nativitas est hodie," "Regali ex progenie," "Corde et

animo," Cum iocunditate"; Chapter, "Hodie nata est"; Hymn, "O gloriosa femina"; Versicle, "Elegit eam"; antiphon at the Benedictus, "Nativitatem hodiernam"; Prayer, "Famulis tuis."

*At Prime:* Antiphon, "Nativitas gloriose"

*At Terce:* Antiphon, "Nativitas gloriose"; Chapter "Hodie nata"; Short Responsory, "Diffusa est" Versicle "Specie Tua"

*At Mass:* Introit "Gaudeamus" with the tropes "Hodie," except for the verse that belongs to the Assumption. Epistle "Ego quasi"; Graduel, "Benedicta"; Alleluia, "Nativitas gloriose" [In the OV the Alleluia is "Per te Dei" with "Nativitas" as an alternative; "Per te Dei" was sung with organum at the Assumption, and surely here too]; Sequence, "Alle celeste" [no sequence is mentioned in the OV]; Antiphon before the Gospel, "Nativitas tua"; Gospel, "Liber generationis" (Matthew 1:1–18); the "Credo in unum" is sung; Offertory, "Felix namque"; Preface, "Et te in veneratione"; Communion, "Regina mundi."

*At Sext:* Antiphon, "Regali ex progenie"; Chapter, "Nativitas est"; Short responsory, "Specie tua"; Versicle, "Adiuvabit eam"

*At None:* Antiphon, "Cum iocunditate"; Chapter, "Per te dei"; Short responsory, "Specie tua"; Versicle "Elegit eam."

*At Vespers:* Antiphon, "Nativitas" and the others as at Lauds; Chapter, "Nativitas est hodie"; Responsory, "Solem iusticiae"; Hymn, "Ave Maris Stella;" Versicle "Diffusa est"; At the Magnificat, antiphon, "Nativitatem"; Prayer, "Adiuvet nos"

*At Compline:* Antiphon, "Tota pulchra est"; Hymn, "Salve porta"; Antiphon for the Nunc Dimittis, "Anima Mea"

Observations concerning the octave of the Nativity of the Virgin at Chartres from the OC: The reading throughout continues to be the Commentary on Matthew 1:1–18 by Rabanus Maurus; members of the antiphon set "Hec est Regina" are used for the Magnificat at Vespers throughout the week; on Sunday within the week, the sequence "Hac Clara Die" (which in the OV was the sequence for the feast) is sung. On the octave itself, however, "Alle celeste" was sung.

*Hec est Regina set of Antiphons, in English and Latin:* These antiphons were used processionally at the return to the Royal Portal throughout the year; they were sung at First Vespers of every Marian feast at Chartres; they were sung throughout the octave of the Nativity of the Virgin at the Magnificat of Vespers; and they were sung on the liturgy for the feast of the Dedication (the *Commemoratio*) composed after the fire of 1194.

1. This is the Queen of virgins who bore the king even as a beauteous rose, the virgin Genetrix of God, through whom we find God and humanity. Nurturing virgin, intercede for us all!

2. You are the beautiful maidenly virgin, the genitrix of God, Mary, we beg you alone among all maids the most chaste, that you will deign to intervene with God for our salvation, alleluia.

3. Blessed are you virgin Mary: you who carried God bore the creator of the world, who made you, and you remain a virgin for eternity; pray for us to Lord Jesus Christ, alleluia, alleluia.

4. Blessed Genetrix of God, Mary, perpetual virgin, temple of the Lord, shrine of the Holy Spirit: you alone, without an exemplar, were pleasing to the Lord Jesus Christ. Pray for the people, intervene for the clergy, intercede for the devoted female sex, alleluia.

5. Rejoice Virgin Mary, alone you have destroyed so many heresies: you had faith when the archangel Gabriel told you that while a virgin you would give birth to God and humankind, and after birth, you would remain an inviolate virgin. Alleluia.

1. Hec est regina virginum que genuit regem regum uelut rosa decora uirgo dei genitrix per quam reperimus deum et hominem alma virgo intercede pro nobis omnibus alleluia (CAO3002).

2. Te decus uirgineum virgo dei genitrix maria te solam inter omnes virgines castissimam exoramus ut pro salute nostra apud dominum interuenire digneris alleluia (CAO5116).

3. Beata es virgo maria que dominum portasti creatorem mundi genuisti qui te fecit et in eternum permanes virgo ora pro nobis dominum ihesum Christum alleluia, alleluia, alleluia (CAO6163).

4. "Beata Dei Genetrix Maria, virgo perpetua, templum Domini, sacrarium Spiritus Sancti: sola sine exemplo placuisti Domino Ihesu Christo: ora pro populo, interveni pro clero, intercede pro devoto femineo sexu" (CAO1563).
Sarum 519 NatBVM

5. Gaude maria uirgo cunctas hereses sola interemisti que gabrielis archangeli dictis credidisti dum uirgo deum et hominem genuisti et post partum uirgo inuiolata permanisti alleluia (CAO6759). [Sarum 402, but it's a responsory]

Hymn: Ave Maris stella in English and Latin:

> Hail star of the sea
> Tender mother of God
> And ever virgin
> Happy door of heaven.
>
> Putting on that "ave"
> From the mouth of Gabriel
> Changing the name "Eve"
> Establish us in peace.
>
> Dissolve the chains for the prisoners
> Bring light to the blind
> Rout our evils
> Request many good things.
>
> Announce yourself to be mother
> That he may take up your petition
> Who born for us
> You carried as your own.
>
> Singular virgin
> Sweet among all
> Absolve us from sins
> Make us sweet and chaste.
>
> Show the pure life
> Prepare the safe journey
> That seeing Jesus
> Ever we may ever be glad together.

Let there be praise to God the Father
And glory to the most high Christ
With the Holy Spirit
One honor to all three.

Ave maris stella
Dei mater alma,
Atque semper uirgo,
Felix celi porta.

Sumens illud "aue"
Gabrielis ore
Funda nos in pace
Mutans Eve nomen.

Solve uincla reis
Profer lumen cecis
Mala nostra pelle
Bona cuncta posce.

Monstra te esse matrem
Sumat per te precem
Qui pro nobis natus
Tulit esse tuus.

Virgo singularis
Inter omnes mitis
Nos culpis solutos
Mites fac et castos.

Vitam presta puram
Iter para tutum
Ut videntes Jesum
Semper colletemur.

Sit laus deo patri
Summo Christo decus
Spiritui Sancto
Honor tribus unus.

Feast of the Dedication compiled after the fire of 1194.

The traditional feast of the Dedication of the church, and its commemoration, as found in Chartres can be reconstructed from the OV and the OC (181–84). The feast composed after the fire, however, is uniquely Chartrain, and in the later Middle Ages became the feast for this day at the cathedral, giving the liturgy a powerful Marian cast and relating it to the historiography of the cathedral. Some features of this commemorative dedication feast are outlined below:

At the memorial of the dedication of the church of Blessed Mary of Chartres [Ad memoriam dedicationis ecclesie ecclesie beate marie carnotensis]:

*At First Vespers:* The antiphons "Hec est regina," etc.; Chapter "Beata est Virgo";
Responsory, "Styrps iesse"; Hymn "Ave Maris stella," Versicle "Diffusa est";
Antiphon at the Magnificat, "Alma redemptoris"; Prayer: "Concede nos"
*At Compline:* Antiphon, "Tota pulchra es"; Hymn "O gloriosa femina"
Antiphon, "Sub tuum presidium."
*At Matins*
Responsories for Matins:

Readings from the Song of Songs, Osculetur me.
Missus est (Annunciation)
Ave Maria (Annunciation)
Styrps iesse (Nativity BVM)

Confirmatum est (Annunciation)
Annunciatum est per Gabriel (Advent)
Sancta et immaculata (Nativity)

Beatam me (Assumption)
Beata es virgo (Assumption)
Gaude maria virgo cunctas (Purification; Annunciation, without its verse)

At Mass: Introit, "Salve sancta parens"; Alleluia, "Per te Dei"; sequence, "Hac clara" or "Ave Maria";
Gospel, "Exsurgens Maria" from Luke 1, the Visitation text.

Figure App.F.1a–d. Chartres, Bmun 1058, early thirteenth century, photographs of the incipits for texts and music for the feast of the Nativity of the Virgin Mary. Médiathèque de Chartres. Credit, Delaporte.

284 a̅ Natiuitas. p̄. Cantate. i. a̅ Ista e̅. p̄ d̅n̅s̅ reg
nauit exul. a̅ felix. p̄ Cantate. ij. R̄ Adiuuab
eam. R̄ Corde ramo. R̄ Natiuitas. R̄ Sole.
Rursum incipiuntur tria t̅c̅ia. R̄ Ad laud. a̅
Natiuitas gl̅iose. a̅ Natiuitas e̅ hodie. a̅ Re
gali ex pg̅eñ. a̅ Corde 7 a. a̅ Cum iocunditate.
cp̄. Hodie nata e̅. hy̅. O gl̅iosa fe. V̄ llegit e̅a̅.
Ad b̅n̅d̅. a̅ Natiuitate hodiernam. o̅r̅ famu
lis tuis. Ad p̄mā. a̅ Natiuitas gl̅iose. Ad. ij.
a̅ Natiuitas. cp̄ Hodie nata. R̄ Diffuse e̅.
V̄ Specie tua. Missa. Gaudeamus. trop̄ ho
die. excepto V̄. de Assumptione. l̅p̅t̅a̅. Ego
quasi. R̄ B̅n̅dicta. All̅r̅ V̄ Natiuitas gl̅io
se. seq̅n̅ Alle celeste. An̅ eu̅ng̅l̅i̅m̅. a̅ Natiui
tas tua. eu̅ng̅l̅. liber generationis. 7 dicatur.
Credo in unum. off̄. felix. p̄facio Et te in
uenerat̅o̅e̅. co̅ Regina mundi. Ad vi. a̅ Re
gali ex pg̅. cp̄ Natiuitas e̅. R̄ Specie tua V̄
Adiuuabit ea̅. Ad. ix. a̅ Cum iocunditate.
cp̄. p te dei. R̄ Adiuuabit ea̅. V̄ Llegit eam.
Ad uespas. a̅ Natiuitas 7 cetera. cp̄ Natiui
tas e̅ hodie. R̄ Solem. hy̅. Aue maris. V̄
Diffusa e̅. Ad mag̅. a̅ Natiuitas tua. o̅r̅.

Adiuuet nos. Ad copt. a' Tota pulchra. hii. 285.
Salue porta. a' Anima mea. Jn totas octab. Per
legitur ad mat. de omet. euangtu. Liber ge octauam
neratiom. inuit. Adoremus. sup psalmos
ad mat. a'. Hodie nata e. una tm p septima
na. similit ad laud. una tm. a' Natuitas
gtiose. Ad bnd. qq die. a'. Natuitate. oro.
famulis tuis. prima die. iii. r. Hodie nata.
e. r Beatissime. z r Gtiose. seda die. r. Na
tiuitas tua. r. Corde z animo. r. Cum iocun
ditate. Teia die. r. Regali ex progie. r. Na
tiuitas gtiose. r. Felix namqz. Ad horas sic z
festo. Ad missam. Gaudeam. z oro. famulis.
z dicunt alternando. Lpte. Ab initio. Locu
tus e dns ad achaz. Egredietur. z similiter
euangtia. Loquente ihu ad turbas. Exur
gens maria. Missus e gabriel. dicuntur e
ciam alternando. Atta. post partum. Atta.
Pie dei. Atta. Natuitas gtiose. Ad uespas. a' z prosa condie de missa. z eccs. z
statuitas gtiose. una tm. p fr. cp. Natui      ad extom' plac
tas e. Ad mag. a'. Hec e regina. z cetere p cete      emt.
ros dies. oro. Supplicationem. z oro Adiuuet
nos. que dicantur alt          nando. In dne

r Ad completor. p chs sicut in uigtia.

que euenit infra oct. Ad missam. Allá. V.
post partum. Sequi. Hac clara. In octab ad
mat. a. Hodie nata e. cum ceteris sic sunt
.ix. R. suprascripta. sunt in dnica ad mis
sam Allá. V statuitas. Sequi Alle celeste. R. V.
.iX. septemb. S. Golgoni ml. mem. C. iij. iX.
S. mrm. pchi z Jacincti mem. oy. Beati pchi.
iX. septemb. S. maurilionis epi z pfessois
mem. oy. Beatus maurilio. R. viij. kl. octo
bris. Exaltatio. S. crucis. z mem. S. mrm. Cor
neli z Cypriani. Custodes chori canonici de
.iiij. statu. Ad vespas. a. z p. dici. cp. Michi au
hy Salue crux. V. Hoc signum crucis. Ad mag.
a. Sup omnia. oy. Vs qui unigeniti. f. t. peio
so. Ad mem. mrm. a. Sci ludibria. V. Justoy
aie. oy. Beatoy mrm. post pessio ad crucifi
rum. a. O crux splendidior. e. p. Magnificat
oy. Vs qui unige. f. t. p. S. humanu genus.
In reditu. a: de. S. MARIA. Gaude ma. cu. V.
zoy. Ad mat. Inuit. Regem mrm. hy. Lma x.
a. Beati paupes. z cetere. cu. ix. psalmis ptmo
tu mrm. pimi. V. Justoy aie. ij. Justi aut. iij.
Hoc signum                    crucis. te. Xi. de mar

# APPENDIX G:
## OBITUARIES OF FOUR BISHOPS OF CHARTRES
### Ivo, Geoffrey, Goslen, Robert

Dec. 28. On this same day, in the 1115th year of the Lord's incarnation, father Ivo died. He was the head priest of this most sacred see, a man of great holiness, most prudent in secular and ecclesiastical business, mild in speech, outstanding in patience, strong in chastity, as erudite in divinity as in philosophy. He bestowed six good pallia, seven copes, three headbands, and three tapestries for the decoration of this church; he gave a missal and an epistolary, a Gospel book, and a book of readings for Matins, all set out in silver; he constructed a *pulpitum* [rood screen or *jubé*] of wondrous beauty; he established schools. He rebuilt from its foundations the bishop's house, formerly worthless and of wood, and which upon the death or absence of bishops, by some wicked customs introduced by the violence of the counts of Chartres, he had found in the condition of a slave woman; this he rebuilt, commodious and of stone, with all that pertained to it, whether moveable or immoveable. He delivered it from slavery to freedom, and he confirmed its liberty with documents of privilege, held in the archives of this church, from the Roman see, from the king, and from the count. To increase the size of this same house, he acquired certain lands contiguous to it from the vicelord, and he enclosed them with a wall. For episcopal use he built other houses in Pontgouin (Pontem Godanum), and he improved many things in this village. He converted the Abbey of St. John from secular canons to regular canons, and he established and enriched it. With his counsel and help, a monastery for the sick was established in Beaulieu. He collected all first-fruits and bequests of this church into a common fund, and prohibited their distribution to people's posterity, either by the bishop's own or by apostolic privilege. By the same privilege, he forbade forced service, unjust taxes, and the wicked raiding of servants by the provosts. Even when he was dying, Ivo gave one hundred measures of wine for enlarging the table of the altar, and in countless other ways he did many good things for this church and its clergy.

Jan. 24. On this same day our father Geoffrey of pious and sweet memory was released from the prison of the flesh. He was the bishop of this holy see, and, under the blessed Pope Innocent, he was the legate of the apostolic see for about fifteen years over the provinces of Bourges, Burgundy, Tours, and Dol. Having served religiously and piously in this office, from the infestation of schismatics he called back many in his legation to the fold of mother church; having suffered its dangers, he was the great extirpator of the pestilence of simony, keeping his hand free from bribery, so that in his

time the pillars of the church of God were flowering and firm, as much in priestly dignity as in regal honor. He was a remarkable preacher of divine doctrine and a generous benefactor, able to subtract all his own expenses to give to the poor. An especial lover of uprightness and charity, holy in soul and pure in body, as long as he lived in great tranquility he governed the present church, placing himself as a strong wall for it and strenuously defending it from countless disturbances. He conferred many benefits upon it: he gave pallia and many silken garments, he instituted two candles that burn continuously before the memorial of blessed Mary; among the many protections of Roman pontiffs and of kings and princes that he acquired were those concerning immunity of the possessions of this church both from labor and expenses, and others concerning the freedom of people whether working for the bishop or for us (canons), so that when opposing anyone, whether free or a serf, in all causes, these men would have unrestrained and complete license with their pleas and negotiations in testifying and fighting. He was granted these greatly advantageous privileges by the pious King Louis, by the common assent and counsel of his bishops, and princes, and the illustrious Count Thibaut, and indeed also of the king's wife Adela and of his son Philip, now designated as king, and by Pope Honorius of blessed memory. For his soul we have an anniversary on the day he died, which we instituted to be celebrated every successive year solemnly with fourteen candles, from his account, who would leave houses that he himself built, to whit, Yvelines, Le Thieulin and Le Bois Saint-Martin, and to every canon who will be present in the future on the same anniversary it will offer 19 denarios and to every non-canonical clerk of the choir six denarios. [The rest of the notice is a 14th century addition.]

### GOSLEN, OPS1032 37–38

1 February. On this day Goslen died, reverend high priest of this holy see [1155], who presented to this church a Gospel book decorated wonderfully with 52 ounces of purest gold and painstakingly adorned with precious gems, as well as two pallia and a gold tablet weighing 72 ounces. He constructed new episcopal dwellings, in large part from his great wealth; he built a sufficiently appropriate house in Berchières; he transferred Ingré [near Orleans, and probably what is meant by *Prepostitura de Unogradu*] by episcopal law and with great generosity perpetually to the use of the brothers who will be taking part in Matins; dying, he transferred with paternal affection 10 solidi to each canon, and he had one hundred pounds distributed to the non-canonical clerks of the choir, and he left one hundred pounds for the work of the tower. With the great worth of his properties, King Louis, the son of King Louis, by the authority of his special right and by the witness of his seal, corroborated the freedom of the episcopal dwellings and all things pertaining to them. To lessen the burdens of both the mayors and the peasants, upon whom he saw the recently instituted bond fall, the aforementioned august father (with the common assent of the chapter having been given), had reckoned the penalties upon the mayors of the villages, as was his right, and then, prohibiting under anathema that those other, new bonds be carried out, he cared to provide for the advantage of all and for the peace of the poor. He obtained the villages written below: Mongerville, Launs (Dreux), Les Châtelets, a centrally located village called Ponthévrard, a centerpoint they call Les Pinthières, and its midpoint which they call Villebon. By this proposal, the successors of this bishop will possess these villages, so that, for each canon who will attend on his anniversary, they will contribute 18 denarios, and six for those who are not canons [i.e., who are noncanonical clerks]. [Later additions from the fourteenth century follow.]

### ROBERT, OPS1032 95–96

23 September. Solemn Anniversary. On this very day, in the Incarnation of our Lord 1164, Robert of good memory departed this world, the reverend high priest of this holy see. He presented to this church many gifts, to whit, silver marks, a tapestry, a cope, a chasuble, sandals, an episcopal stole,

many precious gems, an artificially concealed crystal vase, copper basins marvelous with beautiful sculpture, and his blessed ring affixed to the reliquary of blessed Mary. He repaired the pavement in the entrance of the choir wonderfully. He repaired the episcopal dwellings in great part, and he re-made from its foundations and consecrated the chapel there, sufficiently funded in honor of blessed Martin. A certain house located in the cloister, which he found excessively small, he improved at great expense, and, to expand it, he acquired the land contiguous to this house from a layperson in honor of the church. He established three monasteries, namely the Blessed Mary of Clairfontaine [Augustinians], St. Remigius des Landes [Benedictine nuns], and St. Cyr [Benedictine nuns], and he bequeathed many books and many other things to these houses as he was dying. In Berchères he enclosed the granary with a wall. In Pontgouin he repaired a mill and small pond and improved the village in many ways. He repaired the church in Bailleau-l'Evêque and strengthened the episcopal house there with great expense. With great expense and labor, he transferred Boissy-en-Drouais from lay jurisdiction to episcopal use, and he confirmed this with special rights. At great cost, he freed La Bazoche-Gouet from the royal tax which is called "brennagium" [brennage]. From the laity, through his great expense and labor, he acquired land in Berchères-sur-Vesgre near to the land of its church, enlarging the bishopric there by building an estate. He restored a certain tithe in Voise at the place called Capella, retroactive to the time it became disassociated from the church. In the episcopacy of Évreux, in the territory of Illiers-l'Evêque, he acquired a very good tithe, in common with the monks of St. Peter's. And from both of these tithes he bequeathed an amount to his successors from its holding, so that from that time forth they might confer twelve denarios for each canon who will attend on his anniversary, and six for a non-canonical clerk.

# APPENDIX H:
## TABLE OF DONORS; GENEALOGY OF THE LÈVES; GENEALOGY OF THE THIBAUDIANS

| Bishop | Ivo of Chartres 1092–1115 | Geoffrey of Lèves 1115–49 (also papal legate from c. 1130) | Goslen of Musy 1149–55: Matins, bequeathed for the work of the tower [and vast numbers of other gifts] | Robert (who was first dean) 1155–64 | William, served 1164–68 but continued in the office after becoming archbishop of Sens (and then of Reims) |
|---|---|---|---|---|---|
| Dean | Difficult times especially because of Ivo's struggles with Arnaud de la Ferté, who served off and on from 1092 until 1119 | Arnaud, 1092–1119: for completing the altar (BVM); Samson Mauvoison, 1119–27 (becomes provost and then archbishop of Reims); Zachary 1134–43: Altar tab; marble paving in front of dean's station; matins; Salomon, 1143–44, matins, library, res. cross; Robert, 1144–55 | Robert, will become bishop | Ivo, 1155–64; left large library to St. John | Geoffrey de Berou was an especially prominent dean, serving from 1166 until 1202, that is throughout the pontificates of John of Salisbury, Peter of Celle, and into that of Reginald of Mouçon. It is a figure such as this that provided the strong continuity for the community before and after 1194. He left income from property on his death (November 26, 1202) |

| | | | | | |
|---|---|---|---|---|---|
| Cantor | Hilduin, 1083–1108: alms-house | Gerogius, 1114–24: Antiphoner with gradual; Salomon, 1128–43, becomes dean; Reginald, 1143, matins; Goslenus, 1146; Hamelin (1147–49) work on tower; res. Crux; | Hugh, 1149–59: work on tower; matins; altar of Trinity | Hugh | Amaury Goalt, 1163–71: Precious necklace for Mary's reliquary; for work on the church; two significant cantors served after him, Richard, 1173–88; and Goslenus, 1206–21, who was raised at Chartres, and served in earlier administrative offices |
| Subdean | Goslenus, earlier a provost, then subdean 1092–97: three most deluxe windows; nocturnal lamp; Serranus and Fulco, Ivo's appointments, did not give | Samson, 1119 (becomes dean) Hugh, c.1119–24: martyrology, homiliary, doors in front of altar BVM. Zachary of Tardais, 1129–32, becomes dean. Hugh of Lèves, 1139–61 | Hugh | Hugh, very precious window | Gilbert of Tardais, 1164–88 |
| Succentor | | Guarinus, 1099–1124: graduel | | Robertus Parvus, 1144–64 | Richerius: succ. 1167–73/cantor 1173–88 Liturgical compiler |
| Chancel. | Vulgrin, 1099–1119 | Vulgrin; Silver reliquary Bernard, 1124: 24 books; Gilbert, 1126–41: Library of 7 liberal arts; law | Ernaldus, c.1149; Work of tower | Robert, 1159–73: work of the crypts | Robert |
| Chamb. | | | | | |
| Arch-C | William, 1087–1107 | Walter of Bonavalle, fl. 1114–32: gold chal, best brev; expanded houses, tower (died after 1134) Robert, 1135–44 and becomes dean and then bishop | Drogo, 1149, expanded houses, rep reliquary of Piat Milo, 1149–81 Left cap frieze | Milo | Milo |
| Arch-Dun | Guerry, 1092–99 Goslenus | Goslenus, 1114–20 Richerius, 1126–49 mat., likeness BVM at entrance | William, 1156–64 | William | |

Appendix H

| Arch-Pins | Odo, 1087–1119 | | | | |
|---|---|---|---|---|---|
| Arch-Blois | Hugh of Lèves, 1111–14, becomes subdean Ansgerius, 1114–39 | Ansgerius, three gold rings for rep crux; antiphoner and gradual, for daily use of the altar of the crucifixion; for building the tower Robert, 1141–49 | Reinerius 1149, tower | | |
| Arch-Dre. | | Zach, 1119–26 Subdean, then dean | | Arnoldus Fouaille three windows | Arnoldus Fouaille 1156–73 and later? |
| Arch-Ven | Raimbald, monk | Salomon, became cantor, then dean Robertus Ragan, fl. 1136–49. The very best window; necklace with emerald; table near altar BVM; matins | John, 1149–51 | | |
| Cheficier (Sacristan) | Evardus | Bernard, 1119–37; book of readings for the BVM; window of BVM; poorhouse; Refectory for Jos. | Goslenus, c. 1153: gold altar table for the BVM; silver for the crux. | | |
| Provosts | Hilduin, monk | Henry the Provost, 1115–49: prepared a deluxe Bible and book of passions; gold necklace with precious emerald for BVM; rebuilt the roof of the chevet; angel placed on top of the church and covered with gold; work of the towers; Samson (see dean above) founded St. Madeline in Mantes, which he gave to Coulombs | Odo, 1149–61: work of the towers, emerald ring for the reliquary BVM | Odo | |

| | | | | | |
|---|---|---|---|---|---|
| Other donors: Approx dates are known in most cases | | Henry, bishop of Winchester (s.1129–71), gave deluxe materials for the decoration of the cathedral; his cross is described and was famous at Chartres | | | |
| Work on tower/towers | | Adam, canon. Simon, fl. c.1153, gave for work of the tower | Gui, canon. | | Nivelus: work on tower |
| Rep. cross, etc. | | Adam, repairing ciborium | Gui, repairing cross, and reliquary of St. Lubin | | |
| Window/s | Aimericus, 1080s-90s | | Ernaud de Folieto, fl. 1150s, 2 windows | Arnaldus Quadrigarius (after 1134; before 1180), window | Nivelus: two deluxe windows; |
| Reliq. BVM | | | Ernaud de Folieto, table left of altar, 4 rings | A. Goalt, affixed most precious necklace; work of church; Arnaldus Quadrigarius: gold necklace. | Nivelus: affixed gold cross with 5 gems |
| Matins | | Hugh, canon; Adam, canon | | Hubert, after 1134, before 1180 | |
| Other choral | | | Gui, canon. Lambertus, canon, 1137–87: gave a gradual and a troper for the use of this church | | |

PART II. THE MOST NOTABLE OF THE LÈVES/MUSY FAMILY
IN THE SERVICE OF THE DIOCESE OF CHARTRES DURING
THE FIRST THREE QUARTERS OF THE TWELFTH CENTURY[1]

1. Guy, uncle of Bishop Geoffrey and abbot of St. John in the Valley during the time of Ivo.[2]
2. Geoffrey, first a provost, and then bishop from 1116–1149.[3]
3. Hugh of Lèves, a provost, c. 1124–c. 1130. He became subdean, serving from c. 1136 to 1161. He was "of Lèves," and was probably a first cousin of Bishop Geoffrey and his brother Goslen IV, the lord of Lèves.[4] There seems to have been a Lèves daughter named Adela who died young and who may have been his mother. See OPSSJ 229F (May 23).
4. Goslenus of Musy (his mother was Berta of Lèves, the sister of Bishop Geoffrey), first a provost, briefly an archdeacon, and then bishop 1149–55.[5]
5. Milo of Musy, nephew of Bishop Geoffrey and brother of Bishop Goslen, served first as a provost and subsequently as archdeacon, from the late 1130s, flourishing through the 1140s.[6]
6. Geoffrey the Provost, served actively 1143–60s. He was a son of Goslen IV, lord of Lèves, and thus a nephew of Bishop Geoffrey and a first cousin of Bishop Goslin.[7]
7. Rahier of Musy, brother of Bishop Goslenus, served for decades as a provost.[8]

PART III: THE THIBAUDIANS THROUGH THE
MID-TWELFTH CENTURY

A. Genealogical Background

**Generation I:** Thibaut the Old, who may have been married to a sister of the Robertian Hugh the Great.

**Generation II:** Thibaud I (the Trickster), married to Leutgard of Vermandois, patroness of St. Peter

**Generation III:** Odo I (died 996), married to Bertha of Bourgogne ("Queen Bertha"). His sister Emma was the wife of William IV of Aquitaine; his older brother Thibaut died in battle. Bertha left a bequest to the Cathedral of Chartres.

**Generation IV.** Odo II (died in 1037), married to Hermengarde of Auvergne, became count of Champagne (although he never used this title); his older brother Thibaut died in 1004; Hermengarde and her sons left a bequest to the cathedral of Chartres in honor of Odo II.

**Generation V.** Thibaut III (inherited the core of the Thibaudians' lands); his brother Stephen acquired the lands Odo II had obtained upon the death of his cousin Stephen (the great nephew of Leutgard). After his brother Stephen's early death, Thibaut III had trouble with Odo III, Stephen's son. Thibaut's sister Berta's son, Conan, died in 1064 fighting a vassal of Anjou. Berta was a major presence in Chartres and left a generous bequest to the cathedral and founded the Hôtel Dieu.

**Generation VI.** Count Stephen-Henry, son of Thibaut III, and Gersent of LeMans; half brother Odo IV died young in 1093; Odo's inheritance passed to his younger brother Hugh, who became count of Troyes and died around 1130. Stephen-Henry, count of Blois, Chartres, and Meaux, died in the Holy Land in 1102; by an earlier relationship, he had an illegitimate daughter. His wife, Adela of Chartres/Blois, daughter of William the Conqueror, was a strong supporter of the cathedral of Chartres and left a bequest to support the Virgin's cult of the main altar.

B. The Family During the Building Campaign

**Generation VII:** The Children of Countess Adela of Chartres/Blois and her husband, Count Stephen-Henry.

1. *William*, the first child, named for the Conqueror, may have been unsuited for leadership; he was married at a young age to Agnes of Sully. Neither he nor his wife have obits in the Chartrain necrologies. He died in the early 1130s.

2. *Thibaut IV* ("the Great"), count of Chartres/Blois and eventually, upon the death of his uncle

Henry in 1125, count of Champagne; he died in 1152. Several obits in the necrologies of churches in the diocese of Chartres are either for him or mention him.[9] Although he made no specific donations to the cathedral, his wife, Mathilde of Sponheim, is called a "lover of the beauty of the church of God" and is said to have given a great number of "ornaments" (the common term for furnishings and fixtures) to the cathedral. His son Thibaut V left substantial income from taxes on the sale of surplus wine (*banneria*) to the cathedral. The only stipulation was that masses be said in honor of Thibaut IV, of his wife, Countess Mathilde, and of their child Count Thibaut V, on their anniversaries:

> January 10. On this day the most illustrious count Thibaut died, the palatine count, whose son Thibaut, count of Blois and seneschal of France, concerning the winesales which he held in certain of our villas, from which he was accustomed to receive three hundred *solidos* annually, retaining a third for himself, and the other two, that is ten pounds each year, he gave to our church, holding them in perpetuity as long as successively the anniversaries of his forenamed father and his mother Mathilde and his own, when he dies, will be solemnly celebrated each year in our church.[10]

Of several other references to him in churches throughout the diocese, the most important is that found in the twelfth-century martryology of the Hôtel Dieu, Châteaudun. It shows that Count Thibaut supported the construction of this building: "Jan 9. Count Teobaldus died, who built this church [*domus*]."[11] Mathilde of Sponheim, Count Thibaut IV's wife, has an obituary in the cathedral necrology, as her son made a gift in her name (see above): "On this day the noble Countess Mathilde died, the mother of the most reverend William, archbishop of Sens, and of the illustrious noblemen Count Henry, Count Theobaldus, and Count Stephen, who, loving the beauty of the house of God, bestowed many ornaments on this church."[12]

3. *Stephen*, named for his father, who became count of Mortain and Boulogne, and subsequently king of England, is mentioned in his brother's obituary (OPS 81D). His wife, Mathilde, has an obit in the necrology of St. Nicasius (OPS 239E).

4. *Odo* died young.[13]

5. *Henry*, having been a monk of Cluny, became abbot of Gloucester and then bishop of Winchester. When King Henry II took over in England from Bishop Henry's brother King Stephen, the bishop was forced to retreat for several years, while many of his properties and the magnificent buildings he had created were destroyed.[14] After this hiatus he was able to return to England, where he remained until his death in 1171, keeping a lower profile than before. He took an interest in the cathedral of Chartres, as his lavish obituary demonstrates:[15]

> August 8. On this day the most reverend father Henry died, bishop of Winchester of good memory, brother of the most illustrious men Stephen, King of the English, and Thibaut, the Palatine Count. Enhancing his outstanding generosity with a noble spirit, and greatly loving the beauty of the house of God, he was concerned to lavish special honor upon our church with a sincere feeling of love, bestowing ornaments on it of most precious materials and most elegant workmanship. In fact, he gave to it a very fine crucifix, containing thirty-three marks of purest gold in its composition and distinguished by a variety of gemstones; the weight of the finest gold [it contained] was estimated by many learned men. A gold chalice and paten weighing fourteen marks, decorated most beautifully with gems, and also pontifical regalia: a silk cope with gold like stars, and an *infula*, an alb and an amice with stole and maniple, and miter, and belt, all of these most precious and outstanding in material and workmanship; and a pallium, and a truly distinguished candelabra, the forenamed bishop gave to our church (OPS1032, 81D-F).

6. *Mahault*, married Richard, earl of Chester, vicount of Avranches. She perished with her husband in the White Ship disaster of 1120, along with her cousin William, son of King Henry I, the heir to the English throne, and many other flowers of the Anglo-Norman nobility. She has no apparent obituary at Chartres.

7. *Agnes*, perhaps an illegitimate daughter of Stephen-Henry, married Hugh III of Le Puiset and was the mother of Hugh of Le Puiset, bishop of Durham in the second half of the twelfth century. Bouchard of Le Puiset, chancellor of Chartres from 1176 until 1186, may have been her son as well.

C. The Generation at the End of the Campaign

**Generation VIII**

Children of Thibault IV and Mathilde[16]

1. *Henry*, "the Liberal," count of Troyes and Meaux, then also of Champagne. His wife was Marie, daughter of Louis VII and Eleanor of Aquitaine. He has simple obituaries at the cathedral and the ND-J.[17] Countess Marie has an obituary that mentions gifts to the cathedral: "3 March. On this day Marie died, the illustrious countess of Champagne [1198] who loved the beautiful house of God, and decorated this holy church with many ornaments."[18]

2. *Thibaut V* ("the Good"), count of Blois and Chartres.[19] He left income to support the anniversaries of his father, Thibaut IV, his mother, Mathilde, and (on 3 March) himself.[20] He was also mentioned in the obituary of Bishop Peter of Celle (who died in 1183) in regard to the selling of wine in the city of Chartres. He also had a simple obit at Trinité de Vendôme, as did his father (OPS 200), and at Pontlevoy (OPS 209). Count Thibaut and his wife, Countess Alix of France, daughter of King Louis VII and Eleanor of Aquitaine, were both remembered in the necrology of the Madeleine of the Grand Beaulieu, and for specific bequests.[21] The count's obit was even more extensive at the Hôtel Dieu of Châteaudun, a church building begun by his father: "January 16. On this day Thibaut the younger, illustrious count, died. He conferred many benefices on this holy house for the remedy of his soul and returned one hundred *solidos* on the Octave of the Nativity of the Lord from the office of the provost of Châteaudun."[22] He died at Acre crusading with Philip Augustus in 1191.

But his most lavish obituary is in the necrology of ND-J:

> Jan. 16. The burial of Thibaut, count of Blois and seneschal of France, our friend and benefactor. Among the other benefices that he conferred upon our church, he gave us one measure of grain in the mill of Soors, and a tenth [*deimam*] of the mills of Subculeto, and of all the others that he built there on the Eure or acquired; besides he established and ordered that one hundred solidi be returned to us per year for the tolls [*borra*] from his mills which he had donated to the fullers; and so that all these rights might be made permanent, he confirmed the charters by the authority of his seal.[23]

Countess Alix was also remembered at ND-J,[24] and both Count Thibaut and his wife, Alix of France, were mentioned in the obituary of Bishop Geoffrey of Lèves. In a charter dated June 26, 1165, Thibaut, at the urging of the countess, and with his sons Thibaut and Louis and daughters Margaret and Isabel, gave a villa to the monks of the Tiron (CTT 2:91–92).

3. *Stephen*, Count of Sancerre.[25]

4. *William of the Whitehands*, bishop of Chartres, archbishop of Sens, then archbishop of Reims, also a cardinal.[26] He was a canon of Cambrai and Meaux, provost of the chapters of St. Quiriace of Provins and of the cathedrals of Soissons and Troyes. He died on September 7, 1202.

From its very opening, William's obituary makes clear that he played a major role in the realm of King Philip Augustus: "The magnificent man William died, archbishop of Reims, illustrious uncle of the most victorious Philip, King of the Franks." Further on the notice says that William ruled "like a second king," a description his nephew would not have appreciated. He is noted for reclaiming land and buildings in the diocese and for conferring many ornaments on the cathedral, including two large, well-made tapestries for the choir, one depicting the history of the Lord's incarnation (for the right side) and the other the history of St. Stephen (for the left side). Geoffrey of Alneolo gave the income on lands he owned or purchased in memory of William, the money to be distributed on the feast of the Nativity of the Virgin Mary. Bishop Reginald (William's nephew) and Adam the

sacristan arranged that a special light would be prepared throughout the year to burn on the day of William's anniversary.[27]

5. *Marie*, wife of Odo II, duke of Burgundy, born in 1142 or a bit later. She had three children: Hughes III, duke of Burgundy; Mahaut, wife of Robert III, count of Auvergne; Alix, wife of Archambaut VIII, lord of Bourbon. Odo II died in 1162, and Marie entered the monastery of Fontevrault, where she became abbess. No obit at Chartres.

6. *Agnes*, wife of Renaud II, count of Bar-le-Duc. Her sons were Henri I and Thibaut I, successive counts of Bar; Hughes; and Renaud, who was elected bishop of Chartres in 1182. "August 7. On this day Agnes died, countess of Muntionis." A note says she was the mother of Renaud de Mousson, who died in 1217 (OPS 81B). This son was bishop of Chartres during the fire of 1194 and was responsible for initiating the building campaign that produced the thirteenth-century cathedral.

7. *Elizabeth*, wife of Roger II, duke of Pouille, who was the son of Roger I, king of Sicily. The marriage took place in 1139 or 1140. On the occasion of this marriage Roger II gave Thibaut a very beautiful vase, which Thibaut gave to Suger, Abbot of St.-Denis.[28] Roger died in 1149, and Elizabeth then married William Gouet, lord of Montmirail and of Perche-Gouet. The Gouets held vast territories in the region of Perche, called Perche-Gouet to distinguish these holdings from lands held by the count of Perche.[29]

8. *Mahaut*, wife of Rotrou III, count of Perche, who died in 1191. She had five children: Geoffroy III, count of Perche; Rotrou and William, successively bishops of Chalons-sur-Marne; William, chancellor of Chartres before becoming bishop (1211–13);[30] and Stephen, duke of Philadelphia in the East; and a daughter, Beatrix, who was married to Renaud III, lord of Chateau-Gonthier. "3:10. Jan 1, Mathildis, countess of Perche, wife of Rotrou, the count. For whose anniversary we have twenty solidos super spernagili nemore de Authoyo per prebendarium." "St. Jean de Nogent-le-Rotrou. Jan. 1. Ob. Countess Maheust, who gave to the chapel of St. Stephen 20 solidos in Furno Vias." The royal abbey of Notre-Dame des Clairets, of the order of Citeaux, was founded by Mahaut, countess of Perche. [Date in OPS is 1204, however.] "281A. 13 Jan. Mathilde the Countess died, founder of the Clairets."

9. *Marguerite*, nun at Fontevrault.

10. *Alix* or *Adele*, third wife of Louis VII. The mother of Philip-Augustus, she is mentioned only in the obit of William of the Whitehands, her brother and close associate.

*Hugh.* Illegitimate son of Thibaut IV. From Ruth Harwood Cline (2007): "Hugh (d. 1171), a natural son of Count Thibaut IV of Blois and II of Champagne (d. 1152), was a half-brother of Count Henry I of Champagne (1127–1181) and Adèle (d. 1206), queen of France and mother of Philip Augustus. A knight wounded in battle, Hugh became a monk of Tiron Abbey near Chartres. Supported by his uncles King Stephen and Bishop Henry of Winchester, Hugh became abbot of St. Benet of Holme in Norfolk and of Chertsey outside London. Hugh returned to Champagne ca.1155 and became abbot of Lagny near Paris (1163–1171). A castrate, Hugh may have inspired Chrétien de Troyes' Fisher King."[31]

*Emma*, illegitimate daugher of Thibaut IV. She married Herbert the Chamberlain and lived in England. Of her three children, William, the unfortunate archbishop of York, had the most interesting noncareer (see Poole, 1930).

# ABBREVIATIONS

| | |
|---|---|
| *AASS* | *Acta Sanctorum.* Ed. J. Bollandus et al. Antwerp and Brussels, 1643–. |
| *AB* | *Art Bulletin* |
| *AHR* | *American Historical Review* |
| *ANS* | *Anglo-Norman Studies* |
| *BEC* | *Bibliothèque de l'École des Chartes* |
| *BM* | *Bulletin monumentale* |
| *CAO* | *Corpus antiiphonalium officii.* Ed. René-Jean Hesbert. 6 vols. Rome, 1963–79. |
| CCCM | Corpus Christianorum, continuation medievalis |
| *CCM* | *Cahiers de civilisation médiévale* |
| CCSA | Corpus Christianorum, series apocryphorum |
| CCSL | Corpus Christianorum, series latina |
| *CNDC* | *Cartulaire de Notre-Dame de Chartres*, ed. Ernest de Lépinois and Lucien Merlet. 3 vols. Chartres, 1862–65. |
| CSEL | Corpus Scriptorum Ecclesiasticorum Latinorum |
| *CSP* | *Cartulaire de l'abbaye de Saint-Père de Chartres*, ed. M. Guérard. 2 vols. Paris, 1840. |
| *CTT* | *Cartulaire de l'abbaye de la Sainte-Trinité de Tiron*, ed. Lucien Merlet. 2 vols. Chartres, 1883. |
| *DIGS* | *Dignitaires de l'Église Notre-Dame de Chartres. Listes chronologiques*, ed. Lucien Merlet and René Merlet. Chartres, 1900. |
| *Divine Office* | *The Divine Office in the Latin Middle Ages: Methodology and Source Studies, Regional Developments, Hagiography*, ed. Margot E. Fassler and Rebecca A. Baltzer. Oxford, 2000. |
| *EHR* | *English Historical Review* |
| *FC* | *Fulbert de Chartres, précurseur de l'Europe medievale?*, ed. M. Rouche. Paris, 2008. |
| *JAMS* | *Journal of the American Musicological Society* |
| *JC* | *Cartulaire de Notre-Dame de Josaphat*, ed. Charles Métais. 2 vols. Chartres, 1911–12. |
| *JWCI* | *Journal of the Warburg and Courtauld Institutes* |
| *LPFC* | *The Letters and Poems of Fulbert of Chartres*, ed. and trans. Frederick Behrends. Oxford, 1976. |
| *Marie* | *Marie: Le culte de la Vierge dans la société médiévale*, ed. Dominique Iogna-Prat, Eric Palazzo, and Daniel Russo. Paris, 1996. |

| MGH | Monumenta Germaniae historica |
| | SS Scriptores (in folio) |
| *MMSC* | *Monde médiéval et société Chartraine*, ed. Jean-Robert Armogathe. Paris, 1997. |
| *MSC* | *Un manuscrit Chartrain du XIe siècle*, ed. René Merlet and Jules Alexandre Clerval. Chartres, 1893. |
| *OC* | *L'ordinaire chartrain du XIIIe siècle*, ed. Yves Delaporte. *SAEL-M* 19. Chartres, 1953. |
| *OPS* | *Obituaires de la Province de Sens*, ed. Auguste Molinier. Recueil de des Historiens de la France, Obituaires. 4 vols. Paris, 1902–23. |

*OPS* is, in part, divided as follows (with page numbers in parentheses):

*OPS*1032 (26–114) The twelfth-century Chartres cathedral necrologies, Chartres, BM 1032 and 1033, both of which were destroyed in 1944. 1032 was begun in the middle of the twelfth century and continued for centuries after that; its lacunae were fillled in by Molinier from 1033, a fair copy of 1032, begun soon after 1190.

*OPS*A32 (120–25) The Book of Anniversaries found in Chartres, BM 1032, dating from around 1255.

*OPS*SP (179–99) Molinier used three sources to compile this obituary from St. Père: (A) Chartres, BM 1038, from the mid-twelfth century with later additions; (B) Chartres, BM 1031, an ancient opening predating *OPS*SP was followed by a thirteenth-century copy; (C) faulty copy of A and B made in the late fifteenth century, with later additions.

*OPS*SJ (226–34) The twelfth-century obituary of St. John in the Valley, Paris, BN lat. 991.

*OPS*J (243–57; 257–70) Paris, BN lat. 10104, fols. 145–79 and 105–40, copies from the early sixteenth century of two now-lost necrologies from the abbey of Josaphat; a second copy of both made a bit later in the same century (Paris, BN lat. 9224).

| OV | Ordo veridicus |
| PL | Patrologia Latina. Ed. J.-P. Migne. 221 vols. Paris, 1844–64. |
| *RB* | *Revue bénédictine* |
| *RHE* | *Revue d'histoire ecclésiastique* |
| *RHG* | *Recueil des historiens des Gaules et de la France.* 25 vols. Paris, 1738–1904; nouv. ed. 19 vols. Paris, 1869–80. |
| *Roi de France* | *Le roi de France et son royaume, autour de l'an mil*, ed. Michel Parisse and Xavier Barral I Altet. Paris, 1992. |
| *RTAM* | *Recherches de Théologie ancienne et médiévale* |
| *SAEL-B* | *Bulletin de la Société archéologique d'Eure-et-Loir* |
| *SAEL-M* | *Mémoires de la Société archéologique d'Eure-et-Loir* |
| *SAEL-PV* | *Procès-verbaux de la Société archéologique d'Eure-et-Loir* |
| SC | Sources chrétiennes |
| TSMAO | Typologie des sources du moyen âge occidental |
| *VC* | *Vieille chronique* |
| VdM | *Chartres: Sources and Literary Interpretation: A Critical Bibliography*, ed. Jan van der Meulen et al. Boston, 1989. |
| *VND* | *La Voix de Notre-Dame de Chartres* |

*On captions for figures:*
I have used some abbreviations: RP=Royal Portal; RPN, Northern Door; RPC, Central Door; RPS, Southern Door. Numbers for scenes in the capital frieze follow Heimann (1968); numbers for panels of glass follow Deremble (2003); these are keyed as well to Alison Stone's online database of artworks from Chartres:
(vrcoll.fa.pitt.edu/medart/image/France/Chartres/Chartres-Cathedral/chartres)

# NOTES

## 1. CHARTRES IN EARLY HISTORIES AND LEGENDS

1. The Augustinian church of St. John in the Valley was reformed by Bishop Ivo of Chartres in 1098 (see chapter 6). The monastery and its church, destroyed in the religious wars of the sixteenth century, were relocated close to the cathedral; its seventeenth-century ruins are today incorporated as part of the Maison de la Diocèse de Chartres.

2. No remnant of the chateau remains today. The Place Ballard is occupied by shops surrounding a marketplace and parking lot. During the light show of *Le Spectacle* in modern-day Chartres, the site "burns" with revolutionary fires. In his edition of the chronicle of Nantes, Merlet argues that Thibaut the Trickster was building fortifications in Chartres, Blois, Châteaudun, and Chinon in the mid-tenth century (108). Werner (1980) agrees with the general dating and points to a poem found in Marchegay's and Mabille's edition of the *Chroniques des églises d'Anjou* (247–52) that mentions the impressive height of the castles Thibaut constructed in Chartres and Châteaudun in the mid-tenth century.

3. One can still get a good sense of this kind of arrangement from Durham, where the cathedral and castle are also built on a high cliff. The bishop of Durham in the second half of the twelfth century was Hugh of Le Puiset, whose father was of the ancient family of the vicounts of Chartres and whose mother was a Thibaudian, a daughter of Count Thibaut IV. Bonnard (1912) describes fortified churches in the region of Chartres and notes the relationship between the church of the Madeleine in Châteaudun and the count's palace (see chapter 10). Bonnard's paper (1936) describes the ancient walls of the city as well as their portals, along with ramparts and fortifications. The magnificent tower of St. Peter's church dates from around 1000; it provided protection for citizens who lived outside the walls of the city.

4. Marie Tanner (1993) explores the importance of Aeneas to ruling families in the West, ending with the imagery of the Hapsburgs in the early modern period. (See chapter 12 for discussion of late medieval myths of pagan origins in Chartres.)

5. Gregory of Tours, *Historia* 7:17. In addition to Gregory's *History of the Franks*, which is the most studied, Fredegar's *Chronicle* and the anonymous *Liber historiae Francorum*, edited and translated into English by Bernard Bachrach, are also crucial.

6. CNDC 1:67–68: "Epistola synodi Parisiensis IV ad Sigibertum regem, ut causam Promoti non defendat, quem Aegidius, episcopus Remensis, in Dunensi castro episcopum consecraverat." King Sigebert had made Promotus a bishop of Châteaudun; when the archbishop of Sens refused to consecrate him, the archbishop of Reims stepped in to do the job. This action was opposed by the bishops, who united under the leadership of Pappolus, bishop of Chartres, and appealed to the king. When Sigebert died in 575, as negotiations were ongoing, getting

the intruder deposed became easier for the bishops. King Guntram wins the credit for listening to them, and this is part of his profile in Gregory's writings. See *RHG* 4:79, and Heinzelmann (2001), 55. This story is not found in the fourteenth-century bishops' list from Chartres. A Pappolus (Papulus) is listed as a bishop of Chartres during the time of King Clovis II in the mid-seventh century (*CNDC* 1:8); the theme of the primacy of the bishop of Chartres over Châteaudun is found in the entry for Sollempnis, whose cult was celebrated in Chartres on February 4. He was known as the figure who catechized and then, along with Saint Remigius and others, baptized the Merovingian king Clovis I, for which see *CNDC* 1:5, and *RHG* 5:381.

7. See *RHG* 5:707. A ninth-century copy of the eighth-century original (French National Archives, K5, n. 9) is found in facsimile in Lot and Lauer, *Diplomata Karolinorum*, 1936, no. 7.

8. See the *Annales Mettenses* 328, which reports that Hunald, the duke of Aquitaine, burned the town and the cathedral dedicated to the Virgin Mary in 743. Irene Haselbach (1970) has proposed that the *Annales* was written around 805; Janet Nelson (1996) suggests that Gisela, abbess of Chelles and sister of Charlemagne, was its author.

9. On Neustria in the pre-Carolingian and Carolingian periods, see the two volumes of papers edited by Atsma (1989). Werner's essay asking, "What Is Neustria?" (1985) is an excellent introduction to the region and its complexities in the seventh through the ninth centuries. For more recent scholarship, see the summary of the territories of Carolingian Neustria in Bauduin (2004), 100–101.

10. The *Annals* are named for the monastery of St. Bertin because the only complete copy was produced there in the eleventh century; this manuscript is now found in the Municipal Library of St. Omer. See Levillain's introduction to the Latin text by F. Grat et al., xxiii–xxxii. For a succinct discussion of the chronicle, its authors, and its sources, see Janet Nelson's introduction to the English translation, *Annals of St-Bertin*. Prudentius became bishop of Troyes around 844, and in the 850s was a supporter of Gottschalk of Orbais, whom Charles the Bald and his court condemned under the advisement of Hincmar of Reims. The *Annals* of Flodoard of Reims, written between 919 and 966, are a continuation of Hincmar. The history of Richer of Reims (see below and chapter 5), continued the work of the *Annals of St-Bertin*, beginning with the year 888 and continuing until Richer's death in 995, making extensive use of Flodoard. Glenn (2004) studies the relationship between Richer and Flodoard.

11. Dunbabin (1985), 4. A sense of the relationships between the three brothers, Louis, Lothair, and Charles, can be found in the entry for the year 854 in the *Annals of St-Bertin* (trans. Nelson, 79): "Lothair held discussions with his brother Louis on the Rhine, about fraternal behaviour in regard to Charles. But though at first they were snapping fiercely at each other, in the end they came back into agreement. . . . Charles was greatly disturbed when he learned this." The annals were being written at Troyes, where Prudentius had become bishop in 843, and so are increasingly removed from the action of Charles's court; Hincmar took them up between 861 and 866, continuing them until his death in 882.

12. For views of these years and of Charles's reign, see Pierre Riché (1983, tran. 1993), Janet Nelson (1990 and 1992), and, above all, Maclean (2003). Nelson (1992), 13, says that Charles's nickname may have been ironic. For the acts of Charles the Bald, see Giry, ed., *Recueil des actes de Charles II le Chauve*. What to call the Vikings, a term not used in the Middle Ages, is a problem for historians. The general term for the raiders from the north used by ninth- and tenth-century chroniclers was "northmanni." For introductions to the problem of naming them and for terminology distinguishing between those from Denmark and elsewhere, see introductions to Harper-Bill and van Houts (2003), Albu (2001), and van Houts, ed. (2000), as well as Janet Nelson's ever-useful introduction to the *Annals of St-Bertin*. For shifts in the politics and piety of these times as found in hagiographic writings, see Lifshitz (1995) and Herrick (2007).

13. Chartres, BM 24, a lectionary of Chartres (Epistles and Gospels), was prepared by Audradus; See Wilmart (1926); and Delaporte (1929), 1–2.

14. On Audradus, and for selections from his *Revelationes*, see Traube (1892), 374–91.

15. Delaporte's photos of now-destroyed manuscripts are available for study not only in the diocesan archive and in the Bibliothèque Municipale (now called the Mediathèque, but I use the former name throughout this study), but also in the invaluable collections he edited (see appendix A), along with a copy of his self-portrait. He was a skilled photographer and this aspect of his work deserves a study of its own.

16. Both Wilmart (1931) and Rand (1931) present more plates.

17. *Annals of St-Bertin*, trans. Nelson, 79, 81, 82–83.

18. See Bauduin (2004), 99–103.

19. *Annales*, trans. Nelson, 85; see Grat et al., 75, for the Latin: "Frotbaldus episcopus Carnotum, insistentibus sibi Danis in eadem ciuitate, pedibus fluuiumque Auduram natatu petens, aquis interceptus moritur." Nelson says that the passage regarding Frotbald is a marginal note and may have been placed in the wrong year, added perhaps by Hincmar "to correct the bias of Prudentius's silences." The year given in the Chartrain necrology, Chartres, BM Na4, is 858, rather than 857. See below for further discussion of this passage. Na4 is the abbreviation I use for Chartres, Bibl. Municipal. nouvelle acquisition 4; references are usually to *MSC*, the edition of the manuscript. (See appendix A and chapter 4 for further discussion of this central source.)

20. See *Gallia christiana* 8: cols. 1106–07; Fisquet, *Actes*, 38040; Kaiser (1997), 120; Tessier, ed., *Recueil des actes de Charles II*, 3, introduction, pp. 67–71; and Jusselin (1951) on his autographs. Merlet and Clerval report that Giselbert's obituary was recorded in the early Chartrain martyrology, Chartres, BM 150, on January 2, but that it did not survive into the twelfth century as part of the tradition ("Ipsa die, obitus domini Gisleberti, episcopi Carnotensis"); for discussion see *MSC* 36; for the entry in the necrology itself, *MSC* 150: "iii non. Jan. [Jan. 2] Obiit Gislevertus, episcopus Carnotensis." Jusselin (1951), following Tessier, describes the office of notary in Charles's entourage, saying that the men were more than simple scribes, being highly educated, intelligent, and especially trustworthy, and that many became bishops, including Jonas of Autun (850), Aeneas of Paris (856), Folcheric of Troyes (861), Hildebald of Soissons (870), and, of course, Gislebert of Chartres in 858. In this period the production of charters and the making of liturgical books were tasks requiring shared materials and personnel, and the early careers of these bishops surely boded well for the scriptoria of the cathedrals to which they were sent. Further study of these notaries would doubtless shed light on the history of the liturgy and chant as well.

21. Both books, Paris, BN lat. 9386 and 9452, provide readings for the Mass liturgy (see appendix A). Davezac (1978) discusses the artistic importance of lat. 9386, and the book is catalogued in *Les plus beaux manuscrits*, no. 14.; Gamber, *Codices*; Wilmart (1937). Zaluska and Granboulan (2005) locate these volumes and others like them in the tradition of early medieval lectionaries. Delaporte suggests (*OC* 211) that a concentrated look at the ways specific Carolingian books supported the use attested at Chartres in the eleventh century would indeed begin with Paris, BN lat. 9386. Other Carolingian liturgical books once at Chartres include Paris, BN lat. 9452, a ninth-century collection of lessons and epistles for the Mass, and the precious tenth-century graduel Chartres, BM 47, now destroyed but available in facsimile; see also Hiley (1990). For more on Chartrain books in the French National Library, see Delisle (1860).

22. See Hen (2001), 122–47, for an introduction to liturgical book production in the reign of Charles the Bald, and his liturgical proclivities. For a useful overview of liturgical music during the Carolingian empire, see Susan Rankin (1994). Walahfrid's liturgical treatise has been edited and translated by Alice Harting-Correa.

23. Jones (2001) provides an excellent introduction to the works of Amalarius and their dissemination. For brief discussion of Rabanus's liturgical occupations and bibliography, see Hen (2001), 103–04.

24. For the passage in Latin, see *MSC* 166. For the reading in the Chartrain martyrology, see Paris, BN lat. 5250, f. 89v. June 12, the day chosen for this event in the obituary, was the feast of Saints Basilides, Cyrinus, Nabor, and Nazarius. These martyrs, commemorated in both the Gregorian and Gelasian sacramentaries, were four soldiers killed in Rome during the time of Aurelius. Chrodegang of Metz brought their relics north, as reported by Paul the Deacon and other eighth-century writers. The feast is noted in *OC* (159) but without mention of the Chartrain martyrs or any indication of a commemoration for them. This day was a suitable choice for the ninth-century event, but many other feasts would have served as well.

25. Surprisingly, Paul is not found in any of the necrologies of the diocese of Chartres collected by Molinier (*OPS*). In the Middle Ages recorders of the deaths and deeds of others were themselves commonly forgotten. Van Houts (1995) describes the genre in which Paul wrote: "The last problem to be mentioned is that of the overlap between local and regional chronicles on the one hand and collections of documents pertaining to one institution on the other. The former are historical narratives in chronological order which sometimes contain the text of documents, whereas the latter consist mainly of documents with some connecting prose. The most famous examples of the latter group are the so-called cartulary chronicles of medieval monasteries and the document books of towns compiled in the later Middle Ages" (16). For discussion of English examples, see Genet (1977). Keeping these words of warning in mind, we have four sources, either extant or edited, of the charters from St. Peter containing the history of Chartres as it was made through its first surviving collection of charters. Late copies also exist and are mentioned in VdM. The entire complex is ripe for study by a scholar trained in medieval charters:

    A. Chartres, BM 1060, a late eleventh-century copy of the cartulary prepared by the monk Paul of St. Peter. Used as the basis for Guérard's edition (abbreviated *CSP* in this book) (his manuscript A), it was destroyed in the fire of 1944.

    B. Chartres, BM 1061, a twelfth-century copy of Paul's work. The additions made in this source to texts found in BM 1060 are frequently noted by Guérard (BM 1061 is his manuscript B). The source was destroyed in the fire of 1944. He notes that Muley thought this collection should be dated to the thirteenth century (cclxxii, note 7). Until further study, manuscript B must be seen as a later recension of manuscript A, including information supplied in the twelfth century.

    C. Paris, BN lat. 10101, a twelfth-century copy of the charters of St. Peter with additions, called the Codex argenteus. This collection of charters was divided into four parts: the first contains copies of charters relating directly to the privileges of St. Peter's, and the rest concern other related churches. This manuscript survives and was partially edited by Guérard.

    D. A fourth copy of the St. Peter's charters was made from all three of the above sources by D. Muley, a Benedictine in the employ of the king, who worked in Chartres from 1772 to 1775. The manuscript of his work in the Municipal Library of Chartres (BM 1136) was burned around the edges in the fire of 1944 but can be used. Muley included parts of the original manuscripts that Guérard omitted in his edition.

26. One of Paul's most famous forgeries purports to be a charter of King Lothair dating from 987 (the year after his death). A critical edition of this fabrication, with full apparatus, is to be found among the "Actes faux" in Halphen and Lot's *Recueil des actes de Lothaire et de Louis V*, no. LXVIII, pp. 163–66, with a lengthy discussion ("Examen") of the circumstances of its creation on pp. 166–67. (For another copy of the text, see *CSP* 81–83.) Halphen and Lot do not attribute this charter to Paul specifically and are quite circumspect in their attribution to "les moines de Saint-Père." They make an argument that an "original prétendu" (which elsewhere they call a "bon acte de Lothaire") was destroyed in the devasting fire of 1078 at St. Peter's; its substance survived only in some kind of summary ("analyse"), which was then used by a

monk of that house to recreate a forged copy of the original charter. This was "sous les yeux" of Paul when he composed the *Vetus Agano*, as well as of later copyists; indeed, it seems to have survived up until the time of Dom Muley, in 1774, who described it as "tombait en lambeaux par vétusté" (*Recueil*, p. 163, n. 2). I am grateful to Christopher Crockett for a discussion concerning this charter and for his affirmation of its likely attribution to Paul, who may or may not have worked from an earlier source as he fashioned it.

27. See Fassler (1985), Piper (1994), and Gullick (1994).

28. For discussion of the library, see Giacone (1974). In the preface to his work Paul speaks of the desire of the brothers that he perform the work of collecting and editing documents, and of the fire that has left the monastery vulnerable to the loss of its privileges. See *CSP* 1:3.

29. Paul must be mentioned in this study of the earliest evidence for the Virgin's cult because many of the details of early Chartrain history depend on his work and on the additions to it made in Chartres in the twelfth century. Paul's history and these additions provide a sense of these ninth-century events as they were reported in Chartres itself, but significantly later.

30. See *CSP* 1:6–8. The attack on the city of Luni, referred to in Paul's work, resonates with the incident as told in the early eleventh century by Dudo of St. Quentin, whose history is mentioned below (see also chapters 2, 4). Luni was raided by the Moors in 849 but never by Vikings: see Christiansen's notes to Dudo, *History of the Normans*, 18; Busch (1991); and Mc-Turk (1991), 227–29. For the story of the raid, see Dudo, 17–20, especially regarding the slaughter of a bishop and his people inside the church. This seems to have points in common with Richer's story of Ingo (related below), who acted to prevent such an action. Dudo's account is far more detailed than Paul's throughout, as a brief excerpt (section 20) shows: "The dire one attacked the bishop as he held the book in his hand. He murders the bishop and slays the count, and then the unarmed clergy standing in the church. The pagans had blocked the doors of the temple, so that no one could escape. Then the raging pagans massacre the unarmed Christians. . . . They rage within the precinct of the sanctuary 'like wolves inside a sheepfold.'" In Dudo's version of the conquering of Luni by Hasting, the slaughter takes place in a church, but the pagans gain access by trickery rather than by storming the edifice. Hasting pretends to be baptized and then to die, and his body is borne by his men to church. Once all the soldiers and all the people are in the building and the door is shut, Hasting springs from his bier, sword in hand, and the devastation begins. Another great difference in Dudo's story is the presence of "the count." Hasting's baptism provides a foil for Rollo's acceptance of the sacrament. For a discussion of related sources and the muddied discussions of Rollo and Hasting, see Abbott (1898) and Armory (1979). For more on the legend of Hasting, see van Houts (1984); notes to pages 16–22 in Christiansen's introduction to Dudo's *History*; and Albu (2001), 15–16. William of Jumièges has Hasting die in Chartres, as its leader; see his *Gesta*, 22. Every region had its own oral tradition and its own agenda in the telling and retelling of these stories (William of Jumièges was patronized by William the Conqueror in the later stages of his work).

31. *CSP* 1:45–46. "Jamque securi, relictis ibi navibus et variis praedarum manubiis, ad hanc urbem pernici cursu pervenere. Noctu denique, circumdata urbe et civibus ex improviso obsessis, barbari per moenia ab hostibus persepe diruta ac per portas irruentes, obviantes sibi, sine differentia, ferro necaverunt, atque, intra matrem aecclesiam, non modicam plebem cum suo episcopo, nomine Frodboldo, canonicisque aeclesiae et monachis qui ad eandem aecclesiam confugerant, cruentis gladiis velut oves mactaverunt, urbeque depopulata atque succensa, laeti et alacres, uti suae libidinis compotes, dum ad rates relictas arbitrantur cum magnis copiis redire, interveniente beata Dei genitrice Maria quam parvi penderant offendere, per os janitoris inferi ad inclementem barathrum una die, merita morte, descenderunt; Nam Franci, antequam ad rates suas potuissent pervenire, congressi sunt cum eis, et opitulante Deo victoria ex eis potiti, per campos cadavera eorum trucidata avibus et feris corrodenda reliquerunt." The

revenge does not take place in Dudo's description of Hasting; there the Franks pay a massive tribute, buying peace from him (*History*, 22).

32. Trans. Nelson, 127 (Grat, 122–23). The rise of the Robertians has long been a central topic in French medieval history. For a summary of recent scholarship and theories about their relationships with their most important vassals, see Werner (1997), who provides bibliography. Robert the Strong is said to have slain five hundred Vikings in 865 without losing a single man and sent all their standards and weapons to King Charles. Shortly thereafter Charles sent his son Louis into Neustria and "neither restored nor withheld his royal title, but he endowed him with only the county of Anjou, the abbacy of Marmoutier, and some villae. To Robert, however, who had been marcio in Anjou, he gave the counties of Auxerre and Nevers, in addition to the honores he held already" (trans. Nelson, 127–28).

33. On the origins of the holy cloth and the donation of it to Chartres by Charles the Bald, see especially Delaporte (1927), J. Villette (1976), with recent summaries in Burns (2006). No evidence of this gift exists in ninth-century documents, but this meeting in 867 suggests itself as an occasion on which it could have happened, as also the dedication of a rebuilt cathedral. The traditional date given for Charles's presentation is 876, and Souchet (*Histoire*, 2:87–96), drawing heavily upon the miracles of the Virgin from the thirteenth century, speaks of Charlemagne's supposed role in securing this relic in Constantinople, from whence it later came to his grandson. The thirteenth-century Charlemagne window at Chartres Cathedral depicts the mythic journey of the king to Constantinople and his acquisition of precious relics. For analysis and further bibliography, see Maines (1977) and Pastan (2008). Pastan relates the iconography of the window to a thirteenth-century understanding of the relic.

34. The Office texts (edited by Clerval) were probably written in the second quarter of the twelfth century during the episcopate of Geoffrey of Lèves. See also *MSC* 57. Clerval based his edition on three now-destroyed Chartrain manuscripts, all once in the Municipal Library: *190* (twelfth to fourteenth century); *52* (dated 1373); and *473* (from the fifteenth century). (The Municipal Library was destroyed by Allied bombs on May 26, 1944; see Joly, 1995.) The Office is discussed in detail at various points in this study and is translated in full, with later additions from the thirteenth century, in appendix C.

35. See Clerval, "Translationes," 331, and *MSC* 56–57, as well as appendix C.

36. Clerval, "Translationes," 323.

37. "Nam Franci undecumque cumglobati, antequam barbari ad relictas naves adtingere potuisset, congressi sunt cum eis, et, Dei praesule, victoria ex eis potiti, sicut usque hodie aparet, per campos trucidata eorum corpora avibus et feris corrodenda reliquerunt. Populus denique qui effugere potuit gladium barbarorum, ad concrematam urbem regreditur, atque collegit busta crematorum, et in puteo quodam, intra ipsam aecclesiam sito, projecit; unde ipse puteus Locus Fortis a civibus usque hodie vocitatur, ubi jugiter meritis eorum quorum ibi cineres praestolantur cum Christo resurgere atque in coelis cum eo regnare, ipso cooperante, multa fiunt mirabilia" (*CSP* 1:46n). See Jean Villette (1989, 5), who writes about seeing a surviving page of the burned twelfth-century manuscript containing this passage.

38. Merlet and Clerval published the text in *CNDC*, vol. 1; it has been translated into modern French by Guy Villette (1977).

39. The poem, which survives complete in a single manuscript that may be an autograph (Paris, BN lat. 13833), falls into three books, the last being far shorter and providing a moral lesson to monks; the notes to Abbo's sermons as edited by Ute Önnerfors (22 *Predigten*) and Werner (1979) situate his theological ideas. There are three editions of Abbo's history: Pertz in MGH, Scriptores, 1 (Hannover, 1871); Paul von Winterfeld in MGH, Poeatae Latini 4/1 (Berlin, 1899; rpt. 2000); and an edition and English translation by Nirmal Dass (2007). In addition to Dass, there are several translations, most notably Henri Waquet, *Le siège*, with French translation,

which omits book 3; Anton Pauels, which includes book 1 only, with German translation and useful notes; and Adams and Rigg, "A Verse Translation" (2004), also with valuable notes; an introduction to the poem itself is found in all these editions and translations and in Laistner (1924). Abbo, in spite of his over-the-top flourishes, has won respect for exemplifying a then-prevailing classicizing trend; see P. Lendinara (1986) and the introductions to Pauels, Adams and Rigg, and Dass. Abbo depends on Virgil for many of his allusions and was steeped in the *Georgics* and the *Bucolics* as well as the *Aeneid.* Maclean (2003) studies the political undercurrents of Abbo's history. For the dating of his work and bibliography, see Maclean, 55, and Dass, *Vikings.* Abbo is believed to have composed a first draft around 890 and then made additions to it a few years later.

40. Gozlin's hymn is as translated by Dass, p. 45, lines 314–19. The text refers to the famous Carolingian hymn "Ave Maris stella": Pauels (43) identifies this and other sources. The opening of Abbo's hymn resonates with the Introit antiphon sung for the Purification of the Virgin Mary, and other Marian feasts: "Salve sancta parens enixa puerpera regem qui celum terramque regit in secula seculorum," with its verse "Post partum virgo inviolata permansisti dei genitrix intercede pro nobis." This introit was entering sources in northern Italy and southern France in the tenth century, and it, like the passage in Abbo, apparently relies upon the early fifth-century Sedulius's *Paschale Carmen,* 3, verses 63–64. On the many roles played by Gozlin (also Josselin and other spellings), see Tessier, *Recueil des actes de Charles II le Chauve,* 3:42–46; Grat et al., *Recueil des actes de Louis II le Bègue, Louis III et Carolman II,* LXII–LXV; and Werner (1979).

41. See Abbo, *Bella,* 2:84–89, Dass, pp. 68–69. On Saint Geneviève: "The reign of Mars grew vaster and vaster and he filled with pride. God's virgin, Geneviève, was then brought before the city. And then, by the merit of her grace, our men were favored, and they put the enemy to flight; chased the Danes from the walls." (Dass, *Bella,* 2:246–49, pp. 76–77). The merits of Saint Germain are discussed in much greater detail; after he has been invoked by prayer, the saint himself appears and enters into the thick of the fray: "And then the church bells let loose their mournful, grief-stricken peals, at the sound of which the earth trembled and the river did moan . . . and then behold—Germain, worthy of praise by the world, showed himself in body, to bring aid in answer to our pleas" (275–80), tr. Dass, p. 79.

42. The surviving acts of King Odo are collected in a critical edition by Tessier and Bautier. Maclean (2003), 62, says that Abbo's characterization of Count Odo, the future king, makes him great because of his association with the saints and their relics, especially with Saint Germain; see Favre (1893; rpt. 1976) for an overview of Odo's life.

43. See Abbo, *Le siège,* lines 242–48, p. 34, in which these characters are described as being present at the siege of Paris. In both instances Odo is lionized for his bravery, and Abbo has written to promote his leadership. See also Dufour, *Recueil Robert I .* Lot (1891) suggests that the "Capetian" name came from their being early counts of Tours and so in possession of the sacred relic of Saint Martin's cape (*cappe*) (320–22). Maclean (2003) evaluates the complexity of Abbo's viewpoint regarding the Robertian and the Carolingian kings, see esp. 55–64.

44. It follows directly on the earlier incident, which is reported in the *Annals of St-Bertin* as well. If Hincmar added the note on the battle of Chartres, we must remember that he was in Paris, at St. Denis, as a young man and may have had knowledge of the local oral tradition.

45. *Bella parisiacae urbis,* 1:646–50, pp. 62–64, tr. Dass.

46. One day to be king and nicknamed "the Simple" or, as Nelson (1992), 257, and Glenn (2004), 2–3, would have it, "the Straightforward."

47. Maclean describes the difficult situation surrounding Charles the Fat's loss of power. Key to his study are the writings of two musician/historians, Notker the Stammerer and Regino of Prüm. Maclean (2003) points out ways in which Notker's famous book of sequences, the *Liber*

*Hymnorum*, reflects his support of Charles and his understanding of liturgy and politics at his court. Lori Kruckenberg (1997) alludes to the musical instabilities of the Notkerian sequences, even when they did cross the Rhine, and the political divisions then taking place that account for this lack of continuity. For the difficulties of getting back to the earliest layers of music, see Richard Crocker (1977).

48. The liturgist/historian Adémar of Chabannes, who wrote in the generation after Richer, alludes to it. See his *Chronicon*, 3:20.

49. The situation was complicated: political circumstances reversed themselves abruptly in the region after the death of the Thibaudian count Odo I of Chartres in 996 (see chapter 3).

50. References are to the new critical edition of Hartmut Hoffmann, which includes a facsimile of the manuscript. The pagans are led by Catillus, who Richer claims was the father of Rollo, scion of the Norman dukes (book 1:27; Hoffmann, 65).

51. No such battle has been documented. See Bautier, *Recueil des actes d'Eudes*, 11, for discussion of the difficulties with the documents and the impossibility of constructing an itinerary for the decade in which Odo reigned. We know from the surviving charters that he was in Chartres on December 30, 889, his only known visit to the city. See *Recueil des Actes d'Eudes*, 72–73.

52. Attempts to uncover the early history of the Thibaudians in the late ninth century, the period before Flodoard, include Lex (1892), 198–99, Métais (1908, 1908b, 1911), Depoin (1908), Boussard (1979), Lesueur (1963), Chédeville (1973), Werner (1980), Dunbabin (1985), Sassier (1997), and Le Hête (2003). Many early discussions are problematic because of their reliance on charters now known to be later forgeries. Some genealogies, such as that prepared by Evergates (1975, 193), list Thibaut le Tricheur as Thibaut II, and his father, Thibaut le Vieux, as Thibaut I; older charters begin with le Tricheur as Thibaut I, which I do as well, although acknowledging that indeed he was not the first. Thibaut the Old was vicount of Tours by 908. The question of how and when the vicount of Tours acquired Chartres is discussed in chapter 2. During the period studied in this chapter the family is not yet known in Chartres. For convenience, I use the appellation "Thibaudian" here and in chapter 2, but in reality the family was not yet well enough established in the ninth and early tenth centuries to warrant it.

53. See especially Lifshitz (1995) on the ways in which the later Christianized Normans came to terms with an earlier historiography that made them forces of evil; and Herrick (2007) for an in-depth exploration of the ways cults of the saints shaped history and identity in Normandy.

54. Henri Prentout (1916), 445–47, evaluates the story as found in various medieval chronicles and arrives at the conclusion that the account found in the chronicle of St. Colomba from Sens is the fullest and probably the best. This account gives the date of the battle as July 20, 911. On Rollo, see Howorth (1880), Douglas (1942), Searle (1988), and Arnoux (1999).

55. The quotation is from the vita of Geran, bishop of Auxerre, *AASS* July 28, vol. 6, p. 598. "Hujus victrix dextra, una cum Richardo et Roberto duobus maximis proceribus, praelio quod apud Carnotum urbem gestum est interfuit, ubi, interventu Dei genitricis Mariae, maxima paganorum caedes acta est. in tantum, ut innumerabili multitudine palante, inventa sunt jugulatorum cadavera plusquam sex millia quingenta, exceptis his, quos vorago fluminis Audurae afforbuit, longusque fugae tractus siluarumque vastitas vulneratos et exanimes obtinuit." The story is related among the miracles from Chartres, circulating in their Latin versions in the twelfth century but collected and written down in the early thirteenth century and then translated into French in the mid-thirteenth century, with some changes. See Thomas, "Miracula," 549–50; and Jean Le Marchant, *Miracles*. For other citations, see Mussafia, *Studien*, 119, part 9 (1889): 38; *Bibliotheca hagiographica*, 5365 and 5389; Ward, *Catalogue*, 2:603, 693; Poncelet, "Index Miraculorum B.V.M.," 76, p. 250 passim. For historical studies of the siege, see Lair (1902) and W. Vogel (1906).

56. Regino's references to the family have been studied by Karl-Ferdinand Werner; his compilations reveal numerous references to both Normans and Thibaudians. See especially Werner

(1992), which also contains extensive bibliography. On Regino's historical writings, see Werner (1959). Regino's *Chronicle* has been edited by Ernst Dummler.

57. For the three regional branches, see W. Vogel (1906), 397–98, the earliest detailed study of the broad reception and development of the legend.

58. The Normans were commissioning histories in the early eleventh century, and this early foundation long sustained their traditions. Dudo of St. Quentin's *Historia* was first requested by Duke Richard I and then by his half-brother Count Rodolf of Ivry and his son, Duke Richard II (996–1026); Dudo's history was then taken up by William of Jumièges, who revised it and added to it in two stages, first before the Conquest and then, at the request of William the Conqueror, after 1066. This *Gesta Normannorum ducum* was subsequently redacted by four anonymous authors and then, in the early twelfth century, by two major historians, Orderic Vitalis and Robert of Torigni. In her edition and translation of the revised work, Elisabeth M. C. van Houts says that through their work of revision both Orderic and Robert gained the skills needed to write their own histories later. The many sources directly dependent on Dudo for their versions of the tale studied here include William of Jumièges and Paul of St. Peter, as will be seen in the discussion to follow. See V. Jordan (1991) on the lives of the saints in Dudo, Lifshitz (1994) on his biblical language, and Bouet (1990) on his dependence upon Virgil, especially upon the *Aeneid*. On the dukes of Normandy and the cults of the saints, see also Herrick (2005) and (2007). Arnoux (1999) positions Dudo in Norman historiography.

59.
> If music's complicated forms you understood
> Which into three degrees division make,
> You could have played among the swans, with sweet
> Melodious sound, harmonically tuned,
> Eight modes, which each involve five tetrachords, and which
> The intervals of fourth and fifth embrace,
> And with commingled tones form jarring semitones,
> When the art's unequal metres are applied;
> Because the nine-to-eight ratio defines the tune [should be tone],
> And the four to three ratio enfolds the fourth
> And three to two establishes the fifth
> Under the law of arithmetic art.
> And fourth and fifth, combined together, consummate
> The octave, when the double number's set.
> The octave's triplicate, and the fifth; and twice
> The octave, makes a fourfold (symphony).
> (Dudo, *History*, 2:23–24, modified)

The way of illustrating the mathematical ratios governing the intervals in contemporary theoretical treatises, from the whole step to the octave, is an excellent introduction to the science of proportion as taught in the schools during Dudo's time. The standard medieval textbook for the study of music as a liberal art was Boethius's *Fundamentals of Music*, which has been translated by Calvin Bower. The art of proportion used for the tones was applied in Dudo's period to the arts of rhythmic poetry. See Fassler (1987a).

60. The entry for Frotbald in the fourteenth-century bishops' list found in the *Vieille Chronique* attempts to redeem Hasting.

61. As Christiansen translates the name Gantelmus. The quotations are from Dudo, *History*, 43.

62. Richard, duke of Burgundy (877–921), also called the Justiciar, is known as the founder of the Duchy of Burgundy; see Dhondt (1948), 159–63. Brother-in-law of Charles the Bald, he was famed as a skilled warrior and died in 921. Ebalus of Poitou, son of Count Ramnulf II of Poitou, was known for his prowess in battle against the Northmen but was opposed by the powerful East Aquitanians, one of whom, William the Pious, had taken the title of duke in 898. For

bibliography, see Dudo, *History*, nn. 181, 182, and the notes and introduction to Fanning and Bachrach's translation and edition of Flodoard's *Annals*, which covers the years 919–66.

63. "Cum subito Guvaltelmus episcopus quasi missam celebraturus, infulatus bajulansque crucem atque tunicam sacrosanctae Mariae virginis in manibus, prosequente clero cum civibus, ferratisque aciebus constipatus, exsiliens de civitate, paganorum terga telis verberat et mucronibus. Cernens autem se Rollo inter utrumque exercitum stare, seque non praevalere, suosque decrescere, transiens per medium illorum, coepit ab eis declinare, ne praeoccuparetur morte" (*PL* 141:645BC).

64.              Rollo potensque valensque asperrimus armis,
                 Ne verecunderis si jam fugitivus haberis,
                 Non te Franco fugat, te nec Burgundio caedit,
                 Concio multimodae gentisque utriusque phalangis:
                 Sed tunica alma Dei genitricis Virginis, atque
                 Reliquiaeque simul, philateria, cruxque verenda.
                 Quam velut in manibus meritis praesul reverendus. . . .
                 (*PL* 141:645C o)

65. Dudo, *History*, 50. "And so, in the 912th year from the Incarnation of our Lord Jesus Christ, Archbishop Franco baptized Rollo, after he had been instructed in the catholic faith of the Holy Trinity. And Robert, duke of the Franks, received him from the font of the Savior, bestowed his name upon him, and honourably enriched him with great rewards and gifts." For discussion of the actual date of the baptism, believed to have been between 911 and 918, with bibliography, see Dudo, *History*, n. 210.

66. "Postremo Carnotenam urbem obsidione circumdat. Quam cum machinis et tormentis impugnaret, Richardus Burgundionum dux cum suo Francorum exercitu adueniens, super eum irruit. Cum quo congressus, cum suis atrociter resistebat, quousque Antelmus episcopus, ex ciuitate cum armatis inopinato prosiliens, sancteque Dei genitricis Marie supparum preferens, a tergo eum cedendo inuasit. Hic tandem uidens Rollo se suosque in extremo mortis, decreuit ad horam hostibus cedere, quam cum suorum detrimento pugnare et prouido consilio non timida ignauia declinauit a certamine" (van Houts, ed. and trans, 1:62–63).

67. The major versions are found in the *History of the Bishops of Autun* (in Duru, *Bibliothèque*, 1:369); *Annales de Sainte-Colombe de Sens*; Hugh of Fleury, *Historia Francorum*, 365; Clarius, *Chronique*, 70; as a brief entry in the *Chronique de Saint Maurice* and also in the *Chronique de Saint-Maixent*, both of which are among the *Chroniques d'Anjou* (see Marchegay and Mabille, *Gesta*.8 and 374). This tradition also survives in Hugh of Flavigny (*Chronicon*, 357) and, as might be expected, in *The Five Books of the Histories* of Rudulfus Glaber, ed. and trans. France, 35–37. An example as part of hagiographic writing is found in the Life of Saint Viventius, 8.46, in *AASS* Jan. 13, vol. 1, p. 813: "Contigit etenim post aliquot annorum curricula, repullulante paganorum saeuitia, atque inuadente Astingo Normannorum Principe sum suis Burgundionum fines, vt praedicta B. Viuentii nuper data possessio cum tota pene prouincia ab eisdem Normannis depopulata incendio cremaretur. Praeterea paullo post respectu supernae misericordiae fortificati viribusque resumptis quidam Francorum ac Burgundionum primores, Duce Richaro praeeunte, cum iam terna caede quod supererat iidem Normanni delere molirentur, irruerunt in eos in pago Carnotense, tantaque strage illos deleuerunt vt vlterius in exerorum fines minime raptim exire tentarent." Chartres is mentioned, but the Virgin Mary is not.

68. Glaber, *Five Books*, 35 and 37. For the Latin, see 34 and 36. Glaber wrote his *Five Books* in stages; these are discussed by John France in his introduction to his edition and translation: "The pattern which emerges is of a work written over a long period of time. Some time after 1040, which is the last date in Book 4, the author decided to call a halt and begin to have a fair copy made, which provided opportunities for revision, but he never carried the project

through." Book 1, in which the description of the siege of Chartres is found, is "historical and brings us to the later tenth century and a little beyond" (xxxvii).

69. Clarius, *Chronique*, 70–71: "Eodem tempore, pagani obsederunt Carnotum civitatem. Collecto igitur exercitu, Richardus dux et Rotbertus princeps inruerunt in eos, perhemtis ex paginis sex milibus octingentis, capientes obsides a reliquis. Consilio igitur accepto Karlos rex cum obtimatibus, tradidit Neustriam Normannis: ex illo tempore vocata est Normannia. Post hec, mediante martio, apparuit stella a parte circii, emittens radium magnum, fere diebus XIIII. Sequenti anno, fuit fames magna per totam Galliam." The king is Charles the Simple (reigned 898–923, died 929). The Treaty of Sainte-Claire-sur-Epte (911), in all its mythic trappings, was surely not what the historians of the eleventh century make it out to be. It seems rather to have ceded a significant block of land around Rouen to Rollo, from which the kingdom eventually grew; he was to convert and to assist in controlling other invaders. See discussion and further bibliography in Potts (2003), 20–21. By the death of William Longsword in 942 enough deals had been made to expand the holdings significantly. See Bates (1982), 8–10, Dunbabin (1985), 79, and Potts (2003), 23–24. The *Chronicle* was put together from earlier sources and contemporary happenings in the closing years of the eleventh century. See the notes, xxxvi–xxxviii.

70. See Glaber, *Five Books*, 37; for the Latin, 36. France says in a note to this passage, "In fact, the Normans continued to ravage France well into the mid-10th century and beyond."

71. Dudo, *History*, 49. The action evinces the attitude of a writer who, at least at some point during his working life, sought to lionize the Normans at the expense of the Franks, as here, where the barbarians, in spite of their crudity, have the better of the situation. Dudo contrived to liken the Normans to the Trojans, who came to Rome destined to rule it as outsiders and who joined in a successful alliance with native lords through intermarriage: "Now when Duke Robert heard that King Charles would give his daughter to Rollo, and that they would make peace with one another, and that there would be peace for the whole kingdom, he sent a messenger to Rollo" (48). The question of Dudo's patrons is a thorny one, discussed in Christiansen's note, xxiii–xxix. See also Koziol (1992), 150–59, and Albu (2001), 14–16. On the practice of foot kissing in Carolingian courts, see Koziol (1992); on this incident, 152–53. On rituals that misfire and their interpretation, see Buc (2001, 2002).

72. See *Historiae*, ed. Hoffmann, 65. In spite of the errors in dating, this is likely a reference to Robert I of Neustria (reigned 922–23), a contemporary of Rudolf of Burgundy (reigned 923–36). These Robertians were superceded for a while by the line of Charles the Simple, whose son Louis IV d'Outremer (936–54), grandson Lothair (954–86), and great-grandson Louis V (986–87), were the last of the Carolingian line in the region. After the death of Louis V, Lothair's brother was passed over, and Hugh Capet was elected king, permanently establishing the Robertian lineage.

73. The relic and its legends and other cultic manifestations are discussed at great length in the writings of modern historians of Chartres. (I make reference to these materials throughout the book.) A useful introduction to this literature, broken down into time periods treated, is found in VdM, 247–93. The best summary of the subject as related directly to the sacred cloth is Delaporte (1927); the transportation of this particular cult to North America is discussed in Lucien Merlet (1858). Bugslag (2005) is a detailed study of the cult and pilgrimage in the later Middle Ages. Burns (2006) is a study of the culture of cloth in the twelfth century with focus on the relic of Chartres.

74. For an overview of the Rouen Dudo knew and its literary culture, see the prefatory material to Ziolkowski's edition of *Jezebel*.

75. See Huisman (1983) for discussion of the sources. Thirteen copies of Dudo's history survive: five are from the eleventh century and three from the twelfth. Dudo was still read, even after his work was "pillaged and continued" (as Christiansen says, Dudo, *History*, xxxv) by William of Jumièges.

76. See, for example, *CNCD* 2:11. The name is also close to the name of the bishop of Paris during the ninth-century siege of that city as described by Abbo of St. Germain. These bishops not only have similar names, but also, as mentioned above, are of similar character.

77. *CSP* 1:46: "Operae precium duxi huic orationi inserere obsidionem factam tempore Gancelini praesulis, cum propter novitatem temporis, tum propter memorandum miraculum quod in ea patrare dignatus est Dominus Jhesus Christus, interventu ejusdem genitricis beatae Virginis Mariae."

78. "Ibi denique navibus relictis, praepeti cursu, ad urbem veniunt, eamque in circuitu obsidione vallant. Verumenimvero praefatus praesul venturam obsidionem divino relatu praenoscens, Pictavensem comitem venire sibi in auxilium mandat, ducemque Burgundiae atque duos potentissimos Franciae comites, qui die consituto a preaesule, pari voto cum exercitu maximo parati, christiano populo auxilium ferre adsunt. Cumque pagani viribus et armis confidentes admodum insisterent, et civitatem capere festinarent, pontifex, die qua noverant supra dictos comites sibi venire in auxilium, valde diluculo jubet omnes suos armis muniri et ad portas ventum ire. Trahens itaque interiorum tunicam Dei genitricis Mariae super portam quae Nova vocatur, obtutibus paganorum obtuilit portasque urbis aperuit, et christianos fidenter praeliare jubet" (*CSP* 1:47).

79. The pilgrim today need only stand on the north side of the cathedral, at the rue de l'Horloge, to gain the site of the first recorded miracle effected by the Holy Chemise. See Delaporte (1927), 5, note.

80. See Chartres, N₄.

81. For an introduction to the subject of the liturgical framework of time and the cantor's role in producing and maintaining this framework, see Fassler (2007). For further exploration of the cantor in medieval understandings of time and history, see Fassler (1985); Grier (1990, 1995, 2006); Boynton (1998, 2000, 2006); and Boynton and Cochelin (2006).

82. The passage reads: "viiii kal. Jan. Anno Domini DCCCCXLI, indictione XIIII, obiit Haganus, episcopus et comes, Leobino beatissimo primus consimilis; cujus anima, sicut ei in hac vita jure potestatis coaequata est, ita cum eo in futura perhenni felicitate perfruatur" (*MSC* 149). The vita of Saint Lubin states that he was named to his see by the Merovingian king Childebert I. For this tenth-century life, see *Bibliotheca hagiographica* 4847, "Igitur bb. Leobinus Pictavorum urbis indigena," and references in Lépinois (1854–58). The fourteenth-century bishops' list forming part of the *Vieille Chronique* referenced here and elsewhere is edited by Lépinois and Merlet, *CNDC* 1:5–6. It has a long description of Lubin and names him as the sixteenth bishop of Chartres, saying that he is buried in the Church of St. Martin in the Valley, but that the cathedral has the relic of his head. Lubin was venerated twice a year in medieval Chartres, on March 14 and September 15. Delaporte has transcribed the texts in an appendix of the *OC* 245–50.

83. David Hiley has distinguished the core repertories of French sequences both in his dissertation (1980) and in his edition of the sequences of Norman Sicily (*Repertoire*). Both Hiley and Kruckenberg (1997) have discussed the striking separation of repertories between the western and eastern Carolingian kingdoms before 1050, a division not found in the trope repertories. The absence of this sequence from OV is striking; it is found in all other Chartrain sources and was well established in the region, as witnessed by the Norman-Sicilian sequence repertories, the earliest of which dates from around 1100. OV simply has no sequence, but its presence can be assumed.

84. See *Analecta hymnica* 53:111, and appendix D, below.

85. For the melody "Mater," see Bower (1982). For discussion of Saint Michael the warrior in the historiography of the ninth century, see Lifshitz (1995); Richard F. Johnson (2005) is a story of the Archangel in medieval England, with discussion of his role in Assumption narratives at 76–82. See *Analecta hymnica* 7:195/53:306 for the text. For the text and melody in a ver-

sion close to that found at Chartres, see Hiley's edition of the Norman-Sicilian repertory, 117–19.

86. On the processes involved in creating identity through popular cults, compare the work of Peter Brown (1981) to that of William Christian (1981). The shift between cults of local celebration only and the regional and interregional veneration of saints is a complex subject requiring more study, even though saints' cults have received much attention in recent decades. Mary Clayton (1994) shows the shift between the boundaries of the local and the universal and cautions against drawing the line too strictly.

87. See especially Sharon Farmer's discussion of Saint Martin of Tours (1991) and the means by which the monks of Marmoutier were able to control the veneration of the great saint and, by the twelfth century, to shatter the sense of ownership that the town and the cathedral and its archbishop once had over the cult. Michael Powell (1998) has studied the situation in Lyon, demonstrating the tension between religious communities and burgesses; he concentrates, as does Farmer, on the use of topography, bridges, and the order of processions to define relationships between groups and to make powerful statements about cults and their management. The tense relationship between canons and monks in twelfth-century Chartres is suggested by the nature of processions in the town (see chapter 8).

88. See Geary (1994b), speculating upon the conclusions of his book *Phantoms of Remembrance*: "This study began with the premise that what we think we know about the early Middle Ages is largely determined by what people of the early eleventh century wished themselves and their contemporaries to know about the past" (177).

## 2. WAR AND PEACE IN THE MID-TENTH CENTURY

1. For two views of the ways in which medieval families kept track of their histories, see Duby (1966), who describes the importance of recording marriages and studying family lines, and Freed (2002), who extends his earlier work on German families and marriage to the realms of art and literature. The writings of Gabrielle Spiegel (1983, 1997) have been highly influential regarding historiography and lineage over many years, as have the works of Howard Bloch in lineage and literature; see Bloch (1987) for an example of his way of thinking. Of direct relevance to my book is the collection of papers edited by Keats-Rohan (1997) on the prosopography of Britain and France in the central Middle Ages, especially the paper by Michel Bur (333–48).

2. See Geary (1994a, 95–124) on the humiliation and coercion of saints through ritual practices that reversed the norms of reverence. See David Bachrach (2003) for discussion of liturgy and warfare in the later Middle Ages.

3. Grier (2006) is the definitive work on Adémar's liturgical agenda.

4. See Glaber, *Histories*, ed. and trans. France, 4:14 and 15 (pp. 194–97). For discussion of the Peace of God and especially of its relation to notions of the end of time, see Cowdrey (1970) and Head and Landes (1992). In his introduction to Glaber's history, France suggests that he died around 1046; he believes that Glaber wrote book 4 of the *Histories* at St. Germain-d'Auxerre between 1036 and 1041.

5. See Jesch (2004) on the Vikings' desire to create settlements and their ultimate success in this regard.

6. For the classic debates on change and continuity around 1000, and whether or not new kinds of lords were making a new social world suddenly enough to make the term "revolution" appropriate, see especially Bisson (1994), the replies to his work, and his counterreply. The kind of close study one needs to answer the central questions of the debate is exemplified in Barton (2004). How one comes down on the issues will depend on methodology and the kinds of materials chosen for study, for it is apparent, at least in the region studied here, that certain

families were growing more powerful, consolidating their territories, and attempting to govern them through force and coercion and by setting up agents of their own power in strategic ways. As Bachrach (1993) has argued in his study of Fulk Nerra, the Angevin counts were particularly good at this. It is also true that knowing the long-standing tensions between the great families is crucial to understanding both the choices they made in later periods and the nature of the balance of power in the eleventh and twelfth centuries.

7. The lineage of Thibaut I, whose father was apparently also named Thibaut, depends on the identity of his mother, Richildis, and on the untested validity of a small group of charters, most recently discussed by Boussard (1979), Sassier (1997), and Le Hête (2003). By midcentury the territories under Thibaut's control included Chartres/Blois, Tours, Chinon, and Saumur, and he had temporary claims on Laon, Montaigu, Coucy, and Evreux; see Lex (1892) and Boussard (1979). At the time of the warfare described here, Evreux was a bone of contention. Through his marriage to Leutgard of Vermandois, Thibaut acquired Bray-sur-Seine and Chalautre-la-Grande in Champagne and laid claim to land in the Vexin; the connection to these lands would prove of great importance to the family in the early eleventh century.

8. Flodoard also wrote a history of the church of Reims and three works of hagiography: see Brunhölzl (1996), 114–16. All quotations here are from the edition and translation of Fanning and Bachrach, based on the critical edition by Philippe Lauer.

9. Louis IV d'Outremer replaced King Raoul, who was also duke of Burgundy, in 936. Louis had been exiled in England, and his return was negotiated by Hugh the Great. Flodoard says he was consecrated in Laon (18A, p. 28).

10. McKitterick (1983) and Sassier (1997) offer detailed discussions of these years and are foils for the arguments of Werner (1980) in some cases. Bauduin (2004) provides a fresh look at the politics of the times and the historiography of Dudo of St. Quentin.

11. See the genealogical charts in Bachrach (1993) and discussion, 7–12.

12. But Settipani (1997) believes the date of the marriage was not 970 but only between 970 and 980 (250), which may explain this. In any case, the countess Adela bore a second son, Geoffrey, about a year after Fulk Nerra's birth.

13. It is one of history's ironies that the offspring of these two sisters, Leutgard and Adela, were mortal enemies for two centuries; their warfare defined the politics of the region in the early eleventh and the twelfth centuries. Adela, mother of Fulk Nerra, the greatest foe to Odo I of Chartres/Blois and to his son Odo II, died in the spring of 974, when Fulk was four years old; thus she could not influence him or promote peace and understanding between him and her sister's children and grandchildren. Bachrach (1993) is a detailed study of the history of the period, centered around Fulk Nerra and the house of Anjou. For the earliest legends of the counts of Anjou, see Settipani (1997), who has challenged some details in the work of Bachrach and K. F. Werner. The *Chronicle of the Counts of Anjou* (ed. Halphen and Poupardin), from the first half of the twelfth century, parallels the evolving story of the counts of Chartres/Blois in many ways.

14. See Bachrach (1993), 8–9 and notes. Dudo's editor, Christiansen, claims that the actual relationship between Richard I of Normandy and his stepmother's husband, Thibaut of Chartres, cannot be known, but his is a minority opinion. See notes to his edition of Dudo, 218.

15. MSC 171. The *Vieille Chronique* puts the date of the fire at 963; see *CNDC* 1:13.

16. Delaporte (1953) provides a discussion of medieval lists of bishops of Chartres.

17. Souchet, whose history (*Histoire*) was not issued until centuries after his death, 2:157; Lépinois (1854–58), 1:42.

18. Mabille, in his reconstruction of the destroyed *Pancarte Noire* of Tours (p. 188), reports that young Thibaut was mentioned in a charter dated March 26, 957, but not again after this time. See Lot (1907), 176, and Lex (1892), 202. For a lively retelling in English of the history of the tenth and eleventh centuries and the rise and establishment of the Capetians, Jean Dunbabin's

*France in the Making* (1985) cannot be surpassed in spite of the voluminous waters that have poured over the historiographical dam since she wrote it. For the best scholarly studies of the events in Chartres at this time, which do not greatly differ in their arguments in spite of the distance between them, see Lot (1891), 33–44, and Bauduin (2004), 166–73. Bauduin provides an excellent introduction to recent scholarship.

19. See Marchegay and Mabille, eds., *Chroniques*, 247–48.

20. See the collected acts of the dukes of Normandy (911–1066) in *Recueil*, ed. Fauroux, no. 3, p. 71.

21. 44G, p. 66. Flodoard tells of Thibaut I's excommunication by the bishop of Reims and of the resolution of his difficulties; these occurred about 964, soon after his humiliating defeat at the hands of the Normans. See the *Annals*, trans. Fanning and Bachrach, years 962 (44) and 964 (46), pp. 66–67.

22. The passage that first gives Thibaut I his nickname is found in book 3, chapter 2 of Glaber's *Histories*, which France says was written before 1030, and at Saint-Bénigne at Dijon. See section 5: "Inter quos fuit Odo rebellionum maximus, qui fuit filius Tetbaldi Carnotensis cognomento fallacis, ceterique quamplures inferioris potentiae, qui exinde extiterunt ei rebelles unde esse debuerant humiliores" ("Chief among these rebels was Odo, son of Theobald the Deceiver, count of Chartres, with very many others of lesser rank, who rebelled against the king from positions that should have made them humble") (trans. France, 104).

23. On her dowry, see Musset (1959), esp. 28–31. That the Normans wished to keep Leutgard's rich dowry was not unusual; neither was their failure to do so. Women who lost power and position owing to the deaths of their husbands often remarried and sought to even the score with the families of their deceased husbands; these families frequently disowned the widows and yet continued to hold their dowries, or parts of them. In any case that both the Thibaudian and Angevin counts were able to marry women who were direct descendents of Charlemagne on their father's side and granddaughters of King Robert I on their mother's side demonstrates that they had arrived, no matter what various chroniclers may have to say about them.

24. See Christiansen's notes to Dudo, *History*, 201. Her name was spelled in a variety of ways, including Legardis, Leutgarde, Liégard, and Leyarda. Heribert II of Vermandois (d. 943), a great power in the first half of the tenth century, is also described as a deceiver, much as Thibaut I of Chartres/Blois was by Glaber. Instead of murdering King Charles the Simple, however, as some historians say, Heribert trapped him and held him prisoner until his death. See Glaber, *Histories*, 1.5, pp. 12–13.

25. See Dudo, *History* 3.32, p. 70. The notes in Christiansen's translation are confused (two of the texts quoted are omitted). That the Vermandois wife is Leutgard may be correct, but that she is William of Normandy's sister is wrong. See also Bates (1982), 12, and Searle (1988), 54. The erudite Jules d'Arbois de Jubainville argues that Leutgard's early marriage is only a fable, but it would seem that his arguments are overly dependent on the dates of Paul of St. Peter's charters.

26. For evaluation of the story, see Lot (1891), 347–52, and others as above. The countess Leutgard's possible role in the strife is discussed below.

27. Dudo, *History*, 150. See also William of Jumièges, *Gesta*, ed. van Houts, 1:125n. It has been suggested that the son who was killed must have been Thibaut's by an earlier marriage, but if he had married Leutgard in 943 and she produced a child soon thereafter, the boy could surely have been in the field by around 960.

28. Van Houts (1995), 29: "The authors of chronicles were often motivated by events in the present rather than in the past. Not infrequently, a dispute over the acquisition or loss of property, whether in the form of land, or rights or relics, provided the stimulus." Christiansen says in his notes to Dudo, *History*, xxiv: "In particular, the emphasis on the way Richard's forebears dealt with the English, the Flemings, the Bretons and the house of Blois-Chartres may be dictated

by what happened after 996, rather than before 966." Dudo's history is, however, difficult to date with precision. Christiansen says, "Dating it, within the limits 996–c.1020, seems impossible. Some of it appears to echo, or relate to, the historical events of that period, but the 'Mickey-Mousing' of the text with current affairs has not so far produced a convincing chronology of composition. It is an elaborate and imitative book, and may well have taken twenty years to complete" (xiii).

29. On Dudo's introduction as inspired by fear of the house of Blois/Chartres, see Lifshitz (1994).

30. In the late twelfth-century *Chronique des ducs de Normandie* by Benoît de Sainte-More, the polarities developed by Dudo are taken even further; Thibaut le Tricheur plays a major role in the opening of the second book.

31. Jane Michel's forthcoming study of Leutgard as patroness of St. Peter is anticipated.

32. When the great donor Bishop Ragenfredus of Chartres died, "the remains of his body were buried in the monastery upon the memorial before the altar of the blessed apostle Peter, with choirs of psalm singers, and with the honor of mourners." Paul is careful to show that this great bishop of Chartres lies with great men of the distant and more immediate past: "To his left Guantelmus rested in body, the venerable priest, who by his own intervention and by the display of the interior tunic of the ever virgin Mary, drove out the odious troops of the Normans from a siege of the city. Then Fulbert, a bishop to be remembered, who was of such great wisdom that his hagiographical writings make their ways into his readers with marvelous sweetness. To the right, Bishop Thierry, whose Ambrosian powers, like a torrent in flood — completing the outstanding work of the hall of the Lord's mother, and unfailingly supplying a place of eating and drinking for the poor — brought about something worthy of holy praise"("eius gleba corporis in coenobio supra memorato ante altare beati Petri apostoli cum choris psallentium simul et flentium honore debito est sepulta . . . , ad cuius levam in corpore quiescit Guantelmus, venerandus antistes, qui proprio interventu, atque ostensione interioris tunicae semper virginis Mariae, ab obsidione urbis odiosas Normannorum abegit phalanges. Deinde Fulbertus praesul memorandus, qui quantae fuerit sapientiae eius agiographa mira dulcedine flagrantia legentibus insinuant. Ad dexteram vero, Teodericus episcopus, cujus Ambrosiae opes velut torrens affluentes, preclarum opus almae matris Domini aulae complentes, perediae quoque atque bibesiae inopum jugiter oviantes, sacro dignum praeconio efficiunt") (*CSP* 1:12).

33. For this bishop in Chartres, see *CNDC* 1:12. His role in restoring the Abbey of St. Peter is not mentioned in the entry.

34. *CSP* 1:10–11. The liturgy of St. Benedict of Fleury can be studied in a twelfth-century ritual edited by Anselme Davril. One point of contact between it and the little-studied liturgy of St. Peter is the "clamor," for which see Davril's edition, 156, and *MSC* 231–38, as well as Little (1993).

35. According to the fourteenth-century *Vieille Chronicle*, Ragenfredus was the forty-ninth bishop of Chartres; he reigned from 941 to 955, that is, just before the time of the outbreak of war between the count of Chartres and the Normans which resulted in the burning of Chartres, but in time to be present at the time of Leutgard's charter. Both the cathedral and the abbey have entries for Ragenfredus in their necrologies, showing that they both claimed him as a figure who contributed to their churches.

36. *CSP* 1:63: "Mirabiliter laudabilis et laudabiliter semper mirabilis provida dispensatio Conditoris notri, a primordialis exordio mundi, qui redemptis sui sanguinis precio, et, sacri baptismatis ablutione, originali mundatis crimine, praevidens et praesciens post ista omnia nec unius diei spatio a qualicunque peccato quempiam vivere inmunem, nec humanae corruptionis labem posse evadere, contulit multa animae salutis remedia, quibus non solum vitiorum curantur morbida, set etiam beatae inmortalitatis adquiruntur gaudia; inter quae, elemosinarum plurimum valet largitas, cui non solum plurimorum patrum astipulatur auctoritas, set etiam ipsius

voce Domini laudatur beata dicentis: 'Dimittite et dimittemini, et quaecumque feceritis uni ex minimis meis, michi exibebitis.' Super his etiam quidam sapiens dicit: 'Redemptio animae viri, propriae divitiae ejus;' et illud: 'Date elemosinam, et omnia munda sunt vobis;' et multa his similia inveniuntur in dando elemosinam ad hortationem praecipua, in quibus longum est ire per singula." This resembles in style and content several other charters that Paul may have designed, perhaps from original sources or from the memory of such sources.

37. See *CSP* 1:65. Chartres, BM 577, a now-destroyed sacramentary from St. Peter's (f. 162v), witnessed to a Mass for Countess Leutgard and other women of the family.

38. See *MSC* 172: "id. Aug. [August 13] Obiit Harduinus, episcopus carnotensium." The editors note that he died in 962, although the VC supplied other dates (see *CNDC* 1:13). A Harduinus is mentioned by Flodoard as being one of the dependents (*subiecti*) of Count Thibaut in 958, and we see him fleeing the defense of Coucy-le-Château, the stronghold in the territories of Reims that Thibaut continuously battled to keep in the period (Flodoard, 40A, pp. 62–63). Vulfad was better known. Paul (*CSP* 1:51) claims him as a former abbot of St. Benedict of Fleury who brought monks of the order to St. Peter. Hugh of Fleury, in his history dedicated to Adela of Chartres (*PL* 163:889D), says that "Vulfad, abbot of the monastery of St. Benedict of Fleury, became bishop of Chartres. He was a man vigorous and very wise."("Et eodem anno Vulfadus abbas monasterii sancti Benedicti Floriacensis presul efficitur urbis Carnotensis. Erat enim vir strenuus et sapientissimus.") On Hugh's work more generally, see Vidier (1965), 76–81; for Hugh's *Ecclesiastical History* and its audience, see Wilmart (1938). Vulfad's obituary notice as found in *MSC* (177) has been revised (revision in italics): "vi non.oct [October 2] Obiit Deo acceptissimus omniumque laudabilium virtutum claritate decoratus, abbas *primum, postque pontifex sedis istius* Vulfaldus" ("Vulfaldus, most pleasing to God, and adorned with the radiance of all praiseworthy virtues, *first* abbot *and then bishop of this see*, died.") Paul of St. Peter (*CSP* 1:54) noted the difficulty in writing about this period owing to the scarcity of documents. We can imagine that the fire of around 962, which apparently was especially severe, must have caused the destruction of many Chartrain documents. This event may explain why few charters remain from before that time, and a relative abundance from the years afterward (some of which are, of course, supplied by the active pen of Paul himself). Geary (1994b) discusses the change in culture from the tenth to the eleventh centuries, from one that seemingly cared little about documents to one that did.

39. See *VC*, which has two descriptions of Odo, one in the list of bishops (*CNDC* 1:13–14) and the other in the body of the work (*CNDC* 1:47–48).

40. See *MSC* 100. This manuscript (Na4) contained death notices prepared during the time Fulbert was bishop. These show a cult promoted during his lifetime, rather than during Bishop Odo's, and that a desire to establish a history for the relic and reliquary was a possible inspiration to the compilers.

41. See *DIGS* 29 and 6; our knowledge of him is based on his association with charters from St. Peter's: see *CSP* 1:60, 62, and 86. The first charter he signed as dean dates to 988.

42. *CSP* 1:66. The charter, which offers rights pertaining to land, is dated 16 August 979.

43. For Leutgard, see *OPSSP* 197F (14 Nov.) and *MSC* 182 (14 Nov., in an addition made long after the compilation of the book); she also has an entry from the thirteenth century in the necrology of Mantes (*OPS* 376B [12 Nov.]); for Godeleia, see *OPSSP* 189E (20 May) and *MSC* 164 (21 May).

44. See *MSC* 184 (15 December). Merlet suggests that because the entry was written before 1028 it cannot refer to a man who lived during Fulbert's time; this Teudo built roofs and the front of the church, and Merlet believes that these did not belong to the church begun during Fulbert's lifetime.

45. Another name that shows up in the documents is Suger, with multiple spellings. A Suggerius from the late tenth century is sacristan in two charters from St. Peter's (*CSP* 60 and 62) and

*DIGS* 282; the Merlets believed him to be the same as Suggerius the Chancellor of the Cathedral, who witnessed a document in 968 (*CSP* 58) and became a monk at St. Peter's. Around a century later, another Suggerius shows up in Chartres, this time as a provost (*DIGS* 227), whose obituary the Merlets claim is that on 13 September, dated by handwriting style to the late eleventh century: *MSC* 176: "Obiit Suggerius, canonicus and prepositus Sanctae-Mariae" (Suger died, a canon and provost of St. Mary's). Abbot Suger of St. Denis has a one-line obituary in the necrology of St. Denis (*OPSSP*, 180E); the necrology of St. John in the Valley contains a twelfth-century entry for William (26 January), who was the brother of Suger. For his soul, Suger gave a silk cape to the church of St. Stephen in Chartres (*OPSSJ*, 227D). These bits of evidence are suggestive of the origins of the abbot's family.

46. *MSC* 157: "Obiit Hilduinus, alme Marie canonicus, custos scrinii sacre vestis et totius aecclesie ornamenti, rei familiaris servator fidelis et distributor dapsilis." The wording "holy garment" ("sacre vestis," in Latin) is significant, for it demonstrates that the relic was not consistently called a tunic at this time. Note that Paul of St. Peter's history calls it *interior tunica* and Dudo calls it a tunic as well. The relic itself actually was a long piece of cloth, and none of the descriptions are really accurate. See Delaporte (1927), whose photographs are featured here.

47. The prominence of the name Odo ties the history of Chartres and the Thibaudians to the reign of King Odo, who, Richer says, relied upon Ingo as his standard bearer (see chapter 1). Leutgard and Thibaut I named their first son Thibaut and their second son, who became heir after his brother was killed by the Normans, Odo.

48. "Que scrinio Dei genitricis affigendas reliquid aureas aquilas miro opere sancti Eligii informatas" (*MSC* 157; Rotlindis, 29 March). At St. Peter's, she is simply called the mother of Odo the bishop (*OPSSP* 186B; Roduidis, 31 March).

49. Odo's brother Vuitger was an "outstanding soldier." See *MSC* 167.

50. The life of St. Eligius, ascribed to Bishop Ouen of Rouen, translated by Jo Ann McNamara, is found online at http://www.catholic-forum.com/saints/st009001.htm (accessed December, 2009).

51. The feast was elevated in Chartres in the course of the thirteenth century. See Appendix B, p. 381 below. The date of the Feast of St. Eloi is one of the ways that the liturgy of St. John differed from that of the Cathedral.

52. This is Reine Berthe (see below).

53. See *VC* 47 for Odo's association with the number seventy-two, comparable to apostolic witnesses. The superiority of the musical establishment has little to support it after the eleventh century. The only first-rate composer associated with the cathedral in the early modern period is Brumel, who was apparently trained there and who worked at Chartres early in his career. For a biographic sketch and bibliography, see Sherr (1994).

54. For evaluation of these legends and their development, see chapter 1.

55. These dates are not verifiable at present, but see Bautier (1992), 29, Sassier (1987), 194–98, and Glenn (2004), 2. In his notes to Richer's reference to Hugh's coronation (*Historiae*, 4.12), Hoffmann provides a resume of the scholarship (239). The notes to A. W. Lewis (1992) often contain references to feasts chosen for coronations and their symbolic meanings. For a discussion of ceremony and architecture regarding coronations in the time of Hugh Capet, see Bur (1984, 1992). For comparative discussions of situations that brought Robertians to the throne in place of the hereditary Carolingian line, see Sot (1993). Hugh Capet's royal ancestors were Odo, his great uncle (ruled 888–98); Robert, his grandfather (ruled 922–23); and Raoul, his uncle (ruled 923–36).

56. Bautier (1992) suggests that Charlemagne was pronounced king in Noyon and that the Capetians were making a deliberate parallel. The importance of liturgical reforms from the tenure of Archbishop Adalbero to the final triumph of the Capetians is emphasized in Koziol (1992). Three generations of Adalberos can be found in the late tenth- and early eleventh-

century political sphere of the Capetians: the first is Adalbero, bishop of Metz (929–62), who groomed his nephew Adalbero for high ecclesiastical office, which the younger man eventually achieved as archbishop of Reims. Adalbero of Reims (whose death date of 989 has been disputed by Bur in *Chronique*, his edition of the "Foundation of Mouzon") in turn had a nephew of the same name. This Adalbero became bishop of Laon, and in spite of his criticisms of King Robert and his sometime treachery he remained in office until his death, probably in 1031. Adalbero of Laon had powerful friends: his relative Bishop Gerard of Cambrai, Fulbert of Chartres, Foulques of Amiens, and Dudo of St. Quentin, who dedicated his chronicle to him. He is the only Adalbero of whom there is a modern, full-length study: Coolidge (1965); his writings have been edited and collected by G.-A. Hückel but, with the exception of the long, famous "Song for Robert" (ed. and trans. Claude Carozzi), they lack a modern critical edition. There were other Adalberos who served as bishop of Metz besides the figure mentioned here. Jaeger (1983) is an introduction to the "courtier-bishop."

57. Hoffmann points out in his notes (Richer, *Historiae*, 240) that according to the *Annales de Saint-Denis* (ed. Berger, 275) for the year 987, Robert was crowned on a Friday; Christmas day 987 was a Sunday.

58. The "Laudes regiae" (see chapter 4) has been much studied by historians of various disciplines, the work of Kantorowicz (1946) remaining foundational. Works that include discussion of the subject as related to England and northern France demonstrate the breadth of interest: Johnson (1961) on Chartres and resonances of the "Laudes" in the Tree of Jesse window; Nelson (1986) on the Carolingians; Andrew Hughes (1988a) on the coronation of Edward II; and Robertson (2002), whose focus is on the meanings of the "Laudes" in late medieval Reims and the further development of the figure of David as a model for kings in the second half of the fourteenth century. The best discussion of the "Laudes" in Chartres is that of Delaporte in OC 240–44.

59. For figures who dominate Chartrain history around 1000 and in the decades thereafter, see the lives of Fulbert and Robert II by Pfister (1885a and b); the appropriate chapters in Souchet (*Histoire*) and in Arbois de Jubainville's history of the counts of Champagne (1859–69); Lex's discussion of Odo II (1892); the notes to Behrends's edition and translation of Fulbert's letters (*LPFC*); the notes to Hoffmann's critical edition of Richer; and the many writings on Fulk Nerra by Bernard Bachrach, especially his book (1993). In addition to these special studies, historical overviews of great usefulness are found in Lot (1891, 1903); Petit-Dutaillis (1936); Lemarignier (1965); Bur (1977); Dunbabin (1985); A. W. Lewis (1992); the rich collection of essays in Parisse and Barral I Altet (1992 = *Roi de France*), especially those by Robert-Henri Bautier, Michel Bur, Guy Lanoë, and Karl-Ferdinand Werner; Sassier (1987); Barthélemy (1999); and Bauduin (2004). The monograph by Laurent Theis on Robert the Pious (1999) is a useful, clearly written summary of the life of Robert, but it lacks a bibliography and contains few notes; it was written before Hoffmann's critical edition of Richer appeared. LoPrete (2003) is a cogent introduction to the historiography of medieval Capetian queens and lays out broader issues that relate to the treatment of royalty more generally. There is no edition of the scattered acts of Hugh Capet; the acts of Robert are catalogued by William Mendel Newman (1937), and a critical edition is now in progress.

60. In their attempt to oust the Capetian kings Robert II and his father, Hugh, and to replace them with Duke Charles of Lotharingia (brother of the Carolingian king Lothar, who had died in 986, and whose young son Louis V had died the following year), Odo and Adalbero of Laon were acting with the support of the emperor Otto III. Odo's actions are interpreted in Pfister (1885b), 46–60; Lot (1903), 104–25; Coolidge (1965); Dhondt (1964–65); Bachrach (1993), 50–51; Sassier (1987), 261–64; Theis (1999), 80–87; and Glenn (2004), 160–61. The relevant passages in Richer's history are found in book 4.96–98, pp. 297–99.

61. The contents of Bamberg, Staatsbibliothek misc. bibl. 30 are inventoried in Planchart (1988).

The troper is a fragment from Reims copied around 1000, and so was prepared at some point during the years of turmoil discussed in this chapter.

62. Richer, 4.94, pp. 295–96. The count seems to have died in Châteaudun, and his body was transported to Marmoutier. See Hoffmann's notes, p. 295.

63. On Richer, see Bur (1992), Bautier (1992), Glenn (1997, 2004), and, most important, the notes to Hartmut Hoffmann's edition, which also includes a facsimile of the treatise. Glenn, whose analysis of this very complex work (1997) is controversial, theorizes that the manuscript contains three recensions written over one another; from these the author doubtless either intended to make a fair copy or made a fair copy that no longer survives. The first recension occupies what is now the fifth quire and part of the sixth and probably ended with the death of Odo of Chartres in March 996. A second recension was made in the summer and autumn of 996 and was dedicated to Gerbert of Aurillac, who was then struggling to hold on to his office as archbishop of Reims. A third and final recension, left incomplete, was likely worked on in 998 and early 999 but not after the time that Gerbert, as pope, reinstated his old rival Arnulf as archbishop of Reims, an event that goes unmentioned. This reconstruction, which Glenn himself admits is highly speculative, would have Arnulf as Richer's final dedicatee.

64. See MacKinney (1937, 1957). Richer had been invited to Chartres by the cleric Heribrand, ostensibly to study the *Aphorisms* of Hippocrates and work with Heribrand, who was "most expert in the art and not ignorant of pharmacology, pharmacy, botany, and surgery": Richer, 4.50, p. 266, and MacKinney (1957), 32. For the description of this harrowing journey, see Richer 4.50, pp. 263–66, and the long interpretation in Glenn (2004), 252–66. Heribrand's obituary (June 22, "levita et canonicus Sancte-Marie") was a part of the first Chartrain necrology, MSC 167.

65. Glenn (2004), 159. But see Elisabeth van Houts's critical review (2006) of Glenn's theory that Richer wrote the chronologically earlier part of his history after he had completed the later chapters in his story.

66. Then there is Fulbert's letter to Abbo of Fleury, written in 1004. This describes the attempt of Count Thibaut of Chartres ("bishop designate") to impose his own candidate for abbot of St. Peter. We have no reason to believe he is the Richer listed among the monks of St. Peter's, a figure also mentioned in a charter dated by Guérard to c. 1001 (CSP 99–11). There is no record of this Richer having died in Chartres.

67. Duby (1991) contains a study of Berta of Blois, but it is told without the emphasis on the Thibaudians found here. Duby's work on the importance of genealogy to the noble families of the region resonates with my beliefs concerning the importance of the liturgical framework of history. Berta was supported by Bishop Fulbert and gave to the cathedral and the Virgin's cult. (See below for details of her bequest.)

68. Richer, 4.109, p. 308: "Hugo rex papulis toto corpore confectus, in oppido Hugonis Judeis extinctus est." It is now believed that Richer was referring not to the Jews as those who killed the king but to the name of the place, now thought to be near Prasville, south of Chartres, where excavations in the 1990s revealed the foundations of an ancient chateau. See Blumenkranz (1957).

69. Hoffmann's notes to this passage (308–09) say that Robert was William's uncle through his mother, Adelheid, the sister of Hugh Capet. William's mother was Emma, the sister of Count Odo I and Berta's sister-in-law.

70. Henry the Fowler (d. 926) sired five children: Otto I, Havide, Bruno, Henry, and Gerberge. His daughter Havide married Hugh the Great, and their union produced Hugh Capet, father of Robert II. The Fowler's other daughter, Gerberge, married King Louis IV d'Outremer (reigned 936–54), son of Charles the Simple, the Carolingian king of the West Franks referred to in chapter 1. King Louis and Queen Gerberge had three children: King Lothaire, Duke Charles of Lorraine, and Mathilde, who married Conrad the Pacific, king of Burgundy. Berta was a

child of this union and was thus the great-granddaughter of Charles the Simple, the West Frankish Carolingian king, who was a direct descendent of Louis the Pious, son of Charlemagne. For discussion, see Rouche (2000).

71. See the genealogical tables in appendix H. In the Ottonian empire during this period men sometimes circumvented this problem by contracting marriage with noble Greek women, and in the case of Robert's son King Henry I by selection of a Russian princess, Anna of Kiev, for whom see Bogomoletz (2005). For a critique of Hugh Capet's supposed attempt to find a Byzantine wife for his son Robert, see Vasiliev (1951). There is an enormous bibliography on medieval marriage and the attempts of reformed clergy to control it; two scholars in particular have been concerned with these issues throughout their careers, Georges Duby (1983, 1991), whose second work is especially concerned with the marriage of Berta of Chartres/Blois and Robert II, and Constance Bouchard, whose book of 2001 contains references to much of her earlier work on the subject.

72. Raymond Brown (1979) contains a classic discussion of Christ's lineage as found in Matthew 1 and Luke 3.

73. See Lot (1891), 378–94. Theis (1999), 83, says it this way: "She was of a blood the most noble that one could conceive: her father was Conrad, king of Burgundy, whose son Rudolf was then reigning, and who issued from the prestigious family of the Welfs, that of the empress Judith, wife of Louis the Pious and mother of Charles the Bald; her mother Mathilde was the daughter of the Carolingian Louis IV d'Outremer and thus directly descended from Charlemagne." Bertha was the name of Charlemagne's mother.

74. Bachrach (1993), 65, citing Lot and Pfister, says that "King Robert had begun his dalliance with Bertha of Blois even before Odo I's death, and this affair had precipitated a breach between Hugh Capet and his son." Shadis (2003) offers a critique of the ways in which Capetian queens have been treated by historians in general, citing the work of Marion Facinger (1968) as a turning point in seeking the queens' own voices and motivations. She is especially troubled by Dhondt (1964–65): "His superficial study barely grapples with the queen's role at court, and speculates wildly on their feminine motivations: Rozala aspired to royalty; Berthe seduced the unwitting Robert; Constance seems downright evil in her unnatural hatred for her son Henry" (139). In the case of Robert's wives, the evidence for breaking down these stereotypes is unfortunately often lacking, and the men who wrote about them were unsympathetic.

75. For a comparison of the two kings' adulterous actions, see Helgaud, *Epitoma*, 17, pp. 92–94. The critical edition by Robert-Henri Bautier, with its commentary and notes, is exemplary. Philippe Buc's translation of Bautier's text into English is available online as *Helgaud of Fleury, a Brief Life of King Robert the Pious*. For further discussion of Helgaud's various strategies for lionizing Robert the Pious, especially as related to the liturgy, see Carozzi (1981) and Fassler (2009).

76. The poem has been studied by Lot (1903), 414–22, and is edited by Hückel among the several works of Adalbero of Laon.

77. For a sketch of Queen Adelaide's attributes and her devotion to the saints, especially as demonstrated through her designing of beautiful vestments in their honor, see Helgaud's *Epitoma*, 82–85. For Adelaide's parentage, see Lot (1891), 200–204, 358–69.

78. See Bachrach (1993), 51. Souchet knows the history of Emma's difficult relationship with her husband as told in the oral tradition at Chartres and expends many pages of his history on the legends.

79. Fulbert's letters reveal much about his warm relationship with William V, whom he must have known well from boyhood. For the place of correspondence to and from William V in Fulbert's letters, see *LPFC*, lxxxii–xc. The role Fulbert's disciple Hildegar played in the initial collection of Fulbert's works is evident by the position of his own letters within it and by Hildegar's long-suffering service in Fulbert's place in the church of St. Hilary in Poitiers.

80. See Pfister (1885b), 45–46 (who depends on Richer), and Lot (1891), 219. Part of the negotiations involved the Abbey of St. Vaast, which as a result was given over to the counts of Flanders. For study of St. Vaast and the magnificent Romanesque Bible produced there in the eleventh century, see Reilly (2006). Cambrai, BM 75, an important troper/proser, comes from St. Vaast.

81. Berengar had been vanquished and exiled by Otto I in 962. The age difference between Suzanne and Robert was great. During this period young women might be married to men the age of their grandfathers, and, as Robert's first marriage demonstrates, noble teenage boys were married to middle-aged widows to gain control of lands that had belonged to their husbands, thus depriving the natural heirs of their inheritances. Another well-known case was the marriage of Louis V, son of Lothaire, to Adelaide-Blanche, widowed sister of Geoffrey Greymantle, Fulk Nerra's father. This attempt of the House of Anjou to control the king's heir faltered when the fifteen-year-old boy and his wife of around forty proved completely incompatible. See Bachrach (1993), 15, for discussion and bibliography.

82. Richer, 4.87–88, pp. 290–91. On the history of the House of Arnolf II (Arnulf the Great), see Dunbabin (1985) and Ganshof (1943). On women and their ability to inherit and control land, see J. Green (1997).

83. Bernier, in his *Histoire de Blois*, claims that Robert married Berta for her beauty (284). See also Dupré (1872), 200–201.

84. For the documents, see Gerbert, *Acta concilii Remensis*, esp. 659, and discussion in Mostert (1990), 40–41.

85. See Richer, 3.66, p. 205, for a tantalizing brief report of a synod that met at St. Macre to hear the charges against Arnulf.

86. Summaries of these events, especially as revealed through Gerbert's letters, are found in Harriet Pratt Lattin's introduction to *The Letters of Gerbert*, esp. 13–14; in Theis (1999), 55–74; and in Glenn (2004), 89–109. Riché (1987) offers a concise study of Gerbert's attempts to be archbishop of Reims.

87. See *Letters*, and Riché (1987) throughout.

88. Mansi, *Sacrorum conciliorum*, 19:223. See especially Rouche (2000), 158.

89. Duby (1991, 53 and 127) points out that the legend originated with the sharp-tongued reformer and hymnwriter Peter Damian: see his letter to Abbot Desiderius of Monte Cassino in *RHG* 10:493 and a fragmentary history of France (*Ex historiae franciae*) in the same volume, p. 211. Duby connects the year with Ivo of Chartres' own attempts to charge incest in adulterous marriages. Souchet (*Histoire*, 2:179) knows Peter Damian's letter but does not believe in the legend.

90. William Newman's catalogue (1937) lists two authentic charters produced by Robert and Berta, one dated in 997 and the other in 999.

91. Constance is mentioned as queen in a charter from perhaps 1000, but only as an addition to the document. The queen's name is not found in subsequent charters until around 1026. On Constance's lineage, see Lot (1891), 349–69, and Adair (2003).

92. For another view of this *ménage à trois*, see Duby (1991), 45–54.

93. *LPFC* lxix–lxx, and *Ep.* 1, 2–9. It seems that Thibaut, bishop-designate, died on July 11, 1004. He had been involved in an attempt to install Mengenard as abbot in Saint-Père, but Mengenard had not been duly elected. The importance of the *adventus* procession is revealed in the story told in Fulbert's letter: the monks refused to receive Thibaut processionally unless he would come in without Mengenard. The passage describing this part of the action is one of the most telling in all medieval literature for understanding the importance of right reception and also shows the strong association of the cathedral with the protective powers of the Virgin Mary at this time: "On the next day Count Thibault returned [to Chartres] and sent ahead word that he was to be received in the monastery with a procession. The monks replied that

they would gladly do it if he did not bring that usurper with him. Though he again became enraged, he controlled himself on that day; but on the next, with thundering threats he thrust his Mengenardus into the monastery of Saint-Père. On his forcing his way in, the holy brothers, from fear of being contaminated by communicating with him, took their leave of the church and went forth in tears; and knowing no other place of refuge, they fled to the threshold of the cathedral. When they found no shepherd there either, the sheep, abandoned on both sides, comforted each other with words of sorrow. But the Lord's holy mother received them with her wonted affection; and your servant Ralph [bishop of Chartres at that time], with sweet kindness" (*LPFC* 6–7). On this event, see the forthcoming study by Olivier Guillot.

94. "Obiit Berta, mater Odonis comitis, que dedit canonicis Sancte-Marie alodum nomine Marcilliacum, cum toto ovili suo et carruca. Cujus anima paradisum possideat" ("Berta, mother of Count Odo, died, who gave to the canons of St. Marie an *alodum* by the name of Marcilly, with its whole sheepfold and a coach. May her soul possess paradise") (*MSC* 152).

95. For the distinction between eastern and western sequence repertories, including ways of notating and naming, see Kruckenberg (1997), chapter 3: "An East-West Reception Barrier: Sequence Transmission—Sequence Repertories." Kruckenberg (124–25) points to Paris, BN lat. 1169 from Autun as an exception, although the eastern sequences seem to have been added as something of an afterthought. The manuscript and its musical and poetic contents have been studied by Flynn (1992). All manuscripts from Autun, regardless of their present location, can now be studied and situated with great precision thanks to the new catalogue of sources published under the direction of Claire Maître (2004).

96. See Crocker (1977), 242, and the discussion following, esp. 256–58.

97. For discussion of the dating and early transmission of Notker's "Prooemium," the introduction to his *Liber hymnorum*, see Susan Rankin (1991). The earliest sources of Notker's sequences are St. Gallen, Vadiana 317, and Paris, BN lat. 10587.

98. See Kruckenberg (1997), 79. She says the a-assonance "aurally dominates" the West Frankish sequence.

99. On this subject, especially as related to the teaching of Latin through the hymns, see Boynton (1998, 2000) and select papers in Boynton and Rice (2008).

100. See Fassler (1993a) for discussion and bibliography, and Elfving (1962) and Iversen (2002) for discussion of the vocabulary of "angelic discourse." For further investigation of the roles of children in the singing of sequences, see Kruckenberg (2006).

101. Elsakkers (2001) is a study of prayers from the Middle Ages for a woman in childbirth. Estimates of the percentages of women who died in childbirth and its complications vary from place to place and century to century. Detailed study of human remains by scientists is necessary, as revealed in Fleming (2006).

## 3 · ADVENTUS AND ADVENT

1. On Fulbert generally, see Jeauneau (2008).

2. Fassler (2000b) is a study of the formation of the Advent season, showing how to use sermon collections, prayers, and other tools to study the pre-Carolingian liturgy and the work of the reformers. Advent is the one season in the Latin rite that does not have its roots and development in the liturgy of the East.

3. There has been much scholarship in recent decades on the subject of *adventus* and its significance. Adventus in the fourth century is related by Geir Hellemo (1989) to the significance of the eucharistic liturgy, the iconic programs furnishing "certain support for members of the congregation in their participation and understanding of the ritual celebration itself" (281); the parallels between Christian and pagan concepts of adventus in the same period are explored by Dufraigne (1994). In his discussion of the meaning of royal entrance rites in late

antiquity, Ernst Kantorowicz (1957) applied his understanding of select biblical and liturgical texts and visual archetypes to the iconography of two panels from the fifth-century door of Santa Sabina in Rome. The entrance of rulers and of relics in the same period has been studied by a number of scholars, including Sabine MacCormack, whose work on the Byzantine court (1982) demonstrates ritual rhythms and designs that governed culture to an extraordinary degree. The multifold meanings associated with public entrance ceremonies in East and West in the fifth through the eighth centuries are described by Michael McCormick (1986); Kantorowicz (1946) wrote a penetrating analysis of medieval acclamations of kings, the "Laudes regiae," which was based on understanding of the reuse of certain elements from late antiquity in the formation of something new. Gunilla Björkvall (1991) outlines the themes of advent in liturgical poetry from the tenth and eleventh centuries; Ottosen (1986) is a comparative catalogue of Advent responsories in the manuscripts consulted in Hesbert's *Corpus Antiphonalium Officii*; Fassler (2007) is a study of the elemental rhythms and themes of numerous adventus ceremonies.

4. Psalm 23/24:3–8. For detailed description of the use of this text at the Easter Vigil, see, for example, Hardison (1965).

5. For a twelfth-century study of them, see Richard of St. Victor, *L'edit d'Alexandre*. For discussion of these three major processions as modeled upon adventus as found in medieval Chartres, see Fassler (2007).

6. Luke 1:68–79; 1:46–55; and 2:29–32.

7. McCormick (1986) provides several examples of painful public humiliations of conquered rulers and their people by victors.

8. Fassler (2007) analyzes numerous examples from the twelfth century, with focus on liturgical ceremonies at Chartres.

9. "Thus we are left with excellent liturgical studies of supplication which omit its political dimension, political studies that ignore its liturgical aspects, and no studies at all of its role in ordinary social intercourse. The result is a fractured image of supplication, in which the sum of the parts does not equal a whole. Our primary task, then, is to establish that in tenth- and eleventh-century northern France, all facets of supplication, whether diplomatic, liturgical, legal, or political, did form a coherent whole and that they were perceived as such by contemporaries" (Koziol, 1992, 13). I applaud Koziol's attempt to rectify fractured views of history through his more comprehensive examination of a broader spectrum of evidence. The way adventus has been studied presents similar problems. Adventus, as a whole, is a very large subject; it conditioned how history was written and understood and how cult developed, especially when related to the messianic coming, as at Chartres.

10. Robertson (2002) describes the music and ceremony for hailing the king in the fourteenth century at Reims and demonstrates how a work by Machaut combines the "Laudes regiae" and contemporary ideals of David the King.

11. Throughout this work we encounter the merging of the sacred prototype of Christ as king with the earthly king who comes forth and is often greeted by assimilation of liturgical formulae: "Whenever a medieval civic triumph employs emblems of the Nativity, it dramatizes a ritual and dramatic metaphor essential to medieval ideas of Christian kingship: each princely accession re-enacts a symbolic Nativity. This idea reflects familiar biblical conceptions of holy kingship according to which the kings of Israel become the begotten sons of God at their inaugurations. In a psalm made familiar to the Middle Ages through its repeated use in the first Mass on Christmas Day, King David thus rejoices: 'The Lord hath said to me: Thou art my son, this day have I begotten thee' (Ps. 2:7). Because every king comes to his city for the first time as a newly born son of God, prophets may aptly proclaim his advent, Jesse Trees may fittingly display his messianic lineage, and the people, like shepherds, may rightly cry 'Noel!' in joy upon hearing the glad tidings" (Kipling, 1998, 71).

12. See Gabrielle Spiegel (2002) for further discussion of the nature of time as understood within medieval Jewish ritual. Ivan Marcus (1996) has written compellingly about the ways in which medieval Jewish children and their teachers transformed Christian symbols to make sense within their own traditions. Elisheva Baumgarten's book on Jewish mothers and their children (2007) mentions singing and teaching of music within the culture.

13. Björkvall (1991) outlines themes found in tenth- and eleventh-century poetic interpolations of the Advent season established by the Carolingians.

14. On the identity of Honorius, see especially Flint (1982–83). Honorius is the most prolific liturgical commentator of the twelfth century. His liturgical writings and other exegetic works (*PL* 172) are little studied. On his anti-Jewish polemic, see Signer (1984). The process of change from regional variation in the number of Sundays of Advent to a standard number (four) is discussed in Fassler (2000b).

15. For the commonplace of assigning each of the canonical Hours to a stage in the Passion of Christ, see Praepositinus of Cremona (who flourished in Paris in the twelfth century), *Tractatus de officiis*, 4.1 (ed. Corbett, 217–18). The practice of assigning the various hours of the day to a series of events underlay the development of the various Hours of commemoration at the close of the regular Office. Most important among these were those for the blessed Virgin, for the Cross, for the dead, and for the Trinity. In the later Middle Ages these votive offices developed into Books of Hours and other kinds of prayer cycles. See Fassler (2004b) for a summary view and bibliography.

16. On Honorius's sense of historical as compared to astrological time, see Flint (1982–83).

17. Liturgical commentators frequently note correspondences between various units of historical time and liturgical structures. For another example along a somewhat different line, see Amalar, *Liber officialis*, 4.12 (*Opera*, 2:454), "On the Morning Office through the Daily Hours." Each of the Hours had a symbolic meaning, one related to the passage of historical time.

18. I have explored the symbolic meaning of Lauds as a dawnsong in Fassler (1998) and in a paper on the psalmody of Lauds in the work of Hildegard of Bingen (Fassler, 2003).

19. The ages of the world as viewed by liturgical commentators are often four, but interpretations of them vary. Praepositinus, for example, states that the first age was from Adam to Moses and was like winter; the second age, from Moses to Christ, was like spring; summertime was the age of the early Church; and the present is the autumn of the ages. See his *Tractatus de officiis* 1, Prologue (ed. Corbett, 3–4). The ways in which liturgical commentators discuss the ages are flexible and change according to cultural norms and the authors' agendas. Background for the subject of the ages of man and their treatment in the Middle Ages, from two different angles, is found in Burrow (1986) and Sears (1986).

20. For an introduction to the number of Sundays in Advent and their development, see Fassler (2000b).

21. "Suppose I am about to recite a psalm [*canticum*] which I know. Before I begin, my expectation is directed towards the whole. But when I have begun, the verses from it which I take into the past become the object of my memory. The life of this act of mine is stretched two ways, into my memory because of the words I have already said and into my expectation because of what I am about to say" (*Conf.* 11.27.38, trans. Chadwick, 243).

22. The idea that histories of people were based on models of salvation that brought conversion and ended in peace comes directly from this liturgical understanding, which was deeply ingrained in the medieval imagination. Most instructive in this regard is the influential *Ecclesiastical History of the English People* by the Venerable Bede, which surely was a model for Dudo of St. Quentin, whose history is described in chapters 1 and 2. See Shopkow (1997), 148–49.

23. On Maximus and his identity, see Fassler (2000b), 19. For discussion of the homiliary of Paul the Deacon, see especially Réginald Grégoire (1980).

24. "Incipit: Cum adpropinquasset Ihesus Hierosolimis et venisset Bethfage ad montem . . . [Matt

21, 1–9]. Mediator dei et hominum homo Christus Ihesus qui pro humani generis salute de caelo descendit ad terras adpropinqunte iam hora redemptionis." *Homilia in Mattheam* 21.1–9 (CCSL 122, p. 200; *PL* 94:121).

25. By the Carolingian period this text was read at both the Office and Mass on the second Sunday in Advent. Its position in the Roman Mass liturgy was established by the mid-seventh century. See Klauser, *Das römische Capitulare*, 43.

26. The reliance of eleventh-century historians on natural phenomena as parallel to human events is attributed not only to knowledge of classical models, but more directly to knowledge of scripture, and scripture as known in liturgical contexts. No historian of the central Middle Ages writes more about the predictability of events from natural phenomena than Rudulfus Glaber in the mid-eleventh century. In regard to a comet, he says, "What is very certain is that whenever such a prodigy appears to men it clearly portends some wondrous and awe-inspiring event in the world shortly after" (*Five Books* 3.3.9; trans. France, 111).

27. For the history of Advent in the Latin West, see Fassler (2000b), which includes bibliography. Amalar's trouble with sources is discussed there (36–37).

28. The so-called great responsories for the Office are among the most important and most studied genres of liturgical chant. For introductions to this repertory, see Hiley's "Great Responsories of the Night Office" (1993, 69–76). Responsories consist of two sections, the respond and the verse. Although practice varied from place to place and time to time, the responds traditionally belonged to a small group of singers, and the verse to a soloist (although in some traditions it seems that the respond was soloistic as well). The music in the Gregorian repertory is virtuosic, and yet in many cases composed of formulae arranged in fluid patterns. A section of the respond was repeated to form a kind of refrain, and the Gloria Patri was sung as a kind of final verse before a repeat of the respond (either partial or full, depending on the tradition) at the end. For an example of a specific group of responsories within the tradition of rhymed Offices, see Hughes (1988b). The ways in which the responsories of the Advent season can be used to study liturgical affiliation are treated in Ottosen (1986).

29. For an introduction to the construction of chant texts from varied passages of scripture, creating a kind of libretto, see Kenneth Levy (1984).

30. His notes survive and can be consulted in the diocesan archive of Chartres. I am grateful for the advice and assistance of Pierre Bizeau, archivist during the time I wrote this book, as well as for his astute observations concerning these materials.

31. See Gryson (1988) for discussion of the manuscript tradition in the Middle Ages. The now barely usable Chartres, BM 4 dates from the second half of the ninth century and contains books 1–9 of Jerome's commentary on Isaiah.

32. "Prophetae enim prius uocabantur uidentes, qui dicere poterant: 'Oculi nostri semper ad Dominum.' Et: 'Ad te leuaui oculos meos qui habitas in caelo.' Vnde et apostolis a Salvatore praecipitur: 'Leuate oculos uestros, et videte regiones, quia iam albae sunt ad metendum.' Istos cordis oculos et sponsa habebat in Cantico canticorum, cui sponsus dicit: 'Vulnerasti cor meum, soror mea sponsa, uno ex oculis tuis.' Et in evangelio legimus: 'Lucerna corporis tui est oculus tuus.' In ueteri quoque dicitur instrumento, quod populus viderit vocem Dei" (*Commentariorum* 1.1.1, pp. 5–6, lines 38–47). See Exodus 20:18: "And all the people saw the voices and the flames, and the sound of the trumpet, and the mount smoking: and being terrified and struck with fear, they stood afar off."

33. See R. Green (1946). Medieval concepts of seeing, visuals, and the visionary are cogently described in B. Newman (2005). The idea of Jewish blindness and Christian abilities to see and recognize Christ is developed at length as found in Anglo-Saxon exegesis in Scheil (2007).

34. "Si quis igitur caelum est et habet municipatum in caelestibus, audiat mystice quae dicuntur. Si quis terrenus, simplicem sequatur historiam" ("Therefore, if anyone is heaven, and holds

citizenship among the heavenly beings, he may hear mystically what they are saying. If anyone is earthy, let him follow the simple history") (*Commentariorum* 1.1.2:25–27, p. 7).

35. See especially Fassler (1993a) and Kruckenberg (2006).

36. The extent to which the anti-Jewish polemic was sustained by the Advent liturgy has been little studied, and the analysis of Fulbert's sermons below in chapter 4 is the first example known to me. On traditional twelfth-century Jewish exegetical understanding of this theme, see Signer (1997).

37. Ezek 38:9: "Ascendens autem quasi tempestas venies et quasi nubes, ut operias terram" ("And thou shalt go up and come like a storm, and like a cloud to cover the land").

38. *Liber de ordine antiphonarii* 8.2–5, p. 38. Amalar's commentary on the antiphoner, unlike several of his other writings, was not widely copied or known in the Middle Ages; nonetheless, his words introduce us to the thought-world of the very period that saw the compilation of the first standardized Office chants and readings and are an excellent guide to their original context. For a recent appraisal of Amalar's liturgical agenda, see Jacobson (1996). Amalar's liturgical commentaries were well known at Chartres in the twelfth century.

39. For evaluation of his life and works, see the introduction to the *Opera Omnia* by Bautier and Gilles.

40. *Commentariorum* 1.1.3, p. 9, lines 24–41.

41. As in chapter 65:9: "And I will bring forth a seed out of Jacob, and out of Juda a possessor of my mountains: and my elect shall inherit it, and my servants shall dwell there."

42. The *Protevangelium* and *Pseudo-Matthew* are discussed in chapter 6. See also Fassler (2000a) for further bibliography and discussion of editions of the text.

43. There were four Ember weeks in the Roman rite, one each season; they were liturgically solemn and viewed as times of fasting and penance. See Talley (1990) for further discussion of their difficult history.

44. See Fassler (2000a, 2001) for the background to these various traditions.

45. Ember Wednesday, Vat. lat. 4756, ff. 71r and v.

Responsory 1, CAO 6292: "Clama in fortitudine qui annuntias pacem in ierusalem dic civitatibus iude et habitatoribus syon ecce deus noster quem expectamus adveniet. V. Super montem excelsum ascende tu qui evangelias syon exalta in fortitudine vocem tuam" (primarily an adaptation of Isaiah 40:9).

Responsory 2, CAO 7338: "Orietur stella ex iacob et exurget homo de israel et confringet omnes duces alienigenarum et erit omnis terra possessio eius. V. Et adorabunt eum omnes reges omnes gentes servient ei" (from Num 24:17–18).

Responsory 3, CAO 6640: "Egredietur dominus et preliabitur contra gentes. Et stabunt pedes eius super montem olivarum ad orientem. V. Ex syon species decoris eius deus noster manifeste veniet" (from Zach 13:3–4; V. from Ps 49:2).

46. The readings from Gregory in the Chartrain breviary are as follows: "[1] The recalling of the rulers of the Roman republic and in Judea indicates the time when our Redeemer's forerunner received his mission to preach: In the fifteenth year . . . John the son of Zechariah in the wilderness. [2] Since John was coming to preach one who was to redeem some from Judea and many from among the Gentiles, the period of his preaching is indicated by naming the Gentiles' ruler and those of the Jews; but because the Gentiles were to be gathered together, and Judea dispersed on account of the error of its faithlessness, this description of earthly rule also shows us that in the Roman republic one person presided, and in the kingdom of Judea there were several ruling in four different areas. [3] In our Redeemer's own words, Every kingdom divided against itself will be laid waste. It is apparent, then, that Judea, which lay divided among so many kings, had reached the end of its sovereignty. It was also appropriate to indicate not only under which kings but also under which high priests

this occurred." (In the English translation noted in the bibliography, homily 20 has been renumbered homily 6.)

47. The authentic f-mode antiphon (*CAO* 4156) for the Advent season was in circulation in the tenth century and is found throughout Europe, usually for Lauds, although not always for the Benedictus. In several northern European sources it has the same position as at Chartres, including the Sarum use and the early twelfth-century antiphoner Paris, BN lat. 12044 from the monastery of St. Maur-des-Fosses, near Paris.

## 4. TRAUMA AND THE REMEDIES OF HISTORY

1. For discussion of the full passage, see chapter 1. The translation of the complete series of readings is in appendix C. For the fire of 962 and the political situation in the second half of the tenth century, see chapter 2.

2. See Pintard (1972).

3. The two major relics were the Virgin's mantle, or *maphorion*, which resided in the church of the Blachernae, and the Virgin's belt or girdle, preserved in the church of the Chalkoprateia, near Hagia Sophia. Both of these garments played significant roles in the stational liturgy of Constantinople. For introductions to the founding of early cults of the Virgin in Constantinople and Jerusalem, see Fassler (2001). The liturgy of Constantinople as it developed over the centuries was fundamental to the Chartrain use of icons and to the sense of art and incarnation from the time of Fulbert on; it was equally so in many other Western centers as well, culminating in the artistic programs of the twelfth century (see chapters 9–12). Several recent publications explore visualization in Western art from various angles: most important are the collections edited by Moss and Kiefer (1995), by Hamburger and Bouché (2006), and Kessler's collection of essays gathered in his provocatively titled *Spiritual Seeing* (2000). My book works toward an understanding of twelfth-century liturgical art through the rise of cult and foundational liturgical understanding taking place in the late tenth and eleventh centuries.

4. The May 13 feast on which the Dedication fell in the tenth century celebrated the consecration of the former Pantheon in Rome in honor of Mary and the saints. See Delaporte (1960) and Rankin (2010).

5. For the Chartrain liturgy during Fulbert's episcopacy, see De Clerck (2008); on Fulbert's works generally, see Clément (2008).

6. The feast of the Assumption has the appearance of being the major Marian feast at Chartres when the Carolingian liturgical reforms were first established there; later, various strategies were adapted to change this, at least to a degree. For discussion, see chapter 5, and Delaporte (1950, 1951).

7. For Fulbert on kingship, see Sassier (2008).

8. *Approbate consuetudinis* is translated in appendix E from the text in *PL*; cf. the text edited by J. M. Canal in "Texto crítico." On the authenticity of sermons attributed to Fulbert, with special attention to *Approbate*, see Canal (1962, 33–51); this discussion forms the introduction to his edition of these texts. Canal's work, his choice of sources, and his decisions have been sharply criticized by Henri Barré (1964).

9. R. Beyers, ed., *Libellus de nativitate sanctae Mariae* (hereafter *Libellus*). The once-accepted earlier dating was based on an interpretation of a passage by Hincmar of Rheims: C. Lambot (1934) argued that Hincmar's defense of these texts referred to the *Libellus* and that thus it must date from before the letter, which was written in 868–69. Hincmar also stated that the Pseudo-Hieromian letters prefacing the text were by Paschasius Radbertus, as was the famous treatise written for the Assumption *Cogitis me*, also written as if by Jerome. Rita Beyers and Jan Gijsel believe that Hincmar's reference is rather to a version of *Pseudo-Matthew* and that this passage offers no proof that Hincmar knew the *Libellus* at all (see Gijsel, 1969, 504–05,

and *Libellus*, 28–32). Beyers and Gijsel do not question the attribution of the letters and the treatise *Cogitis me* to Paschasius Radbertus. For an evaluation of the passage from the *Libellus* which Fulbert cites in *Approbate consuetudinis*, see Beyer's edition, 140–46. Yet another apparent reference to the *Libellus* is found in a second sermon frequently attributed to Fulbert (used for the Octave of Mary's Nativity at Chartres): see Canal's edition of *Mutuae dilectionis amore* in his "Texto crítico," esp. 64.

10. An apocryphal infancy narative; see Amann, *Le Protévangile*, and the discussion in Beyers, *Libellus*.

11. See Amann, *Le Protévangile*, 278–81. *Libellus*, 268–76, contains an edition of the letter and translation into French, with notes.

12. See Barré (1962), 17–25, for an inventory of the Chartrain homiliary. For discussion of a similar work in Anglo-Saxon, see Cross (1999). A variant text is found in Vattioni (1975).

13. Trends found in Fulbert can also be discerned in his contemporaries. Fulton (1994) compares the much-studied *Cogitis me* on the Assumption by Paschasius Radbertus to the eleventh-century sermon of Aelfric based on it, finding that whereas Paschasius's work is "interrupted by doubts, digressions and exhortations," Aelfric "condenses and reorganizes Paschasius's arguments" (see 185). Aelfric also briefly sums up two Marian miracles at the close of the sermon, one of which is that of Theophilus, highly favored by Fulbert as well. In contrast to Fulbert, however, Aelfric, who struggled with similar problems regarding apocryphal material, did not rely upon, or even mention, the legends of Mary's infancy. See Clayton (1986).

14. *MSC*, between pages 46 and 47. It is discussed later in this chapter.

15. From Canal, "Texto crítico," 56: "Approbate consuetudinis est apud xpistianos, sanctorum patrum dies natalitios obseruare diligenter, et tunc praecipue virtutes eorum, assignatas litteris, in aecclesia recitare ad laudem dei, ex cuius munere sunt, et ad instrumenta minorum. Inter omnes autem sanctos, memoria beatissimae uirginis eo frequentius agitur atque festiuius, quo maioruem graciam apud deum creditur inuenisse. Unde post alia quaedam ipsius antiquiora sollempnia, non fuit contenta deuotio fidelium, quin natiuitatis eius solempne superadderet hodiernum. Hac itaque die peculiariter in aecclesia recitandus esse uideretur ille liber qui de ortu eius atque uita scriptus inueniebatur, si non iudicassent eum patres inter apocrifa numerandum. At quoniam magnis ac sapientibus uiris ita uisum est, nos alia quaedam sed non aliena legentes, aecclesiasticum morem digitis officiis exequamur."

16. The phrase used by Fulbert, *linea generationis humanae*, is rare in medieval exegesis.

17. For a further discussion of the use of the Bible in Fulbert's writing, see Dahan (2008). I have followed the edition of Gijsel for the text of the *Pseudo-Matthew* and that of Rita Beyers for the *Libellus*, which depends upon the text edited from Chartres, BM 162, as transcribed by Amann. Chartrain BM 162 (second half of the eleventh century), burned completely in the fire of 1944, is discussed in greater detail below.

18. The strong emphasis on the consecrated virgin, which relates to religious practices of the period, provides *Pseudo-Matthew* with its monastic flavor.

19. *Pseudo-Matthew*, 7.2 and 3, pp. 354–63. Through this dove the author makes reference to the dove present at the baptism of Christ, Mark 1:10. Another rod of Joseph is alluded to in Hebrews 11:22. There it is claimed that the patriarch blessed the tribes, bowing in worship over his staff. Although this staff is not actually mentioned in Genesis 50, the passage from Hebrews that contains it was explored in the Middle Ages, especially by Rabanus Maurus, who mentions the passage in his commentaries upon Genesis, Ezechiel, Jeremiah, and Paul. The word for the tip of the patriarch's staff, *cacumen*, is used for the tip of Joseph of Nazareth's rod in the story of the emerging dove: *Pseudo-Matthew*, 8.3, p. 363; *Libellus*, 8.6, pp. 311–13. The importance of Hebrews to the cult of the Virgin of Chartres as depicted in the visual arts is discussed in chapters 9–11.

20. The sermon *Vos, inquam, convenio* is taken from Quodvultdeus's *Contra Judaeos* (sections 11–18, *Opera*, pp. 241 ff.). The connection between root of Jesse imagery and the prophets' plays

has long been recognized, but the process by which this connection was established requires further exploration; Fulbert's words are surely an important piece of the puzzle. Emile Mâle claimed early in the last century, "These examples will suffice, I believe, to demonstrate that there is a close connection between the Play of Prophets and the Tree of Jesse; both works come out of the same atmosphere. The Play of Prophets must have predated the Tree of Jesse by several years; consequently, since the earliest Prophets play, that of Limoges, seems to date from the late eleventh century, the conception of the Tree of Jesse must not go back beyond that date" (1928, 173–74). For further discussion, see Watson (1934), 24–36.

21. Apponius, *In Canticum Canticorum*, 5.32 (p. 130) reads, "sibi hunc lectulum de uirga quae egressa est de radice Jesse fabricauit in Virgine Maria" ("formed for himself in the Virgin Mary this bed of the rod that has sprung from the root of Jesse"). See Frank (1985) and Clayton (1990), 228. The commentary of Apponius appeared in truncated form in a series of twelve sermons attributed to Jerome, but these are related to the feast of the Assumption rather than to the Nativity of the Virgin.

22. *Liber promissorum*, 2.10, line 17, in *Opera*; the reference is to part 2, cap. 10, line 17.

23. See Sermon 111, in *Sermones*, ed. G. Morin, 460–61. The relevant sections of Origen are found in his Homily 9, 7–9, in *Homélies sur les Nombres*. For this text, see 9.9.2, p. 262.

24. Long attributed to Saint Augustine, *Legimus sanctum Moysen* is a composite work: the first half is taken from a letter written in 437 by the African Antonius Honoratus and the rest from the Pseudo-Augustinian sermon *Sanctus hic*. For analysis and discussion, see Barré (1957). The sermon is printed among the works of Augustine in *PL* 39:2196–98. The biblical texts cited are not from the Vulgate. Another sermon, *Ecce ex qua tribu nasciturus*, which frequently circulated with *Legimus* in early homiliaries, is edited among the works of Maximus of Turin, *PL* 57:845–48. The sermon emphasizes the Davidic lineage of Christ and connects this with the root of Jesse and the prophecies of Isaiah.

25. The mention of these towns is found only in the *Libellus*, not in *Pseudo-Matthew*.

26. Medieval exegesis on this passage is abundant, and the tradition as found in the commentaries of Rabanus Maurus and others would have been well known to Fulbert.

27. For conflicting views of Mary's lineage, see the notes to relevant passages in *Pseudo-Matthew*, 286, and *Libellus*, 277. Mary's cousin Elizabeth was "of the tribe of Levi": Luke 1:5. Rabanus Maurus, in his commentary on Matthew, speaks at length of Mary's Davidic and royal lineage; see *PL* 107:747–70.

28. "Ave, maris stella, / Dei Mater alma, / Atque semper Virgo, / Felix caeli porta.
    Sumens illud Ave, / Gabrielis ore, / Funda nos in pace, / Mutans Hevae nomen.
    Solve vincla reis, / Profer lumen caecis / Mala nostra pelle / Bona cuncta posce.
    Monstra te esse matrem / Sumat per te preces, / Qui pro nobis natus / Tulit esse tuus.
    Virgo singularis, / Inter omnes mitis, / Nos culpis solutos, / Mites fac et castos.
    Vitam praesta puram, / Iter para tutum, / Ut videntes Jesum, / Semper collaetemur.
    Sit laus Deo Patri, / Summo Christo decus, / Spiritui Sancto, / Tribus honor unus."
    ("Hail, Star of the Sea, nourishing Mother of God, and ever Virgin, auspicious gate of Heaven. / Receiving that 'Ave' from the mouth of Gabriel, establish us in peace, reversing the name of Eva. / Break the sinners' fetters, bring light to the blind, drive out our evils, beg for all good things. / Show yourself to be a mother, that he may receive prayers through you, who, born for us, bore to be yours. / Matchless Virgin, gentle among all, make us, when loosed from sin's bonds, meek and chaste. / Grant us a pure life, prepare a safe journey, so that, seeing Jesus, we may ever rejoice together. / May praise be to God the Father, glory to the supreme Christ, [and] to the Holy Spirit, a single honor to all three"). For discussion of this hymn text, see Lausberg (1976); for its foundational use in the twelfth-century sequence repertory, see Fassler (1987b, 1993a, chap. 14).

29. See Song 2:2. The connection of Mary with the Song of Songs was central to the Assumption

liturgy, for which see Rachel Fulton (1994, 1996): "It is my contention that, just as the liturgists used the Song of Songs to suggest the story of Mary's Assumption because they had no other scriptural, canonical authority, so the commentators discovered in the dialogue of the Song of Songs a way to eavesdrop on Christ and Mary" (1996, 105). Fulton's book on the Virgin Mary (2002) explores these ideas further.

30. In this passage Fulbert reviews central *topoi* for Marian veneration in the later Middle Ages. The designation of Mary as "Star of the Sea" comes from Jerome, who used a false analogy to the Hebrew word *Maria*. Fulbert would have known other probable Hebrew words in the text from Jerome, including *Almah*; see Pascher (1963), 618–19. The language he uses in this passage of the sermon is reminiscent of that employed in an early letter to Leothericus, archbishop of Sens (*LPFC* 34–35). It builds directly upon the text of the hymn, linking it to the prominent liturgical text: "For [her name] is interpreted 'star of the sea.' What mystery this interpretation bears we will demonstrate by analogy: when sailors cross the sea they must observe this star, gleaming from afar at the highest pole of heaven, and from its consideration estimate and direct their course, that they may be able to achieve their destined port. Similarly, brothers, it is fitting that all Christians, rowing in the midst of the waves of time, direct attention to this star of the sea, that is, Mary, who at the height of the pole is near to God, and direct the course of life by regard for her example. And he who will do this shall not be tossed by the wind of vainglory, nor broken on the crags of adversities, nor be swallowed up by the Scylla's abyss of sensual pleasures, but will come successfully to the port of eternal peace."

31. Theophilus was a cleric who sold his soul to the devil and was later restored to his senses by the blessed Virgin Mary. See Plenzat (1926) and Lazar (1972) on the history of the legend; and as expressed in the visual arts, Cothren (1984), Davis (2002), and Patton (2008). Theophilus was also referred to in other Marian sermons attributed to Fulbert; see Deremble (2008). The association of Theophilus's fall to the devil with a Jewish intercessor is found in Fulbert, lending credence to the view that he wrote as an apologist for the Virgin, a view also found in his Advent sermons "Contra Judeaos."

32. Prayers to encourage joining of the pleas of well-known local figures were written throughout the eleventh century. Fulton (2006) is a discussion of popular prayers attributed to Anselm. For the longevity of this tradition as seen through the lens of a prayerbook from c. 1400, see Fassler (2004b).

33. For more on the prayer, see Barré, *Prières anciennes*.

34. When he refers to Basil in the prayer, Fulbert prays for Chartres, "May you be to me, pious Lady, gentle and merciful, and to our city, just as you were to Basil the bishop, and to the church at Caesarea, by freeing it from Julian the Apostate." The legend of the Jewish boy in the fiery furnace has parallels with the story of three boys found in Daniel 3:8–30, a text of great liturgical prominence in the Gallican liturgy of Gregory's time. The legend was very popular in the Middle Ages, serving to stir Marian devotion and to foment anti-Jewish sentiment as well.

35. Gregory of Tours, *Glory of the Martyrs*, trans. van Dam, 30. For a view of miracles based on this tradition at Chartres in the thirteenth century, see Gros (1981).

36. The responsory, "Non auferetur sceptrum de juda," is (*CAO* 7224); is transcribed in appendix D.

37. See Blanchard (1911) and Blumenkranz (1963), 184–91. The *De benedictionibus patriarcharum Iacob et Moysi* by Paschasius Radbertus contains a section on Genesis 49:10 that discusses Herod and the end of both Jewish kingship and priesthood. See book 1, 1244–62, 44.

38. Only in recent decades has the treatise been restored to its rightful author; throughout the Middle Ages it was attributed to Augustine. Of the fifty-seven manuscripts containing Quodvultdeus's *Contra Judaeos*, only twelve contain the entire work. The long passage against the Jews was commonly excerpted, as in Rheims, by the ninth century (Rheims, BM 296). See the notes to the critical edition by R. Braun in *Opera*, XL–LXI.

39. See, for example, discussion of the text and the exploitation of its dramatic potential in later plays of the prophets by Karl Young (1921).

40. The section just before the reading begins as follows: "Say, Herod, if Christ offended you because you heard of his royal authority through the declaration by the Magi, how did these leaders of the Jews who were united with you in opposition to Christ offend you, those whose sons you killed, afflicting them the more with atrocious pain through their own children? For you were not able to find Christ at all. But why should I deal with you longer? I might assemble the Jews themselves, those Jews who while they were unwilling to acknowledge the infant Christ, were compelled to lose their own sons for him—them your friend Herod condemned to death and killed, but on these Christ bestowed immortality and eternal life, Christ, whom even now you call your enemy" (*Contra Judaeos* 10.11–12).

41. Scheil (2007) is a study of the understanding of Jews where there were no Jews, in Anglo-Saxon England; Christian exegesis, especially the works of Bede and his contemporaries, are the focus of Scheil's study.

42. See Blumenkranz (1964, 1977) and Signer (1999).

43. See Sider (1971) and Aziza (1977).

44. For discussion of Chrysostom's polemic, see Wilken (1983).

45. *City of God*, trans. Bettenson, 826–27.

46. Gilbert Dahan has provided an introduction to Fulbert's exegetical strategies in Fulbert of Chartres, *Oeuvres*, 417–26. See also Dahan (1991) for discussion of the Jewish–Christian polemic in this period.

47. Dahan (Fulbert of Chartres, *Oeuvres*, 423–24) says that the actual exposition of the Jewish side of the arguments by Christian polemicists is rare and is one of the most notable aspects of Fulbert's sermons. For Dahan, Fulbert's polemic suggests some sort of real contact between Christians and Jews, and this may be reflected in the apologetic tone also employed in *Approbate consuetudinis*.

48. On Rashi, see Michael Signer (1983, 1998b).

49. As Blumenkranz (1963) argues, the translation of Genesis 49:10, a text long disputed by translators on both sides, is a case in point. On Jerome, see A. Cain and J. Lössl, eds. (2009).

50. See Berger's introduction to the *Nizzahon Vetus* in *The Jewish–Christian Debate*, 8: "Indeed we find Jews arguing that Christianity is so inherently implausible that only the clearest biblical evidence could suffice to establish its validity." Fulbert seems to be aware of this when he claims to be rational and of sound reason; these claims, in and of themselves, seem misplaced in the sermons as a whole.

51. See the context, Gen 49:8–12: "Iuda, te laudabunt fratres tui, manus tua in cervicibus inimicorum tuorum, adorabunt te filii patris tui. Catulus leonis Iuda. Ad praedam, fili mi, ascendisti requiescens accubuisti ut leo et quasi leaena: quis suscitabit eum? Non auferetur sceptrum de Iuda et dux de femoribus eius, donec veniat qui mittendus est; et ipse erit exspectatio gentium. Ligans ad vineam pullum suum et ad vitem, o fili mi, asinam suam. Lavabit in vino stolam suam et in sanguine uvae pallium suum. Pulchriores sunt oculi eius vino et dentes eius lacte candidiores" ("Juda, thee shall thy brethren praise: thy hands shall be on the necks of thy enemies: the sons of thy father shall bow down to thee. Juda is a lion's whelp: to the prey, my son, thou art gone up: resting thou hast couched as a lion, and as a lioness, who shall rouse him? The sceptre shall not be taken away from Juda, nor a ruler from his thigh, till he come that is to be sent, and he shall be the expectation of nations. Tying his foal to the vineyard, and his ass, O my son, to the vine. He shall wash his robe in wine, and his garment in the blood of the grape. His eyes are more beautiful than wine, and his teeth whiter than milk").

52. The *Nizzahon Vetus* has a long exegesis of this passage which forms a compendium of varied Jewish interpretations. Regarding this particular point, the text (ed. Berger, 60) says, "The

answer is that they are refuted by their own words, for how can one maintain that the kingdom of Judah did not cease until Jesus? There was, after all, no king in Israel from the time of Zedikiah, for even in the days of the second Temple there was no king in Israel but only governors subordinate to the kings of Media, Persia, or Rome. Now a long time passed between Zedekiah and the birth of Jesus, and so how can the verse say that the kingdom would not depart from Judah until Jesus comes?"

53. Dahan (*Oeuvres*, 424) describes Fulbert's tone as "serene," surely meaning in comparison to what was to follow in the twelfth and thirteenth centuries.

54. The "Laudes regiae" as sung in Chartres are printed in the OC 242–44. They were performed on Christmas, Easter, and Pentecost, but the ordinals state that they are not sung on the Ascension. See OC 128. In addition to the classic study by Kantorowicz (1946), see also Johnson (1961) on the way they are embodied in the Styrps Jesse window at Chartres, and Cowdrey (1981) for the importance of the particular form of the "Laudes regiae" that was employed by Anglo-Norman rulers (see chapter 12).

55. This development is discussed, with further bibliography, in Fassler (2000a).

56. For discussion of Christian liturgical texts as found in the *Nizzahon Vetus*, see Jeffery (2004).

57. See MSC 105–06. The editors distinguish the various layers as follows and change typefaces within the edition accordingly: (1) entries copied in the original hand: people recorded here died between c. 940 and 1027, though the necrology may well contain materials from earlier sources that no longer survive; (2) additions in the first group of hands date from the death of Fulbert (1028) through the death of his successor Thierry (1048) and up to the embroilments surrounding Dean Hugh in 1060; (3) the second group of additions dates from 1060 to the coming of Ivo as bishop in 1090; (4) the third group of additions dates from around 1090 to 1130 and encompasses the tenures of Bishop Ivo and the first years of Bishop Geoffrey of Lèves. Their dating was accepted by Molinier for his edition of this necrology in OPS, which I do not cite.

58. On the earlier standardizing, the martyrology of the ninth-century Ado, see the edition by Dubois and Renaud; for the slightly later work of Usuard, a monk at the Benedictine Abbey of Saint-Germain-des-Prés, see the edition by Dubois. Both books are attentive to the reception of the works and to the nature of their textual traditions.

59. For the elemental shift that took place in the thirteenth century when Rome took over the canonization processes more forcefully, see Vauchez (1981). His widely accepted theories underscore the importance of earlier saints for local history.

60. Michel Huglo (1986) discusses Prime and its importance to a religious community.

61. Michael Gullick's paper (1994) on Symeon and the cantor's book found in the Durham Dean and Chapter's Library (MS B.IV.24) is an excellent introduction to the role of the monastic cantor in the preparation and copying of books. It was Alan Piper who gave the source its name, "cantor's book," a term I have used for this similar Chartrain source. I am grateful to Joan Williams, curator, for her kindness on my visit to the Durham Cathedral Library, and for the opportunity to speak with Alan Piper, the archivist of Durham Cathedral. The so-called cantor's book contains obituaries organized into two groups, those read along with the martyrology, and those grouped in the margins of the calendar. See Piper (1994, 86–87) for study of the obituaries; Gullick discusses the role played by the cantor in the production of various layers of the book.

62. For his agreement with this supposition, see Huyghebaert (1972, 48). Only the cantor possessed the knowledge and institutional support to prepare such books.

63. See the discussion in Ganshof (1970), esp. 746.

64. Sigo's reputation and his leadership role in the preservation of Fulbert's papers and the bishop's commemoration are also discussed in chapter 5.

65. For discussion of the attribution to Andrew of Mici, see *MSC* 47–51. This part of the inscription in the manuscript reads, "Ultimus in clero Fulberti nomini Sigo / Andreae manibus haec pinxit Miciacensis; / Det quibus unica spes mundi requiem / paradysi." Merlet and Clerval (*MSC* 53–55) have demonstrated that the original program included three paintings; the other two were of Fulbert instructing his students and taking care of the poor and the sick; see also Lesne (1938), 139 and MacKinney (1957), 57–58. The inscriptions that were once part of the program are preserved in Paris, BN lat. 14167, a manuscript I discuss in chapter 5.

66. The figures show the original as photographed in the late nineteenth century and Merlet's reconstruction of this illumination for *MSC*. The manuscript has recently been restored, and pictures of the illumination as it appears today can be found on the Internet. Many pages from it in color can be found on Alison Stone's medieval art Web site, including the portrait of Fulbert and the page containing his obituary. See http://vrcoll.fa.pitt.edu/medart/image/France/Chartres/Chartres_Cathedral/Manuscripts/Martyrology/Martyrology.

67. At present I assume, along with most other historians, that it is a view of the cathedral and that it was drawn within a decade or so after Fulbert's death. Anticipated arguments to the contrary from Georges Bonnabas have not yet appeared in print. One can argue too about what is actually being depicted here, for the painting might represent Fulbert just after he became bishop. If this were the case, the building depicted would have been the cathedral that burned in 1020.

68. "Pavit oves domini pastor venerabilis annos quinque quater mensesque decem cum mensibus octo." For discussion of the epitaph as it appears in its more lavish form, see *MSC* 47–51.

69. In the later part of Fulbert's reign these men were, respectively, Albert and Sigo.

70. See MacKinney (1957), 37. The reference to worldly wealth surely relates to the riches at his disposal as bishop of Chartres. In an autobiographical poem Fulbert carried out a dialogue with his sinful self, saying, "You, a child of poor parents, Christ took up to raise as his own; and undeserving as you were, he so nourished and blessed you that the world marvels at the gifts he bestowed." For the entire work, see *LPFC* 242–45. This theme is echoed in others of his poems.

71. See especially MacKinney (1957), 24–27, 49–51.

72. MacKinney attempts to discount the fabled prowess of Fulbert's teaching and even the importance of his school. But to reason away the number of pupils he produced and their influence in a variety of spheres, both as administrators and as teachers, is difficult. The subject is ripe for further study.

73. A fuller version of the poem is found in Paris, BN lat. 14167. See MacKinney (1957), 57–58.

74. *MSC* 169: "Obit Sigo, levita, sapientia clarus vitaque venerandus, cantor huius sanctae matris aecclesiae amantissimus, ammirandi presulis Fulberti, dum terris exularet, fidus a secretis, post, ut datur cerni, tumulator liberalis."

75. For a recent study of Robert, see Theis (2008).

76. For texts and translations of the three letters, see *LPFC* 230–37.

77. See Bachrach (1993), 212–17, for bibliography and a discussion of the political situation. The archbishop of Sens was the ecclesial overlord of the bishop of Chartres and the most powerful churchman in the realm of Chartres/Blois. To understand the times it is important to realize that after acquiring vast territories around Troyes and Meaux the Thibaudians looked on Sens with new interest; the city provided a geographic link between what had recently become a major segment of the Thibaudian domain and their older ancestral lands in the Loire valley.

78. He was serving as head sacristan at the time two charters were signed, one dating from around 1025, a document in which Bishop Fulbert negotiated certain rights with the church of Naveil,

and the other a charter of foundation for the abbey of St. John in the Valley, which was signed around the year 1027, soon before Fulbert's death (*DIGS* 282, and René Merlet, *Cartulaire de l'Abbaye de Saint-Jean-en-Vallée de Chartres*).

79. For the entire life, see appendix C. The vita is discussed more fully in chapter 1; thirteenth-century additions to it are discussed in chapter 12.

80. On the crypts, see Sapin and Suffrin (2008).

81. VdM (43–45) explains the way in which 1037 was chosen as the dedicatory year for the cathedral and was repeated uncritically in the scholarship for generations. There is no evidence from Chartres itself that the cathedral was formally consecrated in 1037, but because the date is mentioned in the *Chronicle of Anjou* it has been accepted. Van der Meulen questions the importance of this source, but it is worthy of note that Fulbert's student Bernard, the man who wrote the life of Saint Foi and dedicated it to Fulbert, was running the school there in these years.

82. "Deinde Fulbertus praesul memorandus, qui quantae fuerit sapientiae eius agiographa mira dulcedine flagrantia legentibus insinuant. Ad dexteram vero, Teodericus episcopus, cujus Ambrosiae opes velut torrens affluentes, preclarum opus almae matris Domini aulae complentes, perediae quoque atque bibesiae inopum jugiter oviantes, sacro dignum praeconio efficient" (*CSP* 1:12). *Peredia*, "Gobbledom" or "Eatingland," and *Bibesia*, "Drinkland," are attributed to the *Curculio* of Plautus by Lewis and Short (*A Latin Dictionary*, Oxford, 1975).

83. See Paris, BN lat. 17177, 68v, and *MSC* 80. Odo's entry in *MSC* (15 November, p. 182) includes the sentence "Qui plurimis hoc Divinitatis templum clarificavit donariis ac in ejus restauratione multiplices largitus est gratias" ("Who brightened this temple of Divinity with many gifts and in its restoration bestowed many favors").

84. "Extitit antistes Teodericus hic vocitatus, / Sed factus pulvis his jacet inanimis. / Virgo Dei genetrix, tibi templum tegit habendum. / Vivendo sollers tribuit quibus ecce refulget. / Munera, Petre, tuis sacra dedit monachis. / Fessus Ovis, conjunx Phebi, cum poneret estus, / Membra dedit matri, dans spiritale Patri" (Paris, BN lat. 17177, 68v.). The "tired Ram" alludes to a sign of the zodiac and the date of Thierry's death. He died when the sun was on the point of leaving the sign of the ram to enter that of the bull, that is, on April 17 (Thierry actually died on April 16). For the interpretation of this difficult (and previously misunderstood) passage, see *MSC* 80, note.

85. See *MSC* 128. The two are as follows: Teudo, Dec. 15 in *MSC* 128, Dec. 11 in OPS1032 112C (death dates are commonly off by a day or two in medieval necrologies; they depend on how the time was measured and when the news of death was received). As mentioned above, he gave for the façade of the church and for its roofs (*MSC* 184), but because Fulbert's campaign seems to have been cut short soon after his death, these contributions were likely made in the 1030s. Rodulfus (May 8) "devotedly dedicated many expenditures for the restoration of this church" (*MSC* 163).

86. Lucien Merlet (1892) claimed he was a member of an important colony of Bretons in eleventh-century Chartres. For more on this colony and artisans associated with the Abbey of Tiron, see Ruth Cline (2007) and her forthcoming translation of Bernard of Tiron, which she generously shared with me in mansucript form.

87. See *MSC* 180. Merlet and Clerval believe that the handwriting in the necrology would place his death at just around 1050, or almost precisely contemporary with the death of Bishop Thierry (*MSC* 127).

88. Unlike several other prominent cathedral officers of the time, he does not appear in any of the lists compiled by the Merlets in *DIGS*, nor is he present as a witness in any of the documents compiled by Paul of St. Peter. For dating and discussion, see *MSC* 82.

## 5. THE VIRGIN IN THE SECOND HALF OF
## THE ELEVENTH CENTURY

1. In the introduction to his provocatively titled collection of essays *Living with the Dead in the Middle Ages* (1994a), Patrick Geary sums up the powers of the saints in Latin medieval culture: "The dead were present among the living through liturgical commemoration, in dreams and visions, and in their physical remains, especially the tombs and relics of the saints. Omnipresent, they were drawn into every aspect of life. They played vital roles in social, economic, political, and cultural spheres." Although Geary leaves out the visual arts, art historians have shown the importance of studying the saints in a host of recent works, finding the text in both written and pictorial narratives. See, for, example Abou-el-Haj (1991), Hahn (2001), Hamburger (2002), and, in regard to Chartres in particular, Pastan (2008) and Lautier (2009).

2. The many collections of papers from conferences on the saints often include studies of the patristic period to the later Middle Ages and are deliberately interdisciplinary. One such collection, *Les fonctions* (L'École français de Rome, 1991), contains papers that wrestle with the differing ways in which various ages achieved identity through the cults they both invented and destroyed. Küchler and Melion (1991) is a collection related to memory and the visual arts.

3. Of special importance here is the recently inaugurated series *Historiae*, published by the Institute of Medieval Music in Ottawa and including editions by David Hiley of Arnold of Vohburg's Office of Saint Emmeram and by Barbara Haggh of Offices for Saint Elizabeth of Hungary found at Cambrai. Exemplary in the integrated study of music and liturgy in a broader consideration of cult is Slocum (2004) on Thomas Becket, which must be framed by Andrew Hughes's catalogue of sources on music for Becket (1988b). Tova Choate's recent study of St. Denis (2009) demonstrates the importance of the setting and resetting of musical and liturgical materials to interrelate regional saints' cults.

4. For an excellent introduction to the importance of liturgy for the study of art and architecture, see Reynolds (1995).

5. The marvelously rich *Marie* (see abbreviations) shows the sophistication with which scholars are beginning to treat the Virgin in the Middle Ages. Rachel Fulton's book on the Virgin's cult (2002) demonstrates the ways in which a broad understanding of cult was in the process of transformation during the twelfth century. The study of Mary by Miri Ruben (2009) provides a stimulating overview of the subject.

6. This theme proved especially important in Dominican Mariology of the thirteenth century; see Fassler (2004a). For the way in which Dominican Mariology was turned against the Jews in mid-thirteenth-century debates, see W. Jordan (2001).

7. Changes taking place in the eleventh century in England regarding the Virgin's cult have been studied by Mary Clayton (1990), with emphasis on the feasts of the Conception and Presentation of the Virgin in the Temple. She discusses the coming of the feasts in 1030 and their texts and reception; the feasts were abolished in many places after the Conquest. She also mentions various Offices for the Virgin introduced in the eleventh century, including a mid-eleventh-century Office found in London, BL Cotton Tiberius A.iii; it is edited in Dewick, *Facsimiles of Horae de Beata Maria Virgine*, cols. 19–48. Clayton says, "The early history of the Offices of Mary is obscure and it is complicated by the fact that early allusions, and many modern commentators, do not distinguish between the various forms this devotion could assume" (65). See further J. M. Canal (1961). Boynton (1994) is a fine introduction to shifts in Mariology as reflected within sequence poetry in the late tenth to the eleventh century. Votive offices for the Virgin Mary are studied in Baltzer (2000); Harper (1993); and Cavet (2005).

8. An entire issue of *Gesta* (1997) was devoted to the subject of body-part reliquaries and body

parts in the Middle Ages. Shapes and decorations of reliquaries were often related to the nature of the relics themselves and provided means of contemplating hidden mysteries and associations. The Chasse that contained Mary's cloth relic at Chartres was a heavily bejeweled box decorated by two golden eagles (see chapter 2). By the late seventeenth century it had been despoiled of at least some earlier decoration, as can be seen in the engraving discussed in chapter 12.

9. Its contents are also partially listed in Omont, ed. (1890), 11:84–85, and most fully in the unpublished thesis of Laurent Cavet.

10. For the early elements of Vespers and Matins services proper to the Virgin, see Frénaud (1961), esp. 191–211. Baltzer (2000) describes the Office of the blessed Virgin in Paris as celebrated in the thirteenth century. Common texts and chants for the Virgin are the subject of a recent doctoral thesis of Laurent Cavet; in this work he evaluates the role of Chartrain materials in their development, especially as related later to Books of Hours. For an introduction to his work, see Cavet (2005). Vat. lat. 4756, the thirteenth-century noted breviary from Chartres, contains the text only, added in a later hand, of a Little Office for the Virgin Mary, containing a nine-lesson Matins and Lauds but no Vespers (fol. 44v–46r). Comparison with the Little Office in Paris as catalogued by Baltzer reveals many points of similarity, but it is not the same Office; the work would repay further study for scholars studying the cult of the Virgin of Chartres in the thirteenth century.

11. For discussion of the truncation of Office readings, see Étaix (1994), especially his discussion of lectionaries from Cluny (139). The same tendency to shorten can be found in music: in the later Middle Ages editing melismas out of the chant repertory became common.

12. Two of these men are described in chapter 9; both owned copies of the book and bequeathed them to the cathedral.

13. The addition was prompted by the acquisition of Saint Anne's head by the Thibaudian count Louis in 1204 and the establishment of a cult for Saint Anne. The thirteenth-century north portal of the cathedral features Saint Anne, especially as portrayed in her Chartrain Office and sequence, "Mater matris domini," briefly discussed in chapter 12 and transcribed in appendix D, as well as in other liturgical texts for her feast. The cult of St. Anne at Chartres is a topic in Colleen Farrell's forthcoming Yale dissertation on the north portal of Chartres Cathedral.

14. The contents of Paul the Deacon's homiliary are catalogued in Grégoire (1980).

15. As at Chartres Cathedral; see OC 141.

16. The feast of her conception (December 8, tied to the feast of her birth) was not of major importance in Chartres and the surrounding region in the eleventh century and only began to be celebrated widely in some places in the twelfth century, where its acceptance was gradual and often grudging. It did not become a part of the calendar of Chartres Cathedral until around 1300. The Immaculate Conception was important in Anglo-Saxon England, for which see Clayton (1990).

17. Barré (1962), 151, discusses the stylistic differences between this and other sermons from the eleventh century. He notes that the sermon is attributed to Fulbert in three late eleventh- or early twelfth-century collections: Paris, Arsenal 371A (St. Victor), fols. 57–63v; Paris, Arsenal 372 (Fleury?, then St. Victor), fols. 69v–79; and Paris, BN lat. 18304 (St. Arnoul de Crépy), fols. 129v–137. Attributions to Fulbert generally follow Barré (1962, 1964), but the subject awaits a new critical edition of the sermons that would take into account Barré's discussion of the sources and his criticisms of Canal's work, as in his "Pro Fulberto" (1964). The recent French translation of Fulbert's writings (2006) omits all sermons (except the three "Contra Judaeos").

18. Chartres, BM 162, line 33, p. 70. The phrase is from Malachi 4:2 (3:20 in the Hebrew).

19. For bibliography on eastern Marian exegesis and the catalogue of attributes, see Fassler (2001).

20. "Nativitas gloriosae," along with other material attributed to Fulbert, is edited by Canal in "Texto crítico," 72–83; the corrected attribution to Bernier is made by Barré (1964), 328–29. On Notre Dame of Homblières, see William Mendel Newman's introduction to *The Cartulary*, edited by Theodore Evergates. According to Newman, Bernier wrote the vita in the time of the translation of the nun Hunegund, supposed founder of his abbey, "to generate interest" in the place (4). He sought to draw attention to the patron saint as well, as his sermon shows.

21. See Canal, "Texto crítico," 73, lines 19–21: "Voluit quidem omnipotens deus quaedam suae dispositionis archana, quae scienda mortalibus iudicauit, quatinus gradatim, pro sui capacitate, ad noticiam hominum scripta tradantur."

22. In Canal's edition (from Rouen 471), 75, lines 83–86.

23. Canal, "Texto crítico," 80, lines 251–61: "Beatam dei genitricem ac perpetuam uirginem mariam, cuius annua natiuitatis festa percolimus, de radice iesse oriundam, sancto in se spiritu loquente, uates cecinit. Exiet, inquiens, uirga de radice iesse et flos de radice eius ascendet. Radix uero iesse est familia iudeorum; uirga, maria; quae florem luminosum, inflexibili in se casitatis uigore perhenniter manente, uirgineo de corpore, sancto spiritu cooperante, ueraciter factum mundo protulit, dominum nostrum ihsum xpistum. Nata est ergo beata dei genitrix maria de sanctorum stirpe patriarcharum, quorum successio quam frequenter diuinitus benedicta, ex qua aetiam, qualiter eadem benedictio in cunctas terrarum nationes sit processura, ueteris instrumenti pene cunctarum testatur pagina scripturarum."

24. For discussion of the text as found in Chartres, BM 162, see Beyers's edition of the *Libellus*.

25. The work was edited by Canal from the version in this manuscript.

26. See Hamburger (2002) on the deified St. John the Evangelist in the visual arts; his special veneration by communities of religious women in the later Middle Ages relates to his unique connections both to Jesus and to the Virgin Mary.

27. For detailed discussion of Rabanus's homiliary and his work as a writer of sermons, see Barré (1962); his treatise is discussed further in chapter 11.

28. See discussion in *PL* 107:731AB. This text, which by the mid-twelfth century was read throughout the octave of the Virgin's Nativity at Chartres Cathedral, is discussed in chapter 10.

29. "Si autem aliquis quaerendum putat cum Joseph non sit pater Domini Salvatoris, quod pertineat ad eum generationis ordo deductus usque ad Joseph, sciat primum non esse consuetudinis Scripturarum ut mulierum in generationibus ordo texatur" (748A).

30. See discussion in S. Mowinckel (1956).

31. See especially the writings of Rachel Fulton.

32. For further discussion, see Fassler (2001). For the Latin texts, see Fassler (2007), 25–26.

33. See the contents as transcribed in appendix E. The final reading is from Song 3:3b–5: "Have you seen him, whom my soul loveth? When I had a little passed by them, I found him whom my soul loveth: I held him: and I will not let him go, till I bring him into my mother's house, and into the chamber of her that bore me. I adjure you, O daughters of Jerusalem, by the roes and the harts of the fields, that you stir not up, nor awake my beloved, till she please."

34. See Delaporte (1950, 1951). As we will see in subsequent chapters, the cult of the Virgin was divided in the early twelfth century by Bishop Geoffrey of Lèves, the cathedral continuing to focus upon themes of birth and renewal, while the newly formed Abbey of Notre Dame de Josaphat concentrated on the Assumption. The Assumption was celebrated at the cathedral, but in the twelfth century the Nativity of the Virgin was the festal equal of its older and more generally prominent sister. The way the chants attributed to Fulbert were used in the liturgy was a key to this liturgical revisionism doubtless put in place in the eleventh century. In accordance with Bishop Geoffrey's ideas, John the Baptist continued to be the second dedicatee of the cathedral, whereas John the Evangelist became the secondary dedicatee of the Josaphat. From the time of Geoffrey forward, bishops of Chartres were buried at Josaphat; there were no tombs in Chartres Cathedral.

35. For discussion of the group A1, see *Libellus*, 37–43.

36. See Bouhot (1990), Vezin (1974), and Martin (1989) for a description of the manuscript and discussion of the contents of this source.

37. For the introductory epistle in English, see Bernard of Angers, *Liber miraculorum sancte Fidis*.

38. On Bernard of Angers's career and the political difficulties his friendship with Fulbert sometimes presented, see Fanning (1988), esp. 69–70.

39. See Branch (1974) for discussion of the manuscript and its handwriting style.

40. See Beyers, *Libellus*, 38–39.

41. For discussions of Alan of Farfa and Paul the Deacon and inventories of early examples of their works, see Grégoire (1980).

42. For a study of the influence of Fulbert and his students on the development of liturgical song, see Goudesenne (2008).

43. For the text of this letter, see *LPFC* 273–74.

44. The state of this original collection was reconstructed from the sources by Margaret Gibson and Richard Southern in an unpublished document to which Behrends had access. Their discussions led to the following conclusions: "The underlying collection was not a bound codex, but consisted of small gatherings and separate leaves which could be rearranged. Moreover, the letters within the individual groups possibly stand in chronological order" (*LPFC* li).

45. My own paper on Fulbert (2000a), through an unfortunate comedy of errors, states that the texts are neumed in this manuscript. This is not the case.

46. He left his cape and a two-part Bible to the abbey and his house in the cloister to the cathedral. His obituary is found in *MSC* 181 (November 9) and in *OPSSJ* 231 E (November 8).

47. Many scholars, including Delaporte, have searched for this Office, as it would provide much useful information about the Chartrain school of chant in the eleventh century. It seems to have been lost, although Delaporte (1957), 53, mentions two sources that might contain part of it (they have nothing in common): leaves from a sixteenth-century source from Saint-Evroult-de-Mortain now at the Abbey of Solesmes contain a noted Office of Saint Evroult; and Rouen U 158 (1386) contains an antiphon and an invitatory for Saint Evroult.

48. See Goudesenne (2008).

49. See Delaporte (1957), 53 and note. The Office is found in Saumur 16 (245), a fifteenth-century breviary of the use of Saint Florent.

50. See especially Jansen (1982) for comparisons of the Abbey of St. Riquier with the eleventh-century drawing of Chartres Cathedral. Fulbert's student Angelran was abbot at St. Riquier from 1020 to 1045, during a time of substantial rebuilding. See discussion of Fulbert's students in Clerval (1895) and MacKinney (1957). The cathedral schools of the eleventh century are studied in Verger (2008).

51. On Olbert, see Sigebert of Gembloux, *Gesta abbatum Gemblacensium*, c.xxvi (MGH SS 8:536).

52. M. Bernhard (1990) provides an overview of medieval glosses to Boethius's *De Institutione Musicae*.

53. From a private communication: see Munich, lat. 14372 (second half of the eleventh century), f. 24v RISM ser. B III.3, p. 113: the responsories are "Styrps Jesse," "Solem justitiae," and "Ad nutum," with neumes. On the manuscripts that Hartwic had copied, see Huglo (1988), 183–89.

54. For reproductions, see MacKinney (1957), plate 2, and Klemm (2004), plate 22. On his students' aspirations for Fulbert's canonization, see Bozoky (2008).

55. See Delaporte, *Fragments*, 23, for discussion of Chartres, BM 78, f. 1, and a photograph of this now-destroyed volume of the lesser works of Augustine. The manuscript belonged to St. Peter. For analysis of the handwriting style, see Langlois (1905–06), 162. Cullin (1999) discusses further the responsories and their implications for the visual arts.

56. For an introduction to the subject of numerical ordering by the modes in Great Responsories and antiphons, see Crocker (1986).

57. I once heard Richard Crocker lead a performance of an entire modally ordered Office, relating it to some of the ideas developed in his article cited above (1986). It was a musical experience of great excitement, never to be forgotten. The dramatically powerful effect of the kinds of music composed in Chartres in the eleventh century, where sets of modally ordered Offices were the musical tours de force of the day, should not be forgotten in our own age, when to hear individual pieces out of context is commonplace; having the ability to specialize in the composition of such Offices meant that one's musical expertise was considerable for the times.

58. Pothier wrote an analysis of the responsories and other chants for Saint Giles found in Chartres, BM N4 for Merlet and Clerval's edition (MSC 198–229), comparing the unheightened neumes to a later source from Beauvais (Paris, Bibl. Ste Geneviève MS 26). He notes that the style and even some melodic turns of phrase for the responsories in this set resemble those of the Marian responsories attributed to Fulbert; see *MSC* 225–29. Delaporte (1957) lists the Offices believed to have been written in Chartres in the eleventh century (in addition to the materials for the Virgin's Nativity): St. Cheron (music in Vat. lat. 4756); St. Laumer (music in Vat. lat. 4756); St. Lubin (Delaporte edited some chants for it from Chartrain processionals, pp. 71–72); St. Piat (Delaporte edited some chants from processionals, see pp. 72–73, but most is lost); St. Eman (music in Vat. lat. 4756); St. Giles, as above.

59. The eight festive readings referred to earlier in this chapter were presented in such a way as to invite flexibility in choice and order; they could have been divided so as to provide the nine readings of the Office, or in combination with other appropriate texts.

60. An overview of the process of change in Office lectionaries from the tenth through the thirteenth centuries can be found through the study of sources from Cluny as usefully inventoried in Étaix (1994), 137–206. Regarding the feast of Mary's Nativity, we can see that sources from the tenth and early eleventh centuries take readings 1–8 from the Song of Songs 1:1–4 and 15, while all sources from the late eleventh century on take them from *Approbate consuetudinis*. Subsequent readings are from Matthew 1:1–18, with commentary from Jerome on the book of Matthew. The twelfth reading begins, "In Isaia legimus. . . ." Note that the Benedictine Office had twelve readings rather than the nine found in the cathedral Office.

61. Although all three of the Chartrain responsories were widespread, "Styrps Jesse" was the most popular of the three. It is found both east and west of the Rhine, in the British Isles, and in Austria and eastern Europe. It is rare in Italy in the twelfth century, however.

62. For a brief introduction to this subject, see Hiley (1993), 69–76.

63. The set of five does not appear as an entity in any early liturgical book known to me, although elements can be found in the late tenth-century Paris, BN lat. 1085 from Limoges, and in the early twelfth-century Paris, BN lat. 12044 from St. Maur-des-Fossées. On lat. 1085, see Grier (2000); some unique features of the Office in lat. 12044 are described in T. Kelly (1977). Both sources are indexed in Cantus, the online database. The twelfth-century antiphoner from the Holy Sepulchre in Jerusalem (Lucca, Bibl. Archep. 5) contains all five antiphons, although they are not used as at Chartres Cathedral.

## 6. NEW MODES OF SEEING

1. For discussion of the formation of the sequence repertory at Chartres, see Fassler (1992, 1993a). The text of "Interni festi" is translated in full at the end of this chapter, as it is directly representative of the ways in which the Augustinians of Chartres thought about the past and their place in it during the first half of the twelfth century. The sequence is not among those Anglo-Norman pieces edited by David Hiley; this, along with its presence in Chartrain sources

from the twelfth century and later, suggests that it was a local production and not in general circulation around the turn of the eleventh century.

2. According to the modern calendar, Ivo died in December 1116; by the calendar of the time, when the new year began in March, he died in 1115. A bull from Pope Pascal II to the clergy and people of Chartres, dated April 5, 1116, speaks of Ivo's recent death and of the election of the new bishop, Geoffrey, who had been driven from the city (*CNDC* 1:124–25; Jaffé, *Regesta*, 6518; for the context, cf. Jaffé 6519; Pascal to Archbishop Daimbert, the same day, *CNDC* 1:125). See further discussion of Bishop Geoffrey's troubles in chapter 8.

3. Maier (1967) places Paris, BN lat. 1794 among a group of eleven manuscripts from Sidon.

4. For the various arguments for and against his having been at Bec, see Barker (1988), 14. There are many brief accounts of his life in the scholarship, but presently little is known of him before he became bishop of Chartres. A reliable introduction is that provided by Leclercq in *Correspondence*, viii–xi, and in Sprandel (1962), 5–8.

5. See Dereine (1948). Among the acts of King Philip I is a charter of 1079 confirming the rights and privileges of the Abbey of St. Quentin in Beauvais but giving the bishop of Beauvais the right to confirm the election of the abbot. Among the witnesses to the document signed by King Philip and William the Conqueror are Anselm of Bec and Ivo, "eiusdem ecclesie prelatus." See Prou, *Recueil des actes de Philippe Ier*, no. XCIV, pp. 242–45 (from a copy in a twelfth-century cartulary of St. Quentin, after the lost original).

6. The character of Countess Adela has been carefully fleshed out in the writings of LoPrete; see especially her dissertation (1991), which has a chapter dedicated to Ivo of Chartres, and her later articles (1996, 1999); her recent book (2007) is the definitive study. Ivo's life as bishop and his view of the church are treated at length in Sprandel (1962). Still useful for its discussion of medieval documents is Souchet's account of Ivo (*Histoire*, 2:305–83). Little work has been done on Ivo as a liturgical commentator; Reynolds (1978) points to his importance in this regard.

7. Philip I, his liaison with Bertrade, and Ivo's reactions to the situation are discussed in Duby (1978), 29–45, who examines the charters, letters, and narratives that relate to this famous case. For further historical background, see Augustin Fliche (1912) and the primary sources cited in *RHG* 15. The most extraordinary of the contemporary depictions of Bertrade is in Orderic Vitalis, 11.9 (ed. Chibnall, 6:50–55). In this recounting Bertrade employed sorcerers to carry out a kind of reverse novena to kill the king's son Louis, the rival of Philip, her own son (by the king); when the ritual failed, Bertrade turned to poison. Louis was finally cured by "a shaggy doctor from Barbary," but it is said that, as king, Louis VI remained pale ever after as a result. Bertrade was implicated in the actual death of another of her stepsons, Geoffrey Martel, count of Anjou, who was killed in 1106 by a crossbowman "inspired by the devil" and eventually replaced by Fulk, her son by Fulk le Rechin. See 11.16 (ed. Chibnall, 6:76–77); the *Chronicle of Tours* (*RHG* 12:468); and Halphen and Poupardin, eds., *Chroniques des comtes d'Anjou*, 66.

8. The earliest origins of the Le Puiset family are difficult to trace; it appears that by the time of King Robert the Pious they held the *castrum* of Le Puiset in fief from the king and probably also held, from the count of Blois/Chartres, the benefice of the viscounty of Chartres. Castellans having different overlords were not unusual during the eleventh and twelfth centuries, especially in "marche" areas situated on the borders between two (or more) powerful overlords. Their powers and the locations of their lands resulted in making an already chaotic feudal situation even more unstable. At the same time, added to the mix of king and count in the Le Puiset topography, was the wild card of the king of the English, and the fact that the Le Puisets and the Thibaudians intermarried, as we will see. For a holder of multiple fiefs like the lords of Le Puiset, this provided an opportunity to play one of their overlords off against others, while they acted as free agents whenever possible. The Le Puisets appear to have been masters at this game, able to combine shifting allegiances with their own self-serving ravagings "of the

land of the saints" in the Beauce, as Suger notes (*Deeds*, p. 86). Suger is referring primarily to the saints of his own abbey of St. Denis, but the term applies equally to both St. Peter in the Valley (see, for example, *CSP* 270) and St. Mary of Chartres, which also suffered from the Le Puisets' exploits; this forms the underlying circumstance of the narrative in books 19–23 of Suger's *Deeds* (see chapter 7). Christopher Crockett has a prosopographical study of the Beauce forthcoming, and I am grateful to him for his observations on the Le Puisets; the best works in print on their genealogy remain La Monte (1942) and LoPrete (2007); LoPrete discusses the major members of the family during the lifetime of Adela and provides a genealogical table (579).

9. Useful introductions to Ivo's troubles at the beginning of his tenure are found in Leclercq's preface to his first (and only completed) volume of Ivo's letters, *Correspondence*, and in Sprandel (1962), 101–15.

10. See *Correspondence*, ed. Leclercq, ix. According to Orderic (5.6; ed. Chibnall 3:158), Geoffrey was chosen over a candidate of King Philip's, suggesting that he was the favorite of the comital family. The well-connected Bishop Geoffrey I—nephew of both the bishop of Paris of the same name and of Eustache, count of Boulogne—initially got the charges of the legatine Council of Issoudun, March 1081, overturned and was reinstated in December of the same year; this decision, however, was overturned by Pope Urban II, who insisted that the people and clergy of Chartres elect a new bishop. The case against Bishop Geoffrey was spearheaded by the Burgundian Hugh of Die (c. 1020–1106), who served as papal legate from 1074 and throughout his lifetime strove to depose high-ranking officials who kept concubines or who he believed had achieved their offices through simony. Ivo, apparently reluctant to accept the episcopal call, was pressed to do so by the pope and by King Philip I, who surely came to regret his decision. Richer, the archbishop of Sens, took Geoffrey's side; he refused to anoint Ivo and claimed that Geoffrey had been deposed without his consent. Ivo traveled to Capua, whence the pontiff had fled from Emperor Henry IV, and there was consecrated by the pope himself. Declamations from the pope, issued from Capua, reveal more details of this case: see Urban II to the people of Chartres, *Ep*.1, 2–4, Nov. 24, 1090 (Jaffé 5438; *PL* 151:325; *RHG* 14:698; and *CNDC* 1:96–97), and to Richer, archbishop of Sens, *Ep*.2, 4–8, Nov. 25, 1090 (Jaffé 5439; *PL* 151:326; *RHG* 14:698; and *CNDC* 1:97–98). Perhaps because of the wealth of documentation, Bishop Geoffrey I is the only deposed bishop from the eleventh century to have secured a place in the bishops' list found in the *Vieille Chronique*, *CNDC* 1:16.

11. *CNDC* 1:104–08, no. 24, with an abundance of witnesses, indicating its importance. The count's concession was confirmed by a papal bull, dated February 14, 1100 (*CNDC* 1:109; Jaffé 5818, GC VIII, *Instr.* 307; *RHG* 15:18 as above; *PL* 163:35). Ivo was able to obtain from Philip I a confirmation of the renunciation made by Count Stephen-Henry in a charter of 1105 (Prou, Charter no. 152, pp. 383–85). The document and its confirmation are discussed in some detail in LoPrete (2007), 451–52. Similar exemptions from the pillage of episcopal property on the death of bishops by local secular powers were enacted to protect the properties of the bishops of Laon (1158) and of Paris (1143). The second instance makes a good point of comparison with the Chartrain case (see *CNDC* 1:36). The confirmation Ivo obtained from King Philip I was renewed by Louis VII (Luchaire, *Annales*, no. 356, dated by him to between March 27, 1156, and April 14, 1156), who addressed it to "Clericos nostros Carnotensæ Civitatis existentes ad huc in desolatione, quam acceperant ex morte bonæ memoræ episcope Gosleni"; it repeats, verbatim, and confirms the "tenor præceptum avi [i.e., grandfather] nostre Regis Philippi." The pillaging of episcopal property and the revocation of the right to do so would make a fine topic for a detailed study, especially for a scholar with expertise in medieval charters.

12. Souchet, *Histoire*, 2:333. "Ex auctoritate dei omnipotentis patris et filii et spiritus sancti et beate marie semper virginis et sanctorum apostolorum Petri et Pauli et sancte sedis apostolice nostrique ministerii et omnis ordinis ecclesiastici excommunicamus et portas paradisi ei

claudimus et portas inferni aperimus quicumque de hac episcopali domu et appenditiis eius abstulerit lapidem pignum ferrum plumbum vitrum aut integritatem eorum violaverit aut dehonestaverit hoc anathema confirmavit daimbertus senonsenis archiepiscopus cum suis suffraganeis in concilio stampensi hoc idem rome confirmavit pascalis papa cum romane ecclesie cardinalibus."

13. See *MSC* 179 (*OPS* 21G), 15 October: "Et Vitalis, artifex hujus sanctae ecclesiae, qui reliquit canonicis eiusdem ecclesie tres quadrantes vineae, post decessum Ebrardi, filii sui," and discussion (*MSC* 127–28).

14. Chartres, BM 138. See the manuscript list in appendix A for this important source. Ivo's sermons were much copied; nine of his sermons were included in the great lectionary compiled at Corbie in the second half of the twelfth century, for which see Étaix (1994), 206–74.

15. The twelfth-century pontifical of Chartres (listed in appendix A) details the ceremonial for this synod; the ceremony and Ivo's preaching on this occasion are the subject of a forthcoming paper.

16. "Quoniam populus ad fidem vocatus, visibilibus sacramentis instruendus est, ut per exhibitionem visibilium, pertingere possit ad intellectum invisibilium, nosse oportet, Domini, sacerdotes, qui haec sacramenta contrectant, modum et ordinem sacramentorum, et veritatem rerum significatarum: alioqui dispensatores tantorum mysteriorum sunt tanquam caeci duces caecorum, tantum utilitatis inde habituri, quantum capiunt jumenta quae portant panes ad usus aliorum, licet divina gratia non deserat sacramentum, quod per eos operatur salutem populorum. . . . Unde ab initio saeculi in omni aetate sacramenta Christi et Ecclesiae celebrata sunt quibus et ille populus nutriretur, et nostrae redemptionis modus insinuaretur" (*PL* 162:505C–506BC).

17. The seven-fold system has been much discussed by scholars. For discussion of ideas concerning the organization of the ages of history in the twelfth century, see Zinn (1977); for a more general introduction, see Burrow (1986) and Sears (1986). In the twelfth century the seven ages of man were compared by some authors to the seven tones of the Guidonian scale; for discussion of an example, see J. W. Marchand (1975).

18. See especially Bynum (1979) and Fassler (1993a).

19. See Fassler (1993a). Hugh of St. Victor would later argue this point in book two, part five of his *De sacramentis christianae fidei.*

20. The term "mater ecclesiae" (mother church) was well established in the Chartrain liturgy by the early eleventh century and appears in the sermon *Approbate* by Fulbert of Chartres for the feast of Mary's Nativity as well as in chant texts (see chapters 4, 5).

21. These verses were proclaimed as well in the readings for the Purification collected in Chartres, BM 162 (see page 119 above).

22. "Per carnem enim suximus majestatem" (*PL* 162:585D).

23. For an introduction to this commonplace image, which appears in Christian exegesis from the patristic period on, see Meiss (1945), a classic study that inspired many later treatments of light and form. The idea appears in other twelfth-century sermons that would have been known in Chartres, including Homily 3 of Amadeus of Lausanne (ed. Deschusses; trans. Said and Perigo). Amadeus was at Cluny before he left for Clairvaux in 1125, and so probably would have known the young Henry of Blois, a figure of some importance later in this book. See the introduction to Amadeus's Marian sermons by Bavaud for an account of his life.

24. *PL* 162:585A–C. The reference at the end of this passage is to Psalm 18:6–7/19:4–6: "He hath set his tabernacle in the sun: and he, as a bridegroom coming out of his bride chamber, hath rejoiced as a giant to run the way: His going out is from the end of heaven, and his circuit even to the end thereof: and there is no one who can hide from his heat." An antiphon based on this text (*CAO* 3287) was sung throughout Europe in the Christmas season, most commonly on the octave of Christmas.

25. Ivo's sermon suggests that the feast must have been important in Chartres in the late eleventh and twelfth centuries; many bishops of Chartres had close relationships with Rome, including, most prominently, Ivo's successor Geoffrey of Lèves, who was a papal legate. The feast would have fallen either during the solemn pre-Lenten season or in Lent itself, so it would not have been heavily decorated or joyous in character. *OC* 150–51 describes the feast and lists the changes that needed to be made when various other feast days intruded. The readings for the Office came from "Institutio festivitatis," attributed to Leo the Great and found in *PL* 95:1463–65.

26. *PL* 162:595C. The dance would have been solemn; for discussion of ritual dance as carried on by clerics in the Middle Ages and Renaissance, see Craig Wright (2001) and Greene (2001).

27. John 10:9 is quoted by Ivo (*PL* 162:597B). See the entry in the index of Kendall (1998), "Christ the door (typological allegory of)," 383, for information on the quotation and its importance as an inscription on medieval portals. The prominence of Peter in twelfth-century portal sculpture is doubtless dependent upon this idea and would be worthy of further exploration.

28. See Reynolds (1978). Ivo's sermons are usually not a part of his or other scholars' discussions of aesthetic principles and of function underlying the art of the early twelfth century. He receives barely a mention in Otto von Simson's classic discussion (1988) of the formation of the "gothic." The useful compilation edited by Binding and Speer (1993) has no mention of Ivo; the most recent work on the Victorines and the rise of the Gothic, edited by Dominique Poirel et al. (2001), also contains no reference to him, although his writings were well known in the Parisian schools of the early and mid-twelfth century. As a reformer he would have been something of a hero among the Victorines; see Châtillon's study of Ivo (1972).

29. LoPrete (2007) says of Adela, "To rule effectively Adela, like Ivo, had to rely on others, such as the knights at her command. . . . One way to undergird her power would be to cooperate in the promulgation and enforcement of the peace" (239).

30. The *Gesta Francorum et aliorum Hierosolimitanorum (The Deeds of the Franks and the other Pilgrims to Jerusalem)*, by an anonymous and still-unidentified author, is in ten books: nine were written between November 1095 and August 1099, the month after the siege and battle of Jerusalem, and a tenth book in 1101. This was a source for later crusader historians, including Fulcher of Chartres and Baudri of Bourgueil, whose knowledge of the Thibaudians, especially of the countess Adela, is discussed in detail in LoPrete (2007), 191–205. The Anonymous's depiction of Stephen-Henry was powerfully negative: "Now it happened that, before Antioch was captured, that coward Stephen, Count of Chartres, whom all our leaders had elected commander-in-chief, pretended to be very ill, and he went away shamefully to another castle which is called Alexandretta. When we were shut up in the city, lacking help to save us, we waited each day for him to bring us aid. But he, having heard that the Turks had surrounded and besieged us, went secretly up a neighbouring mountain which stood near Antioch, and when he saw more tents than he could count he returned in terror, and hastily retreated in flight with his army" (99:27; trans. by Rosalind Hill [p. 63] from the Latin edition of Roger Mynors, which is included in her edition of the work). In his history of the crusade Baudri redeems Count Stephen-Henry to a significant degree, even though the Anonymous's chronicle is his main source. He was well aware of the count's redemptive return to the Holy Land and of the history of the Thibaudians; the latter is revealed in some detail in a letter he wrote to Count Stephen's half brother Philip in the late eleventh century. LoPrete (2007): "Tracing Philip's paternal ancestors back to his great-grandfather Odo I, the poet took pains to emphasize the addressee's noble orgins, showering Philip's father and grandfather with sycophantic praise" (192). Baudri was a well-informed poet whose writings demonstrate the self-understanding of Adela and her children during the time of Ivo of Chartres and immediately after his reign. Baudri was a disciple of Godfrey of Reims, who also wrote stanzas in praise of Adela before her marriage, depicting her as a blessed and regal virgin (see LoPrete, 2007, 554–56).

31. See Shirley Brown (1988), and Brown and Herren (1994). The translation of lines 207–578 of Baudri's "Adelae Comitissae" is based on the Latin of K. Hilbert (*Carmina*), 154–64. See also Baudri, trans. M. Otter.

32. *MSC* 180: October 31: "Obiit Mathidis, Anglorum regina, que, hanc ecclesiam dilectionis privilegio amplectens et venerans, plumbeo tegmine decoravit, et, preter alia multa beneficia, casulam ei deauratam et xl libras nummorum ad usus fratrum donavit." Merlet erroneously dated this obit to 1118, making it the obituary of Queen Matilda, wife of Henry 1, who died in May. Matilda, the wife of the Conqueror, died on November 2, and so this is doubtless her notice, misplaced by two days (this would not be unusual). Orderic Vitalis, among other historians, mentions the date of William's Matilda (book 4, 44–46), and of Queen Matilda on May 1 (book 12, ed. Chibnall, 6:188).

33. See *Ep.* 107 (*PL* 162:125–26): "Unde a tua excellentia mutuam promereri cupimus dilectionem, quam propter praeclaram memoriam reginae Angelorum Mariae, Ecclesiae, cui auctore Deo, licet indigni, deservimus, ante tua tempora exhibuerunt reginae Anglorum." The title of *Ep.* 143 (*PL* 162:148) reads, "Ivo, humilis Ecclesiae Carnotensis minister, Mathildi Angelorum reginae, cum Regina angelorum in caelo regnare."

34. *MSC* 149, *OPS* 4BC, 25 December. The Porta Nova was a gate in the cloister; see Chédeville (1983), 425.

35. *MSC* 164. LoPrete (2007), 128, 4939, 514, states that Geoffrey Brito was the son of Giles of Galardon. In addition to Galardon he held land at Maves (near Blois) and a castle in the pagus of Rennes.

36. "Adela, nobilis Blesensium comitissa, regis Anglorum Willelmi filia, que presentem ecclesiam toto cordis affectu diligens, domibus episcopalibus libertatem cum viro suo Henrico comite et filiis concessit. Dedit etiam huic ecclesie duo candelabra eleganti opere informata, et tres gemmas sacro scrinio infixas, et quatuor clericis custodibus altaris donavit furnum et quicquid juris in eo et in pertinentibus ad eum habebat, eo tenore ut predicti clerici pro anima ejus singulis sabbatorum diebus duos cereos consuetudinarios ante sacrum scrinium ponant et pallium obtimum" (OPS1032 46EF). LoPrete (2007, 527–28) catalogues and transcribes Adela's obits.

37. From Chibnall's introduction to vol. 1 of her edition of Orderic Vitalis, 26.

38. For further discussion, see Dondi (2004), 137. Bartholemew Boel and his son Girard were frequently attested in the entourage of Adela and her sons; see LoPrete (2007), 362. For the association of the family with an early miracle of the Virgin, see Hermann of Laon, *Miracula sanctae Mariae Laudunensis* 1.13 (*PL* 156:972C), quoted on pages 165–66.

39. Orderic Vitalis, 11.12 (ed. Chibnall, 6:70–71). Bohemond's attempt to take the Byzantine empire was a failure. We have a probable firsthand description of the wedding ceremony at Chartres in Orderic, and, to complete the scene in our imaginations, a closeup of Mark Bohemond in the *Alexiad* of Princess Anna Comnena, who admires his beautiful, powerful body but fears his savagery and cunning: "He was so tall in stature that he overtopped the tallest by nearly one cubit, narrow in the waist and loins, with broad shoulders and a deep chest and powerful arms. And in the whole build of the body he was neither too slender nor over-weighted with flesh, but perfectly proportioned . . . he had powerful hands and stood firmly on his feet, and his neck and back were well compacted . . . his skin all over his body was very white, and in his face the white was tempered with red. His hair was yellowish, but did not hang down to his waist like that of the other barbarians; for the man was not inordinately vain of his hair . . . his blue eyes indicated both a high spirit and dignity; and his nose and nostrils breathed in the air freely. . . . A certain charm hung about this man but was partly marred by a general air of the horrible . . . even his laughter sounded to others like snorting" (book 13, x; trans. Elizabeth A. S. Dawes, 347). Bohemund I died in Apulia in 1111, leaving children, among them a son who bore his name.

40. The same phrase is used in the *OC* 126, but within a fuller description.

41. Jean Mallion's study of the thirteenth-century jubé of Chartres Cathedral (1964, 11–21) in-

cludes references to several historians from the later medieval and early modern periods, but he believes Ivo's obituary is the only surviving contemporary reference to the structure, which should be qualified by Orderic's description. In any case, the obituary made the structure part of local history, and its thirteenth-century successor was linked to Bishop Ivo in Chartrain history.

42. Fulcher of Chartres, *A History of the Expedition to Jerusalem*, 1, 6, 13 (trans. Ryan, 74). For scenes of farewell in medieval literature of the period, including discussion of Fulcher's, see Morse (2005).

43. For a study of the Passion of Christ and the sufferings of the Virgin Mary in the wake of the First Crusade, see especially Rachel Fulton (2002).

44. Adela's penchant for the reformers' cause is discussed at several points in LoPrete (2007); see, for example, 289–90, which discusses her reception of papal legates in 1101, and Ivo's and Adela's well-known reception and entertainment of Pope Paschal II on Easter, 1107. The visit was reported by Orderic, who gets the date wrong: "In the year of our Lord 1103 [1107] Pope Paschal came into France; he was received with honor by the inhabitants and faithfully carried out his spiritual duties. At that time Ivo, bishop of the town of Chartres, outshone all other distinguished teachers in France by his learning, both spiritual and secular; at his invitation the Pope celebrated the feast of Easter at Chartres. The countess Adela too gave generous sums for the Pope's needs and earned the eternal blessing of the apostolic see for herself and her house. This noble lady governed her husband's county well after his departure on crusade and carefully brought up her young sons to defend the church" (11.5; ed. Chibnall, 6:42–43).

45. Count Stephen-Henry's supposed cowardice (see note 30 above) and his return to the Holy Land to make amends and ultimately to die have been much discussed by scholars. The best analysis is that of LoPrete (2007), 110–17, who summarizes the writings of medieval historians and modern authors. She is not convinced that Stephen-Henry was guilty of anything except bad judgment and believes it likely that Adela took a hand in encouraging her husband to redeem his reputation. Crusaders who came home without reaching Jerusalem were subject to excommunication, and the count's return to the Holy Land inspired thousands to join him. Orderic's account of Adela speaking to her husband as they lay in bed together demonstrates how quickly the support of famed individuals for the First Crusade could turn to legend: "Far be it from you, my lord, to lower yourself by enduring the scorn of such men as these for long. Remember the courage for which you were famous in your youth, and take up the arms of the glorious crusade for the sake of saving thousands so that Christians may raise great thanksgiving all over the world, and the lot of the heathen may be terror and the public overthrow of their unholy law" (Orderic 10.20, ed. Chibnall, 5:324–25). The relationship between Adela and Count Stephen-Henry was romanticized by later medieval historians. Although he was some twenty years her senior, the couple produced at least six children, and one of them, Henry, was apparently conceived during that brief time that Stephen-Henry returned home to put his affairs in order before his final departure; their few letters imply affection, but the conventions of letter writing undercut any certainty. That the numerous children of the family grew up without a father and in the shadow of legends promoted by their mother and others surely filled their minds and hearts with a desire to defend the count's honor and their own. The pathos wrought by the First Crusade is now being told from the perspectives of Jews, Muslims, and Greeks as well as Christian northern Europeans. Chazan (1997) and Cohen (2004), for example, provide introductions to Jewish perspectives, and Hillenbrand (2000) on Muslim views, as does Jotischky (2001). The massive *Recueil des Historiens des Croisades*, collected and published in the second half of the nineteenth century, is now available online. The four-volume collection of essays forthcoming from Routledge and edited by Andrew Jotischky will provide an overview of the scholarship in the past two decades and the major rethinking of the Crusades that has taken place in this time. The concept of geopiety, that is, the sacralization

of place, is useful when treating the many ways in which Western Christians justified their repeated attempts to rule the Near East. In places such as Egypt, where there were large native Christian populations whose cultures were ancient, the history and historiography are especially complicated.

46. Lépinois (1854–58, 1:73–77) scoured contemporary documents for the names of men from the region who were involved in the First Crusade and its immediate aftermath, including, of course, Count Stephen-Henry, who left for the first time in September 1096. With him were Rotrou, count of Perche; Ebrard of Le Puiset (son of "Hugh Blavons" and Alice of Montlhéry); Philibert of Chartres; Miles of Braies; Geoffrey of Berou; Normand of Morvillers; Isnard of the Garenne; and "a crowd of other men of the Beauce and from around Gâtins, Blois, and Perche." Many followed the standard of Count Mark Bohemond, including Fulcher Boël, brother of the vidame of Chartres, who is mentioned in the *Gesta Tancredi* by Raoul de Caen as the first to follow Bohemond into the city of Antioch: "Therefore, just as he had begun, Bohemond came to the wall and found a rope hanging outside. He bound himself in the rope and the young birds, with armored bodies and girded with swords, flew along the ropes. The first of these was Govel of Chartres [this would be our Boël]. Just as an eagle summons its young to fly and flutters over them, this noble man, who from his youth had eaten and drunk nothing other than praise, did not wish to be praised in order to live, but sought to live for the sake of praise." From the translation by Bernard Bachrach and David Bachrach, chapter 66, p. 91.

47. For an introduction to Fulcher, see his *Historia Hierosolymitana*, edited by Heinrich Hagenmeyer (1913), and Harold Fink's introduction to the English translation (*A History of the Expedition to Jerusalem 1095–1127*) by Frances Rita Ryan (1969). On the First Crusade, see especially Erdmann (1977) and several works by Jonathan Riley-Smith. Folda (1997–98) and Jotischky (2008) are useful for attitudes toward the Holy Sepulchre. Forthcoming articles by Maier and Folda will add further understanding to the interrelationships between art, liturgy, and historical understanding in the twelfth century, especially in regard to understanding Western concepts of the Holy Land. Most important for this study is a book by Verena Epp (1990), the only monograph entirely devoted to Fulcher's work. She studies the two recensions of Fulcher's history and points to shifts in his thinking about the cruel deeds the crusaders carried out in order to achieve their goals. Historiographical considerations concerning the murder of Jews in the Rhineland in 1096 are studied by Stow (2001), with suggestions for further research on this deeply troubling subject. The collection of primary texts related to the First Crusade in translation by Edward Peters has appeared in a much-expanded revised edition; it includes the voices of Jewish and Muslim witnesses as well as those coming from the Christian perspective. Fulcher refers to himself as being "of Chartres" three times in his history, and when describing an ambush in Nahr al-Kalb (north of Beirut) speaks of Chartres as if it were his home: "We did not want to seem afraid as we would if we left the place as if in flight. We pretended one thing, but we thought another. We feigned boldness, but we feared death. It was difficult to retreat but more difficult to advance. On all sides we were besieged by our enemies. . . . That day nothing went well; we had no rest, nor were our thirsty beasts even watered. Indeed I wished very much that I were in Chartres or Orleans, and so did others" (2, 4, 139). As to his age, he says he was sixty-five in 1123 and sixty-six in 1125 (see 3, 14, 17, 44, 4).

48. At the same time, his last words tell of a plague of rats (3, 62) soon after Christmas in 1126, which for him was the beginning of a new year. It is not possible to say for sure what event this natural disaster portended for Fulcher, but the Angevin count Fulk was soon (spring, 1128) to arrive in the Holy Land as heir to the Kingdom of Jerusalem. Doubtless in Fulcher's mind Fulk was a rat who was to bring a plague of Angevin rats. By the time the Angevins arrived, Fulcher was, as far as we know, either dead, incapacitated, or removed from the region.

49. *Gesta Francorum*, trans. Rosalind Hill, 98–99.

50. It is possible that Stephen of La Ferté, a former abbot of St. John in the Valley and patriarch of Jerusalem in 1128–30, played a role in introducing elements of the Chartrain liturgy into the city. The controversies and major players in these disputes are listed in Dondi (2004), 53–60.

51. Introduction to the *History of the Expedition to Jerusalem*, 37, and Fulcher, 1, 5, 1–8, trans. Ryan, pp. 69–70, and 7, 1–3, pp. 74–75.

52. Linder (1990) has transcribed the incipits for the feast of the retaking of Jerusalem as represented in its pre-1149 state and found in London, BL add. 8927, ff. 134–35, a copy in various hands from the twelfth and thirteenth centuries of three primary historians of the First Crusade, Fulcher of Chartres, Walter the Chancellor, and Raymond of Aguilers. The outline of the feast closes out the book and appears to be in the same hand that copied Raymond's history, the sequence being the only chant written out in its entirety. Linder (1990, 131) says that through this feast, "the new earthly Jerusalem was assimilated to a new church, with the rich cluster of ideas and sentiments that became associated with the term in twelfth-century Europe."

53. See Pedersen et al. (2004) on ritual and reality in the Middle Ages. Wulf Arlt has written extensively about the coming of the "new song" into liturgies of the eleventh and early twelfth centuries. His paper "Sequence and 'Neues Lied'" (1992) is a classic, and he speaks particularly of the kind of sequences that were greatly in favor among the Augustinians in the twelfth century; see also Fassler (1993a) on the reasons for this association and the character of the class of pieces to which the two sequences presented here belong.

## 7. INTRIGUE, FERVOR, AND THE BUILDING OF CHURCHES

1. Salve porta perpetue lucis fulgida. Maris stella inclita domina, Virgo materque Dei, Maria. Praeelecta ipsius gratia ante secularia tempora.

2. It is no. 51 in Hiley's edition of the Norman Sicilian repertory; he places it within a group of twenty-eight sequences composed before 1000 that circulated throughout the region that became France.

3. The idea of the new tabernacle appearing when the old no longer existed is an idea parallel to that of the departing scepter explored by Fulbert in his Advent sermon against the Jews. The understanding that one group, its temples and rites, needed to be destroyed for another to flourish was promoted by the crusaders and those who supported them (see chapter 6).

4. The general facts of the political situation are well known, although many of the particulars are disputed. The sketch here provides context for the history-making project embarked upon in Chartres in the mid-twelfth century and manifested in the surviving artworks. Understanding the degree to which various donors' ideals may be found in the art and having a sense of their interests and the pressures brought to bear upon those involved during these decades are critical.

5. Brown and Cothren (1986) explore political relationships involving St. Denis, Louis, and Eleanor during the time of the Second Crusade. Choate (2009) provides a detailed explanation of the ways the feast of the Dedication was linked to history and the cult of the patronal saint at the Abbey of St. Denis.

6. For his career I have depended especially on Arbois de Jubainville, vol. 2 (1860); the count's early years are treated fully in LoPrete (2007). A brief sketch of the members of the family, including the generation of Thibaut the Great, is found in appendix H. For the involvement of Count Thibaut in the building of the Cistercian abbey church of Pontigny, see Kinder (1992).

7. Andreas of Fontevraud's *Second Life* of Robert of Arbrissel, which dates from around 1120, is witness to these events (it would not be surprising to find an Angevin partisan describing the count of Chartres/Blois in unfavorable terms): "The bishop of Chartres . . . had died and an-

other, unanimously elected by the clergy, had been enthroned in his place. But there was such trouble between the clergy and the count of the city that some of the canons, having lost their property, feared that they would be torn limb from limb at the count's command. . . . For the ruler of the city had already ransacked the canons' dwellings, and shut them up in their cloister. Furthermore—it is wicked to speak of—he had driven away from the city the outstanding man, Geoffrey by name, whom the clergy had lawfully set in the place of the departed Ivo on the episcopal throne" (trans. Bruce Venarde, 33–34). "Defunctus quippe jam fuerat Carnotensis antistes . . . et in loco ejus, communi clericorum electione, alius inthronizatus. Tanta autem seditio inter clericatum et comitem illius civitatis versabatur, ut etiam nonnulli canonicorum amissis facultatibus suis, jussu comitis membratim trucidari timerent. . . . Depraedatus etenim jam fuerat ejusdem urbis princeps canonicorum domos, eosque in claustro suo incluserat: et, quod dictu quoque nefas est, praeclarum illum virum, Gaufridum nomine, quem clerici in loco defuncti in pontificalem cathedram canonice inthronizaverunt, ab urbe fugaverat" (*PL* 162:1064C–65A). See Jaffé, *Regesta*, 6519; and *CNDC* 1:XXXVI, for a bull dated April 5, 1116, in which Pope Paschal writes to Archbishop Daimbert of Sens confirming Geoffrey's election and threatening to anathematize Thibaut.

8. *Chronicle of Morigny* 2.6: "Theobaldum . . . comitem Carnotensium, Blesensium, Meldensium . . . comes palatinus, et intra Franciam secundus a rege, divitiis et nobilitate tumefactus, ab adolescentia sua velut hæreditario bellorum jure regem Ludovicum coepit infestare" (*PL* 180:141B). Cusimano's translation (p. 47) is based on the Latin edition of Léon Mirot. The chronicler says that Count Thibaut was already the "count Palatine" and so "second to the king within France" (same passage). The counts of Chartres/Blois held this title in the eleventh century as well and were proud of it, recording it in the cathedral necrology to describe Count Odo II, for example. Suger, who admired King Henry I of England, also thought highly of his sister, Adela of Chartres/Blois, as revealed in chapter 19 of his *Deeds*. There he claims she was always faithful to the king; her son Thibaut, on the other hand, is portrayed as the major foe of the French king during this same period.

9. For Orderic's report of his various battles with Louis VI, see *Historia* 9:159–63. In her notes on these lines Chibnall points out that the count sometimes fought on the side of the French king until 1111, after which he was always allied against him.

10. Orderic, *Historia* 9:36 (ed. Chibnall, 6:158, with notes correcting dates), and Luchaire, *Louis VI le Gros, annales* (=*Annales*) no. 114, p. 61, on the first war between the king and Hugh of Le Puiset in 1111, and *Annales* no. 236, pp. 114–15, on the third in 1118. The genealogy of the Le Puiset family was first established by Alphonse de Dion (1886); significant additions have been made by La Monte (1942) and Livingstone (1992). Along with many other local families, the Le Puisets played a role in both the First Crusade and the consolidation of the Latin Kingdom of Jerusalem in the first half of the twelfth century, for which see La Monte (1942) and Racinet (2006). The warfare between King Louis VI and his various vassals continued for decades, the alliances constantly shifting. When the king's dysentery flared up in 1135, he called both Count Thibaut and Raoul, count of Vermandois, to what he thought was his deathbed for reconciliation. See Luchaire, *Annales* no. 559, p. 254.

11. Suger, *Deeds*, 19, p. 84. The strategic position of familial lands is discussed in chapter 6.

12. Luchaire, *Annales*, no. 262, p. 125 (citing Suger and the Morigny chronicle), dates the incident between September 17 and October 3, 1119, which is within weeks of the feast of the Nativity of the Virgin (September 8). Cf. Dufour, *Actes de Louis VI*, 154, dating Louis's stay in Étampes after this incident.

13. See Suger, *Deeds* 26 (p. 118). In their introduction, the translators mention the liturgical lessons Suger composed for "the liturgical office at St. Denis on the anniversary of Louis VI's death" (*PL* 186:1341–46) and suggest that they predate the *Deeds* and actually are their source. Louis VI died in 1137; Suger was writing about this event decades after it occurred, but his work

demonstrates the close connection between history for liturgical celebration and the recording of deeds and events in a chronicle, or *gesta*. Suger's mode of composition and the interplay between the historical and the liturgical were typical of the age.

14. On the date of the *Chronicle*, see the introduction by Léon Mirot. The author of the first book was a cantor, the monk Thiou. He was named abbot of Morigny in 1109 but left almost immediately to become a monk at St. Crespin of Soissons. Of the fire of 1119 the *Chronicle* says, "King Louis, on returning from Normandy with his army, had arrived at Chartres and burned part of the city" ("Carnotum adventasse, urbisque partem . . . concremasse" (trans. Cusimano, 62–63).

15. See the translation of this document in appendix C and discussion in chapter 1. The likelihood is that areas in the *suburbium* of the city were burned, but that the siege was called off before the city was actually taken, thus accounting for the apparent discrepancy in the sources.

16. The horror of this disaster and the dramatic event of telling the king that his son and heir, his second son, and two natural daughters were dead, captured the imaginations of several twelfth-century historians. Orderic Vitalis was the closest to the actual event; others are William of Malmesbury, the Anglo-Saxon Chronicler, Simon of Durham, and Henry Huntingdon. Orderic 12:26 (ed. Chibnall 6:296) says of Stephen's disembarking that "two monks of Tiron and Count Stephen with two knights . . . realized that there was too great a crowd of wild and headstrong young men on board." One of these monks was doubtless Stephen's half brother Hugh, who was his close friend, and who later joined him in England. Of the couple Oderic says, "Also Richard, earl of Chester, a young man of great valour and notable kindness, with his wife, Matilda, who was the sister of the palatine count, Theobald." Richard of Avranches, earl of Chester, was one of the few whose bodies were recovered. The king's treasury was on board the doomed ship; it washed ashore as a poignant reminder that while the gaudy display survived, the most valuable cargo was lost. Orderic says that Berold, a butcher of Rouen, wrapped in rams' skins, was the only survivor; taken aboard by fishermen after clinging all night to a spar, he "told the whole sad tale to those who wished to learn." Arbois de Jubainville (1860), 2:248–52, argues that the White Ship disaster dramatically transformed both Adela and her son Thibaut, leading them to a more intense piety and greater acts in support of the church and the public good. According to Orderic, it was Count Thibaut who devised the plan of having the king be told of his son's death by a weeping child.

17. Henry's marriage to Adela, daughter of Godfrey of Louvain, in 1121 is depicted as having been celebrated by a flawed ceremony, portending failure. See Elizabeth Brown (1992), 46.

18. Baudri of Bourgueil, in his long poem to the countess Adela, wrote that she was in no way inferior to her father, King William, except that she did not bear arms; but then he states that she would have if custom had allowed. See his poem no. 134, "Adelae Comitissae," in *Opera*, 150, lines 33–36.

19. Peter the Venerable, *Letters*, 1:22.

20. On names and naming, see Dunbabin (1993).

21. LoPrete (2007) describes the sources for what we know of William's character; the reasons for his being passed over are not clear.

22. See King (2000) for a close reading of the documents surrounding Stephen's accession to the throne.

23. See Orderic 11:5 (ed. Chibnall, 6:42–45, and notes).

24. Mathilda was betrothed at the age of seven in 1109 and married in 1114; when Emperor Henry V died he left his young wife the imperial insignia. See Orderic 12:43 (ed. Chibnall, 6:360, and notes) and Chibnall (1991), esp. 45–50.

25. Chibnall (1991) treats the empress more sympathetically than most historians but also recognizes an early desire that her father's crown sit upon her head. Chibnall censures Mathilda's critics by arguing that her ambitions would have been praised in a son.

26. See especially Johnson (1961).

27. Orderic 12:20 (ed. Chibnall 6:454).

28. See OC 240–44; Johnson (1961); and chapter 12 below. For discussion of the scene at King Henry's deathbed and his supposed making of Stephen his heir as he died, see King (2000, esp. 292–93), who believes that King Henry stayed with his daughter to the end. William of Malmesbury says that the king reaffirmed his decision to have his daughter succeed him (*Historia Novella*, 24–25), whereas the *Liber Eliensis* 3.46 relates that he chose Stephen with his dying breath. Edmund King says, following the *Gesta Stephani*, 12–13, that the perceived links between the new king and his talented older and younger brothers only strengthened his position.

29. For this period the *Chronicles* of Robert of Torigny is the best source for details relating to Chartres. I have quoted from the translation of Joseph Stevenson (for the Latin, see *Chronique*). For the year 1137, the chronicler reports on a meeting of the Thibaudian brothers: "At Evreux he (Stephen) had a conference with his brother, Count Tebaud, to whom he promised to pay two thousand marks of silver annually; and this he did because count Tebaud was angry that he, Stephen, being the younger, should obtain possession of the crown that he said belonged to himself" (710).

30. Suger says in his *De administratione* (59), "Their owners (monks from Citeaux and Fontevrault) had obtained them from Count Thibaut for alms; and he in turn had received them, through the hands of his brother Stephen, King of England, from the treasures of his uncle, the late King Henry, who had amassed them throughout his life in wonderful vessels." The king's treasure was kept at Winchester, where Henry of Blois, brother to Thibaut and Stephen, was bishop. On the office of treasurer, see Hollister (1978), who notes that the treasurer's office appears to have been vacant for most of Henry's time as bishop, and it would therefore presumably come under direct control of the bishop. According to a chapter from the part of Saint Bernard's vita written by Arnold of Bonneval, Thibaut delighted in two golden chalices that had been used when Henry I was consecrated as king, but the count eventually broke them up and gave the jewels on them for alms (*PL* 185:301–02).

31. See especially Bates (1989) on the impossibility of maintaining a kingdom of such disparate parts. He questions the degree to which there was a true Anglo-Norman entity after the time of the Conqueror himself.

32. The almshouse mentioned in the sources is apparently identifiable as the Hôtel-Dieu, which was, from the end of the twelfth century until its senseless demolition in the 1860s, located just west of the southwest tower of the cathedral. See the obituary of Bernard the Sacristan, OPS1032 46DE (6 March), which says that he rebuilt the almshouse "after the fire"—"et Elemosinam hujus ecclesie post incendium de proprio reedificavit." Bernard was a major figure in the campaign that built the towers and west façade in the mid-twelfth century (see chapter 9).

33. See *Chronicle of Morigny*, 3.2. The passage concerning Bishop Geoffrey reads, "Also among them was Geoffrey, bishop of the province of Chartres, a man not unworthy in the science of letters, a manager of secular affairs, and a famous negotiator ( . . . . secularium quoque negociorum dispositor ac tractator famosus). His papal superiors always esteemed him as a friend and an intimate, and for his gifts of great courage and dignity they appointed him legate over the entire Aquitaine" (trans. Cusimano, 126–27)(see chapter 8 for discussion of Bishop Geoffrey). For the prenuptial negotiations, see Luchaire, *Annales*, no. 580, pp. 264–65; cf. Dufour, *Actes de Louis*, 386, who wishes to refine the date to the first half of June; *La chronique de Morigny*, ed. Mirot, 67; Suger, *Vita Ludovici*, ed. Waquet, 280. For a well-documented discussion of the journey, the marriage ceremony, and Eleanor's crowning, see E. A. R. Brown (1992), 36–40.

34. *Chronicle of Morigny*, 3.2, trans. Cusimano, 128–31.

35. See Luchaire, *Annales* no. 474, p. 219. The young king's death took place on October 13, and

Louis was crowned as heir designate and "junioris regis" on October 25, see *Annales* no. 476, p. 221. Cf. Dufour, *Actes de Louis*, 307, pp. 155–56, note 1, for an extensive discussion of the refinement of the date of the king's act in favor of St. Vincent of Senlis—which mentions Philip's death and is "signed" by "Ludovici, junioris regis"—to the first or second of November 1131.

36. Louis VII's pillaging of Thibaut's territories in 1142 and 1143 led to a dramatic series of letters from Bernard of Clairvaux (trans. James, nos. 294–304, pp. 361–74; ed. Leclercq and Rochais, nos. 216–17, 220–27, 358; vol. 8, pp. 76–78, 82–97, 303). The difficulties were seemingly provoked by the actions of Ralph, count of Vermandois, who attempted to put aside his wife, Leonora, a niece to Count Thibaut, and marry Petronilla, the sister of Queen Eleanor. When Ralph's second marriage was disallowed, the king, probably under the influence of his wife, began an assault on Thibaut, who was defended by Bernard. Bernard wrote first to Pope Innocent II and then, after Innocent's death in 1143, to Pope Celestine. John of Salisbury speaks of the incident at length in his *Historia Pontificalis* (12–15) and believed that the marriage of Ralph and Petronilla was cursed: she died soon after giving birth to their third child, and John reported that the boy became a leper and the girls were not fruitful in their marriages. The situation is discussed in Duby (1991). King Louis's devotion to the cult of the Holy Innocents probably arises from the disaster at Vitry (see chapter 11). On Louis's acts, see Luchaire, *Études sur les actes de Louis VII.*

37. A. W. Lewis (1978) demonstrates that the Thibaudians followed the practice of anticipatory association of the heir to the domain throughout the eleventh century, but that there is no evidence of the practice in their line after the time of Count Stephen-Henry (d. 1102).

38. For discussion of the ways in which political problems at home were exported to the Holy Land and brought back again, see Paul (2005).

39. King Stephen first had to come to terms when he was taken prisoner at the battle of Lincoln, which was fought on the day of the Purification, February 2, 1141. The era has been studied at disproportionate length, but historians remain divided about many aspects of Stephen's reign. Essays in King, ed. (1994), indicate that the period calls for renewed and interdependent study of English, Norman, Sicilian, and French cartularies to bring in the various threads of influence and to balance the heavily partisan reports of the chroniclers.

40. King Stephen's son and heir designate Eustace, born around 1129, predeceased his father in 1153.

41. The *Gesta Stephani* and Orderic are at odds over Henry of Blois's role, Orderic believing him to be a traitor to his brother. Orderic's recountings may reflect Thibaut's position on various issues. Henry was a patron of historians, including William of Malmesbury and his protégé, Robert of Lewes, bishop of Bath, apparently the author of the *Gesta Stephani*, for which see Ralph Davis (1962). It is wondrous to read in Orderic that following the outbreak of civil war, after Stephen's capture by the empress in 1141, the nobles of the land came together and offered the entire kingdom, including Normandy, to Count Thibaut: "He, however, being a wise and pious man, refused to undertake the heavy burden of such responsibilities and renounced his right to the kingdom in favour of King Henry's son-in-law, Geoffrey, stipulating certain conditions. These were that Geoffrey should hand over to him the town of Tours, which was in his fee, and should release his brother Stephen from his fetters." The passage demonstrates that the Thibaudians continued to lament the loss of Tours in 1044 and remained ever conscious of the earlier history of their family.

42. See Evergates (1992) for a succinct summary of the relationship between King Louis VII and the counts of Chartres/Blois. Warren (1973) is a monograph on the life of Henry II, the details of which depend upon the contemporaries Gerald of Wales (Giraldus Cambrensis) and Walter Map.

43. See Hollister and Keefe (1973) for an explanation of Henry II's consolidation of his empire; they argue that its formation was a result of Henry's own initiative and military prowess, not

the result of seeds planted by his father, his mother, or his grandfather. Henry was born in 1133; his father, Geoffrey of Anjou, had secured Normandy for him by 1144, and he became duke in 1148. When his father died in 1151, he became count of Anjou; in 1152 he married Eleanor of Aquitaine and acquired her lands; in 1153 he invaded England and secured it by the Treaty of Winchester; upon Stephen's death in 1154, he became king. There is more, but these events are the background to those discussed in this chapter.

44. Petit-Dutaillis's *The Feudal Monarchy in France and England* (1936) remains a useful overview. Amy Kelly's *Eleanor of Aquitaine and the Four Kings* (1950) makes excellent reading but is excessively dependent upon chronicles without the balancing evidence of cartularies. For a sensitive portrait of King Louis VII, see Sassier (1991). The Thibaudians have no comparable modern history from the twelfth century, although one can study the writings of historians patronized by them, most important, William of Malmesbury, to get a sense of how they wished themselves and the family to be depicted. Eley and Simons (1998 and 2000) have identified the patronage of the Thibaudians in *Partonopeus of Blois* and traced out vestiges of the ancient rivalry between them and the Angevins in its argumentation and choice of phrase.

45. Once again, in the last decade of the century, yet another Thibaudian, Henry of Champagne, son of Henry the Liberal, became a king, this time of the Latin Kingdom of Jerusalem; he reigned in 1192–97. The Thibaudian counts of Champagne were kings of Navarre for much of the thirteenth century.

46. Arnold of Bonneval devoted a chapter (*PL* 185:299ff.) of Bernard of Clairvaux's vita to Count Thibaut; he describes both there and elsewhere the count's lavish support of Cistercian building projects.

47. This donation is recorded in the necrology two times, the second to correct abuses.

48. See Bernard's letter to Pope Lucius II (April 1144), trans. James, no. 204, pp. 274–76; ed. Leclercq and Rochais, no. 520, vol. 8, pp. 480–82.

49. See Henry of Blois, "Scriptura Henrici," 8, no. 38:26–27, for a description of his work at Cluny, which included paying for all expenses for an entire year. Edmund Bishop (1918) studied an inventory of his many gifts to Winchester Cathedral; Riall (1994) is a study of his life as a patron of the arts. In addition to Riall, see Kusaba (1993), Donovan (1993), Lindley (1993), and the other essays published in Crook, ed. (1993).

50. *Historia Pontificalis*, 40; trans. Chibnall, 79–81. John of Salisbury was a partisan of Theobald, bishop of Canterbury, archrival of Henry of Blois. In the introduction to her edition and translation, Chibnall speculates that, although the work covers the years 1148–52, it was probably composed much later from notes and memories (see especially p. xxx).

51. Hermann of Laon, *Miracula sanctae Mariae Laudunensis* 1.13 (*PL* 156:972C). Yarrow (2006) contains an analysis of Hermann of Laon's miracles, with references to their earlier sources; the Chartrain triple miracle appears only in Hermann's work.

52. See especially Low (2003) on the arrangement of the program at Vezelay and its teaching powers.

53. The cross is called simply "crux" in the Latin: see John of Worcester, *Chronicle*, ed. and trans. P. McGurk, 3:230–31. For discussion concerning the literal truth of the stories emanating from Chartres, see Erlande-Brandenburg (1994). The larger picture is of a general widespread fearfulness, especially in urban areas, and a clergy that was aware of it. See *Medieval Art and Architecture at Winchester Cathedral* (1983).

54. See Constable (1996), Fassler (1993a), and Van Engen (1986) for discussion of the twelfth century as an age of reform and for much additional bibliography. Signori (1995) and Yarrow (2006) provide introductions to the production of Marian miracles in the twelfth century that emphasize the importance of local themes within broadly circulating materials. For discussion of the miraculous within popular liturgies and music for the Virgin Mary in the thirteenth century, see Fassler (2004a). For four case studies that reveal a great variety of circumstances

and attitudes of clergy and people toward the cults of the saints, see Abou-el-Haj (1991); further comparative work is found in the essays on relics and memory by Borgeaud and Volokhine (2004–05). Nugent (2001) offers study of particular rituals of healing and their importance in the development of miracle literature in the period. The importance of Chartres as a pilgimage site is evaluated by Bugslag (2005): many of the old assumptions about Chartres and pilgrimage no longer hold, but it was important as a Marian shrine for pilgrims throughout the Middle Ages; the evidence for pilgrimage remains difficult to find and evaluate.

55. See especially Miracle 3 (Prologue and no. 1 in the Latin version), in Kunstmann, ed., *Vierge et merveille*, 52–60. The fame of miracles could inspire the gifts of people from other towns and regions. In Miracle 10 (no. 3 in the Latin version), for example, people from Château-Landon bring a wagon of wheat as a contribution and are fed miraculously when they suffer a delay (Kunstmann, 112–17). Signori (1995), 174–201, discusses the Latin version of the miracles of Chartres from the early thirteenth century, and Kunstmann, 9, is a comparative table. Kraus (1979) is an engagingly written study of how funds were raised for building campaigns in the late Middle Ages; the relationship between the miracles and pilgrimage throughout the Middle Ages is discussed in Bugslag (2005).

56. Social historians have written copiously about the shifts in demographics taking place in the twelfth and thirteenth centuries, and central to this has been the work of David Herlihy (for example, 1985), who pointed to upper-class women's loss of power over land and money in this period. He has argued that before the twelfth century women were more vulnerable to disease and early death than men and hence in short supply, whereas from the twelfth century on the imbalance was slowly reversed. Martha Howell (1987) has offered a comparative review of Herlihy's studies and several other related books of its time. The ways in which economic shifts affected the lives of women workers are broached in Farmer (1998), which is useful for its imaginative arguments and its bibliography concerning late thirteenth-century women in Paris on the margins of poverty.

57. For a readily available synopsis and bibliography of primary and secondary sources, see Barnes (1996).

58. See *De consecratione*, ed. Panofsky, 93: "Whenever the columns were hauled from the bottom of the slope with knotted ropes, both our own people and the pious neighbors, nobles and common folk alike, would tie their arms, chests, and shoulders to the ropes and, acting as draft animals, draw the columns up."

59. *RHG* 14:319, note (a). For translations, see Coulton (1928), 338, and Branner (1969), 94.

60. Robert of Torigny, *Chronicles*, 721, and *RHG* 14:319, note (a). Coulton (1928), 339–41, has another translation of this passage.

61. See Haymo, "Lettre," ed. Delisle, 122–24, for a transcription from a seventeenth-century copy of a lost original: "Ubi vero ad ecclesiam perventum fuerit, in circuitu ejus plaustra velut castra spiritualia disponuntur, ac tota nocte sequenti a Domini exercitu excubiae in psalmis et canticis celebrantur, tum cerei et luminaria per plaustra singula accenduntur, tum infirmi ac debiles per singula collocantur, tum sanctorum pignora ad eorum subsidia deferuntur, tum a sacerdotibus et clericis processionum mysteria peraguntur, populo pariter devotissime subsequente et Domini simul et beatae ejus matris clementiam pro restitutione debilium attentius implorante. Si autem sanitates ad modicum tardaverint, et non statim ad votum fuerint subsecutae, illico videas universos vestes abjicere, nudos simul viros cum mulieribus a jumbis et supra, confusione omni abjecta, solo incumbere, puerulos et infantes idem devotius agere et ab ecclesiae atriis solo stratos non jam genibus et manibus, sed potius tractu corporis totius primum ad altare majus dein ad altaria singula repere, matrem misericoridae, novo quodam obsecrantium genere, inclamare atque ibi statim ad ea petitionum suarum pia desideria extorquere certa."

62. Bugslag (2005) discusses the cult of the carts as depicted in the Miracles of the Virgin window

in the east end of the south nave aisle, usually dated to 1205–15, only the bottom of which is original (see Delaporte [1926], 189–94).

63. Kupfer (2000) is a richly detailed study of art created for the nurturing of the sick. See Touati (1980) for discussion of the Grand-Beaulieu in Chartres in the twelfth and thirteenth centuries and the treatment of lepers there.

64. A long discussion of the disease is found in the *Chronicon* of Sigebert of Gembloux. For religious objects associated with disease and late medieval depictions of ergotism, see Husband (1992).

65. See his *Libellus de miraculis beatæ Mariæ Virginis in urbe Suessionensi* (Paris, BN lat. 2873) and the extended discussion of this work and its significance for pilgrimages generally in Signori (1995), 125–51.

66. See Jean Le Marchant, *Miracles*, 52–60, ed. Kunstmann, for the Latin and Old French.

67. Wilson's discussion of various aspects of Marian miracles, which deals extensively with the twelfth century, is found in her edition of John of Garland, *The Stella Maris*, 195.

68. The fragmented collection by Walter (in Latin "Gauterius") of Cluny (sometimes known as "of Compiègne") was written in the mid-twelfth century; see *PL* 173:1379–86. It has several similarities with the *De laude sanctae Mariae* of Guibert de Nogent but is not closely enough related to suggest a direct dependency. Like that of Hugh Farsit of Soissons, these collections illustrate the kinds of legends in circulation in northern France and England in the middle of the twelfth century. For a general discussion of the twelfth-century Marian legends, in addition to Evelyn Wilson's introduction to John of Garland, see André Wilmart (1932), and Signori (1995).

69. See Kunstmann's introduction to his edition.

70. See Arnold of Bonneval's treatise on the six days, *PL* 189:1554BC: "Non invenitur prudentia in terra eorum qui vivunt suaviter, sicut Job ait; quippe in locis humentibus et secreto calami sub umbra dormiens (Job 4) Satanas commoratur. Panem arctum et aquam brevem praedicat Isaias (Isa. 30), et David ex verbo Dei per Spiritum sanctum per vias duras ingreditur. In multa sapientia, multa indignatio, et qui apponit scientiam apponit dolorem (Eccl. 1), quia vere adversus vanitatum amplexus semper indignans ratio colluctatur, et laborat sanctimonia, ne adulatione titillatoria mentis integritas corrumpatur. Nullus in hoc labor est effeminatis et mollibus, qui ultro se ad omnem divaricant corruptelam. In tentationum infirmitate, virtus servorum Dei perficitur et augetur, et ex luctu compunctionis, devotio sancta gaudium concipit. Circuit poenitens, et per intimos animae suae recessus sparsa congerit, et fasces alligat admissorum. Circuitus contra circuitum, quia flexibile corpus gyrat draco volubilis, et perplexis innodationibus vagos et improvidos usque in labyrinthum impellit, et immersos tenebris in desperationis abyssum concludit."

71. When Louis VII tried once again to organize a crusade, this time in 1150, he had one of the three meetings at Chartres, where the Virgin Mary, whose cult and whose church might have offered blessings; but it was not to be. See note 17 in chapter 12.

72. For discussion of a consecration ceremony in the thirteenth century at Le Mans Cathedral and its influence upon architectural design, see Lillich (1982).

73. For an overview of the chant texts used for the Mass and Office and ways in which they became standardized and transmitted, see Kozachek (1995). He does not discuss tropes and sequences. Fassler (1993a) contains an analysis of Hugh of St. Victor's commentary upon the feast and the incorporation of these themes into the Victorine sequence repertory. Bodil Asketorp has a volume on the tropes for the Dedication feast forthcoming in the *Corpus Troporum*.

74. For a detailed discussion of the feast of the Dedication and the use of its themes as imported by the mendicant orders to the New World, see Jaime Lara (2004), and his second volume on the liturgical texts (2008).

75. See Chartres, BM 520, 432v–33: "Deus qui per singulos annos huius sancti templi tui consecrationis reparas diem et sacris semper misteriis representas incolumes; exaudi preces populi tui et presta ut quisquis hoc templum beneficia petiturus ingreditur cuncta se impetrasse letetur. Per Dominum nostrum [Jesum Christum: qui vivit et regnat in unitate Spiritus Sancti, Deus, Per omnia saecula saeculorum. R. Amen.]"

76. The best example of language from the biblical building of the Temple used to describe a donor's bequest is found in the obituary of Milo of Muzy (OPS1032 64BD, May 1). (See the discussion in chapter 9).

77. For example, it is instructive to compare Suger's discussion of how he got the huge timbers for his church to the passage in 3 (1) Kings 5 concerning Solomon's difficulty in getting the beams he needed (see *De consecr.* 5 in *Oeuvres*, ed. Gasparri, 1:18ff.).

78. The passage in 3 (1) Kings 5:13–18 calls to mind the medieval idea of people bearing burdens for the sake of building as well as the great numbers that Bishop Geoffrey assembled to carry out his vast building campaigns: "And king Solomon chose workmen out of all Israel, and the levy was of thirty thousand men. And he sent them to Libanus, ten thousand every month by turns, so that two months they were at home . . . and Solomon had seventy thousand to carry burdens, and eighty thousand to hew stones in the mountain: Besides the overseers who were over every work, in number three thousand, and three hundred that ruled over the people, and them that did the work. And the king commanded, that they should bring great stones, costly stones, for the foundation of the temple, and should square them. And the masons of Solomon, and the masons of Hiram hewed them: and the Giblians prepared timber and stones to build the house." See the discussion in Barnes (1996).

79. OPS1032 35H–36A. See discussion in chapter 8 and appendix G for a translation of the obituary.

80. Sauerländer (1992) says, "With their sculptured decoration, Romanesque churches begin to resemble the public monuments of a Roman forum. Their façades evoke the triumphal arches, the city gates, the palaces and the *scenae frons* of the pagan past" (22); see also idem (1982).

81. See Rubenstein (2004) for discussion of the manuscript containing Fulcher's text and its purposes. The brief account of the Second Crusade in the Würzburg Annals provides a discussion of the despair and discouragement felt at the time and offers reasons why some individuals supported it. The passage claims that Bernard of Clairvaux was actually reluctant, but Pope Eugenius persuaded him. For a further lament concerning the Second Crusade, see *Annales herbipolenses*, MGH SS 16.3.

82. Delaporte (1960) discusses this earlier feast as it appeared in two early (and now lost) Chartrain liturgical books: one Chartres, BM 507, a passionale/martryology from the tenth century (note that the Omont *Catalogue générale* calls BM 507 a "legendarium" and dates it to the eleventh century); and Chartres, BM 578, an early eleventh-century Gospel book. As can be seen in a photograph taken by Delaporte of BM 578, the rubric for the Gospel read, "III idus mai. [May 13] dedicatio ecclesie sancta Marie Carnotensis." Delaporte (p. 152) notes that the table of liturgical incipits that once formed a part of the now-lost Chartres, BM 1058 and that predated the ordinal also contained the feast on May 13. Given that descriptions of liturgical books in manuscript catalogues, which are prepared by scholars without specialized knowledge of the liturgy, are as often wrong as right, Delaporte is to be trusted over Omont.

83. Bede's sermons were often chosen to supplement the work of Paul the Deacon, from the late eighth century. For discussion of the development of medieval sermon collections, see especially Réginald Grégoire (1966 and 1980) and the collected works of Raymond Étaix (1994).

84. In the capital frieze of Étampes the entrance to Jerusalem scene features Zacheus in a tree. See Nolan (1989) for discussion of this work.

85. A. Prache (1993) has described the thirteenth-century cathedral of Chartres that would rise

behind the west façade in terms of a new Jerusalem, but its builders took their cues from the twelfth-century west façade, where there already was a particular model of church—and of liturgical art—that plays upon meanings associated with the Temple of Solomon recast in a Marian vein and with constant reference to the actions that highlight the Incarnation. In addition to Lara (2004), see Krinsky (1970) for an overview of replicas of the Temple in Christian art; for twelfth-century Parisian drawings of Ezechiel's temple vision, see Cahn (1976).

86. The feast as celebrated in the diocese of Chartres in the thirteenth century, when its liturgical nature was in flux, is discussed in chapter 12. The only study of this feast at Chartres is that of Delaporte (1960) and his notes on the celebration in OC. As noted by Dondi (2004), the twelfth-century feast at Chartres Cathedral was the source for the feast of the dedication in the liturgy of the Holy Sepulcher in Jerusalem.

87. Eric Fernie (1980, 1984) discusses the principles of deliberate variation found in medieval art and architecture and some biblical texts that relate to these ideas; the differences between the descriptions of Solomon's building projects in 3 Kings and 2 Chronicles are discussed in Talshir (2000); Schwartz (2001) is a popular study of how the Temple may have looked at various stages in its construction.

88. "The former indeed had also justifications of divine service, and a worldly sanctuary. For there was a tabernacle made the first, wherein were the candlesticks, and the table, and the setting forth of loaves, which is called the holy. And after the second veil, the tabernacle, which is called the holy of holies: having a golden censer, and the ark of the testament covered about on every part with gold, in which was a golden pot that had manna, and the rod of Aaron, that had blossomed, and the tables of the testament. And over it were the cherubims [*sic*] of glory overshadowing the propitiatory: of which it is not needful to speak now particularly. Now these things being thus ordered, into the first tabernacle the priests indeed always entered, accomplishing the Offices of sacrifices. But into the second, the high priest alone, once a year: not without blood, which he offereth for his own, and the people's ignorance: the Holy Ghost signifying this, that the way into the holies was not yet made manifest, whilst the former tabernacle was yet standing. Which is a parable of the time present: according to which gifts and sacrifices are offered, which can not, as to the conscience, make him perfect that serveth, only in meats and drinks, and divers washings, and justices of the flesh laid on them until the time of correction. But Christ, being come an high priest of the good things to come, by a greater and more perfect tabernacle not made with hand, that is, not of this creation . . . And therefore he is the mediator of the new testament: that by means of his death, for the redemption of those transgressions, which were under the former testament, they that are called may receive the promise of eternal inheritance" (Heb 9:1–11, 15).

89. In the later Middle Ages and the early modern period both motets and masses incorporated texts from the Dedication feast to make powerful statements about the church. Craig Wright (1994) has explored a dedication motet by Dufay, showing how the musical structure embodies the dimensions of the Temple of Solomon, with reference to studies of other later repertory related to the Dedication feast.

## 8. THE CAMPAIGN AT MIDCENTURY

1. Guibert of Nogent, *Self and Society*, 1.16; trans. Swinton Bland, 84–85:. "Cumque pro meo et tantae Ecclesiae moesta foret discrimine, ecce infinitae pulchritudinis ac majestatis femina per mediam basilicam ad altare usque processit, quam quasi juvencula sequebatur, cujus species ejus multum idonea videbatur obsequio quam consectabatur. Cum ergo curiosissima esset scire quaenam foret domina ipsa, dictum est ei quia esset domina Carnotensis. Quod nec mora conjiciens, beatam Dei Genitricem intellexit, cujus nomen et pignora ibidem totius

pene Latini orbis veneratione coluntur" (*PL* 156:871C). Guibert's interest in the Virgin Mary is manifested in his treatise on the Incarnation, which contains evidence for the way the Virgin was part of an anti-Jewish polemic, for which see Abulafia (1996).

2. Herlihy (1990) writes of cloth making as the work of women, central to their identity, through the twelfth century, when men began to join the trade and transform it. To have the Virgin Mary championed through a cloth relic would have had a socioeconomic meaning, not explored here in any detail. One of the miracles recorded in the thirteenth century at Chartres involves a woman who continued to weave cloth through Saturday Vespers; this was forbidden, as the service was devoted to the Virgin Mary, and the woman should have been in church. The legend is Miracle 25 in Kunstmann's edition of Jean le Merchant, *Miracles*, and the story is told as Cantiga 117 among those from the court of Alphonsus the Wise (for both and for further bibliography, see Kunstmann's notes, 43–44). In another of the Chartrain miracles (27), a woman who weaves linen cloth for the altar of the Virgin has her work preserved from fire (see Kunstmann, 44–45 for commentary). The industry and its later survivals in Chartres are reported in Jusselin's article on the history of the Church of St. Andrew as found in Brandon (1924); the industry was long centered near the river Eure in the neighborhood of this church.

3. On the office of Prime generally, with discussion of the ways remembering the dead were a part of it, see Huglo (1986).

4. In a charter that Métais dates "before 1168," William is called "electus" and found in the company of Gaufredus decanus (see *JC* CCLI). In a note to a later chapter, Lepinois and Merlet (*CNDC* 2:24) say that the house of Berou was prominent in the region; Robert of Berou, a great nephew of Dean Geoffrey, became chancellor and gave a window to the cathedral after the fire of 1104.

5. The charters of bishops of Chartres from the first half of the twelfth century have been studied by Combalbert (2007). In evaluating the state of these sources and the number of documents, he offers the following useful summary: "un acte d'Arrald (attesté en 1072 et 1075), quatre actes de Geoffroy Ier (v. 1077–1090), vingt-deux actes d'Yves (1090–1115), quatre-vingt-onze actes de Geoffroy II, mieux connu sous le nom de Geoffroy de Lèves (1116–1149), quarante-trois actes de Goslein de Lèves, neveu du précédent (1149–1156) et trente-et-un actes de Robert (1156–1164), soit au total cent quatre-vingt-douze actes. Contrairement au corpus ébroïcien [he is comparing the acts of the bishops of Evreux to those of the bishops of Chartres], le corpus chartrain n'est pas le reflet quasi exhaustif de la production diplomatique épiscopale sur la période considérée: l'écrasante majorité des actes pris en compte provient des fonds d'archives des grandes abbayes et des prieurés du diocèse de Chartres, laissant de côté les établissements extérieurs au diocèse" (141–42).

6. Especially useful in tracing the first members of the family are *MSC* (see the introduction, 119–20) and Depoin, ed., *Cartulaire*. Several members of the family can also be found in numerous charters from the Abbey of St. Peter, but some of these documents appear to have been forged or at least redacted, and their information must be used with care. The genealogical listings in appendix H are based on the printed documents mentioned here, on discussion with Christopher Crockett (who most generously shared drafts of forthcoming work), and on a study of nine generations in a paper on the parish church of St. Lazare in Lèves by Métais (1908), 19–21. His study, found in volume 4 of *Églises et chapelles du Diocèse de Chartres*, a series of collected papers that appeared in the early twentieth century, is not easy to obtain (papers published in this and other volumes of the *Archives du Diocèse de Chartres* are paginated successively). Although the best general study of the Riche family is the appendix devoted to them in Depoin's cartulary of St. Martin of Pontoise (*Cartulaire*), he has nothing to say about the Chartrain branch. Members of the family in Chartres are discussed by Amy

Livingstone (1992, 1997). The earliest document concering them in *CNDC* (1:91) is published after the original in the Archive Départmentale Eure-et-Loir, G 1112; the last document signed by the patriarch is edited in Prou's acts of Philip I, no. 8 (*Cartulaire*, 24–27).

7. See *CSP* 28–31, at p. 31: "Gauslinus denique de Leugis, non longe a fluvio Auduræ pertinaciter sibi retinet censum nobis annuatim reddendum, de quibusdam vineis ab episcopo Hugone sibi relictis." Bishop Hugh is one of the deposed Chartrain bishops of the eleventh century. Delaporte, in a list of the bishops of Chartres in his article "Chartres" in the *Dictionnaire d'histoire et géographie écclesiatique* (1953), describes him as "Hugo, simoniaque, déposé par Alexandre II vers 1063." For further discussion, see Ziezulewicz (1991).

8. The great number of vineyards mentioned in the charters and necrologies shows the centrality of wine production to the economy of the region in the twelfth century. L. Merlet suggests that the study of wine production in the Beauce in the Middle Ages would be a research topic worth pursuing (*CTT* 1:45, note). For discussion of wine making and the guilds in the thirteenth century, see Williams (1993), who depends on Chédéville (1983).

9. The generations at midcentury are particularly difficult, as can be seen in the genealogical discussion in appendix H: Goslen III, husband of Odelina (a Le Puiset), produced at least three sons, Goslen IV, Geoffrey (who became bishop in 1116), and Milo; Goslen III also had a daughter, Bertha, who married Rahier of Muzy. Goslen IV, married to Lucia, produced six children: three daughters, Odelina, Lucia, and Cecilia; and three sons, Goslen V, Geoffrey, and Milo; his sister Bertha also produced at least four sons: Milo, Goslen (who succeeded his uncle Geoffrey as bishop in 1149), Geoffrey, and Rahier. For further bibliography and discussion of the Muzy family, see Power (2004), esp. 269–71, and Combalbert (2007). Rahier du Donjon appears in the entourage of Louis VI and Louis VII and apparently supported the count of Dreux, a king's man. In the first half of the twelfth century the family started using the name Muzy, taken from their stronghold on the Norman border, near the Avre, midway between Dreux and Nonancourt; Rahier du Donjon was the primary founder of the Cistercian abbey at Estrée. Scholarship by Livingstone and by Crockett is forthcoming.

10. Métais (1908), 13. See Paul of St. Peter and discussion in chapter 3. Note that the story with the reference to the hill in Lèves was added in the twelfth century and could well have been adapted from local legends under the influence of the Lèves bishops: "Unde factum est ut, jam sero facto, in monte Leugarum devenirent, ibi castrametati sunt atque de coriis animalium se undique muniunt. Christiani vero eos insequentes, montem vallant ut proxima die fugientes aggrediant. Quem videntes pagani pavefacti, machinantur quodmodo a periculo mortis se salvare possent" (*CSP* 47).

11. The charters of Josaphat demonstrate the control that the family and the monks they sponsored had over several mills, both near the marshy site of the abbey itself and elsewhere along the Eure.

12. Métais (1908), 19. The close relationship of the Lèves, as a family of castellans, to the Thibaudians in the early twelfth century is evaluated in LoPrete (2007), 97.

13. For his career, see especially *Histoire littéraire de la France*, 13:82–87, Janssen (1961), 18–31, and Combalbert (2007). His work as a religious reformer and his associations with and mentorship of other reformers are treated in Combalbert (2007), Grant (2004), Grauwen (1982), and Smits (1982) "An Unedited Letter." It is greatly to be lamented that none of his sermons have yet been identified, although he is depicted in the act of preaching in the life of Saint Anianus (see appendix C). The *Chronicle of Morigny*, reporting the consecration of an altar of the abbey church by Pope Innocent II in 1130, listed all the major prelates of the region who were pleased to attend, adding, "Archbishop Henry of Sens was indeed there next to the lord pope in place of the royal chaplain, but Bishop Geoffrey of Chartres delivered the sermon to the people" (trans. Cuisimano, p. 103). For his obituary (translated in appendix G), see *OPS*1032 35G.

14. Book 4:14, trans. Anderson and Kennan, p. 127; for the Latin, see *Sancti Bernardi Opera* 3:459–60. John of Salisbury, who studied at Chartres and became bishop there in 1180, knew the story Bernard told: "I pass along without comment that the venerable father Geoffrey of Chartres, legate of Aquitaine, did not receive presents from the provincials, except in cases of food and drink, and these with the greatest frugality; but everything that was offered in the way of a gift he disparaged as excrement. The holy man of Clairvaux testifies that Geoffrey declined to accept a free fish, which is commonly called a sturgeon, from a devoted cleric in his own legation and afterwards he only acceded to the rejected offering once he had paid out the price of the gift" (*Policraticus* 5.15, p. 98).

15. McLaughlin (1995) has demonstrated that the canons of St. John created their books from elements of the cathedral liturgy but sometimes rearranged them.

16. See Delaporte's introduction to *OC*. Richerius, who first appears as succentor in 1167, had been elevated to the office of cantor by 1173 and last appears as such in 1188 (*DIGS* 34, 72). He seems, from his obituary, to have been a significant liturgical editor; books compiled in the generation and a half after his, such as Chartres, 520, which has many changes in the sequence repertory, may reflect his work, as may also the upgrading of some feasts that took place in the course of the twelfth century. Still, the differences between the two ordinals are surprisingly few, especially when one considers (as will be done in chapter 12) that the cathedral burned between the making of the two. *OPS*1032 32C: 9 January, "He bestowed on this church the best gradual, suitable for daily customs and services" ("Graduale quoque optimun huic eidem ecclesie contulit, cotidianis usibus et officiis opportunum").

17. See Souchet (*Histoire*) and Lépinois (1854–58), 1:90. See also Métais (1908), 22. In fact, there seems to be a reference to an early charge of simony in Geoffrey's obituary: see the translation in appendix G. The brand of nepotism he fostered was typical of the era and seems not to have drawn criticism.

18. Bishop Geoffrey's brother Goslen IV was a crusader who departed for the Holy Land in 1107; he surely returned filled with stories that inspired his family and the projects he supported with his brother. A charter dated 1107 has to do with the donation of a family of serfs by the lord of Lèves to the Abbey of St. Peter (*CSP* 274–77). The money the monks gave to Goslen IV as part of the conditions of the gift of the serfs was for his journey to the Holy Land, and he was also giving the serfs for the souls of his parents (who would have been Goslen III and his wife, Odelina). The charter implies that both Goslen III and Odelina had died by 1107, although this cannot be said for sure. These detailed documents point to the later activities of Milo, lord of Lèves, who attempted to go back on some of the concessions made by his more generous uncles, father, and brother (Goslen IV) to local monasteries after the deaths of bishops Geoffrey and Goslen (his brother and his nephew). Members of this family of serfs resurface in a charter from around 1130, which explains the conditions related to the selling of a house. Anseau, a son of the family, has become a monk at the Tiron but still must continue service at the Abbey of St. Peter. See *CTT* 1:148, note.

19. See the foundation charters in *JC* as well as Goslen IV's epitaph (Sept. 30), *OPSJ* 249.

20. The famous quarries at Berchères-l'Évêque (changed to Berchères-les-Pierres after the Revolution) have long been identified as sources of the building stone of Chartres Cathedral and other local churches. Early visits to Chartres and its surroundings were made by Cecil Headlam (1902), whose history is very much in the vein of Henry Adams's poetic descriptions. A. L. Lewis (1890) took a tour in and around Chartres with his son, looking for Druidic dolmens, and comments on the qualities of local stone. Local paving companies still mine stone from these quarries and have pictures of the operations on their Web sites.

21. His obituary (*OPS*1032 37E–38B) is translated into English in appendix G.

22. *OPS*1032 78BC (July 29). "Eodem die ob. Hugo, hujus ecclesie sacerdos venerabilis et subdecanus, utilis in amministratione quam vel intus gessit vel foris, sermone vigens, consilio pro-

vidus, actione strenuus, qui sacrosanctum genitricis Dei templum pretiosa vitrea et pallio bono et capa decoravit optima."

23. *DIGS* 52 and 230.

24. See *OPS*1032 64 BD (May 1) and *DIGS*, xiv, xvi, xvii, xx, xxiii, 128–29; and named as provost of Nogent-le-Faye, 230. The passage in question in Milo's obituary reads, "Capitellum ecclesie a sinistra parte decenti pictura decoravit." The Lewis and Short *Latin Dictionary* says that "capitellum" is the same as "capitulum" and means "the capital of a column" (with reference to 3 [1] Kings 7:16). Niermeyer's first definition is "a capital, on top of a column." The word "pictura" can be translated many ways, including "relief carving." It has this meaning in the Vulgate's description of the carved doors of Solomon's temple, carvings that were then overlaid with gold. See 3 (1) Kings 6:32: "Et duo ostia de lignis olivarum: et sculpsit in eis picturam cherubim, et palmarum species, et anaglypha valde prominentia: et texit ea auro" ("And two doors of olive tree: and he carved upon them figures of cherubims, and figures of palm trees, and carvings very much projecting: and he overlaid them with gold").

25. See *OPS*1032 58E (April 14). Christopher Crockett pointed out to me that the "treasurer of Tours" was not a dignitary of the cathedral there but essentially the abbot of the royal collegial of St. Martin of Tours, and so his was a more important office than it appears on the surface.

26. For discussion of this window, see Lautier (2003). The couple named one of their sons Goslen (1215–39), the last in the line to bear the ancient names of Goslen and of Lèves: his son Thomas took the name of Bruières when he inherited the lordship of Bruières-le-Châtel. The last of the line, Jean of Nesle and Ade of Mailly, sold the château of Lèves and all its dependencies to the chapter of Notre Dame in 1365 (see Métais, 1908, 20–21).

27. There were two Roberts with the title archdeacon in the mid-twelfth century. One of them, the Robert who became dean and bishop, was archdeacon of Chartres from around 1136 to 1144; the other Robert was archdeacon of Blois and served in this office around 1150. *DIGS* is deficient in its treatment of the first Robert. He is an archdeacon in charters 91, 93, 95, 113, 117, and 127 (and retrospectively in 164), or from around 1136 to 1144; he is dean of the cathedral in 128, 133, 134, 135, 137, 140, 165, 197, 198, 202, 210, 211, and 229, or from 1144 to 1155; he is bishop in 230, 231, 232, 237–47, and restrospectively in 350, or from 1155 to 1164.

28. Archbishop William was sometimes dubbed of Chartres, of Blois, and of Champagne in addition to his later appellation, of the Whitehands. The biography found in *Gallia Christiana* 9 (95–101) serves as the basis for the more recent sketch with bibliography found in Pierre Desportes, *Fasti Ecclesiae Gallicanae*, 3:151–55, and the article by J. R. Williams (1929). A lengthy study, not generally available, is J. Mathorez (1912). According to notes in *JC*, his election was disputed by members of the chapter who were uncomfortable with having the young Thibaudian as their leader. See *JC* 1:205: "The sub-dean, the archdeacon, and others presented themselves to Pope Alexander to invalidate the election. William was not consecrated until 1168."

29. See Henry of Blois, "Scriptura," no. 53, p. 37: "Willelmo milite nepote episcopi."

30. Anne Prache's monograph on St. Remi of Reims (1978) offers a case study of donations, including those of William of the Whitehands, to this church; her work shows how generous he was toward building projects in his episcopal realm. Prache's book centers around the building activities and ideas of Peter of Celle, who also became bishop of Chartres, but only in the final two years of his life (1180–82). For the influence of Peter of Celle's writings on thirteenth-century Chartrain glass, see Rauch (2004).

31. See appendix A for further details. My study of these books is forthcoming.

32. Measurements: *Libra* is a pound; *solidus* is a shilling; *denarius* is a penny. 12d=1s; 20s=1lb. Pennies were actual coins, but *libre* and *solidi* were "moneys of account" (see Evergates, 1975). An arpent is a measure of land, about one acre, but precise measurements varied by locale. *Modius* is a unit of dry or liquid measure, which equaled twelve *sextarii* dry or about twice

that liquid. A *sextarius* consisted of about twelve bushels, but once again the precise measure varied.

33. The massive tapestries given by William of the Whitehands for the walls of the choir came later (*OPS*1032 89–90).

34. Gauterius (Walter) signed charters at Josaphat from around 1119 to before 1130. Molinier (*OPS*1032 71, note 2) says that Gauterius was the archdeacon of Poissy and died after 1181, but this cannot be correct as his obituary has the language and mission of donors who contributed to the mid-twelfth-century campaign. He had been an appointment of Ivo of Chartres, as he signed a charter as archdeacon in 1114; this was the foundation charter of Tiron (*CTT* 2). He is known as Walter of Bonneval: see *DIGS* 128. His nephew, also named Walter, signed charters at Josaphat too, demonstrating the influence of the archdeacon's family even after his death. Ansgerius, also an archdeacon, was, like Gauterius, present at the foundation of Tiron in 1114 and thus first served during the episcopate of Ivo of Chartres. His name is found in many charters, from Josaphat, St. Peter, and Marmoutier, which shows his power and influence. The first charter he signed at Josaphat is dated c. 1124 (XIV) and the last to 1136 (XCV); the last known charter he signed was for the chapter on Jan. 14, 1139 (*CNDC* 1:148). See *DIGS*, 178.

35. For Ansgerius (June 25): "And Ansgerius, archdeacon and priest of Blessed Mary [i.e., in the cathedral], who gave to this church houses that he had bought in the street called *Vassalaris* and *Canones* with certain stipulations, and three gold rings for the repair of the Crucifix, and two deluxe books, to whit an antiphoner and a gradual, for the daily service at the altar of the Cross, and 20 solidos for the building of the tower, and he did many other good things" ("Et Ansgerius, archidiaconus et sacerdos Beate Marie, qui dedit huic ecclesie domos quas emerat in via que dicitur Vassalaris et Canones cum quibusdam decretis, et tres anulos aureos ad reparationen Crucifixi, et duos optimos libros, antiphonarium scilicet et gradale, ad cotidianum servitium altaris Crucifixi et XX sol. ad edificationem turris, et multa bona alia fecit") (*OPS*1032 72A). For Walter, who left various liturgical furnishings, a deluxe breviary, land for expanding the canons' houses, and for the work of the tower: (4 June): "Et Gauterius archidiaconus, qui dedit huic ecclesie aureum calicum trium marcarum, breviarium optimum, capsam de purpura, duos lumbos de aurifriso, duas areas in claustro quibus domos canonicales amplificavit . . . ad opus turris XX libras" (*OPS*1032 71BC).

36. See *JC* XCVII (1:123–24): "Bernardus vero capicerius stallum quendem institorum quem ipse proprium habebat sub turre Beate-Marie dedit capicerie" and chapter 9.

37. See *DIGS* 230 and *OPS*1032 54H–55C.

38. See *DIGS* xxv. *OPS*1032 32A: "LX$^a$ quoque solidos ad turrem et argenti marcam ad Crucifixum reparandum legavit."

39. For his dates, see *DIGS* 104, and *CNDC* 3:204; for his obit: *OPS*1032 107H–108A: "atque ad opus turris C solidos dedit."

40. For his dates, see *DIGS* xiv; *OPS*1032 33A, C: (12 Jan.) "obiit Richerius, hujus sancte ecclesie sacerdos et archidiaconus, qui ea que inferius annotata sunt, multo labore suo et sumptu acquisita, eidem ecclesie contulit, cessura in usum canonicorum ad matutinas surgentium. . . . Decoravit etiam introitum hujus ecclesiæ imagine beatæ Mariæ, auro decenter ornata" ("who, as can be seen from the list below, and undertaken by his own great trouble and expense, conferred upon this very church"). Income from many properties is recorded for the choral endowment. The evidence of this entry is not, to my mind, sufficient to prove that the statue of the Virgin that is mentioned was the famous work in the present southern tympanum; it could refer to some other sculpture placed "at the entrance to this church."

41. On his dates, see *DIGS* xxvi, correcting *DIGS* 178; *OPS*1032 101A: "Rainerius . . . archidiaconus, qui . . . ad edificationem turrium C sol. dimisit."

42. On Hugh the Cantor, see *DIGS* xi–xii, proving *JC* CXV to be a forgery, and xxv, noting his

only appearance in early 1152 in CBL no. 33, p. 66, and *CNDC* 3:137; *OPS*1032 74D: 14 Jul. "Hugo . . . levita et precentor, qui . . . C sol. ad opus turris . . . dereliquit"; on Amauric, see *DIGS* 33, citing CMMB, p. 160; on Odo, see *DIGS* 232: perhaps as early as 1133, certainly by April 1149, until at least 1161, and *OPS*1032 77F: 26 Jul. "Odo, levita et prepositus, qui huic sancte ecclesiæ ad opus turrium XV^cim libras dedit."

43. *OPS*1032 106E: 21 Oct. "Et Symon, diaconus et canonicus Sancte Marie, qui . . . XL quoque solidos ad opus turris tribuit." For Adam, *OPS*1032 71B: 3 June: "Adam . . . levita et canonicus, qui fratribus ad matutinas surgentibus XL sol. reliquit, et ad opus turris L sol. et ad reparandum ciborium VI libras dedit"; Guy, *OPS*1032 73C: 9 July: "Et Guido, levita et canonicus . . . [qui ad edificium turris dedit C] sol. et ad capsam beati [Leobini reparandam] septem marchas argenti et septem [uncias auri] . . . et ad Cru[cifixum reparandum marcam] argenti dereliquit"; and Thibaut, *OPS*1032 114F: 3 Dec. "Et Teobaldus, hujus sancte ecclesie sacerdos et canonicus, qui ad usum canonicorum ad matutinas surgentium centum solidos reliquit, et decem ad opus turris, totidemque Elemosine istius ecclesie dedit."

44. He last appears in the surviving documents in 1173; his successor, Burcard of Le Puiset, first appears in 1176, so this latter date is the absolute terminus for Robert. Of course, many dignitaries retired from their positions, and this further skews attempts to understand their dates. *OPS*1032 100B, D: 28 Sept. "Ob. Robertus, Beate Dei genitricis levita et cancellarius, tam divinarum scripturarum quam liberalium artium disciplinis ad plenum eruditus. . . . ad opus criptarum ecclesie XV libras fecit distribui."

45. According to Métais, the long-standing difficulty over who had the right to name canons was still in play at this time, and this disagreement was causing Geoffrey's appointments to be held up. He says in a note to *JC* XCV, dated 1136, that the nominations of Zachary as subdean and Solomon as cantor were delayed for years. Hugh did not appear as succentor until 1134, after a vacancy of ten years, and Raignaud, the chamberlain, after a period of fifteen years. However, given the nature of the documents and the need for further work to date them precisely (if indeed this is possible), much cannot be made of Métais's observation. The *termini* in *DIGS* are sometimes absolute, but more often not. This is particularly true of the lesser personae of the chapter.

46. Because of the dates provided by Suger for completion of two projects at St. Denis (1140 and 1144), Chartres is commonly seen in relationship to the campaigns conducted there, with scholars energetically discussing the connections between the two monuments, one of which—Chartres—survives in a significantly less altered state than the other. See, for example, the differing viewpoints found in Schenkluhn (1994) on the innovative superiority of St. Denis and a view of the humanism found in the Chartrain sculpture summed up in Debicki (1992). Armi (1993) has argued for the brilliance of a particular Chartrain master who carved the jamb statues of the central and southern portals; he believes that this master incorporated an understanding of human features that worked from the inside toward the surface, and thus made everything—from locks of hair to hands and clothing—burst with a revolutionary sense of life. Baxter's review of Armi's book (1995) is critical of this approach in general.

47. Blum (1986) describes the ways in which choristers could make the angels on the façade of the west portal of Wells Cathedral sing: there were megaphones leading from the mouths of the sculptures to the platforms where the boys could have been standing.

48. *JC* CXXVI. This charter is crucial for establishing the names of Goslen's children and the approximate date of his wife's death.

49. Five people are mentioned as giving gold and silver for the Chartrain cross, and several others gave metals for other purposes as well as chalices and other precious items.

50. See *JC* LXXIII, 1:94. Radulf the goldsmith is also mentioned in a charter from around 1130 (*CTT* 1:158); he also was present at Tiron around 1140, along with his relative Ernaud; see *CTT*

2:7. Perhaps he is the same figure as Radulph the *monetarius*, who gave a house to the monks of Tiron: see *CTT* 1:122. His connection with the monastery of Tiron suggests the presence there of artists and artisans, especially metalworkers. This connection has been explored in the work of Ruth Harwood Cline, and I am grateful to her for sharing some of her observations before publication.

51. OPS1032 44GH (27 Feb.): "Ob. Robertus Aurifaber, qui huic ecclesiæ dedit aream quam in claustro habebat, eo tenore ut in ea semper sacerdos canonicus mansitaret." A later addition to the necrology of the chapter of St. Maurice (located just beyond the Porte Drouaise, the original parish church of Lèves) has an obit for Marota, wife of Robert the goldsmith, a house having been left to that church to endow her anniversary (*OPS* 355D: "Ob. Marota, condam uxor Roberti Aurifabri, pro anniversario cujus habemus super domum de Chiefdeville ante putheum. Lucas Gastellarius tenetur solvere v. solidos [*sic*] [XIV saec]"). It is possible that the position was hereditary, father training son, and that this land was acquired far earlier; it is also possible that the earlier Robert was a father, but there is no proof.

52. My study of the masons of Josaphat is forthcoming.

53. *JC* LII, 1:74–75.

54. See *JC* CCXLV, 288–89. His father was also Robert, and his mother's name was Augardis. As her name is unusual, it may be she who witnessed a charter in 1127–30 (*JC* XLIV) and also in 1145–48 (*JC* CLII).

55. See *JC* 2:322. The date of the entry is not known, and the name Jacobus is not common at this time in the Chartrain.

56. On the dating of her death, see *DIGS*, xxiv–xxv. For her obituary (*Helisabeth vicedomina*) see OPS1032 59EF (17 April).

57. See Clerval (1895), and Southern (1970, 1979, 1982); Southern's ideas circulated in lectures and conversations before his first publication of them in 1970.

58. As Winthrop Wetherbee, a specialist in medieval Platonism, has said, Southern believed that "too much has been made of their originality . . . their programme was in fact hopelessly old-fashioned" (1988, 28).

59. Various modifications of Southern's position have been offered in Dronke (1969, 1988), Häring (1974), Jeauneau (1995, 1997), Luscombe (1997), and Speer (1997). Dronke is sharply critical of Southern at several points. Regarding the claim that Thierry was not even in Chartres, he says, "Southern's assertion (1979, p. 26) that 'from about 1115 to 1142 . . . we know him as a Breton master teaching in Paris,' has nothing to support it"; see Dronke (1988), 359. Even more damning of Southern is Dronke's view that the famous student of medieval humanism completely misread the relationship between Thierry of Chartres and his student Clarembald of Arras. Dronke implies that Southern's treatment of the texts reveals an inability to deal with the finer points of medieval philosophical argument; see especially Dronke (1988), 381.

60. For discussion of Thierry and his contributions, which lay in "combining an extreme Platonism in which forms and names exist indissolubly in the mind of God, and in which names essentiate things" with a far-reaching naturalism, see Dronke (1988), 384.

61. From Thierry's commentary on Cicero's *De inventione*, as translated by K. M Fredborg, and cited from an unpublished manuscript by Peter Dronke (1988), 362. Fredborg has since edited Thierry's commentaries on rhetorical texts: see Thierry, *The Latin Rhetorical Commentaries*.

62. If John was born around 1115–20 he would have attended grammar school in the 1120s and early 1130s. He was a student in Paris by 1136.

63. On Bernard of Chartres, see Dutton (1984), who has uncovered previously unknown works. Once again, in disagreement with Southern, Wetherbee (1988) says, "I would argue that it is largely their willingness to engage an ancient source, directly and as nearly as possible on its own terms, that distinguishes the work of Thierry, Bernard of Chartres, and William of

Conches from that of their contemporaries" (32); see also Wetherbee's summary of the scholarship (2003).

64. The Merlets (*DIGS* 103) were able to find in the charters only a single appearance of Bernard as chancellor, in 1124 (*CSP* 469). His predecessor, Vulgrin, last appears in an act which can only be after 1118 (*MSC* 196), and his sucessor, Gilbert, first appears on Nov. 28, 1126 (*CSP* 267). See Dutton (1984) on commentaries now attributed to him. For further discussion of his ideas of matter and creation, see Annala (1997).

65. See *DIGS* 103; and van Elswijk (1966); for an overview of art in Poitiers during his lifetime and the decades immediately after, see Grinnell (1946).

66. The council, which involved attacks from Saint Bernard and the Cistercians, has been much discussed. See Karl Joseph Hefele, *Histoire des conciles d'après les documents originaux*, 5/1: 823–38, for the primary sources for the council, an extended discussion of its context, and the "affaire de Gilbert." Nikolaus Häring, his modern editor, says of Gilbert, "His equal is not found in Latin theology from St. Augustine to the most celebrated theologians of the thirteenth century" (*The Commentaries on Boethius*, 4). See Häring (1951), Evans (1981), and Monagle (2004) on the attack and Gilbert's defense as well as discussion of the viewpoints of those who described it. John of Salisbury was present at the council and shares his observations, including a statement demonstrating the great learning of Gilbert: "The bishop [Gilbert], trusting in the support and advice of the cardinals, joined conflict with confidence, and though many men questioned him searchingly he supported his answers with such sound arguments and authorities that he could not be tripped up verbally. . . . I cannot recall that anyone boasted there of having read anything that he had not read"; *Historia Pontificalis* 10 (trans. Chibnall, 21).

67. Oct. 31. "And Ernald, priest and chancellor of Blessed Mary, who gave two houses which he had acquired by his own wealth and industry to this church, and stipulated that they be occupied by canons in perpetuity; also when dying he left twenty *libras* to his brothers and fellow canons, and to each non-canonical clerk of the choir he had two *solidos* distributed, and he gave one hundred *solidos* for the work of the tower," (*OPS*1032 107H–108A).

68. See especially his commentary upon the creation narrative, which has been edited and studied by Richard Upsher Smith ("Liber").

69. Arnold is known to have flourished at least from 1144 to 1156 and thus was active in the time Geoffrey (until 1149), Goscelin (until 1156), and Robert (until 1164) were bishops.

70. The suggestion made by Lépinois that Bishop Geoffrey founded a hospital in the crypt (1854, 225) cannot be proved from twelfth-century sources now available. No documentary evidence that the work on the crypts took place during his reign can be found, just as (as I say in chapter 9) there is no evidence proving that a statue of the Virgin was found there in the twelfth century, although it is certainly likely.

71. See Paris, BN lat 14758, 91–112.

72. See Beck, *Saint Bernard*, 65, and *CTT* 1:1–2.

73. See Beck, *Saint Bernard*, 65, 215–16.

74. For discussion, see Beck, *Saint Bernard*, 41. For discussion of the author's way of working and his sources, see ibid., 44–58.

75. See the notes to her forthcoming translation. I am grateful to her for sharing information with me before publication. She has also worked on tracing a colony of Breton craftsmen who were part of the monastic establishment and who were employed locally on many projects. Dean Robert was called "the Breton" by Souchet and may have been associated with this group.

76. See the Latin edition of Godefroy Henskens (*Vita Beati Bernardi*), as annotated and translated into French by Bernard Beck, 9:77, 78 (*Saint Bernard*, 396–97).

77. Mayeux (1906a) argued for the influence of the Benedictines of Tiron on Chartrain art and architecture.

## 9. THE VIRGIN AND THE TABERNACLE

1. See Fassler (1993a) and Chartres, BM 520, fols. 433–434r, ed. Hiley (*Missale*). Set to the widespread melody "Congaudentes" for Saint Nicholas, "Clara chorus" was probably written in the mid-eleventh century, for it came to Cluny and Cambrai soon after that time. Kruckenberg (1997), 157–58, lists it with a small group of "internationally-known transitional sequences." For a discussion of the parent melody and its text, see ibid., 227–36.

2. See Eusebius, *Life of Constantine* 3.28 and 3.33.1, trans. Cameron and Hall, pp. 133 and 135. Robert Ousterhout (1990) on the buildings of Constantine is fundamental. He offers a warning, one to be taken to heart when studying the "new temples" of twelfth century crusaders: "Architecture may comment on or interact with the rituals it houses, but I think it is a mistake to expect a direct symbolic correspondence. In the architectural setting, there was perhaps by necessity only a general association of form and meaning. It was the function—the liturgy—that added texture, nuance, and specificity" (52). Osterhout both depends upon and offers refinements to the works of Richard Krautheimer (for example, the seminal article from 1942) on the reuse of earlier architectural models in medieval churches.

3. The idea that the physical fabric of the church expressed God's mysteries for contemplation has a long history. The opening of a sixth-century Syriac hymn for the Dedication feast, studied by McVey (1983), 95, makes the point: "Bezalel constructed the Tabernacle for us with the model he learned from Moses, / And Amidonius and Asaph and Addai built a glorious temple for You in Urha. / Clearly portrayed in it are the mysteries of both Your Essence and Your Dispensation. / He who looks closely will be filled at length with wonder."

4. The idea of a medieval church as a temple or a new Jerusalem has been espoused as a worthy archetype glistening with jewels of understanding—Prache (1993)—and debunked as a Nazi reverie fostered by German and Austrian Roman Catholics—Schlink (1997/98). It is an idea that should not be assumed to be operating consistently in medieval Christian architecture and its decoration. Every church and every community had unique ways of embodying this theme, although it grows primarily from the liturgy, most notably from the feast of the dedication of a church.

5. Because the seal has long been detached from its original document it can be dated only by stylistic evidence and not specifically ascribed. The mid-twelfth-century date is traditional, beginning at least with Merlet (see *DIGS* LVII), but the seal has not been studied. To locate others in the same style would be helpful, for the few later examples from Chartres that have survived are not of this type. On the importance of medieval seals and the documents to which they were affixed, see Bedos-Rezak (2000). All that survives of the legend is *sigillum . . . notensis*.

6. The role of the *Sedes* in the lancet windows of the west façade is discussed in chapter 12.

7. All studies of these twelfth-century statues begin with Forsyth (1972), whose excellent collection of plates allows for comparative study. On the development of the crowned Virgin in the West until the time of the mid-twelfth-century Chartrain examples, see Lawrence (1925).

8. See, for example, the apse mosaics at Santa Maria in Dominica, Rome. On early mosaics embodying these ideas, see Cormack (2000) and Freytag (1985).

9. For a beautiful example, see the Virgin of Saint-Savin (Haute-Pyrénées), figure 134 in Forsyth (1972), with discussion on page 182.

10. See fig. 9.1 above; and Forsyth (1972), 139, who places this heavily painted example in the stylistic sphere of the Morgan Madonna.

11. The famous Morgan Madonna, a twelfth-century wooden statue found today in the Metropolitan Museum in New York City, has a niche with a tightly fitting cover on its back. The cover cannot be removed from the cavity without causing harm, but when the statue was X-rayed a piece of cloth was seen within, doubtless believed to be a swatch from the Virgin's robes. I owe this information to a private communication from Charles Little.

12. There is no more striking description of Mary's action than that offered by Hugh of St. Victor, *On the Sacraments* 2,1,8, trans. Deferrari, 230: "Therefore, Mary conceived of the Holy Spirit not because she received the seed of the fetus from the substance of the Holy Spirit, but because through the love and operation of the Holy Spirit nature provided the substance for the divine fetus from the flesh of the Virgin. For since in her heart the love of the Holy Spirit was especially ardent, on this account in her flesh the virtue of the Holy Spirit worked marvelous things. And love of Him in her heart did not take an associate, whose operation in her flesh had no example. Therefore this alone did the Virgin conceive, which she received from her flesh through the love and operation of the Holy Spirit, from whom alone also without the admixture of virile seed she gave birth to a son."

13. See Pourreyron (1936), 169–70. The idea that the Virgin and her statuary and relics could benefit sick children can be seen in this description. Sigori (1995) explores this aspect of the Chartrain cult of the Virgin; see especially 174–201.

14. On the crypts at Chartres, see Sapin and Suffrin (2008).

15. See, for example, Robert Branner's introduction (1969, 70–71) to his collection of documents, essays, and excerpts. For an explication that has become standard and that is dependent upon later sources, see Forsyth (1972), 105–11. The first mention of the statue in textual evidence is from the fourteenth century: see VC 38–39, and Lépinois (1854–58), 542. Delaporte's discussion (1955) is basic; knowing the sources from Chartres better than any person before or after, he said that the reference in *VC* is the earliest one known (p. 9).

16. See Bernard of Anger's writings on Saint Foi. Bernard, who was schooled at Chartres, speaks of his incredulity at the miracles surrounding the statue of Saint Foi and of his initial lack of respect for cult objects of this sort. Judging from his writings, the Chartres he knew possessed no such statue. See Ashley and Sheingorn (1999) on Bernard and his work.

17. The Miracles of the Virgin window, dated to the early thirteenth century, was heavily restored in 1927; its lowest roundel, the only one that is medieval rather than modern, depicts the adoration of a golden image of the Virgin by the sick. Delaporte speaks of a miracle that occurred after the fire of 1194 in which the Virgin came down from heaven to deliver a statue to Chartres; this legend and its relationship to the cult in the thirteenth century require further exploration from scholars who work on the thirteenth-century church and the Virgin's cult. Delaporte (1926), pp. 189–195, pl. 29–31; Deremble and Deremble (2003), 62–64. Lautier (2009) ties the window to the Chasse and its location.

18. See Jusselin (1922), who evaluates various copies supposedly of the twelfth-century statue. One of the most famous of these seems to have been located in the local church of Mainvilliers and traditionally dated to the end of the twelfth century (the statue there now is a modern copy). It was common for wooden Madonnas to be burned publicly (or later said to have been miraculously saved from such burning) during the course of the Revolution. Every reconstituted cult statue has a story bound up with its survival. The famous late-twelfth-century Madonna of Notre Dame de Chargnat (apparently at St. Rémy de Chargnat), reported to have a cavity in its back containing fragments of cloth, survived because a bishop, during a visit in 1773, asked that the statue be placed in a niche far above the main altar. It is there to this day and thus very difficult to inspect. Forsythe was not able to examine it, to see if the relic-hole is indeed present and to answer questions about its nature and location. See Forsythe (1972), 163, and figure 76.

19. See Kunstmann's edition, *Miracles de Notre-Dame de Chartres*, with its excellent notes. Spitzer (1994) presents arguments for a struggle between those in charge of the major altar and those in charge of the cult of the Virgin in the crypt.

20. See Kunstmann, *Miracles*, 76–77.

21. Haggh (2006) is a discussion of the responsory and its role in Gautier de Coinci's *Miracles de Nostre Dame*. Haggh, 169–71, describes the complex cluster of musical works that grew out of

this and interrelated chants. Barré (1967), 209, describes sermons that employ the text and its themes. The text was often used to foment anti-Jewish sentiments within Christian congregations, as was the case with the miracle Gautier de Coinci associates with it.

22. *CNDC* 2:56–62, this passage on pp. 60–61 (translation modified from Richard Barton on the Internet Medieval Sourcebook): "Facta sunt igitur omnia sicut Rex imperaverat. Quibus peractis, clerus ad processionem se praeparans, quaedam primum solemnia, quae ad sacrorum reconciliationem locorum liber ordinarius fieri indicat, celebravit. Hiis expletis solemniis, ad pulsandas ecclesiae campanas quorumdam astantium laicorum multitudo cucurrit; responsorium 'Gaude, Maria,' ante altare gloriose Virginis, altissimis vocibus decantatum est; altari vero interim decenter ornato, sacrosanctum scrinium super illud respositum est; capsae Sanctorum reliquias continentes, a terra elevatae, ad loca propria cum gaudio et exsultatione et canticis reportatae sunt; imago quoque Crucifixi in eminentiori loco, sicut solebat, reposita est. Et sic facta est letitia magna in clero, in populo autem gravi adhuc iniquitate et peccato confusio maxima." The tenderness which the Mother of God is said to have shown in the twelfth century was not matched by King Philip Augustus or the bishop of Chartres, the Thibaudian Reginald of Mouçon. After paying a huge fine, the criminals were made part of a procession into the cathedral. Nude and carrying whips, they marched before the Virgin's altar and were punished with lashes (pp. 61–62). This was the age of war against the Cathars; the "heretics" who had attacked the dean's house lived in a diocese where the bishop had just been fighting in the south of France.

23. Haggh (2006), 193.

24. Today, Paris, BN Lat. 10439. See Lowe (1934–66, 5:24).

25. Discussions of the reliquary and its contents are found in both Lucien Merlet (1885) and Fernand de Mély (1886, and later editions of this study). The best summary regarding the reliquary is that of Delaporte (1927). An opening of the Chasse or reliquary took place in 1712 and is described by Lucien Merlet, ibid., 76–77, and by Delaporte, 13–14, with quotations from the original report in the latter. The despoiling of the reliquary that took place in 1793 is reported by de Mély and by Delaporte, 14–16; the preservation of the art of the cathedral during the terror and its aftermath is discussed in Cooney (2006). The story of the surviving shred of cloth and the reconstitution of the reliquary is found in Delaporte, 16–24. The engraving by Larmessin discussed in chapter 12 contains a late seventeenth-century depiction of the Chasse (see p. 362). The coming of the Feast of Corpus Christi into the Diocese of Chartres, probably in 1320 (see *OC* 222), and the general late medieval emphasis on the host and its meanings in the liturgy, may have conspired to displace the relic from its earlier association with the main altar, and the addition of new altars in the choir. Lautier (2009) emphasizes that it would have been difficult for ordinary people to see the Chasse in the thirteenth century, but that platforms were built to raise some reliquaries up on high so they could be viewed from afar, the most important in the later Middle Ages being the "tribune des Corps-Saints": "on this platform were presented a certain number of reliquaries and above all the large chasses of the treasury (with the exception of the Sainte Chasse)." For the twelfth century itself, however, there is little evidence regarding precise placement or information about whether or not the Chasse could generally be viewed by the people in the nave.

26. The chronicler is commonly thought now to have been a cantor, a member of the priestly class, whose own genealogy may appear in 2 Par. 3:19–24. He portends the tradition of cantor-historians in the Latin Middle Ages. See discussion by North (1989), 364.

27. Solomon's Temple was destroyed by Nebuchadnezzar in 587 BCE. The final description in the book of Kings was written by exiles in Babylon after the destruction but incorporated information and understandings from earlier sources now lost. The vision of Ezechiel (40–43) is of a building never made. The Temple itself was eventually rebuilt, a project carried out in 520–516 BCE; this building was expanded and refurbished by King Herod from 19 to 9 BCE.

28. See Forsyth (1972), 198–200, and figs. 103 and 104. According to her, both are related to the so-called Senlis style, which, in turn, was related to both Mantes and Chartres.

29. David Nirenberg (2006) explores the various ways in which a so-called Jewish voice representing the literal (and therefore shallow) level of poetic understanding was part of a long tradition of interpretation, argument, and counterargument. For further discussion of this theme, see Michael Signer (1998a).

30. For arguments from the Carolingian period regarding images, see Blumenkranz (1960), 285–89. A late medieval catalogue of the arguments surrounding the Christian veneration of images is found in the *Epistle of Rabbi Samuel of Morocco*, a treatise apparently actually written by Alfonso Buenhombre and first presented by him in 1339; see Limor and Stroumsa, eds. *Contra Judaeos*. The treatise has a section entitled "Concerning Images," for which see Limor (1996).

31. The text is edited by Abulafia and Evans in *Works*, 1–61; they point out in their introduction that it was extremely popular, with thirty-two extant manuscripts; twenty of these are from the twelfth century. The treatise was used as a source by Lambert of St. Omer and Alan of Lille and was translated into Hebrew in 1170 by Jacob ben Reuben. Abulafia and Evans believe the dispute was based on actual conversations between Jews and Gilbert, but that he Christianized the Jewish side of the dialogue in his work.

32. See Bland (2000), 128. On Rabbi Joseph, see Urbach (1975).

33. Exod. 33.20. This is discussed by Blumenkranz with reference to the idea that God was too powerful to be contained in human flesh and, most important for the Chartrain aesthetic, unable to be seen. Exod. 33:15–20 reads, "And Moses said: If thou thyself dost not go before, bring us not out of this place. For how shall we be able to know, I and thy people, that we have found grace in thy sight, unless thou walk with us, that we may be glorified by all people that dwell upon the earth? And the Lord said to Moses: This word also, which thou hast spoken, will I do: for thou has found grace before me, and thee I have known by name. And he said: Shew me thy glory. He answered: I will shew thee all good, and I will proclaim in the name of the Lord before thee: and I will have mercy on whom I will, and I will be merciful to whom it shall please me. And again he said: Thou canst not see my face: for man shall not see me and live." Nestor the Priest argues at several points that Jesus' visibility proves that he cannot be God, using Exodus 33:20 as the proof text. See, for example, *The Polemic*, 1:127, and notes by Lasker on pp. 155, 159. Kessler (1997/98) treats the Mosaic prohibition as an impetus for the visual arts in the Latin Middle Ages.

34. The crusaders' view of Jerusalem and the Holy Sepulchre and of the Temple in general are studied in Folda (1997/98) and Weiss (1997/98). Of further relevance to the themes and modes of seeing developed at Chartres in the mid-twelfth century are the slightly earlier and contemporary ideas surrounding Christ's revelation to his disciples at the Transfiguration, a scene from which appears in the southern west lancet window at Chartres. For bibliography on Peter the Venerable's authorship of the texts and music for the feast of the Transfiguration and its establishment at Cluny, see Hiley (1998). The window at Chartres not only depicts the Transfiguration, but also presents a second scene in which Jesus seizes upon the teaching moment and explains to the apostles what was meant by what they saw.

35. For an earlier discussion of this document, see Métais's notes in *JC* 1:123–26, and Fernand de Mély (1891).

36. "Bernardus vero capicerius stallum quendam institutorum quem ipse proprium habebat sub turre Beate-Marie dedit capicerie, ita ut deinceps capicerius ecclesie ministret ante vitream imaginem lampadem, oleum, cereos que predicte elemosinarie minister dare solebat. Et nos ita statuimus et confirmamus, ut amplius qui capiceriam habebit, ymagini Beate-Marie de Vitrea hoc servitium faciat illuminando lampadem de oleo et de cereis, sicut ordinatum est. Et quicumque hoc contempserit et statutum nostrum infregerit, anathemati subjiciatur. Hoc

factum est in presentia nostra in eodum capitulo, venerabilibus fratibus nostris astantibus et concedentibus" (*JC* XCVII 1:125–26).

37. See *CTT* 1:38 and *DIGS* 283–84.

38. Bernard is mentioned in the Josaphat charters numbered 9, 17, 23, 25, 26, 28, 31, 33, 55, 68, 71, 72, 73, 81, 90, 91, 95, 96, 97, 98, 191, with a lavish obituary in the abbey's necrology as well. He is more prominent in earlier charters, in which he is often one of only a few dignitaries to sign in the bishop's company. After the filling of more offices, he signs later and less frequently. He may be the Bernard who signs two charters in the company of Bishop Geoffrey, although from archdeacon to sacristan was a lateral move at best, and so this casts doubt (see *DIGS* 123). He appears with the title *capicerius* (another term for sacristan) in four charters in the St. Peter collection, pp. 264, 307, 469, 470, all dated within his supposed time of service, from 1119 to 1137. At present there is no evidence that *Bernardus medicus*, who was involved with a quitclaim to a prebend in St. Martin's church, should be identified with the *capicerius* of Chartres Cathedral. The charter involving *Bernardus medicus* is undated but was enacted between 1102 and 1122.

39. Bernard's obituary at the cathedral: March 6. "Bernard, the *capicerius*, later a monk, who gave 40 pounds for roofing this church, and a Gospel lectionary covered with silver, and a silver vessel weighing five marks from which holy water was dispensed. He also gave another book decorated with silver for readings at feasts of blessed Mary and for the use of brethren serving in choir every day; he acquired a half a mill, and after the fire he rebuilt the almshouse of this church from his own income" (*OPS*1032 46D). Merlet (*MSC* 85) says that this predecessor of the Hôtel Dieu was located only a few meters southwest of the church and was completely destroyed by the fire of 1134. The original almshouse had been built by Countess Berta of Blois (the second), who left lavish gifts to honor the Virgin of Chartres in the late eleventh century. Her epitaph in Na4 shows her interest in a hospice for the sick, for pilgrims who came to Chartres for veneration of the cult she celebrated, and for cures. This hospice, located near the western end of the cathedral, was likely that burned in the fire of 1134 and rebuilt by Bernard. The countess's obituary shows her devotion to the Virgin's cult: "ii. ides April. And Countess Berta who conferred many things for the decoration of this church, to wit a pectoral cross made from the purest gold and precious gems, divided in two parts, which decorates the altar of the reliquary of the chemise, two gold thuribles, a great phylactery, two chasubles, and two tapestries. Also she bought land from Fulcher, son of Girard, on which the almshouse of this church was made, from her own means, and she gave an oven for the benefit of the infirm of this almshouse, and many other things (d. 1085)" (*MSC* 159).

40. Bernard's obituary at Josaphat may have been revised after his death, for the chapel he constructed is described as being old, and the formulaic opening suggests that it might have been written by someone who was used to drawing up charters: "March 6. Bernard the Sacristan [died]. Let it be evident to those present, and let future people know, that this church of Josaphat was greatly enriched by the gifts of Bernard the sacristan before he himself became a monk there. So it is that the refectory of the brethren was constructed at his expense, and likewise the kitchen, and the old chapel for the sick [*capella infirmorum antiqua*], and the mill [near St. Piat] called 'Le Déserts.' Hence it was conceded to him in the common chapter that every day, as long as the daily worship of God takes place in this church, a Mass for the dead will be celebrated. The first prayer of this Mass will be for his soul alone, except on solemn days in which proper Masses are to be celebrated" ("Pateat presentibus, noscant et futuri quod hec ecclesia de Josaphat in multis largiter adjuta est beneficiis Bernardi capicerii, antequam in ea fieret ipse monachus. Inde est refectorium fratrum eius expensis constructum, inde et coquina et capella infirmorum antiqua et molendinum de Desertis. Unde concessum est ei in communi capitulo ut omni die, quamdiu servicium Dei fiet in hac ecclesia, missa pro defunctis celebretur. Cujus oratio prima sit pro ejus anima singularis, exceptis tamen diebus solemnibus

in quibus misse debent proprie celebrari") (*OPSJ* 244FG and *JC* 2:265–66). (The final sentence of the obituary is found only in *JC* 2.)

41. The charter must have been signed just before Robert became archdeacon "of Vendôme," an office he held apparently until he was named dean.

42. Manhes-Deremble (1993), pp. 64–66, 170, 176, 191; figs. 1, 2, 10, 24, 28, 41, 86; Manhes-Deremble dates the thirteenth-century panels to the second decade of the thirteenth century.

43. A recent restoration resulted in some repainting, as can been seen in the gallery, with a close-up of the Virgin's famous crown (see figure 9.4 and plate 6). On medieval coronations and crownings, see the collection edited by Bak (1990). The process of conservation and restoration of stained glass is a much-discussed subject; many major projects are under way to protect these treasures against further corrosion, and the work is being done in the knowledge that restorers can unwittingly become devastators. At present the Corpus Vitrearum Medii Aevi leads efforts in education on the topic; their Web site includes a section entitled "Guidelines for the Conservation and Restoration of Stained Glass."

44. Bouchon et al. (1979) speak of the robe as ancient glass; its drapery folds were painted in the twentieth century.

45. J. R. Johnson (1965) contains a discussion of the preparation of glass at Chartres as well; Meredith Lillich (1984) analyzes the theological meanings of the famous St. Denis blues.

46. See H. Pinoteau (2000) and Lautier (2004). The treasury of St. Denis was catalogued in 1634, and engravings depicting it were published in 1707 by Félibien. A study by Montesquiou-Fezensac and Gaborit-Chopin (1973–77) was followed by a show reassembling many of the surviving objects in the Louvre, Gaborit-Chopin (1995). On the crown depicted in the St. Clement crypt at Chartres, which may date from the twelfth century, see Maines (1977). A Book of Hours of Chartrain use (Trinity College Dublin, MS. 108, dated to 1511) contains a full-page illumination (f. 50r) of King David praying before his harp as golden rays come down upon him from God the Father, who raises his hand in blessing. King David wears a crown almost identical to that of the Virgin in Belle Verrière, perhaps because it is stylized by this time or perhaps because of the connection between his royal lineage and her own.

47. This red color as part of contemporary imagining of the tabernacle can be seen in Andreas of Fontevraud's life of Robert of Arbrissel, who when speaking of choosing an abbess who is not a cloistered nun, says, "Therefore let a covering be chosen that will protect the Lord's tabernacle, and manfully weather the storms of external affairs, so that the scarlet glows inside with perfect color. Let Mary attend ceaselessly to celestial concerns, but let us choose Martha, who knows how to minister wisely to external affairs [cf. Luke 10:38–42]" in the *Second Life of Robert of Arbrissel* 5, trans. Velarde (2003), 28–29; for the Latin, see *PL* 162, col. 1060.

48. Others have argued, although with less detail than is presented here, that the window represents the inner sanctum of Exodus 26 and Hebrews 9: see Deremble and Deremble (2003), 50, and discussion in Bouchon et al. (1979); the antiphon text too has been recognized as an Advent chant but not placed in liturgical context.

49. The relationship between John and Peter is evaluated in Barker (1978).

50. See discussion of Peter of Celle in von Simson (1988), 192–95. Peter's treatise on the tabernacle has appeared in a modern critical edition (CCCM 54). Mary Carruthers (1993) has discussed the role his works played in the art of memory in the mid-twelfth century.

51. C. Hahn's introduction to visualization (2006) raises many of the issues discussed here and in chapters 10–12.

52. See Exod 25:18–21: "Thou shalt make also two cherubims of beaten gold, on the two sides of the oracle. Let one cherub be on the one side, and the other on the other. Let them cover both sides of the propitiatory, spreading their wings, and covering the oracle, and let them look one

towards the other, their faces being turned towards the propitiatory wherewith the ark is to be covered. In which thou shalt put the testimony that I will give thee."

53. This concept is explored in many medieval Christian writings in both eastern and western traditions.

54. From "Salve Mater Salvatoris, Vas," for the Nativity of the blessed Virgin, strophe 8. The entire text may be found in *Analecta hymnica* 54:383.

55. Hebrews 9:3–4: "And after the second veil, the tabernacle, which is called the holy of holies: having a golden censer, and the ark of the testament covered about on every part with gold, in which was a golden pot that had manna, and the rod of Aaron, that had blossomed, and the tables of that testament."

56. See Deremble and Deremble (2003), 52–53.

57. See Adams (1989) on the iconography of Christ and Satan on the roof of the temple.

58. The entire tympanum has been much discussed in the scholarly literature, most notably by Katzenellenbogen (1959), whose interpretation is the standard work. Analysis of the Virgin's cult and the liturgical framework of time then operating in Chartres offers yet other layers of meaning. Hélène Toubert (1974) offers a skilled summary of Katzenellenbogen's arguments.

59. Vincent Sablon, as edited by Merlet, seems at first glance to report that the sculpture was a replica made in his lifetime of a fourteenth-century work of art: "In the highest part of the tympanum, the holy Virgin is seated, a scepter in her hand, holding the baby Jesus on her knees; to the sides are two angels, each holding a thurible. These statues of the fourteenth century were very mutilated; they were replaced about five years ago by other images following the model by the sculptor Pascal." See *Histoire et description*, 14. This reference is not to the statue in the tympanum, however, and represents Merlet's heavy-handed editing of Sablon's original text, which does not contain this discussion. Bulteau, in volume 2 of his *Monographie* (with Brou, 1887–92, 21), claims that the outer archivolt of the Royal Portal was restored by M. Parfait, "l'habile sculpteur chartrain." He also says that the ninth king from the left in the Gallery of Kings above was damaged by a cannon ball in the siege of 1591 and was remade by M. Fromanger, a Parisian sculptor, and put in place in 1855. I am grateful to Jim Bugslag for his clarification of this passage.

60. Psalm 33 (34): 9, "O taste, and see that the Lord is sweet: blessed is the man that hopeth in him." This text is not featured in the Roman rite for communion chants, but commentary abounds.

61. Katzenellenbogen argued for this interpretation in regard to the southern tympanum and its lintels.

62. The composition of this nativity scene is very close to that found at La Charité-sur-Loire, a Cluniac church whose sculptural program, now located inside, dates from the mid-twelfth century. The same template was followed for both scenes, and although the shepherd in question has lost his head at La Charité, his posture suggests that he too may have faced forward. See fig. 9.18 above.

63. "Una est Mariae et Christi caro, unus spiritus, una charitas, et ex quo dictum est ei: 'Dominus tecum,' inseparabiliter perseveravit promissum et donum, Unitas divisionem non recipit, nec secatur in partes, et si ex duobus factum sit unum, illud tamen ultra scindi non potest, et filii gloriam cum matre non tam communem judico quam eamdem. Ecce tabernaculum Dei, habens intra se Sanctum sanctorum, virgam signorum, tabulas testamenti, altare incensi, ambo cherubin respicientia in alterutrum, manna, et sine umbra propitiatorium palam expositum. Haec non in figuris, sed in ipsa veritate sacrarium Virginis in se continabat reposita, exhibens mundo legem et disciplinam, incensionem zeli, castitatis odorem, concordiam testamentorum, panem vitae inconsumptibilem cibum, sanctitatem, humiliatatem, et obedientiae holocaustum, poenitentiae omnibus tutum naufragis portum" (*PL* 189.1729B–1730A).

64. For the most detailed medieval commentary on the meaning of the feast of the Purification, which in the East was a feast of the Lord, see Richard of St. Victor's treatise on the three major processions of the church year (*L'Edit d'Alexandre*), see also Fassler (1993a), 328–34.

65. "Responsum accepit symeon a spiritu sancto non visurum se mortem nisi videret cristum domini et cum inducerent puerum in templo [sic] accepit eum in ulnas suas et benedixit Deum et dixit nunc dimittis domine servum tuum in pace" (Chartres, BM 520, f. 340v).

66. The texts are found in *Provins*, 12; see Hiley (1993a) for discussion of this manuscript and the tropes in it. The chants with their tropes are performed by Schola Hungarica or "The Holy Lady of Chartres."

67. See discussion in chapter 5 and Ambrose of Milan's commentary on Luke, 2:58 (*Expositio*, 56).

68. Cant. 2:16–3:3a: the Voice of the Church, as in Chartres, BM 162.

69. Cant. 3:3b–5: the Voice of the Church concerning Christ, as in Chartres, BM 162.

70. *PL* 89:1291–1304, and CCCM 27B, 985–1002. See discussion in chapter 5.

71. "And when the days of her purification are expired, for a son, or for a daughter, she shall bring to the door of the tabernacle of the testimony, a lamb of a year old for a holocaust, and a young pigeon or a turtle[dove] for sin, and shall deliver them to the priest: who shall offer them before the Lord, and shall pray for her, and so she shall be cleansed from the issue of her blood. This is the law for her that beareth a man child or a maid child. And if her hand find not sufficiency, and she is not able to offer a lamb, she shall take two turtles, or two young pigeons, one for a holocaust, and another for sin: and the priest shall pray for her, and so she shall be cleansed" (Lev 12:6–8).

72. Quoting Ephesians 5:2 and Galatians 2:20 as well as Romans 12:1.

73. "Viderunt omnes fines terrae salutare Dei nostri: jubilate Deo omnis terra. Notum fecit Dominus salutare suum: ante conspectum Gentium revelavit justitiam suam" (Ps 97:34, 2).

74. "Radix iesse virgo flore fronduit/Quoniam maria virgo deum nobis genuit; Quem patriarchis deus promisit signisque prefiguravit. Desinat esse dolor pro antiqua lege quia ecce: Viderunt ... Cernere quod verbum domini meruere canamus Salutare. Viderunt omnes fines terre salutare dei nostri." See *Provins*, 12, 18r, and discussion in Hiley, (1993a) 255, for the presence of this trope in other traditions.

75. Katzenellenbogen (1959), 15–16, pointed out that the arts were depicted in the laudatory poem Baudri of Bourgueil wrote for Adela of Chartres/Blois, but there they accompany Philosophy and sustain the baldachin over Adela's bed.

76. This argument might seem slender to those who know that in most calendars the month and its sign changed before these feasts, which occur late in the month, are celebrated, but at Chartres, as the discussion in Merlet's work on Na4 demonstrates, these symbols stood for the particular months.

## 10. ADVENTUS AND LINEAGE

1. I choose 1164 because Bishop Robert, the last of the interconnected group of three bishops who managed the mid-twelfth-century campaign, died that year. The election of the Thibaudian William of the Whitehands brought a changing of the guard. This nephew of Henry of Blois was one of his protégés, along with another nephew, Hugh of Le Puiset, who became bishop of Durham in 1153. Both became great builders and patrons of the arts, in the mold of their uncle. An overview of the topography of the town is available in Coulon (2008).

2. See *OC* 8–16. Studies of the interaction of portal sculpture and liturgical action include Zink (1989–90) on Autun Cathedral, Fassler (1993b) on Chartres Cathedral, Angenendt (1994) and McAleer (2001) on Durham, Schilling (2003) on Sant'Andrea in Vercelli, and Low (2003) on

Vézelay. In addition to Blum (1986) on the thirteenth-century façade of Wells Cathedral, see McAleer (1988), and especially Malone (2004), 131–56.

3. The Ordo Veridicus (OV) was copied for the hospital of Châteaudun (a dependency of the Madeleine); it, like St. John, St. Andrew, and St. Cheron in Chartres (after their reforms), was an Augustinian church. While the book postdates the fire of 1134, it retains many archaic features. Now that the long-missing manuscript has been located, it will surely yield more information through paleographic and codicological study.

4. For an introduction to the subject, see Juin (2001). Jansen (1982) discusses the importance of the tower that supposedly fronted Fulbert's cathedral. For the Carolingian westworks that were the architectural predecessors to the *tour-porche*, see McClendon (2005), especially 188, where he speaks of the few examples that survive and the difficulties of extrapolating theories from meager evidence. For later examples in Burgundy of the "avant nef" see Krüger (2003).

5. Branner (1969), 72–74, points to the west tower of Ebreuil as an example of the kind of structure that—with its expansion in the later eleventh century—would have fronted Chartres Cathedral around the year 1100. The tower of Ebreuil has a triple portal in the front and other doors to the side.

6. As can be seen from the donors' table in appendix H, two men gave "for the towers," as opposed to "a tower," and both were provosts. The first, Henry, served in this office for many years (1115–49), and is the only official to have worked for Bishops Ivo, Geoffrey, and Goselin. His successor in this office was Odo, who served from 1149 into the 1160s. That they both gave for towers should not surprise us, but other officials who worked during the same years gave for only one, demonstrating, I believe, that the phrase "for the tower" was generic and indicated the campaign to rebuild the entire façade, towers included. For study of the Parisian limestone imported to create the Royal Portal at Chartres and contemporary programs in the region, see Annie Blanc (1988), (1990), and Blanc et al. (1991).

7. The Chartrain tropes for the Introits are discussed in chapter 9, in Fassler (1993b), Hiley (1993a), and Karp (2001).

8. For the interrelationship of liturgical commentary and the Introit tropes, see Fassler (1993b).

9. Kendall (1998), with its catalogue of all known portal inscriptions, translations, and discussions, is a very useful work.

10. For example, on Saturdays from the octave of Pentecost to Advent there was a procession to the Cross, unless it was a day of nine readings. The departing procession sang antiphons for the Trinity—the ordinal mentions specific chants in honor of the Trinity—and on the return the cantor chose an antiphon, versicle, and prayer for the Virgin Mary. See OC 134.

11. In his article on how to read a medieval Office book, Dobszay (2000) addresses these problems.

12. On the decoration of dedicated chapels in the Middle Ages, see Hahn (1997) and Crook (2000), and, on the Virgin in particular, Palazzo (1996) and Signori (1996).

13. For early plans of St. Peter's church, see Joly (1993).

14. During the stational liturgy of Lent, the procession to St. Peter's church featured a prayer for Bishop Fulbert (OC 101).

15. The most common substitute for the Marian chants on reentry during Easter season was "Ego sum Alpha," the antiphon before the Gospel in the Easter Mass. Of the liturgical dialects studied by A. Robertson (2000) only Chartres has "Ego sum Alpha." The text and music are found in the Vatican Breviary, Rome, Vat. lat. 4756, f. 195. The antiphon was sung with the Versicle "Dicite in nationibus" (see chapter 11 below).

16. See, for example, OC 99.

17. The set of five includes the following: "Hec est Regina," "Te decus Virgineum virgo dei,"

"Beata es virgo Maria," "Beata dei genetrix Maria," and "Gaude Maria virgo cunctas." For texts in Latin and English, see below and appendix F.

18. "Haec est Regina virginum quae genuit regem velut rosa decora virgo dei genetrix per quam reperimus deum et hominem alma virgo intercede pro nobis omnibus." See *CAO* 3002.

19. "Post partum virgo inviolata permanisisti." R. "Dei genitrix intercede pro nobis."

20. "Famulorum tuorum quesumus domine delictis ignosce et qui tibi placere de actibus nostri non ualemus genitricis filii tui domini dei nostri intercessione saluemur."

21. See Cavet (2005) for discussion of the complexity of the process by which various liturgical elements were standardized for Books of Hours. For other early repertories of Marian antiphons see Steiner (1993).

22. "Beata Dei Genetrix Maria, virgo perpetua, templum Domini, sacrarium Spiritus Sancti: sola sine exemplo placuisti Domino Ihesu Christo: ora pro populo, interveni pro clero, intercede pro devoto femineo sexu."

23. "Letare virgo Maria de te flos pulcher processit qui odore replet caelos fructu qui pascit angelos de cuius nube lux lucet talem nec ante caelum genuit nec post terram parturit habens ergo qua laeteris de te Christus natus est creator astorum expectatio gentium alleluia, alleluia." The text transcribed is that found in the twelfth-century antiphoner from Jerusalem, Lucca, BArch 5, p. 315, for the feast of the Assumption. See also Paris, BN lat. 12044 from St. Maur-des-Fossés, a Benedictine abbey on the outskirts of Paris, *CAO*, MS F and the online datebase, *Cursus*, antiphon no. 3565. The work was found as a processional antiphon in Aquitania as well (see Roederer, *Festive Troped Masses*).

24. For an introduction to these Chartrain chants, see chapter 5.

25. See OC 87. Thomas of Canterbury's relationship with Count Thibaut V and with John of Salisbury, who became bishop of Chartres in 1176 and gave his cult prominence at Chartres Cathedral; Chartres had his relic early and introduced his feast almost immediately after his canonization in 1173. The absence of any reference to him in OV helps to establish its date, which can now be studied through its paleographical and codicological details. See discussion by Delaporte (OC 8 and 13).

26. The jambs of the west portal have been much described and evaluated. Authors from Bulteau to Klinkenberg have attempted to identify particular statues. See Beaulieu (1984), Bulteau (1850, 1872, 1882), Bulteau and Brou (1887–92), Clerval (1907), Durand (1881), Fleury (1904), Grodecki (1963), Halfen (2001), Hénault (1876), Houvet (1919), Klinkenberg (2008), Kidson (1958), Mâle (1948, 1963), Mayeux (1900, 1906b), Priest (1923), Sauerländer (1954, 1956), Schöne (1961), Stoddard (1987), Terpak (1972), Van der Meulen and Price (1981), Vanuxem (1957), J. Villette (1994), and Vöge (1894). Cataloguing of fragments promises important results: see Chevallier (1982), Pressouyre (1982), and Erlande-Brandenburg's classic study of fragments (1982), which generated further work on Notre-Dame of Paris. Staebel (2006) treats the Royal Portal as an arrangement of twelfth-century spolia reassembled by later hands, with additions and rearrangements.

27. On the original polychrome of Chartres, see Nonfarmale and Manaresi (1987); for a church in the lands of the Thibaudians (Provins), see Vuillemard (2006). For the subject in general, see the monograph of Erlande-Brandenburg (1994). On pictorial records, including Gaingnière's drawings, see Chadefaux (1960), with corrections and more materials in Hoyer (1991). VdM 170 says that earlier drawings and their study "indicate a high degree of correspondence between the Gaignières drawings of the west portal and the present condition, i.e. the good state of preservation maintained since the late 17th century and throughout the restorations since the 19th century, as documented by the earliest photographs." Headlam (1902), 128, claimed remnants were visible to him: "Once the whole porch was a blaze of color. Of this color and gold you may still see a few traces left."

28. This description is not found in the second edition of Sablon's work dated to 1683 and published in Chartres. Sablon does include a poem in which the portals of the church are described very briefly.

29. Montfaucon's study in *Monumens de la monarchie françoise* (1729–33, 5 vols.) has been evaluated by Jacques Vanuxem (1957), whose paper is reproduced in Branner (1969), 169–85, and also crticized by VdM 173–74. In his own pronouncement, Van der Meulen resents the condescending tone of Vanuxem and argues that the statues clearly sometimes did represent actual kings and queens; see further his studies from 1977 and, with Nancy Price, 1981. Two points made by VdM are particularly important: first, that three-quarters of the general engravings found in Montfaucon were dependent upon the work of Gaignières, and this includes those of Chartres; and second, that Montfaucon was in steady conversation with Brillon, who advised him, but that he also acknowledges his debt to the canons of Chartres for the work he produced from the region. Brillion's manuscript, entitled by Souchet *Description des portiques et de la porte royale de l'église de Chartres*, was Chartres, BM 1099, destroyed in 1944; a handwritten copy made by Hérisson survives as Chartres, BM 1510. For detailed general discussion of Montfaucon, see the papers edited by Hurel and Rogé (1998); art historians who have recently studied Montfaucon's influence include Hurley (2000) and Maxwell (2003).

30. As Cahn (1969), 55, says, the drawings are useful for "general character, if not precise appearance."

31. See Vanuxem (1957), in Branner (1969), 183.

32. See discussion in Vanuxem, with reference to Plancher, *Histoire . . . de Bourgogne*, 1:503, in a photograph of a liturgical procession taken in the early twentieth century. Plancher's sources and his ways of writing history are evaluated in Auger (1987).

33. "The designer of the central portal was one of the great sculptors of the Chartres school. He also had the idea of turning the statues into columns, an original idea which was only suggested at St. Denis, if Montfaucon's drawings are taken as a guide. . . . His female figures, however, are true marvels, and there his talent is given full scope. They are even taller than the male ones, and seem like actual columns, fluted with innumerable grooves." See Mâle (1948), 24. A critique of Mâle's contributions to general understanding of the period is provided in Crossley (2009).

34. "At Saint-Denis the idea of *regnum* and *sacerdotium* seems to have been represented for the first time. It was to remain a most important theme on French church exteriors for a century to come. . . . On the facade of the royal Abbey Church at Saint-Denis the jamb statues honor primarily the *regnum*. On the façade of the Bishop's Church in Chartres (and in a more abbreviated manner on other churches) crowned and uncrowned figures are still intermingled, but tribute is paid more equitably to both *regnum* and *sacerdotium*." Katzenellenbogen (1959), 35.

35. Halfen (2001). Bulteau (with Brou, 1887–92) was the first scholar to present a detailed attempt at identifying all the jamb statues.

36. For a schematic diagram, see Halfen (2001), 318, and below.

37. Heimann's work is discussed in detail in chapter 11.

38. On earlier attempts to restore the portal, see Pressouyre (1982), who argues that work carried out before the late seventeenth century replaced all three heads and that only two of these three jamb statues are by the so-called Étampes master.

39. The "angel" is a copy of the original, now in the crypt, where it, along with several other jamb statues that have been replaced, awaits careful study by experts in the field.

40. See Harper-Bill and Van Houts (2003), esp. 286–89, on Bishop Henry's own attempts to rein in the attacks of his brother, King Stephen, on the clergy and the church in the late 1130s and 1140s. The resemblances between the strained relationships of Bishop Henry to King Stephen and Chancellor Becket to King Henry are provocative. A detailed treatment of the relationship between Becket and the bishop of Winchester is found in Senette (1991), esp. 217–36.

41. For an analysis of an "L" from the twelfth century and its program, see Heimann (1965); for further bibliography on the iconography of the so-called Jesse tree, see Watson (1934) and Fassler (2000a). The "styrps Jesse" is discussed further in chapter 12.

42. Haney (1981) relates the iconography to the liturgical veneration of the Virgin in England.

43. The *Liber Vitae* of the New Minster, Winchester (1031), London, British Library, MS Stowe 944, has a portrait of Canute and his Norman queen Emma as a donor to the church as its frontispiece. This book continued to serve Winchester in the time of Bishop Henry.

44. William of Malmesbury, *Chronicle of the Kings of England*, II.ii, p. 204. Cf. *Ep.* 37, *LPFC*, 66–69.

45. See Fulbert, *Approbate consuetudinis* (*PL* 141:321C–D). The entire sermon is translated into English in appendix E.

46. Most known surviving Chartrain liturgical sources, or copies of those sources, are listed in appendix A. Other fragments are found in the Archives départementales and will be catalogued by Fiona Edmund.

47. "Sicque finita serie generationum quasi rememorando dixerit: 'Christi autem generatio sic erat,' ac si diceret: Sic ordo humanae generationis Christi per parentes ejus usque ad eum pervenit. Sive ad id iungatur, quod subsequitur de disponsatione matris ejus (quomodo, antequam iungeretur suo sponso, *inventa est in utero habens de Spiritu sancto*, ut quantum generatio Christi a ceteris distet, aperiatur, cum ceteri per conjunctionem maris et feminae solitam, ipse autem per virginem utpote Dei Filius nascebatur in mundum). Si autem aliquis quaerendum putat, cum Joseph non sit pater Domini Salvatoris, quid pertineat ad eum generationis ordo deductus usque ad Joseph, sciat primum non esse consuetudinis Scripturarum ut mulierum in generationibus ordo texatur. Deinde ex una tribu fuisse Joseph et Mariam, unde ex lege eam accipere cogebatur ut propinquam et quod simul censentur in Bethleem ut de una videlicet stirpe generati" (CCCM 174:40, reading "ad Deum pervenit" with *PL* 107:747D–748A, in place of CCCM's "ad eum pervenit").

48. "*Filii David, filii Abraham.* Ordo praeposterus, sed necessario commutatus. Si enim primum posuisset Abraham et postea Dauid, rursus ei repetendus fuerat Abraham, ut generationis series texeretur. Ideo autem caeteris praetermissis horum filium nuncupavit, quia ad hos tantum facta est de Christo repromissio: Ad Abraham *In semine*, inquit, *tuo benedicentur omnes gentes terrae*; ad David vero ait: *De fructu ventris tui ponam super sedem tuam*" (CCCM 174:13).

49. See Hopper (1938), the classic study of medieval number symbolism, and Simson (1988), chap. 2, "Measure and Light," and passim; see also Hiscock (2007). The popular book by Louis Charpentier, *The Mysteries of the Cathedral of Chartres* (1972), has been translated into many languages and offers short chapters on the various geometrical shapes implicit in the design of the cathedral. Chapter 13 of Charpentier's study concerns the importance of the twin towers of the west façade to the design of the thirteenth-century cathedral.

50. "*Abraham genuit Isaac, Isaac autem genuit Iacob* et reliqua. Exsequitur ergo humanam generationem Christi Matthaeus, ab ipso promissionis Christi exordio, hoc est ab Abraham, generatores commemorans. Quos perducit ad Joseph virum Mariae, de qua natus est Jesus. Mysticeque demonstrat, quomodo de gentilitatis caligine quasi de Aegyptia servitute per XLII viros ac si ejusdem numeri mansiones ad virginem Mariam plenam sancti Spiritus gurgite fluentem ac si intelligibilem Jordanem duce Domino Jesu Christo velut Josue, filio Nun, ventum sit" (CCCM 174:13).

51. The numbers may be sophisticated mystically but are simple mathematically. The ordering of multiplicands makes no difference in the result.

52. "[II.] *Omnes*, inquit, *generationes ab Abraham usque ad David generationes XIIII, et a David usque ad transmigrationem Babylonis generationes XIIII, et a transmigratione Babylonis usque ad Christum generationes XIIII.* Quarum divisionum ratio ita constabit, si ab Abraham prima tesserescaedecadis incipiens in David finiatur; secunda vero a David (hoc est juxta David a

Salomone inchoans) in Iechoniam priorem (hoc est, patrem, qui Ioakim apud Hebraeos voca-tur) desinat; tertia quoque a Iechonia secundo (id est filio Ioakim, qui Ebraice dicitur Ioachin) initium sumens usque ad Christum pertingat, ut ipse Christus connumeretur. Quod autem XIIII in tota genealogia sunt positi, historice quidem tres Ebraici populi distincti sunt tempo-rum articuli, quorum primo sub patriarchis et sacerdotibus et judicibus ante reges; secundo sub regibus et prophetis et sacerdotibus; tertio sub ducibus et prophetis et sacerdotibus post reges conuersatus est. Mystice vero perfecti et Divino karismate pleni in unum redacti sunt numerum. Nam X ad decalogum, IIII ad Euangelium, tria ad Trinitatis respiciunt fidem. Et omnia haec eidem conueniunt sacramento, quia, sicut ter quaterni et deni sive quater decies terni in numero concordant, ita in fide sanctae Trinitatis lex et Euangelium coaduuantur, et per legem atque Euangelium sanctae Trinitatis fides praedicatur" (CCCM 174:35).

53. The narrative of the frieze is discussed in chapter 11.
54. "Ipsumque Christum de Maria natum esse testatur, qui uelut hamus in retis capite sic in fine genealogiae positus et in mare huius mundi a Patre missus tortuosum draconem aduncatum occisus occidit atque humani generis mortem mortuus mortificauit. Et ideo uelut fune dupli-cato, iterato uidelicet uniuscuiusque nomine, in retis similitudinem genealogiae ordo contexi-tur, donec ab huius principio, hoc est ab Abraham, ad hamum usque, hoc est Christum, adue-niatur. De quo ad sanctum Iob dicitur: *Numquid aduncabis Leuiathan hamo tuo, aut armilla perforabis maxillam eius?* In hamo ergo incarnationis Christi iste captus est, quia, dum in illo appetit escam corporis, transfixus est aculeo Diuinitatis" (CCCM 174:13–14). This idea is ref-erenced as well in the Easter sequence *Ecce uicit*, discussed further in chapter 12 and included in the appendix.
55. The paper "Le cathédrale de Chartres, oeuvre de haut savoir," was first published in 1957. It was reprinted in 1994 in a collection to which it lent its name, prefaced by Jean Villette, Guy's brother, who also dedicated his life to the study of the cathedral. Guy died in 1991 and Jean in 2005; the intimate knowledge they had of the cathedral, its arts, and its legends cannot be replaced.
56. Guy Villette (1994), 51. In his analysis of the central tympanum, for example, he finds these numbers expressed in several ways: fourteen apostles (on the lintel, the twelve plus Enoch and Elijah); ten apostles on the lintel of "what they call the Ascension"; the twenty-four elders in the archivolts of the middle portal (fourteen plus ten); fourteen figures representing the liberal arts in the north; the twelve signs of the zodiac reduced to ten on the north, with two displaced to the south (these are discussed in chapter 11); and the fourteen angels in the middle archi-volts. He also discusses the jamb statues in these terms and says there must have been "without doubt" ten women and fourteen men in the original display (52).
57. The jambs in the north portal also contain the Davidic lineage and those deemed to have been its prophets. The numbers of the jambs are symbolic here as well, and the number fourteen figures prominently.
58. See this theme as developed in the early twelfth century by Bishop Ivo (chapter 6).
59. Stoddard (1987) believes that the lower lintel of the north portal is spolia. If true, this is useful information for those scholars who concentrate on iconography.
60. Wirth (2004), 150–51: "Dans le cas de la façade occidentale de Chartres, par example, on soup-çonne le sculpteur particulièrement auquel sont dues les statues-colonnes du portail central d'avoir organisé le travail commun. Mais la qualité et l'originalité des deux ou trois sculpteurs qui collaborent avec lui laissent supposer qu'il était 'primus inter pares,' comme le fut probable-ment Etienne de Bonneuil au siècle suivant."
61. The careful architectural investigations carried out on the church at St. Denis have no parallel at Chartres; the forthcoming collection of essays edited by Pamela Blum will be the latest in a long parade of close studies, none of which has seriously challenged the dating of Suger's work and its role in architectural history. Blum's own work, both on the dating and construction of

St. Denis and on its iconography, suggests the fruitfulness of comparative study. She points to some of the ways in which the façade sculpture at St. Denis embodied ideas about history: "In the archivolts, the intertwined vine of the Tree of Jesse forms a niche for each of the fourth archivolt figures and also provides a frame for the entire sculptural ensemble above the jambs. The vine, which equates the elders of the Apocalypse with the patriarchs and ancestors of Christ, the major figure on the central axis, frames a representation that selectively refers to the entire history of the Christian universe as understood by medieval theologians. The sculptural program encompasses that version of world history, spanning events from the Fall of man, a reference implicit in the angel with the flaming sword set by the Creator to bar the way to the Tree of Life, through the continuum represented by the Old Testament precursors of the crucified Christ, and finally to the raising of the dead by the angel sounding the last trumpet, the Second Coming of Christ, and Last Judgment" (1992, 120). For provocative arguments about the importance of other churches contemporary with St. Denis, see especially the writings of Stephen Gardner (e.g., 1984a and b), whose early death was a great loss to the field of art history. Since Panofsky's translation of Suger's writings on his administration and the building campaign, his writings have also been much considered. With the work of Anne Robertson (1991), Brown and Cothren (1986), Grover Zinn (1986), and Tova Choate (2009), liturgical material has been offered of direct relevance to art historical arguments. Kidson (1987) provides an analysis of Suger's lack of artistic understanding and faults Panofsky with misinterpretations that have taken art historians down unfortunate paths, ideas that are taken further by Speer in his edition of Suger, *De consecratione*. Kurmann-Schwarz and Kurmann (1995) study various disjunctions in several aspects of the entire monument.

62. For discussion of the reform and relevant documents, see Merlet and Jarry, *Cartulaire de l'Abbeye de la Madeleine*, xxii–xxiii, and charter no. 7. A charter of Louis VI dated 1120 calls the church an abbey. See also L. Grant (1982).

63. See Paris, BN, Estampes Ve, 20 fol. and Va 48 b; for further discussion, see E. Lambert (1945–46).

64. See Antoine Lancelot, "Descriptions."

65. L. Merlet and Jarry, the editors of the cartulary, say in their introduction (xxii–xxiii) that Bishop Geoffrey wished to do for the La Madeleine what Ivo had done for St. John and St. Andrew in Chartres, reforming the church, strengthening it through gifts, and installing canons regular who followed the liturgy of the cathedral. Two documents date this reformation to between the years 1118 and 1120.

66. On the regulation of duels and the power of the La Madeleine and of the count, see xxiv–xxv, and Charters no. 11 of Count Thibaut and no. 12 of Geoffrey of Lèves.

67. Corvisier (1997) is dedicated to castles and their towers from this period and in the region.

68. For discussion of the details found in the clothing of the Chartres jambs, see Snyder (1996) and Burns (2002).

69. See Fassler (1993b). A discussion by Robert Deshman (1997) of the ascension in Anglo-Saxon illumination has been useful in providing a visual precedent for my interpretation. In his summarizing of the evidence from patristic texts regarding the cloud of the ascension, Deshman finds parallels to themes from Advent. His insights are directly applicable to the Ascension scene of the northern portal of Chartres, whose prominent cloud is the feature that most distinguishes this scene. As stated above, the problematic lintel of the "apostles" is believed by Stoddard to be a remnant of some other work of art.

70. The theme of kingship is also found in the trope for the Introit, second set, "Elevatus est rex fortis" (see Hiley, 1993a) and the antiphon before the Gospel, "O rex gloriae," also sung as an antiphon at Vespers.

71. For discussion of the work in the context of the Advent liturgy, see chapter 3. The full text is translated and biblical sources and resonances provided.

72. My paper, "Seeing Advent: Early Visualizations of the Responsories 'Aspiciens a longe' and 'Aspiciebam in visu noctis,'" was presented at the annual meeting of the Medieval Academy of America in 2000 and again in honor of Walter Cahn at a conference at the Yale Institute of Sacred Music in 2002. The discussion is incorporated into Fassler (2007) and the theme is treated further in Cahn (2006).

73. Honorius Augustodunensis weaves these ideas together in his commentary on the Ascension, describing the ascending Jesus in terms of a king, another idea central to the meaning of this historic event as represented and reenacted at Chartres. He thinks of the flesh in which Christ is wrapped as a dark cloud, but Christ as he rises redeems the cloud he wears and makes it glorious. See "De ascensione," a chapter of *Speculum Ecclesiae, PL* 172:957.

74. Much as he used the singing of a canticle in his depiction of memory and time, Augustine explicates the mystery of John 1:14 by the act of hearing a spoken text (*De doctrina Christiana*, 1, 13): "Just as when we speak, in order that what we have in our minds may enter through the ear into the mind of the hearer, the word which we have in our hearts becomes an outward song and is called speech; and yet our thought does not lose itself in the sound, but remains complete in itself, and takes the form of speech without being modified in its own nature by the change: so the Divine Word, though suffering no change of nature, yet became flesh, that He might dwell among us."

75. A succinct summary of the theology of Christ's nature as related to the Ascension is found in Augustine's tractates on the Gospel according to John: "You see, he was here, and was also in heaven; he was here in his flesh, in heaven by his divinity—or rather, he was everywhere by his divinity. He was born of his mother without departing from his Father. We perceive two nativities of Christ, one divine, the other human: one by which we were to be made; the other by which we were to be made anew. Both are wonderful; one without a mother, the other without a father" (Tr. 12, 8; *CCSL* 36:125). As Deshman (1997) says, to depict Christ coming and Christ going is especially hard because humans are not able to see either action, nor would it be theologically proper for them to do so: "The visualization of this exegesis presented medieval artists with a difficult problem: the representation of Christ's divinity required his absence from sight, but his omission from the composition would have impaired the depiction of his humanity and obscured the scene's narrative coherence" (534).

76. See Augustine's sermon 243, "Glorificatio Domini nostri," *PL* 38:1211.

77. See Ivo of Chartres, Sermon 19, *PL* 162:591. The entire work makes a fascinating commentary upon the northern tympanum and its relationship to the history depicted in the frieze. Hebrews 10:20–25 is especially well suited to the Mariology of Chartres Cathedral: "A new and living way which he hath dedicated for us through the veil, that is to say, his flesh, and a high priest over the house of God: let us draw near with a true heart in fullness of faith, having our hearts sprinkled from an evil conscience, and our bodies washed with clean water. Let us hold fast the confession of our hope without wavering (for he is faithful that hath promised), and let us consider one another, to provoke unto charity and to good works: not forsaking our assembly, as some are accustomed; but comforting one another, and so much the more as you see the day approaching."

## 11. REALITY AND PROPHECY

1. Caviness (2006) is an overview of the topic, with excellent bibliography; Hahn (2006) deals with the related topic of visualization, which requires thought about ways in which theologians, donors, and patrons embody ideas of both presentation and reception as well as the deeper meanings of the visual. Jørgensen (2004) compares "cultic visualization" in the early Christian period to that of the Middle Ages. He says (174), "An essentially visual conception of ritual seems to have been developed and increasingly promoted during the Middle Ages,

partaking both in the ritual's underlying construction of the sacred and in the resulting modification of the recipient's perceptual and psychological approach to religious ceremonies."

2. Franklin (1992) evaluates what it meant for the audience when a cathedral also served as a parish church for some residents of a city (as was the case at Chartres). Murray (2004) suggests the ways in which medieval audiences processed information as they walked and looked; as viewers engaged the art, memories of liturgical music and ceremony were recalled to shape meaning. This is especially important for the study of the cult of the Virgin at Chartres in the twelfth century. Here, as with the chant texts studied in chapter 3, a kaleidoscope of related images is arrayed in various guises to draw the viewer deeply into the realm of possible meanings and to engage the memory as central to comprehension.

3. Extensive excavations of the area in front of the cathedral in the 1990s revealed a catacomb of medieval houses, many of which may have belonged to dignitaries of the cathedral; see B. Randoin (1991) and B. Randoin et al. (1995). A sixteenth-century wooden library at Noyen Cathedral gives the sense of the kinds of buildings that were attached to medieval cathedrals. Pristine today, the façade of Chartres Cathedral was once crowded by buildings and walkways of various sorts.

4. Inside, too, medieval churches were stuffed: every pillar sustained at least one altar and its statuary and other accoutrements. In his review of Neil Stratford (1993), Peter Fergusson reminds us that "no area of the art of the high Middle Ages has suffered greater losses than that associated with the sanctuaries and chapels of its great churches, where the shrines, portable altars, book covers, reliquaries, retables, and liturgical objects were cherished" (1995, 205).

5. John James has published a three-volume catalogue of carved capitals from throughout the region (2002–06); his collection will help to situate the abundant surviving capitals from twelfth-century churches in the region (he will be cataloging other details in subsequent volumes). It would be useful to compare them to the few surviving works patronized by Henry of Blois, bishop of Winchester as well as to churches built under the patronage of Thibaudians in Burgundy and the Champagne. Fragments of sculpture from works in Winchester, for example, are reminiscent of some of the decorative shafts at Châteaudun; for discussion of these fragments from Henry of Blois's palace, see Riall (1994), Kusaba (1993), and Zarnecki (1986). Designs and decorations used in shafts of letters in great illuminated Bibles prepared under the patronage of Henry of Blois and his brother Count Thibaut could be studied and profitably compared to surviving colonettes and fragments of colonettes from portal sculpture.

6. Heimann's study (1968) of the capital frieze and pilasters and their relationship has unfortunately not inspired further work, although it is widely recognized as the fundamental discussion of the subject. Most scholars accept her interpretations, with only a few quibbles. Crozet (1971a, 159–65) is a short critique; Heimann replies to him in the same issue (1971, 349–50), and he to her (1971b, 350–53). Van der Meulen and Price (1981), in the opening notes, say that it is difficult to tell if the progression of people and events in the pilasters relates to the meaning of the frieze as a whole or to specific events in the frieze (87); some of the most credible examples are discussed below, with new substantiating evidence from the liturgy offered for these and newly suggested connections. Both Nolan (1989, 1994) and Spitzer (1994) have sought overall meanings in the program of the frieze without attention to the pilasters: Nolan emphasizes the ways in which the scenes are related to the subjects of liturgical drama; Spitzer finds close attention to issues of importance to women, especially regarding fertility and childbirth. Other studies since Heimann published her article on the frieze include Pressouyre (1969), Marcus (1972), and Stoddard (1987), 139–48.

7. Alison Stone's summary chart of the frieze at Chartres on the Internet is very useful (see her site: http://vrcoll.fa.pitt.edu/medart/image). Photographs of the entire frieze are published there, each identified and placed within the portal as a whole.

8. Heimann (1968), 89: "The figures become progressively more and more modelled in the

round; the lowest are very flat indeed, whereas those directly under the frieze stand out considerably. Hand in hand with this compositional device goes a tendency to individualize the figures towards the top." She cites the study by Schöne (1961) as the only other work attentive to the pilasters.

9. See Wright (2000).

10. Peter Low's paper on Vezelay (2003) demonstrates the power of the portal iconography to welcome the laity into church at Pentecost, and to instruct through the sculptures and their arrangements about the power of healing.

11. The glorious Gloucester candlestick from the twelfth century is a fine example (see Sydenham, 1984).

12. See Charles Little (1975) on a twelfth-century ivory from Bamberg now in the Louvre. It depicts Bishop Fulbert and Isaiah standing to either side of a simple, elegant Styrps Jesse. This ivory is studied further in Arthur Watson (1934) and in Fassler (2000a).

13. References to the *Protevangelium of James* are to J. K. Elliott's summary and partial translation of Tischendorf's Greek version; for the Latin, see E. de Strycker's version in *Analecta Bollandiana* (1965); references to the *Pseudo-Matthew* are to Gijsel's edition (CCSA 9) and to the *Libellus* from Beyers's edition (CCSA 10). For the rejection of Anna and Joachim, see *Protevangelium* 2; *Pseudo-Matthew* 2.1; and *Libellus* 2.1. In the *Libellus* the figure who refuses their offering is Isachar the high priest; in the *Pseudo-Matthew*, the figure is Reuben the scribe. The refusing figure on the frieze is in priestly garb.

14. This depiction of Joachim's visitation by the angel and the announcement of the Virgin's birth in the *Libellus* emphasize that he was alone. In the *Libellus* the angel mentions other sterile women in the Bible as precedents: Sara, Rachel, and the mothers of Samson and of Samuel. These were not mentioned in the *Pseudo-Matthew*, but Sara was recalled in the *Protevangelium*. The emphasis on lineage found in the *Libellus* is reflected generally in the west portal program.

15. The contrast between this scene and that of the Infancy of the Virgin cycle in the Winchester Psalter (London, BL Cotton MS Nero C IV) is striking; both are mid-twelfth-century works of art commissioned by Thibaudians, but the churches for which they were commissioned had differing attitudes toward the cult of the Virgin. The feast of the Immaculate Conception was favored by the Anglo-Saxons but rejected by the early Normans in the late eleventh and early twelfth centuries. As a result of a council held in 1129 the feast was reinstituted in England, and this liturgical transformation is reflected in artworks from the period, including the Winchester Psalter. In this book the barrier of the Golden Door is placed between Joachim and Anna, indicating that Mary's conception was spotless, whereas in the frieze at Chartres there is physical contact. Bishop (1918), 238–59, discusses the feast in medieval England and proves the historic connection of Winchester with both its founding and its continuation. For discussion of the theme in the Winchester Psalter, see Haney (1981); the apocryphal infancy Gospels transmitted in Anglo-Saxon have been edited and studied by Mary Clayton (1998), who is an authority on early English Mariology.

16. For discussion of the bath of Jesus at Étampes, which is very like this scene in design, see Nolan (1989), fig. 9, and discussion 177–78.

17. The iconography of the fifteen gradual psalms and the fifteen steps in the Books of Hours is studied in some detail by Smith (2003).

18. Study of the manuscript sources of *Pseudo-Matthew* and the *Libellus* found in the new critical editions demonstrates that both were well represented in the region in the twelfth century.

19. Although the figures to the right of Mary's entrance into the temple are usually interpreted as attending priests, they may be part of a second scene. Several are possible, including the story (in *Pseudo-Matthew*) that Mary refused presents from one of the priests on behalf of

his son who wished to marry her. The Virgin Mary of the *Pseudo-Matthew* adopts a monastic regime of prayer and way of living worthy of a child or youth in a monastic or cathedral school in the Middle Ages: "This is the rule she imposed on herself: from morning until terce, she prayed; from terce to none, she wove cloth; from none she prayed again until an angel of God appeared from whom she took her food. And so she progressed more and more in the Fear of the Lord." When her companions, the older virgins, teach her the Offices of prayer, she is the one who shows up first, eager to practice what she has learned in the hours of prayer. She also reaffirms her vow of chastity, refusing betrothal gifts offered by a priest for the sake of his son, explaining that she is consecrated to God (Gijsel, ed., 332–36). The thirteenth-century Saint Cheron window at Chartres depicts another refusal to marry, this by a male saint; see Manhes-Deremble (1993), 15; Delaporte (1926), 42.

20. This group of three initiates the infancy of Christ Window, the central lancet, of the west façade. The nativity scene in the window has been designed to create a parallel with the depiction of Jesse at the base of the Styrps Jesse lancet; these in turn relate both to the two depictions of the nativity in the portal sculpture. The idea emerging from such powerful restatements is that Mary is of the house of David, as is her son. Mary became the new Jesse, Jesus the new David.

21. Heimann (1968), 91, unlocked the series and related it to the frieze above.

22. Described in Fulbert's sermon and in the apocryphal *Libellus*, ch. 7, 306–10, a text perhaps read at Chartres in this period for the special Office for the blessed Virgin outlined in Chartres, BM 162 (see chapter 5). The rod of Joseph is featured throughout the depictions of him on the frieze.

23. Judges 6:36–40. Gideon's fleece, through God's power, is first wet on dry ground, then dry on wet ground. For a depiction of the image decorating a twelfth-century copy of Fulbert's sermon for the Virgin Mary, see Watson (1934) and discussion in Fassler (2000a).

24. At Arras, and in some Italian regions, an antiphon that commemorated David's playing was sung for the *historia* of Kings. The celebration of the art of the minstrel in Arras would justify the inclusion of this work; see Symes (2005) on the culture of minstrelsy. For the diffusion of the piece, see *CAO* 3642 in the Cantus index. Saul's daughter was annoyed by David's playing and dancing, and she, unlike the Virgin depicted above David on the pilaster, was barren. See 2 Kings (Samuel) 6:20–23. In Rabanus's commentary on Matthew 1, sung throughout the week of Mary's Nativity, David is proclaimed in the genealogy as the first king of Juda.

25. The most important biblical references are 2 Kings (Samuel) 6, and 1 Par. (Chron.) 16. Especially important is 2 Kings 6:5, "But David and all Israel played before the Lord on all manner of instruments made of wood, on harps and lutes and timbrels and cornets and cymbals." Bonjour and Petitdemange (1986) have published a study of all the musicians and instruments depicted in the sculpture and glazing of Chartres Cathedral. From tables in their chapter on the west portal one can tell that the *vielle*—a type of medieval fiddle—is the preponderant instrument. Among the twenty-four elders of the Apocalypse, for example, twenty-three have instruments; four of them have disappeared, two are harps, two are psalteries, and all the other elders (fifteen) play some sort of *vielle* or rebec. The name *vielle* became associated with a hurdy-gurdy type instrument in the fifteenth century.

26. A concise view of these incidents was presented in the Christmas sequence "Lux fulget" (see appendix D). It may have originated at Chartres.

27. For discussion, see chapter 6; the texts of the three sermons have been translated into English in the appendices. Although the original liturgical intention of the sermons seems clear, there is no indication within the sources of the twelfth century that these sermons had become part of the liturgy, although they were known and studied at the time.

28. The story of Herod and his son Herod Archelaus is told primarily in *The Wars of the Jews* by

Josephus. For Archelaus's demise, see 2.7.3, William Whiston, trans.; updated edition (1987), 368. Like other doomed kings in the Old Testament, Archelaus dreams of his downfall, represented in his case by nine ears of corn that stand for the nine years of his reign.

29. The stone cut from the mountain without hands is mentioned by Rabanus in the text read for the octave of the Nativity of the Virgin at Chartres. See the text, CCCM 174:741.

30. This image is alluded to in Isa 28:16; Matt 21:42; Luke 20:17; Acts 4:11; Rom 9:33; and 1 Peter 2:7.

31. See Rabanus Maurus, *Expositio in Matthaeum*, CCCM 174:741.

32. Herod's cross-legged stance underscores (and treats ironically) his authority; see Golden (2005).

33. For a detailed discussion of the tradition of Innocents plays and their exegesis, especially as related to parallels between Rachel and Mary, see Boynton (2004). The liturgy for this day at Chartres Cathedral in the mid-twelfth century was elaborate, with a full set of tropes. Hiley (1993a), 259, suggests that one of the additions to the Communion antiphon "Vox Rama" is uniquely Chartrain. Emily Rose pointed out to me that the figures being slaughtered are children, not babies; this too would evoke Innocents' plays, traditionally performed by acolytes.

34. Bernard, in a letter to Louis (ed. Leclercq and Rochais, no. 221, vol. 8, pp. 84–86; trans. James, no. 297, p. 364). This cruel scene has been evaluated by historians of the crusades and of medieval warfare. If this section of the portal was designed and constructed during the 1140s, it was built during a time of antagonism between Count Thibald IV and King Louis VII, sparked by an event that Souchet and others believed initiated a need in the French king's life for atonement. Raoul, count of Vermandois, had married a relative of Count Thibaut but sought to divorce her and marry the sister of Queen Eleanor, Perronnelle. Thibaut, supported by Bernard of Clairvaux, held out against the king's case for his sister-in-law, and as punishment the Thibaudian realm was once again subject to fire and plunder by the king's armies. In 1141 the king and his forces set fire to the town of Vitry (named Vitry-le-Brûlé), and some thirteen hundred people, many of them women and children, were burned to death. When viewing such an artwork in the 1140s, local viewers surely recalled this incident of civil murder of children by a king (see also discussion in chapter 7). For a sensitive study of the "epistomology of images," see Liepe (2003); she argues for taking care when trying to make exact parallels between what is depicted and actual events contemporary with the making of the image, but here we seem to be on solid ground. Louis VII seems to have favored the iconography of the Innocents later in life: see Cahn (1986), 123, for further discussion of this idea and bibliography. Perhaps Louis associated the biblical event with his own life and desired that he not (like Herod) be the last king in his line, something he deeply feared. See Horste (1987), 206–09, which includes her discussion of A. W. Lewis (1981) and further bibliography concerning the traceable growth of Capetian identity and pride regarding lineage in the twelfth century. Herod commanding the slaughter and the slaughter itself occupy the middle row of the central lancet window as well. Herod's posture as depicted in the glass is also telling: he is seated there like Mary in the familiar *Sedes* posture, but his arms are raised and his lap is barren; in a related frame, Herod holds his doomed scepter against his thigh.

35. *Protevangelium*, trans. Elliott, 66.

36. Guy Villette (1994) has described the role of demons in the sculpture of the west façade and finds their appearances calculated and part of a theme of struggle.

37. In spite of its flaws, *Christian Rite and Christian Drama* by O. B. Hardison (1965) remains the most engaging description of this struggle in all its manifestations.

38. Heimann (1986, 81 and plate 36) finds a visual parallel in a pyx from Lavoute-Chilhac (Auvergne, modern diocese of St. Flour), a priory dependent on Cluny and founded by Abbot Odilo in the eleventh century.

39. Nolan (1989) speaks about the importance of sacrament and symbol in the narrative capital freize of Étampes.

40. The south portal, its archivolts, and the frieze have long been thought to have been assembled from earlier elements that had to be recut and repositioned, perhaps after the fire of 1194; the lancet window above this door also shows the most signs of later transformation and restoration, and art historians with the expertise to study the details of these artworks are occupied with these questions. Most recent are the evaluations of Staebel (2006), who treats the west façade as a twelfth-century work that was reconfigured in the thirteenth century. The towers themselves are twelfth-century structures (the north tower having an early sixteenth-century steeple), but what lies between them was transformed over time. In any case, if the frieze has been recast, those responsible have made the Last Supper stand for Christ's sacrifice on the Cross, as it does in the Mass liturgy as well. The influence of Peter the Venerable and artistic programs featuring the Last Supper in Cluniac churches may be at play here. Peter wrote against the heretic Peter Bruyis, who denied the sacrament of the Eucharist. Conant (1956) is a classic overview of the subject.

41. Rupert of Deutz, in his treatise on the Trinity, says the red heifer "designates the maternal charity of Christ, by which he was made obedient to the Father for us, and gave birth to our salvation in his distress" (*De Trinitate*, PL 167:883D: "hic sexus femineus maternam charitatem designat Christi, qua pro nobis factus obediens Patri, salutem nostram in angustia sua parturivit").

42. See Heimann (1968), 98, and plate 42a. Heimann reviews the scholarship concerning the word "Rogerus" written directly above the sacrifice of the red heifer, and sides with those who say it is the name of an artist associated with carving. A mason named Rogerius is referred to in a charter from Josaphat in the late 1130s.

43. Hiley (1998) attributes the Office for the Transfiguration to Peter the Venerable, a figure closely associated with Henry of Blois. The choice of this subject is unusual in the mid-twelfth century.

44. In Hildegard's *Scivias*, Ecclesia holds a chalice at the altar of sacrifice (see book II, vision 5); for discussion, see Fassler (2006).

45. Heimann (1968), 99, cites Rabanus Maurus (PL 107:320–21) for the connection between Noah as cultivator of grapes and the wine of communion offered first by Christ: "Noah was a figure of the passion of the Lord because he drank wine and became drunk . . . let us see in Noah a type of the future truth, when he will drink not water but wine, and thus will express an image of the Lord's passion." ("Noe . . . et figuram Dominicae passionis illic exstitisse, quod vinum bibit, quod inebriatus est . . . quod Noe typum futurae veritatis ostendamus, non aquam sed vinum biberit, et sic imaginem Dominicae passionis expresserit.")

46. See especially Luke 22:3–5: "And Satan entered into Judas, who was surnamed Iscariot, one of the twelve. And he went, and discoursed with the chief priests and the magistrates, how he might betray him to them. And they were glad and covenanted to give him money." Further discussion is found in Heimann (1968), 100, who provides additional evidence for this interpretation.

47. Mary is positioned within a parallel to the procession of the palms in the central lancet, both coming and going on a donkey with Jesus on her lap and being welcomed into Sotine in Egypt, an event described in the *Pseudo-Matthew*. The similarities between the scene of Mary and Joseph at Chartres and in the fragments of a contemporary infancy window from St. Denis are striking; for discussion see Cothren (1986), 413–17.

48. In the Synoptic Gospels, Judas takes the silver soon after the scene of the woman who anoints Christ's feet. In some versions, it is Judas who complains about the expense of the ointment because he desired the money for himself and was a thief.

49. The same scene in the south lancet is telling, for Judas's body is less supple; this is generally true of the figures depicted in the glass, although the figure of Christ on the Cross is more in keeping stylistically with the figures of the frieze. The sense of activity is generally greater in the frieze than in the glazing, perhaps a result of the medium itself rather than of intention; there is certainly an attempt to depict emotion in both displays. According to Perrot (1977), the head and torso of Judas are from the twelfth century (among the few surviving original panes in this scene) and the head of Christ is from 1976. Cothren (1986) says the remains of the mid-twelfth-century glass at St. Denis suggest that the program at Chartres is "more generic" than that at St. Denis, where he believes there was a stronger dependency upon the *Pseudo-Matthew*. Comparisons are difficult, however: the St. Denis windows exist in a small number of fragments, and the Chartrain Passion of Christ window has been heavily restored. Pastan's (1989) study of medieval glass in Troyes is a helpful introduction to the complexities of restoration.

50. Heimann (1968), 87, says that this is the first scene of its type in French art; the same action occurs in the anointing scene of the Passion of Christ window, the southern lancet. There is a scene featuring the anointing in the Winchester Psalter, British Library, Cotton MS Nero C IV, f. 23r, a book produced under the patronage of Henry of Blois. Haney (1981) reaffirms the likelihood of Henry's patronage of this Bible and also connects the psalter to the liturgy of Winchester and the promotion of the feast of the Virgin's Immaculate Conception. One figure is pouring oil into the wound in Christ's side, in a posture resembling that found in the same scene in the south lancet; in the window's present state, the Virgin, with a Greek cross on her headdress, watches, with her hand to her face.

51. An "anointed one," interpreted as Christ, is referred to several times in the Psalms, and these texts were used by Christian liturgists and exegetes to help establish the priesthood and kingship of Jesus. Most important in this regard is Psalm 104/105:15: "Touch ye not my anointed," echoed in the promises of the angel to Mary at the Annunciation, in the text of the Magnificat, and in the canticle of Simeon. The lamp is present in the bottom central scene of the Styrps Jesse window at Chartres and also in the nativity scene of the central lancet (although it must be noted that the sections of the window depicting Jesse, including the lamp, are restorations from 1894–1902, for which, see Perrot, 1977). According to John Crook (2007, 191) the only surviving example of such a medieval lamp has been found at Winchester (Winchester City Museums, Acc. no. 483.34).

52. For a description of this dramatic event, see O. B. Hardison (1965). Rainer Warning (2000), 45–65, discusses the dramatized descent as a "ritual release from the fear of the Devil" (62). Scriptural precedents for the event are weak; the most important is 1 Peter 4:6. The apocryphal Gospel of Nicodemus lays out the Christian story most fully, and the incident became part of the so-called Apostles' Creed, although it is not found in the earliest versions of this text. The hymn "Chorus Novae Jerusalem," attributed to Bishop Fulbert, refers to the Harrowing of Hell. In the twelfth century it was sung at Chartres Cathedral at the Easter Vigil on Holy Saturday.

53. At Chartres and generally throughout Europe Jeremiah was read in the liturgy during the fifteen days before Easter. The Office reading for Easter day at Chartres was Gregory the Great's sermon on Mark 16:1–7, the story of the women at the tomb. Among the several commentaries on Lamentations 3:53 in relation to the burial of Christ is Paschasius Radbertus, *In Lamentationes Jeremiae, PL* 120:1185.

54. See *OC* 115: "Ita per totam ebdomadam in nostra ecclesia, 'Gloria in excelsis,' epistola, 'Aperiens Petrus,' R. 'Hec dies, V. Dicat nunc,' Alleluia, 'Nonne cor,' evangelium 'Duo ex discipulis.'" This Mass was said before a procession to a different church each day for a stational liturgy.

55. So it is that the last scene on the frieze is connected thematically to the northern tympa-

num, an Ascension scene created to contain powerful allusions to Advent and the second coming. The tympana are all "outside time": they depict Christ coming, going, and coming again (north); Christ the eternally begotten in the lap of the Virgin's flesh (south); and Christ coming at the end of time (central).

56. The narration of these events in the south lancet includes two additional scenes. Christ reveals himself to both Mary Magdalene and his mother in the garden; and Magdalene tells of his resurrection to the apostles. Thus the parallel is created between two kinds of appearances, one to the Virgin and the other to the disciples at Emmaus, and, as at the Last Supper and at the Anointing, the Virgin is given a presence that is unusual in standard iconography. So the lancet continues the symmetry found in the freize between events in her life and events in Christ's life, with reference to the sermon *Fratres karissimi . . . natale gloriosae dominae* as well.

57. See discussion of Ivo's sermons in chapter 6. As we have noted, they were read and copied in Chartres in the mid-twelfth century. On Ivo of Chartres and for a commentary on the clerical orders, see Roger Reynolds (1978).

58. On liturgy and drama, see especially Roger Reynolds (2000). Carol Symes (2002) argues for broadening the conventional definition of what constitutes drama; her work is especially useful when considering the line between procession and drama and ceremony and play. On medieval processions and their music, see Terrence Bailey (1971) and the complete, detailed catalogue of medieval manuscripts of processionals by Michel Huglo (1999). Later Chartrain sources are listed and discussed in Jusselin (1923); there is no processional from the cathedral dating from the twelfth or thirteenth centuries, although fragments of a later source survive in Chartres and will be studied by Fiona Edmund in her forthcoming thesis and catalogue of the liturgical/musical manuscripts from the diocese of Chartres.

59. The most famous of twelfth-century outdoor plays is *Ordo representacionis ade*, for which see Fassler (1991) and M. Warren (2002).

60. The study of plays of prophets, for example, has centered not only on texts and music, but also on the representation of prophets on twelfth-century façades. Most discussed in this regard has been Notre-Dame-la-Grande in Poitiers, where Gilbert, who once taught at Chartres, was bishop in the mid-twelfth century. The façade at Poitiers (dated to the first three decades of the twelfth century; see Camus and Andrault-Schmitt, 2002) has inspired historians of drama, music, and art, most notably Mâle (1922), Chailley (1967), Colletta (1979), Riou (1980), and Jeanneau (1997). In a note on previous scholarship, Colletta identifies figures by their inscriptions. Possible interaction between sculpture and Marian plays at Amiens is discussed by Marcia R. Rickard (1983). Dorothy Glass (1991, 2000, 2002) has written on prophets' plays and sculpture in medieval Tuscany.

61. In his provocative paper on the architectural context of Romanesque sculpture (1992), Willibald Sauerländer speaks of the visual language appropriate to differing modes of appearance: "Romanesque sculpture can use different language—or modes—depending on whether it presents the silent sanctity of a celestial image or whether it tells an entertaining story" (28). The zones of the west façade of Chartres Cathedral have been discussed by other scholars, most notably Kidson and Kazenellenbogen.

62. The ancient church at Mimizan, with its Adoration of the Magi in the tympanum, is a charming example chosen out of many early experiments with narrative in twelfth-century portal sculpture. For an early discussion, see Gabriel Fleury (1904), 220–21. He suggests comparison with St. Basil of Étampes, St. Contest at Ruan, and St. Croix at Orleans. For more recent study, see J. B. Cameron (1976) on the precursors of the "continuous capital."

63. If there were some kind of organ in the cathedral in the mid-twelfth century, its location, too, might have been in a gallery of the west façade. Bowles (1962) is an overview.

1. Reasons for the suspicion of "plans" are widely discussed; see, for example, Klukas (1995), Kurmann-Schwartz and Kurmann (1995), and Crossley (2009). Attributions to particular individuals too can be problematic, as in the case of the long-romanticized understanding of Gislebertus of Autun and his identity, as deconstructed in Seidel (1999).

2. Paul Williamson (1995) provides a general introduction to sculptural programs in the Gothic period (from 1140 forward) and the influences of major churches one upon the other, beginning with a chapter on France; more specialized studies are cited in chapters 10 and 11. *Dossiers d'archéologie* 317 (2007) is devoted to "L'architecture religieuse médiévale" and provides an excellent introduction to contemporary French scholarship, including the work of Delphine Christophe, who is particularly interested in the workings of western façade sculpture and its themes. The terms *Romanesque* and *Gothic*, although widely used, are fraught with difficulty.

3. For an example of the interplay between architecture and historiography, see also Dale (1997).

4. These dates are not secure. Most probably these windows postdate the capital frieze, upon which they seem to form a commentary, but, as we have seen, a major glazing campaign unfolded at midcentury, and most of this work did not survive the fire of 1194. It is not possible to say for sure how much of this art was eventually reused or used as models in the lancet windows themselves. See Grodecki et al. (1977), 103; F. Perrot (1977), 15–51; Grodecki, Perrot, et al. (1981), 2:34–36. Grodecki, Perrot, et al. (1981), relying on Perrot's earlier study, state that the northern lancet is heavily restored, that the Jesse at the bottom of the northern lancet is modern, and that only one head in this window is from the twelfth century; they say the central and southern lancets are also heavily restored; the detailed drawings by Perrot (1977) dating every section of the lancets in the article cited above provide the best information, and I have followed her here as well as in chapter 11. Analysis here is of the themes of the program as shaped by musical and liturgical understanding and depends on scholars with expertise in medieval stained glass for all technical matters. I am grateful for discussions over time with Meredith Lillich, whose expertise in Chartres and Chartrain glass is a beacon of light, and Madeleine Caviness, who has attended several of my presentations on this subject and offered advice, criticism, and encouragement. The work of Christine Lautier (especially 1993 and 2009) is ever an inspiration. The close connections she has made between altar shrines and stained glass in thirteenth-century Chartres have made me more confident in my work on the probable influence of liturgical and musical source materials upon the twelfth-century campaign.

5. Perrot (1977) states that the Virgin and Child at the apex of the central lancet are original, except for some details and for the faces of both figures, which are modern replacements.

6. See Delaporte (1926), 1:155; Sowers (1982). Not since Perrot (1977) has there been close analysis of the lancets, although there is a range of overviews from Grodecki, Perrot, et al. (1981) to Deremble's studies, to Lautier (2003). Further work like that of Michael Cothren (1986) on the twelfth-century glass of St. Denis would be useful, especially in regard to dating, as there has been much scholarship since 1977. In his study Cothren (1986) relates the twelfth-century windows at St. Denis to those at Chartres, pointing to one of the differences between the programs: "More and better preserved panels of twelfth-century stained glass from St. Denis are conserved outside the church than are installed within it" (398).

7. "The shoot of Jesse produced a rod, and the rod a flower; and now over the flower rests a nurturing spirit. The shoot is the virgin Genitrix of God, and the flower is her Son." For an excellent overview of the meaning of the window (and bibliography), see Colette Manhes-Deremble (1993), 239–48. According to Manhes-Deremble (245) the political stance of the window, featuring Christ at the apex of his lineage surrounded by the seven doves of the Holy Spirit, is in

line with John of Salisbury's *Policraticus* (4, 2 and 5, 6): the royalty of Christ authenticates the earthly power of kings, whereas kings are invested with the priestly mission to announce Christ. The Styrps Jesse window in Chartres is of the type found in the Winchester Psalter; for discussion of the Mariology of the Styrps Jesse in the Winchester Psalter, see Crown (1975). The connection between the window at Chartres and the Styrps Jesse in Suger's St. Denis has been much discussed; see Cothren (1986).

8. Bernard (1997) points in general to the parallels in his study of the three responsories attributed to Fulbert.

9. Perrot (1977) states that the figure of Christ is original, but his face is from the later Middle Ages; the three doves that surround his head are twelfth century, whereas the lower doves show some replacement of individual pieces of glass within them.

10. Although many of the lower panels have been restored from the thirteenth century to modern times, the upper sections less so; Cothren (1986) says that the arrival of the Holy Family in Sotinen, the Dream of Joseph, and the City of Jerusalem, are original and well preserved (408); Perrot (1977), 39, thinks the same but indicates the few places where there has been work. As for the three scenes compared here, Perrot (1977) notes Jesse at the root of the northern lancet is a modern restoration in a window that is primarily twelfth-century glass; the Nativity scene in the central lancet is a composite of medieval and modern glass, and the only twelfth-century part is Mary's hand, which rises to a golden table: already Christ is on the altar. Joseph's dream in the same window is mostly twelfth-century glass. For studies of the restoration of glass in the Middle Ages, see Lautier (1993, 1999).

11. For discussion of this image in greater detail (with extensive bibliography), see Watson (1934) and Fassler (2000a).

12. For lists of these prophets and discussion, including suggestions about their relationship to contemporary plays of the prophets, see Watson (1934). According to Perrot (1977), 42, the two bottom prophets date from the twelfth century, although their faces and scrolls are later.

13. Manhes-Deremble (1993) mentions the prominence of the number seven in the Styrps Jesse window, and she cites its importance as a mystical number of perfection, found in many guises, including the order of trees of consanguinity (243). The crucial role of the Rabanus commentary on Matthew I as the liturgical reading for the feast and throughout the octave of Mary's Nativity has not previously been noticed.

14. Watson (1934) has transcribed the names of all the prophets in the Styrps Jesse window and studied them, 120–25; in an appendix he compares them with the figures in prophets' plays. According to Watson, and Johnson (1961) following him, the prophets, beginning from the bottom left and ascending, are Nahum, Samuel, Ezechiel, Zechariah, Moses, Isaiah, and Habakkuk; beginning from the bottom right and ascending, they are Hosea, Amos, Micah, Joel, Balaam, Daniel, and Zephaniah (Sophonias).

15. The gymnastic curves of the idols' bodies as they fall makes a symmetrical parallel between them. According to Perrot's (1977) drawing, they are original, as is the beaded doorway above the idol to the left; the lamps hanging above them are unlit.

16. Johnson (1961) discusses the aspects of the windows as related to the Second Crusade, with relevant passages from Saint Bernard, who preached it at Chartres.

17. See Brial (1818), Johnson (1961), Constable (1997), and especially Phillips (2007), 270–73.

18. On his sequences, see John Benton (1961); on his sermons, many of which were once attributed to Saint Peter Damian, see Ryan (1947) and Woody (1966); on the cross imagery in the period generally, see Baert (2004). Calvin Bower is preparing a study of Nicholas and his compositional and poetic styles.

19. The transferal of power from wood to wood is set up in the middle of the poem: "These are not new signs, not recently was this religion of the cross invented: it made waters sweet, through it the rock gave water by Moses' office. No salvation is in a house unless a man protects it with

the cross on his threshold: None felt the sword nor lost a son who did so. The ark floating on the water saves the living species as many as Noah brought together. The ark signifies the cross; Noah, Christ; the waves this baptism which Christ conferred. Gathering sticks in Zarephath, the poor woman obtained the hope of salvation: without the sticks of faith neither the cruse of oil nor the little pile of meal is any good." For further discussion, see Fassler (1993a), 58–82. "Laudes crucis" was not found in the mid-twelfth-century OV but was in place in the OC. Thus we can assume that it was entering the cathedral liturgy during the time the lancet windows were executed, or was at least known in Chartres, where it was added to the repertory of the Augustinian Abbey of St. John, at least as sung in the Holy Land: see 94v of Paris BN lat. 1794, where the sequence title "Alle uox psallat" is crossed out and "Laudes crucis atollamus" written in.

20. *PL* 144:761. For attribution of this work to Nicholas of Clairvaux, see Kennerly M. Woody's article (1982–89) on Peter Damian and her study of him (1966). Woody states that sermons attributed to Peter but actually by Nicholas are numbers 9, 11, 23, 26, 27, 29, 40, 44, 47, 52, 55, 56, 58, 59, 60, 62, 62, and 69. The sermon for the Cross is no. 47.

21. Other designs expressing this thematic idea are the Romanesque windows of Arnstein-sur-la-Lahn, studied by Lech Kalinowski (1983), and the illuminated initial for a copy of Rabanus Maurus's treatise on the praises of the cross (Douai, BM 340, fol. 11r). The stem of the trunk rising from Jesse's loins is marked with the words "styrps Jesse," the opening of Fulbert's responsory. See Arthur Watson (1934), 105–06 and plate 20.

22. For an overview of the legend of the Cross and the Tree of Life in antiquity and the Middle Ages, see Baert (2004).

23. On the Cross of St. Denis commissioned by Abbot Suger, see Verdier (1970); it was decorated with gems that came indirectly from Count Thibaut (see chapter 7).

24. For the Ascension day procession and the dragon as described in OC and further bibliography, see Fassler (2007).

25. This is the antiphon before the Gospel at Easter Mass, also used as a processional antiphon. Of the uses studied by A. Robertson (2000) only Chartres has "Ego sum Alpha" as its Gospel antiphon. The text and music are found in the Chartrain Breviary, Vat. lat. 4756, f. 195.

26. The chant as found in Chartrain sources was transcribed by David Hiley (*Missale Carnotense*, 251–52). For further discussion, see Terrence Bailey (1971), 171–74, and David Hiley (1993), 103–04. The chant is unusual in that Christ speaks in the first person.

27. The text is from a Latin translation of Ps 95:10, as found in the Greek Septuagint Bible.

28. Of particular interest is the Stavelot Triptych, a contemporary artwork from the region of the Meuse valley, a composite of artworks brought from Byzantium and Mosan elements. The style of glass found in the central and southern lancet was also produced under Mosan influence, perhaps via Henry of Blois, who employed artists skilled in this style of metalwork. On the Stavelot Triptych and the legend of the Cross, see especially Ryskamp (1980). The influence of Byzantine art on the program and style of twelfth-century works at Chartres has been broached by many art historians, including Heimann in her much-referenced article on the pilasters and frieze (1968). Once again, one thinks of Henry, who employed artists who tried to copy Byzantine models: see Klein (1998). For bibliography on Henry as patron of the arts, see note 36 below.

29. This subject is not studied in this book, but the art developed in Chartres in the mid-twelfth century forms an appropriate background to it. For an excellent general treatment of visions and their meaning, especially in literature, see Newman (2005). As she points out in this study, a powerful relationship exists between liturgical experience and the visionary. In Fassler (2004a) I argue that much of thirteenth-century miracle literature was written to provide a guide to visualization and the visionary in liturgical and devotional practice, especially in regard to veneration of the Virgin: "In the singing of the 'Salve Regina' at Compline, and in

sequences said or sung in personal devotions or in community before a Marian image, it was possible to talk to Mary in the language she wanted to hear, and to call her into the midst of community. Miracles were imminent, in the life of any person or community; these arts existed to help make them happen" (241–42).

30. For another interpretation, see Cahn (1969). Rebecca A. Baltzer is preparing a study of the Mariological resonances in the portal and the surrounding façade as related to contemporary music and liturgy in Notre Dame of Paris.

31. See Bugslag (2005) and William the Breton, *La Philippide*, ed. Guizot, p. 387.

32. Stirnemann (1997), 89, says that the second artist of the so-called Bible of Bernard (Troyes, BM 458) can also be found at work in the Heptateucon of Thierry of Chartres (Chartres, BM 497), a manuscript destroyed in 1944, although photographs of fragments of it survive. She connects these to a Bible prepared for Count Thibaut as well. The illuminations in Troyes, BM 894, a mid-twelfth-century gradual from the Abbey of St. Peter, is another important source for studying details of artworks produced in Chartres during the decades the Royal Portal was being created.

33. See especially the study of Paris, BN lat. 5323 by Elizabeth Burin (1958), 209.

34. See Walter Cahn (1996), 2:39–40. Harvey Stahl (1986) suggested that the Bible may have been produced in Chartres for Suger of St. Denis.

35. Kaufmann (1975), 107–08; Cahn (1996), 2:91–92; and Stahl (1986).

36. The many studies of Henry as a patron of the arts (Zarnecki, 1986; Mason, 1993; Kusaba, 1993; Riall, 1994) are further illuminated by the recent reevaluation by Crook (1999) of a tomb in Winchester once thought to have been that of William Rufus but now assigned to Henry of Blois.

37. The Henry of Blois plaques (c. 1150) have been much studied and are now believed to depict the bishop supporting a portable altar. The plaques were doubtless a part of this altar's decoration; see Haney (1982) and Stratford (1983). Ivo Rauch (2004) has studied the windows in the new choir at Winchester, identifying a program close in many aspects to that of Belle Verrière.

38. Forsyth (1980) is a provocative study for attempting to understand what was happening in northern France before the kinds of innovations in sculptural decoration found at St. Denis, Chartres, and Étampes took over the imaginations of donors and designers. The west portal of St. Andrew in Chartres, the portal at Dangeau near Chartres, and the north portal of La Madeleine of Châteaudun are local examples of special importance.

39. The story of the relic's survival in the fire of 1194 (see chapter 9) was problematic for later Chartrain historians, who altered the miracle collection; as discussed below, liturgical additions and artistic renderings relocated the miracle story to 1020. For the social history of Chartres in the later Middle Ages, see Billot (1987).

40. Evergates (1975) is a history of the counts of Champagne in the later Middle Ages. He has long studied the charters produced by the family (ed., *Feudal Society*), and has edited their earliest cartulary (*Littere baronum*), a letter collection from 1211. In the introduction to this edition, Evergates describes the extraordinary richness of the thirteenth-century materials: "The chancery of the Counts of Champagne produced eight cartularies in the course of the thirteenth century. Seven survive and the eighth is fully recoverable through modern copies, making them the largest collection of princely cartularies from medieval France" (3). His summary (1995) of the family's activities and lineage is exemplary.

41. The appearance of works by John James (1982) and Van der Meulen and Hohmeyer (1984) launched a series of provocative reviews and further studies; see especially the overview by Michael Davis (1987). More recent scholarship by Georges Lambert and Catherine Lavier and reported upon by Anne Prache (1990) and Christine Lautier (2009) (referenced below) uses analysis of wood sampling for dating.

42. The bishop's head recovered from a tomb at Josaphat was once thought to have belonged to Reginald's tomb; Jean Villette (1985) has assigned it rather to Peter of Celle, who died in 1183. Villette believes the work was done by an atelier that flourished in the last two decades of the twelfth century, working in Mantes and Sens as well as in Chartres.

43. He died on November 26 or 27 (*OPSA32* 125A, obituary from the cathedral; 257A, notice at Josaphat). The local family to which he belonged was prominent in the period. His nephew, Robert of Berou, was chancellor for three years (1213–16; see *DIGS* 105–06) and was the donor of the pilgrims' lancet window in the north choir clerestory.

44. The ordinal cannot be dated by feasts included or excluded, as several feasts that would be expected to be present are missing (see *OC* 18–22); photographs of this precious source can be found in the diocesan archive and await further study; especially needed is paleographic study of the surviving manuscripts from medieval Chartres and photographs of them, work that will be aided by the recently discovered Châteaudun, Hôtel Dieu 13.

45. See Delaporte (1960) and *OC* 61–62, 183.

46. Delaporte (1951) demonstrated the early and constant importance of the feast of the Assumption in Chartres Cathedral, but it was elipsed deliberately in the eleventh and twelfth centuries by the Nativity of the Virgin, which itself was eclipsed in the thirteenth century, especially through the influence of the Conception of the Virgin (December 8).

47. Le Mans, BM 184, for example, a Chartrain breviary from the first half of the fifteenth century, contains only the Office for the *Commemoratio*. Delaporte (1960) studied all the relevant liturgical books and noted that this special liturgy was reformed in the late eighteenth century, during the time of Bishop Lubersac.

48. For the treatment of Jews during the reign of Philip Augustus, see especially W. Jordan (1989). Five statues were removed from the north portal in 1793, including that of a female figure representing Synagoga; for discussion of the events, see Cooney (2006).

49. The iconography of the north portal is studied in great detail by Colleen Farrell in a forthcoming dissertation from Yale University. For discussion of the cult of Saint Anne in Chartres in the thirteenth century, see Sauerländer (1995), Lautier (1993), and Crossley (2009).

50. On the dedication of Chartres Cathedral in 1260, see especially Delaporte (1960), 155. He says that the ceremony was indicated in a bull of concession promulgated in April in Anagni by Alexander IV; see *Gallia Christiana* VIII (1744), col. 370. Although no copy survives from Chartres, according to Delaporte the document is transcribed in papal register XXIV of the Vatican archives.

51. A complete translation of the readings for the feasts of Saint Anianus can be found in appendix C, taken from the Latin of Clerval as found in *Analecta Bollandiana*. Smedt (1889), the best discussion of saints and saints' lives in medieval Chartres, contains many Latin texts copied from now-lost sources.

52. The work is described in Baudoin (1992).

53. The revisionist work of the nineteeth century is briefly summarized in VdM 8–9. "Fulbert après Fulbert" is also discussed in Fassler (2008).

54. For the various lives of Saint Savinien and their manuscript sources, see Fliche, *Les Vies*, 1912. He takes the second redaction from the Bonneval manuscript mentioned above, now found in Paris, BN lat. 5354, fols. 41–48; the edition of Henault follows now-lost Chartrain manuscripts which are later, and, of course, Bonneval was located in the diocese of Chartres. Delaporte (1922) outlined the cult of Saints Savinien and Potentien in Chartres: they were present in the tenth century in local martyrologies with a simple notice on December 31. At some point the passage in the martyrology of Chartres was slightly altered by a single phrase. The feast of the saints was established at Chartres from at least the twelfth century forward on October 19 in celebration of the first finding of the relics in 847; the texts were taken completely from the Office for the common of martyrs, except for the readings taken from what Fliche calls the

second redaction of the life of St. Savenien, the incipit of which is, "In diebus priscis, dum dominus noster Jesus Christus." The breviary of Chartres, Le Mans, BM 184, ff. 493v–494b contains the readings, beginning with the passage describing the arrival of the saints in Troyes (corresponds to Fliche, p. 81). In this late Chartrain source the readings are greatly truncated and altered to a significant degree; the surviving half of the thirteenth-century noted breviary of Chartres does not contain this feast.

55. For a description of this well, over 33 meters deep and round, with a diameter from 1.48 to 1.2 meters, see Jean Villette (1989), 6.

56. The ninth-century description of the siege of Paris by Abbo of St. Germain has a vivid description of the use of towers for protection by both soldiers and civilians. See, for example, Abbo, *Le siège*, 34–45, and discussion in chapter 1.

57. See especially Couturier (1997) and Stegeman (1993, 1997). For maps showing the location of the well, see Couturier (1997), 73, and Stegeman (1997), 31–38, and, in less detail, the map found in appendix A below.

58. Aside from a handful of new or upgraded feasts, very little divergence exists between the twelfth- (OV) and the thirteenth-century (OC) ordinals. When one of them is cited, therefore, the reader can assume that the same holds true in the other. When this is not the case, it has been noted.

59. OC 185. The various names given to the spot and their meaning are discussed in Couturier (1997), 68–69.

60. The chant (CAO 3590) is found in numerous medieval sources indexed on the Cantus database; a modern copy can be found in the *Liber responsorialis*, 388: "Sing praise to our God, all his saints, and you who fear God, the small and the great, for our God reigns all-powerful. Let us rejoice and exult, and give glory to Him." The map in OC reproduced in appendix A, indicates the location of the major altars and other features of cathedral topography. The *saint lieu fort* is located at the east end of the north aisle of the crypt, which would place it almost, although not precisely, below the main altar in the upper church. The location on Delaporte's map corresponds with that proposed in the plans of Couturier and Stegeman, mentioned above, but allows for ready comparison with the major sites of the upper church as well.

61. The correspondences between the upper and lower altars are discussed in Merlet's study of the well in the crypt (1901), esp. 229–31. Lautier (2009) has reconstructed the ways in which pilgrims would be led to understandings of the relic through the new program of glass installed in proximity to the relic. Because the relic was hidden from view in the thirteenth century, art that depicted its mysteries and assured its presence was of fundamental importance to the cult.

62. Bugslag (2005) describes what is known of this area of the crypt and provides further bibliography, making the point that further archeological study is essential.

63. The *Vieille Chronique* was produced by the canons of the cathedral in the late fourteenth century. Its various sources and their vicissitudes are described in VdM 211–13. The modern edition, which has been followed here, was prepared by E. de Lépinois and Lucien Merlet as part of their edition of the cartulary of the cathedral (*CNDC*).

64. For Beyer Ironsides, see William of Jumièges, *Gesta*, ed. Marx, 4–5 and notes; and ed. Van Houts (who calls him Bjǫrn), 1:xxxvii, and 8–11 and notes. Especially important is William's prolongation of Hasting's connection with Chartres; see *Gesta*, ed. Van Houts, 1:28–9, 54–57 and notes.

65. For discussion of the recreated history written by the canons of the cathedral in this period, see especially Sanfaçon (1988) and Bugslag (2005).

66. According to traditions found in legends referenced above, they were the first and second bishops of Sens, who were martyred c. 300; they are the patrons of the diocese. See Watkins (2002), 514, and Delaporte (1922), who refers to Chartres 507, a martyrology from the early

tenth century that contains a prayer for the saints; in the liturgy of Chartres Cathedral they were venerated on October 19, two days after the feast of the Dedication.

67. The relics of St-Pierre-le-Vif were the subject of an extraordinary thirteenth-century explication by Geoffroy de Courlon, *Le livre des reliques*.

68. This blending of cult and a love triangle is discussed in my forthcoming paper on Robert the Pious (2010a).

69. The revisions were taking place in the early fourteenth century. Jusselin (1922) describes a letter from the chapter written in 1322 to Pope John XXII that refers to these foundation myths and the special election by the Virgin of the cathedral of Chartres and its canons. See also Sanfaçon (1988), 339.

70. The coming to Chartres by disciples of Saint Savinianus found in the second redaction of his life is found on p. 80 of Fliche's edition, before the coming to Troyes by Potentianus with which the readings at Chartres in medieval breviaries began. Delaporte (1922) emphasizes that the idea of Potentianus coming to Chartres was added to breviaries from the sixteenth century forward but was not part of the medieval tradition. In 1922 he was able to examine a now-destroyed collection of saints' lives from Chartres, BM 500, from the mid-twelfth century, which contained the full text.

71. A note by Lépinois and Merlet shows how understanding of the tradition had been lost: "The wells, which tradition has made the tomb of the victims of Quirinus, were located in the crypt of Notre Dame and bore the name of the wells of the *Saints-Forts*. No traces of them were found in the excavations of 1816 and 1855" (*CNDC* 1:2).

72. "In dictis autem criptis est hospitale quod dicitur *Sanctus-locus-Forcium*, eo quod pridem multitudo martirum ibi passa fuerit martirium, quorum corpora in magne profunditatis putheum ibidem factum, de tyrannorum mandato, projecta sunt. Locus enim iste mirabilis sanctitatis hactenus est habitus, Nam ad illum ex omni parte concurrunt infirmi qui *ardentes* vocantur et sacro igne qui *ignis Beate-Marie* dicitur infirmantur; sed per [Dei] et ejus genitricis graciam, infra novem dies quibus ibi manere consueverunt, omnino sanantur vel, ut in paucis, cicius moriuntur" (*CNDC* 1:58). The well, which had been called *locus fortis*, "the strong place," became "the holy place of the brave ones" in the fourteenth century.

73. For Chartrain historians, VdM is indispensable. He has synthesized information from the two classic works on the subject, Jean Liron (*Bibliothèque*) and Lucien Merlet (1883; rpt. 1971). Bugslag (2005) is the best introduction to the Virgin's cult in later centuries, supplemented by Hayes (2003); Lambert (1997) evaluates the evidence for a Celtic cult that actually preceded and grew into aspects of the Virgin's cult and notes the need for further scientific study, especially of prehistoric architectural remains and other evidence.

74. Delaporte (1936), 249, cites the passage, found in Gerson's *Josephina*, Dist 5,:

> Sobrius ecclesiae mos est, ideo vetus illud
> Olim pro Druidum fano memorabile templum
> Carnoti, titulus cui Virginis est pariturae,
> Hoc modo conjugium celebri de more colendum
> Coepit, et exemplum devotio sancta sequatur.

[The church acts with discretion, and so the ancient and celebrated church of Chartres, which succeeded a sanctuary of the Druids, and which was dedicated to a Virgin about to give birth, begins in this way to celebrate a marriage (of Joseph and Mary) as it ought to be done, and let holy devotion follow the example.]

The rise of the Druidic aspect of the cult was discussed by Maurice Jusselin (1922). The works of Delaporte and Jusselin are the background for Sanfaçon (1988, 340), who refers to Gerson's commentary on Caesar's Gallic Wars as well. Gerson wrote his epic *Josephina* between 1414 and 1418; in addition to telling the early life of Christ from the point of view of Joseph, the work

advances Gerson's conciliar ideals in the wake of the Council of Constance. The *Opera* of Gerson, as edited by Louis Ellies Du Pin in the early eighteenth century, have been reprinted (1987).

75. An addition to the *Vieille Chronique* made on a blank leaf in the early sixteenth century mentions Chartrain Druids, a beautiful statue of the Virgin before giving birth, and miracles associated with the statue.

76. Isabelle Fabre's excellent commentary and introduction to her critical edition of Gerson's *La doctrine du chant du cœur* explores many aspects of his religious thought.

77. For a discussion of the "filles des saints-lieux," see Challine, *Recherches*, 126–27. A map, a copy of the work by Félibien, shows their quarters to be located in the far west of the northern aisle of the crypt. See *Recherches*, 118.

78. Challine, *Recherches*, 123–24. Emphasis mine. For discussion of a possible statue of Saint Modeste in the north porch, see R. Adams (1973).

79. Challine, *Recherches*, 152. For brief discussion of these reforms, see Sanfaçon (1988), 349–50.

80. Souchet's source for this particular bit of information is the Chartrain canon and theologian Judocus Clichtoveus, whose copious hagiographical writings and liturgical commentaries, especially regarding hymns and sequences, would repay further study. An early study by Clerval (1894) emphasizes the Chartrain elements in his life and work. Clichtoveus, who died in 1543, was buried in the church of St. Andrew in Chartres. For an introduction to his life as an early sixteenth-century biblical scholar, see R. Cameron (1969).

81. His description is quoted in full in Clerval (1908), 8.

82. Pintard had moved away from the idea that the Druids had chosen to make the madonna black "because she came from a country more exposed to the sun than ours," as Sablon reported (see Branner, 1969, 110). On the so-called black madonna, all Romanesque examples of which are thought to be the result of aging, smoke, and other factors rather than deliberate design, see Forsyth (1972), 20–22. See Sheer (2002) for analysis of later examples.

83. The notes accompanying the engraving are discussed in Clerval (1908), and the work is placed in historical context in Sanfaçon (1988).

84. See, for example, the report of René Merlet (1905) offered in 1901 to the Société Archéologique d'Eure-et-Loir.

### APPENDIX B. INVENTORY OF CHARTRES NA4

1. MSC, iv–vi.

2. See MSC, 105–6. Various typefaces distinguish the various layers: 1. materials in the original hand: people recorded here died between c.940 and 1027; the necrology may well contain materials from earlier sources that no longer survive; 2. additions in the first group of hands date from the death of Fulbert (1028) through the death of his successor Thierry (1048) and up to the embroilments surrounding Dean Hugh in 1060; 3. the second group of additions dates from 1060 to the coming of Ivo as bishop in 1090; 4. the third group of additions dates from around 1090 to 1130 and encompasses the tenures of Bishop Ivo and the first years of Bishop Geoffrey of Lèves.

### APPENDIX E. CONTRA JUDAEOS

1. The text is mutilated.

2. Reading *regum* for *regnum*.

3. Reading *Johannes* for *Job*.

## APPENDIX H. GENEALOGIES

1. See DIGS, xiv–xv for a summary of information on the lord of Musy, Rahier, husband of Bertha of Lèves, sister of Bishop Geoffrey and mother of Bishop Goslenus. For the most useful charters, see CSP, pp. 275–76, and several documents in JC. In 1107, Rahier of Musy and his wife, Bertha, and their sons confirmed various gifts presented to the Abbey of St. Peter by his brothers-in-law, Goslin, Geoffrey, and Milo of Lèves. Around 1120 he gave the church of Musy to Coulombs, his four sons underwriting the donation: Geoffroy (his heir), Rahier (the future provost), Goslin (the future bishop), and Milo. Around 1140, he founded the abbey of L'Estrée. Rahier died around 1145 and was succeeded by his son Geoffrey. Rahier, the son of Geoffrey and the grandson of Rahier and Bertha of Lèves, was lord of Musy by 1158.

2. On Guy of Lèves, see MSC, 111, 119, 120, 151, and 155. His obit in OPSSJ (Jan 6) states that he was the son of Goslin Dives.

3. Geoffrey of Lèves, the brother of Goslen IV, lord of Lèves, was provost of the Beauce in 1114–16 (see DIGS, 232–33), before becoming bishop. Although the provosts of the chapter of the cathedral were designated under the names of their benefices, Fontenay-sur-Eure, Nogent-le-Phaye, Beauce, and Amilly, charters usually employ only the general title "provost," without further qualification.

4. This Hugh the subdean is not to be confused with Hugh the subdean who died in 1124 and was discussed at the close of chapter 8. This second Hugh the subdean, who, if Merlet is correct, is one and the same with Hugh of Lèves the provost, was one of the most influential and long lived of all Chartrain administrators. See DIGS, 52. If the charters of Josaphat are taken as an example of his activities, Hugh of Lèves the Provost signed works dated from c. 1124 (no. 14) until around 1130 (no. 48). Hugh the subdean witnessed charters from c. 1136 (no. 91) until the late 1150s or early 1160s through two charters (242 and 243) that cannot be dated precisely. The missing years from around 1130 to 1136 are easily accounted for by procedural difficulties in naming canons that led to a block on naming dignitaries. See JC I, p. 121 (note to charter 95). The obit of Hugh the subdean (OPS1032, 78B, 20 July, and OPS1034, 148B, 29 July) describes him as *sacerdos venerabilis*, which proves he was old when he died. An obit that apparently refers to him is found in OPSJ, calls him "Hugo Dirige, subdecanus," and names him a monk of Josaphat (see JC II, p.297, for the designation "n.c.m. of our congregation, a monk."

5. See DIGS, 230 and 162. His first major office was as provost of Nogent-le-Phaye, as he himself said in a charter, see CNDC, 1:154. In JC 77, he is listed as canon and nephew of the bishop (as is his brother Milo); in JC 78, he is listed as a provost. Both of these date from around 1131. He served as provost from around 1131 to 1144 and served as witness to the foundation of the Abbey of Estrée by his father, Rahier of Musy; see the Cartulary of Estrée, ArchEL, H. 319, no. 4. Around this time, he became an archdeacon. According to the Merlets, he was also abbot of St. Stephen in Dreux for a few years, an office he held while archdeacon. See DIGS 194: for a period of time, Merlet believed that Goselin of Muzy was a different figure from the bishop but later corrected this idea.

6. Milo of Musy was the longest serving of the entire family. It appears that all the references to him as provost (1135–c. 1149) and then as archdeacon (c. 1149–1181) are to the same person, as Merlet suggests in DIGS. The Josaphat charters work well as a test case: Milo the provost was witness or signator to charters nos. 67, 91, 95, 113 (he is called here a nephew of the bishop), 127, 128, 152, 196, and 200; he signed as provost and brother of Bishop Goslen charters no. 114, 115, 143, 167, and 174. He signed as archdeacon of Chartres nos. 165, 213, 229, 230, 231, 240, 251. The overlap is explained by the amount of time it took for the official change to take effect and for scribes to recognize the new title. For example, he is an archdeacon in charter no. 165, which is dated Oct. 6, 1149, soon after Goslen became bishop, yet is still a provost in charter no. 174, dating from Dec. 5, 1150. Soon after this, however, the new title of archdeacon appears

consistently. A charter from the Madeleine, Châteaudun: no. 18, pp. 22–23, dated to c. 1149, claims he was made archdeacon on the day the charter was signed.

7. Crucial is JC 230 (I: 272–75) from 1156, in which Geoffrey the Provost is cited as the brother of Milo, lord of Lèves, who had been withholding rights concerning mills in the region from the monks of the Josaphat. Milo, the uncle of Bishop Goslen, of Milo the Archdeacon, and of Rahier the Provost, succeeded his brother Goslen V, who had died as a young man in 1145, while the other surviving brother, Geoffrey the Provost, had a career in the church. Geoffrey the Provost signed Josaphat charters dating from around 1143 (no. 127) to around 1156 (230); the last charter he signed is from the Tiron (II, 93), dated to the late 1160s or maybe even the early 1170s. In this charter, Geoffrey the Provost calls Bishop Geoffrey of Chartres his uncle.

8. Rahier of Musy's long tenure as provost is represented by four charters from Josaphat: 127 (1143–44), 202 (1151), 240 (1162), 258 (1173).

9. See especially OPS1032,32D (10 January); OPS1032, 112F; OPSPONT, 208B; OPSSPAB, 180C; OPSTV, 200A; OPSJ, 251B.

10. See OPS1032, 32D and E. For discussion of the wine tax, see Chédeville (1973), 233–34; Jane Welch Williams (1993), 77–78, bases her understanding on this discussion.

11. OPSHD in the calendar (409A) and in the martyrology (411D, 9 January).

12. See OPS1032, 112F (13 December). Her death was around the same time as that of her husband, Count Thibaut, but the obit was written after her son William had become archbishop of Sens, or after 1164.

13. MSC, 149. Countess Adela gave in his memory through buying out a butcher's stall that was close to the cathedral and prevented the coming and going of traffic necessary to make repairs to the roof (see further discussion in chapter 7).

14. Edmund Bishop (1884, rpt. 1918).

15. On Henry's life and influence, see Voss (1932), Knowles (1950), 286–93, Senette (1991), Stacy (1999), and Riall (1994). His many artistic campaigns and their importance are treated by Campbell (2002), Donovan (1993), Zarnecki (1986), and Kusaba (1986).

16. Vita B. Petri Juliacensis; D. Bouquet XIV, 307A: "You will bring a daughter into the world and she will be the Queen of France."

17. OPS1032, 116H (20 March); OPSJ (17 March) 252G.

18. OPS 1032 (3 March) 46B. The later necrology specifies income, see OPS1034, 134C.

19. A variety of obits relate to the count and his relatives: for example, OPS1032 32D (see above); OPS1032, 34B; OPS1032, 42E, obit of bishop Peter of Celle (19 February), with further restrictions on the wine tax; OPSPONT, 209B, OPSJ, 251B; and 255F (memorial of the burial of Adelicia, wife of Thibaut V and daughter of Louis VII and Eleanor of Aquitaine, 11 September); OPSBEAU, 404, 406, remembering Thibaut V as its founder; OPSHD, 429E, acknowledges the gift of Isabelle, countess of Chartres and daughter of Thibaut V.

20. See OPS1032 32D and 34C, where the stipulations are repeated for Thibaut's own anniversary, January 16. A note on amount of income was added in the fourteenth century.

21. OPSBEAU 404, 405. The count is called the builder of the church, "fundator domus."

22. OPSHD, 412A (16 January). [Ipso die obiit Theobaldus junior, comes illustris, qui huic sancte domui, pro remedio anime sue, plurima beneficia contulit et centum solidos redditus in octabis natalis Domini in prepositura Castriduni.]

23. OPSJ 251B. [Depos. Theobaldi, Blesensis comitis et Francie senescali, amici et benefactoris nostri, qui inter cetera beneficia que ecclesie nostre contulit, unum modium annone in molendino de Soors et deimam melendinorum de Subculeto et aliorum omnium que inibi super Auduram fecit vel acquisivit nobis donavit, necnon ut centum solidi nobis annuatim redderentur pro borra de molendinis suis fullatoriis quam ipse dederat, statuit et precipit, et ut hec omnia rata permanerent, munimine litterarum et sigilli sui auctoritate roboravit.]

24. OPSJ 255. Her death date in this necrology is Sept. 11.

25. OPS1032 50A (3 June, OPSPAT,175B). Other references listed by Molinier seem to have been to a later figure.

26. For Stephen's adventures in the Holy Land, see Bernard Hamilton, *The Leper King and His Heirs: Baldwin IV and the Crusader Kingdom of Jerusalem* (Cambridge, 2000), 30–33.

27. OPS1032, 90A (September 6).

28. Suger says of this vase (*De Administratione*, 79), "We also gladly added to the other vessels for the same office an excellent gallon vase, which Count Thibaut of Blois had conveyed to us in the same case in which the King of Sicily had sent it to him." Panofsky says in a note (221) that this vase "lagena" (or better "lagona"), which he translates as gallon, must have been much larger than the others Suger mentions. It does not survive.

29. See obits in OPS1034, 129B, 135H; OPSPAT, 167H.

30. OPS, 390E, cf. OPS1032, 75E, 40C; OPS, 281A, from the Clairets of Citeaux.

31. For a charter in which Count Henry calls him "my brother," see CTT 2:83.

# Primary Sources, Including Authors from before the Revolution

Abbo of St. Germain. 22 *Predigten*, ed. with commentary by Ute Önnerfors. Frankfurt am Main, 1985.

———. *Abbonis Bella Parisiacae urbis*, ed. Paul von Winterfeld. MGH Poetae Latini medii aevi 4.1. Berlin, 1899.

———. *Abbonis de bello Parisiaco libri III*, ed. Georg Heinrich Pertz. MGH Scriptores rerum Germanicarum 1. Hanover, 1871.

———. *Bella Parisiacae urbis, Buch 1*, ed. Anton Pauels. Frankfurt am Main, 1984.

———. *Le siège de Paris par les Normands: Poème du IXe siècle* [*Bella Parisiacae urbis*], ed. Henri Waquet. Paris, 1942.

———. "A Verse Translation of Abbo of St. Germain's *Bella Parisiacae urbis*," trans. Anthony Adams and A. G. Rigg. *Journal of Medieval Latin* 14 (2004): 1–68.

———. *Viking Attacks on Paris: The Bella parisiacae urbis of Abbo of Saint-Germain-des-Pres*, ed., trans., and introduction by Nirmal Dass. Paris/Dudley, Mass., 2007.

Adalbéron of Laon. *Poème au roi Robert*, ed. and trans. Claude Carozzi. Paris, 1979.

———. "Les poèmes satyriques d'Adalbéron," ed. G.-A. Hückel, 49–184. Bibliothèque de la Faculté des Lettres, Université de Paris 13. Paris, 1901.

Adelman of Liège. "Poème rythmique d'Adelman de Liège." In *Notices et documents publiés pour la Société de l'histoire de France à l'occasion du cinquantième anniversaire de sa foundation*, ed. J. Havet, 71–73. Paris, 1884.

Ado, Saint. *Le martyrologe d'Adon: ses deux familles, ses trois recensions*, ed. with commentary by Jacques Dubois and Geneviève Renaud. Paris, 1984.

Amadeus of Lausanne. *Huit homélies mariales*. Text estab. by Jean Deschusses, introd. and notes by G. Bavaud. Paris, 1960.

———. *Magnificat: Homilies in Praise of the Blessed Virgin Mary, by Bernard of Clairvaux and Amadeus of Lausanne*, trans. Marie-Bernard Said and Grace Perigo; introd. by Chrysogonus Waddell. Kalamazoo, Mich., 1979.

Amalar of Metz. *Opera liturgica omnia*, ed. Jean Michel Hanssens. Studi e Testi 138–40. 3 vols. Vatican City, 1948–50.

———. *Liber de ordine antiphonarii*. In *Opera*, 3:19–321.

Amann, Émile, ed. *Le Protévangile de Jacques et ses ramaniements latins*. Paris, 1910.

Ambrose of Milan. *Expositio evangelii secundum Lucam*, ed. M. Adriaen. CCSL 14. Turnholt, 1957.

Ambrosius Autpertus. *Sermo de lectione evangelica . . . in purificatione s. Mariae*. PL 89:1291–1304.

*Analecta hymnica medii aevi.* 55 vols. Leipzig, 1886–1922.

Andreas of Fontevraud. *Second Life of Robert of Arbrissel. PL* 162:1057–78; trans. by Bruce Velarde in *Robert of Arbrissel: A Medieval Religious Life.* Washington, 2003.

*Annales de Saint-Bertin,* ed. F. Grat et al. Paris, 1964; trans. Janet L. Nelson, *The Annals of St-Bertin.* Manchester, 1991.

*Annales de Sainte-Colombe de Sens (708–1218),* ed. Bernhard von Simson. MGH SS 1:102–09. Hanover, 1826; rpt. Stuttgart, 1976.

*Annales herbipolenses,* ed. G. H. Pertz. MGH SS 16:1–12. Hanover, 1859; rpt. Stuttgart, 1994; trans. by James Brundage in *The Crusades: A Documentary History,* 115–21. Milwaukee, 1962.

*Annales Mettenses,* ed. Bernhard von Simson. MGH SS 1:314–36. Hanover, 1826; rpt. Stuttgart, 1976.

*Annals of Fulda,* trans. and ed. Timothy Reuter. Manchester, 1992.

Apponius. *In Canticum Canticorum Expositio,* ed. B. de Vregille and L. Neyrand. CCSL 19. Turnhout, 1986.

Arnold of Bonneval (Ernaldus abbatis). *Commentarius in Psalmum CXXXII. PL* 189:1569–90.

———. *De laudibus beatae Mariae virginis. PL* 189:1725–34.

———. *De operibus sex dierum. PL* 189:1513–70.

———. *Tractatus de septem verbis Domini in Cruce, 3, De verbo illo Domini: Mulier, ecce filius tuus. PL* 189: 1693–98.

———. *Vita et res gestae S. Bernardi, Liber II. PL* 185:267–302.

Augustine. *Concerning the City of God against the Pagans,* trans. Henry Bettenson; introd. by David Knowles. Harmondsworth, 1972; introd by John O'Meara. New York, 1984.

———. *Confessions,* trans. Henry Chadwick. Oxford and New York, 1991.

———. *De Doctrina Christiana,* ed. J. Martin. CCSL 32:1–167. Turnhout, 1962.

———. *In Iohannis Euangelium Tractatus CXXIV,* ed. D. R. Willems. CCSL 36. Turnhout, 1954.

———. *Sermones de tempore. PL* 38:995–1246.

Barré, Henri. *Prières anciennes de l'Occident à la Mère du Sauveur: Des origines à saint Anselme.* Paris, 1963.

Baudri of Bourgueil. *Baldricus Burgulianus Carmina,* ed. Karlheinz Hilbert. Heidelberg, 1979.

———. "To the Countess Adela." Trans. Monika Otter. *Journal of Medieval Latin* 11 (2001): 60–141.

Bautier, Robert Henri, ed. *Recueil des actes d'Eudes, roi de France (888–898).* Paris, 1967.

Bautier, Robert-Henri, and M. Gilles, ed. and trans. *Chronicon Sancti Petri Vivi Senonensis.* Paris, 1979.

Beck, Bernard. *Saint Bernard de Tiron: L'ermite, le moine et le monde.* Cormelles-le-Royal, 1988.

Bede. *Historia gentis Anglorum ecclesiastica* [*Bede's Ecclesiastical History of the English People*], ed. Bertram Colgrave and R. A. B. Mynors. Oxford, 1969.

———. *Homilia in Mattheam. PL* 94:121A–125C; ed. D. Hurst. CCSL 122:200–206. Turnhout, 1955.

Benoît de Sainte-More. *Chronique des ducs de Normandie,* ed. Carin Fahlin. 4 vols. Uppsala, 1951–79.

Berger, David, ed. *The Jewish–Christian Debate in the High Middle Ages: A Critical Edition of the Nizzahon Vetus.* Philadelphia, 1979.

Berger, Élie, ed. "Annales de Saint-Denis, généralement connues souls le titre de Chronicon Sancti Dionysii ad cyclos Paschales." *BEC* 40 (1879): 261–95.

Bernard of Angers. *Liber miraculorum sancte Fidis,* trans. Pamela Sheingorn. Philadelphia, 1995.

Bernard of Clairvaux. *De consideratione ad Eugenium Papam.* In *S. Bernardi opera,* 3:393–493.

———. *Five Books on Considerations: Advice to a Pope,* trans. John D. Anderson and Elizabeth T. Kennan. Kalamazoo, 1976.

————. *The Letters*, trans. Bruno Scott James. Chicago, 1953; 2d ed. with introduction by Beverly Kienzle. Kalamazoo, 1998.

————. *Sancti Bernardi opera*, ed. Jean Leclercq, Henri Rochais, et al. 8 vols. Rome, 1957–77.

Beyers, Rita, ed. *Libellus de nativitate sanctae Mariae*. In *Libri de nativitate Mariae*, 276–333. CCSA 10. Turnholt, 1997.

*Bibliotheca hagiographica latina antiquae et mediae aetatis*, ed. Socii Bollandiani. Subsidia hagiographica 6, 12, 70. 3 vols. Brussels, 1898/9, 1986.

Boethius. *Fundamentals of Music*, trans. Calvin M. Bower, ed. Claude V. Palisca. New Haven, 1989.

Bur, Michel, ed. and trans. *Chronique, ou, Livre de fondation du Monastère de Mouzon = Chronicon Mosomense, seu, Liber fundationis Monasterii Sanctae Mariae O.S.B. apud Mosomum in dioecesi Remensi*. Paris, 1989.

Caesarius of Arles. *Sermones*, ed. Germain Morin. CCSL 103. Turnholt, 1953.

*Cantus: A Database for Latin Ecclesiastical Chant*. http://publish.uwo.ca/~cantus. Accessed June 26, 2008.

Challine, Charles. *Recherches sur Chartres transcrites et annotées par un arrière-neveu de l'auteur*, ed. R. Durand. Chartres, 1918.

*Chronicle of Morigny*. PL 180:131–76; *La chronique de Morigny (1095–1152)*, ed. Léon Mirot. 2d ed. Paris, 1912; *A Translation of the Chronicle of the Abbey of Morigny, France, c. 1100–1150*, trans. Richard Cusimano. Lewiston, N.Y., 2003.

*Chronicle of the Counts of Anjou*. *See* Halphen and Poupardin.

Chronicle of Tours. *Ex chronico Turonensi*. RHG 12:461–78.

*Chronique des ducs de Normandie*. *See* Benoît de Sainte-More.

Clarius. *Chronique de Saint-Pierre-le Vif de Sens, dite de Clarius = Chronicon Sancti Petri Vivi Senonensis*, ed. Robert-Henri Bautier, Monique Gilles, and Anne-Marie Bautier. Paris, 1979.

Clerval, Alexandre, ed. "Translationes S. Aniani Carnotensis episcopi annis 1136 et 1264 factae." *Analecta Bollandiana* 7 (1888): 327–35.

Comnena, Anna. *The Alexiad of the Princess Anna Comnena, Being the History of the Reign of Her Father, Alexius I, Emperor of the Romans, 1081–1118 A.D.*, trans. Elizabeth A. S. Dawes. London, 1928.

Crispin, Gilbert. *The Works of Gilbert Crispin, Abbot of Westminister*, ed. Anna Sapir Abulafia and G. R. Evans. London, 1986.

*Cursus: An Online Resource of Medieval Liturgical Texts*. http://www.cursus.uea.ac.uk. Accessed June 26, 2008.

Davril, Anselme, ed. *The Monastic Ritual of Fleury (Orléans, Bibliothèque Municipale Ms 123 [101]*. Henry Bradshaw Society 105. London, 1990.

Delaporte, Yves, ed. *Fragments des manuscrits de Chartres: Reproduction phototypique*. Paleographie musicale 17. Solesmes, 1958.

————. *L'Ordinaire Chartrain du XIIIe siècle*. SAEL-M 19 (1953). = OC.

Depoin, Joseph, ed. *Cartulaire de l'Abbaye de Saint-Martin de Pontoise*. Pontoise, 1895–1909.

Desportes, Pierre. *Fasti ecclesiae Gallicanae*. 9 vols. to date. Turnhout, 1996–.

De Strycker, E. "Une ancienne version latine du Protévangile de Jacques avec des extraits de la Vulgate de Matthieu 1–2 et Luc 1–2." *Analecta Bollandiana* 83 (1965): 365–410.

Dewick, E. S., ed. *Facsimiles of Horae de Beata Maria Virgine, from English MSS. of the Eleventh Century*. Henry Bradshaw Society 21. London, 1902.

Dudo of St. Quentin. *De moribus et actis primorum Normanniae ducum*. PL 141:607–758.

————. *History of the Normans*, trans. Eric Christiansen. Woodbridge, U.K., 1998.

Dufour, Jean, ed. *Recueil des actes de Louis VI, roi de France (1108–1137)*. 4 vols. to date. Paris, 1992–.

————. *Recueil des actes de Robert Ier et de Raoul, rois de France (922–936)*. Paris, 1978.

Duru, Louis Maximilien, ed. *Bibliothèque historique de l'Yonne.* 2 vols. Auxerre, 1850–63.

Elliott, J. K., trans. *The Protevangelium of James.* In *The Apocryphal New Testament: A Collection of Apocryphal Christian Literatuare in an English Translation,* 48–67. Oxford, 1993.

Eusebius of Caesarea. *Life of Constantine,* trans. Averil Cameron and Stuart G. Hall. Oxford, 1999.

Evergates, Theodore, ed. *The Cartulary and Charters of Notre-Dame of Homblières,* ed. with an introduction by Theodore Evergates in collaboration with Giles Constable on the basis of material prepared by William Mendel Newman. Cambridge, Mass., 1990.

———. *Feudal Society in Medieval France: Documents from the County of Champagne.* Philadelphia, 1993.

———. *Littere baronum: The Earliest Cartulary of the Counts of Champagne.* Toronto, 2003.

*Ex historiae franciae fragmento.* RHG 10:210–11.

Farsit, Hugh. *Libellus de miraculis b. Mariae Virginis.* PL 179:1777–1800.

Fauroux, M. *Recueil des actes des ducs de Normandie.* Caen, 1961.

Fisquet, Honoré. *Actes et histoire du concile oecuméniquede Rome 1869 publiés sous la direction de Victor Frond.* 7 vols. in 8. Paris, 1870–71.

Fliche, Augustin. *Les Vies de Saint Savinien, Premier Évêque de Sens: Étude Critique.* Paris, 1912.

Flodoard of Rheims. *Les Annales de Flodoard,* ed. Philippe Lauer. Collection de Textes pour servir à l'étude et à l'enseignement de l'histoire 39. Paris, 1905.

———. *Annales (919–66),* ed. G. H. Pertz. MGH SS 3:363–408. Hanover, 1839; rpt. Stuttgart, 1987. *Annals of Flodoard of Reims, 919–966,* ed. and trans. Steven Fanning and Bernard S. Bachrach. Peterborough, Ont., 2004.

Fredegar. *Chronique de Frédégaire.* Paris, 1823–35.

Fulbert. *The Letters and Poems of Fulbert of Chartres,* ed. and trans. Frederick Behrends. Oxford, 1976. = LPFC.

———. *Oeuvres: Correspondance, controverse, poesie.* Chartres, 2006.

———. *Sermones contra Judaeos.* PL 141:305–18.

———. *Une prière de Saint Fulbert à Notre-Dame,* ed. Yves Delaporte. Chartres, 1928.

———. "Texto crítico de algunos sermones marianos de San Fulberto de Chartres o a él atribuibles," ed. José Maria Canal. RTAM 30 (1963): 55–87; "Los sermones marianos de San Fulberto de Chartres. Adición," ed. Canal. RTAM 30 (1963): 329–33; "Los sermones marianos de San Fulberto de Chartres. Conclusión," ed. Canal. RTAM 33 (1966): 139–47.

Fulcher of Chartres. *The First Crusade: "The Chronicle of Fulcher of Chartres" and Other Source Materials,* ed. and trans. Edward Peters. 2d ed. Philadelphia, 1998.

———. *Historia Hierosolymitana (1095–1127),* ed. Heinrich Hagenmeyer. Heidelberg, 1913.

———. *A History of the Expedition to Jerusalem, 1095–1127,* trans. by F. R. Ryan, ed. with an introduction by Harold S. Fink. Knoxville, 1969; New York, 1973.

*Gallia christiana in provincias ecclesiasticas distributa qua series & historia archiepiscoporum, episcoporum, & abbatum Franciae vicinarumque ditionum ab origine ecclesiarum ad nostra tempora / deducitur et probatur ex authenticis instrumentis ad calcem positis.* 16 vols. Paris, 1856–99.

Gamber, Klaus. *Codices liturgici latini antiquiores.* 2d ed. Spicilegii Friburgensis subsidia 1. 2 vols. Freiburg, 1968.

Geoffrey Grossus. *Vita Beati Bernardi Tironiensis,* ed. Godefroy Henskens and Daniel Papebroch. AASS, April 2:222C–255A.

Geoffroy de Courlon. *Le livre des reliques de l'abbaye de Saint-Pierre-le Vif de Sens,* ed. M. Prou and G. Julliot. Published as *Libellus super reliquiis monasteri Sancti Gaufridi de Gellone.* Documents publiés par la Sociéte archéologique de Sens 1. Sens, 1876.

Gerbert of Aurillac. *Acta concilii Remensis ad Sanctam Basolum,* ed. G. H. Pertz. MGH SS 3:658–86. Hanover, 1839; rpt. Stuttgart, 1987.

————. *The Letters of Gerbert, with his Papal Privileges as Sylvester II*, trans. Harriet Pratt Lattin. New York, 1961.

Gerson, Jean. *La doctrine du chant du cœur*, ed. and trans. Isabella Fabre. Geneva, 2005.

————. *Opera omnia*, ed. Louis Ellies du Pin. 5 vols. Antwerp, 1706; rpt. Hildesheim and New York, 1987.

*Gesta Francorum. See* R. Hill; B. A. Lees.

*Gesta Stephani, Regis Anglorum. See* K. R. Potter.

Gijsel, Jan, ed. *Pseudo-Matthaei Evangelium: Textus et commentarius*. In *Libri de nativitate Mariae*, 276–481. CCSA 9. Turnhout, 1997.

Gilbert de la Porrée. *The Commentaries on Boethius by Gilbert of Poitiers*, ed. Nikolaus M. Häring. Toronto, 1966.

Giry, Arthur, et al., eds. *Recueil des actes de Charles II le Chauve, roi de France*. 3 vols. Paris, 1943–55.

Glaber, Rudulfus. *The Five Books of the Histories*, ed. and trans. John France; with *The Life of St. William*, ed. Neithard Bulst, trans. John France and Paul Reynolds. Oxford, 1989.

Grat, Felix, et al., eds. *Recueil des actes de Louis II le Bègue, Louis III et Carloman II, rois de France (877–884)*. Paris, 1978.

Gregory of Tours. *Glory of the Martyrs*, trans. Raymond Van Dam. Liverpool, 1988.

————. *The History of the Franks*, trans. Lewis Thorpe. Baltimore, 1974.

Gregory the Great. *XL homiliarum in Evangelia libri duo*. PL 76:1075–1312; *Forty Gospel Homilies*, trans. David Hurst. Cistercian Studies Series 123. Kalamazoo, 1990.

Guérard, M., ed. *Cartulaire de l'abbaye de Saint-Père de Chartres*. 2 vols. Paris, 1840. = CSP.

Guibert of Nogent. *De laude sanctae Mariae*. In *Dei gesta per Francos et cinq autres textes*, ed. R. B. C. Huygens. CCCM 127A. Turnhout, 1996.

————. *Self and Society in Medieval France: The Memoirs of Abbot Guibert of Nogent (1064?–c. 1125)*, ed. John F. Benton, trans. C. C. Swinton Bland. New York, 1970; PL 156:837–962.

Halphen, Louis, and Ferdinand Lot, eds. *Recueil des actes de Lothaire et de Louis V, rois de France (954–987)*. Paris, 1908.

Halphen, Louis, and René Poupardin, eds. *Chroniques des comtes d'Anjou et des seigneurs d'Amboise*. Paris, 1913.

Haymo of St. Pierre-sur-Dives. "Lettre de l'abbé Haimon sur la construction de l'église de Saint-Pierre-sur-Dives en 1145," ed. Leopold Delisle. *BEC* 21 (1860): 113–39.

Hefele, Karl Joseph von., ed. *Histoire des conciles d'après les documents originaux*, trans. into French by H. Leclercq. 11 vols. Paris 1907–52; *A History of the Councils of the Church, from the Original Documents*. 5 vols. Edinburgh, 1883–96; New York, 1972.

Helgaud of Fleury. *Epitoma vitae regis Rotberti Pii*. In *Vie de Robert le Pieux*, ed. and trans. Robert-Henri Bautier and Gillette Labory. Paris, 1965.

————. *A Brief Life of Robert the Pious*, trans. Philippe Buc. http://www.stanford.edu/dept/history/people/buc/HELG-W.DOC. Accessed March 18, 2008.

Henry of Blois. "Scriptura Henrici episcopi Wintoniensis et abbatis Glastonienses." In *English Episcopal Acta* 8, ed. David M. Smith. Appendix. 30 vols. to date. London, 1980–.

Hermann of Laon (Tournai). *De miraculis s. Mariae Laudunensis de gestis*. PL 156:961–1018.

Hesbert, René-Jean. *Corpus antiphonalium officii*. 6 vols. Rome, 1963–79. = CAO.

Hildegard of Bingen. *Scivias*, ed. Adelgundis Führkötter, with Angela Carlevaris. CCCM 43–43A. Turnhout, 1978.

Hiley, David, ed. *Missale Carnotense: Chartres Codex 520: Faksimile*. 2 vols. Kassel and New York, 1992.

————. *Das Repertoire der normanno-sizilischen Tropare 1: Die Sequenzen*. Monumenta Monodica Medii Aevi 13. Basel, 2001.

Hill, Rosalind, ed. *The Deeds of the Franks and the Other Pilgrims to Jerusalem* [*Gesta Francorum*]. London, 1962.

Hincmar. *Les annales de Saint-Bertin et de Saint-Vaast, suivies de fragments d'une chronique inédite . . .* , ed. C. Dehaisnes. Paris, 1871.

*Histoire littéraire de la France: Ouvrage commencé par des religieux bénédictins de la congrégation de Saint-Maur et continué par des membres de l'Institut.* 43 vols. Paris, 1733–2005.

Honorius Augustodunensis. *Speculum Ecclesiae.* PL 172:807–1107.

Hugh of Flavigny. *Chronicon*, ed. G. H. Pertz. MGH SS 8:280–503. Hanover 1848; rpt. Stuttgart, 1992.

Hugh of Fleury. *Historia ecclesiastica*, ed. G. Waitz. MGH SS 9:349–64. Hanover, 1851; rpt. Stuttgart, 1983; rpt. PL 163:821–54.

———. *Historia Francorum Senonensis a. 688–1034*, ed. G. Waitz. MGH SS 9:364–69. Hanover, 1851; rpt. Stuttgart, 1983.

Hugh of Saint Victor. *De sacramentis christianae fidei.* PL 176:173–618; *On the Sacraments of the Christian Faith*, trans. R. Deferrari. Cambridge, Mass., 1951.

Hughes, Andrew. *Medieval Manuscripts for Mass and Office: A Guide to Their Organization and Terminology.* Toronto, 1982; rpt. 1995, with addenda.

Hughes, Anselm. *Anglo-French Sequelae*, London, 1934; Farnborough, 1966.

Internet Medieval Sourcebook. http://www.fordham.edu/halsall/Sbook.html. Accessed August 23, 2008.

Ivo of Chartres. *Correspondence*, 1: 1090–98, ed. and trans. Jean Leclercq. Paris, 1949.

———. *Epistolae.* PL 162:9–504.

———. *Sermones.* PL 162:505–610.

Jaffé, Philippus. *Regesta pontificum romanorum ab condita ecclesia ad annum post Christum natum MCXCVIII*, ed. G. Wattenbach. 2d ed. 2 vols. Leipzig, 1885–88.

Jean le Marchant. *Miracles de Notre-Dame de Chartres*, ed. Pierre Kunstmann. Chartres (SAEL-M 26), 1973, and Ottawa, 1974.

Jerome. *Commentariorum in Esaiam libri I–XVIII*, ed. Marcus Adriaen. CCSL 73, 73A. Turnholt, 1963.

John of Garland. *The Stella Maris of John of Garland, Together with a Study of Certain Collections of Mary Legends Made in Northern France in the Twelfth and Thirteenth Centuries*, ed. Evelyn F. Wilson. Medieval Academy of America Publications 45. Cambridge, Mass., 1946.

John of Salisbury. *The Historia Pontificalis*, ed. and trans. Marjorie Chibnall. Oxford, 1986.

———. *The Metalogicon, a Twelfth-Century Defense of the Verbal and Logical Arts of the Trivium*, trans. Daniel D. McGarry. Berkeley, 1955.

———. *Policraticus: Of the Frivolities of Courtiers and the Footprints of Philosophers*, ed. and trans. Cary J. Nederman. Cambridge, 1990.

John of Worcester. *The Chronicle*, ed. R. R. Darlington and P. McGurk; trans. Jennifer Bray and P. McGurk. Oxford, 1995–98.

Josephus. *The Works of Josephus, Complete and Unabridged*, trans. William Whiston. Rev. ed. Peabody, Mass., 1987.

Klauser, Theodor. *Das römische Capitulare evangeliorum: Texte und Untersuchungen zu seiner ältesten Geschichte.* Munster, 1935.

Kunstmann, Pierre, ed. *Vierge et merveille: Les miracles de Notre-Dame narratifs au moyen-âge.* Paris, 1981.

Lancelot, Antoine. "Descriptions des figures qui sont sur la face de l'église de l'abbaye royale de la Magdeleine de Châteaudun." *Histoire de l'Académie royale des inscriptions et belles-lettres* 9 (1742): 181–92.

Lasker, Daniel. *See* Nestor the Priest.

Lees, Beatrice A., ed. *Anonymi gesta Francorum et aliorum Hierosolymitanorum.* Oxford, 1924.

Lemaître, Jean-Loup, ed. *Répertoire des documents nécrologiques français, publié sous la direction de Pierre Marot*. Recueil des historiens de la France. Obituaires 7, in 4 vols. Paris, 1980–1992.

Lépinois, Ernest de, and Lucien Merlet, eds. *Cartulaire de Notre-Dame de Chartres*. 3 vols. Chartres, 1862–65. = CNDC.

Lewis, C. T., and C. Short. *A Latin Dictionary*. Oxford, 1975.

*Libellus. See* Beyers.

*Liber Eliensis: A History of the Isle of Ely from the Seventh Century to the Twelfth / Compiled by a Monk of Ely in the Twelfth Century*, trans. Janet Fairweather. Woodbridge, U.K., 2005.

*Liber historiae Francorum*, ed. and trans. Bernard S. Bachrach. Lawrence, Kan., 1973.

*Liber responsorialis: pro festis I. classis et communi sanctorum: juxta ritum monasticum: adnectuntur invitatorium et hymnus aliorum festorum*. Solesmes, 1895.

Limor, Ora, and Guy G. Stroumsa, eds. *Contra Iudaeos: Ancient and Medieval Polemics between Christians and Jews*. Tübingen, 1996.

Liron, Jean. *Bibliothèque générale des auteurs de France*, 1: *La Bibliothèque Chartraine*. Paris, 1719; rpt. Geneva, 1971.

Lot, Ferdinand, and Philippe Lauer, eds. *Diplomata Karolinorum: Recueil de reporoductions en facsimilé des actes originaux des souverains carolingiens conservés dans les archives et bibliothèques de France*. 9 vols. to date. Toulouse, 1936–.

Luchaire, Achille. *Études sur les actes de Louis VII*. Paris, 1885.

———. *Louis VI le Gros, annales de sa vie et de son règne (1081–1137)*. Paris, 1890.

Mabille, Émile, ed. *La Pancarte Noire de Saint-Martin de Tours*. Paris, 1806.

Mansi, J. D. *Sacrorum conciliorum nova et amplissima collectio*. 54 vols. Florence, 1759–1927; Paris, 1901–27.

Marchegay, Paul, and Émile Mabille, eds. *Chroniques des églises d'Anjou, recueilliés et publiées pour la Société de l'histoire de France*. Paris, 1869.

———. *Gesta consulum Andegavorum*. Chroniques d'Anjou 1. Paris, 1856.

Maximus of Turin. *Ecce ex qua tribu nasciturus*. PL 57:845–48.

Merlet, Lucien, ed. *Cartulaire de l'abbaye de la Sainte-Trinité de Tiron*. 2 vols. Chartres, 1883. = CTT.

Merlet, Lucien, and L. Jarry, eds. *Cartulaire de l'abbaye de la Madeleine de Châteaudun*. Châteaudun, 1896.

Merlet, Lucien, and René Merlet, eds. *Dignitaires de l'Église Notre-Dame de Chartres. Listes chronologiques*. Chartres, 1900. = DIGS.

Merlet, René, ed. *Cartulaire de l'Abbaye de Saint-Jean-en-Vallée de Chartres*. Chartres, 1906.

———. *La Chronique de Nantes (540 environ–1049)*. Paris, 1896.

Merlet, René, and Alexandre Clerval. *Un manuscrit Chartrain du XIe siècle*. Chartres, 1893. = MSC.

Merlet, René, and Maurice Jusselin. *Cartulaire du Grand-Beaulieu-les-Chartres et du prieuré de Notre-Dame de la Bourdinière*. Chartres, 1909.

Métais, Charles, ed. *Cartulaire de Notre-Dame de Josaphat*. 2 vols. Chartres, 1911–12. = JC.

Molinier, Auguste, ed. *Obituaires de la Province de Sens*. Recueil de des Historiens de la France, Obituaires. 4 vols. Paris, 1902–23. Vol. 2, Diocèse de Chartres, 1906. = OPS.

Montfaucon, Bernard de. *Les monumens de la monarchie françoise, qui comprenant l'histoire de France, avec les figures de chaque règne que l'injure des tems à épargnées*. 5 vols. Paris 1729–33.

Mussafia, A. *Studien zu den mittelalterlichen Marienlegenden*. In sections found in *Sitzungsberichte der Kaiserlichen Akademie der Wissenschaften in Wien. Philologisch-historische Classe*, 113 (1887): 917–94; 115 (1888): 5–92; 119:9 (1889): 1–66; 123:8 (1891); 139:8 (1898).

Nelson, Janet. *See Annales de Saint-Bertin*.

Nestor the Priest. *The Polemic*, ed. Daniel Lasker and Sarah Stroumsa. 2 vols. Jerusalem, 1996.

Nicholas of Clairvaux. *Sermo de exaltatione sanctae crucis*. PL 144:761C–766B.

Niermeyer, Jan Frederik. *Mediae Latinitatis lexicon minus.* 2 vols. Leiden, 2002.

*Nizzahon Vetus. See* Berger, David, ed.

Odorannus of Sens. *Opera omnia*, ed. and trans. Robert-Henri Bautier and Monique Gilles. Paris, 1972.

Orderic Vitalis. *The gesta normannorum ducum of William of Jumièges, Orderic Vitalis and Robert of Torigni*, ed. and trans. Elisabeth van Houts. 2 vols. Oxford, 1992.

————. *Historia ecclesiastica*, ed. Marjorie Chibnall. 6 vols. Oxford, 1968–80.

Ordo veridicus. Known through Yves Delaporte's handwritten copy. = OV.

Origen. *Homélies sur les Nombres, 1 (I–X)*, ed. Louis Doutreleau. SC 415. Paris, 1996.

Ottosen, Knud. *L'Antiphonaire latin au moyen-âge: Réorganisation des séries de répons de l'Avent, classés par R.-J. Hesbert.* Rome, 1986.

Paschasius Radbertus. *De benedictionibus patriarcharum Iacob et Moysi*, ed. Bede Paulus. CCCM 96. Turnholt, 1993.

————. *In Threnos sive Lamentationes Jeremiae.* PL 120:1059–1256.

Paul the Deacon. *Homiliarius.* PL 95:1159–1566.

Peter of Celle. *Tractatus de tabernaculo*, ed. G. de Martel. CCCM 54:171–243. Turnhout, 1983.

Peter Damian. Letter to Abbot Desiderius. *RHG* 10:492–93.

Peter the Venerable. *The Letters of Peter the Venerable*, ed. Giles Constable. 2 vols. Harvard Historical Studies 78. Cambridge, 1967.

Peters, Edward, ed. *The First Crusade: The Chronicle of Fulcher of Chartres and Other Source Materials.* 2d ed. Philadelphia, 1998.

Plancher, Urbain. *Histoire generale et particuliere de Bourgogne, avec notes, des dissertations et les preuves justificatives, composée sur les auteurs, les titres originaux, les régistres publics, les cartulaires des eglises . . .* 4 vols. Dijon, 1739–81.

*Les plus beaux manuscrits français de VIIIe au XVIe siècle conservés dans les bibliothèques nationales de Paris.* Paris, 1937.

Poncelet, A. "Index Miraculorum B.V.M. quae latine sunt conscripta." *Analecta Bollandiana* 21 (1902): 241–360.

Potter, K. R., ed. and trans. *The Deeds of Stephen.* New York, 1955. *Gesta Stephani.* New introd. and notes by R. H. C. Davis. Oxford and New York, 1976.

Praepositinus of Cremona. *Tractatus de Officiis*, ed. James A. Corbett. London, 1969.

Prevost, Estienne. *Petit traicté composé par Estienne Prevost, official de Chartres, touchant la fondacion & érection de l'Eglise nostre Dame & cité de Chartres.* Chartres, 1558.

*Processionale à l'usage de l'église cathédrale de Chartres, suivant le nouveau bréviaire.* Chartres, 1788.

*Protevangelium of James. See* Amann; Beyers; De Strycker; Elliott.

Prou, Maurice, ed. *Recueil des actes de Philippe Ier, roi de France, 1059–1108.* Paris, 1908.

Pseudo-Augustine. *Legimus sanctum Moysen.* PL 39:2196–98.

*Pseudo-Matthew. See* Gijsel, Jan.

Quodvultdeus. *Opera Quodvultdeo Carthaginiensi episcopo tribute*, ed. René Braun. CCSL 60. Turnholt, 1976.

Rabanus Maurus. *Commentariorum in Matthaeum libri octo.* PL 107:727–1156; *Expositio in Matthaeum*, ed. B. Löfstedt. CCCM 174–174A. Turnhout, 2000.

Raoul de Caen. *The Gesta Tancredi of Ralph of Caen: A History of the Normans on the First Crusade*, trans. and with an introduction by Bernard S. Bachrach and David S. Bachrach. Aldershot/Burlington, 2005.

*Recueil des actes des ducs de Normandie. See* Faroux, M.

*Recueil des actes d'Eudes. See* Bautier, Robert Henri.

*Recueil des actes de Lothaire et de Louis V, rois de France (954–987). See* Halphen and Lot.

*Recueil des actes de Louis II le Bègue, Louis III et Carloman II, rois de France (877–884).* See Grat, Felix.

*Recueil des actes de Louis VI, roi de France (1108–1137).* See Dufour, Jean.

*Recueil des acts de Philippe Ier.* See Prou, Maurice.

*Recueil des actes de Robert Ier et de Raoul, rois de France: 922–936.* See Dufour, Jean.

*Recueil des Historiens des Croisades.* 17 vols. Paris, 1841–1906. http://www.crusades-encyclopedia .com/recueil.html. Accessed August 23, 2008.

*Recueil des historiens des Gaules et de la France.* 25 vols. Paris, 1738–1904; nouv. edn. 19 vols. Paris, 1869–80. = *RHG.*

Regino of Prüm. *Die Chronik des Abtes Regino von Prüm.* Nach de Ausgabe der Monumenta Germaniae übersetzt von dr. Ernst Dummler. 2d ed. Leipzig, 1890.

Richard of St. Victor. *L'edit d'Alexandre ou les trois processions* [*Super exiit edictum seu De Tribus Processionibus*], ed. Jean Châtillon. Bruges, 1951.

Richer of Rheims. *Histoire de France, 888–945* [*Historiae libri V*], ed. and trans. Robert Latouche. 2 vols. Paris, 1930.

———. *Historiae*, ed. Hartmut Hoffmann. MGH SS 38. Hanover, 2000.

Robert of Torigny. *The Chronicles of Robert de Monte*, trans. Joseph Stevenson. Church Historians of England 4:2. London, 1856.

———. *Chronique: suivie de divers opuscules historiques . . .*, ed. Léopold Delisle. 2 vols. Rouen, 1872–73.

———. *The gesta normannorum ducum of William of Jumièges, Orderic Vitalis and Robert of Torigni*, ed. and trans. Elisabeth van Houts. 2 vols. Oxford, 1992.

Roederer, Charlotte, ed. *Festive Troped Masses from the Eleventh Century: Christmas and Easter in the Aquitane.* Madison, Wis., 1989.

Roulliard, Sébastien. *Parthénie ou Histoire de la très auguste et très dévote Eglise de Chartres, dédiée par les vieux Druides, en l'honneur de la Vierge qui enfanteroit: avec ce qui s'est passé de plus memorable, au faict de la Seigneurerie, tant Spirituelle que Temporelle de la dicte Eglise, ville et païs chartrain.* Paris, 1609.

Rudulfus Glaber. See Glaber, Rudulfus.

Rupert of Deutz. *De Trinitate et operibus eius.* PL 167:199–1828.

Sablon, Vincent. *Histoire de l'auguste et vénérable église de Chartres, dédiée par les anciens druids à une vierge qui devait enfanter: Tirée des manuscrits et des originaux de cette église.* Orléans, 1671; 2d ed., 1683.

———. *Histoire et description de l'église cathédrale de Chartres dédiée par les druides à une vierge qui devait enfanter. Revue et augmentée d'une description de l'église de Sous-Terre et d'un récit de l'incendie de 1836.* Pub. by Lucien Merlet. Chartres, 1860.

Sedulius Scotus. *Paschale Carmen.* In *Sedulii Opera omnia*, ed. J. Huemer, 14–146. CSEL 10. Vienna, 1885.

Sigebert de Gembloux. *Chronicon*, ed. G. H. Pertz. MGH SS 6:381–83. Hanover, 1844; rpt. Stuttgart, 1980.

———. *Gesta abbatum Gemblacensium*, ed. G. H. Pertz. MGH SS 8:523–42. Hanover 1848; rpt. Stuttgart, 1992.

Smith, Richard Upsher, ed. "Liber de cardinalibus Christi domini nostri operibus." Ph.D. diss., Dalhousie University, 1991.

Souchet, Jean-Baptiste. *Histoire du diocese et de la ville de Chartres*, ed. Aldolphe Lecocq. 4 vols. Chartres, 1866–73.

Suger. *De administratione.* In *Abbot Suger on the Abbey Church of St.-Denis and Its Art Treasures*, ed. and trans. by Irwin Panofsky, 40–81. 2d ed. by Gerda Panofsky-Soergel. Princeton, 1979.

———. *De consecratione*, ed. Günther Binding and Andreas Speer. Cologne, 1995; in *Abbot Suger*

on the Abbey Church of St.-Denis and Its Art Treasures, ed. and trans. Irwin Panofsky, 82–121. 2d ed. by Gerda Panofsky-Soergel. Princeton, 1979.

————. *The Deeds of Louis the Fat*, trans. Richard Cusimano and John Moorhead. Washington, D.C., 1992.

————. *Oeuvres*, 1, ed. Françoise Gasparri. Les classiques de l'histoire de France au moyen âge. Paris, 1996.

————. *Vita Ludovici Grossi Regis*, ed and trans. Henri Waquet. In *Vie de Louis VI le Gros*. Les classiques de l'histoire de France au moyen âge 11. Paris, 1929.

Sulpicius Severus. *Life of Martin of Tours*. In *Early Christian Lives*, trans. Carolinne White. London, 1998.

Tessier, Georges, ed. *Recueil des actes de Charles II le chauve, roi de France*. Begun by Arthur Giry, continued by Maurice Prou, completed by Georges Tessier. 3 vols. Paris, 1943–55.

Tessier, Georges, and Robert-Henri Bautier, eds. *Recueil des actes d'Eudes, roi de France (888–898)*. Paris.

Thierry of Chartres. *The Latin Rhetorical Commentaries*, ed. Karin M. Fredborg. Toronto, 1988.

Thomas, A., ed. "Miracula Beatae Mariae Carnotensis." *BEC* 42 (1881): 508–50.

Usuard. *Le martyrologe d'Usuard, texte et commentaire*, ed. Jacques Dubois. Subsidia hagiographica 40. Brussels, 1965.

Villette, Guy, trans. "La Chronique chartraine de 1389, dite 'Vieille Chronique,' traduit du latin." Documents pour l'historie de la region chartraine. Multigraphed typescript, 1977.

*Vita of Geran of Auxerre*. AASS July 28, vol. 6, 597–99.

*Vita of Saint Viventius*. AASS Jan. 13, vol. 1, 804–14.

Wace. *Le roman de Rou*, ed. A. J. Holden. 3 vols. Paris, 1970–73.

Walahfrid Strabo. *Libellus de exordiis et incrementis quarundam in observationibus ecclesiasticis rerum*, trans. with commentary by Alice L. Harting-Correa. Leiden and New York, 1996.

Walter of Cluny. *De miraculis B. Mariae. PL* 173:1379–86.

Ward, H. D. L. *Catalogue of Romances in the Department of Manuscripts in the British Library*. 2 vols. London, 1883, 1892.

William of Jumièges. *Gesta Normannorum ducum*, ed. Jean Marx. Rouen, 1914.

————. *The gesta normannorum ducum of William of Jumièges, Orderic Vitalis and Robert of Torigni*, ed. and trans. Elisabeth van Houts. 2 vols. Oxford, 1992.

William of Malmesbury. *Chronicle of the Kings of England from the Earliest Period to the Reign of King Stephen*, trans. John Sharpe, rev. J. A. Giles. London, 1847.

————. *Historia novella*, ed. Edmund King, trans. K. R. Potter. London, 1955.

William the Breton. *La Philippide*, trans. into French by Guizot. Collection des mémoires relatifs a l'histoire de France 12. Paris, 1825.

Ziolkowski, Jan M., ed. *Jezebel: A Norman Latin Poem of the Early Eleventh Century*. New York, 1989.

# Secondary Sources

Abbott, Wilbur C. 1898. "Hasting." *EHR* 13:439–63.

Abou-el-Haj, Barbara F. 1991. "The Audiences for the Medieval Cult of Saints." *Gesta* 30:3–15.

Abulafia, Anna Sapir. 1996. "Twelfth-Century Humanism and the Jews." In *Contra Iudaeos: Ancient and Medieval Polemics between Christians and Jews*, ed. Ora Limor and Guy G. Stroumsa, 161–75. Texts and Studies in Medieval and Early Modern Judaism 10. Tübingen.

Adair, Penelope Ann. 2003. "Constance of Arles: A Study in Duty and Frustration." In *Capetian Women*, ed. Kathleen Nolan, 9–26. New York.

Adams, Lucy A. 1989. "The Temptations of Christ: The Iconography of a Twelfth-Century Capital in the Metropolitan Museum of Art." *Gesta* 28:130–35.

Adams, Roger J. 1973. "The Column Figures of the Chartres Northern Foreportal and a Monumental Representation of Saint Louis." *Zeitschrift für Kunstgeschichte* 36:153–62.

Albu, Emily. 2001. *The Normans in Their Histories: Propaganda, Myth, and Subversion.* Woodbridge, U.K.

Angenendt, Arnold. 1994. "*In porticu ecclesiae sepultus*: Ein Beispiel von himmlisch-irdischer Spiegelung." In *Iconologia sacra: Mythos, Bildkunst und Dichtung in der Religions-und Sozialgeschichte Alteuropas*, ed. Hagen Keller and Nikolaus Staubach, 68–80. Berlin.

Annala, P. 1997. "The Function of the 'formae nativae' in the Refinement Process of Matter: A Study of Bernard of Chartres' Concept of Matter." *Vivarium* 35:1–19.

Arbois de Jubainville, Henry d'. 1859–69. *Histoire des ducs et des comtes de Champagne.* 7 vols. Paris.

Arlt, Wulf. 1992. "Sequence and 'Neues Lied.'" In *La sequenza medievale: Atti del Convegno Internazionale Milano 7–8 aprile 1984*, ed. Agostino Ziino, 3–18. Lucca.

———. 1993. "Stylistic Layers in Eleventh-Century Polyphony: How Can the Continental Sources Contribute to Our Understanding of the Winchester Organa." In *Music in the Medieval English Liturgy*, ed. Susan Rankin and David Hiley, 101–44. Oxford.

Armi, C. Edson. 1993. *The "Headmaster" of Chartres and the Origins of "Gothic" Sculpture.* University Park, Pa.

Armogathe, Jean-Robert, ed. 1997. *Monde médiéval et société Chartraine.* Paris. = MMSC.

Armory, F. 1979. "The Viking Hasting in Franco-Scandinavian Legend." In *Saints, Scholars and Heroes: Studies in Medieval Culture in Honor of Charles W. Jones*, ed. M. H. King and W. M. Stevens, 269–86. Collegeville, Minn.

Arnoux, Mathieu. 1999. "Before the *Gesta Normannorum* and beyond Dudo: Some Evidence on Early Norman Historiography." *ANS* 22:29–48.

Ashley, Kathleen M., and Pamela Sheingorn. 1999. *Writing Faith: Text, Sign and History in the Miracles of Sainte Foy.* Chicago.

Atsma, Hartmut, ed. 1989. *La Neustrie, les pays au nord de la Loire de 650 à 850: Colloque historique international . . . avec une introduction par Karl Ferdinand Werner.* 2 vols. Sigmaringen.

Auger, Marie-Louise. 1987. *La collection de Bourgogne (MSS 1–74) à la Bibliothèque nationale: Une illustration de la méthode historique mauriste.* Geneva.

Aziza, Claude. 1977. *Tertullian et le judaïsme.* Nice.

Bachrach, Bernard. 1993. *Fulk Nerra, the Neo-Roman Counsul, 987–1040: A Political Biography of the Angevin Count.* Berkeley.

Bachrach, David S. 2003. *Religion and the Conduct of War c. 300–c. 1215.* Woodbridge, U.K.

Baert, Barbara. 2004. *A Heritage of Holy Wood: The Legend of the True Cross in Text and Image,* trans. Lee Preedy. Leiden.

Bailey, Terrence. 1971. *The Processions of Sarum and the Western Church.* Toronto.

Bak, János M., ed. 1990. *Coronations: Medieval and Early Modern Monarchic Ritual.* Berkeley.

Baltzer, Rebecca A. 2000. "The Little Office of the Virgin and Mary's Role at Paris." In *Divine Office,* 463–84.

Baratte-Bévillard, Sophie. 1972. "La sculpture monumentale de la Madeleine de Châteaudun." *Bulletin archéologique du Comité des travaux historiques et scientifiques, fasc. A.* 8:105–25.

Barker, Lynn K. 1978. "Ecclesiology and the Twelfth-Century Church in the Letters of Peter of Celle." M.A. thesis, University of North Carolina at Chapel Hill.

———. 1988. "Ivo of Chartres and Anselm of Canterbury." *Proceedings of the 5th International St. Anselm Conference* 2:13–33.

Barnes, Carl F. 1996. "The Cult of Carts." In *Grove Dictionary of Art,* ed. Jane Turner, 8:257–59. New York.

Barré, Henri. 1957. "Le sermon 'Exhortatur' est-il de saint Ildefonse?" *RB* 58:10–33.

———. 1962. *Les homéliaires carolingiens de l'école d'Auxerre: Authenticité, inventaire, tableaux comparatifs.* Studi e testi 225. Vatican City.

———. 1964. "Pro Fulberto." *RTAM* 31:324–30.

———. 1967. "Antiennes et répons de la Vierge." *Marianum* 29:153–254.

Barthélemy, Dominique. 1999. *L'an mil et la paix de Dieu: La France chrétienne et féodale, 980–1060.* Paris.

Barton, Richard E. 2004. *Lordship in the County of Maine, c. 890–1160.* Woodbridge, U.K.

Bates, David. 1982. *Normandy before 1066.* London.

———. 1989. "Normandy and England after 1066." *EHR* 104:851–80.

Baudoin, Jacques. 1992. *La sculpture flamboyante en Normandie et Ile-de-France.* Nonette.

Bauduin, Pierre. 2004. *La première Normandie (Xe–XIe siècles): Sur les frontières de la haute Normandie: Identité et construction d'une principauté.* Caen.

Baumgarten, Elisheva. 2007. *Mothers and Children: Jewish Family Life in Medieval Europe.* Princeton.

Bautier, Robert-Henri. 1992. "L'avènement d'Hughes Capet et le sacre de Robert le Pieux." In *Roi de France,* 27–37.

Baxter, Ronald. 1995. Review of Armi (1993). *Journal of the British Archaeological Association* 148:179–81.

Bedos-Rezak, Brigitte Miriam. 2000. "Medieval Identity: A Sign and a Concept." *AHR* 105:1489–1533.

Benton, John F. 1961. "Nicholas of Clairvaux and the Twelfth-Century Sequence, with Special Reference to Adam of St. Victor." *Traditio* 18:149–80.

Bernard, Philippe. 1997. "Les répons chartrains pour la Fête de la Nativité de la Vierge Marie à l'époque de l'Evêque Fulbert." In *MMSC,* 137–50.

Bernhard, Michael. 1990. "Glosses on Boethius *De institutione musica.*" In *Music Theory and Its Sources,* ed. A. Barbera, 136–49. Notre Dame Conferences in Medieval Studies 1. Notre Dame.

Billot, Claudine. 1987. *Chartres à la fin du Moyen Âge.* Civilisations et sociétés 76/1. Paris.

Binding, Günther, and Andreas Speer, eds. 1993. *Mittelalterliches Kunsterleben nach Quellen des 11. bis 13. Jahrhunderts*. Stuttgart-Bad Cannstatt.

Bishop, Edmund. 1918. *Liturgica Historica: Papers on the Liturgy and Religious Life in the Western Church*. Oxford.

Bisson, Thomas N. 1994. "The 'Feudal Revolution.'" *Past and Present* 142:6–42; replies from Dominique Barthélemy, Timothy Reuter, Chris Wickham, and Stephen D. White in "Debate: The 'Feudal Revolution.'" *Past and Present* 152 (1996): 196–223, and 155 (1997): 197–255.

Bizeau, Pierre, ed. 1969. *Bibliographie du chanoine Yves Delaporte, archiviste du diocèse de Chartres*. Luisant.

Björkvall, Gunilla. 1991. "*Expectantes Dominum*: Advent, the Time of Expectation, as Reflected in Liturgical Poetry from the Tenth and Eleventh Centuries." In *Quest of the Kingdom: Ten Papers on Medieval Monastic Spirituality*, ed. Alf Härdelin, 109–34. Stockholm.

Blanc, Annie. 1988. "Étude géologique des anciennes carrières de Paris: Son utilité pour la connaissance et la restauration des monuments." In *The Engineering Geology of Ancient Works, Monuments, and Historical Sites*, ed. P. Marinos and G. Koukis, 2:639–47. Rotterdam.

———. 1990. "Observations sur la nature des matériaux de la cathédrale Notre-Dame de Paris." *Gesta* 29:132–38.

Blanc, Annie, Claude Lorenz, and Marc Viré. 1991. "Le liais de Paris et son utilisation dans les monuments." In *Carrières et constructions en France et dans les pays limitrophes*, ed. Jacqueline Lorenz and Paul Benoit, 1:247–59. Congrès national des sociétés historiques et scientifiques 115, Avignon, April 9–12, 1990. Paris.

Blanchard, D. P. 1911. "Un traité *De benedictionibus patriarcharum* de Paschase Radbert?" *RB* 28:425–32.

Bland, Kalman P. 2000. *The Artless Jew: Medieval and Modern Affirmation and Denials of the Visual*. Princeton.

Bloch, R. Howard. 1987. "Genealogy as a Medieval Mental Structure and Textual Form." In *La Littérature Historiographique des Origines à 1500*, ed. Hans Ulrich Gumbrecht et al., 135–56. Grundriss der Romanischen Literaturen des Mittelalters 11:1. Heidelberg.

Blum, Pamela Z. 1986. "Liturgical Influences on the Design of the West Front at Wells and Salisbury." *Gesta* 25:145–50.

———. 1992. *Early Gothic Saint-Denis: Restorations and Survivals*. Berkeley.

Blumenkranz, Bernard. 1952, 1977. "A propos du (ou des) 'Tractatus contra Iudaeos' de Fulbert de Chartres." *Revue du moyen âge latin* 7:51–54; rpt. in *Juifs et Chrétiens: Patristique et moyen âge*. London.

———. 1957. "Où est mort Hugues Capet?" *BEC* 115:168–71.

———. 1960. *Juifs et chrétiens dans le monde occidentale, 430–1096*. Paris.

———. 1963. *Les auteurs chrétiens latins du moyen âge sur les juifs et le judaïsme*. École pratique des hautes études, Études juives 4. Paris.

———. 1964, 1977. "Anti-Jewish Polemics and Legislation in the Middle Ages: Literary Fiction or Reality?" *Journal of Jewish Studies* 15:125–40; rpt. in *Juifs et Chrétiens: Patristique et moyen âge*. London.

Bogomoletz, Wladimir V. 2005. "Anna of Kiev: An Enigmatic Capetian Queen of the Eleventh Century: A Reassessment of Biographical Sources." *French History* 19:299–323.

Bonjour, André, and André Petitdemange. 1986. *Les traces de la musique dans la cathédral de Chartres*. Chartres.

Bonnard, Louis. 1912. "Fortifications d'églises en Eure-et-Loir." *SAEL-M* 14:310–22.

———. 1936. "Les fortifications de Chartres: Essai historique et archéologique." *SAEL-M* 16:257–320.

Borgeaud, Philippe, and Youri Volokhine, eds. 2004–05. *Les objets de la memoire: Pour une approche comparatiste des reliques et de leur culte*. Bern.

Bouchard, Constance B. 2001. *"Those of My Blood": Constructing Noble Families in Medieval Francia*. Philadelphia.

Bouchon, Chantal, Catherine Brisac, Yolanta Zaluska, and Claudine Lautier. 1979. "La 'Belle Verrière' de Chartres." *Revue de l'art* 46:16–24.

Bouet, Pierre. 1990. "Dudon de S. Quentin et Virgile." In *Recueil d'études en hommage à Lucien Musset*, 215–36. Cahiers des Annales de Normandie 23. Caen.

Bouhot, Jean-Paul. 1990. Review of Martin, Henri-Jean (1989). *Revue des études augustiniennes* 36:386–87.

Boussard, Jacques. 1979. "L'origine des comtés de Tours, Blois et Chartres." In *Principautés et territoires et études d'histoire Lorraine. Actes du 103e Congrès national des sociétés savantes*, Nancy-Metz, 85–112. Paris.

Bower, Calvin. 1982. "An Alleluia for Mater." In *Essays on the Music of J. S. Bach and Other Diverse Subjects: A Tribute to Gerhard Herz*, ed. Robert L. Weaver, 95–116. New York.

Bowles, Edmund A. 1962. "The Organ in the Medieval Liturgical Service." *Revue belge de Musicologie / Belgisch Tijdschrift voor Muziekwetenschap* 16:13–29.

Boynton, Susan. 1994. "Rewriting the Early Sequence: 'Aureo flore' and 'Aurea virga.'" *Comitatus* 25:19–42.

———. 1998. "The Liturgical Role of Children in Monastic Customaries from the Central Middle Ages." *Studia Liturgica* 28:194–209.

———. 2000. "Training for the Liturgy as a Form of Monastic Education." In *Medieval Monastic Education*, ed. Carolyn Muessig and George Ferzoco, 7–20. London.

———. 2004. "From the Lament of Rachel to the Lament of Mary: A Transformation in the History of Drama and Spirituality." In *Signs of Change: Transformation of Christian Traditions and Their Representation in the Arts, 1000–2000*, ed. Nils Holger Petersen et al., 319–40. Amsterdam and New York.

———. 2006. *Shaping a Monastic Identity: Liturgy and History at the Imperial Abbey of Farfa, 1000–1125*. Ithaca.

Boynton, Susan, and Isabelle Cochelin. 2006. "The Sociomusical Role of Child Oblates at the Abbey of Cluny in the Eleventh Century." In *Musical Childhoods and the Cultures of Youth*, ed. Susan Boynton and Roe-Min Kok, 3–24. Middletown, Conn.

———, eds. 2005. *From Dead of Night to End of Day: The Medieval Customs of Cluny*. Turnhout.

Boynton, Susan, and Eric Rice, eds. 2008. *Young Choristers, 650–1700*. Woodbridge.

Bozoky, Edina. 2008. "Le culte de sainteté de Fulbert." In *FC*, 173–87.

Branch, Betty. 1974. "The Development of Script in the Eleventh- and Twelfth-Century Manuscripts of the Norman Abbey of Fécamp." Ph.D. diss., Duke University.

Brandon, Raoul Jacques. 1924. *Eglises Saint André et Saint-Nicolas de Chartres, relevés de l'état actuel: Etudes et projet de restauration (1902–1911). Précédé d'une histoire des églises Saint-André et Saint-Nicolas de Chartres par Maurice Jusselin*. Paris.

Branner, Robert. 1969. *Chartres Cathedral: Illustrations, Introductory Essay, Documents, Analysis, Criticism*. New York.

Brial, M.-J. 1818. "Mémoire sur la véritable époque d'une assemblée tenue à Chartres relativement à la croisade de Louis le Jeune." *Histoire et mémoires de l'Institut royal de France: Classe d'histoire et de littérature ancienne* 14:508–29.

Brown, Elizabeth A. R. 1992. "'Franks, Burgundians, and Aquitanians' and the Royal Coronation Ceremony in France." *Transactions of the American Philosophical Society*, n.s. 82:7:1–189.

Brown, Elizabeth A. R., and Michael W. Cothren. 1986. "The Twelfth Century Crusading Window of the Abbey of St. Denis." *JWCI* 49:1–40.

Brown, Peter. 1981. *The Cult of the Saints: Its Rise and Function in Latin Christianity*. Chicago.

Brown, Raymond. 1979. *The Birth of the Messiah: A Commentary on the Infancy Narratives in Matthew and Luke.* Garden City; rev. edn., New York, 1993.

Brown, Shirley Ann. 1988. *The Bayeux Tapestry: History and Bibliography.* Woodbridge, U.K.

Brown, Shirley Ann, and Michael W. Herren. 1994. "The *Adelae comitissae* of Baudri of Bourgueil and the Bayeux Tapestry." *ANS* 16:55–73.

Brunhölzl, Franz. 1996. *Histoire de la littérature latine du moyen âge, 2, De la fin de l'époque carolingienne au milieu du XIe siècle,* trans. Henri Rochais. Turnhout.

Buc, Philippe. 2001. *The Dangers of Ritual: Between Early Medieval Texts and Social Scientific Theory.* Princeton.

———. 2002. "Text and Ritual in Ninth-Century Political Culture: Rome, 864." In *Medieval Concepts of the Past: Ritual, Memory, Historiography,* ed. Gerd Althoff et al., 123–38. Cambridge.

Bugslag, James. 2005. "Pilgrimage to Chartres: The Visual Evidence." In *Art and Architecture of Late Medieval Pilgrimage in Northern Europe and the British Isles,* ed. Sarah Blick and Rita Tekippe, 135–83. Leiden.

Bulteau, Marcel Joseph. 1850. *Description de la cathédrale de Chartres, suivi d'une courte notice sur les églises de Saint-Pierre, de Saint-André et de Saint-Aignan de la même ville.* Paris and Chartres.

———. 1872. *Petite monographie de la cathédrale de Chartres.* Cambrai.

———. 1882. "Étude iconographique sur les calendriers figurés de la cathédrale de Chartres." *SAEL-M* 7:197–224.

Bulteau, Marcel Joseph, in collaboration with the abbé Brou. 1887–92. *Monographie de la cathédrale de Chartres.* 2d edn. 3 vols. Chartres.

Bur, Michel. 1977. *La Formation du comté de Champagne v. 950–1150.* Mémoires des Annales de l'Est 54. Nancy.

———. 1984. "Architecture et liturgie à Reims au temps d'Adalbéron (vers 976): Á propos de la Chronique de Mouzon, II." *CCM* 27:297–302.

———. 1992. "Adalbéron, archevêque de Reims, reconsidéré." In *Roi de France,* 55–63.

———. 1997. "De quelques champenois dans l'entourage français des rois d'Angleterre aux XIe et XIIe siècles." In *Family Trees and the Roots of Politics: The Prosopography of Britain and France from the Tenth to the Twelfth Century,* ed. K. S. B. Keats-Rohan, 333–48. Woodbridge, U.K.

Burin, Élizabeth. 1958. "Réflexions sur quelques aspects de l'enluminure dans l'ouest de la France au XIIe siècle: Le manuscrit latin 5323 de la Bibliothèque nationale." *BM* 143:209–25.

Burns, E. Jane. 2002. *Courtly Love Undressed: Reading through Clothes in Medieval French Culture.* Philadelphia.

———. 2006. "Saracen Silk and the Virgin's Chemise: Cultural Crossings in Cloth." *Speculum* 81:365–97.

Burrow, James A. 1986. *The Ages of Man: A Study in Medieval Writing and Thought.* Oxford.

Busch, Sylvia. 1991. "Luni in the Middle Ages: The Agony and the Disappearance of a City." *Journal of Medieval History* 17:283–96.

Bynum, Caroline Walker. 1979. *Docere verbo et exemplo: An Aspect of Twelfth-Century Spirituality.* Missoula.

Cahn, Walter. 1969. "The Tympanum of the Portal of Saint-Anne at Notre Dame de Paris and the Iconography of the Division of the Powers in the Early Middle Ages." *JWCI* 32:55–72.

———. 1976. "Architectural Draftsmanship in Twelfth-Century Paris: The Illustrations of Richard of Saint-Victor's Commentary on Ezechiel's Temple Vision." *Gesta* 15:247–54.

———. 1982. *Romanesque Bible Illumination.* Ithaca.

———. 1986. "The 'Tympanum' of Saint-Pierre at Étampes: A New Reconstruction." *Gesta* 25:119–26.

———. 1992. "Romanesque Sculpture and the Spectator." In *Romanesque Frieze and Its Spectator: The Lincoln Symposium Papers,* ed. Deborah Kahn, 44–60. London.

———. 1996. *Romanesque Manuscripts: The Twelfth Century: Survey of Manuscripts Illuminated in France.* 2 vols. London.

———. 2006. "Observations on the 'A of Charlemagne' in the Treasure of the Abbey of Conques." *Gesta* 45:95–107.

Cain, Andrew, and Josef Lössl, eds. 2009. *Jerome of Stridon: His Life, Writings and Legacy.* Farnham, UK.

Cameron, John B. 1976. "The Early Gothic Continuous Capital and Its Precursors." *Gesta* 15:143–50.

Cameron, Richard. 1969. "The Attack on the Bible Work of Lefevre D'Etaple, 1514–1521." *Church History* 38:9–24.

Camus, Marie-Thérèse, and Claude Andrault-Schmitt. 2002. *Notre-Dame-la-Grande de Poitiers: L'oeuvre romane.* Paris/Poitiers.

Canal, José Maria. 1961. "Oficio parvo de la Virgen." *Ephemerides Mariologicae* 11:497–525.

———. 1962. "Los sermones marianos de San Fulberto de Chartres." *RTAM* 29:33–51.

———. 1968. "Antiguas versiones latinas del Proto-evangelio de Santiago." *Ephemerides Mariologicae* 18:432–43.

Carozzi, Claude. 1981. "Le roi et la liturgie chez Helgaud de Fleury." In *Hagiographie, cultures et sociétés, IVe–XIIe siècles,* ed. Evelyne Patlagean and Pierre Riché, 417–32. Paris.

Carruthers, Mary. 1993. "The Poet as Master Builder: Composition and Locational Memory in the Middle Ages." *New Literary History* 24:881–904.

Cavet, Laurent. 1999. "Le Culte de la Vièrge à Chartres," Unpublished MA Thesis. Sorbonne.

———. 2005. "'Les heures de la Vierge' dans les manuscrits liturgiques, cycle thématique." In *Ædilis* 9, 2003–04 of the IRHT, Paris. http://aedilis.irht.cnrs.fr/liturgie/06_2.htm. Accessed August 23, 2008.

Caviness, Madeline. 1995. "Artistic Integration in Gothic Buildings: A Post-Modern Construct?" In *Artistic Integration in Gothic Buildings,* ed. Virginia Raguin, Kathryn Brush, and Peter Draper, 249–61. Toronto.

———. 2006. "Reception of Images by Medieval Viewers." In *A Companion to Medieval Art,* ed. Conrad Rudolph, 65–85. Oxford.

Chadefaux, M.-C. 1960. "Le Portail Royal de Chartres." *Gazette des beaux-artes* 76:273–84.

Chailley, Jacques. 1967. "Du drame liturgique aux prophètes de Notre-Dame-la-Grande." In *Mélanges offert à René Crozet,* ed. Pierre Gallais and Yves-Jean Riou, 2:835–42. Poitiers.

Charpentier, Louis. 1972. *The Mysteries of Chartres Cathedral,* trans. Ronald Fraser. London.

Châtillon, Jean. 1972. "Les écoles de Chartres et de Saint-Victor." In *La scuola nell'Occidente latino dell'alto medioevo, 15–21 aprile 1971,* 2:796–839. Spoleto.

Chazan, Robert. 1997. *In the Year 1096: The First Crusade and the Jews.* New York.

Chédeville, André. 1973, 1991. *Chartres et ses campagnes (XIe–XIIIe siècles).* Paris.

———. 1983. *Histoire de Chartres et du pays chartrain.* Toulouse.

Chevallier, Marie Anne. 1982. "Fragments récemment retrouvé du Portail Royal de Chartres." *Revue de l'art* 57:67–72.

Chibnall, Marjorie. 1991. *The Empress Matilda: Queen Consort, Queen Mother, and Lady of the English.* Oxford.

Choate, Tova Leigh. 2009. "The Liturgical Faces of St. Denis: Music, Power, and Identity in Medieval France." Ph.D. diss., Yale University.

Christian, William. 1981. *Local Religion in Sixteenth-Century Spain.* Princeton.

Christophe, Delphine. 2007. "L'architecture religieuse médiévale: art roman et gothique, une novelle vision." *Dossiers d'Archéologie* 319.

Clayton, Mary. 1986. "Aelfric and the Nativity of the Blessed Virgin Mary." *Anglia* 104:286–315.

———. 1990. *The Cult of the Virgin Mary in Anglo-Saxon England.* Cambridge.

————. 1994. "Centralism and Uniformity Versus Localism and Diversity: The Virgin and Native Saints in English Monastic Reform." *Peritia* 8:95–106.

————. 1998. *The Apocryphal Gospels of Mary in Anglo-Saxon England*. Cambridge.

Clément, Juliette. 2008. "Fulbert de Chartres, Œuvres, correspondance, controverse, poésie." In *FC*, 121–25.

Clerval, Alexandre. 1894. *De Judoci Clichtovei neoportuensis doctoris theologi Parisiensis et Carnotensis canonici, vita et operibus (1472–1543)*. Paris.

————. 1895. "Les écoles de Chartres au moyen-âge du Ve au XVIe siècle." *SAEL-M* 11; repr. Frankfurt am Main, 1965, and Geneva, 1977.

————. 1908. *Petite histoire de Notre-Dame de Chartres, d'après les quatorze gravures du "Triomphe de la sainte Vierge dans la cathédral de Chartres": Dessinées par N. de Larmessin en 1697 . . .* Chartres.

Cline, Ruth Harwood. 2007. "Abbot Hugh: An Overlooked Brother of Henry I, Count of Champagne." *Catholic Historical Review* 93:501–16.

Cohen, Jeremy. 2004. *Sanctifying the Name of God: Jewish Martyrs and Jewish Memories of the First Crusade*. Philadelphia.

Colletta, John Philip. 1979. "The Prophets of Notre-Dame-la-Grande at Poitiers: A Definitive Identification." *Gesta* 18:27–28.

Combalbert, Grégory. 2007. "Les évêques, les conflits et la paix aux portes de la Normandie: Les exemples des diocèses de Chartres et d'Évreux (première moitié du XIIe siècle)." *Tabularia. Sources écrites de la Normandie médiévale, "Etudes"* 7:139–77.

Conant, Kenneth John. 1956. "Cluniac Building during the Abbacy of Peter the Venerable." In *Petrus Venerabilis (1156–1956): Studies and Texts Commemorating the Eighth Centenary of His Death* (Studia Anselmiana, 40), 121–27. Rome.

Constable, Giles. 1996. *The Reformation of the Twelfth Century*. Cambridge and New York.

————. 1997. "The Crusading Project of 1150." In *Montjoie: Studies in Crusade History*, ed. Rudolf Hiestand, Benjamin Z. Kedar, and Jonathan Riley-Smith, 67–75. Aldershot.

Coolidge, Robert. 1965. "Adalbero, Bishop of Laon." *Studies in Medieval and Renaissance History* 2:1–114.

Cooney, Mary Kathryn. 2006. "'May the Hatchet and the Hammer Never Damage It!' The Fate of the Cathedral of Chartres during the French Revolution." *Catholic Historical Review* 92:193–214.

Cormack, Robin. 2000. *Byzantine Art*. New York.

Corvisier, Christian, ed. 1997. *Seigneurs de pierre: Les donjons du XIe au XIIIe siècle en région centre*. Paris.

Cothren, Michael W. 1984. "The Iconography of Theophilus Windows in the First Half of the Thirteenth Century." *Speculum* 59:308–341.

————. 1986. "The Infancy of Christ Window from the Abbey of St.-Denis: A Reconsideration of Its Design and Iconography." *AB* 68:398–420.

Coulon, Laurent. 2008. "Topographie chartraine 950–1100." In *FC*, 255–83.

Coulton, G. G. 1928. *Art and the Reformation*. Oxford.

Couturier, Marcel. 1997. "Chartres ville et cathédrale avant l'an mille." In *MMSC*, 63–73.

Cowdrey, H. E. J. 1970. "The Peace and the Truce of God in the Eleventh Century." *Past and Present* 46:42–67.

————. 1981. "The Anglo-Norman 'Laudes Regiae.'" *Viator* 12:37–78.

Crocker, Richard. 1977. *The Early Medieval Sequence*. Berkeley.

————. 1986. "Matins Antiphons at St. Denis." *JAMS* 39:441–90.

Crook, John. 1999. "The 'Rufus Tomb' in Winchester Cathedral." *Antiquaries Journal* 79:187–212.

————. 2000. *The Architectural Setting of the Cult of the Saints in the Early Christian West, c. 300–1200*. Oxford.

———. 2007. "St. Edgar's Reliquary of St. Swithin." *Anglo-Saxon England* 22:177–202.

Cross, James E. 1999. "On Hiberno-Latin Texts and Anglo-Latin Writings." In *The Scriptures and Early Medieval Ireland*, ed. Thomas O'Loughlin, 69–79. Turnhout.

Crossley, Paul. 2009. "The Integrated Cathedral: Thoughts on 'Holism' and Gothic Architecture." In *The Four Modes of Seeing: Approaches to Medieval Imagery in Honor of Madeline Harrison Caviness*, ed. Evelyn Staudinger Lane, Elizabeth Carson Pastan, and Ellen M. Shortell, 157–73. Burlington.

Crown, Carol Uhlig. 1975. "The Winchester Psalter and 'l'Enfance du Christ' Window at St. Denis." *Burlington Magazine* 117:79–83.

Crozet, René. 1971a. "À propos des chapiteaux de la façade occidentale de Chartres." *CCM* 14:159–65.

———. 1971b. "Replique de M. Crozet." *CCM* 14:350–53.

Cullin, Olivier. 1999. "Le labyrinthe et la musique: Chemins du sens et de la Forme." In *Un fil d'Ariane pour le labyrinthe de Chartres*, 39–46. Chartres.

Dahan, Gilbert. 1991. *La polémique chrétienne contre le judaïsme au Moyen Age*. Paris.

———. 2008. "Éléments d'exégèse biblique dans l'œuvre de Fulbert de Chartres." In *FC*, 137–50.

Dale, Thomas E. A. 1997. *Relics, Prayer, and Politics in Medieval Venetia*. Princeton.

Davezac, B. 1978. "L'evangéliaire de Chartres B.N. Lat. 9386: Contribution à l'étude de la peinture monastique carolingienne." *Cahiers archéologiques* 27:39–60.

Davis, Michael T. 1987. Review of James (1982) and Van der Meulen and Hohmeyer (1984). *Speculum* 62:956–59.

———. 2002. "Canonical Views: The Theophilus Story and the Choir Reliefs at Notre-Dame, Paris." In *Reading Medieval Images: The Art Historian and the Object*, ed. Elizabeth Sears and Thelma K. Thomas, 102–16. Ann Arbor.

Davis, Ralph H. C. 1962. "The Authorship of the *Gesta Stephani*." *EHR* 77:209–32.

Debicki, Jacek. 1992. "Les sources idéologique du nouveau type de la statuaire de la façade ouest de la cathédrale de Chartres." *Art and Fact* 11:9–20.

De Clerck, Paul. 2008. "La liturgie au temps de Fulbert." In *FC*, 91–101.

Delaporte, Yves. 1922. "Les saints Savinien et Potentien et leur culte dans l'église de Chartres." *VND* (Novembre): 171–75.

———. 1926. *Les vitraux de la cathédrale de Chartres: Histoire et description par l'abbé Y. Delaporte; reproductions par É. Houvet*. 1 vol. of text, 3 vols. of photographs. Chartres.

———. 1927. *Le voile de Notre-Dame*. Chartres.

———. 1929. *Les manuscrits enluminés de la Bibliothèque de Chartres*. Chartres.

———. 1936. "Les druides et les traditions chartraines." *VND* (Septembre): 245–55.

———. 1950, 1951. "L'Assomption dans la liturgie chartraine." *VND* (Novembre): 98–104; expanded version in *Ephemerides liturgicae* 65:5–23.

———. 1953. "Chartres." In *Dictionnaire d'histoire et de géographie ecclésiastiques*, ed. A. Baudrillart et al., 12:544–74. Paris.

———. 1955. *Les trois Notre-Dame de la cathédrale de Chartres*. Chartres.

———. 1957. "Fulbert de Chartres et l'école chartraine de chant liturgique au XIe siècle." *Études grégoriennes* 2:51–81.

———. 1960. "Notes sur la fête de la dédicace de la cathédrale de Chartres au cours d'un Millénaire." *VND* 104, October: 151–58.

Delisle, Léopold. 1860. "Notes sur les manuscrits de Chartres envoyés à la Bibliothèque nationale pendant la Révolution." *SAEL-M* 2:192–95.

Depoin, Joseph. 1908. "Études préparatoires à l'histoire des familles palatines, 1: La famille de Robert le Fort; 2: Le problèm des origines des comtes de Vexin; 3: Thibaud le Tricheur fut-il bâtard et mourut-il presque centenaire?" *Revue des études historiques* 74:321–32, 473–82, 553–602.

Dereine, Charles. 1948. "Les coutumiers de Saint-Quentin de Beauvais et de Springiersbach." RHE 43:411–42.

Deremble, Colette, and Jean-Paul Deremble. 2003. *Vitraux de Chartres*. Éditions Zodiaque. Paris.

Deremble, Jean-Paul. 2008. "Fulbert et Théophile, l'art de la prédication: Le IVe sermon de la fête de la nativité de Marie." In *Fulbert de Chartres, précurseur de l'Europe médiévale?*, ed. M. Rouche, 79–89. Paris.

Deshman, Robert. 1997. "Another Look at the Disappearing Christ: Corporeal and Spiritual Vision in Early Medieval Images." *AB* 79:518–46.

Dhondt, Jan. 1948. *Étude sur la naissance des principautés territoriales en France, IXe–Xe siècles*. Bruges.

———. 1964–65. "Sept femmes et un trio de rois (Robert le Pieux, Henri Ier, et Philippe Ier)." *Contributions à l'histoire économique et sociale* 3:37–70.

Dion, Alphonse de. 1886. *Le Puiset au XIe et au XIIe siècle: Chatellenie et Prieuré*. Chartres. Orig. pub. in *SAEL-M* of that year.

Dobszay, László. 2000. "Reading an Office Book." In *Divine Office*, 48–60.

Dondi, Christina. 2004. *The Liturgy of the Canons Regular of the Holy Sepulchre of Jerusalem: A Study and a Catalogue of the Manuscript Sources*. Bibliotheca Victorina 16. Turnhout.

Donovan, Claire. 1993. "The Winchester Bible." In *Winchester Cathedral: Nine Hundred Years, 1093–1993*, ed. John Crook, 80–96. Chichester.

Douglas, David Charles. 1942. "Rollo of Normandy." *EHR* 57:417–36.

Dressler, Rachel. 1992. "Medieval Narrative: The Capital Frieze on the Royal Portal, Chartres." Ph.D. diss., Columbia University.

Dronke, Peter. 1969. "New Approaches to the School of Chartres." *Annuario de estudios medievales* 6:117–40.

Dronke, Peter, ed. 1988. *A History of Twelfth-Century Western Philosophy*. Cambridge.

Duby, Georges. 1966, 1978, 1991. *Medieval Marriage: Two Models from Twelfth-Century France*, trans. Elsborg Forster. Baltimore.

———. 1983. *The Knight, the Lady, and the Priest: The Making of Modern Marriage in Medieval France*, trans. Barbara Bray. New York.

Dufraigne, Pierre. 1994. *Adventus Augusti, Adventus Christi*. Paris.

Dunbabin, Jean. 1985. *France in the Making, 843–1180*. Oxford.

———. 1993. "What's in a Name? Philip, King of France." *Speculum* 68:949–68.

Dupré, Alexandre. 1872. "Les Comtesses de Chartres et de Blois." *SAEL-M* 5:198–234.

Durand, Paul. 1881. *Monographie de Notre-Dame de Chartres*. Paris.

Dutton, Paul Edward. 1984. "The Uncovering of the *Glossae super Platonem* of Bernard of Chartres." *Mediaeval Studies* 46:192–221.

L'École française de Rome. 1991. *Les Fonctions des saints dans le monde occidental (IIIe–XIIIe siècle): actes du colloque*. Rome.

Eley, Penny, and Penny Simons. 1998. "A Subtext and Its Subversion—The Variant Endings to 'Partonopeus of Blois.'" *Neophilologus* 82:181–97.

———. 2000. "Poets, Birds and Readers in *Partonopeus de Blois*." *Forum for Modern Language Studies* 36:1–15.

Elfving, Lars. 1962. *Etude lexicographique sur les sèquences limousines*. Stockholm.

Elsakkers, Marianne. 2001. "In Pain You Shall Bear Children (Gen. 3:16): Medieval Prayers for a Safe Delivery." In *Women and Miracle Stories: A Multidisciplinary Exploration*, ed. Anne-Markie Korte, 179–209. Leiden.

Epp, Verena. 1990. *Fulcher von Chartres: Studien zur Geschichtsschreibung des ersten Kreuzzuges*. Studia Humaniora 15. Dusseldorf.

Erdmann, Carl. 1977. *The Origin of the Idea of Crusade*, trans. M. W. Baldwin and W. Goffart. Princeton.

Erlande-Brandenburg, Alain. 1982. *Les sculptures de Notre-Dame de Paris au Musée de Cluny: catalogue*. Paris.

———. 1994. *The Cathedral: The Social and Architectural Dynamics of Construction*, trans. Martin Thom. Cambridge.

Étaix, Raymond, ed. 1994. *Homéliaires patristiques latins: Recueil d'études de manuscrits médiévaux*. Turnhout.

Evans, Gillian R. 1981. "Godescalc of St. Martin and the Trial of Gilbert of Poitiers." *Analecta Praemonstratensia* 57:196–209.

Evergates, Theodore. 1975. *Feudal Society in the Bailliage of Troyes under the Counts of Champagne, 1152–1284*. Baltimore.

———. 1992. "Louis VII and the Counts of Champagne." In *The Cistercians and the Aftermath of the Second Crusade*, ed. Michael Gervers, 109–28. New York.

———. 1995. "Champagne." In *Medieval France: An Encyclopedia*, ed. William W. Kibler and Grover A. Zinn, 190–94. New York.

Facinger, Marion. 1968. "A Study of Medieval Queenship: Capetian France, 987–1237." *Studies in Medieval and Renaissance History* 5:1–48.

Fanning, Steven. 1988. *A Bishop and His World before the Gregorian Reform: Hubert of Angers, 1006–1047*. Transactions of the American Philosophical Society 78. Philadelphia.

Farmer, Sharon. 1991. *Communities of Saint Martin: Legend and Ritual in Medieval Tours*. Ithaca.

———. 1998. "Down and Out and Female in Thirteenth-Century Paris." *AHR* 103:345–72.

Fassler, Margot E. 1985. "The Office of Cantor in Early Western Monastic Rules and Customaries: A Preliminary Investigation." *Early Music History* 5:29–51.

———. 1987a. "Accent, Meter, and Rhythm in Medieval Treatises 'De Rithmis.'" *Journal of Musicology* 5:164–90.

———. 1987b. "The Role of the Parisian Sequence in the Evolution of Notre Dame Polyphony." *Speculum* 62:345–74.

———. 1991. "Representations of Time in *Ordo representacionis Ade*." In *Contexts: Style and Value in Medieval Art and Literature*, ed. Daniel Poirion and Nancy F. Regalado, 97–113. New Haven.

———. 1992. "The Disappearance of the Proper Tropes and the Rise of the Late Sequence: New Evidence from Chartres." In *Cantus Planus: Papers Read at the Fourth Meeting, Pécs, Hungary, 3–8 September 1990*, ed. László Dobszay et al., 319–35. Budapest.

———. 1993a. *Gothic Song: Victorine Sequences and Augustinian Reform in Twelfth-Century Paris*. Cambridge.

———. 1993b. "Liturgy and Sacred History in the Twelfth-Century Tympana at Chartres." *AB* 75:499–520.

———. 1998. "Composer and Dramatist: 'Melodious Singing and the Freshness of Remorse.'" In *Voice of the Living Light: Hildegard of Bingen and Her World*, ed. Barbara Newman, 149–75. Berkeley.

———. 2000a. "Mary's Nativity, Fulbert of Chartres, and the *Stirps Jesse*: Liturgical Innovation circa 1000 and Its Afterlife." *Speculum* 75:389–434.

———. 2000b. "Sermons, Sacramentaries, and Early Sources for the Office in the Latin West: The Example of Advent." In *Divine Office*, 15–47.

———. 2001. "The First Marian Feast in Constantinople and Jerusalem: Chant Texts, Readings, and Homiletic Literature." In *The Study of Medieval Chant: Paths and Bridges, East and West: In Honor of Kenneth Levy*, ed. Peter Jeffery, 25–87. Woodbridge, U.K.

———. 2003. "Hildegard and the Dawn Song of Lauds: An Introduction to Benedictine Psalmody." In *Psalms in Community: Jewish and Christian Textual, Liturgical, and Artistic Traditions*, ed. Harold W. Attridge and Margot E. Fassler, 215–39. Atlanta.

———. 2004a. "Music and the Miraculous: Mary in the Mid-Thirteenth-Century Dominican Se-

quence Repertory." In *Aux origins de la liturgie dominicaine: Le manuscript Santa Sabina XIV L 1*, ed. Leonard E. Boyle and Pierre-Marie Gy, 229–78. Paris and Rome.

———. 2004b. "Psalms and Prayers in Daily Devotion: A Fifteenth-Century Devotional Anthology from the Diocese of Rheims: Beinecke 757." In *Medieval and Modern Europe: Change and Continuity in Religious Practice*, ed. Karin Maag and John D. Witvliet, 15–40. Notre Dame.

———. 2006. "Hildegard of Bingen and the Song of Songs." In *Scrolls of Love*, ed. Peter S. Hawkins and Lesleigh Cushing Stahlberg, 255–67. New York.

———. 2007. "*Adventus* at Chartres: Ritual Models for Major Processions." In *Ceremonial Culture in Pre-Modern Europe*, ed. Nicholas Howe, 13–62. Notre Dame.

———. 2008. "Fulbert après Fulbert: le mythe d'un évêque de Chartres." In *FC*, 113–19.

———. 2010a. "Helgaud of Fleury and the Liturgical Arts: The Magnificence of Robert the Pious." Forthcoming in *Magnificence and the Sublime: The Aesthetics of Grandeur*, ed. C. Stephen Jaeger.

———. 2010b. "The Liturgical Framework of Time and the Representation of History." Forthcoming in *Representing History, 1000–1500*, ed. Robert A. Maxwell.

Fassler, Margot E., and Rebecca A. Baltzer, eds. 2000. *The Divine Office in the Latin Middle Ages: Methodology and Source Studies, Regional Developments, Hagiography*. New York. = *Divine Office*.

Favre, Édouard. 1893, rpt. 1976. *Eudes, comte de Paris et roi de France, 882–898*. Geneva.

Fels, E. 1955. "Die Grabung an der Fassade der Kathedrale von Chartres." *Kunstchronik* 8:149–51.

Fergusson, Peter. 1995. Review of Stratford (1993). *Speculum* 70:205–06.

Fernie, Eric. 1980. "The Spiral Piers of Durham Cathedral." In *Medieval Art and Architecture at Durham Cathedral*, ed. N. Coldstream and P. Draper, 49–58. London.

———. 1984. "The Use of Varied Nave Supports in Romanesque and Early Gothic Churches." *Gesta* 23:107–17.

Fleming, Robin. 2006. "Bones for Historians: Putting the Body Back into Biography." In *Writing Medieval Biography, 750–1250: Essays in Honour of Professor Frank Barlow*, ed. David Bates, Julia Crick, and Sarah Hamilton, 29–48. Woodbridge.

Fleury, Gabriel. 1904. *Études sur les portails imagés du XIIe siècle: Leur inconographie et leur symbolisme*. Mamers.

Fleury, Gerard. 1999. "Le choeur et le transept de la Collégiale de Loches: Restaurations du XIXe siècle et sculpture romane en Touraine du sud." *Bulletin de la Société archéologique de Touraine* 45:789–817.

Fliche, Augustin. 1912. *La règne de Philippe Ier roi de France (1060–1108)*. Paris.

Flint, Valerie. 1982–83. "Honorius Augustodunensis: *Imago mundi*." *Archives d'histoire doctrinale et littéraire du moyen âge* 49:7–153.

Flynn, William T. 1992. "Paris, Bibliothèque de l'Arsenal, MS 1169: The Hermeneutics of Eleventh-Century Burgundian Tropes, and Their Implications for Liturgical Theology." Ph.D. diss., Duke University.

Folda, Jaroslav. 1997/98. "Jerusalem and the Holy Sepulchre through the Eyes of Crusader Pilgrims." *Jewish Art* 23/24:158–64.

Forsyth, Ilene H. 1972. *The Throne of Wisdom: Wood Sculptures of the Madonna in Romanesque France*. Princeton.

———. 1980. "The Romanesque Portal of the Church of Saint-Andoche at Saulieu (Côte-d'Or)." *Gesta* 19:83–94.

Frank, K. S. 1985. "Apponius, *In Canticum canticorum explanatio*." *Vigiliae christianae* 39:370–83.

Franklin, Michael. 1992. "The Cathedral as Parish Church: The Case of Southern England." In *Church and City 1000–1500*, ed. D. Abulafia, M. Franklin, and M. Rubin, 173–98. Cambridge.

Freed, John B. 2002. "Artistic and Literary Representations of Family Consciousness." In *Medi-*

*eval Concepts of the Past: Ritual, Memory, Historiography*, ed. Gerd Althoff et al., 233–52. Cambridge.

Frénaud, Georges. 1961. "Le culte de Notre-Dame dans l'ancienne liturgie latine." In *Maria: Études sur la sainte Vierge*, ed. Hubert du Manoir, 6:157–211. Paris.

Freytag, Richard Lukas. 1985. *Die autonome Theotokosdarstellung der frühen Jahrhunderte*. Beiträge zur Kunstwissenschaft 5. 2 vols. Munich.

Fulton, Rachel. 1994. "The Virgin Mary and the Song of Songs in the High Middle Ages." Ph.D. diss., Columbia University.

———. 1996. "Mimetic Devotion, Marian Exegesis, and the Historical Sense of the Song of Songs." *Viator* 27:85–116.

———. 2003. *From Judgment to Passion: Devotion to Christ and the Virgin Mary, 800–1200*. New York.

———. 2006. "Praying with Anselm at Admont: A Meditation on Practice." *Speculum* 81:700–33.

Gaborit-Chopin, Danielle. 1995. *Le trésor de Saint-Denis au Musée du Louvre*. Photos by Laziz Harmani. Paris.

Ganshof, François L. 1943. *La Flandre sous les premiers comtes*. Brussels.

———. 1970. "L'historiographie dans la monarchie franque sous les mérovingiens et les carolingiens." In *La storiographica altomedievale*, 2:631–85, with discussion 743–50. Milan.

Gardner, Stephen. 1984a. "The Influence of Castle Building on Ecclesiastical Architecture in the Paris Region, 1130–1150." In *Medieval Castle: Romance and Reality*, ed. Kathryn Reyerson and Faye Powe, 97–123. Dubuque, Iowa.

———. 1984b. "The Church of Saint-Etienne in Dreux and Its Role in the Formation of Early Gothic Architecture." *Journal of the British Archeological Association* 137:86–113.

———. 1986. "L'église Saint-Julien de Marolles-en-Brie et ses rapports avec l'architecture parisienne de la génération de Saint-Denis." *BM* 144:7–31.

Geary, Patrick. 1994a. *Living with the Dead in the Middle Ages*. Ithaca.

———. 1994b. *Phantoms of Remembrance: Memory and Oblivion at the End of the First Millennium*. Princeton.

Gelting, Michael H. 2008. "Un évêque danois élève de Fulbert de Chartres?" In *FC*, 63–75.

Genet, Jean-Philippe. 1977. "Cartulaires, registres et histoire: l'exemple anglais." In *Le métier d'historien au Moyen Âge: Études sur l'historiographie médiévale*, ed. B. Guenée, 95–138. Paris.

Giacone, R. 1974. "Masters, Books and Library at Chartres according to the Cartularies of Notre-Dame and Saint-Père." *Vivarium* 12:30–51.

Gijsel, Jan. 1969. Review of J. M. Canal (1968). *Analecta Bollandiana* 87:503–05.

Glass, Dorothy F. 1991. *Romanesque Sculpture in Campania: Patrons, Programs, and Style*. University Park, Pa.

———. 2000. "Prophecy and Priesthood at Modena." *Zeitschrift für Kunstgeschichte* 63:326–38.

———. 2002. "'Then the Eyes of the Blind Shall be Opened': A Lintel from San Cassiano a Settimo." In *Reading Medieval Images: The Art Historian and the Object*, ed. Elizabeth Sears and Thelma K. Thomas, 142–50. Ann Arbor.

Glenn, Jason. 1997. "Political History: The Work of Richer of Saint-Remigius." Ph.D. diss., University of California, Berkeley.

———. 2004. *Politics and History in the Tenth Century: The Work and World of Richer of Reims*. Cambridge.

Golden, Judith. 2005. "The Iconography of Authority in the Depiction of Seated, Cross-legged Figures." In *Between the Picture and the Word: Manuscript Studies from the Index of Christian Art*, ed. Colum Hourihane, 81–99. Princeton.

Goudesenne, Jean-François. 2008. "Fulbert et son école dans l'histoire du chant liturgique." In *FC*, 301–17.

Grant, Lindy. 2004. "Geoffrey of Lèves, Bishop of Chartres: 'Famous Wheeler and Dealer in Secu-

lar Business.'" In *Suger en question: Regards croisés sur Saint-Denis*, ed. Rolf Grosse, 45–56. Munich.

———. 1982. "Aspects of the twelfth-century design of La Madeleine at Châteaudun." *Journal of the British Archeological Association* 135:23–34.

Grauwen, W. M. 1982. "Gaufried bisschop van Chartres (1116–1149), vriend van Norbert en van de 'Wanderprediger.'" *Analecta Praemonstratensia* 58:161–209.

Green, Judith. 1997. "Aristocratic Women in Early Twelfth-Century England." In *Anglo-Norman Political Culture*, ed. C. Warren Hollister, 59–82. Woodbridge, U.K.

Green, Rosalie. 1946. "A Tenth-Century Ivory with the Response 'Aspiciens a longe.'" *AB* 28:112–14.

Greene, Thomas M. 2001. "Labyrinth Dances in the French and English Renaissance." *Renaissance Quarterly* 54:1403–66.

Grégoire, Réginald. 1966. *Les homéliaires du moyen âge: Inventaire et analyse des manuscrits*. Preface by Jean Leclercq. Rome.

———. 1980. *Homéliaires liturgiques médiévaux: Analyse de manuscrits*. Spoleto.

Grier, James. 1990. "'Ecce sanctum quem Deus elegit Marcialem apostolum': Ademar of Chabannes and the Tropes for the Feast of Saint Martial." In *Beyond the Moon: Festschrift Luther Dittmer*, ed. Bryan Gillingham and Paul Merkley, 28–74. Ottawa.

———. 1995. "Roger de Chabannes (d. 1025), Cantor of St Martial, Limoges." *Early Music History* 14:53–119.

———. 2000. "The Divine Office at Saint-Martial in the Early Eleventh Century: Paris, BNF lat. 1085." In *Divine Office*, 179–204.

———. 2006. *The Musical World of a Medieval Monk: Adémar de Chabannes in Eleventh-Century Aquitaine*. Cambridge.

Grinnell, Robert. 1946. "Iconography and Philosophy in the Crucifixion Window at Poitiers." *AB* 28:171–96.

Grodecki, Louis. 1963. *Chartres*. Paris.

Grodecki, Louis, Catherine Brisac, and Claudine Lautier. 1977. *Le vitrail roman*. Paris and Fribourg.

Grodecki, Louis, Françoise Perrot, et al. 1981. *Les vitraux du Centre et des pays de la Loire*. Paris.

Gros, G. 1981. "Le thème de l'enfant sauvé dans les miracles de Notre Dame de Jean le Marchant." *SAEL-B* 85:145–60.

Gryson, Roger. 1988. "Le Commentaire de Jérôme sur Isaïe: État de la question." In *Jérôme entre l'Occident et l'Orient*, ed. Yves-Marie Duval, 403–25. Paris.

Gullick, Michael. 1994. "The Scribes of the Durham Cantor's Book (Durham, Dean and Chapter Library, MS B.IV.24) and the Durham Martyrology Scribe." In *Anglo-Norman Durham: 1093–1193*, ed. D. Rollason et al., 93–109. Woodbridge, U.K.

Gushee, Marian S. 1964. "Romanesque Polyphony: A Study of the Fragmentary Sources." PhD diss., Yale University.

Haggh, Barbara. 2006. "From Auxerre to Soissons: The Earliest History of the Responsory 'Gaude Maria Virgo' in Gautier de Coinci's *Miracles de Nostre Dame*." In *Gautier de Coinci: Miracles, Music, and Manuscripts*, ed. Kathy M. Krause and Alison Stones, 167–93. Turnhout.

Hahn, Cynthia J. 1997. "Seeing and Believing: The Construction of Sanctity in Early-Medieval Saints' Shrines." *Speculum* 72:1079–1106.

———. 2001. *Portrayed on the Heart: Narrative Effect in Pictorial Lives of Saints from the Tenth through the Thirteenth Century*. Berkeley.

———. 2006. "Vision." In *A Companion to Medieval Art*, ed. Conrad Rudolph, 44–64. Oxford.

Halfen, Roland. 2001. *Chartres: Schöpfungsbau und Ideenwelt im Herzen Europas*. Stuttgart.

Hamburger, Jeffrey F. 2000. "Seeing and Believing: The Suspicion of Sight and the Authentication of Vision in Late Medieval Art and Devotion." In *Imagination und Wirklichkeit: zum Verhältnis*

*von mentalen und realen Bildern in der Kunst der frühen Neuzeit*, ed. Klaus Kruger and Alessandro Nova, 46–69. Mainz.

———. 2002. *St. John the Divine: The Deified Evangelist in Medieval Art and Theology.* Berkeley.

Hamburger, Jeffrey F., and Anne-Marie Bouché, eds. 2006. *The Mind's Eye: Art and Theological Argument in the Middle Ages.* Princeton.

Haney, Kristine Edmondson. 1981. "The Immaculate Imagery in the Winchester Psalter." *Gesta* 20:111–18.

———. 1982. "Some Mosan Sources for the Henry of Blois Enamels." *Burlington Magazine* 124:220–30.

Hardison, O. B. 1965. *Christian Rite and Christian Drama in the Middle Ages: Essays in the Origin and Early History of Modern Drama.* Baltimore.

Häring, Nikolaus M. 1951. "The Case of Gilbert de la Porrée, Bishop of Poitiers." *Mediaeval Studies* 13:1–40.

———. 1974. "Chartres and Paris Revisited." In *Essays in Honour of Anton Charles Pegis*, ed. J. Reginald O'Donnell, 268–329. Toronto.

Harper (Roper), Sally. 1993. *Medieval English Benedictine Liturgy: Studies in the Formation, Structure, and Content of the Monastic Votive Office, c. 950–1540.* New York.

Harper-Brill, Christopher, and Elisabeth van Houts, eds. 2003. *A Companion to the Anglo-Norman World.* Woodbridge, U.K.

Haselbach, Irene. 1970. *Aufstieg und Herrschaft der Karlinger in der Darstullung der sogenannten Annales Mettenses priores: Ein Beitrag zur Geschichte der politichen Ideen im Reich Karls des Grossen.* Lubeck.

Haug, Andreas, ed. 1995. *Troparia tardiva. Repertorium später Tropenquellen aus dem deutschsprachigen Raum*, Monumenta Monodica Medii Aevi, Subsidia I. Kassel.

Hayes, Dawn M. 2003. *Body and Sacred Place in Medieval Europe, 1100–1389: Interpreting the Case of Chartres Cathedral.* New York.

Head, Thomas, and Richard Landes, eds. 1992. *The Peace of God: Social Violence and Religious Response in France around the Year 1000.* Ithaca.

Headlam, Cecil. 1902. *The Story of Chartres.* Illustrated by Herbert Railton. London.

Heimann, Adelheid. 1965. "A Twelfth-Century Manuscript from Winchcombe and Its Illustrations. Dublin, Trinity College, MS. 53." *JWCI* 28:86–109.

———. 1968. "The Capital Frieze and Pilasters of the Portail Royal, Chartres." *JWCI* 31:73–102.

———. 1971. "A propos des chapiteaux de la façade occidentale de Chartres: Réponse de Mme. Adelheid Heimann à M. René Crozet." *CCM* 14:349–50.

Heinzelmann, Martin. 2001. *Gregory of Tours: History and Society in the Sixth Century*, trans. Christopher Carroll. Cambridge.

Hellemo, Geir. 1989. *Adventus Domini: Eschatological Thought in 4th-Century Apses and Catecheses*, trans. E. R. Waaler. Supplements to Vigiliae Christianae 5. Leiden and New York.

Hen, Yitzhak. 2001. *The Royal Patronage of Liturgy in Frankish Gaul to the Death of Charles the Bald (877).* London.

Hénault, Adrien. 1876. "Études sur des sculptures du portail royal de la cathédrale de Chartres." *SAEL-M* 6:76–88.

Henriet, I. 1984. "L'abbatiale Notre-Dame de Fontgombault." *Congrès archéologique de France* 142:98–116.

Herlihy, David. 1985. *Medieval Households.* Cambridge, Mass.

———. 1990. *Opera muliebria: Women and Work in Medieval Europe.* Philadelphia.

Herrick, Samantha Kahn. 2005. "Saintly Power and Ducal Authority in Hagiography of Early Normandy." In *The Experience of Power in Medieval Europe, 950–1350*, ed. Adam J. Kosto, Alan Cooper, and Robert Berkhoffer. Aldershot.

———. 2007. *Imagining the Sacred Past: Hagiography and Power in Early Normandy.* Cambridge, Mass.

Hicks, Leonie V. 2007. *Religious Life in Normandy, 1050–1300: Space, Gender and Social Pressure.* Woodbridge, Suffolk, and Rochester, N.Y.

Hiley, David. 1980. "The Liturgical Music of Norman Sicily: A Study Centered on Manuscripts 288, 289, 19421 and Vitrina 20–4 of the Biblioteca Nacional, Madrid." Ph.D. diss., University of London.

———. 1980–81. "The Norman Chant Tradition—Normandy, Britain, Sicily." *Proceedings of the Royal Musical Association* 107:1–33.

———. 1990. "The Sequentiary of Chartres, Bibliothèque Municipale, Ms. 47." In *La Sequenza Medievale: Atti del Convegno Internazionale, Milano, 7–8 aprile 1984,* ed. Agostino Ziino, 105–17. Lucca.

———. 1993a. "Provins, Bibliothèque Municipale 12 (24): A 13th-Century Gradual with Tropes from Chartres Cathedral." In *Recherches nouvelles sur les tropes liturgiques: Recueil d'études,* ed. W. Arlt and G. Björkvall, 239–69. Stockholm.

———. 1993b. *Western Plainchant: A Handbook.* Oxford and New York.

———. 1998. "The Office of the Transfiguration by Peter the Venerable, Abbot of Cluny (1122–1156) in the manuscript Paris, Bibliothèque Nationale de France, fonds latin 17716." In *Chant and Its Peripheries: Essays in Honour of Terence Bailey,* ed. Bryan Gillingham and Paul Merkley, 224–40. Ottawa.

Hillenbrand, Carole. 2000. *The Crusades: Islamic Perspectives.* New York.

Hiscock, Nigel. 2007. *The Symbol at Your Door: Numbering and Geometry in Religious Architecture of the Greek and Latin Middle Ages.* Aldershot and Burlington.

Hollister, C. Warren. 1978. *Medieval Europe: A Short History.* 4th edn. New York.

Hollister, C. Warren, and Thomas K. Keefe. 1973. "The Making of the Angevin Empire." *Journal of British Studies* 12:1–25.

Hopper, Vincent. 1938. *Medieval Number Symbolism.* New York.

Horste, Kathryn. 1987. "'A Child is Born': The Iconography of the Portail Ste.-Anne at Paris." *AB* 69:187–210.

Houvet, Étienne. 1919. *Cathédral de Chartres (Portail royal).* Chelles.

Howell, Martha C. 1987. "Marriage, Property, and Patriarchy: Recent Contributions to a Literature." *Feminist Studies* 13:203–24.

Howorth, Henry. 1880. "A Criticism of the Life of Rollo as Told by Dudo of St. Quentin." *Archaeologia* 45:235–50.

Hoyer, Rüdiger. 1991. *Notre-Dame de Chartres, der Westkomplex: systematische Grundlagen der bauarchäologischen Analyse.* 2 vols. Frankfurt am Main.

Hughes, Andrew. 1988a. "Antiphons and Acclamations: The Politics of Music in the Coronation Service of Edward II, 1308." *Journal of Musicology* 6:150–68.

———. 1988b. "Chants in the Rhymed Offices of St. Thomas of Canterbury." *Early Music* 16:185–202.

Huglo, Michel. 1986. "L'Office du Prime au chapître." In *L'église et la mémoire des morts dans la France médiévale,* ed. Jean-Loup Lemaître, 51–54. Paris.

———. 1988. "Notice sur deux nouveaux manuscrits d'Aristote en Latin." *Scriptorium* 42:183–90.

———. 1999. *Les manuscrits du processionale.* 2 vols. Munich.

Huisman, Gerda C. 1983. "Notes on the Manuscript Tradition of Dudo of St. Quentin's *Gesta Normannorum.*" *ANS* 6:122–35.

Hurel, Daniel-Odon, and Raymond Rogé, eds. 1998. *Dom Bernard de Montfaucon: Actes du colloque de Carcassonne, octobre 1996,* preface by Yves Chaussy. 2 vols. Carcassonne.

Hurley, Cecilia. 2000. "The Vagaries of Art-Book Publishing: Bernard de Montfaucon, 1660–1741,

and His Subscriptions Enterprises." *Georges-Bloch-Jahrbuch des Kunsthistorischen Instituts der Universität Zürich* 7:84–95.

Husband, Timothy B. 1992. "The Winteringham Tau Cross and *Ignis Sacer*." *Metropolitan Museum Journal* 27:19–35.

Huyghebaert, Nicolas. 1972. *Les documents nécrologiques*. TSMAO 4. Turnhout.

Iogna-Prat, Dominique, Eric Palazzo, and Daniel Russo, eds. 1996. *Marie: Le culte de la Vierge dans la société médiévale*. Paris. = Marie.

Iversen, Gunilla. 2002 "'Verba canendi' in Tropes and Sequences." In *Latin Culture in the Eleventh Century: Proceedings of the Third International Conference on Medieval Studies*, ed. Michael Herren et al., 444–73. Publications of the Journal of Medieval Latin 5:1. Turnhout.

Jacobson, Paul. A. 1996. "*Ad memorian ducens*: The Development of Liturgical Exegesis in Amalar of Metz's *Expositiones Missae*." Ph.D. diss., Graduate Theological Union.

Jaeger, C. Stephen. 1983. "The Courtier Bishop in *Vitae* from the Tenth to the Twelfth Century." *Speculum* 58:291–325.

James, John. 1982. *Chartres: The Masons who Built a Legend*. London.

———. 2002–2006. *The Creation of Gothic Architecture: An Illustrated Thesaurus*. 3 vols. Hartley Vale, Australia.

Jansen, Virginia. 1982. "Round or Square? The Axial Towers of the Abbey Church of Saint-Riquier." *Gesta* 21:83–90.

Janssen, Wilhelm. 1961. *Die päpstlichen Legaten in Frankreich, vom Schisma Anaklets II. bis zum Tode Coelestins III. (1130–1198)*. Cologne.

Jeanneau, François. 1997. "Restauration des portials occidentaux, cathédrale Saint-Pierre: Poitiers, Vienne." *Monumental* 17:48–53.

Jeauneau, Édouard. 1995. *L'âge d'or des écoles de Chartres*. Chartres.

———. 1997. "Les maîtres chartrains." In *MMSC*, 97–111.

———. 2008. "Fulbert, notre vénérable Socrate." In *FC*, 19–32.

Jeffery, Peter. 2004. "A Medieval Jewish View of the Catholic Liturgy." *Colloquium* 1:29–38.

Jesch, Judith. 2004. "Vikings on the European Continent in the Late Viking Age." In *Scandinavia and Europe, 800–1350*, ed. Jonathan Adams and Katherine Holman, 255–68. Turnhout.

Johnson, James R. 1961. "The Tree of Jesse Window of Chartres: Laudes Regiae." *Speculum* 36:1–22.

———. 1965. *The Radiance of Chartres: Studies in the Early Stained Glass of the Cathedral*. New York.

Johnson, Richard F. 2005. *Saint Michael the Archangel in Medieval English Legend*. Woodbridge, U.K.

Joly, Roger. 1993. "Histoire d'un monument: L'église Saint-Pierre de Chartres." *SAEL-B* 38:1–48.

———. 1995. "Bombardement de Chartres, 26 mai 1944." *SAEL-B* 47:48–55.

———. 2001. *A Lost Work by Amalarius of Metz: Interpolations in Salisbury, Cathedral Library, MS 154*. Woodbridge, U.K.

Jordan, Victoria B. 1991. "The Role of Kingship in Tenth-Century Normandy: The Hagiography of Dudo." *Haskins Society Journal* 3:53–62.

Jordan, William Chester. 1989. *The French Monarchy and the Jews: From Philip Augustus to the Last Capetians*. Philadelphia.

———. 2001. "Marian Devotion and the Talmud Trial of 1240." *Wolfenbütteler Mittelalter-Studien* 4 (1992); rpt. in *Ideology and Royal Power in Medieval France: Kingship, Crusades and the Jews*, 61–76. Variorum Collected Studies 705. Aldershot.

Jørgensen, Hans Henrik Lohfert. 2004. "Cultic Vision: Seeing as Ritual: Visual and Liturgical Experience in the Early Christian and Medieval Church." In *The Appearances of Medieval Rituals: The Play of Construction and Modification*, ed. Nils Holger Petersen, Mette Birkedal Bruun, Jeremy Llewellyn, and Eyolf Østrem, 173–97. Turnhout.

Juin, Florence. 2001. "Les tours-porches occidentales des provinces de la Loire Moyenne, XIe–XIIe siècles, et du Berry: état de la question." *Cahiers de Saint-Michel de Cuxa* 32:169–80.

Jusselin, Maurice. 1922. *La chancellerie de Charles le Chauve, d'après les notes tironniennes.* Paris.

———. 1923. *Histoire des livres liturgiques de la cathédrale de Chartres au XVIe siècle.* Chartres. Extr. from *SAEL-M* 16 (1923–36): 1–61.

———. 1951. "Les autographes de Gislebert, éveque de Chartres au IX siècle." *SAEL-M* 18:201–03.

Kaiser, Reinhold. 1997. "Les évêques neustriens du Xe siècle dans l'exercice de leur pouvoir temporel d'après l'historiographie médiévale." In *Pays de Loire et Aquitaine de Robert le Fort aux premiers capétiens,* ed. Olivier Guillot and Robert Favreau, 117–43. Poitiers.

Kalinowski, Lech. 1983. "Virga versatur: Remarques sur l'iconographie des vitraux romans d'Arnstein-sur-la-Lahn." *Revue de l'art* 62:9–20.

Kantorowicz, Ernst. 1946. *Laudes Regiae: A Study in Liturgical Acclamations and Mediaeval Ruler Worship.* Berkeley.

———. 1957. *The King's Two Bodies: A Study in Mediaeval Political Theology.* Princeton.

Karp, Theodore. 2001. "Exploring a Little-Known Chant Source: Provins, Bibl. Mun. MS 12." In *A Compendium of American Musicology: Essays in Honor of John F. Ohl,* ed. Enrique Alberto Arias et al., 3–28. Evanston, Ill.

———. 2007. "The Twilight of Troping." In *Music in Medieval Europe: Studies in Honour of Bryan Gillingham,* ed. Terence Bailey and Alma Colk Santosuosso, 79–94. Aldershot, U.K.

Katzenellenbogen, Adolf. 1959. *The Sculptural Programs of Chartres Cathedral: Christ, Mary, Ecclesia.* Baltimore.

Kaufmann, C. Michael. 1975. *Romanesque Manuscripts 1066–1190.* London.

Keats-Rohan, K. S. B., ed. 1997. *Family Trees and the Roots of Politics: The Prosopography of Britain and France from the Tenth to the Twelfth Century.* Woodbridge, U.K.

Kelly, Amy R. 1950. *Eleanor of Aquitaine and the Four Kings.* Cambridge, Mass.

Kelly, Thomas Forrest. 1977. "New Music from Old: The Structuring of Responsory Prosas." *JAMS* 30:366–90.

Kendall, Calvin B. 1998. *The Allegory of the Church: Romanesque Portals and Their Verse Inscriptions.* Photographs by Ralph Lieberman. Toronto.

Kessler, Herbert. 1997/98. "'Thou Shalt Paint the Likeness of Christ Himself': The Mosaic Prohibition as Provocation for Christian Images." *Jewish Art* 23/24:124–39.

———. 2000. *Spiritual Seeing: Picturing God's Invisibility in Medieval Art.* Philadelphia.

Kidson, Peter. 1958, 1974. *Sculpture at Chartres.* Photos by Ursula Pariser. London.

———. 1987. "Panofsky, Suger, and St. Denis." *JWCI* 50:1–17.

Kienzle, Beverly Mayne, ed. 2000. *The Sermon.* TSMAO 81–83. Turnhout.

Kinder, Terryl N. 1992. "Toward Dating Construction of the Abbey Church of Pontigny." *Journal of the British Archaeological Association* 145:77–88.

King, Edmund. 2000. "Stephen of Blois, Count of Mortain and Boulogne." *EHR* 115:271–96.

King, Edmund, ed. 1994. *The Anarchy of King Stephen's Reign.* Oxford.

Kipling, Gordon. 1998. *Enter the King: Theatre, Liturgy, and Ritual in the Medieval Civic Triumph.* Oxford.

Klein, Holger A. 1998. "The So-Called Byzantine Diptych in the Winchester Psalter, British Library, MS Cotton Nero C.IV." *Gesta* 37:26–43.

Klemm, Elisabeth. 2004. *Die ottonischen und frühromanischen der Bayerischen Staatsbibliothek.* Wiesbaden.

Klinkenberg, Emanuel. 2008. "Die Identität der Säulenstatuen in Étampes und Chartres." *Zeitschrift für Kunstgeschichte* 71:145–87.

Klukas, Arnold W. 1995. "Durham Cathedral in the Gothic Era: Liturgy, Design, Ornament." In

*Artistic Integration in Gothic Buildings*, ed. Virginia Chieffo Raguin, Kathryn Brush, and Peter Draper, 69–83. Toronto.

Knowles, David. 1950. *The Monastic Order in England*. Cambridge, U.K.

Kozachek, Thomas Davies. 1995. "The Repertory of Chant for Dedicating Churches in the Middle Ages: Music, Liturgy and Ritual." Ph.D. diss., Harvard University.

Koziol, Geoffrey. 1992. *Begging Pardon and Favor: Ritual and Political Order in Early Medieval France*. Ithaca.

Kraus, Henry. 1979. *Gold Was the Mortar: The Economics of Cathedral Building*. London.

Krautheimer, Richard. 1942. "The Carolingian Revival of Early Christian Architecture." *AB* 24:1–38.

Krinsky, Carol Herselle. 1970. "Representations of the Temple of Jerusalem before 1500." *JWCI* 33:1–19.

Kruckenberg, Lori. 1997. "The Sequence from 1050–1150: Study of a Genre in Change." Ph.D. diss., University of Iowa.

———. 2003. "Some Observations on a Troparium Tardivum: The Proper Tropes in Utrecht Universiteitsbibliotheek, 417," *Tijdschrift van de Koninklijke Vereniging voor Nederlandse Muziekgeschiedenis* 53 (2003): 151–82.

———. 2006. "Neumatizing the Sequence: Special Performances of Sequences in the Central Middle Ages." *JAMS* 59:243–318.

Krüger, Kristina. 2003. *Die romanischen Westbauten in Burgund und Cluny: Untersuchungen zur Funktion einer Bauform*. Berlin.

———. 2005. "Monastic Customs and Liturgy in the Light of the Architectural Evidence: A Case Study on Processions (Eleventh-Twelfth Centuries)." In *From Dead of Night to End of Day: The Medieval Customs of Cluny*, ed. Susan Boynton and Isabelle Cochelin, 191–230. Turnhout.

Küchler, Susanne, and Walter Melion, eds. 1991. *Images of Memory: On Remembering and Representation*. Washington, D.C.

Kupfer, Marcia. 2000. "Symbolic Cartography in a Medieval Parish: From Spatialized Body to Painted Church at Saint-Aignan-sur-Cher." *Speculum* 75:615–67.

Kurmann-Schwarz, Brigitte and Peter Kurmann. 1995. "Chartres Cathedral as a Work of Artistic Integration: Methodological Reflections." In *Artistic Integration in Gothic Buildings*, ed. V. C. Raguin et al., 130–52. Toronto and Buffalo.

Kusaba, Yoshio Leo. 1993. "Henry of Blois, Winchester, and the 12th-Century Renaissance." In *Winchester Cathedral: Nine Hundred Years, 1093–1993*, ed. John Crook, 69–80. Chichester.

Lair, Jules. 1902. *Le siège de Chartres par les Normands*. Caen.

Laistner, M. L. W. 1924. "Abbo of St.-Germain-des-Près." *Bulletin du Cange* 1:27–31.

Lambert, Elie. 1945–46. "Un recueil d'abbayes augustines préparé par les Génovéfains." *Bulletin de la Société d'histoire de l'art français*, 126–29.

Lambert, Pierre-Yves. 1997. "A Propos de l'origine celtique du culte de Notre-Dame de Chartres: Un parallèle irlandais." In *MMSC*, 239–56.

Lambot, Cyrille. 1934. "L'homélie du pseudo-Jérome sur l'Assomption et l'Évangile de la Nativité de Marie d'après une letter inédite d'Hincmar." *RB* 46:265–82.

La Monte, John L. 1942. "The Lords of Le Puiset on the Crusades." *Speculum* 17:100–118.

Langlois, Marcel. 1905–06. "Scribes de Chartres." *Revue Mabillon* 1:161.

Lanoë, Guy. 1992. "Les *ordines* de couronnement (930–1050): retour au manuscrit." In *Roi de France*, 65–72.

Lara, Jaime. 2004. *City, Temple, Stage: Eschatological Architectual and Liturgical Theatrics in New Spain*. Notre Dame.

———. 2008. *Christian Texts for Aztecs: Art and Liturgy in Colonial Mexico*. Notre Dame.

Lausberg, Heinrich. 1976. *Der Hymnus Ave maris stella*. Opladen.

Lautier, Claudine. 1993. "Les vitraux de la cathédrale de Chartres à la lumière des restaurations

anciennes." In *Künstlerischer Austausch / Artistic Exchange. Akten des XXVIII. Internationalen Congresses für Kunstgeschichte, Berlin, 15.-20. Juli 1992*, 3:413–24. Berlin.

———. 1999. "Les restaurations des vitraux de la cathédrale de Chartres du Moyen Age à nous jours." *La Sauvegarde de l'art français* 12:6–19.

———. 2003. "Les Vitraux de la cathédrale de Chartres: Reliques et images." *BM* 161:3–96.

———. 2004. "Le vitrail de Charlemagne à Chartres et les reliques du trésor de la cathédrale." In *Actes du colloque: Autour de Hugo d'Oignies, Namus, 20–21 octobre 2003*, 229–40. Namur.

———. 2009. "The Sacred Topography of Chartres Cathedral: The Reliquary Chasse of the Virgin in the Liturgical Choir and Stained-Glass Decoration." In *The Four Modes of Seeing: Approaches to Medieval Imagery in Honor of Madeline Harrison Caviness*, ed. E. S. Lane, E. C. Pastan, and E. M. Shortell, 174–96. Burlington.

Lawrence, Marion. 1925. "Maria Regina." *AB* 7:150–61.

Lazar, Moshe. 1972. "Theophilus: Servant of Two Masters. The Pre-Faustian Theme of Despair and Revolt." *Modern Language Notes* 87:31–50.

Le Hête, Thierry. 2003. "Richilde, Wife of Thibaud the Old, Viscount of Tours: A Marriage Intended to Increase Thibaudian Power." *Newsletter of the Foundation for Medieval Genealogy* 1:3–4.

Lemarignier, Jean-François. 1965. *Le gouvernement royal aux premiers temps capétiens, 987–1108*. Paris.

Lemay, Helen Rodnite. 1977. "Science and Theology at Chartres: The Case of the Supracelestial Waters." *British Journal for the History of Science* 10:226–36.

Lendinara, Patrizia. 1986. "The Third Book of the *Bella Parisiacae Urbis* by Abbo of Saint-Germain-des-Près and Its Old English Gloss." *Anglo-Saxon England* 15:73–89.

Lépinois, Ernest de. 1854–58. *Histoire de Chartres*. 2 vols. Chartres.

Lesne, Emile. 1938. *Histoire de propriété ecclésiastique en France, 4, Les livres, scriptoria et bibliothèques du commencement du VIIIme siècle à la fin du XIme*. Paris.

Lesueur, Frédéric. 1963. *Thibaud le Tricheur, Comte de Blois, de Tours et de Chartres*. Blois.

Levy, Kenneth. 1984. "Toledo, Rome and the Legacy of Gaul." *Early Music History* 4:49–99.

Lewis, A. L. 1890. "On Rude Stone Monuments in the Country of the Carnutes (Department Eure et Loir, France)." *Journal of the Anthropological Institute of Great Britain and Ireland* 19:66–75.

Lewis, Andrew W. 1978. "Anticipatory Association of the Heir in Early Capetian France." *AHR* 83:906–27.

———. 1981. *Royal Succession in Capetian France: Studies in Familial Order and the State*. Cambridge, Mass.

———. 1992. "Successions ottoniennes et robertiennes: un essai de comparison." In *Roi de France*, 47–53.

Lex, Léonce. 1892. *Eudes, Comte de Blois . . . et Thibaud son frère . . .* Troyes.

Liepe, Lena. 2003. "On the Epistemology of Images." In *History and Images: Towards a New Iconology*, ed. Axel Bolvig and Phillip Lindley, 415–30. Medieval Texts and Cultures 5. Turnhout.

Lifshitz, Felice. 1994. "Dudo's Historical Narrative and the Norman Succession of 996." *Journal of Medieval History* 20:101–20.

———. 1995. *The Norman Conquest of Pious Neustria: Historiographic Discourse and Saintly Relics, 684–1090*. Toronto.

Lillich, Meredith P. 1982. "The Consecration of 1254: Heraldry and History in the Windows of Le Mans Cathedral." *Traditio* 38:344–351.

———. 1984. "Monastic Stained Glass." In *Monasticism and the Arts*, ed. Timothy G. Verdon, 207–54. Syracuse.

Limor, Ora. 1996. "The Epistle of Rabbi Samuel of Morocco: A Best-Seller in the World of Polemics." In *Contra Iudaeos: Ancient and Medieval Polemics between Christians and Jews*, ed. Ora Limor and Guy G. Strousma, 177–194. Tübingen.

Linder, Amnon. 1990. "The Liturgy of the Liberation of Jerusalem." *Mediaeval Studies* 52:110–31.

Lindley, Phillip. 1993. "The Medieval Sculpture of Winchester." In *Winchester Cathedral: Nine Hundred Years, 1093–1993*, ed. John Crook, 97–122. Chichester.

Little, Charles. 1975. "An Ivory Tree of Jesse from Bamberg." *Pantheon* 33:292–300.

Little, Lester. 1993. *Benedictine Maledictions: Liturgical Cursing in Romanesque France*. Ithaca.

Livingstone, Amy. 1992. "The Nobility of Blois-Chartres: Family and Inheritance, 980–1140." Ph.D. diss., Michigan State University.

———. 1997. "Kith and Kin: Kinship and Family Structure of the Nobility of Eleventh-and Twelfth-Century Blois-Chartres." *French Historical Studies* 20:419–58.

LoPrete, Kimberly Anne. 1991. "A Female Ruler in Feudal Society: Adela of Blois (ca. 1067–ca. 1137)." Ph.D. diss., University of Chicago.

———. 1996. "Adela of Blois as Mother and Countess." In *Medieval Mothering*, ed. John Carmi Parsons and Bonnie Wheeler, 313–33. New York.

———. 1999. "Adela of Blois: Familial Alliances and Female Lordship." In *Aristocratic Women in Medieval France*, ed. Theodore Evergates, 7–43. Philadelphia.

———. 2003. "Historical Ironies in the Study of Capetian Women." In *Capetian Women*, ed. Kathleen Nolan, 271–86. New York.

———. 2007. *Adela of Blois, Countess and Lord*. Dublin.

Lot, Ferdinand. 1891. *Les derniers Carolingiens: Lothaire, Louis V, Charles de Lorraine (954–991)*. Paris.

———. 1903, 1975. *Études sur le règne de Hugues Capet et la fin du Xe siècle*. Paris.

———. 1907. "Le origine de Thibaud le Tricheur." *Le Moyen Âge* 20 (2d series, 11): 179–83.

Low, Peter. 2003. "'You Who Once Were Far Off': Enlivening Scripture in the Main Portal at Vézelay." *AB* 85:469–89.

Lowe, E. A., ed. 1934–66. *Codices Latini antiquiores: A Palaeographical Guide to Latin Manuscripts Prior to the Ninth Century*. 11 vols. Oxford.

Luscombe, David E. 1997. "L'aréopagitisme et Chartres." In *MMSC*, 113–22.

McAleer, John Philip. 1988. "'Particularly English?' Screen Façades of the Type of Salisbury and Wells Cathedrals." *Journal of the British Archaeological Association* 141:124–58.

———. 2001. "The North Portal of Durham Cathedral and the Problem of 'Sanctuary' in Medieval Britain." *Antiquaries Journal* 81:195–258.

McClendon, Charles. 2005. *The Origins of Medieval Architecture: Building in Europe A.D. 600–900*. New Haven.

MacCormack, Sabine G. 1982. *Art and Ceremony in Late Antiquity*. Berkeley.

McCormick, Michael. 1986. *Eternal Victory: Triumphal Rulership in Late Antiquity, Byzantium, and the Early Medieval West*. Cambridge.

MacKinney, Loren C. 1937. *Early Medieval Medicine, with Special Reference to France and Chartres*. Baltimore.

———. 1957. *Bishop Fulbert and Education at the School of Chartres*: Studies in the History of Mediaeval Education 6. Notre Dame.

McKitterick, Rosamond. 1983. *The Frankish Kingdom under the Carolingians, 751–987*. London.

McLaughlin, Megan M. 1995. "The Twelfth-Century Ritual of Death and Burial at Saint-Jean-en-Vallée in the Diocese of Chartres." *RB* 105:155–66.

Maclean, Simon. 2003. *Kingship and Politics in the Late Ninth Century: Charles the Fat and the End of the Carolingian Empire*. Cambridge.

McTurk, Rory. 1991. *Studies in Ragnars Saga*. Oxford.

McVey, Kathleen E. 1983. "The Domed Church as Microcosm: Literary Roots of an Architectural Symbol." *Dumbarton Oaks Papers* 37:91–121.

Maier, Anneliese. 1967. "Die Handschriften der *Ecclesia Sidonensis*." *Manuscripta* 11:39–45.

Maines, Clark. 1977. "The Charlemagne Window at Chartres Cathedral: New Considerations on Text and Image." *Speculum* 52:801–23.

Maître, Claire, et al., eds. 2004. *Catalogue des manuscripts conservés à Autun.* Turnhout.

Mâle, Émile. 1922. *Art religieux du XIIe siècle en France: Étude sur les origines de l'iconographie du moyen âge.* Paris. 3d ed., 1928.

———. 1948, 1983. *Notre-Dame de Chartres.* Paris.

———. 1963. *Notre-Dame de Chartres. Cent quarante-six photographies de Pierre Devinoy. Ce livre a été conçu et realizé par Paul Hartmann.* Paris.

Mallet, J. 1995. "La place de la priorale de Cunault dans l'art local." In *Saint-Philibert de Tournus: Histoire, archaéologie, art,* 473–86. Tournus.

Mallion, Jean. 1964. *Chartres: Le jubé de la cathédrale.* Chartres.

Malone, Carolyn Marino. 2004. *Façade as Spectacle: Ritual and Ideology at Wells Cathedral.* Leiden.

Manhes-Deremble, Colette. 1993. *Les vitraux narratifs de la cathédral de Chartres: Étude iconographique.* Corpus Vitrearum—France, études 2. Paris.

Marchand, James W. 1975. "The Old Icelandic Allegory of the Church Modes." *Musical Quarterly* 61:553–59.

Marcus, Ivan G. 1996. *Rituals of Childhood: Jewish Acculturation in Medieval Europe.* New Haven.

Marcus, Susan W. D. 1972. "A Scene on the Capital Frieze at Chartres and a Twelfth-Century Theological Debate." *RTAM* 39:5–13.

Markale, Jean. 1988. *Chartres et l'énigme des Druides.* Paris.

Martin, Henri-Jean. 1989. "Le manuscrit U 36 de la Bibliothèque municipale de Rouen: un homéliaire-légendier d'origine lochoise?" In *Mediaevalia christiana, XIe–XIIIe siècles: Hommage a Raymonde Foreville . . . ,* ed. C. E. Viola, 3–17. Paris.

Mason, Emma. 1993. "The Purposeful Patronage of Henry of Blois." *Medieval History* 3:30–50.

Mathorez, Jules. 1912. *Guillaume avec Blanches-Maines, évêque de Chartres.* Chartres.

Maxwell, Robert A. 2003. "Misadventures of a Style: Romanesque Art and the Druids in Eighteenth-Century France." *Art History* 26:608–37.

Mayeux, Albert. 1900. "Étude sur la façade de la cathédral de Chartres du XIe au XIIIe siècles." *SAEL-M* 12:434–47.

———. 1906a. "Les grands portails du XIIe siècle et les bénédictines de Tiron." *Revue Mabillon* 2:97–122.

———. 1906b. "La porche occidental de la cathédral de Chartres: État de la question." *Cinquantenaire de la SAEL* 1:495–507.

*Medieval Art and Architecture at Winchester Cathedral.* 1983. London.

Meiss, Millard. 1945. "Light as Form and Symbol in Some Fifteenth-Century Paintings." *AB* 27:175–81.

Mély, Fernand de. 1886. *Le trésor de Chartres (1310–1793).* Paris.

———. 1891. Note on the "Notre Dame de la Belle-Verrière" stained glass at Chartres. *Bulletin archéologique,* p. xxxvi.

Merlet, Lucien. 1858. *Histoire des relations des Hurons et des Abénaquis du Canada avec Notre-Dame de Chartres, suivie de documents inédits sur la Sainte Chemise.* Chartres.

———. 1883, rpt. 1971. "Bibliothèque chartraine antérieure au XIXe siècle." *Mémoires de la Société archéologique et historique de l'Orléanais* 19:1–447; rpt. Orleans, 1882; Geneva, 1971.

———. 1885. *Catalogue des reliques et joyaux de Notre-Dame de Chartres.* Chartres.

———. 1892. *Une colonie de Bretons à Chartres-Vannes.* Lafolye.

Merlet, René. 1901. "Le puits des Saints-Forts et l'ancienne chapelle de Notre-Dame-sous-Terre." *Congrès archéologique de France* 67:226–55.

———. 1905. "Le puits des Saints-Forts." *SAEL-PV* 11:43–49 and 96.

Métais, Charles, ed. 1897, 1900, 1904, 1908. *Églises et chapelles du diocèse de Chartres.* 4th series. Archives du diocèse de Chartres 2, 4, 9, 15. Chartres.

————. 1908. "L'église abbatiale de Notre-Dame de Josaphat d'après des fouilles récentes." *Bulletin archéologique du Comité des travaux historiques et scientifiques* (1907) 4:167–83.

————. 1911. "L'église abbatiale de Josaphat." *Églises et chapelles du diocèse de Chartres* 8:1–40.

Monagle, Clare. 2004. "The Trial of Ideas: Two Tellings of the Trial of Gilbert of Poitiers." *Viator* 35:112–29.

Montesquiou-Fezensac, Blaise, with Danielle Gaborit-Chopin. 1973–77. *Le trésor de Saint-Denis.* 3 vols. Paris.

Morse, Charlotte C. 2005. "Scenes of Farewell in the Middle Ages." In *Studies in Late Medieval and Early Renaissance Texts in Honour of John Scattergood*, ed. A. M. D'arcy and A. J. Fletcher, 241–58. Dublin.

Moss, Christopher, and Katherine Kiefer, eds. 1995. *Byzantine East, Latin West: Art-Historical Studies in Honor of Kurt Weitzmann.* Princeton.

Mostert, Marco. 1990. "L'abbé, l'évêque et le pape. L'image de l'évêque idéal dans les oeuvres d'Abbon de Fleury." In *Religion et culture autour de l'an Mil: Royaume capétien et Lotharingie. Actes du Colloque Hugues Capet, 987–1987: La France de l'An Mil, Auxerre, 26 et 27 juin 1987/ Metz, 11 et 12 septembre 1987*, ed. Dominique Iogna-Prat and Jean-Charles Picard, 39–45. Paris.

Mowinckel, Sigmund. 1956. *He That Cometh*, trans. G. W. Anderson. Oxford.

Murray, Stephen. 2004. *A Gothic Sermon: Making a Contract with the Mother of God, Saint Mary of Amiens.* Berkeley.

Musset, Lucien. 1959. "Actes inédits du XIe siècle III: Les plus anciennes chartes normandes de l'abbaye de Bourgueil." *Bulletin de la Société des antiquaires de Normandie* 54:15–54.

Nelson, Janet. 1986. "The Earliest Surviving Royal *Ordo*: Some Liturgical and Historical Aspects." In *Politics and Ritual in Early Medieval Europe*, 341–60. London.

————. 1990. "The Reign of Charles the Bald: A Survey." In *Charles the Bald: Court and Kingdom*, ed. Margaret T. Gibson and Janet L. Nelson, 1–22. 2d edn. Hampshire.

————. 1992. *Charles the Bald.* London.

————. 1996. "Gender and Genre in Women Historians of the Early Middle Ages." Chap. in *The Frankish World, 750–900.* London.

Newman, Barbara. 2003. *God and Goddesses: Vision, Poetry and Belief in the Middle Ages.* Philadelphia.

————. 2005. "What Did It Mean to Say 'I Saw'? The Clash between Theory and Practice in Medieval Visionary Culture." *Speculum* 80:1–43.

Newman, William Mendel. 1937. *Catalogue des actes de Robert II roi de France.* Paris.

Nichols, Stephen G. 1989. "Periodization and the Politics of Perception: A Romanesque Example." *Poetics Today* 10:127–54.

Nirenberg, David. 2006. "Figures of Thought and Figures of Flesh: 'Jews' and 'Judaism' in Late Medieval Spanish Poetry and Politics." *Speculum* 81:398–426.

Nolan, Kathleen. 1989. "Narrative in the Capital Frieze of Notre-Dame at Etampes." *AB* 71:166–84.

————. 1994. "Ritual and Visual Experience in the Capital Frieze at Chartres." *Gazette des beaux-arts* 123:53–72.

Nonfarmale, Ottorino, and R. Rossi Manaresi. 1987. "Il restauro del 'Portail Royal' della cattedrale di Chartres." *Arte medievale* 1:1–2:259–75.

North, Robert J. 1989. "The Chronicler. . . ." In *The New Jerome Biblical Commentary*, ed. Raymond E. Brown et al., 362–98. London.

Nugent, Patrick J. 2001. "Bodily Effluvia and Liturgical Interruption in Medieval Miracle Stories." *History of Religions* 41:49–70.

Olson, Vibeke. 2003. "Oh Master, You're Wonderful! The Problem of Labor in the Ornamental Sculpture of the Chartres Royal Portal." *Avista* 13:6–3.

Omont, Henri Auguste, ed. 1890. *Catalogue général des manuscrits des bibliothèques publiques de France*, 11, *Départments: Chartres*. Paris.

Orlowski, Tomasz H. 1991. "La façade romane dans l'Ouest de la France." *CCM* 34:367–77.

Ottosen, Knud. 1986. *L'Antiphonaire latin au Moyen-Âge: Réorganisation des séries de répons de l'avent classés par R.-J. Hesbert*. Rome.

Ousterhout, Robert. 1990. "The Temple, the Sepulchre, and the Martyrion of the Savior." *Gesta* 29:44–53.

Palazzo, Éric. 1996. "Marie et l'élaboration d'un espace ecclésial au haut Moyen Âge." In *Marie*, 313–25.

Parisse, Michel, and Xavier Barral I Altet, eds. 1992. *Le roi de France et son royaume, autour de l'an mil*. Paris. = *Roi de France*.

Pascher, Joseph. 1963. *Das Liturgische Jahr*. Munich.

Pastan, Elizabeth Carson. 1989. "Restoring the Stained Glass of Troyes Cathedral: The Ambiguous Legacy of Viollet-le-Duc." *Gesta* 29:155–66.

———. 2008. "Charlemagne as Saint? Relics and the Choice of Window Subjects at Chartres Cathedral." In *The Legend of Charlemagne in the Middle Ages: Power, Faith, and Crusade*, ed. Matthew Gabriele and Jace Stuckey, 97–135. New York.

Patton, Pamela A. 2008. "Constructing the Inimical Jew in the Cantigas de Santa Maria: Theophilus' Magician in Text and Image." In *Beyond the Yellow Badge: Anti-Judaism and Antisemitism in Medieval and Early Modern Visual Culture*, ed. Mitchell B. Merback, 233–56 (text) 506–14 (plates). Leiden/Boston.

Paul, Nicholas L. 2005. "Crusade, Memory and Regional Politics in Twelfth-Century Amboise." *Journal of Medieval History* 31:127–41.

Pedersen, Nils Holger, et al., eds. 2004. *Transformations in Christianity: Interpretations and Representation in the Arts, 1000–2000*. Amsterdam.

Perrot, Françoise. 1977. "Les verrières du XIIe siècle de la façade occidentale, étude archéologique." *Monuments historiques de la France* 1:39–51.

Petit-Dutaillis, Charles. 1936. *The Feudal Monarchy in France and England: From the Tenth to the Thirteenth Century*. London.

Pfister, Christian. 1885a. *De Fulberti Carnotensis episcopi, vita et operibus. Thesim*. Nancy.

———. 1885b. *Études sur le règne de Robert le Pieux (996–1031)*. Bibliothèque de l'École des hautes études 64. Paris.

Phillips, Jonathan. 2007. *The Second Crusade: Extending the Frontiers of Christendom*. New Haven.

Pinoteau, Hervé. 2000. "Une couronne de Charles le Chauve visible par tous." *Emblemata* 6:39–60.

Pintard, Jacques. 1972. "Saint Fulbert et l'origine du culte chartraine de la Nativité de Notre-Dame." In *De cultu mariano saeculis VI–XI: Acta Congressus Mariologici Mariani Internationalis in Croatia anno 1971 celebrati*, ed. J. Lecuyer, 3:551–69. Rome.

Piper, Alan J. 1994. "The Durham Cantor's Book (Durham, Dean and Chapter Library, MS B.IV.24)." In *Anglo-Norman Durham: 1093–1193*, ed. D. Rollason et al., 79–92. Woodbridge, U.K.

Planchart, Alejandro. 1988. "On the Nature of Transmission and Change in Trope Repertories." *JAMS* 41:215–49.

Plenzat, Karl. 1926. *Die Theophiluslegende in den Dichtungen des Mittelalters*. Berlin.

Poirel, Dominique, Alain Erlande-Brandebourg, et al., eds. 2001. *L'abbé Suger, le manifeste gothique de Saint-Denis et la pensée victorine: Colloque organisé à la Fondation Singer-Polignac . . . Actes*. Turnhout.

Potts, Cassandra. 2003. "Normandy, 911–1144." In *A Companion to the Anglo-Norman World*, ed. Christopher Harper-Bill and Elisabeth van Houts, 19–42. Woodbridge, U.K.

Pourreyron, C. 1936. *Le culte de Notre-Dame au diocèse de Clermont en Auvergne.* Nancy.

Powell, Michael. 1998. "Feast of Marvels: Restructuring Lyon, 1193–1400." Ph.D. diss., Yale University.

Power, Daniel. 2004. *The Norman Frontier in the Twelfth and Early Thirteenth Centuries.* Cambridge.

Prache, Anne. 1978. *Saint-Remi de Reims: L'oeuvre de Pierre de Celle et sa place dans l'architecture gothique.* Geneva.

———. 1993. *Chartres Cathedral: Image of the Heavenly Jerusalem,* trans. Janice Abbott. Paris.

Prentout, Henri. 1916. *Étude critique sur Dudon de Saint-Quentin et son histoire des premiers ducs normands.* Paris.

Pressouyre, Leon. 1969. "Chronique: Contributions à l'iconographie du Portail Royal de Chartres." *BM* 127:242–45.

———. 1982. "Précisions sur l'oeuvre du 'maître d'Étampes' au Portail Royal de la cathédrale de Chartres." *Bulletin de la Société nationale des antiquaires de France* 97:96–97.

Priest, Alan. 1923. "The Master of the West Façade of Chartres." *Art Studies* 1:28–44.

Racinet, Philippe, ed. 2006. *Archéologie et histoire d'un prieuré bénédictin en Beauce: Nottonville, Eure-et-Loir, Xe–XVIIe siècles.* Paris.

Rand, E. K. 1931. "A Supplement on Dodaldus." *Speculum* 6:587–99.

Randoin, Bernard. 1991. *Fouilles archéologiques du parvis de la cathédrale de Chartres. Premiers résultats, supplément à quinze années de recherches archéologiques en Eure-et-Loir, Comité archéologique d'Eure-et-Loir.* Maintenon.

Randoin, Bernard, T. Massat, and Hervé Sellès. 1995. *Devant le portail royal: Fouille archéologique du parvis de la cathédrale de Chartres. Catalogue d'exposition, Chartres, Maison del'archéologie, 8 juil. 1995–28 avr. 1996.* Chartres.

Rankin, Susan. 1991. "The Earliest Sources of Notker's Sequences: St. Gallen, Vadiana 317, and Paris, Bibliothèque nationale lat. 10587." *Early Music History* 10:201–33.

———. 1994. "Carolingian Music." In *Carolingian Culture: Emulation and Innovation,* ed. Rosamund McKitterick, 274–316. Cambridge.

———. 2010. "*Terribilis est locus iste:* The Pantheon in 609." In *Rhetoric Beyond Words,* ed. Mary Carruthers. Cambridge.

Rauch, Ivo. 2004. "Die Bundeslade und die wahren Israeliten: Anmerkungen zum Mariologischen und politischen Programm der Hochchorfenster der Kathedrale von Chartres." In *Glas, Malerei, Forschung: Internationale Studien zu Ehren von Rüdiger Becksmann,* ed. Hartmut Scholz, Ivo Rauch, and Daniel Hess, 61–71. Berlin.

Rawcliffe, Carol. 2002. "'Written in the Book of Life': Building the Libraries of Medieval English Hospitals and Almshouses." *Library* 3:127–62.

Reilly, Diane J. 2006. *The Art of Reform in Eleventh-Century Flanders: Gerard of Cambrai, Richard of Saint Vanne and the Saint-Vaast Bible.* Leiden.

Reynolds, Roger. 1978. *The Ordinals of Christ from Their Origins to the Twelfth Century.* Berlin and New York.

———. 1995. "Liturgy and the Monument." In *Artistic Integration in Gothic Buildings,* ed. Virginia Chieffo Raguin et al., 57–68. Toronto.

———. 2000. "The Drama of Medieval Liturgical Processions." *Revue de musicology* 86:127–42.

Riall, Nicholas. 1994. *Henry of Blois, Bishop of Winchester: A Patron of the Twelfth-Century Renaissance.* Winchester, U.K.

Riché, Pierre. 1983. *Les Carolingiens: Une famille qui fit l'Europe.* Paris. Trans. Michael Idomir Allen, *The Carolingians: A Family Who Forged Europe.* Philadelphia, 1993.

———. 1987. *Gerbert d'Aurillac: Le pape de l'an mil.* Paris.

Rickard, Marcia R. 1983. "The Iconography of the Virgin Portal at Amiens." *Gesta* 22:147–57.

Ridder, R. Todd. 1993. "Musical and Theological Patterns Involved in the Transmission of Mass Chants for the Five Oldest Marian Feasts." Ph.D. diss., Catholic University of America.

Riley-Smith, Jonathan. 1986. *The First Crusade and the Idea of Crusading*. Philadelphia.

———. 1997. *The First Crusaders, 1095–1131*. Cambridge and New York.

———. 1999. *Hospitallers: The History of the Order of St. John*. London.

Riley-Smith, Jonathan, ed. 1995. *The Oxford Illustrated History of the Crusades*. New York.

Riou, Yves-Jean. 1980. "Réflexions sur la frise sculptée de la façade de Notre-Dame-la-Grande de Poitiers." *Bulletin de la Société des antiquaires de l'Ouest et de Musée de Poitiers*, series 4, 15:497–514.

Robertson, Anne Walters. 1991. *The Service-Books of the Royal Abbey of Saint-Denis: Images of Ritual and Music in the Middle Ages*. Oxford.

———. 2000. "From Office to Mass: The Antiphons of Vespers and Lauds and the Antiphons before the Gospel in Northern France." In *Divine Office*, 300–23.

———. 2002. *Guillaume de Machaut and Reims: Context and Meaning in His Musical Works*. Cambridge.

Rouche, Michel. 2000. "Gerbert face aux marriages incestueux: le cas de Robert le Pieux." In *Gerbert: Moine, evêque, et pape: d'un millénaire a l'autre*, 153–60. Aurillac.

Rubenstein, Jay. 2004. "Putting History to Use: Three Crusade Chronicles in Context." *Viator* 35:131–68.

Rubin, Miri. 2009. *Mother of God: A History of the Virgin Mary*. New Haven.

Ryan, J. Joseph. 1947. "Saint Peter Damiani and the Sermons of Nicholas of Clairvaux: A Clarification." *Mediaeval Studies* 9:151–61.

Ryskamp, Charles. 1980. *The Stavelot Triptych: Mosan Art and the Legend of the True Cross*. New York.

Sanfaçon, André. 1988. "Légendes, histoire et pouvoir à Chartres sous l'Ancien Régime." *Revue historique* 566:337–57.

Sapin, Christian, and François Heber Suffrin. 2008. "Les cryptes de Chartres." In *FC*, 285–300.

Sassier, Yves. 1987. *Hugues Capet: Naissance d'une dynastie*. Paris.

———. 1991. *Louis VII*. Paris.

———. 1997. "Thibaud le Tricheur et Hugues le Grand." In *Pays du Loire de Robert le Fort aux premiers capétiens: Actes du colloque scientifique international tenu à Angers en septembre 1987*, ed. Olivier Guillot and Robert Favreau, 145–57. Poitiers.

———. 2008. "Royauté et conception du pouvoir chez Fulbert de Chartres." In *FC*, 221–29.

Sauerländer, Willibald. 1954. *Die Kathedrale von Chartres*. Stuttgart.

———. 1956. "Zu den Westportalen von Chartres." *Kunstchronik* 9:155–56.

———. 1982. "Architecture and the figurative arts: the North." In *Renaissance and Renewal in the Twelfth Century*, ed. R. L. Benson and Giles Constable, 671–710, Cambridge, MA.

———. 1992. "Romanesque Sculpture in Its Architectural Context." In *The Romanesque Frieze and Its Spectator: The Lincoln Symposium Papers*, ed. Deborah Kahn, 17–43. London.

———. 1995. "Integrated Fragments and the Unintegrated Whole: Scattered Examples from Reims, Strasbourg, Chartres, and Naumberg." In *Artistic Integration in Gothic Buildings*, ed. Virginia Raguin, Kathryn Brush, and Peter Draper, 153–66. Toronto.

Scheil, Andrew P. 2007. *The Footsteps of Israel: Understanding Jews in Anglo-Saxon England*. Ann Arbor.

Scheer, Monique. 2002. "From Majesty to Mystery: Change in the Meanings of Black Madonnas from the Sixteenth to Nineteenth Centuries." *The American Historical Review* 109: 1412–40.

Schenkluhn, Wolfgang. 1994. "Die Westportale von Chartres und Saint-Denis: über Lehrbeispiele in der Kunstgeschichte." In *Studien zur Geschichte der europäischen Skulptur im 12./13. Jahrhundert*, ed. Herbert Beck and Kerstin Hengevoss-Dürkop, 387–95. Frankfurt-am-Main.

Schilling, Martina. 2003. "Victorine Liturgy and Its Architectural Setting at the Church of Sant'Andrea in Vercelli." *Gesta* 42:115–30.

Schlink, Wilhelm. 1997/98. "The Gothic Cathedral as Heavenly Jerusalem: A Fiction in German Art History." *Jewish Art* 23/24:275–85.

Schola Hungarica. 2000. "The Holy Lady of Chartres." Performances conducted by László Dobszay and Janka Szendrei, with notes by Margot Fassler. Hungaroton 31922; also on Naxos Audio Database.

Schöne, Wolfgang. 1961. *Das Königsportal der Kathedrale von Chartres.* Stuttgart.

Schwartz, Max. 2001. *The Biblical Engineer: How the Temple in Jerusalem Was Built.* Hoboken, N.J.

Searle, Eleanor. 1988. *Predatory Kingship and the Creation of Norman Power, 840–1066.* Berkeley.

Sears, Elizabeth. 1986. *The Ages of Man: Medieval Interpretations of the Life Cycle.* Princeton.

Seidel, Linda. 1999. *Legends in Limestone: Lazarus, Gislebertus, and the Cathedral of Autun.* Chicago.

Senette, Douglas John. 1991. "A Cluniac Prelate: Henry of Blois, Bishop of Winchester (1129–1171)." Ph.D. diss., Tulane University.

Settipani, Christian. 1997. "Les comtes d'Anjou et leurs alliances aux Xe et XIe siècles." In *Family Trees and the Roots of Politics: The Prosopography of Britain and France from the Tenth to the Twelfth Century,* ed. K. S. B. Keats-Rohan, 211–67. Woodbridge, U.K.

Shadis, Mariam. 2003. "Blanche of Castile and Facinger's 'Medieval Queenship': Reassessing the Argument." In *Capetian Women,* ed. Kathleen Nolan, 137–61. New York.

Sheridan, Ronald, and Anne Ross. 1975. *Grotesques and Gargoyles: Paganism in the Medieval Church.* Devon: David and Charles.

Sherr, Richard. 1994. "A Biographical Miscellany: Josquin, Tinctoris, Obrecht, Brumel." In *Musicologia humana: Studies in Honor of Warren and Ursula Kirkendale,* ed. S. Gmienwieser et al., 65–73. Florence.

Shopkow, Leah. 1997. *History and Community: Norman Historical Writing in the Eleventh and Twelfth Centuries.* Washington, D.C.

Sider, Robert D. 1971. *Ancient Rhetoric and the Art of Tertullian.* Oxford.

Signer, Michael. 1983. "King Messiah: Rashi's Exegesis of Psalms 2." *Prooftexts: A Journal of Jewish Literary History* 3:273–84.

———. 1984. "The *Speculum Ecclesiae* by Honorius Augustodunensis on Jews and Judaism: Preaching at Regensburg in Twelfth Century." In *Crossroads of Medieval Civilization: The City of Regensburg and Its Intellectual Milieu,* ed. E. DuBruck and K. H. Goller, 121–37. Detroit.

———. 1997. "The *Glossa Ordinaria* and the Transmission of Medieval Anti-Judaism." In *A Distinct Voice: Medieval Studies in Honor of Leonard E. Boyle, O.P.,* ed. Jacqueline Brown and William P. Stoneman, 591–605. Notre Dame.

———. 1998a. "Do Jews Read the Letter: Reflection on the Sign in Medieval Jewish Exegesis." In *The Quest for Context and Meaning: Studies in Biblical Intertexuality in Honor of James A. Sanders,* ed. Craig A. Evans and Shemaryahu Talmon, 614–24. Leiden.

———. 1998b. "Rashi as Narrator." In *Rashi et la culture juive en France du Nord au moyen âge,* ed. G. Nahon and G. Dahan, 103–110. Frankfurt.

———. 1999. "'Adversus Judaeos' and 'Jews and Judaism.'" In *Augustine through the Ages: An Encyclopedia,* ed. A. Fitzgerald, 12–14, 470–74. Grand Rapids, Mich.

Signori, Gabriela. 1995. "Städtisches Marien patronat und ländliche Subsistenzproleme im Spiegel nordfranzösisch-belgischer Ergotismusepidemien: Hugo Farsits '*Libellus de miraculis beatae Mariae Virginis in urbe Suessionensi.*'" In *Maria zwischen Kathedrale, Kloster und Welt,* 125–51. Sigmaringen.

———. 1996. "The Miracle Kitchen and Its Ingredients: A Methodical and Critical Approach to Marian Shrine Wonders (10th to 13th Century)." *Hagiographica* 3:277–303.

Simson, Otto von. 1988. *The Gothic Cathedral: Origins of Gothic Architecture and the Medieval Concept of Order.* 3d ed. Princeton.

Slocum, Kay Brainerd. 2004. *Liturgies in honour of Thomas Becket.* Toronto.

Smedt, Charles de, et al. 1889. "Catalogus codicum hagiographicorum latinorum bibliothecae publicae civitatis Carnotensis." *Analecta Bollandiana* 8:86–208.

Smith, Kathryn A. 2003. *Art, Identity, and Devotion in Fourteenth-Century England: Three Women and Their Books of Hours.* London.

Smits, Edmé R. 1982. "An Unedited Letter to Geoffrey de Lèves, Bishop of Chartres, Concerning Louis VI and the Reform Movement." *RB* 92:407–17.

Snyder, Janet E. 1996. "Clothing as Communication: A Study of Clothing and Textiles in Northern French Early Gothic Sculpture." Ph.D. diss., Columbia University.

Sot, Michel. 1993. *Un historien et son église au Xe siècle: Flodoard de Reims.* Paris.

Southern, Richard W. 1970. *Medieval Humanism and Other Studies.* Oxford.

———. 1979. *Platonism, Scholastic Method and the School of Chartres.* Reading, U.K.

———. 1982. "The Schools of Paris and the School of Chartres." In *Renaissance and Renewal in the Twelfth Century*, ed. R. L. Benson and Giles Constable, 113–37. Cambridge, Mass.

Sowers, Robert. 1982. "A Hypothesis about the West Front of Chartres." *AB* 64:622.

Speer, Andreas. 1997. "The Discovery of Nature: The Contribution of the Chartrians to Twelfth-Century Attempts to Found a *Scientia naturalis*." *Traditio* 52:135–51.

Spiegel, Gabrielle M. 1983. "Genealogy: Form and Function in Medieval Historical Narrative." *History and Theory* 22:43–53.

———. 1997. *The Past as Text: The Theory and Practice of Medieval Historiography.* Baltimore.

———. 2002. "Memory and History: Liturgical Time and Historical Time." *Memory and Theory* 41:149–62.

Spitzer, Laura. 1994. "The Cult of the Virgin and Gothic Sculpture: Evaluating Opposition in the Chartres West Façade Capital Frieze." *Gesta* 33:132–50.

Sprandel, Rolf. 1962. *Ivo von Chartres und seine Stellung in der Kirchengeschichte.* Stuttgart.

Stacy, N. E. 1999. "Henry of Blois and the Lordship of Glastonbury." *The English Historical Review* 114:1–33.

Staebel, Jochen. 2003. *Notre-Dame von Étampes: die Stiftskirche des 11.-13. Jahrhunderts unter besonderer Berücksichtigung ihrer frühgotischen Bauskulptur.* Worms.

———. 2006. "Das Königsportal von Chartres." *Mitteilungen der Gesellschaft für vergleichende Kunstforschung in Wien* 58.

Stahl, Harvey. 1986. "The Problem of Manuscript Painting at Saint-Denis during the Abbacy of Suger." In *Abbot Suger and St. Denis*, ed. Paula Gerson, 163–81. New York.

Stegeman, Charles. 1993. *Les crypts de la cathédral de Chartres et les cathédrals depuis l'époque gallo-romaine.* Chartres.

———. 1997. "Les cathédrals pré-romanes de Chartres." In *MMSC*, 21–38.

Steiner, Ruth. 1993. "Marian Antiphons at Cluny and Lewes." In *Music in the Medieval English Liturgy: Plainsong & Mediaeval. Music Society Centennial Essays*, ed. Susan Rankin and David Hiley, 175–204. New York.

Stirnemann, Patricia. 1997. "Gilbert de la Porrée et les livres glosés à Laon, à Chartres et à Paris." In *MMSC*, 83–96.

Stoddard, Whitney. 1987. *Sculptors of the West Portals of Chartes Cathedral: Their Origins in Romanesque and Their Role in Chartrain Sculpture Including the West Portals of Saint-Denis and Chartres.* New York.

Stones, Alison. "Images of Medieval Art and Architecture." http://vrcoll.fa.pitt.edu/medart. Accessed August 25, 2008.

———. 1992. "The Decoration and Illumination of the *Codex Calixtinus* at Santiago de Compos-

tela." In *The "Codex Calixtinus" and the Shrine of St. James*, ed. John Williams and Alison Stones, 137–84. Tübingen.

Stow, Kenneth. 2001. "Conversion, Apostasy, and Apprehensiveness: Emicho of Floheim and the Fear of Jews in the Twelfth Century." *Speculum* 76:911–33.

Stratford, Neil. 1983. "The 'Henry of Blois Plaques' in the British Museum." *British Archaeological Association Conference* 6:28–37.

———. 1993. *Catalogue of Medieval Enamels in the British Museum, 2: Northern Romanesque Enamel*. London.

Sydenham, Colin. 1984. "Translating the Gloucester Candlestick." *Burlington Magazine* 126:504.

Symes, Carol. 2002. "The Appearance of Early Vernacular Plays: Forms, Functions, and the Future of Medieval Theatre." *Speculum* 77:778–831.

———. 2005. "The Lordship of Jongleurs." In *The Experience of Power in Medieval Europe, 950–1350: Essays in Honor of Thomas N. Bisson*, ed. Robert F. Berkhofer III, Alan Cooper, and Adam J. Kosto, 231–46. Aldershot, U.K.

Talley, Thomas J. 1990. "The Origin of the Ember Days: An Inconclusive Postscript." In *Rituels: Mélanges offers au Père Gy, OP*, ed. Paul de Clerck and Eric Palazzo, 465–72. Paris.

Talshir, Zipora. 2000. "The Reign of Solomon in the Making: Pseudo-Connections between 3 Kingdoms and Chronicles." *Vetus Testamentum* 50:233–49.

Tanner, Marie. 1993. *The Last Descendant of Aeneas: The Hapsburgs and the Mythic Image of the Emperor*. New Haven.

Terpak, Francis. 1972. "Elements of Creation Iconography in the Incarnation Portal on the West Façade of Chartres Cathedral." Masters thesis, Pennsylvania State University.

Theis, Laurent. 1999. *Robert le Pieux: le roi de l'an mil*. Paris.

———. 2008. "Robert le Pieux était-il pieux?" In *FC*, 129–35.

Thérel, Marie-Louise. 1975. "Pierre le Vénérable et la création iconographique au XIIe siècle." In *Pierre Abélard, Pierre le Vénérable: Les courants philosophiques, litteraires et artistiques en Occident au milieu du XIIe siècle*, 733–44. Paris.

Touati, François-Olivier. 1980. "Une approche de la maladie et du phénomène hospitalier aux XIIe et XIIIe siècles: La Léproserie du Grand-Beaulieu a Chartres." *Histoire des sciences médicales* 14:419–24.

Toubert, Héléne. 1974. "Iconographie et histoire de la spiritualité médiévale." *Revue d'histoire de la spiritualité* 50:265–84.

Traube, Ludwig. 1892. "O Roma nobilis: philologische Untersuchungen aus dem Mittelalter." *Abhandlungen der Philosophische-Philologischen Classe der Königlich Bayerischen Akademie der Wissenschaften* 19:296–397.

Urbach, Efraim Elimelech. 1975. *The Sages, Their Concepts and Beliefs*, trans. Israel Abrahams. 2 vols. Jerusalem.

Van der Meulen, Jan. 1977. "Chartres. Die Weltschöpfung in historicher Sicht. Francia." *Forschungen zur westeuropäische Geschichte* 5:81–126.

Van der Meulen, Jan, and Jürgen Hohmeyer. 1984. *Chartres: Biographie der Kathedrale*. Cologne.

Van der Meulen, Jan, and Nancy Price. 1981. *The West Portals of Chartres Cathedral, 1: The Iconology of the Creation*. Washington, D.C.

Van der Meulen, Jan, et al. 1989. *Chartres: Sources and Literary Interpretation: A Critical Bibliography*. Boston. = VdM.

Van Elswijk, H. C. 1966. *Gilbert Porreta: Sa vie, son oeuvre, sa pensée*. Louvain.

Van Engen, John H. 1986. "The 'Crisis of Cenobitism' Reconsidered: Benedictine Monasticism in the Years 1050–1150." *Speculum* 61:269–304.

Van Houts, Elisabeth. 1984. "Scandinavian Influence in Norman Literature of the Eleventh Century." *ANS* 6:107–21.

———. 1995. *Local and Regional Chronicles*. TSMAO 74. Turnhout.

―――. 2006. Review of Glenn (2004). *Early Medieval Europe* 14:332–36.

Van Houts, Elisabeth, ed. and trans. 2000. *The Normans in Europe*. Manchester, U.K.

Vanuxem, J. 1957. "The Theories of Mabillon and Montfaucon in Franch Sculpture of the Twelfth Century." *JWCI* 20:45–59.

Vasiliev, A. A. 1951. "Hugh Capet of France and Byzantium." *Dumbarton Oaks Papers* 6:227–51.

Vattioni, Francesco. 1975. "Frammenti biblici latini." *Augustinianum* 15:389–422.

Vauchez, Andre. 1981. *La Saintété en Occident aux derniers siècles de moyen âge d'après les procès de canonization et les documents hagiographiques*. Rome.

Verdier, Philippe. 1970. "What Do We Know of the Great Cross of Suger in Saint-Denis?" *Gesta* 9:12–15.

Verger, Jacques. 2008. "Les écoles au XIe siècle." In *FC*, 33–42.

Vernet, André. 1955. "Une épitaphe inédite de Thierry de Chartres," in *Receuil de travaux offert à C. Brunel 2*, 660–70. Paris.

Vezin, Jean. 1974. *Les Scriptoria d'Angers au XIe siècle*. Paris.

Vidier, Alexandre. 1965. *L'historiographie à Saint-Benoît-sur-Loire et les miracles de Saint Benoît*. Posthumously edited and annotated by the monks of Saint-Benoît de Fleury. Paris.

Villette, Guy. 1957, rpt. 1994. *La cathédrale de Chartres, oeuvre de haut savoir*. Chartres.

―――. 1988. "L'art de déterrer une légende impossible: Jean Markare, 'Chartres de l'énigme des druides.'" *Notre-Dame de Chartres* 77:6–14.

Villette, Jean. 1976. "Le voile de la Vierge depuis onze siècles à Chartres." *Notre-Dame de Chartres* (Sept): 4–11.

―――. 1985. "La tête sculptée dite de Regnaud de Mouçon provient plus probablement du gisant de l'évêque Pierre de Celle." *Bulletin Monumental Paris* 143:227–236.

―――. 1989. "Le Puits des Saints Forts et son eau prétendue miraculeuse." *Notre-Dame de Chartres* 79 (June).

―――. 1994. *Les portails de la cathédrale de Chartres*. Paris.

Vöge, Wilhelm. 1894. *Die Anfänge des monumentalen Stils im Mittelalter*. Strassburg.

Vogel, Walther. 1906. *Die Normannen und das fränkische Reich bis zur Gründung der Normandie (799–911)*. Heidelberg.

Vuillemard, Anne. 2006. "Les polychromies architecturales de la collégiale Saint-Quiriace de Provins." *BM* 164:271–80.

Walter, Barbara R., Vincent J. Corrigan, and Peter T. Ricketts, eds. 2007. *The Feast of Corpus Christi*. University Park.

Warning, Rainer. 2000. *The Ambivalances of Medieval Religious Drama*, trans. Steven Rendall. Stanford.

Warren, Michelle. 2002. "The Flavor of Sin in the Ordo Representacionis Ade." *Neophilologus* 86:179–95.

Warren, Wilfred Lewis. 1973. *Henry II*. Berkeley.

Watkins, Basil. 2002. *The Book of Saints*. 7th ed. New York.

Watson, Arthur. 1934. *The Early Iconography of the Jesse Tree*. London.

Weiss, Daniel H. 1997/98. "*Hec est Domus Domini firmiter edificata*: The Image of the Temple in Crusader Art." *Jewish Art* 23/24:210–17.

Werner, Karl Ferdinand. 1959. "Untersuchungen zur Frühzeit des französischen Fürstentums (9.–10.Jht.)." *Die Welt als Geschichte* 19:146–93.

―――. 1979. "Gauzlin von Saint-Denis und die westfränkische Reichsteilung von Amiens (880)." *Deutsches Archiv für Erforschung des Mittlalters* 35:395–462.

―――. 1980. "L'acquisition par la Maison de Blois des comptés de Chartres et de Châteaudun." In *Mélanges de numismatique, d'archéologie et d'histoire: Offerts à Jean Lafaurie*, 265–72. Paris.

―――. 1985. "Qu'est-ce que la Neustrie?" In *La Neustrie: Les pays au nord de la Loire de Dagobert à Charles le Chauve (VIIe-IXe siècles)*, ed. P. Périn and L. C. Feffer, 29–38. Rouen.

———. 1992. "Les Robertiens." In *Roi de France*, 15–26.

———. 1997. "Les premiers Robertiens et les premiers Anjou (IXe siècle-debut Xe siècle)." In *Pays de Loire et Aquitaine de Robert le Fort aux premiers capétiens*, ed. Olivier Guillot and Robert Favreau, 9–67. Poitiers.

Wetherbee, Winthrop. 1988. "Philosophy, Cosmology, and the Twelfth-Century Renaissance." In *A History of Twelfth-Century Western Philosophy*, ed. Peter Dronke, 21–53. Cambridge.

———. 2003. "The School of Chartres." In *A Companion to Philosophy in the Middle Ages*, ed. Jorge J. E. Gracia and Timothy B. Noone, 36–44. Oxford.

Wilken, Robert L. 1983. *John Chrysostom and the Jews: Rhetoric and Reality in the Late Fourth Century*. Berkeley.

Williams, Jane Welch. 1993. *Bread, Wine and Money: The Windows of the Trades at Chartres Cathedral*. Chicago.

Williams, John R. 1929. "William of the White Hands and Men of Letters." In *Anniversary Essays in Mediaeval History by Students of Charles Homer Haskins*, ed. Charles H. Taylor and John L. La Monte, 365–87. Boston.

Williamson, Paul. 1995. *Gothic Sculpture, 1140–1300*. New Haven.

Wilmart, André. 1926. "Le Lectionnaire de Saint-Père." *Speculum* 1:269–79.

———. 1931. "Dodaldus, Clerc et Scribe de Saint-Martin de Tours." *Speculum* 6:573–86.

———. 1932. *Auteurs spirituels et texts dévots du moyen âge latin: Études d'histoire littéraire*. Paris.

———. 1937. "Le lectionnaire d'Alcuin." *Ephemerides liturgicae* 51:136–97.

———. 1938. "L'Histoire Ecclésiastique composée par Hugues de Fleury et ses destinataires." *RB* 50:293–305.

Wirth, Jean. 2004. *La datation de la sculpture médiévale*. Geneva.

Woody, Kennerly Merritt. 1966. "Damiani and the Radicals." Ph.D. diss., Columbia University.

———. 1982–89. "Peter Damian." In *The Dictionary of the Middle Ages*, ed. Joseph R. Strayer, 9:508–09. New York.

Wright, Craig. 1994. "Dufay's 'Nuper rosarum flores', King Solomon's Temple, and the Veneration of the Virgin." *JAMS* 47:395–427 and 429–41.

———. 2000. "The Palm Sunday Procession in Medieval Chartres." In *Divine Office*, 344–71.

———. 2001. *Maze and Warrior: Symbols in Architecture, Theology, and Music*. Cambridge, Mass.

Wright, Roger, ed. 1991. *Latin and the Romance Languages in the Early Middle Ages*. London.

Yarrow, Simon. 2006. *Saints and Their Communities: Miracle Stories in Twelfth-Century England*. Oxford.

Young, Karl. 1921. "Ordo Prophetarum." *Transactions of the Wisconsin Academy of Sciences, Arts and Letters* 20:1–81.

Zaluska, Yolanta, and Anne Granboulan. 2005. "Manuscrits des lectures liturgiques du Nord de la France." In *Les manuscrits liturgiques, cycle thématique 2003–2004 de l'IRHT*, ed. O. Legendre and J.-B. Lebigue. Ædilis, Actes 9. Paris.

Zarnecki, George. 1986. "Henry of Blois as a Patron of Sculpture." In *Art and Patronage in the English Romanesque*, ed. Sarah Macready and F. H. Thompson, 159–72. London.

Ziezulewicz, William Charles. 1991. "The School of Chartres and Reform Influences before the Pontificate of Leo IX." *Catholic Historical Review* 77:383–402.

Zink, Jochen. 1989–1990. "Zur Ikonographie der Portalskulptur der Kathedrale Sainte-Lazare in Autun." *Jahrbuch des Zentralinstituts für Kunstgeschichte* 5/6:5–160.

Zinn, Grover A. 1977. "The Influence of Hugh of St. Victor's *Chronicon* on the *Abbreviationes Chronicorum* by Ralph of Diceto." *Speculum* 52:38–61.

———. 1986. "Suger, Theology, and the Pseudo-Dionysian Tradition." In *Abbot Suger and Saint-Denis: A Symposium*, ed. Paula Gerson, 33–40. New York.

# SCRIPTURAL CITATIONS

Quotations from the Vulgate Bible are taken from the so-called Douay Rheims Version. The Old Testament was first published by the English College at Douay in 1609, and the New Testament by the English College at Rheims in 1582.

Genesis 28, 176
Genesis 49:10, 90–95, 219, 271, 296–97, 299
Exodus 26:31–33, 221
Exodus 33:20, 214
Numbers 17, 85, 125, 177, 294
Numbers 19:1–5a, 303–4
Judges 6:36–40, 294–95
3 (1) Kings 6:29, 177
2 Paralipomenon (Chronicles) 5:4–8 & 12–13, 212–13
2 Paralipomenon (Chronicles) 6–8, 173, 176
Tobias 12:13–15, 315
Psalm 23/24, 57
Psalm 44:3/45:2, 86
Psalm 47:10–11/48:9–10, 232
Psalm 97/98, 232, 236
Psalm 117/118:22, 297
Psalm 132/133, 197
Song of Songs, 209
Song of Songs 2:16–3a, 233–34
Song of Songs 3:3b-5, 233–34
Isaias 1:1–3, 67
Isaias 1:4–6a, 70
Isaias 1:6b-9, 72
Isaias 6:1–8, 288–90
Isaias 7, 86
Isaias 7:14, 290

Isaias 11, 86, 125
Isaias 11:1–3, 290, 294, 326
Isaias 19:1, 331
Jeremias 7:2–15, 57
Lamentations 3:53, 311–312
Daniel 2:34, 297

Matthew 1:1–17, 47, 87, 95, 115, 259, 268–72
Matthew 21:1–9, 63, 73, 74
Mark 9:2–8, 306
Luke 1:26–38, 75
Luke 1:30, 225–26
Luke 2:8–19, 229–30
Luke 2:25–38, 118, 232–36
Luke 3:1–6, 75–76, 219, 221
Luke 4:3–9, 222
Luke 19:1–10, 176
Luke 21:25–28, 64
Luke 24: 13–35, 314
John 1:14, 280
John 2:1–11, 222
John 3:13, 280
John 10:9, 142–43, 248
Acts 1, 278
Acts 10:34–42, 312–14
Hebrews 9, 157, 177–78, 206, 219, 221, 222, 230
Apocalypse (Revelation) 12:6–7, 302

# INDEX OF MANUSCRIPTS

# General Index

Aaron's rod, 85–86, 177
Abbo of St. Germain, 12–14
Adalbero of Reims, 45
Adela of Chartres/Blois, 158, 162
Adela, Countess, 31, 134, 143–46, 181, 191
Adelman of Liège, 101
Adémar of Chabannes, 28
Advent, 42, 47, 55–78, 81, 89–90, 93, 95, 286;
  fourth Sunday, 89–90
Advent, first Sunday, 62–74; Matins, 62–74
*adventus*, viii, 43, 56–59, 61, 248, 284
Albert, Dean, 98, 102–3
Amalar of Metz, 7, 64, 68–69, 71
Ambrose, Saint, 119, 233
Ambrosius Autpertus, 119–20, 234
Andrew of Mici, 98, 102
Anianus, Saint, *vita*, 10–11, 159, 198, 382–86;
  on the fires, 79, 103, 161, 344–45
*Annales Mettenses*, 4
*Annals of Fulda*, 10
*Annals of St-Bertin*, 4–8, 10, 12, 14, 347
Anne, Saint, 251, 344
antiphons: Adorna thalamum, 118–19; Ave
  gracia, 118; Ave Regina celorum, 272; Beate
  Dei Genetrix, 252; Ego sum alpha, 323, 333–
  34; Hec est Regina, 128, 171, 234, 242, 251–
  53, 259, 287, 343, 419, 438–40, 442; Letare
  virgo Maria, 252–53; Responsum accepit
  symeon, 118–19, 231; Omnis vallis, 77
Apponius, 86
*Approbate consuetudinis*, 79, 81–89, 112–16,
  122, 268, 282, 325, 426–29
Arnold of Bonneval, 171–72, 194–95, 197, 223,
  230–31, 306

Arnoul, cantor, 123
Arnulf, Bishop of Reims, 49
Ascension of Jesus, 278
Audrad the Short, 5
Augustine, Saint, 61, 91–92, 119, 280
"Ave maris stella," 87, 127, 272, 438–42

Baldwin, count of Boulogne, 148–49, 150
Basil of Caesarea, Saint, 88
Baudri of Bourgueil, 144
Bayeux tapestry, 144
Bede, the Venerable, 74, 75
Benedictus, 57, 76–77
Bernard, Saint, 158, 164, 168, 183
Bernard of Angers, 210
Bernard of Chartres, 195–96
Bernard of Tiron, 199–200, 317–19
Bernard the sacristan, 214–16
Bernier of Homblières, 113–14
Berta II, Countess, 134
Berta, Countess and Queen, 41, 45–51, 88
bibles, 338
Bizeau, Pierre, frontispiece, xiii
Blois, 6
Bohemond of Antioch, 140–146
"Book of the Cult" (Chartres, BM 162), *see*
  Mss index

Caesar, *Gallic Wars*, 3
Caesarius of Arles, Saint, 86
cantors, 24, 97–98
Capetians, 13, 14
Carolingians, 14, 29
Catillus, 15

# Index of Modern Authors